COLOR

THE VIKING PRESS, DISTRIBUTORS, NEW YORK
THE KNAPP PRESS, PUBLISHERS, LOS ANGELES

Color was conceived, edited and designed
by Marshall Editions Limited
71 Eccleston Square
London SW1V 1PJ

Editor: Helen Varley
Assistant Editor: Patrick Harpur
Research Assistants: Helen Armstrong, Pip Morgan
Editorial Assistant: Alison Tomlinson

Art Director: Barry Moscrop
Designers: Simon Blacker, Heather Garioch
Picture Editor: Zilda Tandy
Picture Researcher: Mary Corcoran

Production: Hugh Stancliffe

The Knapp Press, Publishers, Los Angeles
The Viking Press, Distributors, New York

© 1980 by Marshall Editions Limited

Library of Congress Cataloging in
Publication Data
Pavey, Donald.
 Color.

 Includes bibliographical references and indexes.
 1. Color—Psychological aspects. I. Title.
BF789.C7P38 152′.1′45 80–15393
ISBN 0–89535–037–8

Consultants

Consultant editors

Yale Forman (U.S. colour and design consultant; President, Yale Forman Designs Inc.; President of the Color Marketing Group, 1976–7)
Carl Foss (U.S. creator of the Foss Color Order System)
Dr. John Gage (Lecturer at the Department of Architecture and History of Art, University of Cambridge; author of *Colour in Turner* and *Rain, Steam and Speed*)
Madge Garland (Former Fashion Editor of British *Vogue*; founder Professor of the School of Fashion Design, Royal College of Art, London)
Sydney Harry (British artist and lecturer in colour theory)
Deryck Healey (Chairman of Deryck Healey International; Chairman of the Council of the National Academic Awards Fashion and Textile Board)
Donald Pavey (Artist-designer of colour-gaming systems and founder of the Colour Collection at the Royal College of Art)
Dr. John Scholes (Scientist, Medical Research Council)
Professor R.A. Weale (Professor of Visual Science, Institute of Opthalmology, University of London)

Consultants

Dr. J.J.G. Alexander (Reader in History of Art, University of Manchester; author of *The Decorated Letter and Insular Manuscripts, Sixth to Ninth Centuries*)
Dr. David Arthey (Head of the Department of Agriculture and Quality, Campden Food Preservation Association,)
Dr. N. Barley (Research Associate, University of London)
Ian Bristow (ARIBA)
Ken Charbonneau (Color and Merchandising Manager, Benjamin Moore & Co., President of the Color Marketing Group, 1979–80)
Brian Coe (Curator of the Kodak Museum, Harrow)
Dr. E.D. Cooke (Research Consultant, Clinical Thermographic Unit, Department of Medical Electronics, St. Bartholomew's Hospital, London)
Jules Davidoff (Research Psychologist; author of *Differences in Visual Perception: The Individual Eye*)

Theo Gimbel (Research Director, Hygeia Studios Ltd.)
Andy Harris (Holographic Developments Ltd.)
Keith McLaren, FSDC (Instrumental Colour Systems Ltd.)
Audrey Mitchell (Director of Hayward, Mitchell and Pavey Limited, Colour Practitioners)
Paul Murray (Lighting Designer)
Charles Nicholl (Author of *The Chemical Theatre*)
Dr. Mark Newcomer, FSA (Lecturer at the Department of Prehistoric Archaeology, Institute of Archaeology, London)
Professor Roy Newton, OBE, FSA (President of the Society of Glass Technology, 1973–5; Director of the British Glass Industry Research Association, 1955–74; Honorary Visiting Professor at the University of York, 1974–9)
Peter Payne, FInstMP, MIOP, MIRT (Head of the School of Graphic Reproduction, London College of Printing)
Tom Porter (Artist; author; Senior Lecturer in Graphics and Design, Department of Architecture, Oxford Polytechnic)
Professor Stephen Rees Jones, FInst P, FSA, FIIC (Former Head of Technology Department, Courtauld Institute of Art, University of London; Professor of Chemistry, Royal Academy of Arts)
N.K. Sandars, FSA
Peter J. Staples, Dip. IMIWM, AMBIM (Technical Director of the Leisure Division of Reckitt & Colman Ltd.; lecturer on artist's materials)
Professor Andrew Strathern (Head of the Department of Anthropology, University College, London)
Bob Tate, FCIBS (Editor of the Thorn Lighting Journal)
Dr. William Vaughan (Reader in History of Art, University College, London; author of *Romantic Art* and *German Romanticism and English Art*)
Dr. Philip Whitfield (Lecturer at the Department of Zoology, King's College, University of London)
Thomas Woodcock, Rouge Croix Pursuivant (College of Arms)

Throughout the text of this book the word color appears as colour.

The first appearance of the word had the most practical spelling: colur, in 1290. Cooler, culler and a dozen other spellings came and went, and the debut of colour in text, in 1398, was in a thought of some insight: 'Colour accordeth to the lyghte as the doughter to the moder.' America's founders used colour; the nineteenth century pragmatists settled on the simpler form. Since colour has 600 years of pedigree, the editors selected this slightly more colourful style.

Contents

The nature of colour

12 An image from the sun
14 The rhythms of light
16 The architecture of iridescence
18 The goddess Iris
20 The substance of light
22 Orchestrating sunlight
24 Colours for survival
26 The alluring hues of plants
28 Animal display and discretion
30 The evolution of colour vision
32 How we see colour
34 Coding colour
36 What the eye doesn't see
38 Confusion by colour
40 The mind's eye
42 Three dimensions of colour
44 Colour in psychology
46 Colour in healing

The progress of colour

50 The vocabulary of colour
52 Body-painting: signs of life and death
54 Body-painting: statements of status
56 The cave painters
58 Symbols of ritual and change
60 The art of dyeing
62 Ceramics and glazes
64 Metals and jewels
66 Lacquer and enamel
68 Colour for buildings
70 Wall-painting
72 Illuminated manuscripts
74 Windows of coloured glass
76 The tinctures of chivalry
78 The tradition of the alchemists
80 The rebirth of colour
82 The decorative arts
84 The impact of science
86 The Romantic view
88 The colour revolution
90 The artist's palette
92 The Impressionist eye
94 The abstraction of colour
96 Other times, other faces
98 Colour on the page
100 Capturing colour
102 Colour in motion
104 Colour by the line
106 Paints for all purposes
108 The highlights of drama
110 Lasers: the purest light

Fashions in colour

114 The century opens quietly
116 A brilliant explosion—and a war
118 The subdued twenties
120 White satin and glitter
122 Bright badges of wartime courage
124 The fifties thought pink
126 Psychedelia and pale faces
128 The satiated seventies
130 The colours to come

Colour at work

134 Naming and identifying
 colours
136 The colours of cultures
138 The power of colour
140 The power of colour 2
142 Colour combinations
144 Colour combinations 2
146 The size of colour
148 The size of colour 2
150 The many moods of natural
 light
152 Artifice with light
154 Painting with light
156 Making faces
158 Colour in dress
160 Furnishing with colour
162 Cultivated colour
164 Colour gets down to business
166 Colour's grand façades
168 Bright lights, city flickers
170 Colour in the market-place
172 Colour in the market-place 2
174 The flavour of colour

The palette of colours

178 The colourless colours
186 Red, the dynamo
194 Orange, the understudy star
200 Yellow's tidings of joy
206 Green for life and love
212 The infinity of blue
218 Deep, deep violet

The potential of colour

226 Mixing and matching
228 Mixing and matching 2
230 Solo
231 Duo, Trio
232 Happy Family
233 Exploring contrasts
234 Discords
235 Perm 4
236 Complementary contrasts
237 Zing
238 Fret
239 Grid
240 Jazz
241 Sphere

242 Glossary of terms
246 Index
251 Recommended books
255 Acknowledgements

Foreword

In the days when I began a life in colour it was a lonely trail. It seemed that very few knew colour led into virtually all realms of human life and culture; how there was hardly a single aspect of progress that had not been tinted by colour. I saw, at that time, in the twenties and thirties, monumentally ambitious books . . . Durrant's *The Story of Philosophy* and Larrett's *The Story of Mathematics*. I knew *The Story of Colour* was on that scale.

It is a chronicle of great men. Pythagoras and Hippocrates dwelt upon it. Plato, Aristotle and Pliny attempted to explain its mysteries. Da Vinci related colours to the elements: yellow for earth, green for water, blue for air, red for fire. Then there was Newton, who founded the science of colour as accepted for generations. He was as much an alchemist as a scientist, and his perception of seven colours in the spectrum may have been influenced by a mystical strain in his character which has been quite overlooked. Seven was the alchemical magic number, the holy number, the number of notes in the diatonic musical scale and the purported seven planets. Voltaire declared that Newton was the greatest man who ever lived. Goethe thought Newton's colour theories an 'old nest of rats and owls'.

But the point is that all these great men were bewitched by

colour. And there were others: physicians who proposed the curative properties of colours; sages and mystics concerned with colour's role in assuaging gods, ensuring bountiful harvests; composers, such as Wagner, who related colour to musical expression; scientists who explained the rainbow, the vivid display colours of insects and animals, and the role of the peacock's extravagant costume; psychologists who postulated colour's ability to reveal the elements of the human personality.

Since my early literary ambitions, the story has exploded. For colour is no longer a province of the privileged. In discotheques and psychedelic art, in fabrics and plastics and the metal finishes on our cars and cookers, colour is showing its potential for enriching life. It can astonish dangerously, as in the effects of taking LSD; but, more importantly, it can be a power for healing, understanding and communication.

Now we have a book that celebrates the whole, rich pageant. With so much new knowledge it needed a team of specialists—scientists, designers and doctors, artists and architects, advertising men and fashion women. What is so thrilling about *Colour* is that today's understanding enables them to tell you how to orchestrate the spectrum in *your* life.

Faber Birren

Faber Birren is a leading international colour consultant advising industries, schools and hospitals, even governments, on response to colour. In support of colour education he established at Yale University's Art and Architecture Library the Faber Birren Collection of books, a unique reference source on the subject.

THE NATURE OF COLOUR

Colour impinges on our every waking moment and penetrates our dreams. There is colour in daylight, in the sky and in the landscape, in our skin, hair and eyes. Every object we manufacture to use or wear is coloured.

But what is colour? All-pervasive, it is carelessly taken for granted and, curiously, is largely unstudied by the majority. It affects us emotionally, making things warm or cold, provocative or sympathetic, exciting or tranquil. Colour enriches the world and our perception of it; a colourless world is almost unimaginable.

Colour is light. So that we see the world as constant and unchanging, the brain reduces our awareness of the ceaseless, subtle changes in the colours of daylight. We have to be persuaded to believe the evidence of our eyes. Yet the colours in light are manifest in the blue of the sky and ocean and in the red and gold glow of dawns and sunsets. Proof of Newton's discovery that sunlight is composed of the colours of the spectrum is apparent every time the sun's rays are dispersed by the droplets of water in a rainbow or a bubble, by a film of oil on a puddle or by the transparent structure of a damselfly's wing.

Bats detect objects by reflected sound; snakes detect the presence of their prey by reflected heat. Most seeing creatures distinguish objects by reflected light. Almost unbelievably, the colours in the plumage of iridescent birds and in the integument of iridescent flies, bugs and beetles are caused by light whose rays are not coloured, as Newton observed. Their surface scales are transparent, but look coloured because their structure disperses the light that falls on them into its component colours. Birds and insects that are not iridescent, and most animals and plants, owe their colours to pigments. Hemoglobin, melanin, carotene and chlorophyll are the colours of nature.

Colour is pigment—but even the colour of a pigment is the colour of the light it reflects. Whenever we see colour we are seeing coloured light, for pigments have a special ability to absorb certain wavelengths from the light that falls on them, and to reflect others to the eye.

Colour is a sensation. The sense of sight functions only when light reaches the eye. The simplest, most primitive organisms react to light, moving towards it or away from it.

The eyes of higher animals are able to decode the colour information carried by the particles of energy of which it is composed and recode it for transmission to the brain. Until it reaches the brain, colour does not exist. But how the brain decodes the complex information it receives, and how it reconstructs in the mind a moving colour picture of the world beyond the eye, has yet to be discovered.

Colour is information. We stop at red lights and move on when they change to green. We use colour to identify objects—fruit that is ripe, decaying vegetables, flowers, birds and animals, the local football team. Colour helps us to diagnose illness and recognise anger, fear and embarrassment. We respond to colour; our colour preferences are keys to buried emotions.

Light is a form of energy, a range of electromagnetic radiations characterized as colours, each of which has a different wavelength and frequency. Colours can be measured. When in 1880 a British brewer, Joseph Lovibond, sought the means to ensure that his beer was of a consistent colour, he became the patriarch of colorimetry, the measurement of colour. Inspired by the constancy of the colour of the stained glass in Salisbury Cathedral, he bought quantities of brown glass to test the beer against. The idea quickly proved to be marketable, so he persisted with it, learning to produce any desired shade by combining different glass tints of magenta, yellow and cyan. These are the artist's primary colours. When mixed or combined together, they absorb almost all the light that falls on them, and look almost black.

The possible permutations of the Lovibond filters came to approximately 9,000,000, a measure of how many colours there are. They were used in a simple machine rather like a slide projector, called the Lovibond Tintometer. This basic model colorimeter has scarcely changed since the turn of the century, and is in universal use today for quality control.

There are additive colorimeters which use the seventeenth-century notion of trichromacy as a basis, the fact that only three primary colours, blue, green and red, when mixed together in equal proportions will produce 'white' light, but when mixed in unequal proportions will produce almost any other colour. The most advanced device for colour measurement is the spectrophotometer, which first appeared in 1929. It measures the amount of light reflected or transmitted by a coloured sample or object at each wavelength in turn throughout the visible spectrum. A spectrophotometer used in conjunction with a standard light source and observer gives a precise, objective definition of any colour, and the recorded definition can be represented on a graph known as a chromaticity chart. Colours can be reduced to mathematical formulae. But the curve plotted from measurements of wavelength on a graph does not show what colours look like; its co-ordinates show only how they can be built up.

To explain why the sky is blue, how a rainbow is formed or why a spectrum can sometimes be seen through the fine mesh of a cobweb, involves the most complex physics and encompasses almost all that is known about the nature of light.

Yet somehow, to understand the complexity of colour enriches our perceptions and deepens our pleasure in small, everyday occurrences—the glimpse of a diffraction spectrum formed by a car's headlights shining through a fold in a nylon curtain, a pale mauve sunset on a stormy day, or the faint moonbow encircling the lunar disk captured in the photograph opposite. To understand colour is to add a dimension to life.

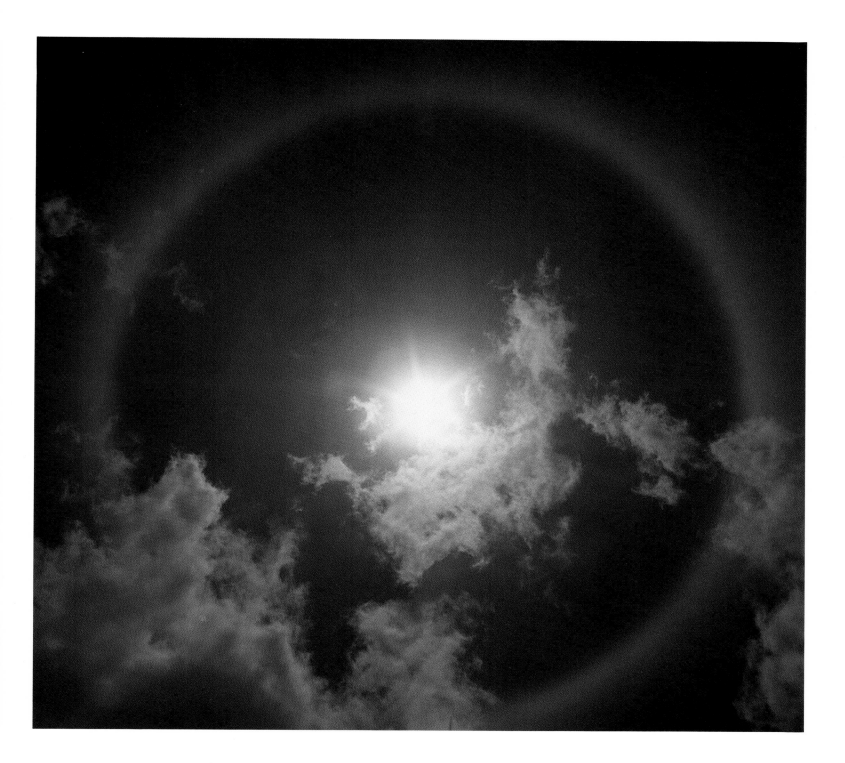

An image from the sun

One precise arrangement of colours turns up again and again in a predictable and unvarying succession of hues: the spectrum. It can appear in the sparkle of a diamond or the glitter of a crystal chandelier, shimmering in the plume of spray over a waterfall—or, most spectacularly of all, arcing right across the sky in the brilliant curve of a rainbow.

For centuries men wondered what caused these vivid bands of colour. Why did they appear in so many different places, and why was the arrangement of the colours always the same? From the time of Aristotle, philosophers had made elegant but unverifiable attempts to explain the colours as the results of differing mixtures of light and dark. The purest, most brilliant light was, they said, white light. But if white light were mixed with a little shadow, it became red light, just as the red glow of sunrise or sunset came in between the brilliant whiteness of daylight and the blackness of night, or the red glow of a fire was caused by the fire's white light mixing with the darkness of the smoke. A greater proportion of shadow would produce green, and more shadow still would give rise to blue, the nearest colour to black; this, they correctly assumed, was not a colour, but resulted from a privation of light.

But theories like these brought no closer an understanding of the spectrum. That had to wait for Sir Isaac Newton who, while investigating something entirely different, chanced to stumble across the truth behind the spectrum—which led in turn to the explanation of how it is that colours are produced.

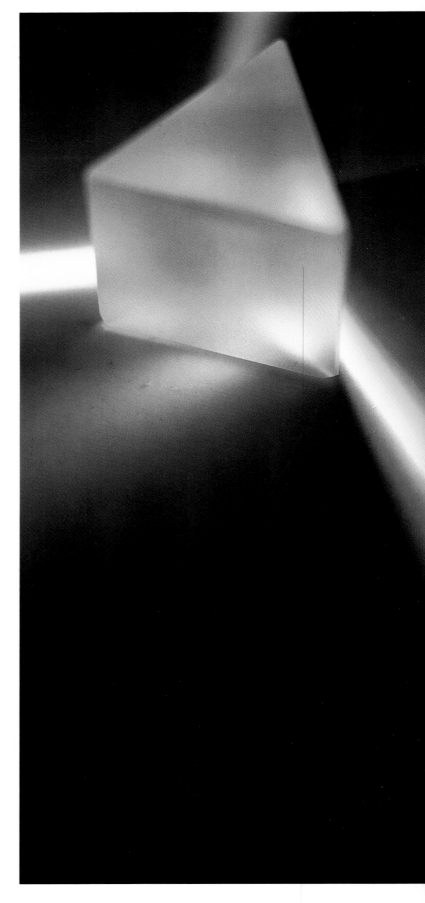

The spectrum of light occupies just a narrow band within an infinitely wider spectrum of electromagnetic radiations. X-rays, radio waves, ultraviolet, infrared and 'white' light are just a few of the radiations emitted by the sun and other stars. Towards the end of the nineteenth century, James Clerk Maxwell, a Scottish physicist, identified them all as belonging to the same range, the electromagnetic spectrum, *right*. Some of these radiations are screened from the Earth by the atmosphere, but many of those that penetrate it have been put to practical use.

Although electromagnetic radiations are so different from one another, they all have certain characteristics in common: they behave as waves radiating in all directions from their sources, and travel through space in straight lines at a speed of about 186,000 mi per second.

The electromagnetic spectrum is measured in metres. Some radio waves are several hundred metres long, but the wavelength of visible light is very much shorter, about half a millionth—or 0.0000005 m. To avoid having to use such large numbers, visible light is usually measured in nanometres (nm); *nanos* is the Greek word for nine; 1 nm = 10^{-9} m (or 0.000000001 m). The wavelength of visible light ranges from about 380 nm to 760 nm and measures on average about 500 nm.

The electromagnetic spectrum

	Wavelength (metres)
	10^{-16}
	10^{-15}
Gamma rays	10^{-14}
	10^{-13}
	10^{-12}
X-rays	10^{-11}
	10^{-10}
	10^{-9}
Ultra-violet light	10^{-8}
	10^{-7}
Visible light	10^{-6}
Infrared light	10^{-5}
	10^{-4}
Microwaves	10^{-3}
Radar	10^{-2}
FM radio	10^{-1}
Television	1
Short-wave radio	10
AM radio	10^{2}
	10^{3}
	10^{4}

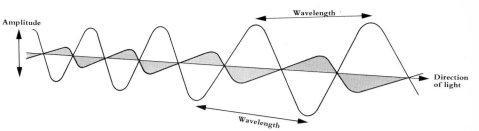

A wave's motion is like that of a rope being shaken up and down—the vibrations are perpendicular to the direction of propagation. The wavelength is the distance the wave travels in one cycle of vibrations, between two crests or troughs, and frequency is the number of waves passing a point each second. The energy, or brightness, of a wave is proportional to the amplitude from the crest or trough to a zero, or centreline. A single wave like this is monochromatic and saturated, but 'white' light is a mixture of many wavelengths.

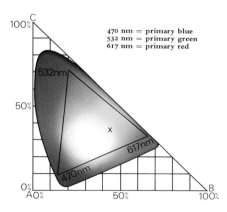

'In a very dark Chamber,'

Newton recorded in his *Opticks*, 'at a round Hole, about one third Part of an Inch broad, made in the Shut of a Window, I placed a Glass Prism, whereby the Beam of the Sun's Light, which came in at that Hole, might be refracted upwards toward the opposite Wall of the Chamber, and there form a colour'd Image of the Sun.'

Newton understood that when light falls upon a transparent object, most of the rays are bent or refracted through it: a stick in a bucket of water seems to bend at the point where air meets water. Refraction occurs because rays of light, on penetrating a medium denser than the one they are travelling in, are slowed down, and if they strike it obliquely they are deflected at an angle proportional to that at which they strike. Light is composed of a number of waves all having different wavelengths and frequencies, or rates of vibration. Newton observed that each component wave, on penetrating the prism, is refracted at a different angle: red light, with the longest wavelength and lowest frequency, is refracted least; violet light, with the shortest wavelength and highest frequency, is refracted most. So in this reconstruction of Newton's experiment, the light on passing the prism's first surface is dispersed—or separated—into its constituent wavelengths. When light falls on any polished object some is always reflected at an angle equal to that at which it falls, so some light is reflected at an angle from the sides of the prism in the illustration.

The prism's second surface refracts the emerging rays again, dispersing them more widely as they pass out into the thinner medium of air. But the rays that emerge are not coloured. The spectrum becomes visible only when it is directed on to a surface. Reflected from that surface, the component wavelengths of light produce in the eye the sensations of the spectral colours.

Newton found that if he isolated any colour from the spectrum and passed it through differently coloured solutions, or reflected it from coloured surfaces, he could not change its hue. The spectral colours he termed primaries, and demonstrated that if they are all mixed together they will recombine into 'white' light.

But he failed to make one important discovery: that 'white' light can be produced by adding together as few as two or three primaries. When, for example, blue and yellow, greenish blue and red or, *above*, red, green, and blue lights are projected at equal intensities on to a white surface, 'white' light appears where all three overlap. Where two of the colours overlap, the secondaries—yellow, magenta (bluish red) and cyan (greenish blue)—appear. Colour television is based on this principle of additive mixture.

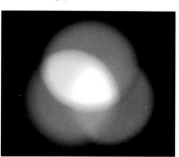

470 nm = primary blue
532 nm = primary green
617 nm = primary red

Adding red, green and blue

lights together does not only produce 'white' light: by varying the intensities of the three primaries, almost any other colour can be obtained. On the chromaticity chart, *above right*, the light primaries are marked by the vertices of the inner triangle; their intensity lessens in relation to their distance from the source. Using such a graph, the television engineer can define any colour in terms of the primaries needed to mix it: colour X is a mixture of 35% green, 45% red and 20% blue. The range of colours within the inner triangle, then, results from mixtures of the three primaries and represents all the colours reproducible on television.

Points A, B and C on the graph are theoretical colours, termed supersaturated blue, red and green respectively; they are unachievable because they are more intense—or saturated—than any existing coloured lights. Any of the blues, reds and greens in the inner triangle could be used as primaries. The television primaries are selected for their efficiency in reproducing the greatest number of colours possible in that medium.

13

The rhythms of light

The Black Death closed down Cambridge University in 1665. Isaac Newton, then a 23-year-old postgraduate at Trinity College, returned home and there turned his mind to improving the telescope, the most advanced scientific tool of the day.

Galileo had combined a convex magnifying lens with a concave eyepiece lens, producing a telescope rather like a pair of modern opera glasses— but the concave eyepiece limited the field of view. A better version had convex lenses both for the magnifying lens and the eyepiece, but this introduced another defect. The rays of light passing through the centre of the spherical lens then in use were brought to a focus slightly farther away from the lens than those passing through the periphery. The effect of this spherical aberration causes a blurring of the image.

The key to the problem was to change the shape of the lens and bring all the light rays to a focus at the same point, but Newton found that the improved lenses he ground had yet another problem: what should now have been a sharp image was spoiled by the edges being blurred by rims of colour. In fact, the surfaces of his lenses were behaving like thin prisms and producing a spectrum, a phenomenon known as chromatic aberration.

Intrigued by these colours, Newton set up an experiment to examine them using a strip of paper coloured half red and half blue, with a black silk thread wrapped around it many times to make a pattern of fine lines across the surface. He illuminated the paper with candle-light. With a convex lens he tried to focus on each colour in turn, and found he had to move the lens an inch and a half closer to the paper to bring the black lines on the blue part into focus than was necessary to keep the black lines on the red part in focus. Clearly there is no sharp focus for 'white' light; different colours refract differentially, so the focal length of a lens depends on the colour of light.

At this point Newton abandoned his work on telescopes to investigate the phenomenon of colour. With a prism he dispersed sunlight into the spectrum, just as his lenses had been doing. In his *Opticks* he described how 'an Assistant, whose Eyes for distinguishing Colours were more critical than mine, did by Right Lines . . . drawn across the Spectrum, note the Confines of the Colours'. Since the colours of the spectrum merge into one another, identifying each one precisely can be difficult. Most people see only six, so to be able to mark the boundaries of indigo in the spectral range between blue and violet, Newton's assistant must have possessed a high acuity for colour vision.

Newton experimented on all of these spectral colours in turn and discovered that when he passed each one through a prism, it would refract, but would not disperse into other colours. Only 'white' light would form a complete spectrum.

Newton was not the first to discover that colours are produced when a beam of sunlight is directed through a prism. A Dalmation Jesuit, Marco Antonio de Dominis, described such an experiment in a treatise published in 1611, but he explained colour in traditional Aristotelian fashion. Newton's genius lay in his scientific method of investigation. Suspecting that the band of colours that make up the spectrum must be mixed together in 'white' light to begin with, and that they become visible only because each colour is refracted to a different extent by the prism, he tested his hypothesis by placing a second prism in the path of the spectrum formed by the first. By inverting this second prism so that the order of the different effects of refraction was reversed, he caused the spectral colours to recombine into a beam of 'white' light. This was solid proof of his theory. He concluded that all spectra are formed by the action of light on transparent objects such as pieces of glass and drops of water, all of which behave like miniature prisms.

Newton noticed that the arrangement of colours in the

If a soap bubble is illuminated with 'white' light, coloured bands appear on the surface. There is no pigment in a soap bubble; the colours are caused by the interaction of light with the film, and they vary according to its thickness. The ultra-thin part at the top is usually dark, giving way to a broad white band followed by red yellow, purple and blue bands. Below are bands of yellow, purple and green, and at the bottom, where the soap film is thickest, the bubble may be white. But the colours change as the film gravitates downwards, evaporates and moves.

Understanding the wave nature of light meant that Newton's rings could be explained: when light is shone on the lens, some waves are reflected from the surface— and some refract through the lens. These are reflected from the glass pane beneath and refract again as they emerge. Coloured circles appear where the waves passing through the lens emerge in phase with those of the same length reflected from the surface. Dark rings appear where the two emerge out of phase and interfere destructively, cancelling each other out.

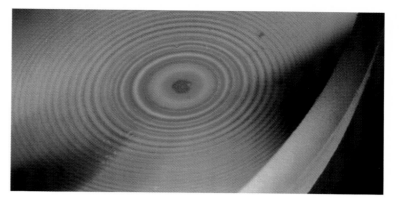

spectrum is ordered and predictable: red light, refracted least, is always at the opposite end of the spectrum from violet light, whose refraction is greatest. But every rule has its exceptions, and he could not understand why the colours he saw in a soap bubble appeared in a different order.

Sensing that this shuffling of the normal arrangement of colours had something to do with the thinness of the soap film which formed the bubble, he tried to produce a similar effect by laying a very thin convex lens on a pane of glass and shining a beam of 'white' light on to it. He found that the point of contact between the centre of the lens and the pane was dark, but around this point were coloured rings: faint blue around the contact point, then white, orange, red, dark purple, blue and green. Although they are still called Newton's rings, Newton was unable to explain them.

Newton was handicapped by not knowing enough about what light is. He thought of a ray of light as a stream of tiny particles travelling in a straight line. Two of his contemporaries, Robert Hooke and Christian Huygens, began to suspect the truth: that light behaves as a wave, which could account for this strange effect. But it was not until the early nineteenth century that an English physician, Thomas Young, first proved the idea to be true. If light were made up of waves, he reasoned, waves vibrating in step would tend to reinforce one another, but waves vibrating out of phase—in the same spot at the same instant, but in opposite senses—would tend to cancel each other out.

Young cut two very narrow slits close together in a screen and shone monochromatic light through them to fall on to a second screen just behind. A central bright band of light appeared on the second screen, with alternate light and dark bands on either side.

Where the waves were vibrating out of phase they interfered destructively, cancelling one another out. The dark bands ap-

peared where this happened. But where they were vibrating in phase they were reinforcing—or interfering constructively with —one another and where this happened, bright bands appeared. Since the wavelength of light is so small (about 1/2,000,000 of a metre) the difference between waves in and out of phase is so slight that the pattern they produce can be seen only when the two sets of waves have the same length and travel in the same direction—through the two slits in Young's experiment, between the thin lens and the glass pane in Newton's experiment, or between the inner and outer surface of a soap bubble.

Young's proof of the wave nature of light led to the discovery that light has properties in common with other electromagnetic radiations. Just as the electromagnetic spectrum stretches from long radio waves at one end to very short-wavelength gamma rays at the other, each colour in the spectrum of light is in fact a different wavelength, or more exactly a group of wavelengths, bearing the same relation to the spectrum as a whole as a note on a piano keyboard or a particular station on a radio tuning dial. Red light, for example, ranges roughly from 760 to 630 nanometres; as the wavelength shortens towards the orange band it becomes tinged with orange. At the other end of the spectrum violet light ranges from about 450 nanometres to 380, at which point it merges into the invisible waveband of ultraviolet light. And since the shorter the wavelength the greater the refraction, this accounts for Newton's discovery of how the prism disperses 'white' light into the different colours of the spectrum.

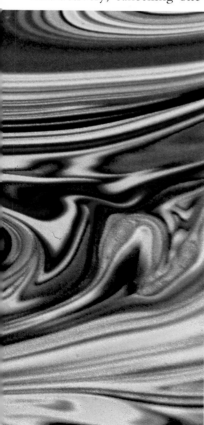

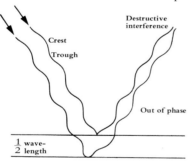

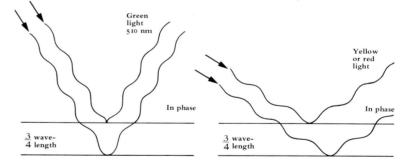

When 'white' light falls almost perpendicularly on to a transparent film half as thick as, say, a wave of green light of 510 nm, the waves that refract into the film travel a distance of one wavelength through it. Logically, waves of 510 nm reflected from the lower surface should emerge in phase with those of the same length reflected from the upper surface. But light waves reflected from a medium more dense than the one they are travelling in undergo a phase change of half a wavelength. So waves of 510 nm refracted through a film thickness half, *above*, or any multiple of half their wavelength emerge out of phase with those reflected from the upper surface. Where this occurs, dark bands show on the film.

Where the film measures a quarter of the thickness of one wavelength of light, or an odd number of quarter wavelengths, the two waves emerge in phase. Waves of 510 nm refracting into a film three-quarters their thickness, *above*, travel a distance of $1\frac{1}{2}$ wavelengths through it, and emerge in phase with those of the same length reflected from the upper surface. The two reinforce one another, and this constructive interference produces the bright green bands on the soap film, *left*. Lighter green bands may appear where the longest green wavelengths emerge slightly out of phase. Where the film is very thick, constructive interference occurs in several wavelengths, and, due to additive mixture, it looks white.

The bubble is green, then, only where light falls almost perpendicularly on to those parts of its surface whose thickness is equal to an odd number of quarter wavelengths of green light. In these areas destructive interference occurs among light waves of other lengths; and constructive interference produces other colours where the film is thicker or thinner. And should the observer or the bubble move to a more oblique viewing angle, the colours change: waves of 510 nm striking a film three-quarters their thickness at an oblique angle, *above*, could travel a distance of two wavelengths through it and emerge out of phase. Longer waves striking the film at this angle emerge in phase, so it looks yellow or red.

The architecture of iridescence

There are colours in nature that are as mobile and as transient as puffs of smoke or ripples on the surface of a pool. The colours of the spectrum are there when sunlight falls on a film of oil on water or shines through the gossamer fibre of a dragonfly's wing, but their order and their positions change continually; the hues shift and shimmer, vanish and reappear with every slight movement. Ironically, these ephemeral and ever-changing colours are called iridescent, from the Greek word for the rainbow—though compared with their fickle brilliance even a rainbow seems a symbol of order and permanence.

The kinetic colours in the wings of some butterflies are created by the same interference effects that produce the colours on the surface of a soap bubble. The light waves refracted by their wing scales interfere constructively with waves of the same length reflected from the upper surface. Since interference colours shift to different wavelengths as the viewing angle changes, their wings change colour as they skim and dart. The iridescent wings of the Madagascan moth, *Urania rhiphoeus*, are used to make jewellery. Each scale consists of five horizontal layers and interference effects cause the wings to vary from green, blue or purple to orange, yellow or green when seen from different angles. The more layers in the structure within the insect's scales, the more brilliant the interference colours produced. Bugs and beetles with multiple layers, such as the Spanish fly, *Lytta vesicatoria*, shine like living jewels with metallic blues, greens and golds. Their colours are so bright because they are caused by additive interference of light; they are not pigment colours.

The spectacular colours in the feathers of the Guatemalan quetzal bird *Pharomachrus mocino*, once an Aztec deity, and of the peacock, are due to interference colours. Precious stones such as opals also display brilliant interference effects—but the colours of mother-of-pearl have been ascribed to another phenomenon. Examined microscopically, the lining of the oyster shell can be seen to consist of layers of crystals inclined at an angle to the shell's inner surface, forming a striated pattern; light passing along these striations bends towards their edges and is diffracted into its constituent wavelengths, producing spectra. Diffraction colours sometimes occur when light shines through the threads of a spider's web woven across a window and the flickering rainbow colours of ctenophores, tiny plankton, are caused by light being diffracted by their hairlike cilia which comb the water in search of microscopic food.

If thousands of grooves are scored only a few wavelengths of light apart in a piece of metal foil, as the light strikes it the sheet seems inflamed with the colours of the spectrum. On the same principle, a diffraction grating can be made by engraving thousands of grooves on a piece of celluloid film or glass. When light shines through the grating each of the grooves causes some to be diffracted and this sets up a complicated pattern of interference resulting in the formation of a whole series of spectra. If pure monochromatic light is passed through a diffraction grating, its wavelength can be accurately measured by observing the interference pattern produced. The science of spectroscopy resulted from the discovery that each chemical element produces its own interference pattern: heating an unknown compound until it glows, then passing the resulting light through a diffraction grating, produces a set of lines which can be related to known wavelengths on the full spectrum. They reveal the elements of which the compound is made—sodium, for example, produces a pure yellow light. And if light from distant stars is passed through a diffraction grating scientists can identify the materials of which they are composed.

Shimmering colours in the wings, thoraxes and even the eyes of many iridescent bugs and beetles are due to interference effects produced by light penetrating many surface layers of ultra-thin transparent scales. The thickness of the scales and their distance apart causes constructive interference in light of specific wavelengths, so the colours change according to the angle from which such an insect is seen. The exquisite diamond beetle, *Entimus formosus viana*, *below*, has stacks of minute scales spread out all over its body. Light is reflected and refracted at each layer, so each stack produces a different colour when seen from a different angle. Since the stacks are inclined at various angles, the bug glitters with all the colours of the spectrum, like an array of sparkling diamonds.

The tropical Morpho butterflies of South America are famed for their large wings of an intense iridescent blue. They look bluest from above, at which angle the wing scales reflect the light falling almost vertically on to them. At more oblique viewing angles the blue deepens into violet, and at the most oblique angle they look dull brown. But Morpho blues vary from an intense metallic ultramarine to a pale moonbeam opalescence. *Morpho peleides*, *right*, of Colombia, has wings of a mid-blue pearly sheen with brown pigmented borders. The blue is lightened by a surface layer of transparent scales whose rough texture reduces the intensity of light from the iridescent scales beneath. The basal membrane is coloured with a brown pigment.

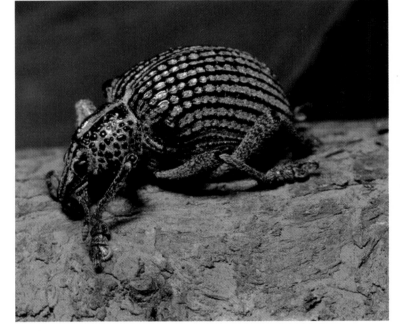

When looking at the sun through half-closed eyes, a spectrum can be seen on the eyelashes. The colours are those produced when light is passed through a prism, but this spectrum is caused by diffraction. The phenomenon occurs when light shines through a narrow slit, or a number of slits closely aligned. Some of the light waves are bent slightly towards the edges of the slit—as if they were exerting an attraction upon the waves passing closest to them.

If the slit is narrow enough, the light will disperse into colours, *right*, because different wavelengths of light diffract differentially. But red diffracts more than blue, so the colours appear in reverse order from that produced when light is refracted through a prism.

Sunlight streaming through a chink between curtains spreads outwards as it is diffracted by the edge of each curtain. The diffracted waves then interfere with each other, accounting for the fuzzy edges of the shadows.

Similarly, if light is projected through two identical slits, A and B, *centre right*, the diffracted waves from slit A interfere with those of the same length from slit B. Where crests meet or troughs overlap, the waves reinforce each other; but where crest meets trough the two cancel each other out. In this two-dimensional representation the lines mark the crests and the spaces between them the troughs—so the lines of reinforcement are visible. Projected on to a screen, they would appear as alternating bands of light and shadow.

A photomicrograph of a Morpho butterfly's wing, *right*, reveals rows of overlapping scales, each only about 0.06mm across. A scale consists of rows of elaborate ribs, *below right*, covered by a layer of rough, transparent cells. Each rib consists of seven vertical leaves, one of which is separated to show the horizontal bars that convert the rib into a lattice-like structure of thousands of rectangular air-filled boxes. Every box is 110mm thick—a quarter of the wavelength of blue light. Light falling on to each rib is reflected and refracted at each layer, but constructive interference occurs only among blue wavelengths falling vertically on to the ribs and violet wavelengths striking at an oblique angle. The lattice structure prevents constructive interference among light waves of other lengths; they are transmitted to the basal membrane and absorbed.

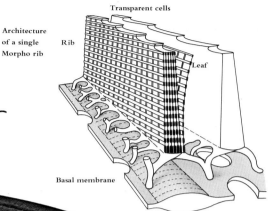

Architecture of a single Morpho rib

Transparent cells

Rib

Leaf

Basal membrane

A diffraction grating consists of 6,000 grooves per cm engraved with a diamond on a piece of celluloid or glass. When light is projected through them on to a screen, the resulting interference between diffracted waves from all the grooves produces a series of spectra, *far right*. The central bright band results from constructive interference producing an additive mixture; the dark bands on either side are the results of all wavelengths interfering destructively and cancelling each other out. Beyond them, the bright band has differentiated into narrow, intense spectra in which blue appears first, followed by green, yellow and red. Toward the outer edges the spectra widen and become darker and fainter, and the dark bands narrow.

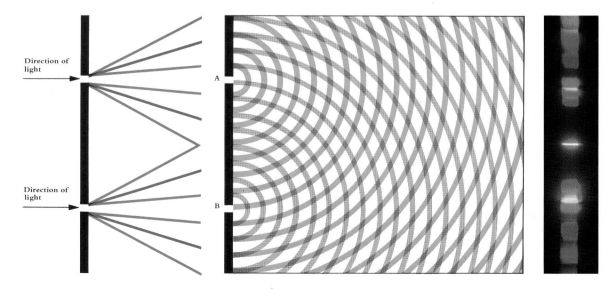

Direction of light

Direction of light

A

B

The goddess Iris

The biggest and most spectacular spectrum of all is the rainbow. Forming a bridge, as it were, between poetry and science it has inspired legends and superstitions among those who watched and wondered. The Greeks saw the rainbow as Iris, messenger of the gods; the Greenlanders said it was the hem of God's cloak and the Norsemen saw it as the bridge by which heroes who died in battle crossed to their reward in Valhalla. It has taken man almost all of his history to explain the rainbow, for it involves everything that is now known about the nature of light.

A rainbow is created when the sun's rays are refracted and reflected by the falling raindrops in a shower. As light from the sun travelling roughly parallel to the ground penetrates each drop, it is refracted into the colours of the spectrum. The refracted rays pass through the drop until they strike the opposite face, where they are reflected and are refracted again as they emerge. A rainbow, then, is the summation of the spectra reflected by millions of raindrops.

Although each drop reflects all the colours of the spectrum, an observer will see from below only the spectra from those drops that are at the correct angle to reflect their dispersed light waves towards him, and even then he will see only one colour at a time from each falling drop. The red light waves are reflected at an angle of about 42 degrees to the direction of the sun's rays, and so all the drops able to reflect red light to the observer lie on a circular arc with its centre opposite to the sun. Red light is reflected at the 'rainbow angle' of 42 degrees; orange light is reflected at a slightly shallower angle, so the drops reflecting orange light form another band across the sky just below the red, and so on.

A rainbow usually appears as a single arc—the primary bow— but a concentric secondary bow sometimes appears above the primary, its colours fainter and in reverse order—the blue at the top and the red beneath. This appears when the raindrops are large enough for some of the sunlight to be reflected twice inside the drop before re-emerging at a different angle. A faint tertiary rainbow, with its colours arranged in the same order as the primary bow, has been seen on very rare occasions, and this bow would be formed by five reflections inside each drop. Under carefully controlled laboratory conditions rainbows have been formed with as many as 18 reflections inside the drops.

Rainbows are produced by drops ranging from 0.01 to four millimetres in diameter. The larger the drops, the purer and brighter the colours, the more widely spaced the coloured arcs and the larger the radius of the bow. Rainbows displaying the brightest colours are formed by intense showers of uniformly large drops. Tiny drops of between 0.01 and one millimetre in diameter may give rise to the rare phenomena of supernumerary arcs beneath the primary bow. They are due to interference among waves emerging parallel from the drops that form the bow. These emerging rays have travelled different distances through the drop, so some reinforce each other and others cancel out. If the droplets are just larger than 0.01 mm in diameter, colourless supernumerary arcs appear as light and dark bands.

So a rainbow may be almost any colour, depending upon the size and uniformity of the drops: the red may be weak, the violet intense; rainbows formed at sunset or sunrise, when the sun's rays penetrating the atmosphere have a distinctly reddish cast, can be mainly or entirely red. Rainbows formed by droplets in mist which are so fine that the spectral colours mix additively may be entirely white—or just tinged with blue and orange. And on rare evenings when the moon is full, just after nightfall a pure white moonbow may appear.

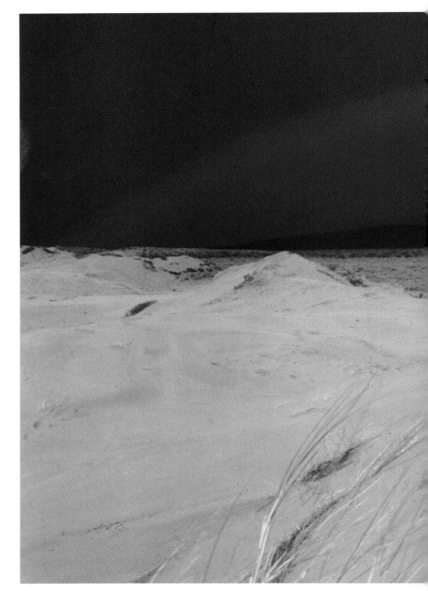

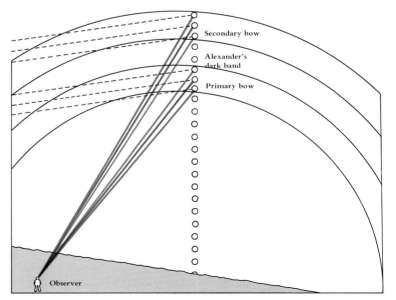

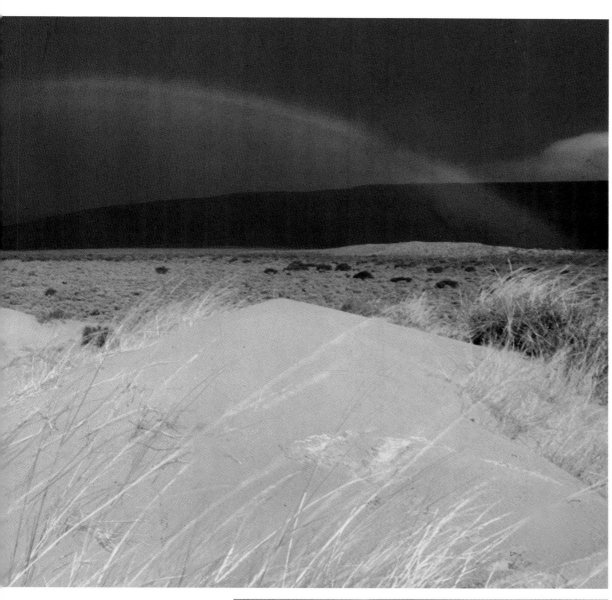

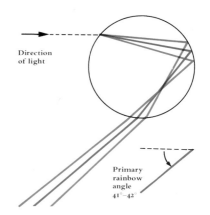

The rainbow can be analyzed by tracing the path of light through a raindrop. Light waves entering close to the top, *above*, are refracted, then reflected from the back and are refracted again on emerging. A falling raindrop is a sphere whose geometry causes waves of the same length refracted close to the top to emerge parallel close to the bottom. Most waves entering elsewhere are scattered, and are invisible, but those emerging parallel enhance one another and so become visible. Their spectrum contributes to the primary bow, *left*. Each wavelength emerges at a different angle: red first at 42° through to violet at 41°.

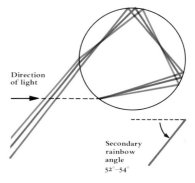

The secondary bow, *left*, is formed by a cluster of light waves penetrating the raindrop close to the bottom. These are refracted on entering the drop, and undergo two internal reflections before being refracted again on emerging, *above*. Each time the dispersed waves are reflected inside the drop, they cross over. At the second reflection, some of the waves emerge from the drop, and from above these would be seen as a primary bow at the correct rainbow angle. The remaining rays are reflected a second time inside the drop, and cross over again at this point, so that when they emerge the order of colours in the resulting spectrum is reversed. The spectrum emerges at a wide angle: violet first at 54° through to green at 53° (the secondary 'rainbow angle') and red last at 52°.

The secondary bow is visible only when the diameter of the raindrops is larger than 0.01 mm. And because some light escapes—and so some energy is lost—at each internal reflection, it is always fainter than the primary bow.

As a raindrop falls it makes a series of decreasing angles between the sun and an observer on the ground below. But only when it moves through the rainbow angles does the observer see its colours, *left*. As it moves through an angle of 54° he sees the violet of the secondary bow; at 53° the green; at 52° the red. The drop then passes through angles at which it transmits no colour. This, the area between the two bows, is known as Alexander's dark band.

As it reaches the 42° angle, the observer sees the red of the primary bow, then all the colours of the spectrum in succession through to violet at 41°. Once the drop passes this point its spectrum ceases to be visible, but the thousands of drops making this journey reveal their spectra at the same angles to form rainbows as long as the sun shines.

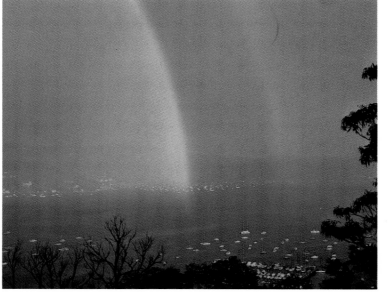

The substance of light

Sensations of colour do not exist without light; the hues in the sweep of a landscape, in the petals of the most vivid flower or in the pattern of a butterfly's wing owe their different appearance to the same daylight which falls on them all. How can there be so many variations in colour?

Common sense says the colour of a carrot has more to do with the carrot than the light falling on it. Scrape the surface of the carrot, slice it, chop it into small pieces and that bright orange colour will still be there, apparently as much a part of the carrot as its taste or its texture.

Yet its colour *does* depend on light, but it was not until the development of the quantum theory that this was understood. The theory originated in 1887 when the physicist Philipp Lenard discovered the photoelectric effect: that certain metals emit electrons, and electric current flows, when light is absorbed.

Nothing in the wave theory of light could explain this mechanism until, in 1900, Max Planck proposed that oscillating atoms emit and absorb energy in packets, or 'quanta'. Einstein proved that light is composed of quanta, which he called photons (*photos* is the Greek word for light). In motion, as propagated light, they behave as waves, travelling with different frequencies, or wavelengths.

Different wavelengths of light, differently coloured, are composed of photons of different energies; those in the short-wave region of the spectrum have most energy and long-wave photons have least. When light falls on an object the photons behave not as waves but as particles, some of which are absorbed, some transmitted and some reflected. The eye sees an object only by the light it reflects, so the wavelengths it reflects determine its colour.

Some objects reflect and absorb light of all different wavelengths equally well. Black velvet absorbs nearly all the light that falls on it—the incident light; snow reflects nearly all the incident light. An object that absorbs some of each wavelength of incident light, and reflects the rest, appears grey, the actual shade of grey depending on the proportion reflected.

But coloured objects are capable of selective absorption: they absorb photons of certain wavelengths from incident light and reflect the rest. In the case of the carrot, most of the photons from the green, blue and violet wavelengths are absorbed and photons from the red, orange and yellow regions of the wavelength spectrum are strongly reflected.

All matter absorbs and reflects light to some extent, but pigments are the most efficient agents of selective absorption. The carrot owes its orange colour to pigments called carotenoids, which absorb the short-wave light and reflect the long wavelengths—and these pigments also give salmon, lobsters and autumn leaves their characteristic reddish colour. Anthocyanin pigments colour beetroot, rhubarb and red wine while hemoglobin, the pigment which carries the oxygen in the bloodstream, gives the blood its red hue.

Dyes and paints make use of this principle: dyes and some inks actually form a compound with the molecules of the object they are being used to colour: henna, a natural vegetable dye, forms a compound with the protein keratin when used as a hair colourant. Paints and Indian ink consist of a suspension of pigment particles in oil or water and dry to leave a layer of pigment which will reflect only its own colour and prevent light reaching and being reflected from the surface beneath.

For thousands of years dyes and paints were obtained from natural pigments only, but discoveries during the last 100 years of ways of synthesizing pigments have led to the almost limitless range of colour available for commercial use today.

The colour of an object results from the selective absorption of light energy by its atoms. An atom consists of a positively charged nucleus orbited by negatively charged electrons. The positive charge of the nucleus is balanced by the negative charge of the orbiting electrons.

Light, though propagated in a wavelike manner, is captured by matter as photons—packets of energy. An electron orbiting in one atomic shell, *below*, selectively interacts with a photon of blue light, absorbs its minute quantity of energy and jumps to a new, higher-energy orbit. It pauses there before eventually returning to its original orbit, releasing absorbed energy as an unmeasurably small amount of heat. In this example, the energy of 'red' and 'green' photons is not high enough to excite the atomic electrons so they are reflected. If they reached the eye their mixture would produce a sensation of colour, and the substance would appear yellow. But in reality, electrons in the other orbits might be capable of absorbing photons of different energies and this would affect the colour reflected.

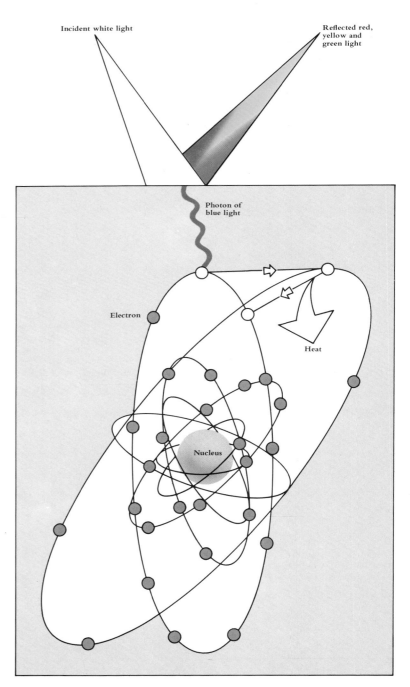

Incident white light

Reflected red, yellow and green light

Photon of blue light

Electron

Heat

Nucleus

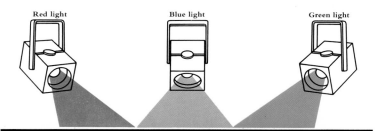

Red light Blue light Green light

Red, green and blue light beams mix additively to produce the 'white' light that illuminates the disk, *right*, and the surface beneath. Where just two of these primary coloured beams overlap, the additive secondaries, yellow, magenta (bluish red) and cyan (greenish blue) appear.

Where the disk throws a shadow in one of the coloured beams, it effectively subtracts a primary colour from the mixture. Where it subtracts red, the shadow is cyan; where it subtracts green, the shadow is magenta and where it subtracts blue, the shadow is yellow. Where all three colours are subtracted, the shadow is black.

Yellow, magenta and cyan are the subtractive primaries. Where they overlap, the subtractive secondaries appear: red, green and blue. These, of course, are the additive primaries of light, and, conversely, the additive secondaries are the same as the subtractive primaries.

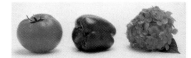

Pigments are compounds which absorb light of particular colours especially efficiently, and this property reflects the energy disposition of their atomic energy orbitals. The tomato, *above*, contains a carotenoid pigment which absorbs light in the wavelength range from violet to green and reflects low-energy (long-wave) photons. These produce the sensation of orange-red when they fall on the eye. The chlorophyll in the pepper absorbs all but the 'green' photons, which it reflects, and the anthocyanins in the hydrangea absorb all but the 'blue' and 'violet' photons.

Colours are sensations which result from light of different wavelengths reaching the eye. As long as these objects are illuminated by 'white' light containing all wavelengths of the visible spectrum, the tomato will look red, the pepper green and the hydrangea blue. But should the wavelength distribution of incident light vary, so that certain frequencies are lacking, they will appear completely different colours.

Illuminated, for instance, by yellowish green; by cyan (greenish blue and by magenta (bluish red) spotlights, that is, by coloured lights lacking one or other of the spectral primaries, *right*, the tomato, pepper and hydrangea reflect significantly different colour mixtures to the eye.

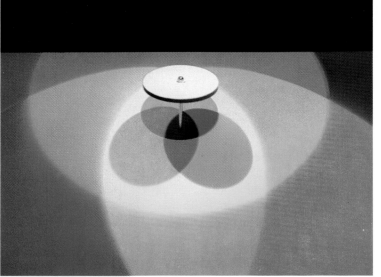

If pigments of all the spectral hues were mixed, together they would absorb all wavelengths from the incident light and the mixture would look black. Theoretically, it should be possible to produce black by mixing only three pigments in equal proportions: the subtractive primaries, yellow, magenta and cyan.

By mixing the subtractive primaries in varying proportions, it should also be possible to reproduce any other colour, but because all known pigments are imperfect, this is not possible. All cyan pigments, for example, reflect some red light with the bluish green.

But almost the entire range of colours in this book was produced using yellow, magenta and cyan inks—except for the blacks. When mixed together in equal proportions, inks of the three primary colours produce an imperfect brownish black, so black has to be printed with special ink.

Illuminated by greenish blue (cyan) light

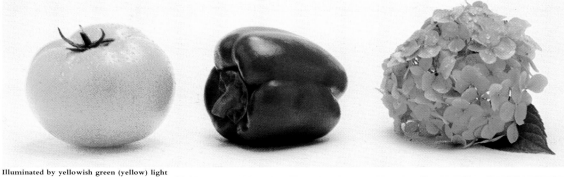

Illuminated by yellowish green (yellow) light

Illuminated by bluish red (magenta) light

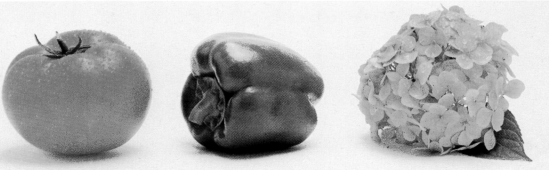

Orchestrating sunlight

The exact colours the eye sees depend on the wavelengths of the light reaching it—and that in turn depends on what happens to the light along the way. The reason the light reflected from objects often has a characteristic colour when it reaches the eye is because a coloured object can completely absorb only photons (the packets of energy of which light is composed) with exactly the right energy levels to fit its own atomic structure. If an object can entirely absorb photons of violet, blue and green light, these colours will not be reflected. But photons of red, orange and yellow light, whose energy levels are lower, are reflected and picked up by the eye which sees the object as red.

These unabsorbed photons can be reflected in different ways. The ordered molecules in solid materials reflect them in a regular pattern, enabling the eye to see a sharp image of the objects of which they are composed. But the disordered molecules in liquids and the sparse ones in gases can also interact with the light that passes through them. Molecules of water and air interact with a tiny fraction of the photons of light passing through them and reradiate them at random in all directions. Instead of reflecting light, they scatter it.

Generally, the photons with the highest energies—violet and blue—are scattered more easily than the lower-energy photons such as red, orange and yellow. This is why the sky looks blue during daylight. A column of smoke from a pipe or a chimney sometimes looks greyish blue to someone standing with their back to the sun: their eyes are picking up sunlight which is being scattered by the particles of smoke in the air, and this is mainly blue. Someone standing on the other side of the column will see the direct rays of the sun, minus the blue wavelengths which have been scattered on passing through the smoke, so it will seem tinged with yellow or red. Irregularities in the surfaces of structures of solids and liquids can have the same scattering effect. Milk has a blue tinge because particles of fat suspended in the liquid scatter photons of blue light.

All these reflection and scattering effects are caused by light being reradiated at the same frequency it had when it struck the object. But some materials have a different effect: they can take energy at one frequency and reradiate it at a lower one. The aurora borealis (and its southern equivalent, the aurora australis) which etches its brilliant patterns across the polar night, is the most spectacular example. The cause is a stream of high-energy particles showering in from space which literally shatter the molecules of air in their path. As the molecules reassemble they release the energy they absorbed from these high-energy particles, some of which is at the frequency of visible light. Oxygen atoms reradiate two wavelengths of visible light, one a brilliant greenish white and the other a deep red.

This phenomenon of converting high-frequency radiation into visible light at a lower frequency is fluorescence. Ultra-violet radiation has a slightly higher frequency than visible light, and produces fluorescence in materials such as butter, eggs, potatoes, skin, teeth and hair. Phosphors are so called after the element phosphorus which in one of its forms shows a similar property. But true phosphorescence is more persistent than simple fluorescence: the photons are not reradiated immediately, but some of the energy is stored for a length of time before reradiating, and it is only released in darkness.

Some living creatures can produce vivid glowing light in the dark, a mechanism known as chemi-luminescence. Glow-worms, fireflies and several types of fish and plants produce their light by a chemical reaction radiating photons of light as a by-product, rather than the heat usually dissipated in metabolism.

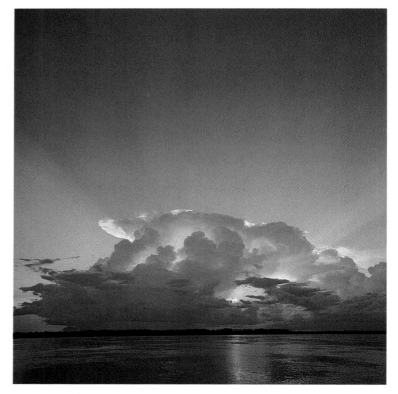

Clouds look solid only when they are distant. They are made up of minute droplets of water which reflect the light in the same way as a solid object does. Light passing through a cloud undergoes multiple reflections and refractions from the surfaces of the individual water droplets—just as when it passes through the large raindrops which generate the rainbow—but its dispersed wavelengths mix additively to form white light, so the cloud looks white. A dark cloud is so dense that sunlight can scarcely penetrate it. From beneath it looks black, but above the light is reflected back into the atmosphere. This is its silver lining. Clouds become tinged with colour at sunset when long wavelengths in the atmosphere illuminate them selectively with yellow, orange or red light.

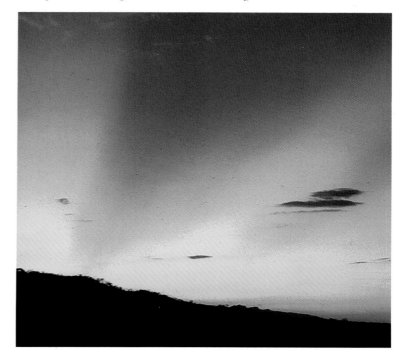

The Earth's atmosphere is responsible for the colours of the sky. For 50 mi (80 km) or so above the Earth, molecules of nitrogen, ozone, oxygen, water, carbon dioxide, dust and trace elements make up the atmosphere. The diameters of these particles approximate to the wavelengths of blue and violet light, so they absorb and reradiate these wavelengths, scattering them in all directions. This scattered light colours the sky blue, *left*. City skies are a pale blue where the particles of pollution are of many sizes; these scatter all the wavelengths in all directions, diluting the blue of the upper sky with white. Without an atmosphere, the sky would be as black as outer space seen from Apollo 8, *below*.

At 2 pm on a clear day in New York, the sky colour is dominated by the blue light scattered by the atmosphere. London sees what is left over—the long-wave photons which penetrate 3,000 miles farther through the atmosphere without being scattered.

As the sun's rays travel across the globe towards London the atmosphere absorbs more and more of the short wavelengths and transmits mainly long ones. As the sun sets in the west, their path becomes larger and longer and the sky above London turns yellow, then orange. The Earth revolves until even these wavelengths become invisible. As the sun sinks to the horizon, only the longest wavelengths remain visible, to turn the skies a brilliant red, *right*.

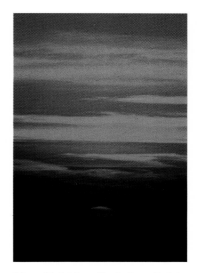

Moonlight is reflected sunlight. A rising moon, reflecting the long wavelengths of the setting sun, may look red, just as a setting moon may reflect the rays of the rising sun and look red.

Seen against the background of a dark sky the full moon takes on a greyish tinge, the result of simultaneous contrast, but because moonlight is an intense light, it looks silvery. Silver is really an intense metallic grey. When the moon sheds a path of golden light across the surface of the sea, *left*, the short wavelengths have been scattered by particles in the atmosphere and the long wavelengths mix together on their journey, producing a yellow beam. Reflected by the glossy surface of still waters, it looks golden.

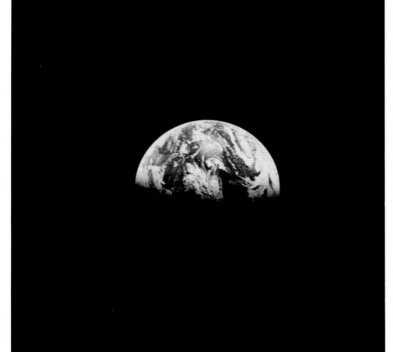

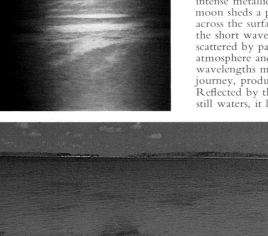

As the sun rises, the long spectral wavelengths are the first to appear, tinting the sky with a reddish-orange glow. Dawn is sunset in reverse, but there are fewer particles in the moist atmosphere of early morning and the colours in the sky at sunrise are often less fiery than at sunset.

On occasions, when the air is very clear and the horizon distinct, as dawn breaks, a green flash may pass instantaneously across the sun's disk. It is caused by the atmospheric refraction of green solar rays. Aircraft and ships in equatorial regions are the most likely vantage points from which to catch a fleeting glimpse of this rare phenomenon.

Although water is transparent, it absorbs red light weakly and has a bluish colour—a white object under the surface looks bluish-green. In 45 ft (15 m) of water red light is reduced to a quarter of its original intensity. The waters of this lagoon are an intense blue in the distance where the blue of the sky is being reflected. If the sky were paler or cloudy, the blue would be less intense, or steely. Near the rocks where the waters are more shallow their intrinsic bluish green colour is reflected by the white sandy bottom, so they look turquoise. The myriad air bubbles in surf reflect sunlight in all directions, so the water looks white where it breaks on the rocks.

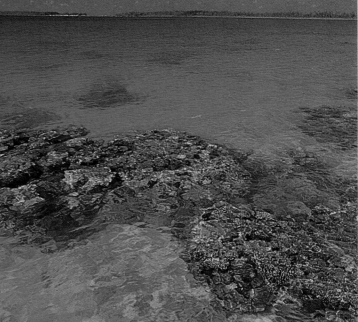

Colours for survival

Colour in living creatures is as old as life itself. Even algae, the simplest of plants which appeared in the sea around 3,000,000,000 years ago, produced colour as a by-product of their life processes. Similar algae still exist: *Trichodesmium erythraeum* contains a pigment, phycoerythrin, which absorbs yellow, green, blue and violet light to provide energy for the biochemical reactions which keep the plant alive. Red light is reflected strongly enough to colour the plant and the waters in which it lives. Strongly enough, in fact, to give the Red Sea its name.

Most land plants are green for a similar reason. They depend on the pigment chlorophyll for photosynthesis, the process by which they harness the energy of sunlight to manufacture vital carbohydrates from water and carbon dioxide. Chlorophyll provides the energy by absorbing red, yellow, blue and violet sunlight, but it reflects the green.

Colours like these are incidental, chance by-products of the basic chemistry of life. The molecules involved in the germination of seeds, plant growth, differentiation into buds, shoots, leaves and flowers, if present in sufficient quantities, colour the plants. And the blueprint of the production of these molecules lies in the arrangement of genes on the chromosomes present in the nucleus of every cell.

Only the simplest of organisms reproduce by splitting into carbon-copy replicas. New individuals are usually created by the fertilization of a female egg by a male germ, so that the offspring embodies characteristics of both parents. Differences between individuals of the same species are usually trivial but abundant; every so often the mingling of the parents' genes produces a significantly new combination, resulting in an individual which differs from the rest of the species.

Darwin thought that all plants and animals were locked in a desperate fight for existence, with the prize of survival going to the strongest and fittest. If a new combination of genes were less well adapted to the struggle than the rest of its species—and most of them were—it would quickly die out. But if it were *better* adapted, its descendants would have a better chance of survival. Colour, an inherited characteristic, was to become a vital weapon in this ceaseless competition for life.

Plants have always been faced with a major handicap: they are stationary. Survival in the vegetable world means spreading fertilized seeds or spores; the greater the distance, the smaller the possibility of new plants competing with their parents.

The first flowering plants, which appeared in the primitive forests of 150,000,000 years ago, let the pollen be carried by wind or water, a highly wasteful method. But there were already insects such as beetles feeding on such plants; these would brush against pollen exposed to the wind. If some stuck to the beetle's back or legs, and if that beetle happened upon another plant of the same species in its quest for food, some pollen would brush off against the plant's ovaries and fertilization could take place.

The plants that made it easiest for this transfer of pollen to occur would have the best chances of survival—those which succeeded in attracting more insects would ultimately drive out their less successful opponents. These early flowers were probably green. By genetic mutation, some species gradually concentrated pigments used in their biochemical processes into the cells of their flowers. Even to insects without colour vision the coloured blooms would contrast with the surrounding greenery, and the contrast would be vivid to those which could see colour. The development of colour and other attractions, such as odour, would invite insects to investigate more closely.

When plants began to produce nectar as another by-product of their chemistry, as food for visiting insects, the interaction became more dependable, and the colours of flowers began to take on a more specialized role. Primitive flowers—probably white or yellow clusters not unlike present-day daisies or dandelions—attracted insects of every kind. But flowers evolved that could most efficiently attract only those insects most suited to spreading their pollen, and sometimes their seeds as well. Colour then became a signal to a particular species.

In time, this relationship became so close that neither plant nor insect could survive without the other. The white flowers of the yucca attract *Pronuba yuccasella*, a night-flying moth. This collects a ball of sticky pollen grains from the bloom and takes it to another where it drills a hole in the ovary wall, deposits the pollen, and lays its eggs alongside the immature seeds. When they hatch the grubs eat some of the fertilized seeds, but the rest are dispersed to become new plants. Without the moth the seeds would never be fertilized, and only fertilized seeds will provide food for the new generation of moths.

Colour, then, is a gift of evolution, and the ways in which plants exploit this gift give the plant world its astonishing variety, for the numbers of pigments found in plants are legion.

In autumn when the chlorophyll in green leaves breaks down, other pigments, carotenoids, are exposed. These are red, orange or yellow—the colours of autumn leaves. They assist chlorophyll in photosynthesis, but they also colour flowers such as tulips, dandelions and crocuses. They act as a sunscreen, protecting delicate plant tissues from damage by atmospheric radiation.

Blackberries, red cabbages, red buds and shoots, the purplish autumn leaves and flowers of the blue-red colour range—sweet peas, lupins, roses, geraniums and many others—are coloured by anthocyanins. These have a role in protecting plant tissues from high levels of radiation and possibly also from the harmful effects of mineral deficiency—leaves of potato, orange, apple, cotton and cabbage turn brown, red or purple when potassium is lacking; alfalfa leaves turn red when boron is lacking and cotton leaves turn blue-red when magnesium is lacking. Anthocyanins act as natural indicators of changes in the acidity of the cell sap in which they are dissolved—red anthocyanins turn blue in alkali conditions, so hydrangeas change from pink to blue if the soil in which they are growing is made more alkali; and blue anthocyanins turn red in acid. In neutral soils they are violet.

The colours of animals may similarly be the result of nature's ingenious success in ensuring the survival of the fittest. The insects and birds that pollinate flowers and disperse seeds are themselves coloured. The variations in colour vision they employ to detect food plants they also employ to detect and recognize each other.

Broadly speaking, animals are coloured either for display or for camouflage. A male peacock in full display is impossible to miss against any background. On the other hand, subtle colouring camouflages the spotted fawn in the dappled sunlight on a forest floor.

Very little is yet known about the genetics of such clever adaptations, but the new science of chemical palaeogenetics is beginning to unlock the secrets. These are held within the complex molecules of DNA, the basic building blocks of life. They contain the entire genetic record of the organism of which they form part. There are, for example, different forms of hemoglobin, the most complex protein and the pigment that colours the blood, the skin and the wattles of birds such as the turkey. These variants evolved from a common origin.

For blood does not have to be red, nor skin pink. They both contain hemoglobin because of the pigment's chemical pro-

However flower petals evolved—from flattened stamens, or modified leaves that ceased to photosynthesize, and whatever their colour, the objective was survival. For flower petals are advertisements designed to lure pollinators to the pollen store.

perties in conveying oxygen to the tissues, and hemoglobin happens to reflect red light. If the pigment were not biochemically essential, evolution would have eliminated it long ago. Instead, mutation has created for it a number of secondary roles. It helps, for example, to colour human lips and cheeks in blushing, contributing to sexual attraction in humans, and so plays a dual role in ensuring the survival of the fittest.

Melanin, a pigment which colours animals black, is also found in the ink employed by the squid and octopus as a water-borne smoke screen to confuse predators. In human skin it acts as a filter for ultraviolet radiation. The prehistoric men living on the edges of glaciers may have evolved light skins to absorb as much ultraviolet as possible from the limited sunlight available; their contemporaries in the tropics evolved skins darkened with melanin to avoid the harmful effects of sunlight.

The basic green colour of chameleons is due to a combination of effects: one layer of cells contains a yellow carotenoid pigment; another is blue caused by light-scattering and a third cell layer contains brown melanin. This can be channelled, under nervous control, into the light-scattering layer and on into the yellow layer, producing a progressively darker green until eventually the blue is obscured and the chameleon is dark brown. In this way it changes colour to merge with its background.

The animal world is rife with pigments. Most abundant are the carotenoids which produce the reds and golds of autumn leaves.

These ubiquitous pigments are stored in the red, yellow and orange feathers of goldfinches, the reddish elytra of the ladybird, the pink muscle of salmon and the scales of goldfish, and they are concentrated in the yolks of eggs. They engender sexual excitement and aggression—the male locust turns bright yellow when it becomes sexually mature. They are responsible for the yellow gapes of nestlings and the warning colours of poisonous creatures. Carotenoids are nature's inexhaustible source of vitamin A, needed by all creatures with eyes because it is a precursor of the photosensitive visual pigments. Oddly, animals cannot synthesize these pigments. They absorb them from their diet. Flamingos are naturally white and turn pink only by eating carotenoid-rich crustaceans.

The yellow Indian hornbill colours its beak and white wing feathers with a yellow carotenoid pigment from a gland near its tail. Spider crabs attach pieces of algae to their carapace—the upper shell—to camouflage it. Man paints his body for sexual attraction or to signal aggression and mimics the colours of the environment to camouflage himself and his weapons in wartime.

There are colours in nature that seem to have no purpose. The lovely swirls of colour in the layers of mother-of-pearl inside an oyster shell can be seen only when the oyster is caught and opened. Sometime, perhaps, evolution might find a use for this potential. For the colours in nature are not there merely to delight the eye. They have a much more serious purpose altogether.

25

The alluring hues of plants

Flowers have a seemingly limitless variety of colours and forms. Evolution coloured and shaped each species to offer the strongest attraction to the insects, birds or mammals best suited to pollinating it. And evolution produced new species of insects and birds to be attracted in turn by new strains of flowers.

Beetles, among the first insects to evolve, have poor eyesight. Flowers such as magnolias and water-lilies, which rely on beetle pollination, tend to have large, conspicuous flowers which are white and strongly perfumed. Similar flowers—the white campion and the butterfly orchid for example—attract night-flying moths because they can easily be located in the dark. Day-flying moths and butterflies have good colour vision. The flowers they pollinate vary in hue across the spectral range: from sea pinks to goldenrod and the blue forget-me-not.

Flies have short tongues and are most sensitive to the long wavelengths of light, so the flowers that attract them are easy to reach and tend to be white, green, red or yellow. Wasps prefer small pink or dark brown-red flowers, but bees are insensitive to red and favour blue, violet or yellow flowers. The red flowers bees visit reflect ultraviolet light which bees can see.

In the tropics birds join insects in the pollen transportation business. They have a high metabolic rate and need more nectar than even the most voracious insect, so they visit flowers by the hundred. Flowers adapted to the poor sense of smell and excellent colour vision of sugar birds, sun birds and humming-birds are coloured according to the birds' spectral sensitivity: red is most common, then orange, yellow, blue, violet, white and cream. Many have sharply contrasting colours which are conspicuous even against a jumbled background of tropical foliage: combinations of red and yellow, blue, white and black.

If parent plants and their offspring are not to choke each other in pointless competition, the fertile seeds plants produce must be dispersed, and colour has an important role here too. Seeds intended to catch on fur or feathers for transport can be inconspicuously dull brown, but fruits have to catch the eye of the consumer. Plants with an ancestry that can be traced to the time before flowers evolved have pulpy, edible, coloured outgrowths called arils: the yew has a green seed with a red aril which provides a colourful contrast. Birds are strongly attracted to red. In Europe, where birds do no pollinating, there are relatively few red flowers, but red fruits aplenty: raspberries, rowanberries, apples. By eating the red fruits, they disperse the seeds within.

Unripe fruits are inconspicuously coloured—usually white. But as they mature, they synthesize pigments and change colour. Some, like bananas, sweeten and develop an appetizing smell. Mammals and birds are attracted to ripening fruits. By the time the fruits have been eaten and digested, and the seeds excreted, some distance will have been covered and seed dispersal achieved.

So subtle is the interaction between plants and the creatures that feed on them that the same colour can attract one disperser and repel another, less efficient species. The purple-black berries of deadly nightshade attract birds, which eat them without harm—but mammals are repelled by the colour.

And there are flowers that change colour as they age. The giant water-lily changes from white to purple in the single day in which it matures; and the nectar-guide spots for the bee at the base of the white hermaphroditic flowers of the horse chestnut turn red when there is no nectar left, so that bees cannot see them.

Buttercup Water crowfoot Peony Columbine Monkshood

Alfred Wallace, a contemporary of Darwin, theorized that colours may have first appeared in the parts of a plant that became adapted to a particular method of pollination. From studies of flower colours, a law of progressive coloration was later proposed. This suggests that petals, which adapted from stamens (male fertilizing organs) became yellow in the most primitive flowers such as buttercups, which have simple flowers open to pollination by many insects. The water crowfoot has white petals with yellow remaining at the base; it is adapted to pollination by water-dwelling insects. Red flowers such as the peony have concealed ovaries and are pollinated by birds and insects sensitive to the longer light wavelengths. Blue flowers such as the columbine and the monkshood are highly specialized, having nectar hidden deep inside their drooping heads; they attract only insects with long tongues.

Flowers with brilliant red petals and concealed nectar attract Anna's humming-bird, *Calypte anna, left.* The eyes of this bird are especially sensitive to the longer wavelengths of visible light. Its elongated pointed beak and long tongue enable it to penetrate deep into the flower to reach the nectar. As it feeds, male pollen collects on its beak, and this may later be deposited on to the female stigma of another flower of the same species. Other flowers adapted to pollination by humming-birds have long tubular flowers with protruding anthers which, heavy with pollen, brush against the head of a hovering bird.

Most insects are short-sighted and initially attracted to flowers by their scent. Coloured petals give approach signals, and many flower petals have guide-marks which, like runway markings to a pilot, lead the insect towards the nectar chamber. As it enters and leaves, pollen sticks to its body, to be transported to other flowers. Guide-marks may be lines and patches—as on the eyebright, *Euphrasia micrantha, right*—spots or a pattern, and their colours contrast with those of the petals. They may reflect ultraviolet, visible to some insects—or the petals may reflect it while the guide-marks do not.

The unripe sloe berries of the blackthorn tree, *Prunus spinosa,* are green and virtually indistinguishable from the surrounding leaves. When they are ready for dispersal they ripen: anthocyanin pigment is manufactured in the skins, causing them to turn blue, *left.* Finches and other birds which feed on sloes are most sensitive to red, but they can also see blue; as the berries turn colour, they become easily distinguishable from the background of green leaves, a signal that the fruit is ready to eat. Birds eat the flesh of the fruit, but discard the hard seed which may be carried some distance before it is dropped to the ground, where it will germinate and so continue the species.

The leaves of the pitcher plant, *right,* are red and yellow to mimic the colour of carrion. Its flowers are green and inconspicuous. The plant's colour and smell of rotting meat attract flies which alight on the rim of the leaves and climb down the inner walls which are slippery, so they fall into the liquid at the bottom and drown. Digestive juices in the liquid then absorb them.

The mirror orchid, *Ophrys speculum, above,* attracts male digger wasps of the species *Campsoscolia ciliata.* It mimics the female wasp in colour, form and scent, and the male seeks the flower, not for nectar or food, but to copulate with it. In its zeal, it transfers pollen packets from the orchid on to its body. These may then be deposited on the ovary of a female mirror orchid in another attempted copulation. The relationship between these species of orchid and wasp is exclusive: the flower relies solely on *Campsoscolia ciliata* for pollination.

Animal display and discretion

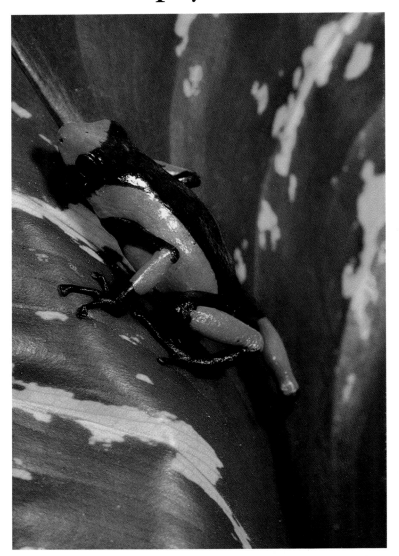

Animals that live in snowy regions tend to be coloured white; those that live in forests may be green—or brown if they live among dead leaves on the forest floor. The dappled pattern of the deer works best in areas of mixed shadow and sunlight. Buff and ochre shades predominate among desert-dwelling species and the iridescent colours of fish camouflage them in shallow water.

An animal's colour plays a vital role in its search for food, for safety from predators and in its breeding behaviour. The Borneo crab spider is shaped and coloured to look like white bird droppings—it preys on insects that feed on real bird droppings. Such coloration often has a dual role. The chameleon changes colour to match different surroundings, but its most striking colour changes take place during courtship display. Gulls have two camouflage schemes: dark colours on top which merge with the ground or sea when they are seen from above, and light colours beneath to be less conspicuous in flight to their prey.

Poisonous insects and animals, such as the red coral snake, are brightly coloured with sharply contrasting patterns so that an attacker will remember the lesson learned each time it spots that colour scheme. Other creatures mimic the colouring of poisonous species as a pseudo-defence: the wasp beetle and the hornet clearwing moth are black and yellow like real wasps and hornets.

Certain insects use their patterns to frighten and confuse birds. The Malaysian back-to-front butterfly has coloured rings looking like eyes on its hind wings, and false antennae and legs on the rear end of its body. When in danger it confuses its attacker by flying off in the opposite direction to that expected.

Colour is used to identify members of the same species, to frighten off males or to attract females. Examples vary from the blue face of the mandrill to the red rump of the baboon and the coloured patches of feathers on the wings and tails of ducks.

And animal colours can change with age or with the season. Vulnerable young birds are often heavily camouflaged, only changing to more colourful adult plumage when they are strong enough to defend themselves. The Arctic fox's coat turns white when the winter snows come. Plaice and turbot, brill and flounder can match patterns of mud, gravel and sand so carefully that they can even mimic a chessboard.

The gaudy patterning of the arrow-poison frogs is an unmistakable warning signal to predatory snakes or birds, species which rely on vision for hunting success. Melanin pigments account for the black stripes and carotenoid pigments colour the red stripes. Mucous glands in the skin secrete poisons—which the Colombian Indians use to poison arrowheads for shooting monkeys. Frogs are poorly equipped for escape, but the semaphoric colours, off-putting smell and taste, and armour of poisonous glands give these species effective immunity from attack.

The conspicuous ocelli—pigmented rings resembling eyes—on the hind wings of the bull's eye moth, *right*, deflect attacking birds from the head and body. On some moths and butterflies the ocelli are hidden by the forewings when the insects are at rest. If surprised they flash them to terrify the predator and deflect the attack.

Birds identify their eggs and young by colour and pattern. The yellow gapes of baby robins are 'releaser' signals that stimulate the parents' instincts to feed them. This begging stimulus is so strong that parent birds will instinctively feed any gape of the 'releaser' shape and colour, even that of another species of animal.

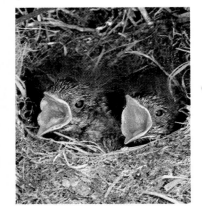

Specks of black melanin mottle the wings of the peppered moth, *right*. When it presses its wings close to the bark of a lichen-covered tree, their shadow is invisible and the camouflage so effective that a bird cannot distinguish its triangular shape. The black form of this moth, more densely pigmented, is now dominant in sooty industrial areas.

The camouflage effect of this disruptive coloration is destroyed once the creature moves but, when still, parts of it become indistinguishable from its background so that its outline is broken up. The haphazard black and tawny stripes of the tigress, *below*, mimic the pattern of colours in her grassy habitat.

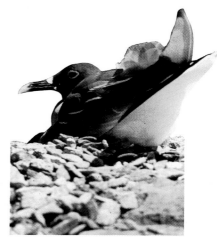

White is a structural colour in feathers, caused by the total reflection or scattering of light. The young of the swallow-tailed gull learn to identify their mother by the single red ring of skin around her eye. When they mature they mate only with birds that carry an exact replica.

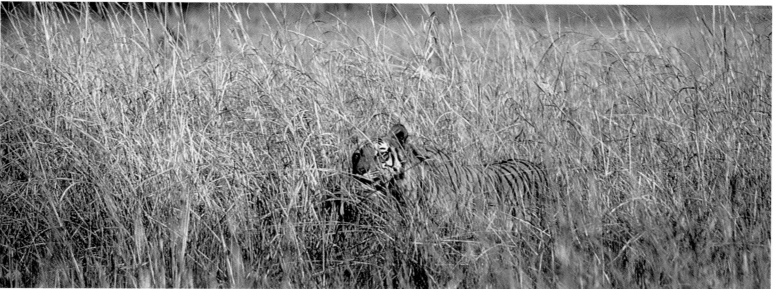

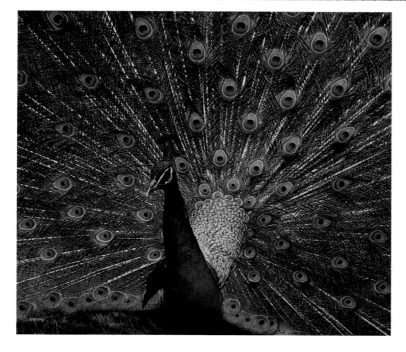

The iridescent colours of the peacock are caused by interference effects. They are so brilliant because light is reflected and refracted by a fine mosaic layer of melanin granules in the filaments of each feather, and the pigment intensifies the colours. In courtship display, the peacock quivers its shimmering tail.

The leaf-mimicking moths of the *Astylis* species deceive the birds that prey upon them by lying motionless among the dead leaves on the forest floor. The shapes and colours of their wings enable them to blend perfectly into their habitat—they are even marked with imitation leaf veins and mould spots.

29

The evolution of colour vision

The story that World War II night-fighter pilots ate carrots to help them see in the dark was a fabrication. It was a cover story, designed to conceal the fact that improved radar was helping to bring down more enemy bombers. The story had credibility because it was well known that carotenoid pigments, which give carrots their orange colour, also play a crucial role in the mechanisms of vision.

All organisms, plants as well as animals, respond to light. In order to be able to detect light, they must absorb it—and absorption implies the presence of pigments. Carotenoids are such pigments. They contain vitamin A which is a precursor of rhodopsin, a universal photoreceptive pigment present in the eyes of nearly all seeing creatures.

Darwin believed that 'natural selection may have converted the simple apparatus of an optic nerve, coated with pigment and invested by transparent membrane, into an optical instrument...'. Such instruments exist even in microscopic, single-celled organisms such as *Euglena viridis*, which inhabits freshwater ponds. It is coloured green by chlorophyll and, like green plants, synthesizes food from inorganic substances in the presence of light. An eyespot, composed of red carotenoid pigment granules, filters light rather like sunglasses, and transmits it to a photoreceptor. This is located near the root of the single whip-like flagellum which propels the organism through the water. It contains a second pigment which behaves like rhodopsin, and enables *Euglena* to distinguish between light of differing intensities. It will swim towards daylight but away from the direct light of the sun.

Creatures like this, which first concentrated the light-absorbing carotenoid pigments present in their structure into specific light-sensitive areas, developed an advantage in the struggle for survival. For light is a source of information about the environment, and any adaptive change that helps to inform a living creature about its habitat must have survival value. Even simple sensory-neural mechanisms may be able selectively to control general behaviour patterns such as hiding, foraging and escaping. Sea urchins, for instance, point their spines towards any shadow that falls on their receptors.

There is a difference between light emitted from light sources and reflected light. The spectral composition of daylight has a relatively high content of short wavelengths because these are scattered by the atmosphere. Chlorophyll in plants absorbs both short- and long-wave light, so the light reflected from them is dominated by green and yellow wavelengths.

Visual mechanisms able to distinguish different wavelengths can take advantage of the differences in spectral composition between direct and reflected light. Some frogs, for instance, which have a primitive form of colour vision, when startled will jump towards blue paper, which to them represents the safety of open water, and away from green paper which represents the diffused light reflected by vegetation.

Many primitive animals possess simple organs of sight called ocelli. Found in worms, molluscs and some insects, these ocelli have primitive lenses and roughly focus light on a very simple retina. They are adequate for resolving dark and light and can give the animal some sense of direction.

Most insects and crustacea have compound eyes made up of many facets. Each facet consists of a minute lens pointed at one part of the field of view, which focuses the light on to a small number—about six—of light-sensitive cells, which comprise an ommatidium. Signals from the receptors in each ommatidium are transmitted directly to the brain, which builds up a mosaic view of the visual field. Different members of each ommatidium contain different photosensitive pigments, showing that they possess photoreceptors adapted for low and high levels of illumination and for colour vision.

Insects with compound eyes are weakly sensitive to red light, but are highly sensitive to the short spectral wavelengths, and particularly to ultraviolet light. For instance it has recently been shown that desert ants of the species *Cataglyphis bicolor* have a spectral sensitivity ranging from the ultraviolet to the red end of the spectrum, and that they possess four types of photoreceptor responsive to light in different parts of the spectral range.

The evolution of visual pigments sensitive to colours has helped in the fine discrimination of the visual field—of objects silhouetted against complex backgrounds, for example. Backgrounds such as blue sky, green leaves, brown earth and blue sea are fairly constant in their colours; if they change, the change is gradual—as from the green colours of summer to the red-browns of autumn. The sharp contrasts between brightly coloured plants and animals and the more uniform background of sky, sea or forest facilitates recognition of friends and food—enemies are usually camouflaged. Colour vision helps insects to distinguish between edible and poisonous plants, between ripe and unripe fruit, between flowers that contain nectar and those whose nectar has been exhausted.

But to be able to image fine details precisely, an eye needs a single lens which can focus light on to a fine array of sensitive cells: a retina. Surprisingly, perhaps, nocturnal insects such as fireflies and night-flying moths have evolved this sort of camera mechanism. Their eyes have a series of lenses, like those of a compound eye, but they also have a retina, like the vertebrate eye. The many lenses act co-operatively to build a single image inside the eye. This superposition mechanism enables them to catch dim light more efficiently. The eyes of deep-water crustacea have a similar structure in which a series of square facets made of soft jelly act like mirrors, reflecting different parts of the image on to the retina.

Vertebrate animals have the most sophisticated of eyes, in which a single lens directs light on to an array of photosensitive cells, just as the lens of a camera focuses light on to a film. The retina translates the elements of the picture into electrical impulses and these are transmitted by nerve fibres to the brain.

The retina's light-sensitive cells are of two types, called rods and cones. Rods all contain the same visual pigment, rhodopsin, and work in dim light to produce the achromatic sensations of night vision. Cones contain pigments sensitive to the different spectral wavelengths, but they only respond in bright daylight. The retinas of nocturnal animals—rats and opossums, for instance—species which are effectively colour-blind, contain almost exclusively rods while some diurnal birds have predominantly cones.

Different types of cones contain different visual pigments, each absorbing light from a different wavelength range. In trichromatic animals there are three types, sensitive respectively to different areas of the spectrum and together to the whole spectral range. Some, like the marine stickleback, have four types.

Many animals possess a more sophisticated retinal apparatus for colour vision than man. Birds and reptiles in particular often have differently coloured oil droplets in front of some of their cones, making them effectively pentachromatic. These filter all but one colour out of the light and focus it accurately on to their associated cones in the retina.

The retinas of lower vertebrates, like reptiles and birds, are highly complex organs which process much of the visual

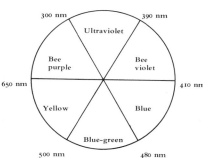

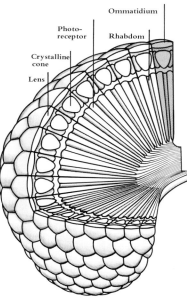

Honey bees have good colour vision, enabling them to discriminate between different flowers. Worker bees are predominantly sensitive to short-wavelength and ultraviolet light. They tend to confuse long-wavelength colours.

The fleabane flower, *far right above*, is yellow when photographed in 'white' light—the way it looks to the human eye. But when photographed in ultraviolet light, *above*, a dark circle appears in the centre. This is a distinct signal to bees, who are attracted to it. The centres of poppies reflect ultraviolet light;

to bees their red colour, which is conspicuous to us, will be a dull background to this ultraviolet.

Some investigators have suggested that the colour which bees see as 'white' is a particular mixture of yellow, blue and ultra-violet. Nearly all flowers that look white to the human eye may look 'blue-green' to bees. Their petals absorb ultraviolet light. In the colour circle of the bee, *above right*, blue-green is complementary to ultraviolet. Blue is complementary to 'bee purple', a mixture of yellow and ultraviolet; and yellow is complementary to 'bee violet', a mixture of blue and ultraviolet.

The compound eye of a bee, *left*, consists of thousands of identical ommatidia, each of which contains several different photoreceptors. These have the requisite photosensitive pigments to enable the bee to discriminate the wavelengths in their colour circle, *left above*. Light is refracted by the lenses of the facets to the underlying rhabdoms, photosensitive structures built up by several surrounding receptor cells. These cells are stimulated by light of different wavelengths, translating it into electrical signals which are conveyed by nerve fibres to the brain. There they reconstruct a map which represents the objects and colours in the insect's field of view. This 'image' is sufficient to enable the bee to search for flowers, recognize landmarks and to be sensitive to moving objects.

information received by the receptors before transmitting it (in the form of impulses) to the brain. The neuronal apparatus in the retinas of primates and man is more simple; although the signals of the photoreceptors are processed in the retina before being passed on to the brain, the newly evolved cerebral cortex has taken over a proportionately far greater share of visual function.

Behaviour experiments to test whether various species of animals can see colours suggest that tortoises have good colour vision, that cats can see colours only if the coloured surface is above a certain critical size and that dogs have only rudimentary colour vision. There is great variety in the ability of different species to discriminate between colours, and some confusion even as to what colour vision *is*. A consensus of opinion defines it as the ability to distinguish between two coloured lights of equal intensity but different wavelength. To do this, two or more types of photoreceptor, each with a different spectral sensitivity, are necessary, and this is why the single population of rods working at night cannot mediate colour sensations.

But an animal's ability to see colour can only be defined strictly in terms of the experiment performed, and the results beg a question. Experiments have proved that bees discriminate colours, but is the blue that a bee sees the same as the blue we see? It is only possible to say that the eyes of a bee are sensitive to the same wavelengths of blue light as ours. Many fish, like ourselves, have three different sorts of cone, sensitive to three different regions of the spectrum. They are trichromatic, and make similar colour confusions to ourselves. But to deduce that they have the same

sensations of colour, when we run into philosophical difficulties trying to communicate our own, would be wrong.

Colour vision probably originated some 400,000,000 years ago, possibly during the Silurian period, in the ancestors of present-day fish. But eyes and vision evolved in the form best suited to the species' own special habitat and not in a linear evolutionary sequence from unicellular organisms to vertebrates. Deep-sea fish now, for example, have little use for colour vision in their dark environment, and tend to be colour-blind, or sensitive only to the deep blue light which penetrates the abyss. Littoral species, such as reef fish, which live close to the surface where the long wavelengths penetrate the water, are sensitive to a wide spectrum and have retinal cones containing three and sometimes four types of visual pigment. Freshwater species whose environment is tinted by, for instance, algal pigments in the water, tend to have retinas containing predominantly cones sensitive to red and green light.

It is sunlight that determines the overall photochemistry of visual pigments. The visual pigment rhodopsin, one of nature's most abundant pigments, absorbs the spectral wavelengths reflected by another, chlorophyll. Creatures whose lives are spent in the sun tend to have better colour vision than those living in the shade. And those creatures tend to be brightly coloured, for the colours of organisms and colour vision evolved together. It is a rule-of-thumb in nature that the more brightly coloured the species, the more likely it is to possess the faculty of colour vision. Man is an exception—but he colours himself.

How we see colour

An hour before dawn the outside world is dark. A crescent moon and the pale starlight are sufficient to enable no more than the outlines of woods and hills to be distinguished against the darkness. As dawn approaches, the stars fade in the brightening sky, and irregularities in the landscape can just be identified as trees or outcrops of rock. The sound of wildlife stirring anticipates sunrise, but there is no colour: the world is grey. Then as the sun emerges, the world assumes its daylight colour; the sky turns from gold to blue and the landscape shows its varied hues. The cock crows.

Of all the photosensitive cells in a cock's eye, only about a third are rods, the receptors responsible for achromatic vision at night. Night must seem much darker to the cock than to man, whose retina (the light-sensitive layer lining the eyeball) has a preponderance of rods. Between five and ten photons of light—equivalent to the light of a candle burning ten miles away—are sufficient to produce a sensation of light, so man can orientate himself in very low levels of illumination. A cock's retina contains predominantly cones, the photoreceptors responsible for colour vision. These are less sensitive to light: about 250 photons are needed to activate a single cone. When the morning light reaches a level high enough to activate the cones in the retinas of diurnal birds, the dawn chorus begins.

Each rod and cone cell contains molecules of pigment which absorb light entering the eye. When light strikes a molecule of the rod pigment, rhodopsin, the pigment bleaches as the molecule splits into its component parts, triggering the release of a chemical transmitter. This process initiates the electrical messages of the rods, which are ultimately conveyed to the brain, and special biochemical mechanisms continually regenerate bleached rhodopsin molecules to their native light-sensitive form. When the intensity of morning light reaches the level which stimulates cones, they take over visual function from the rods, whose signals the brain no longer 'sees'. Cones have pigments closely similar to the rhodopsin in rods, which go through similar cycles of bleaching and regeneration and cause the cone cells' electrical responses to light.

On first entering a dark cinema, it is impossible to see at all. Slowly the eyes adapt to the darkness, though colours appear faint and dull. Out in daylight again, the eyes are dazzled and it takes time, though less, for normal vision to return.

Each time the level of illumination changes, the eye has to adapt. It takes 20 minutes for bleached rhodopsin in the light-adapted eye to regenerate fully, and more for the rods to regain their maximum sensitivity. Whenever photons of light stimulate a rhodopsin molecule, a change takes place in the electrical activity continually being transmitted to the optic nerve, to which the rods are indirectly connected. This change constitutes the electrical message which is conveyed to the brain. Rod signals reach their maximum size, and their system is overloaded, when as few as ten per cent of the rhodopsin molecules—some 100,000,000 per rod—are bleached.

Cones are of three types, containing three different types of visual pigment which are closely similar to rhodopsin, though their exact chemical nature is unknown. They are bleached by light but regenerate much faster than rhodopsin molecules. Human cone pigments are sensitive to three different ranges of the spectrum, called for convenience red, green and blue, but in fact the cones are most sensitive respectively to yellow light of 575 nanometres, green light of 535 nanometres and blue light of 444 nanometres. Since the three types of cone each have broad absorption spectra, the eye is sensitive to a much wider wavelength

range, the visible spectrum between 400 and 700 nanometres.

During the day, when the cones are active, the eye is most sensitive to yellow light of 550 nanometres. This is because the retina has a predominance of 'red' and 'green' cones which, when equally stimulated, generate the sensations of yellow. There are comparatively few blue-sensitive cones, and almost none in the fovea, the fine-grain patch in the centre of the retina. Rods are most sensitive to blue-green light of 505 nanometres. At twilight, when the eye responds to the fall in the level of illumination by gradually transferring from cone to rod vision, a change in spectral sensitivity takes place. As evening falls, the orange and red flowers in a garden begin to darken first, while the blue and white flowers appear brighter by comparison.

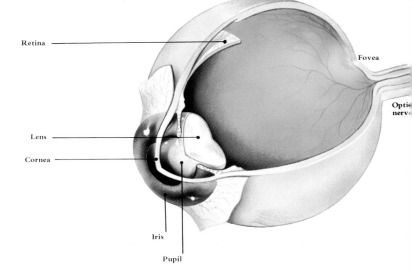

Retina

Fovea

Optic nerve

Lens

Cornea

Iris

Pupil

Light falling on to the eye is refracted by the cornea, the transparent outer layer, and enters the eye chamber through the pupil, the circular opening in the coloured iris. The iris dilates in bright light and constricts in the dark, altering the size of the pupil and so controlling the amount of light admitted.

The pupil is black because most of the light entering the eye is absorbed. The lens is transparent to visible light, but absorbs ultraviolet radiation, so that cataract removal leads to some visual sensitivity to ultraviolet light. The ciliary muscle changes the shape of the lens to focus a sharp image on the retina, which is inverted in relation to the outside world.

The retina, only 0.4mm thick, contains about 120,000,000 rods, and about 6,000,000 cones. The fovea, at the centre of the retina, responsible for acute vision, has no rods and few, if any, 'blue' cones. Instead there is a concentration of 100,000 'red-' and 'green-sensitive' cones. Outside the fovea, cones of all three types are more sparsely scattered among the rods. Light not absorbed by the photoreceptors is absorbed by a layer of cells containing melanin pigment lining the back of the retina.

The light that falls on the human retina, *right,* must penetrate two complex but transparent layers of nerve cells before it reaches the photoreceptors. Only about 20% of the light falling on the retina is absorbed by the photoreceptors. To minimize light-scattering, the nerve cell layers are displaced outwards from the fovea, exposing the cones there more directly to light.

The photoreceptors translate the light they absorb into patterns of electrical signals which are transmitted across synapses (junctions between nerve cells) to the connecting layer of bipolar cells. These collate information from clusters of receptors and transmit it in turn vertically to the next layer, the ganglion cells. Horizontal cells and amacrine neurons distributed among the bipolars transmit the information laterally. Outside the fovea individual bipolar cells collect signals from groups of rods and cones, and many of them converge on a single ganglion cell. But in the fovea one cone connects with one ganglion cell via one bipolar, to convey finer grain information. Fibres from ganglion cells all over the inside of the eye converge on the head of the optic nerve which marks their exit to the brain.

Photons falling on to the retina are channelled along the photoreceptors to be captured by the visual pigments. Rhodopsin in the outer segments of the rod cells is located in a thousand or so membranous disks stacked at right angles to the path of the light. The conical outer segments of the cones have similar structures to contain their pigments.

Light bleaches rhodopsin, but strangely this in turn reduces the electrical activity in the receptors. It is, in fact, darkness, not light, that generates the electrical signals they transmit to the retinal nerve cells.

In the dark, the outer membrane of the rods contains open channels through which positively charged sodium ions can enter from the surrounding fluid. Their movement generates the electrical signal, and it is stopped by the action of light, whose ultimate effect is to close the membrane channels. When a rhodopsin molecule is bleached by a photon, it activates an internal transmitter which mediates between the disks and the membrane by closing the channels.

The brighter the light, the more rhodopsin molecules are bleached, the more channels are closed, and the greater the reduction in the 'dark signal' which the rods continually transmit. This may seem an illogical arrangement but the human eye is most often called upon to distinguish dark objects against light backgrounds (like the black print on this white page) and it means that, in the light, less energy is consumed in generating electricity. It may also be an economical arrangement because the receptors consume less energy when the channels are closed during the day than when they are open in darkness—at night, for example, when the visual system is 'at rest'.

This scanning electron microscope picture shows the photosensitive outer segments of rods and cones in a salamander's retina, magnified some 2,000 times. The conical outer segment of one delicate cone in the illustration has been bent during preparation for the microscope. In a human foveal cone, only 0.001 mm thick and 0.075 mm long, there are about 1,000 membrane disks; a rod, *below*, 0.002 mm thick and 0.05 mm long, has about 700 disks, each rod containing an estimated 100,000,000 molecules of rhodopsin.

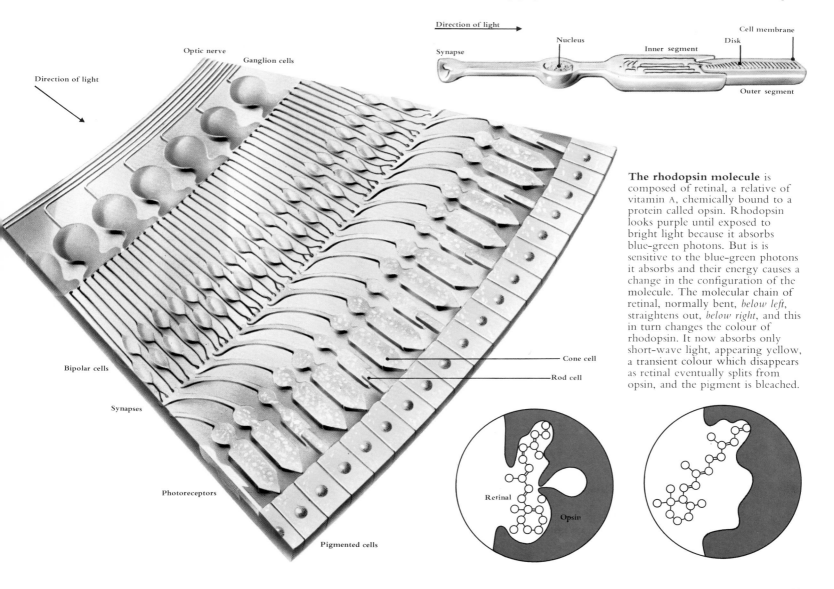

The rhodopsin molecule is composed of retinal, a relative of vitamin A, chemically bound to a protein called opsin. Rhodopsin looks purple until exposed to bright light because it absorbs blue-green photons. But is is sensitive to the blue-green photons it absorbs and their energy causes a change in the configuration of the molecule. The molecular chain of retinal, normally bent, *below left*, straightens out, *below right*, and this in turn changes the colour of rhodopsin. It now absorbs only short-wave light, appearing yellow, a transient colour which disappears as retinal eventually splits from opsin, and the pigment is bleached.

Coding colour

Only when the light and colour signals from the eye reach the brain do we see colour. The rod and cone cells, having absorbed light, convert it into electrical activity which they transmit to the bipolar and ganglion cells. In transmission, these impulses are coded into temporal patterns which are then transmitted to the visual cortex at the back of the brain.

In the retina, rods and cones respond to light stimuli by generating continuous electrical signals. These vary in size (up to one twentieth of a volt) with the strength of the stimulus and last as long as it is applied. Retinal bipolar cells also use such signals to convey information about the retinal image to the ganglion cells. These slow graded responses can transmit both positive and negative electrical potentials, that is, messages that excite or inhibit response: 'go' or 'stop'.

This method of transmission is used in the nervous system only where very short distances, like the thickness of the retina, are involved. A long-distance impulse transmission is used by ganglion-cell nerve fibres transmitting impulses along the visual pathway, and elsewhere in the nervous system. Here, nerve fibres generate trains of electrical impulses, identical in amplitude, called action potentials, whose *frequency* varies with the strength of the signal from the rods and cones, and they propagate—rather like a flame in a powder trail—along the length of a nerve fibre, at a rate usually in excess of ten metres per second. Again, the signals transmitted are excitatory and/or inhibitory: action potential generation represents excitation, while inhibition temporarily prevents impulses being transmitted to the next layer of cells.

Ganglion cells receive signals from bipolar cells via specialized contacts called synapses—the links between nerve cells. The slow graded responses of the bipolar cells cause transmitter chemicals to be released at the synaptic junctions, and these in turn either excite or inhibit impulse trains in the ganglion cells.

This is the way in which the continuous signalling of the receptors and bipolars is converted into the discontinuous impulse traffic of the optic nerve. Thus, variations in the frequency of action potentials in the ganglion cell fibres of the optic nerve constitute a code for the patterns of light, colour and shade that fall on the eye. Neurophysiologists are now attempting to discover how the signals from the different receptors with different photopigments form this code.

How the eye tells the brain that it is seeing red or yellow or brown can be discovered by intercepting, by means of a micro-electrode, optic nerve fibre messages on their journey from the retina to the visual cortex of the brain. Recent research by the neurophysiologist S. Zeki in Britain, C.R. Michael and P. Gouras in the USA, and others, has revealed a wealth of new information about the visual cortex. Experiments on primates (the rhesus and macaque monkeys, thought to have colour vision almost identical to man's) have led to the discovery of an area where the cells are colour-coded. But how the code is deciphered by these cells has still to be revealed, and the gap between neurophysiology and our perception of the world has still to be bridged.

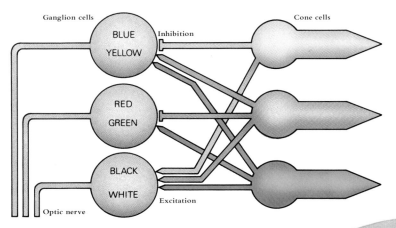

The rods and cones transmit their electrical messages to ganglion cells, whose fibres converge to form the optic nerve. The retina can be thought of as a data-analyzing system, simplified *above*, wherein light is encoded by its cells; a ganglion cell may be excited or inhibited by chemicals reaching it across its associated synapses. The cell responds to the excitation or inhibition by sending more, or fewer, irregular impulses along its fibres. This organization of the code is called opponency. 'White' light, for example, stimulates red, green and blue cones, and the sum of their responses excites their associated ganglion cell, which encodes white/black messages. But black (the absence of light) will inhibit the same cell, whose output of impulses to the brain will then be very small.

The wiring diagram, *left*, is a possible scheme to explain how colours are coded in the retina. Blue light stimulates blue cones, whose output inhibits blue-yellow ganglion cells. Yellow light, via red and green cones, excites them. Thus many impulses from these ganglion cells form the code for yellow and few impulses, the code for blue. Red light via red cones excites red-green ganglion cells, while green light via green cones inhibits them. Few irregular impulses form a code for green, while many are a code for red.

Ganglion-cell signals follow a visual pathway through the brain, *below left*. At the optic chiasma half of the optic nerve's 1,000,000 fibres cross over, so that the right half of each retina (recording from the left half of the visual field) leads to the right cerebral hemisphere and the left half of each retina (recording from the right half of the visual field) leads to the left hemisphere.

The optic nerve fibres relay with the cells of the two lateral geniculate nuclei. Each of these has six layers which separate the impulses from the two eyes: fibres that did not cross over at the chiasma terminate in layers two, three and five; those that did, terminate in layers one, four, and six.

Relay nerve cells in the lateral geniculate nuclei convey information about colour and brightness farther into the cerebral cortex. As well as brightness cells there are four types of colour-coding. Some cells are excited by red but inhibited by green; others are inhibited by red but excited by green; another type are excited by yellow but inhibited by blue, or conversely, inhibited by yellow but excited by blue. This basic opponency between excitatory and inhibitory processes, initiated in the retina and continuing throughout the brain, has the effect of sharpening the discrimination of colour by the visual system.

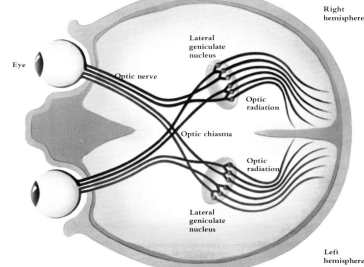

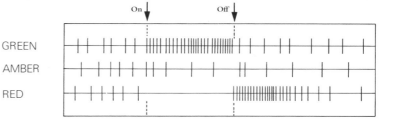

inserted into the part of the cortex under investigation. Having encountered a cell, the area of the retina to which it responds is established. This is then exposed to brief flashes of light of various different wavelengths. A red, amber and green traffic light, *left*, could be used, each one being flashed separately. The oscilloscope, *top*, charts the cell's response to each coloured light.

In this example, the cell responds at once to the green light with a burst of impulses that ceases when the light is switched off. The amber initiates no response at all. But the red inhibits the cell, which gives a response only when the light is turned off. Such responses define the colour-coding characteristics of the cell.

Other cells in the visual cortex may have other characteristics: green inhibition, red excitation; blue inhibition, yellow excitation, and so on. A cell may respond preferentially just to one colour and not others, or to colour only when it is organized into definite spatial patterns at specific orientations in the visual field.

The micro-electrode, *left*, is made of fine tungsten wire enclosed in glass. The tip, which protrudes, has a diameter of 0.001 mm, small enough to probe the electrical activity of cortical nerve cell bodies with diameters of 0.005 mm to 0.1 mm. The electrode is placed near the cell body. The other end is connected to an oscilloscope, an amplifier and a loudspeaker, which give a visual trace and an audible record of the cell's impulses.

To determine the sensitivity of a cell to colour, a micro-electrode is

Almost a third of the cerebral grey matter of the brain is involved in processing visual information. In this map of the cerebral cortex, area V1 appears to sketch the outlines of the visual scene, analyzing details of depth, colour, motion and orientation. This area has six layers of which the fourth receives the input from the optic radiation.

Areas V2, V3 and V3a deal with the more complex aspects of analysis of edges, orientations and depth. The superior temporal sulcus (STS) is predominantly concerned with motion.

The colour area, V4, was discovered by the physiologist Zeki in 1977. He found that 60 per cent of its cells were coded specifically for colour, with no regard for the shapes of the visual objects perceived. Cells in areas V1 and V2 on the other hand also respond to colour, but only when it is defined by a shape. Compared with cones, which respond to a broad range of wavelengths, cells in V4 respond only to very narrow spectral bands.

The retina's especially sensitive fovea with its high concentration of cone cells has an overriding status in the visual cortex. Foveal areas in V1 are 10,000 times the size of the retinal fovea, and many times the size of the areas of V1, which represent the peripheral field of view. In the cerebral cortex, only the foveal area of V1 sends impulses to the colour area V4.

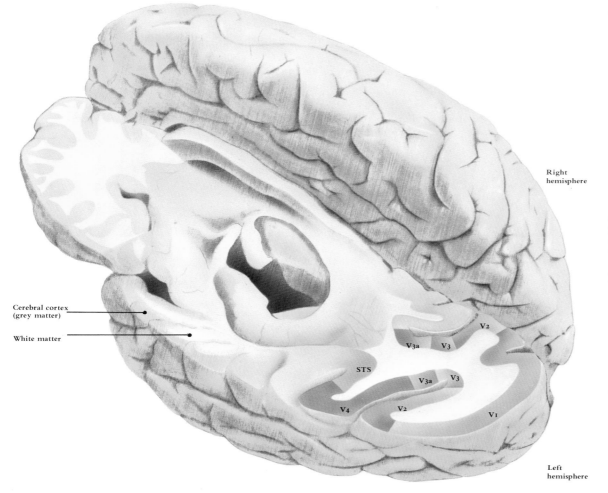

Right hemisphere

Cerebral cortex (grey matter)

White matter

V2

V3a V3

STS

V3a V3

V4 V2

V1

Left hemisphere

35

What the eye doesn't see

The term 'colour blind' is misleading; almost everyone can see colour. People commonly described as 'colour blind' can see colours, but they confuse hues that most people can distinguish clearly. For example, the majority confuse red and orange with yellow and green. They can distinguish colours most easily in the blue-green region of the spectrum.

Colours probably do not all look the same to people with normal colour vision. Similarly, there are many different colour vision defects. About two per cent of men and about 0.3 per cent of women in Britain confuse intense red and orange with brown and green; some six per cent of the population confuse only the lighter tones of these colours, and there are people whose defects fall into intermediate stages between the two.

Defective colour vision is usually sex-linked. Defects are inherited by men and carried by women, although women *can* inherit them. A father with defective, and a mother with normal, colour vision produce normal sons and carrier daughters, and if a carrier woman marries a normal man half of their sons will be colour defective. Each defect is carried by a different gene lying on a different position on the x chromosome, of which men have one and women have two, so it is possible to carry genes for more than one type.

Only since the nineteenth century has it been understood that there are many different types of defective colour vision. The oldest description of a colour vision defect so far discovered was recorded by a British doctor, Turbeville, in 1684. He wrote: 'A maid, 22 or 23 years old, came to me from Banbury, who could see very well but no colour besides black and white. . . . She could see to read sometimes in the greatest darkness for almost a quarter of an hour'. A genealogical record of a family of colour defectives drawn up by an interested doctor in 1777 went unremarked until John Dalton, the father of atomic theory, lucidly described his own defect in 1794, eliciting a stir of interest. Dalton was unable to distinguish between red and grey. He was a Quaker and is said to have attended a prayer meeting one day inappropriately dressed in bright red stockings. A colleague had exchanged them for his usual sober grey ones.

Dalton suffered from a defect termed protanopia, so named because it was the first to be recorded; *protos* is Greek for first. Protanopes confuse red and orange with yellow and green. One per cent of men and 0.02 per cent of women in Britain suffer from this defect. Another group (called deuteranopes from the Greek *deuter* meaning second) confuse green and yellow with orange and red, and cannot distinguish grey from purple. One per cent of men confuse intense, saturated shades of these colours and five per cent confuse pale shades, making this the most common colour vision defect. A third group, tritanopes, confuse green with blue and grey with violet or yellow. This defect is very rare, affecting one in 13,000 to 60,000 in Britain, and may not be sex-linked.

Our understanding of the phenomenon of colour vision and its defects stems from the theory of trichromacy, the idea that three coloured lights, when mixed together in varying proportions, can produce sensations of other colours. During the seventeenth century a French physicist, Mariotte, first observed that 'white' light would result not only from a mixture of all spectral wavelengths, but from a mixture of red, yellow and blue lights.

These ideas were published in 1780 by the French revolutionary, Jean Paul Marat, who was also a doctor of medicine. Around the same time an obscure British physiologist, Palmer, first connected trichromacy and colour vision, but our efforts to understand how the eye sees colour are based on the theories of the British physicist and physician, Thomas Young, who postulated that in the retina are a finite number of particles of three types: red, yellow and blue. 'Each sensitive filament of the nerve may consist of three portions, one for each principle colour'. All other colours were, he believed, the result of these sensations being blended.

These 'particles' are now known to be the colour receptors in the retina, the three types of cone cells. They are maximally sensitive to yellow, green and blue light respectively, although each has a wider spectrum of colour sensitivity.

People with defective colour vision, it is thought, lack, or have few, cones receptive to specific parts of the spectral range; or they lack, or have a reduced concentration of, certain visual pigments. Protanopes are thought to lack 'red-sensitive' cones or pigments, and consequently lack a sensation of red, deuteranopes lack a sensation of green and tritanopes lack a blue sensation. They record coloured light in a different language from people with normal colour vision. If 'green-sensitive' cones are lacking, the task of seeing green is left to the 'blue-' and 'red-sensitive' cones, so deuteranopes see green light in terms of blue and red.

Many colour defectives are dichromatic, that is, they lack one type of cone or visual pigment. There are also people who may lack two types, known as cone monochromats. They have good vision in bright light and restricted colour sensitivity. Rod monochromats are the rare people lacking cone vision.

In 1878, a psychologist, Ewald Hering, proposed a theory to explain how colour sensations are transmitted through the neural tissue of the retina and on to the brain, postulating that when lights of different wavelengths stimulate the cone cells, their responses either excite or inhibit an associated response in the brain. Subsequent attempts to break the colour code in the electrical signals transmitted from cones to ganglion cells to visual cortex were inspired by Thomas Young's trichromatic theory of colour vision and Hering's theory.

A testing session for defective colour vision may involve three or more tests. Most people know of confusion tests such as the Ishihara test, whose purpose is to screen colour defectives from people with normal colour vision. They rely upon patterns of variously coloured dots in which a figure or a letter has to be recognized against a background.

In a matching test, of which there are many, subjects arrange small coloured samples of a known colour specification into a colour sequence. Alternatively they may be asked to match a given hue with the standard proportions of red, green and blue lights; people with slight anomalies of normal colour vision, called anomalous trichromats, will add a higher proportion of red, green or yellow light to the mixture, but protanopes and deuteranopes when asked to match yellow make comparisons of brightness only.

The simple lantern tests in which candidates for military service and certain other jobs had to identify coloured signals are inadequate now that technical assignments involve the use of complicated colour-coded equipment. Sophisticated tests are carried out under medical supervision and under ideal lighting conditions. The diagnosis of a colour vision defect is too complex and delicate an affair for people to be able to do it themselves.

Some colour vision defects are not inherited. Diseases of the liver and the eye may cause colour vision anomalies, as does old age. Reduced colour discrimination may be a symptom of a brain tumour, multiple sclerosis, pernicious anaemia and diabetes. Toxins used in industry, and also excess alcohol and nicotine may cause loss of colour vision. Colour vision may be restored if the diseases are cured, but there is no cure for an inherited defect.

A confusion test, *right,* is most commonly used to detect colour defective vision. The first such test was devised early this century by a Japanese medical officer, Shinobu Ishihara, to distinguish normal from defective colour vision and protanopia ('red blindness') from deuteranopia ('green blindness').

These two plates form part of a confusion test recently devised at the Institute of Ophthalmology in London. To anyone with normal colour vision the top plate depicts a woman wearing a purple hat and an olive-green bikini against a green background. A colour defective person sees a woman, unclothed but for a hat; he or she confuses the green bikini with the reddish orange colour of the flesh, seeing them both as one colour.

A protanope sees the purple spade but fails to perceive the red fork which he confuses with the grey background. A deuteranope, on the other hand, sees the red fork, but confuses the purple spade with the grey of the background. Neither plate can be used to diagnose tritanopia; the condition is more difficult to diagnose and requires a separate test.

The plates as reproduced here are not intended to be used for self-diagnosis. These two plates are part of a series, all of which must be examined in carefully controlled lighting conditions.

Every human being has 23 pairs of chromosomes in the nucleus of every cell in his or her body. Genes, which determine all the body's inherited characteristics, lie in these chromosomes; 22 identical pairs are shared by male and female, but the 23rd, the sex chromosomes, distinguish them.

Females have two X chromosomes, their ova will carry one of them; males have one X and one Y chromosome and their sperm carry either X or Y. Offspring inherit one X chromosome from the mother and an X or Y chromosome from the father, an XX combination produces a daughter and an XY combination, a son.

Certain genes that determine defective colour vision lie on the X chromosome. Men, having only one, are most likely to have their entire X-complement affected; only if both X chromosomes carry a gene for colour defective vision will a woman inherit the condition; if one chromosome only carries such a gene, she will be a carrier but not colour defective.

The hypothetical family tree, *above,* illustrates how the defect could be transmitted through four generations. It shows the offspring of parents with five combinations of genes: a colour defective man and a normal woman; a colour defective man and a carrier woman; a normal man and a carrier woman; a normal man and a colour defective woman and a man and a woman who are both colour defective.

Normal	Carrier	Colour defective

The incidence of defective colour vision varies in different parts of the world, as this map shows. It is divided into five zones, each colour-coded to represent the average percentage of colour defective people in the total population. In the red zones of Europe and the USA, the most technologically advanced areas, one in 12 people is colour defective. In the orange zones of high urban population elsewhere: South Africa, Australia, New Zealand, Israel and the Brazilian seaboard, the incidence lowers to one in 16.

Where there is a mixture of rural and urban populations, coloured yellow, the incidence falls to one in 20 and to one in 30 in the blue zones populated by hunting, fishing and agricultural societies. The lowest incidence, one in 50, occurs among communities in the Arctic and the equatorial rain forests of Brazil, Africa and New Guinea.

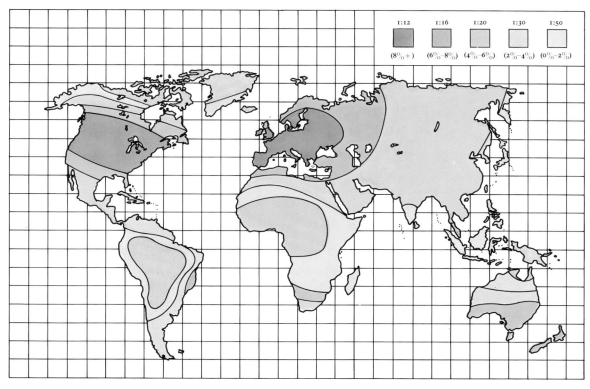

1:12	1:16	1:20	1:30	1:50
(8%+)	(6%–8%)	(4%–6%)	(2%–4%)	(0%–2%)

Confusion by colour

A movie made in the forties portrayed the world through colour defective eyes. The eyes were those of an exceptional woman with a deuteranopic left eye and a colour normal right. Using her left eye she could see only grey, yellow and blue; with both eyes open she could see the full spectral range. No one without this unique ability to see and compare both worlds can guess how colours appear to a colour defective person, for no one can know what another person sees.

Peculiarities of perception can be assessed only by comparison with the norm. When asked to match a monochromatic yellow light, trichromats with normal colour vision mix a given spectral green with a given spectral red in surprisingly constant proportions. People whose colour vision varies slightly from the norm—known as anomalous trichromats—use more green, or more red. Protanopes and deuteranopes use the red or green in abnormal proportions, adjusting only the brightness. To communicate what they see, colour defective people use the same colour terms as everyone else. They learned in infancy that grass is green, lemons are yellow, ripe apples are red, the sky is blue. But the colours they see are different.

Vision is our dominant sense: it informs us about our environment and has been essential for our survival. Defective colour vision now excludes sufferers from certain professions. This story shows why.

On a calm, clear, summer night in 1875, the steamship *Isaac Bell* left Norfolk, Virginia, showing the regulation red port and green starboard lights. The officer on deck noticed the lights of an approaching tug off starboard. Closer and closer it came. The two ships collided and ten lives were lost. In court, the captain and officers of the steamship swore that they signalled their direction with the correct green starboard light, but the captain of the tug testified that he saw a red port light. For four years the disaster remained a mystery, until in a medical test the captain of the tug was found to be unable to distinguish a red from a green light.

Jobs in the armed services and in transportation may now involve far more complex colour-coding than simple red and green signals. Where lives are at stake, applicants must obviously be subjected to screening tests if colour discrimination is part of the job. In the electrical, photographic, printing, dyeing, textile and paint industries, good colour vision is essential. Cotton buyers who have to grade raw materials need good colour vision to be able to spot the discoloration caused by frost, insects and soiling. Some agricultural workers have to judge the ripening of crops by their changing colour.

Yet in professions where good colour vision is an advantage rather than an essential, colour defective people can often work with no impairment of efficiency, making colour discriminations on the basis of brightness and tone and learning how to interpret the language of normal colour vision. 'I've learned how to look at colours and to work them out logically', explained a senior designer at a leading Parisian couture house; 'I just have to remember that funny looking colour is red. Sometimes it can be an asset. I put colours together in unusual combinations which sometimes miraculously work, but someone else has to notice it'.

In everyday life, colour vision defects are rarely a handicap. Red, amber and green traffic lights have been in general use since the thirties yet few, if any, accidents have been reported as caused by colour defective drivers. Theoretically, protanopes and monochromats are at a disadvantage in the traffic lanes (in Austria and Hungary they are forbidden to drive) but colour defective people learn to recognise the positioning of signals and the relative intensities of different colours, and to watch other traffic. In many countries red, amber and green traffic lights are arranged vertically and appear in a memorable succession so that colour defective drivers can learn the sequence. In Baltimore, USA, the red light contains some orange and has a horizontal streak and the green light contains some blue and has a vertical streak. In some cities the words STOP, GO and CAUTION label the relevant lights. In Switzerland, associated shapes are superimposed on the colours.

There have been, and still are, colour defective artists. The Dutch painter Van Goyen may have been a deuteranope—his paintings contain little green. There are theories that Constable and Whistler may have been colour defective.

Many people are not aware until adulthood that their colour vision is abnormal, but they may have suffered at school. Learning involves colour, it is used in teaching mathematics, geography and the sciences and is playing an increasingly important role in modern teaching methods. Since children can adapt if they know they are defective, and teachers can make allowances, children should be tested early in their schooldays.

The London Underground

The London Underground transport system is easy to use because the official map, *left*, has colour-coded routes. Anyone with normal trichromatic vision will distinguish routes by their hues but someone with a colour vision defect is likely to confuse them. The three maps opposite attempt to illustrate these confusions; they offer some insight into the problems people with three different types of defective colour vision may find in trying to negotiate such a system. The choice of colours is unavoidably inaccurate. Colour defectives vary enormously in their perceptions of colour—and it is impossible to know what colours they see.

This map is an attempt to illustrate how the London Underground system may look to a protanope, a person whose 'red-sensitive' cones are either absent or non-functional and who therefore has only 'green-sensitive' and 'blue-sensitive' cones with which to distinguish the whole range of colours. Because of this defect he will suffer confusion when trying to discriminate between red, orange, yellow and green. The District and Circle Lines will both appear to him to be a similar greenish yellow; the Central and Bakerloo will imitate each other's brown colour; the purple of the Metropolitan Line will contain no red and look dark blue, scarcely distinguishable from the black of the Northern Line.

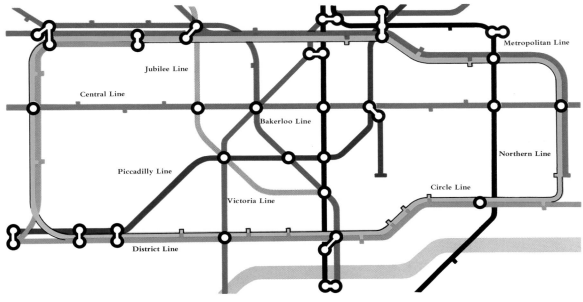

Deuteranopes, like protanopes, are dichromatic; that is, they have only two types of cones with which to distinguish all colours. They lack 'green-sensitive' cones or visual pigments and must use only the 'red-sensitive' and 'blue-sensitive' to distinguish colours. Like protanopes they have difficulty in distinguishing between red, orange, yellow and green, but see green and yellow in terms of red and brown.

This map shows the colour confusions experienced by a hypothetical deuteranope. The Central, Bakerloo and District Lines all appear as varying shades of brown. To those with normal colour vision, deuteranopes would appear to suffer comparatively few confusions, for although the map shows some colour changes, the lines can be identified by tone.

A person whose 'blue-sensitive' cones are deficient, a tritanope, distinguishes all colours by means of his or her 'red-sensitive' and 'green-sensitive' cones. Tritanopes are rare, so knowledge about this defect is sparse, but it is reported that tritanopes appear to confuse shades of blue with shades of green.

The Victoria Line and District Line of the London Underground system may, therefore, both appear green and must be distinguished by tone. The Piccadilly Line may also look green, but perhaps a green so dark that it becomes confused with the black of the Northern Line. The purple of the Metropolitan Line may contain no blue and look deep red, presenting a possible confusion with the Central Line. The tritanope can, however, identify the lines by virtue of their tone.

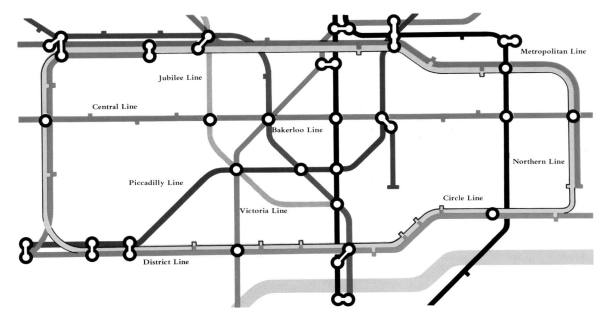

The mind's eye

The retinal apparatus in the eye is the mediator between the external world and perception—the process whereby we build a model of outside reality in the mind. The world as we perceive it seems essentially constant and stable, populated by objects which faithfully retain their appearance and identity regardless of the circumstances in which they are seen.

The senses, however, register these changing circumstances which perception disregards. For example, a plate casts a circular image on the retina when seen from above, and an elliptical one when viewed from the side. These radical differences in physical reality are mere corollaries, so far as perception is concerned, to recognizing the identity of the plate. Likewise, a red coat is physically purple under an artificial light with a bluish cast, but we discount this change, seeing red despite it, because the brain is more interested in the identity of the coat than in the quality of the light by which it is seen.

It is obvious how fundamental to our consciousness of the world these perceptual processes must be when you consider how sparse are the visual clues gathered by the eye and how rich are the visual impressions we gather on their basis. Light entering the eye varies only in three respects: in its brightness, in its colour distribution along the wavelength scale and in the direction from which it arrives to form the retinal image. When you distinguish a friend from her sister in a photographic transparency all of these quantities vary as you pass it around, hold it up to the window or take it to a reading lamp, and they vary in vast degree relative to the subtleties of pattern on which you base your recognition.

A demonstration that the world of perception is quite different from the world of sensation was provided by Edwin Land, founder of the Polaroid Corporation. In 1959, he showed how it is possible to evoke the perception of colours in commonplace scenes, when light of the relevant wavelengths is absent from the image focused on the retina.

One of his demonstrations involved the evidence of two photographs of the same coloured scene, a still life of fruit and flowers. Land used black and white film, which registers different colours in shades of grey. But for his first photograph there was a yellow filter in front of the camera (admitting yellow light and no other to the film); and for the second, an orange one.

The two resulting black and white transparencies were placed in separate slide projectors, their respective yellow and orange filters between the projectors and the screen. When the first projector was turned on, a monochromatic yellow version of the scene appeared on the screen. When the orange projector was turned on it rendered the still life monochromatic orange, with scarcely perceptible different patterns of light and shade. In each case, the spectators could confirm that only yellow or orange light fell on the screen and was directed to the eye.

Land then turned on both projectors, and the yellow and orange beams, falling in register on the screen, produced, not a monochromatic image of the scene, but an image displaying almost the full gamut of colours—reds, greens and blues, and their mixtures—which were present in the original scene. Perception of the whole spectral range of colours (physically absent from the projected image) is achieved as the visual system works on subtle clues embedded in the *pattern* of yellow and orange light reflected from the screen.

These remarkable phenomena led Land to conclusions fundamental to the understanding of perception. He deduced that the wavelength of light is not after all 'colour-making' in its own right, as in the classical Newtonian interpretation. Rather, wavelength carries information which the visual system uses to *assign* colours to objects in a scene, but only in conjunction with clues from other aspects and parts of the image. When such clues dominate, perception of colour is only distantly related to wavelength, as in Land's demonstration.

The eye's role, therefore, is not merely to transmit to the brain the information it receives; it also compares and contrasts it, and adapts it. The eye codes the information received from the visual field for transmission through the visual system as shape, colour, texture, depth and so on. The brain's reconstruction corresponds to but does not exactly replicate, the image that falls on the retina.

The eye is able to discriminate accurately between different wavelengths, but the image the brain assembles differs from the original scene because it takes into account variations in illumination, and responds to the relation of one colour to another.

It is easy to produce an illusory sensation of colour. If the eye is adapted to a particular hue, by staring at it for some seconds and then the gaze is transferred to a white surface, a complementary colour appears. A white surface will look green, for example, after first adapting the eye to a red stimulus. The red light reduces the sensitivity of the red receptor system in the retina, more than that of the green, so that when both systems respond to the 'white' light, the green dominates. Phenomena of this sort are known as successive colour contrasts.

Related effects change the colour of a surface by contrast with neighbouring areas. One coloured surface affects an adjacent one of another colour in such a way as to enhance the contrast between them. Thus, the yellow of a primrose is deepened by the surrounding green leaves; the blue sky above the horizon is lightened by the darker sea below; an orange surface tinges an adjacent white or grey with its complementary colour, cyan (greenish blue). These effects, called simultaneous contrast, are due to inhibitory interactions between the neuronal channels that conduct colour information in the visual pathway. Perceptual processes within the brain also enhance the effect, just as the height of a tall man and the shortness of a small man are enhanced when they stand side by side.

The successive and simultaneous colour contrast effects depend primarily on the colour of the stimuli, and on their relation to one another—adjacency in time or in space. They are not always affected by other aspects of pattern in the retinal image. There are, however, colour illusions which do crucially depend on the spatial patterning of the adapting stimuli used to produce them, and the most famous of these, only quite recently described, is the McCollough effect named after its discoverer.

To see this effect, you first adapt the visual system by roving your eyes over a pattern, say, of vertical red and black stripes for some minutes. Then you transfer your gaze to a pattern of black and white lines, some oriented vertically and some horizontally. The horizontal lines continue to look black and white, but the vertically oriented ones seem to carry the complementary hue, green. This is not an after-image caused by retinal adaptation, because you moved your eyes about over the adapting pattern. It is thought to arise because in inspecting the adapting pattern of red vertical stripes you fatigued the special population of brain cells in the visual cortex of the *brain*, whose function is to respond just to vertical red edges among all the possible patterns of light that can fall on your retina. Their counterparts, other nerve cells sensitive to green vertical edges, dominate the evaluation of colour when the black and white vertical stripes are viewed.

This illusion is a very robust one—if you go to sleep after viewing the adapting pattern it is still there the next morning—and it demonstrates how the perception of colour is dependent on

other clues of spatial pattern, in this case orientation, in the visual scene.

Perception of hue can also be affected by temporal pattern, as the Greeks knew. Their jinx wheel was a coloured disk, whirled on two strings passed through two holes near the centre. It worked as an enchantment to restore the affections of a bored lover, since the colours symbolized the restless movement of the emotions of love. It is not known which colours were used, but their whirling produced hues other than those inscribed upon it. Children's spinning tops when spun, produce colours other than those inscribed on them. The spinning results in optical fusing by mixing reflected light.

Colours can be produced even by temporally varying patterns patterns of 'white' light. Benham's Top is a disk with a pattern of black lines on a white surface. When spun in a clockwise direction at a rate of five to ten revolutions per second, the black lines appear, from the centre outwards, blue, green and red. When it is spun in an anti-clockwise direction, the order of the colours is reversed. These colours can appear even in monochromatic light, and they arise because signals from the different types of cones in the retina travel at different speeds towards the brain. The black-white flicker produced by spinning the top allows long-wave and short-wave signals to arrive at the brain out of step.

Usually colours are seen as surface colours reflected from objects. However, they can appear formless and disembodied, as film colours, when there are no clues of surface texture available to relate to them. Thus, when you look at a distant coloured wall through a hole in a darkened screen, the colour appears as a film-like expanse rather than any attribute of a wall. The colours of objects seen with the periphery of the retina can appear disembodied in a similar way, when it has been possible to endow by surgery sight in the congenitally blind; it has been reported that to them, colours appear formless in a similar way: it is some time before they learn to relate them to objects.

The remarkable ability of the visual system to correctly perceive the physical colour of a surface in spite of wide variations in the light illuminating it (the phenomenon known as colour constancy) pinpoints the fundamental difference in approach to perception between psychologists of different schools of thought. Structural psychologists hold that a given excitatory event leads to an invariant sensory response regardless of the surrounding conditions, while Gestalt psychologists, on the other hand, deny this and emphasize that sensory data entering the eye are irretrievably transformed by their context and their relation to memory.

But if we consider that the physiology and biochemistry of the eye and the visual cortex provide the tools and instruments for the process of vision, and that psychology describes the way we interpret what we see, then we must conclude that there may be an intermediate stage between physiology and psychology where the visual image is reconstructed in the domain of the mind. This is perception, the mind's apprehension of the outside world.

Three dimensions of colour

If you were asked to arrange 1,000 differently coloured squares in order, how would you go about it? This is a problem with which philosophers, artists and mathematicians have been grappling since Newton first dispersed 'white' light into its constituent wavelengths during the seventeenth century. He ordered the spectral colours into a simple circle of hues by joining the red at one end of the spectrum to violet at the other. But colour is more complicated than that.

Each colour, or hue: red, orange, yellow, green, blue and violet (and all the intermediate hues that range between them—greenish blue, for instance, or reddish orange) can be bright and intense, or pale. A colourful paint can be made paler by the addition of white. The colourfulness of a hue is generally known as its saturation—a word coined by the dyeing industry to convey the relative quantity of colour a dye contained. Blues, for example, can range from a desaturated or whitish blue to an intense, or saturated, royal blue.

And pigment colours change again if grey is added to them: mix a pale blue with a light grey, then a dark grey, then a darker grey, and see the colour change gradually from light to dark blue. A colour is described as light or dark, depending upon the amount of grey in it.

Since all colours have three dimensions: hue, saturation and lightness, to order them requires a three-dimensional system: a colour solid. Theorists have tried many geometrical shapes—hemispheres, spheres and so on, but to arrange the thousands of colours available to industry today, a simple and convenient colour order system has been found to be a double cone.

The axis of this double cone consists of a scale of gradations from light to dark; white is at the top and the axis greys progressively to black at the bottom. The hues, aligned parallel with the axis, lighten and darken accordingly. The blues and pinks in the upper cone can be seen lightening towards white at the top, and the oranges and greens in the lower cone darken progressively to black at the bottom.

Any hue of any degree of saturation can be described in terms of its lightness or darkness value: red, for example, lightens if mixed with white, darkens if mixed with black and is of medium tone or value if mixed with grey.

The hues are arranged concentrically around the axis. A single hue is assigned to each arc. Hue is the term that describes what we usually think of as 'colour': red, yellow, blue and so on. Hue is determined by wavelength, and in any colour circle or solid the hues are arranged in the sequence in which they occur in the spectrum.

This is a rudimentary colour solid. Its range is limited by the size of this page and by the narrow range of colours to which even the specialized printer of this book is restricted. It has about 20 arms. To show all the colours the human eye can discriminate, it would need about 200.

The radius of the circle describes the degree of saturation of each hue. The further out from the axis, the more saturated each hue becomes. The saturation of a colour is a measure of its purity, of how different it is from grey. To see why, compare the pure greens around the radius of the circle with those ranged around the axis of the cone. It can be seen that a hue of any given lightness may vary in its degree of saturation. A green when mixed with itself becomes greener—that is, more colourful—and less grey.

At a distance of about two metres, the blue and orange patches in the illustrations, *top* and *centre left*, are clearly distinguishable from each other, but the square, *bottom left*, composed of smaller patches of the same two colours, looks pink. This effect occurs only when the patches are equally bright, are four mm square, or less, and are viewed at a distance of one metre or more. Light reflected from the differently coloured patches resolves into a mixture on reaching the retina.

An optical effect known as simultaneous contrast, first described and practised by Leonardo da Vinci, occurs when certain hues are juxtaposed. Red next to grey makes the grey look green, for example; yellow next to grey shifts the grey to blue. This effect is due to retinal adaptation; nerve cells receiving information about one colour inhibit those receiving information from the adjacent colour.

Another form of retinal adaptation is exemplified in the phenomenon of after-images, *right*. Stare fixedly at the upper black square for 30 seconds and then transfer your eye to the lower black square. In the surrounding white space will appear squares of colour complementary to those in the squares above. This effect occurs because after steady exposure to red, for example, the red receptors in the eye become adapted to red, and the 'white' light reflected from the surface of the paper appears green. Conversely, if you transfer your stare to a black background, the sensation of red persists.

The Mach effect occurs when two areas of uniform brightness, one dark and one light, are placed side by side, separated by a sharp edge. Just along the edge, the dark area seems darker than it really is and along the other side, the light area looks lighter. When the disk, *below*, is spun the eye sees a mixture of light reflected from the yellow and blue sectors, but this mixture is not a smooth progression from dark blue around the perimeter to yellow at the centre. The Mach effect, caused by the jagged 'staircase' pattern of the yellow rays, instead produces a series of fluted concentric bands, *below*.

Kinetic colour fusion disks, or spinning tops, illustrate the difference between mixing paint and mixing light. If the green, orange and blue pigments colouring the disk, *below*, were mixed together, the mixture would absorb more of the incident light than each of the component hues and would therefore look darker. But when the disk is rotated, the light reflected by each hue fuses: the green and blue, for example, mix additively to produce turquoise. This mixture, produced by reflected green light added to reflected blue light, is brighter and more luminous than either of the component hues, *below*.

Colour in psychology

It is not psychology, but common experience which testifies to the fact that colour influences mood and feeling. But the psychological basis of this influence is little understood. There is some evidence to suggest that light of different colours entering the eye can indirectly affect the centre of the emotions in the hypothalamus, which in turn affects the pituitary gland. This 'master' gland controls the entire endocrine system, including the thyroid and sex glands, and so controls the hormone levels of this system and the moods consequent upon them.

In addition, attempts to establish scientifically the effects of colour on the mind, as opposed to the body, have proved inconclusive. Nevertheless, the stubborn fact remains that no matter how contradictory subjective responses to colour are, they cannot be easily disregarded; a green dress can attract or repel, the red walls of a room can be reassuring or discomforting. In the thirties, a neuropsychologist named Kurt Goldstein performed some much-quoted experiments with coloured illumination and concluded that in red light, time is overestimated and objects seem longer, bigger or heavier; while in green or blue light, time is underestimated and objects seem shorter, smaller and lighter. Although, as with all colour experiments of this kind, it is difficult to repeat these results (as the scientific method requires), Goldstein at least attempted to quantify the unaccountable effects of colour that interior decorators, for instance, have intuitively employed for years.

Production at a factory in the United States increased by eight per cent almost overnight after the men's rooms had been painted a ghastly electric green, which had the effect of discouraging malingerers. Blue walls in hospitals where there are emotionally disturbed people have a calming effect; but the same colour in a café caused employees to complain of the cold. The walls were repainted orange. Some shades of yellow can induce nausea and are therefore avoided in aircraft, for instance; others have been used in classrooms to improve the work of schoolchildren. Workmen shifting black boxes complained that they were too heavy; when they were painted green they promptly felt lighter.

Such effects evidently arise in the course of the whole process of vision from eye to visual cortex and thereafter to that even less tangible entity, the mind. They may simply be caused by the change of hue, such that the green boxes may come in time to seem as heavy as the black. An experiment with sound and colour showed that sounds enhanced the sensation of cold colours (violet, blue and green) and depressed the sensation of warm reds, oranges and yellows (yellow-green sensations were unchanged). But a later experiment not only confirmed this result but discovered an intriguing after-effect: whereas sound depressed the sensitivity to red, a reversal occurred after a three minute interval, and red appeared brighter than normal. The same held true for the other colours. Similarly, the increase in blood pressure caused by red is reversed after a short time—it falls below normal; and the same psycho-physiological after-effect can be observed for blue and green, but in reverse.

Children have been popular guinea-pigs in attempts to discover if, and to what extent, human response to colour is inborn or culturally conditioned. One important study consisted of offering nursery-school children a choice of yellow or brown crayons with which to depict happy and sad stories. A significant number chose yellow for the happy and brown for the sad, suggesting that colour preferences are innate. But it would still be difficult to show that the process of learning, even at a very tender age, played no part at all. Children up to the age of three almost universally prefer primary colours over pastel shades.

For their book *Painting and Personality*, Rose H. Alschuler and La Berta Weiss Hattwick had the opportunity to study young children and their painting over a long period of time and with a knowledge of their backgrounds. They confirmed that children with strong emotional drives had strong preferences for certain colours, notably red, yellow and orange, which they employed freely in mass effects on the paper. On specific occasions, too, colour was emphasized whenever powerful emotions were present. A red used to reflect happy adjustment could also reflect emotional stress; the key to its use often depended on whether it was applied in light, circular daubings or heavy, aggressive strokes. The use of 'cooler' colours such as green and blue by children under five years old usually indicated a greater control, or (more seriously) a conscious avoidance, of emotion. The story of one little girl whose emotional maladjustment was evident in her 'cold' paintings, had a happy ending. She spontaneously asked for, and received, red paint from a little boy to whom she had formed a deep attachment.

The desire for more objective data on colour prompted a series of statistical surveys which simply asked people to place colours in order of preference. In 1941, men liked blue best, followed by red, green, violet, orange and yellow, in that order. Women chose the same order but reversed yellow and orange. Two further surveys in 1969 inconsiderately placed orange first, blue second and red and green last. It was suggested that the results were influenced by the fact that orange was a fashionable colour at the time; and, to reduce this factor, tests were carried out among students in Botswana and Kenya (on the highly questionable grounds that they are less fashion-conscious). In Botswana blue followed by green was favourite, red and yellow least favourite; the Kenyans preferred green over blue, but otherwise agreed. The results showed that, in colour preference, much depends on what the colour is wanted for—we do not choose the same green for our kitchens as we do for our cars. Besides, the tests ignored saturation, which, according to a West German study, is the most important criterion for preference.

Conventional psychology dismisses any supposed ability on the part of colour to throw light on the complexity of the human personality. Some psychiatrists are less sceptical and may even use a colour test, in combination with other kinds of test, to help make a diagnosis. For colour is most commonly associated with affect, the psycho-analytical term for desires, impulses and wishes—the emotional as opposed to the intellectual side of life. Freudian psychoanalysts and Jungian analytical psychologists pay attention to the important role of colour in manifestations of the unconscious, such as dreams and fantasies.

But characteristically, the meaning of colours tends to bear the hallmarks of their creeds: Freudians invariably relate hues back to bodily functions—blood, faeces and so on—while Jungians tend towards a more liberal interpretation of hues, believing that the individual's response to colour is too complex to allow of a simple (sexual, for example) mode of interpretation. At the same time, they are able on occasions to discern 'archetypal' connotations for hues—black, yellow, white and red, for instance, can represent basic psychic states corresponding to stages in the alchemist's quest for the Philosophers' Stone.

Research into the psychological effects of colour undertaken in the thirties and forties seems largely to have been discontinued; the lack of conclusive results could not justify the time and expense. But no matter how elusive psychological facts about the influence of colour are, it continues to stimulate, excite and express our deepest impulses.

C.G. Jung encouraged his patients' use of spontaneous paintings to help integrate the unconscious part of the psyche with the conscious. The process, called individuation, aims at reconciling opposites in the psyche and creating wholeness. The tendency of his patients to create patterns based on the archetypal forms of square and circle, led Jung to compare them with Buddhist meditational devices or mandalas, resembling this Hindu yantra.

Rorschach's famous series of ten inkblots can be likened to a mirror in which unconscious psychic contents are reflected. Each person projects a different image on to a blot and the nature of the image can help diagnose a psychic condition. Only one blot is fully coloured, *above*, and Rorschach claimed that a person's response to colour reflected his typical method of dealing with affect; but the vagueness of this term allows only the tentative suggestion that colour response indicates something of the quality of the subject's emotional or impulsive life. Failure to remark on colour in the inkblot may be just as significant as detailed comments.

Margaret Lowenfeld's mosaic test was inspired by the patterns of south-east European embroideries. She evolved a set of shapes and coloured them as closely as possible to jewels (ruby red, emerald green and so on). Patients, especially children, readily gave some indication of the level of their disturbance just by their choice of colour and design. The humour and imagination of the picture, *below*, depicting a cat with its toy, suggest the work of a comparatively well-adjusted child not younger than 12 years. Anthropologists, too, have used the test to help gauge the imaginative capacity of their subjects, which verbal tests neglect.

These mandalas created by a patient of Jung's are only two of a whole series that enact the individuation process. The mandala, *above*, has an outer circle of four colours which the patient ascribed to the functions of consciousness: yellow = intuition, blue = thinking, pink = feeling and brown = sensation (green is more usual than brown). These are comparable to the colours that define the central square of the yantra, *top*. The inner area indicates that the 'dark side' of the psyche has been accepted and illuminated from within by a golden light, the seed of the blue 'soul-flower' that grows at the heart of the mandala, *below*. The four-fold structure is still evident (the hexagrams are derived from the Chinese *Book of Changes*); but the division into an upper half 'many-hued as a rainbow', and a lower, consisting 'of brown earth', characterizes the psyche of a Western person 'whose light throws a dark shadow'.

Colour in healing

There is an ancient and widespread faith in the healing power of colour. Gemstones, seemingly filled with coloured light of a peculiarly mystical kind, have always been held in reverence, and in ancient times were ground and diluted, or dipped in water, to be used as remedies for sickness. Yellow beryls were used to cure jaundice, bloodstones treated haemorrhages and disorders of the blood; the prismatic diamond was considered a cure-all. The Egyptian *Papyrus Ebers* of 1550 BC listed, among other coloured cures, white oil, red lead, testicles of a black ass, black lizards, indigo and verdigris. The last, a green copper salt, was mixed with beetle wax and used to treat cataracts.

Such colour cures were sometimes efficacious. For the Greeks Tyrian purple, obtained from the murex shellfish and used to dye the cloaks of kings, was the perfect remedy for boils and ulcers; owing to its calcium oxide content, it often worked.

The ancient Chinese attached great importance to the use of colour in diagnosis, and read the pulse and the complexion in terms of colour. A 'red' pulse meant 'numbness of the heart'; a yellow complexion, a healthy stomach, while a green one warned of imminent death. The link between colour and medical diagnosis occurs in almost every culture, most commonly and persistently expressed through the Doctrine of the Humours, a system of thought, part medical, part mystical, that may have begun with the Egyptians.

This doctrine linked the four elements of this world—earth, air, fire and water—with the four elements or humours of man. Each humour had its own colour, roughly corresponding to that of a body fluid; thus, black bile produced melancholy, red blood a sanguine humour, yellow bile or spleen a choleric humour, while the white of water represented the phlegmatic element. Imbalance in the humours—and hence in health—was judged by colour variations in complexion, urine or excrement. The Chinese, the Hindus, the Greeks and the Romans all adhered to the Doctrine of the Humours in one form or another. So did medieval western Europe which gained its version from Islam.

To this day, analysis of the colours of the skin, tongue, eyes and secretions of the body is the basis of diagnosis. But doctors now know that purple or blue skin indicates a lack of oxygen in the blood and is probably the result of lung or heart disease; that bright red skin identifies poisoning by carbon monoxide, which combines with hemoglobin more readily than oxygen. They recognize conjunctivitis and alcoholism by redness in the eyes, and diagnose pernicious anaemia, due to vitamin B_{12} deficiency, by a yellow skin and red tongue.

And colour, allied with space technology, now enables the diagnosis of illness and malfunction in the most inaccessible parts of the body. The principle of echo-location used by bats and dolphins is employed in sonography to detect tumours, examine a foetus in the womb or scan a diseased heart. The body is probed with high frequency sound waves, and echoes are reflected by the soft tissues. These are recorded to produce a grey image which, if coded in colour, reveals greater detail.

The infrared thermograph has an extraordinary range of uses, from the early detection of some cancers to determining the precise whereabouts of blood clots or adjusting the fit of an artificial limb. The thermograph registers, and shows on a TV screen, the infrared energy radiated by all matter. To map body temperature distribution, a scanning camera, sensitive to infrared, detects these radiations which are colour-coded according to their intensity. Since every part of the human body has its own temperature range, abnormal readings indicate changes resulting from malfunction or disease.

About 100 years ago, the association of colour and therapy was consigned by most mainstream medical practitioners to the *demi-monde* of their profession. The theories of the majority of its adherents were still based on the aura, the emanations which many psychics claim to sense surrounding the human body. Health of body and mind depend upon a balance of aural colours, it is said, and should a colour be missing or over-dominant the balance must be redressed by colour healing or chromotherapy.

Chromotherapists may prescribe coloured foods, clothes or treat their patients with coloured lights. They believe that red light cures rheumatism, arthritis, poor circulation, stiff joints and chills, that blue soothes inflammation and eases the effects of high

Semyon and Valentina Kirlian photographed an energy field surrounding certain objects, and restored a degree of credibility in the existence of a human aura. This Kirlian photograph recorded the discharges emanating from a healer's thumb placed on a photographic plate through which a powerful electrical charge was passed. From the colours and conditions of human 'auras', researchers claim to be able to diagnose physical and emotional states. One Russian biophysicist has suggested that the 'aura' may be biological plasma, a gas released by the emission of electrons from a live object into the atmosphere of a high frequency electrical field.

blood pressure and that green is a remedy for infection.

And coloured light *is* sometimes efficacious. Blue light treatment, for instance, has replaced blood transfusions in the treatment of jaundice in premature babies: it penetrates the skin, destroying the excess bilirubin that the immature liver cannot remove. The babies stay under the lights for two or three days, by which time the liver has matured enough to cope with the bilirubin. In operating theatres, the antiseptic qualities of ultra-violet light are used to cleanse the air. Sunlight, containing all the colours of the spectrum, is a nutrient. Its absence causes rickets and other diseases of the bones, and its presence is essential to the well-being of the human body.

Density-slicing makes use of a scanning camera to 'slice' a grey image such as an X-ray, *above*, into its photographic densities. By colour-coding each 'slice' details are revealed that might otherwise be lost to the eye. This patient had a malocclusion of the jaw—as a result of an accident, the upper and lower teeth failed to meet properly.

Some injuries, diseases and conditions produce a drop in temperature in the affected part, and others a sharp rise; an infrared thermograph records these changes in a colour scale usually selected to run from white at the hot end, through reds, greens and violets, to blues at the cold end. The toes in the foot, *above*, registered a temperature below the norm because thrombosis—a blood clot—in the femoral artery in the leg was inhibiting the circulation of the blood. After surgery, the thermograph coded the toes white, red and yellow, showing a rise in temperature of 5°C.

THE PROGRESS OF COLOUR

In the beginning, time was the brief span between lightness and dark, darkness and light. Each span thrust the light and life of man nearer to the extinction of darkness and death. And the earliest recognition of the irrevocable fact of death—formal burial—is hallmarked by a strange phenomenon: graves were strewn with red ochre. No one knows why; but the most plausible answer lies in the visible sign of life, blood, and the power of its redness. So, when man was consigned to the black earth, he was accompanied by some of the brightness and some of the redness that would palliate the sting of death and perhaps light his way into another life beyond the grave.

This is only story-telling, but it serves to underline the way that colour was regarded for thousands of years. The relative lightness and darkness of a colour determined its quality at least as much as its hue. Metals and gems were likely to have been precious because they shone with preternatural beauty, not just because they were rare. They seemed to be animate.

The beginnings of colour can be discerned in another story, as told by the ancient Greeks. When Prometheus stole fire from the gods on Mount Olympus and brought it down to man, he brought the means to transform the natural world. The ghosts, spirits and demons that thronged the darkness of the Old Stone Age were banished outside the magic circle of light in which men sat, gazing into the flames and perhaps divining their own future. Just as fire transformed food, it could change the simple raw materials that lay to hand—clay, quartz, sand, iron oxides; and, as they changed substance and hardened or fused or melted, their hues altered marvellously before the eyes of their creators. Like alchemists, the first potters, glaziers and metallurgists turned prosaic minerals and earths into something rich and strange.

The struggle to distil the colours from nature was—and still is—a continuous process. The Egyptians synthesized a wonderful blue pigment probably as a result of glass-making experiments; the early Moslems of the Middle East rediscovered it, or something similar, to manufacture the blues which symbolized divinity for them. Purple was the most sacred colour of the Greeks and Romans, and it was extracted from the *murex* (a kind of whelk) in a process which produced a colour sequence of yellow, green, blue and finally the purple dye which adorned the robes of emperors.

Modern chemistry can synthesize any number of dyes and paints which are both more brilliant and more permanent than anything dreamed of three centuries ago. For, until comparatively recently, pigments for walls as well as canvases were ground by hand from natural ingredients, as they were in the ancient world, or artfully adapted from plant dyes. But still the hues fall short of their ideal. 'When I get to heaven', said Sir Winston Churchill, '. . . I shall require a still gayer palette than I yet have below. I expect orange and vermilion will be the darkest, dullest upon it, and beyond these will be a whole range of wonderful new colours which will delight the celestial eye.'

Every object has colour and form; but, whereas a science of forms has existed since the great Greek geometers, the world had to wait 2,000 years for a comparable science of colour. Primary colours were established at last; science confirmed what artists had always known—that any colour could be mixed from red, blue and yellow. But together, these three hues mix to make black (or, at least, a brownish black)—a very different proposition from the primaries of light, red, green and blue. The reconciling of the two sets of primaries, the transforming of light into pigment, lies at the heart of colour photography, film and modern printing. But these sophisticated processes can only break down the colours of the world and reconstruct them in an image. They have not the transforming vision of a painter—Van Gogh, for example—whose innocent coffee-house becomes 'a place where one can go mad and commit crimes' just through juxtapositions of red and green. For such colour combinations can evoke 'the darkness that holds a sleeping man in its power'.

Colour is an immediate experience, acting directly on the emotions; and yet it is curiously abstract. Once divorced from the object it belongs to, it becomes difficult to grasp. It is notoriously difficult to explain red to a blind man although one such discovered his own solution, as the philosopher John Locke reported in 1690: having 'mightily beat his head about visible objects . . . to understand those names of light and colours . . . he now understood what scarlet signified . . . it was like the sound of a trumpet.'

Music provides the best analogy for colour (they even share a vocabulary with words like 'harmony' and 'tone') and the attribution of colours to sounds is not uncommon among painters and musicians. It rarely occurs the other way round, although a chilling exception is to be found in Munch's account of how his painting *The Scream* was inspired. Tired and ill, he was watching the sun set over a fjord: 'I felt a scream pass through nature; it seemed that I could hear the scream. I painted this picture—painted the clouds as red blood—*the colours were screaming.*'

Modern western man inhabits the same planet as the painted tribesmen of Africa and New Guinea; his art and artifacts rub shoulders with the brightly decorated statues of Catholic saints in Brazil and the brash demon masks that guard funeral pyres in Bali (shown on the opposite page). So, even as our view of colour progresses, it is surrounded by its beginnings. The complete abstraction of colour on canvases in modern galleries seems to have come a long way from the colours that were magical powers inherent in sacred objects. But abstraction is also, in a sense, a return; a recognition of colour as a living force that, as Kandinsky put it, 'directly influences the soul'.

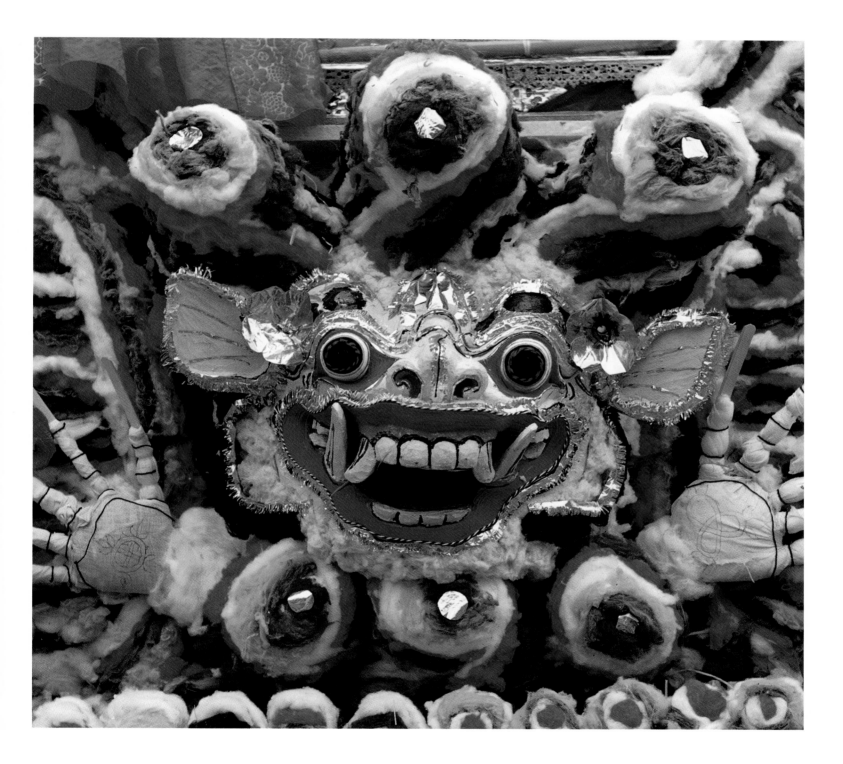

The vocabulary of colour

The human eye can discern the difference between several million colours of varying hue, saturation and lightness. Of these, some thousands have been given names, at least in the more sophisticated languages, and we imagine that since man's ability to differentiate between colours has always been the same, he must always have had words to describe them, and to distinguish one colour from another. But this is not the case. The basic colour vocabulary of even the richest languages is pitifully small—fewer than a dozen words. All other colour terms are a matter of qualifying a basic word, such as light blue or dark green; of attaching the name of an object or material to a colour, like gold, lemon or ivory; of marrying two basic colour words such as blue-green; or of simply drawing a name out of the air, like magenta which was originally the name of a dye invented in 1859, the year in which the French and Sardinians defeated the Austrians at the Battle of Magenta in northern Italy.

When we talk about colours, we usually mean hues. But the fact that the oldest colour terms in every language are always black and white, suggests that, strictly speaking, these should be translated 'dark' and 'light'. They were originally words that referred to degrees of lightness, not hues. When 'red' is added, it is commonly used to describe a whole gamut of colours from brown through red to yellow. In the Hanunóo language of the Philippines, 'green' covers the light greens, yellow and brown— but only in the context of bamboo. We would probably describe freshly cut bamboo as a shiny brown, not green. But this does not mean that Hanunóo speakers have defective colour vision; it means that bamboo is classified according to its relative darkness and lightness, so that the freshly cut bamboo is called 'relatively green' instead of reddish brown.

During the evolution of the English language, the Anglo-Saxon *wann*, which has no modern equivalent, referred to such diverse things as the gloss on a raven's wing, the light that dances on a dark wave and the rippling sheen over dark chain-mail. *Fealo*, the Anglo-Saxon 'fallow', was probably a word referring specifically to horses to start with, but later came to mean the glint along a shield's edge, the light and dark patterning of the sea and, later still, the similar patterning of ploughed land. In the same way, many present-day 'primitive' languages do not, strictly speaking, possess a word for colour at all; the 'colour' of an object instead depends upon its total surface appearance, its texture and shade. A reasonable analogy might lie in the way in which wines are classed as white or red. Red wine can be anything from dark rose to deep purple while white ranges from deep yellow to pale green.

The idea that a large number of the Earth's inhabitants are perfectly happy in classifying colour in terms of light and dark helped to resolve an argument that had been troubling classicists for some time. It began with William Ewart Gladstone who in 1857, having noted all the references to colour in Homer's *Iliad*, decided that the ancient Greeks 'had no clear notion of colour whatever' and that by modern standards their colour vision was actually defective. This was the kind of authoritativeness that was to lead Gladstone to fame as Prime Minister of Great Britain 11 years later. Painstaking research had revealed that in the last eight books of the *Iliad*, colour descriptions occur on 208 occasions. Of these, 148 refer to light and dark, whiteness, blackness and greyness, while the remaining 60 are concerned mainly with red, brown and purple. Blue, for example, receives no mention at all, and from this Gladstone concluded that the Greeks, and hence other early peoples, could not see a great many colours and that fine colour perception was a blessing conferred by the advance of modern civilization. Several other scholars agreed with him, and it was not until the last decade or so of the nineteenth century that it was pointed out that Greek art was exceedingly rich in colours, including blue, and these were used in such a way as to suggest that the artists' perceptiveness was at least as lively as Gladstone's. It was not colour awareness that was lacking, but a colour vocabulary. Like the Anglo-Saxons, the Greek poets were much more concerned about the action of colour rather than the labelling of hues; about the rush of light along a sword as it slid from the scabbard or the turn of a wave beneath the prow of a ship as it slid through the 'wine-dark' sea.

No one knows exactly how precise colour terms develop, but obviously environment, culture and economic growth must play very large parts. Desert dwellers have a large range of words for yellows and browns, Eskimos possess a wide vocabulary to differentiate various colours and conditions of ice and snow, and the Maoris have more than a hundred terms to cover what we would call 'red'. The Maoris too, have colour words for the ages and stages of plant growth that we would describe in terms of time or size, and some forty colour words to help distinguish between one cloud formation and another.

Many African tribes have extensive colour vocabularies to describe their most treasured possessions, cattle, just as the old Germanic peoples had a great many horse adjectives. This tradition has passed into English, which possesses a remarkably large number of horse colour words—roan, strawberry roan, bay, chestnut, grey, piebald, skewbald and so on. English speakers are also curiously preoccupied with specialized hair-colour words such as blond, grizzled, mousy, auburn, fair. This last, in its old-fashioned sense of 'beautiful', is probably a legacy from the Anglo-Saxon conquerors of England. 'Fair' meant Saxon colouring, and therefore handsome and free-born, while 'dark' was the colouring of the conquered Celts, the 'ugly' colouring of the enslaved.

The so-called sophisticated languages require an ever-increasing number of words to make precise colour definitions clear. These are borrowed from almost any source, especially those applying to the blue-violet end of the spectrum which occur but rarely in nature. Some of these are 'look-like' words, that is, the colour resembles that of some object whose name becomes attached to the colour itself—amethyst, peacock blue and violet, for instance. Azure comes from the Persian *lazhward*, meaning a blue stone, lapis lazuli. Ultramarine simply means that the colour came from overseas, while indigo is an abbreviation of 'blue Indian dye'. Puce is the shade of a flea's belly, from the Latin *pulex*, a flea, while mauve is the colour of the wood mallow whose botanical name is *Malva*. Purple comes from the Greek *porphyra*, the whelk from which Tyrian purple is made.

Similar, though perhaps more poetic, derivations occur in oriental languages. The Chinese characters for red, green and purple all contain the radical (or root character) for silk, suggesting that the colours were originally those of silk dyes. Light green is 'kingfisher-colour' and deep green 'jade-colour'; 'ash-colour' is grey. Neither the Chinese nor the Japanese have a word for brown, though the latter employ a number of descriptive definitions such as 'tea-colour', 'fox-colour' and 'kite-colour'. Incidentally, the Chinese do not use the terms 'light' and 'dark' when describing colours; instead, they employ the water images of 'shallow' and 'deep'.

Scholars who study the history and development of languages often look first at the colour words. Colour vision is common to all mankind, and for the sake of communication, all peoples have

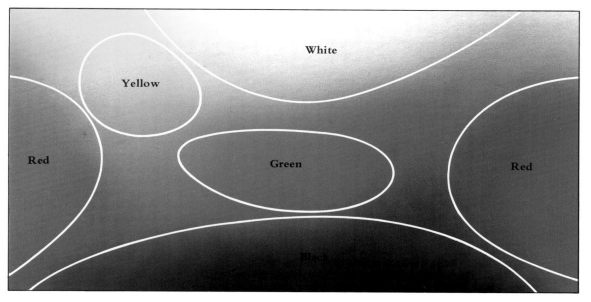

Berlin and Kay established that many aboriginal languages of Central America have only five basic colour terms. They showed native speakers a Munsell chart with 40 hues and asked them to delineate the areas covered by each basic colour term. In this typical chart, colours termed blue in English are included in 'green' areas, while 'red' encompasses many of the purples. Some languages may cover the entire chart with only two basic terms, black and white. Each speaker was also asked to indicate the focal point of each colour—the 'most red', for example. And since the 'red' focus was found to vary no more between a Frenchman and a Cantonese or an Apache, say, than it does between two Frenchmen, Berlin and Kay felt justified in calling the basic colour terms universal.

made some effort at colour definition. Whether a particular tree is described as being a lighter kind of dark (as it might be by a native of New Guinea) or as avocado (by the designer of this book perhaps) does not really matter, providing the audience knows what exactly is being talked about. But to the student of languages the terms used are of supreme importance, for they indicate to him the stage of growth a particular language has reached in the colour domain.

Some languages contain literally thousands of colour terms, but of course most of these are 'look-like' words, derivative words that can change at any time and are therefore of secondary interest to the student. What matters to him is how many of a language's colour terms are basic descriptive words, conveying the idea of a particular colour and nothing else? It does not signify how many expressions there may be for shades of red, for example, for they must all be subordinate to the basic idea of red, just as scarlet, vermilion, crimson, brick-red—all derivative words—are included under 'red' in English. From this a second question arises: if basic colour ideas or mental pictures exist, do they mean the same thing to everyone, irrespective of language? Are there such things as *universal* basic colour terms?

A few years ago, two American anthropologists, Brent Berlin and Paul Kay, made an exhaustive study of colour terms in 98 different languages, and came up with the answer that universal basic colour terms do exist, but that there are no more than 11 of them in any one language. In theory there may be any number from one to 11 and in any combination. But Berlin and Kay's second startling discovery was that if a language has fewer than 11 basic colour terms, there are such strict limitations on which these are, that out of 2,048 possible combinations, only 22 are found. The rules are:

1. No language has only one colour term; they all have at least two. Where there are only two, they are always black and white.
2. If there are three terms, the third is always red.
3. If there are four terms, green *or* yellow is added; where there are five terms green *and* yellow are added.
4. If there are six terms, blue is added.
5. If there are seven, brown.
6. If there are eight or more terms, purple, pink, orange and grey are always added, and these can occur in any order or combination.

The rules suggested that languages acquire colour terms in a chronological order which can, in turn, be interpreted as a sequence of evolutionary stages.

1.	2.	3.	4.	5.	6.	7.
white black	red	green or yellow	yellow and green	blue	brown	purple pink orange grey

From this it would seem that at the beginning of human communication, man had only two colour terms, black and white, before gradually coming to distinguish a third colour, red. Confirmation of this came from a report on the language of the Jalé tribe of New Guinea who have a word *mut* meaning 'red soil' and another, *pianó*, meaning 'a plant whose leaves dye yarn a green colour'. But these are not basic colour terms, for when the reporter used *pianó* for green, he was always misunderstood. Only *sing* and *hóló* (black and white) were used for green, depending on the degree of darkness or brightness. Even blood was *sing* because of its darkness.

In languages which have reached stage four, that is, those which contain five basic colour terms, there is still a certain amount of confusion. Some Tzeltal speakers, for instance, having listed the word *yaš* as a basic colour, indicated it on the chart as what in English would be called green, while others placed the focal point firmly on blue. Possibly this is a language in transition that will shortly borrow a new word for blue from another tongue, just as the Maoris have adopted *puru* and Swahili speakers *bulu*, from the English 'blue'. Languages that have reached the seventh and final stage should also have passed through stage six, at which brown is added. But there are some surprising exceptions to this rule. Melanesian, Welsh, Eskimo and Tamil do not contain brown at all, while the Siamese and Lapps call it 'black-red'; neither ancient Greek nor modern Greek-Cypriot has any word for it. Japanese, too, is a special case, for the word for blue appears to be older than the word for green; if so, this reverses the usual evolutionary order.

The broad outline of Berlin and Kay's thesis has not so far been disputed, and the co-ordination they have achieved between anthropology, linguistics and psychology has opened up a new and fascinating branch of study.

Body-painting: signs of life and death

Some 70,000 years ago, between the last two Ice Ages, the vast expanse of Europe, Asia and Africa was populated by small groups of hominids—man-like creatures representing different stages of the human evolutionary tree. Among them, there lived a people archaeologists labelled *Homo sapiens neanderthalensis*, who immediately preceded modern man.

Named after the discovery in 1856 of a skeleton in the Neander Valley near Düsseldorf, West Germany, the Neanderthals possessed large brains and had a strong, stocky build. They were semi-nomadic hunting peoples who used fire and crafted the first specialized stone tools for killing, cutting and scraping. To hunt deer, bison, wild oxen and mammoths and to defend themselves against enormous cave lions and bears, a degree of social co-operation—and probably therefore of language—would have been essential.

But what most distinguishes Neanderthal man from his predecessors and contemporaries is the fact that he buried his dead. Traces of flowers found in Neanderthal graves suggest that a form of accompanying ritual was involved. This was lent firm support by a grave at La Chapelle-aux-Saints in France, containing the third Neanderthal skeleton to be discovered, which was strewn with colour—red ochre and black manganese dioxide. The fact of death, it seems, was formally recognized for the first time. Through its association with blood, the visible sign of the life force, red ochre was cast on the grave to renew life beyond it.

Discoveries in later graves of Cro-Magnon man, who replaced Neanderthal man in Europe, tend to confirm this hypothesis. The dead were buried in a variety of deliberate postures, accompanied by necklaces and sometimes joints of meat as food for the after-life. And always, red ochre had been smeared on the body or thrown abundantly over the grave.

Similar instances of corpse-daubing among modern tribal communities are legion. From Africa to South America to Indonesia the dead are treated with designs on face and body, always in red and sometimes in black and white as well. And, by analogy, it is reasonable to assume that self-decoration existed among the Neanderthals long before the daubing of art objects and the painting of caves. It is as if man's earliest 'canvas' was his own skin, and the desire to decorate his surroundings came at a later stage when he was, as it were, able to take a step back from the immediacies of his own biological drives and become aware of himself as an entity separate from the outside world.

At first sight, red, black and white would seem to be universally used among tribal communities because they are easily accessible: red ochre is widespread, black comes from soot or charcoal and white from clay, chalk or ash. But where they are not readily available, many tribes go to great lengths to gather their pigments, and subsequently take exaggerated care in preparing them. Australian aborigines travel circuitous routes for hundreds of miles, following the path of a mythical emu and dogs whose blood is said to have created the red ochre deposits at the end of the journey. The Mount Hageners of Papua New Guinea bake

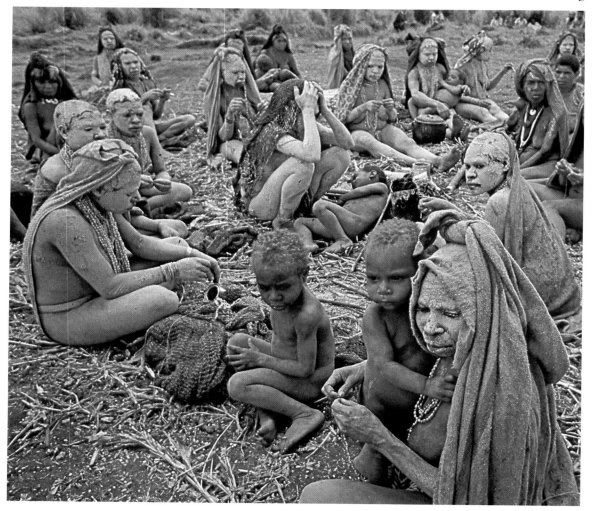

In the southern highlands of Papua New Guinea women cover themselves with clay as a sign of mourning, *left*. Its whiteness may indicate that, through their contact with death, the mourners have a temporary affinity with 'white' ancestor spirits. More likely, it may be the clay that is important and not the fact that it is white. Both Andaman Islanders and Mount Hageners distinguish between the activity of decoration with white paint, derived from clay and applied in patterns, and the activity appropriate to mourning—smearing wet clay haphazardly all over the body. The Crahó Indian of Brazil, *right*, paints his body not just for special occasions, but for everyday adornment that expresses his relationship with other members of the tribe. The Crahó tribe believe that they are descended from the sun and moon, who were human, so that the tribe is divided into sun and moon halves. Stripes on the body indicate which half a person belongs to: vertical for moon and horizontal for sun. Red from the uruku shrub and black from rubber juice rubbed in with charcoal are the most popular colours, followed by white and yellow manufactured from clays. Red paint in particular is deeply bound up with the life-crises of the Crahó: the medicine man paints his face red in ceremonies, corpses are painted with it and the best female singer in the village wears a red scarf in which to carry her first child.

quantities of brown clay wrapped in leaves, finally using only the reddest portions inside for their pigment. And in rites connected with a mythical serpent, the Dogon tribe of the Sudan manufacture white paint for their masks out of powdered limestone, cooked rice and snake excrement. So the use of these coloured pigments is clearly not arbitrary. The evidence points to some magical or quasi-religious aim behind their application on the bodies of the dead. But what of the living?

The simplest use of self-decoration among modern tribal communities is as a form of identification. Particular styles enable members of the same community to recognize each other, just as kilts, college sweaters, even blue jeans enable groups of people to identify one of their number. Indeed, body-painting should be thought of as a kind of clothing; a Kayapo Indian of the Amazon jungle is as well dressed in his black and red patterns, lip plugs, beads, shaved head and plucked eyebrows as is any businessman in a blue suit. The animal patterns that the Nuba people of the Sudan paint on their skins are applied for avowed aesthetic reasons—but each tribal group has a special colour, usually a shade of yellow or red, to which each member must adhere.

On especially important occasions, a whole section of a community must adopt a single predominant colour. The Indians of the Upper Xingu River in Brazil represent on their skins a variety of animals, birds and fish, which define the social unit to which they belong and form a bridge with the spirits on whom they believe their well-being depends. Different patterns are used

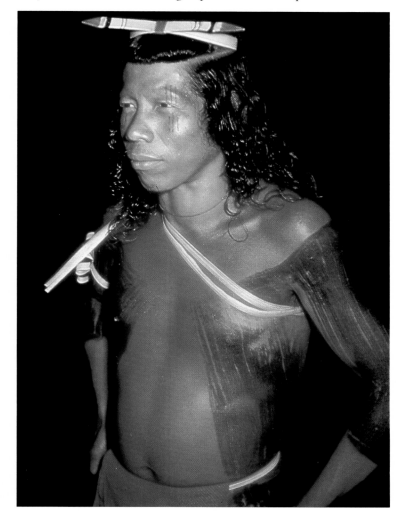

for different ceremonies. However, it often happens that the same colour is used in widely differing contexts.

Increase ceremonies—fertility rites—frequently demand that a group of people attire themselves in, say, black to attract the dark, rain-bearing clouds; to promote fertility Ashanti women shave their heads and paint themselves with blue-black dye at the succession of a new king. In times of war Mount Hagener men would cover themselves in charcoal and wear grey leaves instead of glossy ones, which indicate health and abundance. For blackness obscures individual identity and signals aggression—it is harder to kill someone you recognize. Adult men of the Nuba also use a rich black colour for protection against the evil eye of their enemies, and because it makes them appear more frightening.

But there is an important distinction to be made between these uses of black. The Mount Hageners use it to express the community's collective anger, but among the Nuba it indicates a stage of life—a degree of seniority. As young men, the Nuba adorn themselves with red ochre and simple hairstyles, graduating to more flamboyant colours and elaborate hairstyles as they grow older and their tribal status increases. In the oldest age group, body decoration ceases altogether; clothes are worn and heads are shaved because the body is no longer attractive and must therefore no longer be exposed.

So colour in self-decoration is widely used, not just to indicate membership of a community, but to designate status within that community and to define social rôles.

The supreme ritual use of colour occurs at those critical times of life when the individual is passing from one status to another, coming into existence at birth, for example, or leaving it at death. Tribes on the Andaman Islands in the Bay of Bengal would coat a new-born child with white clay during a ceremony held within a few days of its birth; in mourning, the adult members of the community would cover their bodies and limbs with a wash of clay. Colour is similarly used at marriage and pregnancy and, most importantly, at puberty.

The initiation of boys into manhood in the Ndembu tribe of Northern Rhodesia involves elements which are typical of initiation ceremonies world-wide: isolation from the community, ordeals (notably circumcision) and instruction in tribal lore. Ndembu boys are taught the secret of the 'three rivers': the red 'river of blood' representing 'a man and a woman' (presumably conception or birth) the black 'river of death' and the white river. Also called the 'river of God', the latter takes precedence over the others and explicitly symbolizes two things: the life principle or spirit, and semen or male generative power.

The three colours in combination seem to be rehearsing symbolically the cycle of birth and death, transforming it into the ritual 'death' of the child and his rebirth into adulthood. Semen is defined as red blood 'whitened' by water, indicating that a purification must take place rather in the way that girls of the Ngonde tribe in the same region are purified from the taint of menstrual blood by a transition from red ochre to white cassava flour, symbolizing sexual purity.

The ritual use of colour seems to be a way of ordering life, of bringing the great biological events—birth, puberty and death—into association with some other, more inward life peculiar to man. Apes abandon their dead in the open; our early ancestors buried them carefully with red ochre, the symbol of blood, the very essence of life itself. They knew that death implies rebirth; and their burial sites remind us of what we once knew, that life follows death as surely as day is born from the blackness of night.

Body-painting: statements of status

The variety of self-decoration found among tribal communities often astonished those travellers and explorers who recorded the ways in which peoples of unfamiliar cultures covered their bodies with leaves, shells, feathers, tattoos, scars and coloured paint. Anthropologists have discovered that there is rarely anything arbitrary in tribal self-decoration: all members carry on the surface of the body a precise record of their relation to society. And although a medicine man, for example, may be as easily recognizable as a white-coated doctor or a black-clad clergyman, distinctive dress extends beyond officialdom to every man, woman and child who, by colour as much as by other manifestations, express their personal status within the tribe.

An American anthropologist, Victor Turner, investigated the symbolism of red, white and black among the Ndembu tribe of Central Africa, and discovered meanings associated with these colours, which changed according to their ritual context.

For example, white as semen signified male generative power and was invoked at male initiation rites; as milk it provided a feminine symbol for use at girls' initiation ceremonies. More generally, white could be identified with water or, in a more spiritual sense, with that which purifies. In the cleansing rites for novices in the Bemba tribe of the same region, young girls are washed and covered with whitewash; a lump of black mud in the shape of a cross is placed on their heads and decorated with pumpkin seeds and red dye. The ritual song expresses the need to purify the girl from the taint of menstruation: 'we make the girls white (like egrets). We make them beautiful . . . white now from the stain of blood . . . finished now the thing that was red.'

Similarly red, which symbolizes blood, does not always refer to menstrual or 'bad' blood; it can also be the 'good' blood shed by a hunter and offered at the shrines of hunter ancestors. The red of blood is synonymous with power; and, like power, it can be used for good or ill. Black is equally ambiguous; the use of powdered charcoal signifies death in the circumcision rites of the African Manja tribesmen; but for war they blacken themselves with soot and in mourning they simply remain dirty.

But black is not always malignant. It can symbolize death as the end of a natural growth cycle: either at puberty, when a boy is reborn as a new or 'white' man, or at physical death, when the dead person is transformed into a guardian ancestor spirit or is partially reincarnated in a living kinsman. Among the Ndembu a novice's vulva is blackened to enhance her sexual attraction and, indeed, women with very black skins are thought to make excellent mistresses, but not wives.

It seems then, that no absolute meanings can be attributed to white, red and black. Rather, the secret of their significance lies in their relationship to one another. This, in turn, provides a system by which important experiences can be classified. To take a familiar example, it is usual to think of the white of a bride's dress as meaning one thing, purity perhaps, and the black of a widow's weeds as another, mourning. But many cultures regard these colours as deriving meaning only from their relationship with each other: a bride is to a widow as white is to black. Together, the colours make a statement about the condition of entering marriage as opposed to that of leaving marriage. Similarly, a priest wears black clothes when working among laymen and white when performing religious rites; so, in this context, it might be said that black is to white as profane is to sacred.

So the way in which tribal societies classify social relationships under a colour rubric has far-reaching implications. Traditional ideas about how man organizes and makes sense of the outside world are based on the notion that man is fundamentally a social animal. His perception of the relationship between man and woman, mother and child, children and adults and so on provides a structure for relating one thing logically to another, for 'thinking'; society is a model for classifying individual experience. Victor Turner thought that the reverse is true.

He saw man's primary experiences as being intimately connected with his own body, which terrifyingly bleeds, lactates, ejaculates, excretes and so on at different times, but especially at crises of life such as birth, puberty, pregnancy and death. The intense emotions aroused by these biological events seem to come from outside the body, like supernatural powers. Colour is used to symbolize these powers: the redness of blood, the whiteness of milk or semen, the blackness of excrement, for example, represent the emotional—even spiritual—side of the physical experience. At the same time, the colours are used in ritual to reconcile the physical event with its powerful, often violent, effects, so that the individual can gain some control over the powers and make sense of the total experience. Nature is transformed into culture; social relations stem from individual experience—not the other way round. The mating of man and woman, for instance, is linked to white symbolism through semen; but the bond between mother and child is expressed by white standing for milk.

The idea that the individual forms the basic unit from which all other social configurations derive is supported by the work of the French anthropologist, Claude Lévi-Strauss. In 1935 he gathered 400 facial designs from the Guaicuru people of southern Brazil and noted that the style of these designs was almost identical to those found among the Chinese, the north-west coast American and the Siberian peoples. The face is always divided symmetrically into four quarters and embellished with spirals, tendrils, whorls, crosses and so on. But no two designs are identical; the basic elements remain constant, but the details are different.

This suggests that the traditional framework of the design expresses the social aspect of the individual—his solidarity with the community—while the free interpretation within that framework expresses his individual identity. Called 'split representation', this way of patterning the face aptly embodies the dual nature of man as having both social and individual personality. There is even indication of a further 'split'—that within the individual himself. The same technique is displayed in the famous tattooings of the Maoris. An unpainted face is 'dumb', pointing to the notion that the face is not a face at all until it is painted. The painted face divides the purely biological 'dumb' entity from the social person, conferring on him human dignity and spiritual significance. It is, literally, a mask in the same way as we speak metaphorically of a social mask which, once adopted in adolescence, defines both social role and individual identity.

The outside of our bodies, then, is an interface between us and others. Whether in body paint, self-decoration or dress, we express our affinity with one group rather than another and, at the same time, our separateness from other members of the group. We even seek to indicate outwardly the two inner halves of our selves. In Western society women, not men, tend to paint their faces perhaps because, unlike the Nubans of the Sudan for example, men are not so much interested in attracting the opposite sex as in competing for them. In Regency England, the powdered wigs, beauty spots and gorgeous plumes of the dandies told another tale. We may not have adequate initiation rites at puberty; nevertheless children are still discouraged from wearing make-up too young, lest they prematurely assume their adult sexual role in society.

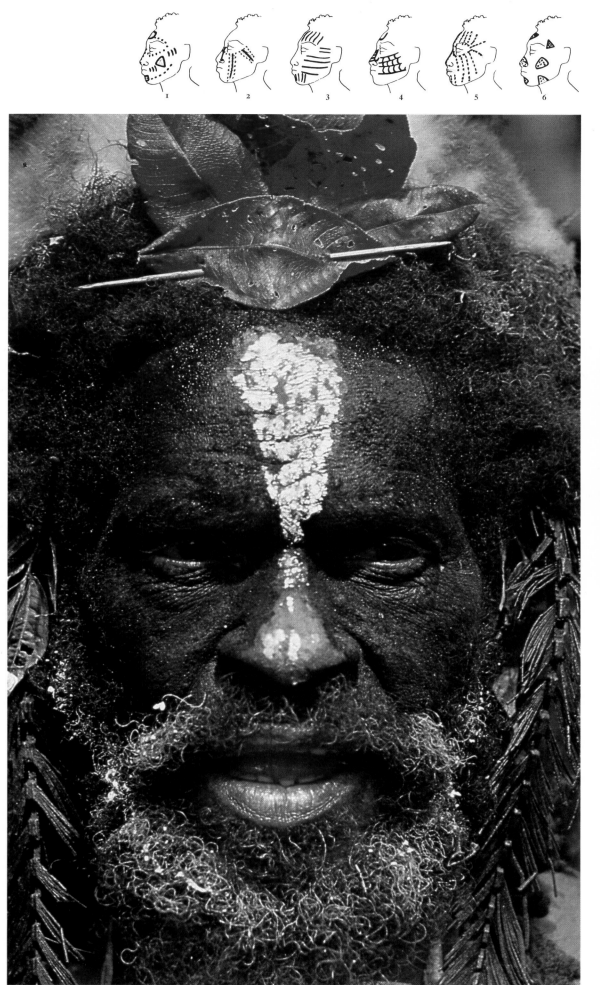

These facial patterns are all used by Mount Hagen women in Papua New Guinea. Since the Hageners emphasize that they are not used for identification, nor for sexual attraction nor even for magical reasons, their exact significance is uncertain. But they are nevertheless important enough to be given definite descriptive names and to be more or less strictly adhered to: a lozenge, **1**, for example, indicates 'water spring or pool paint', chevrons and interlocking diamonds, **4**, are 'snakeskin paint' and white dots, **5**, are 'raindrops'. A typical combination of designs has been applied by the woman, *below*. White eye-circles have been overlaid on a red base, the symbol of femininity—'she excavates her eyes with lime'. The blue streaks are described as being 'like a vertical hanging tree branch'.

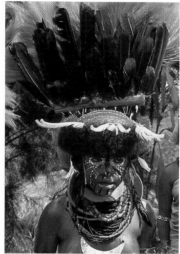

This Chimbu warrior who lives at the opposite end of the Waghi Valley from the Mount Hageners, has shown typical constraint in his facial paint and design. It may be that, as with the Hageners, the black charcoal base is a male identity symbol, as against the red of the women; it signifies that men are thought of as 'dark' while women are 'bright'. Patterning is limited by the presence of a beard which leaves only small expanses of face to be decorated. Boys, who are not so restricted, can paint their faces as lavishly as women.

55

The cave painters

An engraved bone, whose decoration may have been the work of one of man's evolutionary predecessors, was found in a deposit in France that dates from more than 250,000 years ago. This, the oldest decorated object known, may mark the dawning of art, for a priceless heritage of engraved objects has survived from later periods. Accomplished three-dimensional carvings of animals were found in the Vogelherd cave in Württemburg, dating from more than 32,000 years ago. And in 1908, during an archaeological dig near the village of Willendorf on the Danube Plain, a small limestone figurine was excavated. The face of this 30,000-year-old 'Willendorf Venus' is featureless and by modern standards her body is obese. Yet there is no denying her symbolic power as an earth goddess, for she still bears traces of a covering of red ochre.

Red and black, the colours symbolic of life and death first used by Neanderthal man to adorn the graves of his dead, were also employed by his successors to decorate their first works of art. There have been found engraved stone slabs painted more than 30,000 years ago with representations of animals. They are thought to have been the work of Cro-Magnon man, our direct ancestor, who had by then begun to dominate in Europe.

Such decorated objects, called *art mobilier* by the French since they were small enough to be carried by their nomadic craftsmen, have been found throughout Europe and in Siberia, testifying to the widespread activities of early *homo sapiens*. They were found in the habitation sites set up beside rivers, beneath the overhangs of limestone cliffs, and at the mouths of caves where families found shelter. In the limestone areas of Spain, France and Italy (and so far in one solitary example, in the Ural mountains in the USSR) modern man painted the walls of the caves in the places where he sheltered.

The antiquity of the first discoveries of Paleolithic (or Old Stone Age) art was not recognized for some decades. The first finds were made during the nineteenth century, when the existence of 'antediluvian man' was hotly disputed. Not until the turn of the century was their authenticity formally recognized.

Altamira, near Santander in northern Spain, was the first painted cave to be discovered. It was found in 1879 by a local landowner, Don Marcelino S. de Sautuola who, the story goes, was searching for a dog that had fallen into its entrance. His grandchild, Maria, wandered into a low gallery and shouted: 'Toros!' when she saw on the ceiling paintings of extinct bison, a horse and a large hind. Although de Sautuola was firmly convinced of the authenticity of the paintings his discovery was received with derision and rejection, and he was accused of perpetrating a forgery with an artist friend. It was only after his death, when a number of painted caves were discovered in France, that Altamira was eventually authenticated.

The animals on the walls and ceilings of Altamira are typical subjects of Paleolithic art. The cave painters depicted, for the most part, the large herbivores that inhabited the mountains, arctic taiga and temperate grasslands over which they ranged. The horse is most commonly represented, followed by oxen, which together form 50 per cent of the paintings. Bison, deer, mammoth and ibex comprise the majority of the remainder. Before cave art was analyzed, archaeologists surmised that hunting magic—the attempt to secure success in the hunt by representing the hunted species in art—may have been one of the principal reasons why Paleolithic man chose to paint caves, but analyses of the debris in his habitation sites show that he ate reindeer, birds and fish, species that rarely appear in his paintings. Saiga antelope, boar, rhinoceros and the carnivores: bear, hyena, fox and wolf, also appear

Paleolithic art may have originated long before the last Ice Age, for there is no way of knowing whether early man began to draw and sculpt on perishable materials such as sand and wood, or whether he made his first engravings and paintings on the now eroded faces of rocks and cliffs. It is known that Neanderthal man used ochre and manganese and it is possible that he utilized them as painting materials.

It is difficult to establish precise dates for cave paintings; of the 200 or more decorated caves so far discovered, only two or three have been incontrovertibly dated. During the twentieth century, the Abbé Breuil, a French archaeologist who devoted his life to recording and analyzing cave paintings, attributed a special significance to the predominant colours. From his analysis of superimposition (the frequent occurrence of painting superimposed upon engraving, or vice versa, or of one painting superimposed upon another) he built up a chronology of cave art. Engravings, he believed, preceded paintings and developed from finger-drawings in mud to deep engravings to high-relief sculptures to clay modelling. He thought that the earliest paintings consist of spaghetti-like finger markings, and outline drawings in yellow. These were superseded by fine drawings in red, then bold red drawings, flat shading in red (the style of the two central deer in the Rotunda frieze at Lascaux, *right*) then simple bichrome drawings. Black linear drawings mark the end of the first phase. A second cycle begins with more complex line drawings, then flat, shaded brown paintings (seen in the deer in the bottom right-

occasionally. There are one or two mythical, or unreal, animals and the rare human representations are surprisingly inferior in execution to those of animals. As yet undeciphered and unexplained are the many signs to be found in cave art. These take the forms of symbols that may be interpreted as vulvar or phallic, grid-like structures called tectiforms, claviforms (club shapes) dots, strokes and spaghetti-like scribble. Perhaps to twentieth-century man the most evocative signs are hand prints which seem to be a message from 20 millennia past: 'This is my mark; I was here'.

The cave artists used only three pigments in their vivid paintings: red and yellow ochre and manganese, although in some of the earliest paintings mud from the cave floor was used as a pigment. The considerable variation in the shades of these pigments from deposit to deposit accounts for the variety of colours in cave art. In the later paintings, notably at Altamira and Lascaux, the sparkling calcite crystals that line the cave walls were subtly included, introducing white into the paintings, and pigments were used in conjunction to produce shaded perspective effects in bichrome and polychrome.

Techniques were simple. Paint was at first applied with the

Lascaux, near Montignac in the Dordogne in France, was discovered in 1940 by four schoolboys. The Rotunda, or Hall of the Bulls, *right*, is small, about 30 yds long by ten wide, beyond which are two galleries. The irregular limestone cornice formed a perfect base for the frieze of animals which has as its focal point two black bulls facing each other (in the background); the largest is some 12 ft long. The 'Unicorn' in the foreground is a strange, perhaps mythical creature, with a small horse outlined in red upon its hindquarters. Beyond it is a frieze of six black horses and a group of small red deer is scattered between the bulls. Unusually in cave art, the animals are depicted in movement—the black horses are galloping, for instance. The colours and details are remarkably well preserved. Uniquely, the Lascaux friezes were clearly preconceived compositions, even though the paintings were apparently executed at different times.

Illuminated only by the dim light of their discoverers' torches, they must have seemed as awe-inspiring as they did to Paleolithic men some 15,000 years ago.

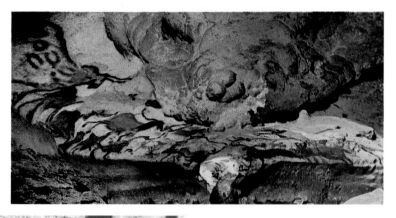

hand corner of the photograph) then polychromes, which were later outlined in black.

He classified Lascaux as belonging to the early period of flat monochrome paintings (borne out by the carbon-dating of charcoal samples found on the cave floor). Yet the cave contains many true polychrome paintings, suggesting a later date, and his theory has been superseded by a chronology based on style, not colour, devised by another Frenchman, André Leroi-Gourhan.

Recent analyses show that red and black predominate in almost equal proportions, while the use of other colours is rare. Ochres vary from red to yellow, orange and brown—and they change with time. A bright red may oxidize to deep maroon or violet. Manganese can be black, brownish or bluish.

The colours do, however, vary slightly from early to late styles (black slowly took over from red which had predominated in early times) and from area to area (there is more black in the Rhône area, more red in the later paintings of the Pyrenees and Spain). Significantly, perhaps, there are 60% black animals and only 26.1% red, but 60% red signs as opposed to 36% black. Bichrome and polychrome paintings occur in early and late styles. This diversity in the use of colour may, when compared with other analyses, provide a clue to the understanding of cave art.

fingers, in blobs, and in daubs smeared together. Later line drawings were adeptly made to capture perfectly the form of an animal at rest or in movement, and these were later filled in with flat washes. Many instances of delicate shading occur in cave art, suggesting the use of a brush, perhaps a pad of fur or moss. Limestone palettes have been found on which colours still remain, arranged as on a modern palette. The fluffy manes of many horses, and the stencilled hands which are found here and there, were coloured with a primitive form of airbrush—hollow bones have been excavated through which paint was blown.

Prehistoric art offers a wealth of unexplained mysteries. Why, when the prevailing themes are predominantly naturalistic, are there almost no representations of plants, trees, sky or landscape, no sun, moon or stars? Why are the early engravings and later paintings so often superimposed one upon another, upside-down or apparently unfinished? Why are the representations of men so crude and childlike in contrast with the sophisticated realism of animal drawings? Above all, what was the meaning of this art, which endured for some 25,000 years—and then ceased abruptly as the Ice Age ended, around 9,000 years ago?

A basic human need for artistic expression, 'art for art's sake', was one of the theories first put forward to explain prehistoric art, although this theory is now considered too simplistic to be credible, as is the idea that there may have been a single reason to account for the phenomenon. Interest in anthropology during the twentieth century has given rise to many ideas based on the theory that cave paintings were the focal points of primitive rites, a totemic system (a belief in the kinship of tribal members through a common ancestry with an animal species or some other object) or other Paleolithic religion. A French anthropologist, André Leroi-Gourhan, carried out a structural analysis of cave art, and from the spatial organization of the paintings he theorized that they may be located according to factors of opposition: masculine and feminine. He divided the species and abstract symbols represented in the paintings into these two classifications: the horse, he thought, was male; the bison, female. Although his theory has met with much criticism, his studies of the style and location of the paintings are invaluable, for only in careful comparison and analysis are the ciphers to this Paleolithic language likely to be found.

Symbols of rituals and change

The simplest use of colour is magical—to make something happen. Rainclouds can be made to appear, for example, by black body-paint or the sacrifice of a black animal. If there is illness, a red petticoat can be used to draw a fever, while porridge made from yellow turmeric can extract jaundice when smeared on the body. In Ireland, black cat's blood was thought to have healing powers, as was the egg of a black hen, while in China violet is believed to ward off epilepsy.

The three earliest and most potent colours—black, white and red—have always provided the strongest magic; and together they formed what was probably the first symbolic colour sequence, applied to the moon goddess of the neolithic hunter. As the new moon, she was the white goddess of birth who waxed in the course of a month to become the red goddess of love and battle, only to fade into the black goddess of the old moon, symbolizing death, mystery and divination, It has been suggested that only when man the hunter became man the farmer did the next two most important colours, yellow and green, emerge. The old moon goddesses were usurped by the sun god, who imparted his yellow colour to the ripening harvest. Green was the colour of young, growing crops.

Once life is geared to the changing seasons, different patterns of colours may appear, or different meanings for the same colours. Black, for instance, may no longer be entirely death-like, for it also represents the dark earth which nourishes the seedling, waiting to be reborn in the green spring. To use colour in clothes or images at the turn of the different seasons can obviously have little effect on these external cycles. But it can express the fact that the changes are taking place. It is essentially a celebration—even an act of worship—which includes man in the whole gigantic process and propitiates the terrible powers of nature that can blight a crop and ruin a family at a stroke. And so use of colour becomes more than a magic spell; it becomes a religious ritual.

The ancient Egyptians observed that during its annual flood, the waters of the life-bringing Nile went through a colour cycle of green, red, white and black. Red was the blood of the god Osiris, shed to rejuvenate the land, white the milk of the goddess Hapi flowing down from the Milky Way, green the colour of the spring vegetation and black the colour of gestation. Statues of Osiris were painted in different colours according to the season; black, for example, as the corn was sprouting underground, and green as the first shoots appeared.

The Greeks also held seasonal festivals in which the presiding gods and goddesses were vested with colours—in fact, the festivals were named after the colouring process. *Xanthosis*, or yellowing, stood for Artemis and spring, *Leucosis*, or whitening, for Athena and summer, *Melanosis*, or blackening, for winter and the infernal gods. *Iosis* or reddening was reserved for painting the ecstatic god Dionysus at the annual celebration of the festival of wine.

The widespread fertility festivals of Europe bear marked similarities to those of the ancients: the King or Queen of the May and their followers are decked with green and with garlands of flowers and dance about the maypole—itself a symbol of fertility. The spirit of growing things is still remembered in the many 'Green Man' pubs in England, and even in the legends of the green-cloaked Robin Hood.

The colours of spring, summer, autumn and winter have frequently come to symbolize the parallel seasons in man's life—birth, puberty, maturity and marriage, and death. Birth is generally associated with white; pregnant women in the Trobriand Islands are shaded with special mantles to keep them in the 'white' condition believed to promote softness and fertility. But, in general, whiteness at birth is not considered nearly so

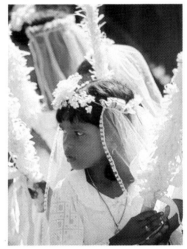

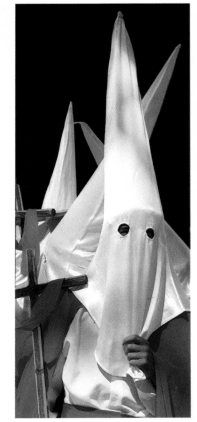

This Roman Catholic girl from Goa, in western India, goes to first communion wearing the white dress of purity and veil of modesty. The sinister, medieval hood of the 'Nazarene', *right*, guards his anonymity as a humble imitator of Christ during a Spanish Easter procession. Its whiteness signifies penitence; the red robes, a reminder of Christ's shed blood, are also the emblem of his 'brotherhood'—similar to a guild—which carries black and gold crosses.

The saffron robes of Buddhist monks, once worn by condemned criminals, are said to have been adopted in a spirit of humility by the Buddha. Less drab than the browns and greys of Christian monks' habits, they symbolize the same renunciation of the world. In the gorgeous decorations of this Thai temple, opposing reds and blues are unified by a gold motif, the radiance of the Buddha, just as contrary passions are reconciled in enlightenment.

Ever since the first rag was dipped in an enemy's blood as a sign of victory, red has symbolized danger, warning, revolution and war. Opposing factions, in war as in football games, have always rallied under a chosen colour, and here there is an almost archetypal quality in the stark conflict between the white-helmeted Japanese students and the uniform black of the riot police—made more frightening through its association with death.

important as its use at puberty. Catholic children wear white at confirmation to symbolize their purity. West African boys are daubed with the same colour at puberty, but whiteness in their case represents either the white spirits of their ancestors, or the white semen of their dawning maturity. In Zaïre, the white paint is supplemented with green foliage, symbolizing fertility and growth, while in other parts of the world the boys are smeared with ashes representing, probably, the death of childhood. Hindu holy men cover themselves with ashes in a similar way to indicate their renunciation of all things earthly and their spiritual rebirth.

White too is the colour of marriage in many places, though for different reasons. A Japanese bride may wear white not so much as a symbol of her purity, but because it signifies that she is 'dead' to her family. In both China and Bolivia, however, the wedding party and the guests alike are decked in red, the colour of sex, love and joy.

Black symbolizes death from Europe to New Guinea, where widows cast themselves into black mud to indicate the extent of their sorrow. But parts of southern Europe adhere to a more complex code; there the funerary garb ranges from the black of full mourning through the grey of half mourning to the touches of purple that indicate quarter mourning.

Cheerfulness and bright colours dominate at obsequies in Bali, Madagascar and the West Indies, celebrating the departure of the dead to a better place. Strangely, the colour of mourning in China is white. There may be a quite simple explanation, that it is not so much 'white' as the colour of undyed cloth, signifying sorrow and humility. But it may be that white is suitable because, in Chinese symbolism, it is linked with metal, the deadest element, and with the West, the land of the setting sun.

At any rate, it is clear that colour symbolism is not always as unambiguous as it seems at first sight. To begin with, the question must always be asked: what *kind* of colour is it? Yellow, the colour of the sun, is often equated with joy and spiritual enlightenment; the yellow robes of a Hindu bride are perhaps an echo of the fruitfulness of the harvest. But yellow is also the colour of cowardice and treachery—the cloak of Judas Iscariot was frequently depicted as yellow. Jews were forced to wear yellow hats by the Venetians and, centuries later, yellow armbands by the Nazis. Obviously a bright, golden yellow is joyous, but a pale, bilious yellow is the shade of disease. Much depends on the black and white content of a colour, the primal opposition of dark and light. The connection between a light cerulean blue, the colour of the sky on a fine day, and the joy of heaven is clear; a richer blue is used for the robes of the Virgin Mary, Queen of Heaven, and represents fidelity, serenity and truth. But the moment it moves towards black, it becomes melancholy (from the Greek *melas*, meaning 'black'); it gives us 'the blues'. Dark blue is worn as mourning dress in places as far apart as Mexico, Borneo and the Levant.

Even red, the earliest and most potent colour symbol, has its ambiguities: the bright blood shed by a warrior wounded in battle was positive and creative, while dark menstrual blood was negative and destructive. Little Red Riding Hood may have owed her life to her headgear since she is always saved from the wolf except in the Swedish version of the story, where her hood is not red. The association with blood led to even deeper paradoxes for it is both the seat of the soul, and the vehicle of the violent instincts. So red stood for divine love but also sexual lust, war and danger as well. In short, red is as contradictory as the crises of human life. Many tribal societies still daub their corpses with red, just as our ancestors did 70,000 years ago. In both cases the desire is the same—to ensure the continuation of this life into the next world.

The art of dyeing

Paleolithic tribes had practical, as well as ritual, uses for colour. Traces of red ochre have been found on stone implements used for scraping pelts, and since animal skins were man's first clothing, it is thought that ochre may have been used for hygienic purposes. The chemical properties of iron oxides discourage lice.

This prehistoric use of colour may be a clue to the origins of dyeing, for rubbing mineral pigments—manganese, haematite, ochres, clay—directly into fabric is the simplest dyeing method, still found among modern tribal and peasant communities. In Japanese, the shades obtained by pigment dyeing are suffixed by the term 'rub': *sabi-suri* (rust rub); *tsui-suri* (soil rub) and *hai-suri* (ash rub).

Radical climatic changes brought about the end of the Ice Age, and an abundance of new vegetation. Plants provided people of the neolithic era with a new means of existence: they learned to harvest them for food, medicines and clothing. The berries, fruits, leaves and roots of many plants when crushed or cooked yield coloured juices which, like mineral pigments, can be used as dyes without modification. The safflower (*Carthamus tinctorius*) for example, used both as food and as a purgative, gives a yellow dye when the petals are steeped in water, as does turmeric root (*Curcuma tinctoria*), a spice. In the temperate zones, certain lichens were used.

Dyes applied directly fade with rubbing or moisture, but prehistoric tribes may not have been concerned about fastness. Coloured clothing may have been used only in ritual contexts, in much the same way as modern tribal communities (and modern royalty) don special dress for ceremonial occasions. One anthropologist described how the peoples of Ajmere-Merwara in India change the colours of their dress with the seasons. Their primitive dyeing methods yield highly fugitive dyes, but they regularly redye the faded fabrics with a new colour.

However in other parts of the world textiles are symbols, associated with women's fertility, that have important roles in social and religious custom. In one Balinese community the dye colours of Ikat textiles are an essential part of their ritual value, requiring a series of dye baths lasting six to eight years. Wherever primitive tribes attached ritual significance to colour they may have attempted to bind dyes to fabric with blood, saliva, resin from trees, egg albumen, glues or wax; and they may have noticed that the light-fastness of many dyes could be improved with the addition of an acid from lemon juice, or lime powder.

If fabric contains a tanning substance, pigment dyes may react chemically with the fibres and so form true dyes, as opposed to a coating of colour. Barks contain such substances, as do rushes and nettles and it is conceivable that prehistoric communities, like many modern tribes, made primitive textiles from such materials. The earliest known textiles were found in a neolithic burial at çatal Hüyük in central Anatolia. Identified as wool, they were dyed red with madder, blue with woad or indigo and yellow with weld, and they date from the first half of the sixth millennium B.C.

The colouring principles extracted from madder (*Rubia tinctoria*) indigo (*Indigofera tinctoria*) and weld (*Reseda luteola*) will only colour fabric when it has first been treated with mordants. These are metal salts which absorb dyestuffs, enabling them to form chemical compounds with textile fibres. The use of alum, with which pelts were tanned, and alkalis such as lye, used in glazing, gave rise to theories that mordant dyeing may have evolved from these technologies. Mordants are found dissolved in river waters, in mud containing iron oxides, in fruit peels, in plants such as rushes, mosses, some tree ferns, lichens and fungi.

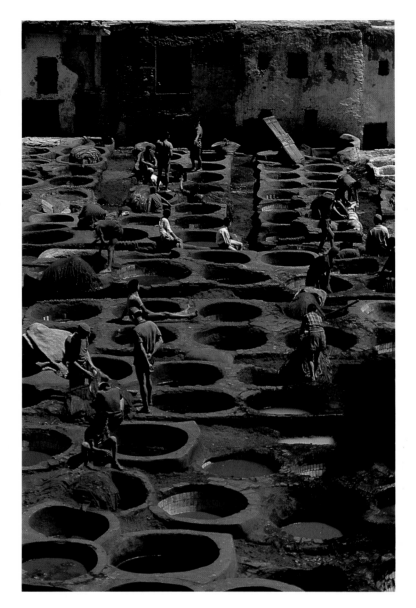

Almost all plant dyes require mordants as fixatives, but a mordant will work on some fabrics and not on others; and different mordants will produce entirely different colours from the same dyestuffs. The unexpected appearance of a new colour when such a substance happened to be present in the water, or even in the material of the utensil used for the dye bath, or in some auxiliary plant or mineral added to the potion, must have seemed magical. Their nature, and the processes of preparing them, were treasured as tribal or family heirlooms and passed from generation to generation as secrets through the ages.

The history of dyeing defies speculation when it is realized how complex were the advances made before the dawn of recorded history. Indigo has a natural fastness to light and water, and needs no mordant to fix it. However to prepare the dyestuff, the leaves of the indigo-bearing plants (of which there are 50 or more species) have to be steeped in a fermenting mixture of fruit, wood ash or putrified urine for some days. The resulting mixture, used as a dyebath, is pale yellow; only when the textile is aired does oxidization cause the colour to appear. Many dyes require extraction processes of equal, or even greater, complexity.

In Morocco, guilds of tanners and dyers work together in ancient outdoor tanneries, crafting leather by the same methods they have used for the last thousand years. Tanning—treating hide with vegetable acids to make it tough and water-resistant and to prevent it from stiffening and decaying—is one of the oldest crafts known to man and may have preceded dyeing. These sunken vats contain the dyes that give the reddish brown leathers for which Fez is famed.

The Malayan silk selendang, or shoulder cloth, *above*, is woven by a method known as *weft ikat*, in which thread for the weft is measured out and wound tightly round with thread at predetermined intervals before dyeing. The tied sections remain undyed, so that the weft emerges from the dyebath in two colours. As the weft is woven over a plain warp, a complex pattern develops. *Ikat* and *batik* are ancient resist-dyeing techniques.

Mordants, metal salts which help fibres to take up dyes, have the effect of altering the end result. The wool swatches, *right*, are all dyed with a crimson dye, cochineal. The wide spectrum of colours was obtained from it by using different mordants and other additives—tin was used to adapt it to scarlet. Knowledge, gained over centuries, of the effects of different mordants, accounts for the varied and brilliant hues of traditional Indian textiles, *below*.

At Ugarit, once the richest city of all Syria, on the Mediterranean coast, hills of crushed murex shells have been excavated, evidence of the dyeing in biblical times of linen and wool with the famous Tyrian purple. The Roman writer, Pliny, recorded that a single drop of glandular mucous was extracted from the purple-yielding mollusc, *Murex brandaris*. On exposure it turned slowly to the reddish purple colour that, in the early Roman Empire, was reserved for kings and priests.

Colour in the ancient world was sacred. Red, mined from the earth to sprinkle on the graves and paint the skin of early man, was extracted from plants and insects to dye the garments of his successors. The Babylonians clothed their priestly elites in fabric dyed with madder, a plant found in different forms from America around the globe to the Far East. Another source of red dyes came from the scale insects: kermes, lac and cochineal.

But most natural dyes came from the plant kingdom, wherever the topography and climate ensured a wide range of dye plants, and where technology in other fields advanced rapidly. Ancient dyeing reached its highest perfection in the tropical regions of India and in Central and South America.

Ceramics and glazes

The cave painters of 2500 B.C. understood the plastic properties of clay: in caves in France clay animals have been found modelled in three-quarter relief. Yet the hunter-artists may not have realized that clay is impermeable. No pottery has been found on their temporary settlements, perhaps because their semi-nomadic existence needed the more portable technology of skin bags and baskets for water and other possessions.

Once ancient man knew that wet clay would dry hard in the sun, he could make simple bowls or even line baskets with it. These would be usable until the brittle material crumbled or became saturated with its contents; but a container placed near the embers of a fire, or hung over the flames, would emerge hardened and heat-resistant, and could be used for cooking.

When tribes settled, they began to make pottery. Fired pots dating from the seventh millennium B.C. have been found in Anatolia in modern Turkey. The natural colours of raw clay give no indication of the hue the pot will be after firing; the emergence of earth reds, reddish browns, yellows and buffs (as a result of impurities in the clay undergoing chemical changes) must have seemed miraculous.

Different types of pottery rapidly evolved: coarse ware of clay roughly prepared and tempered (mixed with sand and straw to 'open out' the texture) and finer ware made of graded clay. The latter was burnished (rubbed to a sheen while still damp, rendering the vessel less porous) and decorated with incised patterns.

The urge to decorate pottery was practically coeval with its invention. Vessels almost 7,000 years old have been found at Halicar in Anatolia, along with the cakes of red and yellow ochre used to paint them. Decoration was usually of abstract and geometric design, but human faces and animal forms appear, suggesting that the vessels may have served ritual as well as practical purposes. Pottery was so widespread an achievement among early settled societies that archaeologists use these most durable remains to identify and date them.

The first potters must have used whatever coloured minerals were at hand for decoration, gradually learning which would withstand firing. Oxides of iron and manganese, graphite and white clay containing quartz or calcite (refined and diluted to make a 'slip', which is used as a paint) gave a colour repertoire of reds, brownish purple, buff, white and grey. When the potter's kiln had evolved from an open fire to a closed furnace with adjustable ventilation, it was discovered that when the atmosphere in the kiln was starved of oxygen the clay turned black.

Kilns, too, were probably instrumental in the making of glaze, a powdered glass coating which is washed over pottery and then fired so that it fuses to a hard protective surface. The ancient Egyptians were the first to chance on glaze. The constituents of glass: sand, soda or potash and lime, occur naturally on seaweed-strewn beaches where open fires might conceivably have caused them to fuse. (Burnt plant matter provides the potash needed to flux, or fuse, the glass). Alternatively, the initial discoveries might have been the result of kiln accidents, perhaps when copper oxide and an appropriate flux happened to occur together. The resulting turquoise vitreous substance must have appeared quite magical and the errors that produced it were duplicated.

In the absence of tin or lead necessary to make glaze adhere to pottery, early glazes could only be fixed on stone. They were first used on tiny Egyptian steatite beads, dating from the fifth millennium B.C. Transparent lead glaze and opaque white tin oxide glaze were in use in the Middle East by the first millennium B.C. and in China by 300 B.C.

Early glass was always coloured; the iron it contained gave it a

The original turquoise hue of this New Kingdom Egyptian sow has become greenish with age. The colour, derived from copper, developed only when the glaze contained an alkaline flux such as soda; and it would only adhere to a silica-containing body—in this case, ground quartz. Islamic artisans revived this composition material centuries later to produce their own distinctive turquoise. The Roman flask, *right*, was made by blowing glass into a mould, and then adding rim and handle.

The invention of glass-blowing enabled the Romans to make glassware cheaply. The beautiful iridescence was the result of decay as the bottle lay buried.

green tint. First produced by the ancient Egyptians some 4,000 years ago, it was carved and polished like stone. More than 1,000 years were to elapse before it could be made colourless. The earliest colouring for glass was blue; cobalt in minute amounts produced a pure violet blue in contrast to the greenish blue resulting from copper. Antimony produced yellow, iron gave green or yellowish brown; an excess of colour made black. Red was difficult; techniques were lost and regained many times until it was realized that the copper that gave blue could be transmuted into a rich opaque red—and by a different process into the clear ruby glass of the Middle Ages and the rare *Sang de boeuf, flambé* and Sacrificial Red glazes of the later Chinese potters.

So much a workaday craft in most parts of the world, ceramics became an art form in the East. The Islamic potteries of Persia vied with the age-old craft of the Chinese, famous for their subtle greyish-green and sky-blue celadon high-fired stonewares tinted with iron oxide. Then, at the turn of the ninth century there arrived at the Court of the Caliph Harun-al-Rashid an extra-ordinary Chinese ceramic of a beautiful ivory white. Attempts to reproduce it proved vain for the ceramic was true porcelain. Called 'hard paste', its vital ingredients were kaolin (white china clay) and petuntse, a powdered feldspathic stone which fuses to give a translucent vitrified body. Porcelain was called *tzu* in Chinese, meaning 'that which resonates when struck'.

Islamic potters were accomplished manufacturers of richly coloured lead-glazed wares; but encountering the delicate mag-

From the building of Samarra—meaning 'delighted is he who sees it'—in 836, until the refurbishing of the mosques of Istanbul, begun by Suleyman the Magnificent around 1546, Islamic buildings were lavished outside and in with massive displays of tiles bearing boldly coloured patterns and complex floral designs. The art of calligraphy, by which love poems, proverbs and Koranic texts were inscribed on walls, underlies much of Islamic design; only the word of Allah, not his image, could be publicly displayed.

The dome of the Shir Dar, *left*, in Samarkand is covered by a mosaic of small tiles making an ideal clothing for the fluted lines of the dome. Tile mosaic was a means of making polychrome displays without the problem of mixing glazes on one tile, when the colours tended to run. Preglazed slabs were cut into interlocking shapes and laid face down on a pattern. Backed with plaster, the mosaic was mounted in panels.

At the Masjid-i-Shah in Isfahan, *below*, polychrome tiles, each one forming an exact part of an intricate pattern, cover walls, arches and cornices as effortlessly as a coat of paint. In Persia in the twelfth century, a fine white body material based on quartz came into use, to which alkaline glazes and the turquoise so beloved of Islamic potters would adhere. Rich monochrome lead glazes gave way to polychrome designs, dominated by turquoise and by deep cobalt blue, with greens, browns and purples obtained from iron and manganese; in the sixteenth century, the new 'sealing-wax' red (a fine clay known as Armenian bole) completed the potter's palette with a hitherto elusive hue. A particular feature of early Islamic pottery was a lustre glaze formed from a mixture of sulphur compounds and silver and copper oxides that could be fired to a glossy metallic finish to imitate gold, although a yellowish brown glaze was more common.

nificence of porcelain, they set out to copy it. Having neither the vital ingredients nor the powerful kilns of the Chinese, they reintroduced instead tin glaze to produce a lustrous, opaque white finish to earthenware. When the excellent white T'ang ware reached them from China in the twelfth century they revived the ancient recipe for 'Egyptian faience', a substance made of powdered quartz fluxed with an alkali such as potash. It provided the perfect ground for the alkaline glaze responsible for the exquisite copper turquoise formerly used by the Egyptians to decorate their beads and amulets.

The Chinese did not remain unaffected by this cultural exchange. Islamic potters had long had access to a high quality cobalt oxide coveted by the Chinese. During the fourteenth century it was imported to China along the same trade routes by which they had exported their white porcelain westwards. Always assured of a ready market in Persia, the Chinese began to produce porcelain painted blue for export. This was a departure from the subdued, usually monochrome hues of their traditional stoneware and white ware, but it became not only the bulk of their export produce but popular in the home market. The blue and white Ming porcelain which spurred the Moslems to even greater achievements swept Europe in the seventeenth century, making 'china' a household word.

But the secret of porcelain remained in Chinese hands until discovered by a young German alchemist at the turn of the eighteenth century.

Metals and jewels

Man's transition from the nomadic life of the hunter to the settled, agricultural life that marks the birth of civilisation brought about many changes in his estate. Not the least of these was in his mode of self-decoration, a custom virtually coeval with the emergence of modern man. For whereas the first 'jewellery' was made of skins, feathers, teeth, pebbles and seeds, the early settlers tended to put down roots on the banks of rivers whose alluvial deposits contained a wealth of minerals.

But it is unlikely that the purpose of jewellery changed as radically as its materials. The animal skins, mammoth tusks and reindeer horns worn by the neolithic hunters were essential to attracting or repelling good and evil powers and to appropriating magically the virtues of the prey they sought to kill—the swiftness of the deer or strength of the tiger. To the early settlers the colour and lustre of gold must have suggested an immediate affinity with the omnipotent sun on which their crops depended. It was readily accessible in places such as Mesopotamia (where it was used before 3000 B.C.), either in nuggets or in dust which could be panned from the rivers by a sheepskin anchored in the current. The legendary Golden Fleece might have been such a skin which, when burned, enabled the gold to be easily washed from the ashes. Those master goldsmiths, the Incas, called gold the 'blood of the sun'; silver they called 'tears of the moon' and, indeed, there is no reason to suppose that silver was less popular than gold with the smiths of antiquity. Its vulnerability to corrosion has simply meant that fewer pieces have survived.

Copper, too, might well have been seized upon primarily for its decorative, rather than its utilitarian, value since in many ways it is no more efficient than stone as a material for tools or weapons. Native copper could, like gold, be hammered and worked into shape—although not as finely—but it must be distinguished from ores such as malachite and azurite to which it imparts green and blue colouring. These ores were used as pigments and were carved into amulets long before they were smelted—perhaps the result of an accident in a pottery kiln where copper ores were being used to manufacture glazes. But it was the discovery of simple smelting processes—heating the ore on charcoal fires and sieving off the slag floating on top—that led to experimentation such as adding small quantities of tin to harden the copper and making bronze as a result.

The invention of closed furnaces improved smelting technology and paved the way for the introduction of iron which was known in its raw state in the Near East at least 4,000 years ago. Initially, iron was used in jewellery because of its rarity, and iron bars were used as currency in Mesopotamia; by 1500 B.C. the Hittites were producing iron on a reasonably wide scale and its use in the first unbreakable blades no doubt played a large part in their military success.

Jewellery in the modern sense was perhaps initiated on a grand scale by the Sumerians. The Royal Cemetery at Ur which dates from the third millennium B.C. yielded a mass of gemstones and decorative bric-à-brac, especially lapis lazuli, carnelian and shell, which not only revealed a working knowledge of most technical skills, from welding and enamelling to filigree work and stone-cutting, but also a variety of forms far greater than those of modern times. The soft glow of precious gems was sufficient to recommend them for aesthetic, if not religious, purposes; their rarity and hardness were secondary qualities. Nor were they cut in any way, a custom which was only perfected at the end of the Middle Ages to give stones the flashing, refractive brilliance that is usually associated with them. Instead, they were simply polished as they were, or rounded into the domed style called

This Stone Age blade was probably valued for its beauty as well as its sharp edge, skilfully cut from a prepared flint core that predetermined the shape of the flake. Equally beautiful tools of jasper, green jade and flint of fine black or brown and white bands have also been found, undimmed by the passage of time.

cabochon and placed in a setting of gold or enamel.

The Egyptians were particularly fond of blue, whether in lapis lazuli and turquoise or in imitations made of a vitreous paste called Egyptian faience. Green felspar, amethyst, jasper, obsidian, agate and crystal or their counterfeits were widely employed in the Middle Kingdom. Certain colours were held to be magical. Green stones, for instance, were often made into heart scarabs, amulets which were placed on the dead to prevent their hearts from testifying against them when they were weighed in the balance by the god Osiris.

Like that of other Mediterranean cultures, Greek jewellery emphasized the head, neck and shoulders, with uncut gems sparkling from settings of gold finely woven like knitted threads. Enamels were at least as common as gems in the classic period until the conquest of Alexander the Great; then the treasure houses of foreign potentates were unlocked and an abundance of coloured stones became available. The Romans inherited much of the restrained beauty of Greek jewellery until the decadence of later imperial days brought excesses that were arguably grotesque. The sheer quantity of coloured stones worn—emeralds, rubies, sapphires, topazes and pearls—had no precedent and was not to be equalled again until the Renaissance.

Decorative metal and gems were by no means confined to the Near East and Mediterranean areas. The inhabitants of the British Isles were smelting copper by 2000 B.C.—about the same time as the Chinese—while the Irish were producing excellent goldwork from 3,500 years ago until the Dark Ages when their jewellery displayed all the exquisite lines and embellishments for which their illuminated manuscripts were famed.

As much as the Emperor Charlemagne did in the way of enabling Byzantine influences to permeate the jewellery of the Frankish lands, he performed a grave disservice for posterity: he abolished the burial of jewels with the dead. The deep belief in the power of gems to sustain the soul in his journey to the afterlife, where they also ensured the continuance of his earthly rank, was the means by which changes in jewellery could be assessed. Subsequently, it was left to the visual arts to keep a record of jewels that were frequently lost or restyled over the years.

It also happened that the wearing of jewels began to be no longer the sole prerogative of royalty and nobility. Amongst the burgeoning merchant classes jewels were used less to intercede with unseen forces than to assume the secular role of proclaiming new wealth. Nevertheless, the colour of stones still competed with their rarity in a determination of their value—although this value lay more in their supposed health-giving attributes than in their exalted powers. Stones became more like lucky charms than powerful talismans and were worn for blood disorders or liver troubles depending on whether they were red like agate, carnelian and jasper or yellow like topaz or amber. Superstitions cling to this day; birth stones bring good fortune to the wearer through their affinity with the ruling planets but the big stones of history such as the Shah and the Koh-i-Noor are attended by ill-luck and even violent death.

The turquoise, or 'Turkish Stone', varies from greenish blue to bluish green—the most precious stones are the deep blue of the summer sky. This literally heavenly colour has made the turquoise a potent amulet; it was said to go pale when its wearer was sick and, certainly, its colour is vulnerable to chemical changes.

Emeralds are a kind of brilliant green beryl, deriving their colour from traces of chromium. Perfect stones free from cracks or impurities are rare. All emeralds have been attributed variously with the power of bestowing the gift of prophecy, of sweating in the presence of poison or curing eye troubles and defective sight.

The most valuable treasure in a man's possession was often his sword. A fine steel blade made at Damascus or Toledo was precious in itself. And to combine a weapon with amulets and religious texts, names or magic symbols, was to create an object of power such as the matchless blades the Japanese Samurai passed from generation to generation. Ancient swords were like allies; they were given names in real life as in legend—Beowulf carried Hrunting and King Arthur was invulnerable while he had Excalibur. The tradition of personalizing weapons continued well into the firearms age, before the mass production of anonymous instruments of death. This early nineteenth-century Persian dagger is rich with carved iron depicting a scene from a romance, and an inlaid design of hunting animals; the scabbard is bound with silver, set with jewels of every colour, particularly turquoise and carnelians, and decorated with a painted miniature. The calligraphy reads: 'The property of Said Aga. Made by the humblest slave, Mohammed Ali.'

The name 'bloodstone' has been given to red stones such as garnet, carnelian and even ruby, all of which were supposed to cure wounds, haemorrhage, and indeed most disorders of the blood. Today, bloodstones are usually of green chalcedony flecked with iron oxide or (as legend has it) stained with the blood of Christ.

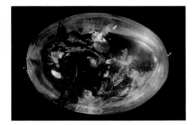

Amber, the translucent gold-brown resin of prehistoric trees, was one of the earliest 'gems' used as an amulet or as medicine when powdered. The Greek for amber is elektron, from which the word 'electric' derives because, when rubbed, amber gives off an electric charge strong enough to attract silky materials.

The opal's iridescent colours are caused by minute, regularly-stacked spheres of silicon which act as a diffraction grating. An ambiguous stone, it was said to possess both the baleful influence of the Evil Eye and the ability to cure eye diseases; its many colours often suggested that it combined the powers of other stones.

Lacquer and enamel

The classification of lacquer and enamel work as decorative rather than fine art is often belied by their appearance, let alone the manifest skill required to apply them. Although their intrinsic value is negligible, their capacity to retain their original colours almost indefinitely encouraged craftsmen in antiquity to combine them with precious and semi-precious metals.

But here their similiarity ends; for lacquer probably began with the simple intention of protecting wood, and finished by providing the basis of some of the world's most subtle ornamentation. Enamel was invariably used as a decoration on a base, usually of metal—its chief distinction from ceramic glazes which have a similar appearance and physical composition. Lacquer is an Oriental art, later imitated but never equalled in the West; enamelling is Western and the Orient was slow to adopt it.

A multitude of different varnishes have been christened lacquer, a word derived from 'lac', the gummy deposit of an insect. But true lacquer is a preparation of sap tapped from the tree *Rhus vernicifera* indigenous to the Far East. After the sap has been strained, stirred and slightly warmed to drive off excess moisture, it is ready to be applied to almost any base, including metal, porcelain and even the skull of a murdered emperor (the eunuch who killed him made it into a drinking vessel); but wood is the standard base, usually a soft, fine-grained pine that can be worked to astonishing thinness.

In ancient times, lacquer could be found all over East Asia on basketry and textiles as well as wood—whatever needed water-

proofing. The miraculous durability of what has been called 'the most ancient industrial plastic known to man' has enabled skins of lacquer to survive long after the objects they protected have deteriorated. It is so impervious to the elements that, in the nineteenth century, a cargo of lacquer was salvaged intact from a shipwreck after eighteen months on the sea bed.

Whether applied to articles of furniture—screens or cabinets for instance—or to whole portions of wooden buildings, lacquer was applied in 20 to 30, or even more, coats, each layer being assiduously ground smooth once it had dried (which it does only in a moist atmosphere). The brilliant gloss finish is a match for any vitreous material. Colours such as buff and greenish yellow were derived from ochre and orpiment (arsenic sulphide), but by far the most common hues were vermilion red from cinnabar, a substance which the Chinese greatly revered, and black from iron oxide.

A lacquered surface could be delicately engraved or boldly incised, but the most spectacular decoration was achieved by carving, for which a thickness of half an inch or more was needed. If many colours were required, each had to be overlaid on another in successive layers and then carved away to reveal the particular colour envisaged in that part of the design. No corrections were possible, so the finished piece had to be perfectly visualized in advance, and the carving had to be undertaken with absolute precision. Inlaying, too, was a potent source of colour; almost anything that glittered was favoured as a design material—mother-of-pearl, sea-ear and precious metals in foil,

powder, fragment or flake form. Jade, coral, ivory, malachite, soapstone and porcelain, too, were embedded in the lacquer, as was the gold and silver which achieved a special prominence in the finest Japanese work.

During lacquer's 3,000-year history its status developed and changed from practical to ornamental to the artistic heights of the Japanese, as well as the superlative carving of later Ming and Ch'ing ware. All shapes and sizes of object from tiny boxes and hats to thrones, armour and even statuary bear witness to the versatility of this material.

It is unclear which culture first fused a coloured glass film with a metal to produce enamel, but the Egyptians practised the technique. Greek enamelled jewellery produced 25 centuries ago shows a sparing use of colour: just a touch of blue or white enamel on a brooch or pendant. During the same period, the Celts were substituting red enamelling for coral inlay in a way that suggests that enamel in the ancient world was looked upon as an imitation of precious materials. Certainly it is mostly associated with personal jewellery, but it has brightened all manner of objects from military armour and horse-trappings to ecclesiastical regalia. Whether or not it was considered an inexpensive form of *ersatz* jewellery, it has come to be valued in its own right.

Enamel is a comparatively soft glass compounded of flint or sand, red lead, and soda or potash which, when melted together, produce a clear glass, or a translucent glass with a bluish or greenish tint, known as frit or flux (the name usually applied to soda or potash alone, the materials which aid fusion in the molten mixture). Like glaze, colour derives from the presence of iron oxides, copper, cobalt or manganese. The mixture is allowed to cool into solid cakes before being pulverized and washed. The powder is positioned while still damp and then briefly fired to fuse it to the metal surface. As with all vitreous materials, the slightest alteration in formula, firing temperature or length of time could radically affect the resulting colours.

Distinctions between types of enamelling are made according to the way the metal base is prepared to receive the powder. The

The hardness and density of lacquer lends itself to intricate carving. This small sixteenth-century Chinese box has a typical combination of glossy black relief contrasted with a softer vermilion background. Thicknesses of half an inch, with several layers of colour and more than 70 coats of lacquer, could be built up and then incised with great skill to precisely the right depth, revealing each colour as part of an elaborate polychrome pattern.

predominance of French terms pays tribute to that nation's high degree of expertise in the art. *Champlevé*, for example, describes the method of gouging compartments out of the base to be filled by the enamel; *basse-taille* is a similar technique, although designs are usually chased (chiselled) within the area that has been dug out, and a translucent enamel is used so that the metal—often gold or silver—can reflect light back through the enamel, the one enhancing the brightness of the other.

Alternatively, enamels were poured into a network or pattern of cells made of thin wire which were soldered to the metal surface. Called *cloisonné*, this kind of work reached a peak of excellence between the sixth and twelfth centuries amongst Byzantine craftsmen who worked almost exclusively in gold. The enamel colours were so intense that the fine partitions of gold, bright as they are, provide welcome relief between hues too vivid to be allowed to touch. Enamels applied as paints, usually on copper, became popular as late as the fifteenth century.

The best Chinese enamel work produced during the Ming and Ch'ing dynasties showed full well their mastery of the art—indeed, the results could be favourably compared to their best lacquer work, which reached full bloom over roughly the same period of time.

Brilliant paint and lacquer adorn the dome and massive pillars of the Hall of Prayer for Good Harvest in the Temple of Heaven in Peking. Founded in 1420, the temple has been restored several times and was last repainted in the seventies. Red, black and gold are colours usually associated with lacquer, but others, particularly brown, yellow and white, were freely used; a still wider range is used today, although some colours are hard to work in lacquer.

Early in the twentieth century, the influence of the Japanese artist Sugawara, working in Paris, led a number of artists to rediscover lacquer in the Art Deco style. Although this coincided with one of the West's periodic vogues for chinoiserie, work such as the screen, *right*, by Eileen Gray, was western and modern in concept. The influence of Japanese techniques is seen in the use of black, white and gold; but designs such as Jean Dunand's fascinating scattered-eggshell patterns made Art Deco lacquer work a unique part of the movement.

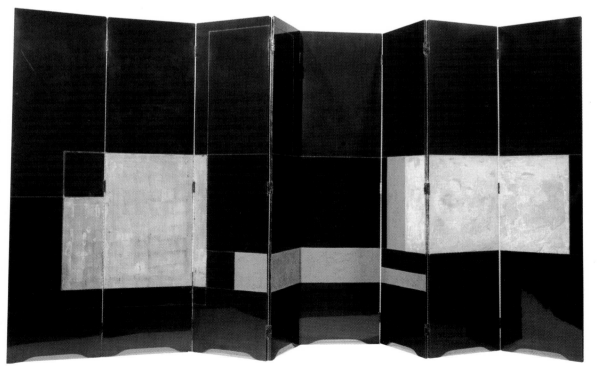

Colour for buildings

For centuries now, the great public buildings of the western world have sought to impress by their monumentality. Built to be forbidding, they declaim the power of Church and State in monologues of grey stone, as if any colourful aside were somehow vulgar or flippant. But, historically, they are exceptional. Wherever people have embodied their deepest values in communal edifices, they laid on colour lavishly inside and out—not from civic pride, but for the greater glory of their gods or, in the case of kings, for themselves.

The prototypes of all western neo-classical architecture were the delicate, finely proportioned temples of ancient Greece. Far from being the bare stone structures we have so often imitated, they were richly painted and glowed like jewels under the mild Hellenic skies. The mellow Penthelic marble of the Parthenon, for instance, was picked out in bright greens, blues and reds, for the celebration of divine events in glorious colour was as much a part of the temple as the columns which supported it.

In Egypt, the temples were larger and more awesome. The columns were carved to resemble their natural counterparts, the palm tree and papyrus; the capitals were painted to represent flowers and leaves. The mythical scenes enacted on walls and pylons were full of fiercer gods and stranger rituals. But the colours of these skilful paintings shone out as clearly as the natural hues of the landscape that gave them birth: the yellow desert, blue sky and green Nile valley.

Surprisingly, the cathedrals of medieval Europe were painted too. Although their soaring spires bear no relation to the shape of ancient pagan temples, they were nevertheless the focal point of people's lives in much the same way, and worthy of the finest decoration. The façades that might have seemed garish to us once, seem sombre enough now—but only because centuries of weathering and not a little scrubbing by the Puritans have removed the paint that adorned the gaily caparisoned saints and angels in their niches. Some cathedrals, such as Wells, were plastered or whitewashed—they must have resembled giant wedding cakes—and painted with black or red lines to simulate

the mortar between blocks of stone.

Stone, of course, is the secret of building to last. The humbler homes of common people usually had to be content with vulnerable mud or brick. But stone tombs and temples must be beautiful as well as functional, and no amount of carving and painting can conceal a flawed or ugly surface. The ancient Egyptians, whose bronze and copper tools were among the first to be equal to the intransigence of stone, built the massive Step Pyramid of Zoser more than 4,500 years ago, out of blocks of brownish limestone. But the outer casing was carefully finished in a finer-grained limestone, just as the Great Pyramid was.

Local stone has the advantage of harmonizing with the landscape. The medieval castles of Europe frequently appear

Natural building materials match the colours of the environment. In the Yemen, *below*, limestone tracery and whitewashed plaster add decorative contrast to mud brick, and stained glass windows provide colour. In the mosques of Manakhah whole limestone blocks are inserted into basalt walls.

Early oriental shrines were built of plain stone or wood; after the spread of Buddhism from India temple architecture was lavishly coloured. Korean temples, *right*, were painted, while Chinese and Japanese temples were traditionally lacquered. Primary colours closely juxtaposed highlighted the carving.

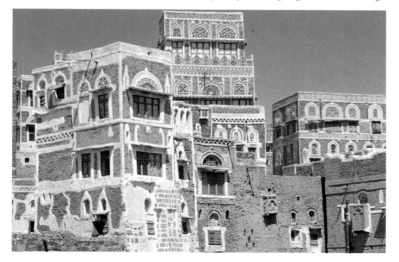

Colour both enriched and preserved the sacred wooden buildings of Japan. The Toshogu Shinto Shrine at Nikko was lacquered, painted and gilded lavishly both inside and out, so that after 350 years brilliant reds and yellows and intense blues and greens are still visible on this detail and the ceramic tiles above it. During the seventeenth century the shrine is said to have blazed with as much as six acres of gold leaf.

more impregnable by seeming to grow from the age-old outcrops of rock they are built on; the red sandstone of the city walls of Marrakesh seems as old as the desert and as warm as the setting sun. But building stone is more often used to contrast with its surroundings, drawing attention to the pre-eminence of the edifice, whether it be the green and white marble shell of Florence Cathedral or the translucent dome of the Taj Mahal by moonlight.

The builders of ancient Rome could draw their colour from all the quarries of the known world, but found it mostly on their very doorstep. The interior of St. Peter's is a living witness to the amazing range of marbles that enabled the Romans to dispense with what they regarded as an effete Greek habit—the painting of buildings. But they were not so foolhardy as to eschew the Greek pattern of architecture; they simply scaled it up and created more virile, militaristic monuments out of patterned stone and bronze plating. Caesar Augustus was said to have found Rome brick and left it marble.

Wherever stone has been scarce, man has contrived to build in the most durable materials to hand. The religious shrines of Mesopotamia 5,000 years ago were made of mud bricks covered with copper sheets and decorated with shapes of archetypal colouring—red sandstone, black shale and white mother-of-pearl. And, not content with this comparative simplicity, later generations raised their glittering shrines high above the dun-coloured plains on huge, multi-layered man-made mountains called ziggurats. They have survived until this day, but their bright mosaic patterns formed from thousands of coloured clay cones, their blue tiling and gilded metal roofs are long since gone.

The Moslem inheritors of the barren plains of Central Asia produced the most brilliant wall-facings ever devised by man. Techniques of glazed faience were, of course, nearly as old as the cities themselves; Nebuchadnezzar used them in the bright blue bricks and golden heraldic beasts of the main entrance to Babylon which he rebuilt in the sixth century BC. Nearly 2,000 years later whole mosques were covered in complex mosaics of turquoise and sky-blue glazed tiles, which shone like spiritual oases in the desert lands. Indeed, the Islamic empire stretched east to the Atlantic and West to the China Sea, and its architecture is as diverse and colourful as the terrain it traverses: the red-tiled Alhambra palace of Spain with its fantastic stalactite plaster hangings, the mauve, blue, brown and umber hues of Tamerlane's mausoleum at Samarkand, the glistening whites and reds of Akbar's Mogul pleasure dome, south of Delhi.

In the far-flung rain forests of Central America, the Mayan masters of stucco adorned their magnificent pyramid-like temples in elaborate and garishly coloured carvings and designs. The awe-inspiring city of Palenque in Mexico was discovered in conditions of almost pristine colour by successive expeditions in the seventeenth and eighteenth centuries. Eager to expose its glories more fully, they hacked and burnt down the surrounding tangle of trees; the delicate balance of the preservative microclimate was upset and the stucco colouring they had intended to reveal was destroyed.

At the opposite side of the world the Chinese, whose early knowledge of vault and arch construction could have raised any number of grand stone temples, preferred instead the simplicity of wood. As one of the five key elements of Chinese philosophy, wood alone provided fit accommodation for the gods. But, then again, columns, lintels and beams were painted, and polychrome decoration sparkled from the eaves of roofs whose semi-circular ceramic tiles were green, blue, purple or, in the case of imperial dwellings, yellow.

Rarely has the ingenious hand of man missed an opportunity to carve or paint, tile or stucco, glaze or gild plain wood or brick or stone. In the past, gods and emperors alone required architectural extravagance to manifest their power on earth; today, civic communities and multinational corporations can compete in terms of size and sometimes in grandeur and beauty—but only rarely in colour.

Wall-painting

The difference between ancient Egyptian wall-painting and the glories of the Michelangelo masterpieces in the Sistine Chapel appears at first sight to be considerable. But the materials of both are much more similar than the 4,000 or so years that separates them might suggest. The same earth and ground mineral pigments were available, from ochres and iron oxides for reds, yellow and brown to green malachite and blue azurite.

The painting surface, too, was much the same: a basic plaster made of sand and lime. But it is the composition of this painting surface and its preparation which must be understood if the widely differing colour effects are to be explained. To begin with, much wall-painting that is called fresco is nothing of the kind. True (or, correctly, *buon'*) fresco belongs largely to the Italian Renaissance: pigments mixed simply with water were applied directly to wet plaster. Uniquely, there was no medium in which the pigments were bound, for binding took place when the plaster set with the pigments embedded in it. And it was mainly because organic pigments such as madder and woad were destroyed by the alkaline lime that the fresco palette was restricted to a range close to that of the ancient world.

The Egyptians seem to have painted on dry plaster with a tempera consisting of pigments bound in gum or egg white. The bright, flat colours appeared in temples and palaces, tombs and houses. In the workmen's village of Kahin built about 1900 B.C., a typical dwelling had a brown-painted skirting with red, blue and white striped walls topped with large buff areas containing brightly decorated panels.

The Minoans of Crete were geographically well-placed to inherit the arts of the Egyptians and perhaps to pass them on to mainland Europe. Their early monochrome washes on pavements and walls graduated to stencilled designs in black and red on white plaster. They introduced natural forms, an early example of which, at Knossos, shows a boy gathering saffron in a meadow filled with crocuses. But the remarkable thing about Cretan artists is that they seem to have employed true fresco and to have carried the technique to Mycenae around 1500 B.C.

The analysis of one Mycenaean fragment showing two women in a loggia cast further light on the technique: the ground colours of blue, yellow and red were painted *al fresco* (while the plaster was still moist) with the remainder superimposed in a tempera *al secco*, on the dried surface. So, a combination of mural techniques appears to gainsay the notion that true fresco was the sole prerogative of the Italian Renaissance. And, in fact, the painters of this period also made *al secco* additions to a fresco, perhaps for the same reason; for although painting *al secco* is more vulnerable to deterioration than pure *buon' fresco*, the desaturation of colour that takes place when the plaster dries sometimes necessitated the strengthening of details—the folds of drapery, for example—to make them stand out.

If there has too often been insufficient surviving wall-painting to gather conclusive evidence about the techniques used, this at least cannot be said of Pompeii and Herculaneum. Perfectly preserved beneath the mass of volcanic ash which descended on them in 79 A.D. the brilliant colours of domestic architecture were revealed in a range of styles. Rural scenes, ornamental landscapes framed by bamboo-like designs, and even an entire scene from one of Euripides' tragedies had been executed in techniques verging on the miraculous when it is considered how successfully the hues have withstood nearly 2,000 years' burial. There is, too, the peculiar shininess of the wall-paintings (which some experts suggest was created by polishing with a final coat of glue or wax) that may well have been intended to simulate marble.

But this is not certain; nor, after all, are the painting techniques. True fresco was advocated initially, but whereas this may be true of paintings executed piecemeal on plaster applied at different times, a recent analysis of over 100 fragments revealed tempera alone. But again, this seems to have been made in an unusual way, using a binder of soapy lime or, more commonly, beeswax treated with natron (hydrated sodium carbonate) to form the mixture referred to as 'Punic wax'. It looks as though at least two quite different techniques were simultaneously in vogue.

Even in the well-documented Renaissance, there are still mysteries to solve—the most famous is that of Leonardo's *Last Supper* in Milan. It is known that he used oil paint on his plaster but it is not known why; Perhaps he found conventional fresco colouring limited or the inability to make corrections restricting. Why did it deteriorate so rapidly (75 per cent is now the work of restorers)? Did he light fires to dry the painting only to find that the paint ran or the ground melted? Was he simply sold bad oil?

The beauty of a Masaccio, Michelangelo or Raphael fresco is self-evident; but the consummate skill required to produce it is less obvious. The wet plaster applied in sufficient quantity for one day's work at a time only (so that it did not dry), was painted with little possibility of alteration, except by replastering. There were no comfortable conditions on the cramped scaffolding and no way of judging how the dried colours would appear, except by experience. Yet wall-paintings like those found in the Sistine chapel are the culmination of a great Christian tradition begun in the catacombs of Rome, and have not been equalled before or since. Nor are they likely to be.

The Florentine painter, Masaccio, began the move towards painting entirely in *buon' fresco* perhaps because the older mixed technique murals (*fresco* and *secco*), such as Giotto's had decayed. In *The Tribute Money* (*c.* 1427) *below*, red, brown and yellow are manufactured from ochres, umber and sienna earths, and green from terre vert. Lime white and carbon black complete the palette. Although the painter Cennini, writing around 1425, named indigo as a blue 'toner' for fresco, the blue here was apparently made by mixing only white and a bluish black pigment. The subdued hues of frescoes are lent strength by colour contrast.

Byzantine painters made free use of rich blue in their backgrounds. *Anastasis* (or *Christ in limbo*), *right*, is an early fourteenth-century fresco in Istanbul. Blue was a comparatively costly colour, making this extravagance the more luxurious. Painters, however, were ingenious in the use of their materials: costly ultramarine was mixed with black, or perhaps underlaid with cheaper azurite. Among the muted tones of fresco, a little bright colour stands out clearly. The brilliance of Christ's aura, the softer coloured robes of Adam and Eve and the deep blue behind them, lend one another a dramatic and other-worldly force by their contrast.

The cloisters at the Rila
monastery in Bulgaria, *right*, were
restored in the nineteenth century.
But the iconography and colouring
remain faithful to the long tradition
of Byzantine art which has been
handed down in such manuals as the
seventeenth-century *Hermeneia* of
Dionysius of Fourna, a Greek
painter-monk. Blue and gold have
always predominated; Dionysius
recommends that the blue pigment
'lazouri lake' should be avoided, as
should white lead and arsenic. Any
other colours will work, except
that cinnabar (vermilion) should
not be used on exteriors as it goes
black; bole (a fine red earth) is best
for lips, and for flesh when mixed
with white.

Illuminated manuscripts

The colour of the many illuminated manuscripts which have endured for 16 or more centuries is remarkably well preserved. For, unlike the other major contemporary art form, fresco, they have been shielded from inclement weather and the ravages of time by the parchment and vellum books in which they appear.

One of the few illuminated books whose pigments have been analyzed is the Northumbrian *Lindisfarne Gospels* (c.698). A highly flexible range of pigments was revealed: different reds, for example, were obtained from red lead and kermes, different blues from woad and ultramarine. Verdigris (a copper acetate) was used rather than malachite for green, while orpiment (arsenic sulphide) provided a light yellow. Such colouring agents are typical of illuminated manuscripts, whatever their period; the aesthetic use of colour, however, changed radically.

The illustrations shown are characteristic of the periods to which they belong. Although the purpose of colour alters within the context of individual illuminations, it is noticeable that (from left to right, top to bottom) there is an initial move away from naturalism followed by a combining of different influences during the Carolingian period. The use of gold, for instance, is found in a naturalistic context in the first picture (on Pharoah's crown) but is symbolic in the second (for haloes) and abstract in the fifth where Abraham and the angels are shown against a gold background. But even more important, in the Middle Ages at least, was the highly prized quality of brightness that gold possessed, expressing the other-worldliness of sacred events.

Illuminations were not just illustrations: they were devotional acts of people who wished to beautify sacred writings for the greater glory of God. It was only from about A.D. 1200 that illumination was increasingly executed by secular craftsmen for secular patrons, providing status symbols for the rich as well as objects of sanctity.

St Matthew sits under an arch, with his angel in the lunette above, in this mid-eighth century English Gospel book illumination. The orange of the cushions and the finials of the throne repeat the colour contrast with blue that appears on the roundels on either side of the arch, forming a symmetrical arrangement which draws attention to the central figure. Naturalistic colour survives in the pink flesh and blue sky, but there are no highlights, and no criteria for modelling the drapery other than the need to create an aesthetically pleasing effect of white and blue tones, whose variation is deliberately restrained.

This sixth-century Eastern Empire illumination (possibly Syrian) of the book of Genesis depicts the reinstatement of Pharoah's butler as foretold to him by Joseph. The modelling of the female drummer's robe, the highlights caused by a light source from the right and the distance implied by the increasingly indistinct background objects all indicate a naturalistic use of colour.

The clothing is based on that worn in Constantinople—the butler's red robes and the Pharoah's Imperial purple, for example. In spite of some signs of stylization in the dark contour lines which define figures and objects, the forms of the picture are built up largely in colour and tone—the whole being distinguished from the purple parchment ground by a mainly grey-blue tonal contrast.

This early ninth-century picture of St Mark writing his gospel inspired by his symbol, the lion, is a typical product of the renaissance begun by Emperor Charlemagne at his court at Aachen. It combines elements of the first two pictures. Naturalism has returned with the highlights on the drapery and tonal modelling of the feet; horizontal bands of graded pink and blue to represent the sky are seen in the

top corners where an angel is foretelling the birth of John the Baptist to his father Zaccharias. St Mark's pose is more natural, but the effect is created by the irregular motif of the orange used on curtains, book, desk and cushions in much the same way—if less rigidly—that St Matthew is delineated in the second picture. A lavish use of purple and gold suggests an Imperial commission.

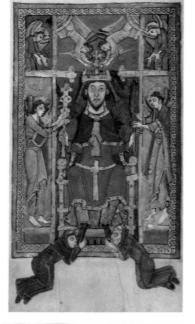

The much brighter colours of this English Romanesque miniature (c. 1130) may, like the stylized white highlights, be the result of Byzantine influence on the West after the First Crusade (1096 to 1099). The artist has consciously used red and gold juxtaposed with blue and green, both to emphasize the hues and to define an abstract space in terms of contrasting colour areas (usually lighter on darker). The red and gold robe of King Edmund of the East Angles, martyred in 869, is not intended to be naturalistic; it symbolizes the King's apotheosis and the colours were chosen for their appropriately supernatural connotations.

The Book of Hours, *below*, was produced for the Duke of Berry in France and contained his private devotional texts, one of the commonest forms of illuminated manuscript in the later Middle Ages. Begun by three Flemish brothers, Paul, John and Hermann Limbourg, the book was left unfinished in 1416 when they—and the Duke—died, presumably of the plague. This picture shows the harrowing of the ground and the sowing of corn in March; the scene takes place on the banks of the Seine in Paris with the medieval palace of the Louvre in the background. The most startling innovation is the exquisitely detailed depiction of shadows, particularly of the peasant in blue, and the reflections in the water. The natural colouring of the horse, the magpies, the slate roofs and the sky paling towards the horizon are also characteristic of the important return to realism at this period—a return of which the artist may have been ironically aware when he contrasted the peasants with the figure carrying a bow: it is not a real person, but a scarecrow! On the other hand, the rose pink and sky blue of the peasants' robes are unlikely to have been real-life colours. They reflect the general ambivalence of the manuscript which combines exaggeration and elegance with realism and direct observation. The Duke of Berry had a taste, like most patrons of the time, for jewels, precious metals and bright enamelling; and the vivid colouring was, perhaps, a concession to this love of richness and splendour.

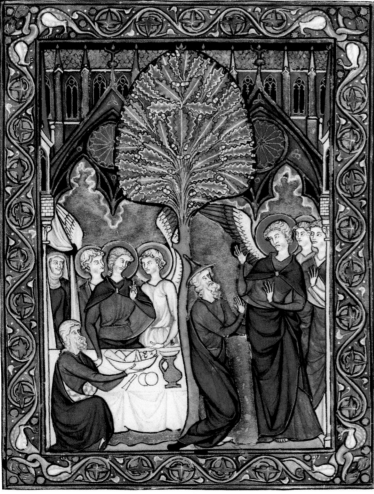

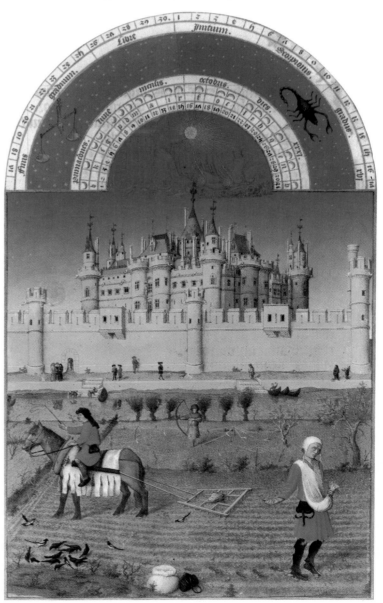

The burnished gold of this mid-thirteenth century miniature also reveals the influence of Byzantine art, which had reached a climax around 1200. As in mosaics, gold implies a limitless but abstract space against which Abraham entertains the three angels, on the left, who announce the birth of Isaac to his wife Sarah, on the right. The background canopies reflect the architecture of the Sainte Chapelle in Paris, built between 1243 and 1248 by St Louis, for whom the manuscript was made. The dark blue and pinkish brown draperies and, indeed, the generally muted colour range, are typical of Parisian early Gothic illumination. This may be a result of a desire to achieve a greater harmony between the hues of the illumination and the black or brown ink (with red and blue initials) of the text script.

Windows of coloured glass

AD 1000: the expected end of the world failed to arrive. Europe exhaled in relief, disappointment and gratitude, which combined to produce a strange spiritual celebration—the most prolific era of ecclesiastical building the world has ever seen. As Romanesque architecture burgeoned into the rib-vaults and flying buttresses of Gothic cathedrals, the reduced load on the walls meant that they could be pierced by vast lancet- or rose-shaped windows, all of which were filled by tons of stained glass.

In an age of almost total illiteracy, stained glass provided a series of cameos, each lit in turn as the sun moved round the building, which illustrated in glowing colour the stories of the Bible. But more than educational, the purpose of stained glass was spiritual, reverently letting in light 'to illumine men's minds so that they may travel through it to an apprehension of God's light'. So said Abbé Suger, builder of St. Denis, near Paris, the first truly Gothic structure.

Though glass had been invented 4,000 years before, and coloured glass was used in windows as long ago as the sixth century, it is hard to account for the sudden profusion and brilliance of medieval stained glass. The earliest surviving stained-glass windows, the famous Five Prophets in Augsburg Cathedral, exemplify the astonishing mastery of technique which had been accomplished by the mid-twelfth century. But exactly when or how the technique evolved remains a mystery.

For a long time, it was generally assumed that the secret of the colours in medieval glass was the cunning admixture of all manner of chemicals and colouring agents. But in 1977 a research student at Erlangen University, Christiane Sellner, who had been experimenting in reproducing medieval glass, mixed a batch containing a particular proportion of iron to manganese. By melting it under a wide variety of conditions, she was able to produce a whole range of colours—bright blue through green, yellow, brown and pink to purple. Since all medieval glass contains varying amounts of iron and manganese, usually derived from the beechwood ash that was added to the melt as a flux (a material which aids fusion and lowers the melting point), it seems likely that Sellner had hit upon the key to the secret of medieval glass-making. And because, in those days, glass-makers would have been unable to make sophisticated changes to the atmosphere of their furnaces, as Sellner could, it looks as though each glass-house would have produced a particular, narrow range of colours. The glazier would then have jealously guarded the 'secret' of his own glasshouse while having to shop around other glass-houses to obtain the full palette of colours he required.

Contemporaneous accounts of glass-making techniques are rare, though a monk named Theophilus, writing in the first half of the twelfth century, says that his glass generally went through a colour sequence of white to flesh-colour to purple. But sometimes the white, freshly melted glass changes as the temperature rises, either to saffron which reddens with time, or to a tawny colour which deepens to reddish purple. Theophilus seems to have had no control over the process; he just took what came at each stage, as Sellner's experiments suggest.

Early Mediterranean glass-making sites were coastal, and maritime plants were used as the source of the alkaline flux. But the prodigious amounts of fuel needed for firing the glass to adorn the many cathedrals meant that a move inland to more wooded areas was inevitable; (the move to Chartres was especially fortunate because of the oustanding purity of the Eure River sand). It is possible that the cathedral architects had planned their buildings with colourless glass but, having begun to use beechwoods as fuel, they added a little ash to the glass mixture and found they had stumbled across the art of coloured glass. Conversely, it is even possible that the fortuitous discovery of coloured glass acted as a catalyst for the construction of cathedrals.

From the fourteenth century to the present day, there have been dozens of improvements in stained-glass techniques—better glass, a much wider range of colours, ever more sophisticated chemicals and tools—yet, paradoxically, a great deal of the early glory has been lost. No stained glass since the Renaissance has equalled the incandescent reds and blues of the windows at Chartres or Notre Dame, for example. The glow of these windows is as much a result of bubbles and impurities in the glass as anything else; the light is not just admitted, but held, giving the window a luminous, jewel-like quality. But even this explanation only partly accounts for the truly extraordinary quality of twelfth- and thirteenth-century red glass.

Red and some blues seem to have been the only colours produced by the addition of an 'ingredient' other than beech ash. In both cases, it was copper; and the almost invariable presence of zinc in the early red glasses suggests that the source was brass filings. Under the microscope, a piece of red glass from Chartres revealed some 50 or more alternating layers and streaks of red and clear glass, which are primarily responsible for the unique 'self-lighting' effect of the old glass; but no one can be sure how it was done, nor whether it was deliberate or accidental.

One suggestion is that the blow pipe was meticulously dipped in molten colourless and red glass alternately. More likely is the hypothesis that the layered effect was produced spontaneously during attempts to make the colour very dilute by reducing the amount of copper added.

In the fourteenth century, the technique of 'flashing' was invented to overcome the problem that red antique—or pot metal—glass is so dense as to be 'black'. If it is made thin enough to look red, it is not self-supporting. The solution was to 'flash' a thin surface layer of red over colourless glass while still in a molten state; the layer could then be abraded with a stone—acid is used nowadays—to reveal more, or all, of the underlying white glass and so achieve differences of tone.

Brown, grey and, of course, black were absent from the medieval glazier's palette because they transmit light poorly or not at all. As a result, blue-haired people in Crucifixion scenes and violet donkeys at Nativities are not uncommon. However, the discovery of silver—or yellow—stain added flexibility to the colour range. A silver compound, such as silver sulphide, is applied to the back of a piece of cold glass. Then, by firing the glass at a suitable temperature—one not high enough to melt the glass—a range of colours from pale lemon to warm orange is produced. The translucency of the glass is unaffected, which means that smaller details, such as golden hair, crowns and haloes, can be added to the original glass without resorting to an inappropriate use of lead. But it must be added that such a use of lead was virtually unknown, the medieval glazier was a past-master at integrating the black lead lines into the total scheme.

There can be no doubt that medieval glaziers were visionary artists on a grand scale. Their raw material was daylight, the visible manifestation of God in creation, which they translated with glass into vibrant colour. Their canvas might be a rose window 40 feet across, but they had no way of knowing how the finished product would look; how the colouring might be affected by the thickness of the glass, by the angle of the sun at different times of day or by the juxtaposition of certain colours when viewed from a distance. Yet the accuracy is uncanny, and the final effect awesome.

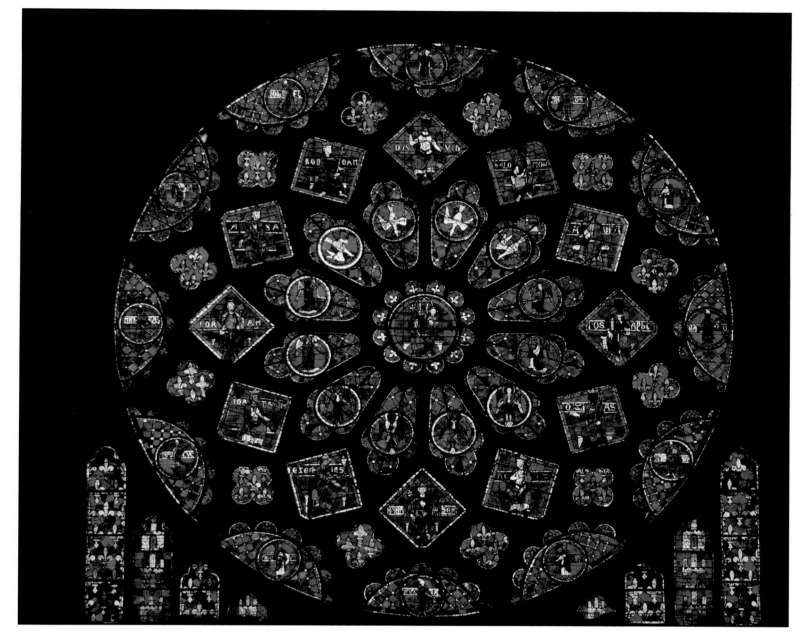

The north 'Rose de France'
window at Chartres Cathedral,
built in about 1233, was dedicated
to the Virgin Mary who sits
enthroned at the centre of
swooping doves (only one in fact,
seen from four directions), angels
and thrones from the celestial
hierarchy, the 12 kings of her
ancestry in the squares and the 12
last prophets of the Old Testament.
The fleurs-de-lis are emblems of
both the Annunciation and the
Kings of France (the window was
given by Blanche of Castille,
Queen of France). The inimitable
blue glass is rightly famous,
probably deriving its colour from
the addition of copper to the
molten glass—like the sample
of Mont St. Michel glass, *right*.

These diagrams compare the
wavelengths of light transmitted by
two samples of blue glass: one
from Mont St. Michel dating from
the twelfth century, and the other
from Beauvais, dating from the
seventeenth. The earlier glass is

Beauvais glass

Mont St. Michel glass

coloured by copper (although there
is a small amount of cobalt present)
while the Beauvais glass is coloured
by cobalt alone.

Most of the light transmitted by
the latter is from 350 nm to 500
nm, giving a strong violent tint to

the blue (ultraviolet is transmitted
up to 380 nm). In contrast, the
glass coloured by copper transmits
a predominantly blue light
tempered by light of longer
wavelengths, notably red, which
gives a degree of luminosity absent
in the later glass. Cobalt seems to
have been used only accidentally to
colour glass blue before the
seventeenth century; an exception
may be a mysterious twelfth
century soda glass found in places
as far apart as Chartres and York.
Its cobalt content may be
connected with Theophilus'
reference to the French use of
'little square stones' (possibly
fragments of Byzantine mosaic) in
their melt to produce a blue glass.
No one knows for sure.

The tinctures of chivalry

Though of very ancient origin, the underlying principles of heraldry still form the base of some of the most lively, colourful and efficient means of human communication. Ensigns, regimental badges, army divisional signs, school and college crests and football club insignia all give a comfortable sense of belonging to those who bear them and throw out something of a challenge to those who do not.

In no other field of human activity is swift recognition so essential as in that of war, and in the days when close combat was the rule rather than the exception, it was positively crucial. It was out of this necessity that true heraldry was born. Painted shields had been carried by warriors since classical times as a means of distinguishing friend from foe or denoting the presence of a leader, but until the beginning of the twelfth century, the choice of colour and motif was largely a matter of individual fancy. Though some sons may have carried their fathers' shields as an act of filial piety, the devices depicted on them had no particular genealogical significance.

It was the blossoming of the feudal system with its firm insistence on rank and title, the growing complexity of warfare and the steady improvement in armour that made some better form of battlefield identification essential. Disguised as they now were by the new closed helms, it was impossible to tell one man from another, much less what side they were on. Men of rank therefore, selected some device that was emblazoned in bright colours on shield and pennant, and to save confusion the same device would usually be adopted by their sons.

The herald's place in the scheme of things—and hence 'heraldry' as the name for this means of identification—was that for centuries he had been the recognized non-combatant messenger between opposing armies, and between princes and military leaders. A knowledge of such men, their families and the lands they held was part of his stock-in-trade; from this it was but a short step to the heralds being recognized as arbiters in determining the device that a particular family was entitled to.

Early shields were simple, perhaps no more than a horizontal or diagonal bar, or a representation of a bird or animal set against a plain coloured background or field. But they swiftly grew more complex as the role of heraldry subtly developed from a means of identification into a declaration of family alliances, rank and land tenure. A man was entitled to join the coat of arms of his wife's family to his own on his shield, since through her he would have acquired new lands. Within a very few generations, therefore, the coats of arms of some great families had become a brilliant and chaotic jumble of symbols, bars and colours that would have been utterly bewildering had it not been for the heralds, and for the passionate interest taken in the subject by all men of property.

While reading and writing did not necessarily form part of a gentleman's education, a knowledge of heraldry did, and by the mid-thirteenth century the rules had become so well established that heraldry had developed its own terminology called blazon. This delightfully archaic language, based on Norman French, is used to describe the ramifications of heraldry to this day.

In blazon, colours are called tinctures, comprising two metals, five main hues and two main furs. The metals are Or and Argent (gold and silver), the hues Azure (blue), Gules (red), Sable (black), Vert (green), Purpure (purple); Tenné (orange) and Murrey or Sanguine (reddish purple) also make rare appearances. The furs are ermine—actually a pattern of spots which, depending on their colours and that of their background, are variously known as Ermine, Erminois, Ermines or Pean; and Vair, a blue and white pattern originally inspired by the belly fur of the squirrel.

The three gold fleurs-de-lis on a blue background, depicted on the flag above the pavilion in this early manuscript, signify that the jousting was taking place under the aegis of the King of France, whose arms they were. The knights on horseback may be brothers, for it was common practice for families to retain the same device (in this

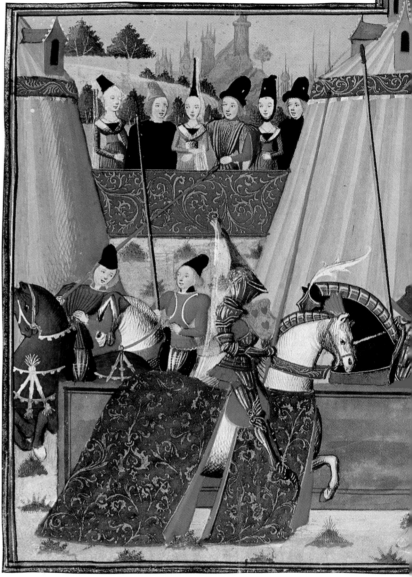

The tinctures cover the field, or the background, of the entire shield, or of its divisions, called parties. These are the most important elements in a coat of arms and no new arms can be created unless they have at least two distinct differences in linear motif from all other arms. Each type of party—and there are many of them—has a different name; for example, a straight horizontal division or party is per fess, a vertical one per pale, a diagonal from the right per bend, and a diagonal from the left, per bend sinister. The left side of the shield is always sinister, hence diagonal stripes from the left are bendy-sinister, while those from the right are bendy. Many of the names, and the patterns too, were taken from stylized representations of everyday objects in the medieval world: *bezant*, derived from a Byzantine coin, *chevron* from a rafter, *cotice* from a thong, and *manche* from a sleeve.

case three hearts) while changing the tinctures. The cardinal rule is that no metal may be overlaid on another metal, and no hue on another hue. The floral designs on the horses' trappings and around the lists were called diapering, purely decorative motifs to add a touch of splendour to an already colourful occasion.

There are only two flowers in heraldry: the rose and the lily. The fleurs-de-lis on the fourteenth-century knight, *right*, were really highly stylized lilies. Crests on knights' helms were originally metal fans, called panaches, which would ward off blows to the head; they later became colourful ornaments made of wood or of boiled leather.

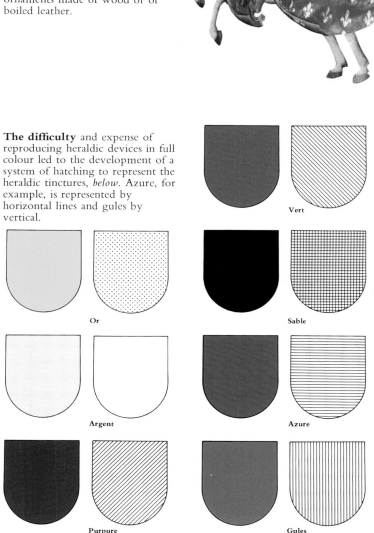

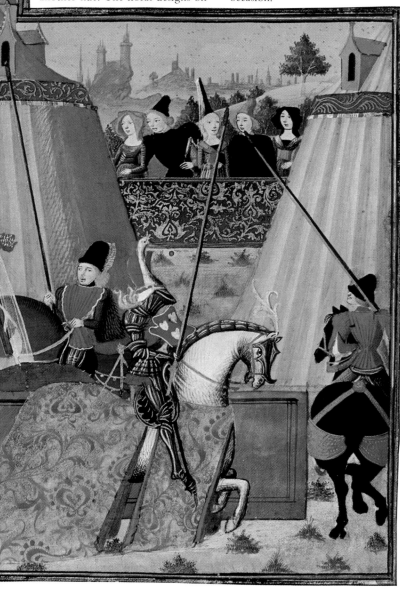

The difficulty and expense of reproducing heraldic devices in full colour led to the development of a system of hatching to represent the heraldic tinctures, *below*. Azure, for example, is represented by horizontal lines and gules by vertical.

Vert

Or

Sable

Argent

Azure

Purpure

Gules

Some of the charges, the designs superimposed upon the parties, were much more imaginative, and included all kinds of creatures and plants from the natural and mythological kingdoms. Lions, leopards, roses, falcons, lilies, gryphons and dragons abounded, together with stars and teardrop-shaped markings called gouttes. Some of the charges were chosen at random, but others were 'canting' arms, based on a punning reference to a family name. The von Salms chose a pair of salmon for their coat of arms; the Shelleys, shells, and the Woodwells a tree growing out of well; Shakespeare's arms, naturally enough, show a spear.

The thirteenth century saw the full flowering of the tournament. Behind these colourful mock battles lay not only the practical aim of keeping knights in trim, but also the romantic ideal of chivalry. For, curiously, the strange combination of mysticism, erotic passion and military virtue which found expression in the romances of the Provençal troubadours influenced the attitudes of knights and courtiers all over Europe. The ritual of induction into knighthood began with a bath, a symbolic cleansing of the soul, after which the aspiring knight donned white clothes and a red cloak and settled down to an all-night vigil before an altar on which his arms had been laid.

The white of purity and the red of sacrifice and courage were familiar motifs in the magic shield of the legendary Lancelot, which was argent three bends gules (white with three diagonal red lines); in the famous Holy Grail story, *Queste de Saint Graal*, Galahad's shield originates with Christ's uncle, Joseph of Arimathea, who traces a red cross on a white shield with blood from his nose. The plain arms of the Red, Black or Green Knights who challenge the heroes of the romance may signify just that they are unknown quantities on the hazardous path of the Quest.

The tradition of the alchemists

Quite early in his researches into the mysteries of the human personality, Carl Gustav Jung noted the constant recurrence of certain symbols and colours in the dreams and paintings of his patients. These, he felt, were the expressions of a shared unconscious, of a common memory handed down to all of us from our remotest ancestors and locked in the most shadowed recesses of our minds. Quite obviously, colours and symbols were the language of this hidden world, yet without a key, or some means of comparison, there was no way of translating it.

Then, in about 1930, he chanced upon some old alchemical texts, and soon found himself drawn into the bizarre world of medieval alchemy. Initially, Jung looked askance at the pseudo-scientific labours of the alchemists with their search for a Philosophers' Stone that turned base metal into gold. But as he delved deeper into the thousand-year tradition of alchemy he understood that, charlatans and tricksters apart, the true alchemist's goal was the purification and transformation of the self. The process was called the *magnum opus* or 'great work': a psychic quest in chemical guise. It was then that Jung realized that the symbols and colours which described each stage of the alchemical *opus* precisely corresponded with the images that occurred in his patients' dreams. He had found his key. 'The experiences of the alchemist were my experiences, and their world was my world . . . I had stumbled upon the historic counterpart of my psychology of the unconscious.'

The role of colour in alchemy was vital. The different hues which appeared as the alchemist transmuted substances in his vessel symbolized each stage of the inner transformation he was undergoing at the same time. Apart from exotic formulations like 'peacock's tail' and 'spotted panther', the basic alchemical spectrum is: green, black, white, red, gold. Using his patients' dream histories, Jung was able to draw a series of detailed parallels between the alchemical process and the psychological growth he deemed indispensable for mental health.

Alchemy came to its fullest flowering during the Middle Ages. Many of its symbols at this time were adapted from a much less occult spiritual body—the Church. Whereas alchemy was a quest undertaken by only a few daring souls, the Church was the centre of popular life. In an otherwise drab world the significant changes of a man's estate—baptism, confirmation, marriage and funeral—were celebrated amidst the dancing hues of stained glass and richly painted walls and icons. Not only did these illustrate familiar biblical scenes such as the Crucifixion and the Day of Judgement, they also depicted the more homely of God's works: the greeness of spring, the golden corn of autumn and ordinary men and women at work. At the heart of this drama stood the altar and the priest. Both were dressed in colours that symbolized—and still symbolize—special dates in the Church calendar. White and gold represent Christmas and Easter while red is worn at Pentecost and on the feasts of the martyrs. The red hats of the pope's cardinals, incidentally, are a reminder that they should defend the Church even to the point of shedding blood, like the martyrs. Green vestments appear at the birth of a new year, after Epiphany until Septuagesima, signifying God's provision for man's needs.

Purple, which at Passiontide represents the penance of the individual sinner and the sufferings of Christ, was the most sacred colour from earliest times, partly no doubt because it was difficult and costly to obtain. The V.I.P. 'red carpet' unrolled to greet the ancient Greek king, Agamemnon, when he returned from vanquishing the Trojans, was probably purple or crimson. However, in those days it was courtesy only; the purple carpet was reserved for the gods, and mortals were not allowed to set foot on it—Agamemnon broke the rule and was stabbed by his wife. The purple togas worn by the Roman Caesars were a sign that they were not just royal, but personifications of the god Jupiter himself. The purple of the Christian vestments is more subtle; being a mixture of blue (for spirit) and red (for blood), it symbolizes both the divinity of Christ and his humanity.

Colour symbolism prevailed outside the Church as well. Medieval man believed that the world was composed of a mixture of four basic elements: earth, water, fire and air. Each of these had its distinctive hue: black, white, red and yellow respectively. In man himself the elements took the form of bodily fluids: black bile, white phlegm, red blood and yellow bile or spleen. It was vital to maintain a balance between them, otherwise one was likely to fall prey to a bad 'humour'. A predominance of spleen, for example, caused a choleric humour, or what we would call a bad temper, while an excess of black bile might induce a black mood of melancholy. Red was the colour of the hearty, sanguine person ruled by the blood, and white belonged to the watery, phlegmatic soul.

China also has a system of elements, as well as an independent alchemical tradition even older than that of Europe. There are five elements instead of four—earth, metal, water, wood and fire, whose colours are yellow, white, black, blue/green and red. Each element and colour also corresponds to an animal, a part of the body, a season, a planet and a cardinal point of the compass with the earth in the centre. The association of earth with yellow may well have stemmed from the colour of the soil in North China, and its central position made yellow the exclusive colour of mankind in general and of the emperor in particular. And because the Chinese conceived their elements as dynamic forces, fire overcomes wood and is overcome by water and so on. This could have a practical purpose for, since 'metal' can overcome 'wood', revolutionaries challenging a dynasty associated with wood were more likely to triumph carrying a banner of white, the colour of the element 'metal'.

After reaching a zenith in the Middle Ages, colour symbolism gradually lost much of its resonance. Green, for example, was still used for bridal gowns up to Elizabethan times and beyond, to express the hoped-for fecundity. But the symbolism became somewhat debased when green came to stand for the tell-tale grass-stains on a previously virgin frock, which signified inconstancy—a charge levelled at 'Greensleeves' in the ballad attributed to Henry VIII. Many such subtle associations have long since vanished from the language, but colours do still possess enormous powers of suggestion if only as a kind of shorthand in everyday speech. Green with envy, Red Army, yellow streak, purple prose, the blues, green thumb, blue jokes, scarlet woman—the list is endless. Revolutionary troops still muster under red flags; many Islamic flags are green because of the tradition that green was the colour of Muhammad's cloak. 'Blue jokes' are green jokes in Spain, pink in Japan and yellow in Hong Kong. 'The blues', meaning depressed, had the same connotations as long ago as 1550 and only became attached to a particular kind of yearning Negro music at the end of the last century; to be blue in the U.S.A.—as well as in Germany—can also mean that you are drunk, but in Finland you are quite simply a little short of money.

All such expressions undoubtedly add flavour to human communication, whether in dreams or in everyday turns of phrase. Their original meaning may go back a long way in history or have gathered power in the depths of our minds.

In medieval times, colours had the power to conjure up a whole chain of associations. Most important, perhaps, was the correspondence of seven hues with the seven planets: yellow or gold belonged to the sun, white or silver to the moon, red to Mars, green to Mercury, blue to Jupiter, and so on. The correlation of the signs of the zodiac with the planets was a later, and largely artificial, scheme which meant that ten of the signs were forced to share a colour. Planets and their colours also possessed a mysterious (perhaps alchemical) affinity with metals and precious stones, so that a Sagittarian, for instance, ruled by Jupiter, might benefit from the magic power of a sapphire amulet. A ruby possessed something of the power of the red planet, Mars. The virtues and qualities of heraldry were also included in the scheme: for example, black stood for penitence, red for courage, blue for piety, green for hope, and purple for majesty and rank. This interrelation of colours provided a way of classifying the world, of relating different areas of experience—yellow is to white, for instance, as the sun is to the moon, as gold is to silver, as godliness is to purity.

This illustration from a sixteenth-century alchemical manuscript, *Rosarium Philosophorum* (*The Philosophers' Rosegarden*), describes the alchemical process in a language of colours and emblematic figures. At the bottom lies the self-devouring dragon whose greenness represents both the base matter, or 'raw stuff', that the alchemist will transmute in his furnace, and a state of psychological immaturity and incompleteness. Its red blood is a promise that the red Philosophers' Stone will be achieved, but is also a warning that the task will be self-sacrificial. The crowned and winged hermaphrodite, standing in conquest over the dragon, symbolizes the glorious stone itself, and the colours of its garments rehearse the stages of the *magnum opus* out of which it has been formed: the blackness signals the 'death' of one chemical form and the gestation of another, corresponding to a period of melancholy and inward searching. The whiteness symbolizes the separation of the mercurial, or spiritual, properties of matter from the sulphurous, or bodily. Psychologically, this signifies the division of opposing tendencies—spirit and body, for instance—within the self, which are to reunite in the redness of the stone, the goal of alchemist and psychiatrist alike. The gold it creates is 'not common gold', but the less tangible brilliance of psychic integration and wholeness. The 'philosophical tree' on the left emphasizes the process: the green stalk bears golden fruit as nature is transmuted into supernature. The green lion shares some of the dragon's complex symbolism, but it also refers to an actual chemical substance, sulphuric acid, which is made from 'green vitriol' (ferrous sulphate) and is chemically fierce (caustic) like a lion. The pelican is a rebirth symbol, shedding its blood to feed its young.

The rebirth of colour

The restoration and cleaning in 1969 of Titian's *Bacchus and Ariadne* (1525) meant that the popular view of the gloomy Old Master might well have to be revised. For beneath the layers of disfiguring varnish which had drawn a yellowy-brown veil over the painting, the colours stand out so vividly that it no longer requires an eye of faith to see how Titian could have been considered the greatest colourist of all time. Indeed, the colour quality of fifteenth- and early sixteenth-century Venetian painting, and Titian's in particular, is so special that an idea has persisted down the centuries that they were possessed of a secret medium, so that in the eighteenth century a number of recipes purporting to contain the 'Venetian secret' changed hands.

The key word is 'medium'. There was no mystery about the pigments available to Titian, although the fact that Venice was the only port through which exotic materials (like lapis lazuli for ultramarine) entered Europe from the East no doubt played a part; a successful painter like Titian could have had the pick of the best pigments from the widest possible range. But the medium necessary to bind these pigments and cause them to adhere to the painting surface was at this time undergoing radical change. Rather in the way that canvas was replacing wood panels as the surface for fine art, oil paint was superseding tempera.

Tempera is an emulsion in which pigments are ground and mixed with the yolk, and sometimes the whole, of an egg; water, varnish or a combination of the two is sometimes added. It was customary for medieval painters to coat a finished tempera painting with a brown-red varnish, *vernice liquida*, made of sandarac dissolved in linseed oil. They were so accustomed to this reddish appearance that they even supplied the tint when it did not exist, rather as some eighteenth-century painters employed as a pigment the highly unstable bitumen to counterfeit the age-darkened appearance of Renaissance paintings.

The mixing of pigments in oil was certainly not a wholly new innovation. The technique had been known for at least two centuries and probably a great deal longer (Pliny reports that the Romans used oil paint on their shields). But it only became widespread in Flanders and Germany, and later in England, during the fifteenth century—perhaps because the addition of oil helped paintings to withstand the vicissitudes of a northern climate. Oil painting was certainly known and used in Italy—notably for the detail on drapery in paintings—but found greater resistance from traditional tempera methods. At any rate, the Renaissance attributed the invention of oil paint to one man: Jan van Eyck of Bruges, in Flanders. In his *Lives of Painters, Sculptors and Architects*, Vasari relates how van Eyck had finished a painting and set it out in the sun to dry, as was the custom. But the wood panel split so badly in the heat of the sun that van Eyck decided at once to abandon his usual tempera and varnish and try to devise a varnish which would dry in the shade. Vasari takes up the story: 'After making a number of experiments and many mixtures, he discovered that linseed oil and the oil of nuts dried more quickly than any which he had tried. By boiling these with other ingredients, he obtained the varnish which he and every other painter had so long desired. Numerous experiments showed him that by mixing colours with these oils he gave them a quality of great strength, and that when they were dry they were not only proof against weather, but the colours were so strong that they were quite lustrous without any varnish and, what was even more remarkable, they blended far better than the tempera. Enchanted with this discovery, as well he might be, Giovanni [Jan] began a large number of works, filling the whole country with them to the infinite delight of the people. . . .'

Van Eyck seems to have dispensed altogether with the customary varnish—which he is supposed to have disdainfully called 'brown sauce'—and to have manufactured a more or less colourless varnish with which pigments could be mixed to form a waterproof oil paint with a gloss of its own. But, more important, there can be seen in his innovation the first stirrings of a truly flexible medium; for the main advantage of tempera—the fact that it dried quickly—also limited the painter's ability to blend colours. They were brilliant, certainly, but lacked the softness and sparkle of oil paint at its best.

Whatever the truth of the claim that van Eyck invented oil paint, the question pales into insignificance beside the manifest genius of his paintings. One at least found its way to the court of King Alfonso of Naples where, according to Vasari, it was seen by an Italian painter, Antonello da Messina, who was so impressed by 'the brightness of the colouring and the unity and beauty of the painting . . . that he laid aside every other care and design and set out for Flanders to seek out van Eyck.' In fact, he did no such thing; he was born too late to have met van Eyck who died in 1441. But he may have carried news of Jan's technique to Italy where it developed among the schools of Venice.

One of the things that perhaps impressed Antonello most about van Eyck's painting was the way he exploited the supreme attribute of oil over tempera—its power to transmit the light of an internal surface or ground through its diaphanous layers. This endowed the colour with a sense of depth and a glow analogous to painted glass (it can be no coincidence that van Eyck was well-versed in the skills of glass-painting). Since a white ground would clearly transmit the most light and give the greatest brilliance to a painting's colouring, it is all the more remarkable that Titian has commonly been credited with the use of a brown-red ground. The idea is that dark grounds provided greater opportunity to explore chiaroscuro and atmospheric effects. But analysis of ten Titian paintings at London's National Gallery revealed in every case that Titian applied a very thin, white gesso ground to his canvases on which drying oil paints were overlaid.

Many fourteenth- and fifteenth-century painters made meticulous underdrawings on their white gesso or chalk grounds before laying on the paint. Alternatively, they made preliminary drawings on paper which would then be confidently transferred to the canvas or wood panel. But infrared photographs of the *Bacchus and Ariadne* show that Titian had apparently abandoned underdrawing; and no studies for the painting survive, if there were any—only 20 drawings in all can be attributed to Titian with any certainty.

Further evidence of Titian's unusual method comes from X-rays of the painting's layers: they reveal far more *pentimenti*, or alterations, than would normally be expected. The dark blue drapery of the Bacchante with the cymbals, for instance, was initially coloured crimson while the figure of Ariadne seems to have been repainted, as if there were some difficulty posing her. Together with the absence of underdrawing, the many corrections suggest that Titian preferred to work out the composition as he went along, organizing the picture as a whole in terms of strong areas of contrasting colour—scarlet and blue, orange and green, crimson and white. These pure colours, employed at full strength (unmixed with other pigments except, occasionally, white) are bound together by the less brilliant earth colours in the foreground. The flesh tones, too, increase in warmth and depth from left to right, culminating in the figure with the snakes. They provide a series of links that help Titian to attain that harmony of colour for which he was most admired.

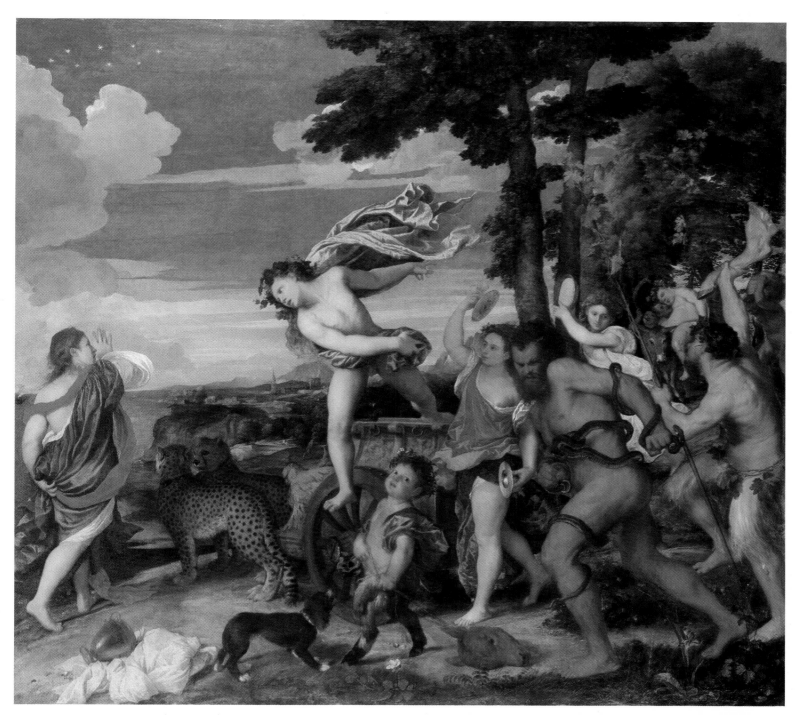

A detail of Titian's *Diana Surprised by Actaeon, right,* gives a good indication of how much duller (flesh and sky especially) *Bacchus and Ariadne, above,* appeared before cleaning.

The huge expanse of ultramarine, the most expensive of contemporary pigments, was a revelation. Analysis showed that it was mixed with varying amounts of lead white in sky but used in its pure state for the dark shadows of Ariadne's cloak and the drapery of the Bacchante with the cymbals. Azurite coloured the sea blue, while the green of landscape and foliage were provided by verdigris (a basic copper acetate) and the bluish green malachite. Crimson lakes mixed with lead white were found in Bacchus's flying cloak and Ariadne's flesh; vermilion makes a single dramatic appearance in her sash. Lead-tin oxide coloured the delicate yellow drapery under the urn; other yellow tints and orange come from orpiment and realgar which, though common in the Far East, were rare in European paintings.

The decorative arts

When Charles Le Brun decorated the Château of Vaux-le-Vicomte for Nicholas Fouquet, the French Minister of Finance, in 1661, he created a landmark in the history of interior design. Perhaps his most startling innovation was his conception of each feature of the interior—hangings, furniture, decorative objects—as part of a total unity. The Château inspired the establishment of the *Manufacture Royale des Meubles de la Couronne* by Fouquet's successor, Colbert, who installed Le Brun at its head.

The young Louis XIV had also been deeply impressed by Le Brun's creation; he was full of new ideas when he set about building a small house of porcelain at Trianon, on the outskirts of Versailles. The exterior was entirely covered with Delft pottery tiles in blue and white, the most fashionable colours of the day. But Louis swiftly outgrew his little porcelain box and in 1688 built the Grand Trianon whose white stone façades and pink pilasters guarded an interior that heralded the first real stirring of the style that is known as rococo.

Asymmetrical curlicues adorned everything from ormolu clocks to furniture and candelabra, keeping the eye in perpetual movement. The rococo mood was one of airiness and light; the heaviness of the baroque was lightened by a new vivacity. Tall windows collaborated with mirrors to illuminate the gilding on ceilings and furniture, the gold and silver thread of rich tapestries and cabinets of ivory inlaid with tortoiseshell. Upholstery and tapestry panels blended their colours with walls of green and lilac, pink and white, yellow and silver.

The accent was on comfort—even cosiness. The great and wealthy of the day, as brilliantly garbed as the setting they moved in, could take their ease more intimately amidst furniture that was smaller and more mobile than earlier furnishings. The fashion spread; Max Emanuel, the Elector of Bavaria, charged his architect and erstwhile court dwarf, François Cuvilliés the elder, with the task of building the Amalienburg in the Nymphenburg gardens in Munich. This, like the Grand Trianon, had a comparatively modest exterior that concealed an inner extravagance; the hall, for example, was silver, yellow and light blue.

At about the same time, the early years of the eighteenth century, Augustus the Strong, Elector of Saxony and King of Poland, found that his passion for Chinese porcelain was becoming too expensive to maintain and so coerced a young alchemist named Böttger into abandoning his search for gold and concentrating instead on the secret of making porcelain. Whatever his failings as an alchemist, he proved himself adept with ceramics, for in 1708 he produced the first European porcelain. Two years later, the famous Meissen factory was founded on the strength of his discovery, and began producing porcelain ware coloured with pink, turquoise and brownish-red enamels; later, yellow, green and lilac grounds—background colours—were added to the repertoire.

Not to be outdone, a French factory at Vincennes put its first porcelain on the market in 1740, the year in which Mme de Pompadour became the mistress of the King of France. Her influence was decisive in the factory's move to Sèvres, near her own château, where a grateful management acknowledged her patronage by naming a new pink ground colour *rose pompadour*. Much of the painted decoration on Sèvres ware was inspired by the glamorous paintings of François Boucher, who typified the versatility required of contemporary fine artists.

Apart from painting charming nudes, he excelled at theatre design, interior planning and even at decorating exquisite gold boxes, a collection of which was essential to every fashionable person of either sex. He was also a highly successful designer of tapestries for the factory at Gobelins, so much so that he became its director in 1755, bringing to everything he made a touch of the colour for which his paintings are famed.

On the other side of the Channel, Britain was having its own Age of Elegance. There was a similar emphasis on unity of colour and form, but the English style was markedly more austere. Rococo was thought amusing on occasion, but in the main the British held firmly to the pure lines and values of the classical world. During the first half of the eighteenth century, clear, clean-limbed Palladian was the style that dictated both the outward and inward appearance of great houses, and later neo-classical architect-designers such as Robert Adam have left an imposing number of carefully conceived designs for interiors and their myriad details: his ceilings, doorways, fireplaces, columns and carpets all reveal a lively and inventive use of strong colour.

Ceramics in the new style and of new material were introduced into such rooms by Josiah Wedgwood. After at least three years of experimentation, he realized an ambition to develop a ware which was coloured throughout and could be decorated with an applied relief of white. He called it jasper; its most vital ingredient was barium sulphate and the colour was provided by metallic oxides: cobalt, for example, produced the famous blue, as well as green, lilac, yellow, brown and black. The style provided one of the few instances when Britain has influenced European decorative arts: jasper ware was copied even at the Sèvres factory.

Adam, Wedgwood and their contemporaries created a backdrop for their customers that was nearly as rich, and at least as elegant, as the setting provided by the continental designers for theirs. But what happened in British design was something at once fastidious and outward-looking, a sense of the wholeness of the arts which extended to the contemporaneous passion for landscape gardening and landscape painting. Otherwise, there is about rococo a certain sadness, a last flash of brilliance before the darkness falls.

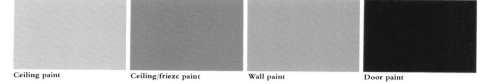

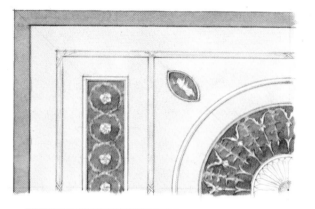

A late eighteenth-century English architect commissioned to design a room for a small country manor house might have produced a scheme similar to that shown on this interior elevation. Working in the tradition popularized by Adam, whose coloured ceilings had represented the height of fashion, he would often have juxtaposed brilliant colours with more subdued tones and applied them to walls and carpets as well to create a balanced whole. Although it is difficult to interpret such drawings directly in the redecoration of eighteenth-century interiors, recent research has revealed a great deal about the ranges of paint colour available during this period. Surviving eighteenth-century paintwork will almost inevitably have discoloured but the patches, *above*, have been reproduced from paints mixed according to eighteenth-century recipes, and could actually have been used on walls of the period. As can be seen, the colours are more full-bodied than many of the pastel tints commonly associated with colour schemes of the period.

This pot-pourri vase, made at the Sèvres factory in 1757, may have added a little rococo whimsy to a neo-classical interior. Its distinctive green, framed by gilding in panels of white and called *vert pomme* (apple green) was one of the ground colours for which Sèvres porcelain is famous; others include *bleu nouveau* (a characteristic deep blue), the turquoise *blue celeste*, and *rose pompadour* which was difficult to reproduce after the death of its inventor, the chemist Hellot. Chinese porcelain and, later, Meissen were hard-paste, which meant that kaolin was added to the paste; Vincennes-Sèvres porcelain was soft-paste, and more porous. It had to be waterproofed with a glaze after firing, and fired again to produce the fine, softly glazed surface into which enamel colours and gilding could sink deeply to give the rich hues.

As an alternative to paint, paper could be used on walls for insulation as well as decoration. This typical, mid-eighteenth-century example was probably painted by woodblock, its immediate ancestors being the Chinese papers which twinkled with trees, shrubs and flowers like the painted silk hangings which inspired them. Only the wealthy could afford such wall covering; the poor had to be content with wool hangings, whitewash or the cheaper papers, usually painted by stencil. Mass production of good quality wallpaper did not begin for another century. Leather hangings, too, were important forerunners; durable and damp-resistant, they could be embossed, as wallpaper was to be, and gilded. The multi-colour printing of wallpaper may have begun with flock papers in which powdered wool was dyed and glued to a design on the paper.

The impact of science

Early in 1790, some 63 years after the death of Sir Isaac Newton, Johann Wolfgang von Goethe looked at a white wall through a prism he had borrowed. He expected to see the whole wall break out in the colours of the spectrum, but was amazed to find that the wall remained as white as before. 'I immediately spoke out loud to myself, through instinct, that Newtonian theory was erroneous. There was then no longer any thought of returning the prisms.'

Although this condemnation of Newton was over-hasty, to say the least, it provided Goethe with the impetus for 20 years' experimentation with colour, culminating in the publication of his massive *Farbenlehre*, or *Colour Theory*, in 1810. And the extraordinary Goethe—poet, novelist, natural philosopher and creator of the immortal *Faust*—saw it as his greatest work. His aim was to rescue colour from 'the atomic restriction and isolation in which it had been banished, in order to restore it to the dynamic flow of life and action.' In other words, the abstract mathematics of optics completely fail to do justice to the experience of colour in everyday life.

To Goethe, the Newtonian approach to colour was rather like describing a rose in terms of a collection of uniformly grey sub-atomic particles: it completely ignored the essence and beauty of the flower. He wanted instead to classify the different conditions under which colour is produced and to assess their reality in terms of ordinary experience.

One of the tests of this reality was to consider the measure of a colour's permanence—a fleeting after-image, for example, was less real than a pigment which might endure for centuries. Goethe called the first kind of colour, that which 'belongs to the eye', 'physiological'; the second kind, belonging to particular sub-stances, he called 'chemical'. Somewhere in between the two came the 'physical' colours which we see in, or by means of, colourless mediums like mirrors, the edge of a window pane, a prism or a pool of oil.

All colours fall into one of these three categories. And, when conducting experiments with these colours, Goethe was careful to distinguish between subjective experiments, in which objects are looked at through mediums, and objective experiments where it is the light passed through a medium that is looked at. So already, by Goethe's criteria, Newton's principal experiment was seriously limited: it was objective only; it was concerned with only one of three possible types of colour—the physical; and it employed only one of many possible types of medium—the glass prism.

However, such limitations did not merit the personal abuse that Goethe heaped on Newton's memory. The unfortunate physicist had never claimed that he was accounting for the whole phenomenon of colour; he was simply more interested in light. And in order to break down light and examine its constituent parts, the artificial conditions of dark-room, aperture, prisms and so on were a positive necessity. Goethe thought that this missed the point. To begin with, light should not be broken down; it should be treated as whole. Secondly, the colours it produced should be studied in their natural habitat—the outside world was Goethe's laboratory. Accordingly, he set out to refute the views he identified with Newton.

If, he reasoned, colours were no more than the components of white light entering the eye in different wavelengths, it would be impossible to distinguish between a coloured lamp, a dull-coloured object seen in a bright light, or a brightly coloured object in shadow. Seeing, he insisted, depends on perception of the light reflected from an object in relation to the light that falls on it. In other words, if we are uncertain about the light source, we cannot be certain about the colour, or even the nature, of the object: a yellow dress seen in daylight is yellow because the surface of the dress is darkening the more or less colourless light towards that shade. But if a yellow light is substituted for daylight, it is impossible to say whether the colour is due to the dress or the light. In any case, a white dress would look exactly the same. Therefore it is essential to know the way in which the object darkens the light and to what extent.

The same processes of darkening and lightening are seen in nature, in a sunset for example. The 'scientific' description says that as the sun's light passes through the more or less opaque medium of the atmosphere, the shorter wavelengths are scattered while the longer, yellow/red ones are transmitted; these cause the colours that appear at sunset. Characteristically, Goethe was not concerned with the ultimate cause of colour, only with its effects on the eye and mind of the observer. He shifted attention from the light to the opacity of the atmosphere: the distant light, he said, is darkened to yellows and reds by the intervening atmosphere.

So, for Goethe, yellow is the first colour to appear when white is darkened and blue the first when black is lightened. These two colours—yellow and blue—are the two poles of a whole system

Moses Harris, an engraver and entomologist, presented the first detailed colour circle in his book *The Natural System of Colours* (1776) which, despite a scarcity of copies, influenced colour theorists for over 100 years. Harris first of all laid down the three primary or 'primitive' colours (red, yellow and blue) from which he derived three secondary or 'compound' colours (orange, green and purple).

Thereafter there were two intermediate colours between each (yellow-orange and orange-yellow came between yellow and orange, for instance) so that an 18-hue 'prismatic' colour circle was formed. Each hue was graded towards the centre in 20 'degrees of power' with the strongest hues innermost; the shading of the circle suggests Harris was anticipating later, three-dimensional models.

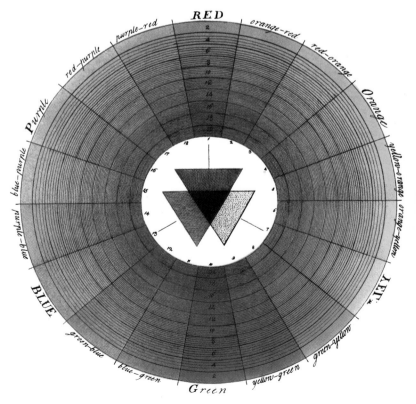

of colour pairs, each of which has opposing qualities—plus/minus, warm/cool, active/passive, for example. He even had a quasi-mystical interpretation of colour not far removed from that of his friend and contemporary, Philipp Otto Runge, who correlated the three primaries with the Holy Trinity: blue was the Father, red the Son and yellow the Holy Ghost.

After yellow and blue, there are two more basic colour pairs: red and green, orange and violet. Orange is formed by a further darkening of yellow, and violet similarly from blue. Actually, Goethe prefers to use the word 'augmentation' to describe the kind of intensification, and not just darkening, which is necessary to produce these colours. And, as orange is augmented to red and violet to blue-violet, they mix to produce the sort of red which Goethe called 'purpur' or 'peach blossom'. We should probably call it magenta. This colour stands at the opposite pole to the mixture of the original yellow and blue: green.

Arranged in a circle, the six colours of Goethe's spectrum express a system of harmony if they are looked at from the point of view of two gradations of colour on the left and right sides of the circle. But if each colour is regarded from the point of view of its opposite, a system of contrast is found. Blue, for example, harmonizes with its neighbours, green and violet, and contrasts with—or complements—its opposite, orange. This grouping of

colours in pairs, the crucial innovation over the conventional seven-colour Newtonian 'wheel', suggested a complementarity of colours which found support in the early physiological theories of R. W. Darwin, Charles' father, and later in the ideas of the physiologist Ewald Hering.

Goethe's ideas were not all, or entirely, new; as regards the constituent colours of light, his reduction of Newton's seven to just two was as old as Aristotle's notion that colour arises out of the interaction between light and dark. Nor was he the first to recognize that red must be added to yellow and blue to form the artist's three primary colours—although it is true that these were not universally accepted until around 1800. Painters such as Leonardo had argued in favour of four primary colours, but it was the chemist Robert Boyle who first asserted in Newton's time that three were the minimum.

It was the sheer range and acuity of Goethe's insights into colour that set him apart. But, above all perhaps, his theory placed him firmly in the van of Romantic opposition to an idea of colour which had come to seem mechanical and dead. Newton was blamed; but without him, Goethe would never have been compelled to formulate that vital and dynamic view of colour such as artists have always held instinctively but had never questioned seriously.

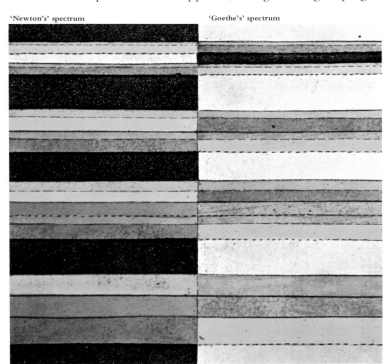

'Newton's' spectrum 'Goethe's' spectrum

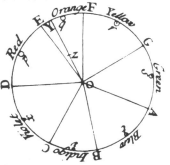

Newton's colour wheel

Goethe's colour wheel

Goethe's delicate watercolour is a rendering of two different sets of prismatic colours. At the top of the column, *far left*, he shows the colours that appear at the edges of a white strip on a black background, when it is looked at through a prism: a thin band of yellow is followed by orange above the white strip, while a thin band of blue followed by violet appears below. This can be equated with Newton's spectrum. Next, a black strip on a white background represents Goethe's experimental conditions, *left*. The colours produced by the 'edge-effects' appear in a different order: blue and violet above the black strip, orange and yellow below. As the prism is placed at an increasingly greater distance, the colours at the edges of the white and black strips merge. The yellow and blue of 'Newton's' spectrum mix over the white strip to make green; the violet and orange of 'Goethe's' spectrum mix over the black—become darkened—to make his 'purpur' or magenta. At a further distance still, 'Newton's' spectrum resolves itself into orange, green and violet while 'Goethe's' becomes yellow and blue—his primary colours—with 'purpur' in between. These six colours form the foundation of Goethe's colour wheel. It contrasts with Newton's wheel which, instead of relating colours to each other in harmony and contrast, relates them to a different discipline—music; the seven primary colours were, according to him, 'proportional to the seven Musical Tones or Intervals of the eight Sounds.'

Philipp Otto Runge's colour solid was reconstructed by another German painter, Johannes Itten, at the Bauhaus art school more than 100 years after its appearance in 1810. Shaped like a globe, it is the first explicitly three-dimensional colour sphere from which later, more practical, models took their cue. The same six colours as in Goethe's system form the basis, so the globe is divided into hues around the equator, a light/dark axis with 'pure grey' at the centre and grades of saturation between the two.

The Romantic view

Turner's painting of *The Slave Ship* luridly depicts the historic moment in 1783 when the captain of the slave ship *Zong* had diseased slaves thrown overboard so that insurance could be claimed. In the foreground of the 'noblest sea that Turner has painted', as the critic John Ruskin put it, the slaves are being devoured by sea beasts. The intermingled reds, blues, and yellows (Turner's favourite colour) of the bruised, angry sky and turbulent sea provide a fittingly symbolic setting, as Ruskin observed, for 'the guilty ship as it labours amidst the lightning of the sea, its thin masts written upon the sky in lines of blood, girded with condemnation in that fearful hue which signs the sky with horror.'

The clamour of colour from all sides of any gallery of modern art testifies to the legacy of the Romantic painters. The ideal of art for the neo-classicists of the eighteenth century was embodied in purity of form and elegance of composition; colour was almost incidental. Then, suddenly, the threshold of the nineteenth century was illumined; from England by the brilliant, elemental paintings of Turner; from Germany by Caspar David Friedrich's mystical, violet-tinted landscapes, and from France by the exotic scenes of Delacroix. Colour was no longer subordinate to form; it was the key to the Romantic impulse, which did not just occur in a prescribed historical period. Rather, it was, as Baudelaire put it, a whole 'way of feeling'.

In an age of great thinkers, the philosopher Immanuel Kant had been partly responsible for dethroning the eighteenth-century's presiding deity, Reason. He showed that it can enlighten only up to a point, beyond which all is a mystery that may be divined, not by the rational brain, but by the imagining mind. The French people demonstrated the frailty of Reason more graphically: a howling mob beheaded the aristocracy, pulled down the Bastille and used its stones to pave the Place de la Concorde—an action symbolizing a complete break with the past. From now on, the individual alone was to be the judge of reality, and the highest individual was the artist. His interest in colour was one of the most important ways in which the new ascendancy of emotion and intuition over reason was expressed.

The wonder and wildness of nature, of which the eighteenth century had been wary, was immensely attractive to the Romantic artist. Turner gloried in land- and seascapes, refining them to pure interchanges between sea and sky, wind and rain, dark and light. In praising Rembrandt's 'veil of matchless colour', he might have been talking about his own work: the eye 'as it were thinks it sacrilege to pierce the mystic shell of colour in

search of form'. Even before 1800, he was experimenting in watercolour with white grounds overlaid with washes of red, yellow and blue, as if striving for an atmospheric base out of which the painting could grow. Some 40 years later, he was still using this technique in his oil paintings; his *Norham Castle* is so reminiscent of an early watercolour that it seems as though a lifetime's struggle with colour's complexities has been fulfilled in a vision of original simplicity.

Yet so bright and dramatic were Turner's mature works that some critics, confronted with such an intensely personal revelation of colour, concluded that he was obsessed with pigments for their own sake, or that perhaps he suffered from some ocular defect. Analysis of the pigments he left in his studio at his death showed that he had experimented with practically every new colour invented during his lifetime, though even this hardly explains the magnificent colour symphonies of his late period. If the rumours of the time are true, and Turner did possess some mysterious, alchemical secret, then it died with him.

Landscapes held little fascination for Delacroix, Turner's French contemporary, whose forte was figure painting. But what they had in common were new and dynamic ways of exploiting colour. Delacroix, for example, developed a concept which he called 'liaison', whereby the colour of one object in a painting was reflected in another so as to provide a link between them. In addition, he had his own particular colour technique when dealing with shadow: instead of adding black, he used a colour which complemented that of another part of the picture that was bathed in light. In this way, figures in shadow would appear quite bright if looked at separately, but in context with the rest of the scene they appear suitably dimmed. The red and green of the background of his *Algerian Women* provide a muted setting in which the rose and gold of the women themselves glow like

The Romantic revival of architectural colour extended well into the Victorian era. The design for the church pillar, *left*, was produced in 1881. Following the example of Owen Jones' *Grammar of Ornament* (1856) which displayed the colourful motifs of the ancient world, it was based on another, rich source—the Church decoration of medieval times.

Edouard Loviot's version of how the Parthenon originally looked, *above*, is a startling innovation over the more usual black and white renderings of the Beaux-Arts style; but it is still subdued by comparison with those speculative attempts to cover the entire temple with vivid hues. The original colossal statue of Athena sculpted by Phidias, who supervised the

building of the Parthenon, was probably chryselephantine (made of gold and ivory) with painted details and jewels for eyes. Similar polychrome reconstructions of the temples at Paestum were considered so outrageous that the nineteenth-century French restorer Viollet-le-Duc attacked them for 'disrupting the State, religion and the sanctity of the French family'.

gems—Renoir swore he could smell incense in the painting. 'A volcano artistically concealed beneath a bouquet of flowers' is how the critic Baudelaire described Delacroix, paying tribute to his fine control over violent passions.

The impact of his colours is so sensuous and immediate that Baudelaire instinctively referred to his paintings in terms of music—'these wonderful chords of colour'. Similarly, Goethe compared the German painter Philipp Otto Runge's series of prints *Times of Day* to the music of Beethoven. Runge himself was less tentative; believing that colour was 'the last art which is still mystical to us', he attributed a many-layered symbolism to the three primary colours, from the times of day through to the Holy Trinity. He wished to create a 'fantastical-musical poem with choirs, a composition for all the arts collectively, for which architecture should raise a unique building'. This concept of the oneness of the arts was very dear to the Romantic heart. Architecture itself was spoken of as 'frozen music'—a reference, in part at least, to the wholly new view of classical antiquity.

Perhaps it was the Romantic love of ruins that led, in the early 1800s, to the attempts to preserve and restore on site the Roman buildings of Herculaneum and Pompeii which had first been excavated early in the previous century. At any rate, it soon became abundantly clear that these cities did not tally at all with eighteenth-century ideals of classical symmetry and cold perfection. Buildings were seen to have been garishly painted, and even decorated with exotic scenes and obscene symbols. Suddenly, the vision of the classical world as serene, orderly and rational was replaced by one of an age charged with a vitality and sensuality that was most congenial to the Romantic spirit. Once again, as in painting, purity of form was being assailed. But if the Romans had succumbed to this 'barbarism' of colour, at least the Greeks remained inviolate. . . .

Then, in the first quarter of the nineteenth century, excavations at Aegina, Burrae and Selinus showed almost without doubt that Greek temples too had been brightly painted. In 1829, the architect and archaeological enthusiast Hittorff published vivid polychrome impressions of the way the temples of Selinus might have looked in their heyday; the sprightly hues he envisaged were, if anything, made more sensational by the comparatively crude lithographic techniques available to him.

Despite impassioned repudiations by the architectural establishment, led by the Paris *Ecole des Beaux-Arts*, heresy mounted upon heresy. Certain rebels declared that even the pristine marble of the Parthenon—the austere model on which half the public buildings in Europe were based—had originally been decked in red, set off with green, purple and gold. Now a number of architects attempted to reconstruct such effects.

Owen Jones, the English architect who had already made reconstructive drawings of Spain's famous palace, the Alhambra, in red, blue and gold, went a step further and applied his knowledge to contemporary architecture. He was commissioned to decorate the interior of the Crystal Palace for the Great Exhibition held in London in 1851. He painted the iron columns in harmonious proportions of yellow, red and blue stripes, giving an effect at a distance of a vibrant blue-grey haze. The exterior colouring of buildings had less success. The Victorians did make attempts to use coloured patterns in bricks occasionally, while the controversial Hittorff decorated the outside of his Church of St. Vincent de Paul in Paris with plaques of enamelled lava—until an indignant populace forced him to remove them. But the harshness and changes of a northern climate just did not allow delicate paintwork to endure as it would in Rome or Athens. Instead, it was left to the great Romantic painters to effect a real and lasting change in our understanding of colour.

The colour revolution

If Tyrian purple, the dye exalted by the ancients, were to be marketed today, it would no longer be called upon to colour the carpets dignitaries tread. Shellfish are now considered an unreliable source of dyestuffs: batch control is difficult, harvests unpredictable—and there are brighter reds and purples around. And should we ever want Tyrian purple again, we can make it more cheaply in a laboratory.

Until the 1860s, the few hundred dyes in common use were largely derived from the same molluscs, insects and plants as those used in Renaissance times. Then, with escalating speed, they changed. Twentieth-century commercial dyes are compounded from petroleum products, not extracted from leaves and roots. By 1980, the number discovered had reached an astonishing total of 3,000,000. Some 9,000 had been marketed and about two new ones were appearing each week.

The event which brought about this change had its origins in the arrival of a German professor, August Wilhelm Hofmann, at London's Royal College of Chemistry in 1845. His interest was in coal-tar derivatives, and it was his work on these unprepossessing substances that was to lead his brightest students to make far-reaching discoveries in the realms of colour. The initial breakthrough happened by chance.

In 1856, one of Hofmann's students, William Henry Perkin, was attempting to synthesize quinine. He obtained only a disheartening black sludge. Instead of throwing it away, he tried diluting it with alcohol and found that the solution was purple. He discovered that it would dye silk and that it was possessed of a quality which is of paramount importance to the dyeing industry: it was resistant both to washing and to the fading effects of light. Perkin borrowed his father's life-savings and put the dye into commercial production.

It was the French who christened the new colour mauve after the delicate purple of the mallow flower, and for the next decade mauve was the rage of the fashionable world. Queen Victoria wore a mauve dress to the Great Exhibition of 1862; a penny stamp was printed in mauve; music-hall comedians made jokes about the colour—and Perkin became rich.

In its day, mauve was a novelty, but it was soon followed by other new dyes. Fuchsine, a brilliant bluish red discovered in France in 1859 and known in England as magenta, was especially successful. Hofmann developed Hofmann's violet, from a colourless base, rosaniline. Aniline black, methyl violet, malachite green and Congo red were outstanding among a flood of new dyes that appeared between 1860 and 1885.

The plant dye industries began to be threatened when it was realized that the supply of the new synthetics was easier to control. Then, in 1868, two German chemists synthesized alizarin, the colouring matter of one of the world's most sought-after dyes, madder. In 1869, a ton of alizarin was produced and two years later 220 tons, which tolled the death-knell of the huge European madder fields (yielding over 70,000 tons a year). They were replaced by vineyards.

Another chemical breakthrough led to the production of an even more valuable family, the azo dyes. The immediate popularity of the first to be marketed, Bismarck brown, far outweighed the success of parallel developments among other aniline dyes; inferior blacks, for instance, had the unfortunate habit of fading to the distinctive mossy green which can be observed on aging dinner suits and academic gowns. Indeed, despite the enthusiasm engendered by the wide colour range of early aniline dyes, their fastness left much to be desired. Unless clothes were stored out of the light, they faded rapidly, and many a dress was 'turned' (unpicked and remade with the reverse side outwards) after a season. For a time the expression 'as fleeting as an aniline dye' was common currency.

The development of new vat dyes went some way to solving the fastness crisis. Indigo was the first to be synthesized—a discovery so valuable that BASF, the German chemical company, invested 17 years and over £1,000,000 in developing an economic method of producing the world's first fast blue. Its success proved the *coup de grâce* to indigo farming in India, where production dropped from 19,000 tons in 1856 to 1,100 tons in 1914, devastating the livelihood of the Indian peasantry.

By the twenties, the chemists had conquered the animal and plant fibres with their new dyes, but the battle was to continue. The potential of the new man-made fibres could not be realized because they would not satisfactorily accept the available dyes. The chemists proved equal to the challenge and invented a new class of acetate (now called disperse) dyes which dissolved into the fibre as fine particles, instead of being applied in solution. Dyes were specially adapted for acrylics, so that immediately after World War II, cheap and colourful acrylics were poised to supersede the plainer hued cottons. But during the fifties, a new, dramatic range of dyestuffs was discovered: ICI's Procions.

Able to bond with cellulose fibres in an entirely new way, the Procions were brightly coloured, cheap to produce and fast, putting colourful cotton dresses within the means of any woman. They were the impetus that led even men's shirts to compete in brightness during the sixties. Procion (or reactive) dyes have now become the 'bread and butter' of the dyeing trade.

Even today, natural dyes continue to be used by those who adhere to the school of thought that nature is more subtle and beautiful than man's inventions. However they cannot claim that nature is more abundant in her dyestuffs (any natural dye colour can be reproduced with chemicals) nor that she is more reliable. Not only have the age-old problems of washing and light-fastness been largely overcome, but the conquest of the destructive effects of bleach, sweat, salt water, dry-cleaning and even tobacco fumes have raised ideals of colour-fastness far above the levels a nineteenth-century dyer could have hoped for.

Victory would be certain were it not for consumer inconsistency. For only recently bright Indian prints on cheap cotton fabrics came to be valued, although the colours did not last; and no matter how the manufacturers pre-fade denim or dye it pale blue, classic blue jeans have to be bought in pristine dark indigo; and they are lovingly encouraged to fade with washing and wear.

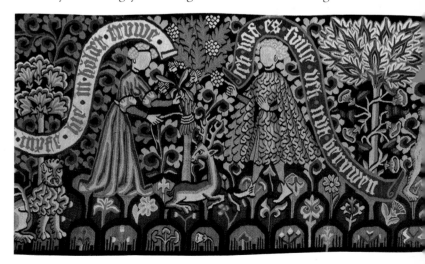

Fernand Léger's preference for pure colours which retain their strength within the context of the whole work was admirably suited to the policy of the Aubusson firm who wove his tapestry in 1962. Mindful of the early failure to retain in tapestry the bright tints of Monet's water lilies (they are now dull grey and wine), the company prefer artists to avoid fragile tints in their cartoons and use strong colours that will translate more easily into the most permanent synthetic dyes. Bold, rather than intricate, colour schemes also keep costs down; a modern weaver might produce twice as much in a month as a weaver 250 years ago produced annually.

A comparison between the front view of a 550-year-old Middle European tapestry, *left*, and its reverse side, *above*, shows how natural dyes are prone to fade. The browns and greens in particular have suffered from the exposure to light and the ravages of time. Green was produced from a mixture of yellow, derived mainly from weld, and blue from woad, which was less fugitive than the yellow dyes so that greens became bluer with time. Woad was replaced by indigo during the eighteenth century. Curiously, the red details on the lips and cheeks of figures, from reasonably permanent madder dyes, have not worn as well as might have been expected; it may be that carmine was used instead, or that the small size of the red areas caused them to fade faster. Pale tints do not appear—partly because they were known to fade and partly because strong colours were naturally preferred to brighten up the small-windowed rooms of the day.

By the eighteenth century, the Gothic range of about 40 colours had multiplied to over 30,000 hues and tones to accommodate the fashion for exactly reproducing oil paintings in every detail. Chevreul at the Gobelins tapestry works did much to curb this excess by devising a chromatic circle with equidistant spacing for each shade; but his system still contains 1,420 different colours from which weavers could choose.

The artist's palette

At first sight, nature appears to offer the artist an infinite number of colours in her many minerals and plants. But of all the minerals that exist, fewer than ten have sufficient colour strength to impart their natural effect when ground and dispersed through a medium. The medium, too, which is essential to carry the pigment to the painting surface and bind it in place, can affect the colour of the pigment for better or worse, depending on whether, for instance, it is egg, gum, oil or even plastic.

The oldest inorganic pigments still in use are the red and yellow ochres that differ very little from those of ancient cave-paintings. And, over the centuries, they have been supplemented by umbers whose deep, bitter brown hues stem from manganese dioxide; by the yellow clays of Siena that turn red-brown when burned; and by terre-verte, a greenish natural earth long used for underpainting and mixing colour for flesh tints. Additional sources of pigments are plants and insects. But only about a score of these pigments are at all satisfactory and only a few, such as madder and indigo, are truly stable.

Nevertheless, the discovery of 'lake' pigments (whose name derives from the red lac insect, although they are in fact made mainly from plants) brought about the chief difference between the prehistoric and medieval palettes. The long-established dyeing industry provided easily accessible colours which could be turned into pigments by precipitating, or fixing, the dyes on an inert base such as aluminium hydroxide. Among the results were the crimson or rose lakes from the madder plant whose success at resisting the chief hazard of lake pigments, the fading effect of light, has made them famous. As late as the eighteenth century, extravagant promises were being made about the light-fastness of new pigments in the way that 'cornflower blue' had been publicized in the previous century by the chemist Robert Boyle—only for it to be found that they faded in sunlight.

Part of the responsibility for this kind of mistake by painters must lie in the change their status was undergoing about this time. From skilled artisan, the painter was metamorphosing into the artist, more concerned perhaps with the ideals of Art and its techniques than with the pedestrian business of paintmaking, which more and more he tended to leave to a new brand of tradesman, the colourman. He, in turn, was probably born out of the vogue for watercolours among amateur enthusiasts whose number had been growing since the Renaissance. As early as 1598, the miniaturist Nicholas Hilliard wrote that 'none should medle with limning [watercolour portraiture] but gentlemen alone'; and clearly, mixing colours was not a suitable occupation for gentlemen.

The colourmen cast their nets widely—as far as the Middle East for ultramarine, the most prized of blues, to Cyprus for umber and India for indigo. They showed, too, considerable ingenuity in providing such pigments as Indian yellow, made from the urine of Indian cows fed on mango leaves; and mummy, a bitumen brown made from ground-up ancient Egyptian mummies. But all this ingenuity was no match for the momentous accident that happened to a German colourman named Diesbach in 1704. He was given some waste potash containing calcined animal matter by an alchemist, Johann Dippel, to make a red pigment. He came up with a deep blue-green instead; this was the first synthetic pigment, known as Prussian blue.

By the turn of the nineteenth century, the synthesizing of inorganic pigments was really under way, producing a train of superior pigments which culminated in the appearance of the most brilliant of all whites, titanium dioxide, during the 1920s. In 1797, the Parisian chemist Vauquelin had discovered chromium,

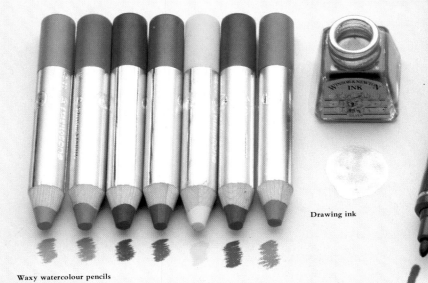

Waxy watercolour pencils

Drawing ink

Modern waxy watercolour pencils can be used on glossy surfaces, unlike either conventional watercolours or wax crayons.

Drawing inks in gaudy transparent colours can be used with brush or pen. They are dyes; pigments would clog fine pens.

which was soon responsible for a range of yellows and oranges that only cadmium colours could surpass 30 or so years later. Some artists stayed with the cheaper chrome colours, either through poverty—like Van Gogh who paid the price by losing some of the brilliance of his paintings—or through perversity: even the renowned colourman George Rowney could not convince Turner to give up his favourite chrome yellows.

Emerald green made from copper aceto-arsenate (and so poisonous that, as Paris green, it was used as insecticide on locust swarms) was thankfully ousted by the chromium-derived viridian; cobalt came out of the German mines to provide the famous blue, as well as violet, yellow and some greens. But, above all, the prize offered by the French Government to the creator of synthetic ultramarine (providing it cost no more than 300 francs per kilo to make) was claimed in 1828 by a M. Guimet of Toulouse. The rare and lovely—but expensive—natural ultramarine vanished almost overnight from the artist's palette.

The developers of organic pigments had by no means remained idle all this time. The story of the synthesizing of plant pigments is linked with that of the colour revolution in dyes, from its inception in 1856 with Perkin's aniline dye, mauve, to the almost indestructible red and yellow quinacridones 100 years later. These were foreshadowed in 1928 by a dramatic accident in a Scottish dye works. A strange blue-green discoloration in a chemical batch was traced to the presence of iron, exposed by a hairline crack in the enamel lining of the reaction vessel. By substituting copper for iron, an extraordinary pigment—called Monastral blue by ICI—came into being. Its chemical structure was found to be similar to two of the most powerful colour principles in nature: chlorophyll, the green of plants, and hemoglobin, the red of blood. It gave rise to a whole range of green and blue phthalocyanines, as they are called, not the least being a near-perfect 'printer's blue' or cyan.

Chemists still hope to find other hues of equal brilliance and durability. Meanwhile, the ingenuity of the colour chemist has placed a wide variety of inexpensive and easy-to-use materials at the disposal of anyone who wishes to try their hand at art.

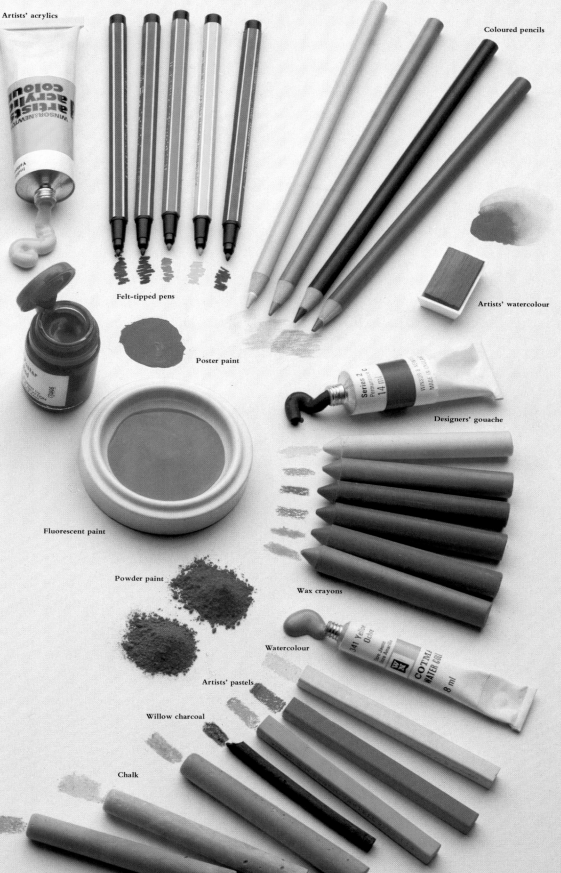

Oil paint

Artists' acrylics

Coloured pencils

Indelible felt-tipped pens

Felt-tipped pens

Artists' watercolour

Poster paint

Designers' gouache

Fluorescent paint

Powder paint

Wax crayons

Watercolour

Artists' pastels

Willow charcoal

Chalk

Felt-tipped pens use coloured inks, which can be washable or indelible. Although the colours are not permanent, felt pens are popular with artists and designers.

Oil paint, based on refined linseed oil, is still the firm favourite, with its vast range of traditional and modern colours, and subtle handling qualities.

Acrylics, fast-drying plastic emulsions, can be used instead of both oil and watercolours.

Coloured pencils are usually for children, but art pencils made with dense, smooth and permanent colours have been used by artists like David Hockney and David Oxtoby. Being graphics materials, they have to meet stringent non-toxicity requirements.

Modern watercolours, in liquid (tube) and solid (pan) form, include glycerine to soften them. Opaque gouaches include very brilliant but fugitive colours.

Poster paints, gouaches in a small range of bright primary colours, are popular with children. Along with cheap, water-mixable powder paints, they are used in schools.

Fluorescents, the most brilliant of all paints, fade very quickly, their colour 'used up' by sunlight.

Artists' pastels are pure, high quality pigments in a minimum of binder, sold in ranges of around 200 hues and tints.

Chalk stained with dye makes cheap colours for blackboards and for sketching. Wood charcoal, the 'oldest pencil', is still the classic black for sketchers.

The Impressionist eye

In 1874 a group of painters who had been drawn together by a common dislike of what they saw as the stultified art of the Paris Academy mounted their first exhibition. The event marked the official birthday of a movement which changed the face of modern art to such an extent that, in retrospect, it is hard to credit the hostility with which the paintings were received. 'Wallpaper in its embryonic state', said a typically scathing critic of a Monet canvas, 'is more finished than that seascape'; but his scorn for the paintings' avowed aim of capturing a fleeting impression was lost on the group of painters, which included Pissarro, Sisley, Renoir and Degas as well as Monet. They happily accepted the label 'Impressionists'.

Initially, the Impressionists' use of colour was widely condemned as irrational, if not downright anarchic. This was simply because they had broken with the conventional idea that objects have a 'true' colour; they realised that colour is as much determined by prevailing atmospheric conditions and the reflections of other objects as it is by its own hue. Thus they worked largely out of doors to observe at first hand the colours of nature and, above all, the effects of light. And, unlike most of their predecessors, the Impressionists did not just make sketches; they painted whole canvasses at a sitting—in a sense the sketch and the completed picture were one and the same.

Abandoning traditional methods of depicting objects by line or chiaroscuro effects, the Impressionists concentrated instead on representing by colour alone the appearance of things under different kinds of light. They wanted to regain the lost innocence of the eye which sees a mass of vibrant and contrasting shades of green, for example, before these are resolved into something called a tree. They laid on colour with quick motions of the brush, seeking to capture at a stroke the grace of a dancer, the bustle of a street or the play of sunlight on a river.

The contemporary development of photography encouraged the idea that single moments could be frozen on canvas, as on film, in a quick 'snapshot'; and, by largely assuming the role which had formerly been occupied by purely descriptive painting, photography helped to free the Impressionists to experiment with their new kind of art. The development of colour photography, meanwhile, drew attention to the problem of representing light (composed of additive primary colours) by means of pigments which are subtractive—when mixed, they tend towards increasingly muddy tones. The Impressionists attempted a solution by juxtaposing pure, unmixed colours on a white canvas. The idea was that neighbouring colours would alter each other by contrast, mixing in the retina of the eye rather than being mixed on the palette, so that the darkening due to subtractive mixture would be avoided.

The absence of light—shadow—was equally absorbing. No assumptions were made about the colours of shadows; instead, fresh observation revealed that they complemented the colours of light. The complementary of yellow sunlight, for example, is purple, so the absence of sunlight makes purple shadows, not the generalized brown or black tones which tradition had decreed—these hues were banished from the palette.

By the 1880s, the Impressionists had evolved highly individualistic styles. Monet was preoccupied with atmospheric effects such as steam and smoke and the changes wrought by light at different times of day, dashing 'impressions' on to a canvas in under 15 minutes; Renoir was painting light dappling through trees on to the skin of his models; Gauguin was brooding on the emotional and symbolic power of colour. It is debatable to what extent they were aware of contemporary colour theory.

M. E. Chevreul formulated his law of simultaneous contrast in 1839 as a result of complaints about the quality of colours he was producing at the Gobelins tapestry works. He found no deficiency in the dyes; rather, the colours were changing appearance depending on their neighbouring colour. He therefore set about devising rules for the effects obtained by the juxtaposition of colours. Complementary colours, he claimed, result in an overall greyish cast when juxtaposed and viewed at a distance, and he cited orange and blue as an example. In fact, these produce a dullish purple (because greenish blue is the true complement of orange), but the principle was correct. The red and blue coloured threads, *left*, however are not complementary; they both 'incline' towards violet such that, at a distance, they mix optically to a violet hue whose distinction is that it is free of grey. Chevreul's influence on the neo-Impressionists may have stemmed from the luxurious colour edition of his book produced 50 years later on the occasion of his hundredth birthday.

Eugène Chevreul, the director of the Gobelins tapestry works, had worked out a law of simultaneous contrast, for instance, which enabled the effect of a colour on its neighbour to be assessed. But such theories were consulted intuitively more than scientifically by the Impressionists, if at all—Monet even expressed a 'horror of theories'. Pissarro only read Chevreul and the work of the American theorist, Ogden Rood, when he later joined the neo-Impressionists for a short time; even at the age of 40 he confessed that he had not the slightest notion of what he was trying to achieve in his painting.

At the age of 20, Georges Seurat knew exactly what he intended: a precise application of colour laws to painting. In 1886 he showed his *Sunday afternoon on the Ile de la Grande-Jatte*, a large, frieze-like painting which attracted a great deal of attention. It displayed a wholly new technique which Seurat called chromoluminarism, believing it to be the logical culmination of the Impressionists' attempt at optical mixing. The whole canvas was covered in small dots of pure colour, and every dot's hue and place could be justified by exact rules, whether from Chevreul's rules for juxtaposed colours or Ogden Rood's diagrams, which showed the complementary of each hue.

The problem of such a picture is to determine the correct viewing distance for the dots to mix optically so that neighbouring yellow and blue dots, for example, fuse to form green. Pissarro suggested that the size of the dots should be calculated to form the required hue at a viewing distance of three times the painting's diagonal measurement. However, certain hues change with distance; blues tend towards black and yellows to white, for example, so that as the hues of the dots blend, they no longer form the right optical mixture.

Nevertheless, Seurat's neo-Impressionism—together with the revolutionary group of painters from which the name derived—exerted a liberating influence on the artist's use of colour which came to flower in the twentieth century.

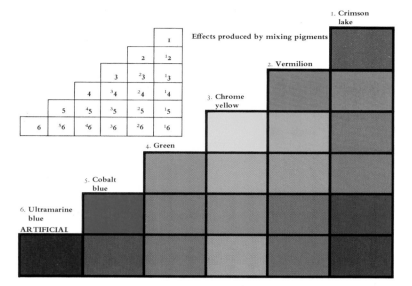

Effects produced by mixing pigments

1. Crimson lake
2. Vermilion
3. Chrome yellow
4. Green
5. Cobalt blue
6. Ultramarine blue ARTIFICIAL

Ogden Rood's *Modern Chromatics* (1879) interpreted the science of colour for artists. Tables and diagrams underlined the essential difference between the primary colours of light and those of pigments. The diagram, *left*, provided a scale of hues mixed from six pigments; other tables designated the hues produced by mixtures of differently coloured lights. Rood noted that complementary colours when side by side together reflected 'white' light.

By transposing these colours to disks which were then rotated, he achieved mixtures of colour closer to light mixtures than pigment mixtures (in fact, grey was produced, not white). Another method of mixing coloured light was to place 'a quantity of small dots of two colours very near each other and [allow] them to be blended by the eye placed at a proper distance'—a statement that lay at the heart of the neo-Impressionist innovation.

In his painting *The Bathers* (1883–4) Seurat's 'method'—the pointillist technique of *La Grande-Jatte*—was still emerging. He employed quite broad brush strokes of hues mixed first on the palette, and not intended to be optically mixed. Dots do appear (on the hat of the boy in the water, for instance) but only as a result of later repainting. Delacroix's influence is evident in the use of earth colours, but especially in the juxtaposition of complementary colours whose laws were laid down by Chevreul: 'In cases where the eye sees at the same time two contiguous colours,

they will appear as dissimilar as possible, both in their optical composition and in the height of their tone'. Seurat even superimposes, as it were, the colour of light over objects, and then casts its complementary 'reaction' over the shadows. The colour scheme corresponds to Ogden Rood's theory of harmonious 'triads' of colours. He devised a contrast diagram in the form of a circle with each colour separated by precisely calculated angles; any three equidistant colours—orange, green and purple-violet, for instance—can be used to contrast harmoniously.

The abstraction of colour

After the Impressionist revolution, there was no longer any doubt about the central importance of colour in art, but there was considerable doubt about exactly how colour should be used. One thing at least was clear: colour was firmly established as a subjective experience both for artist and onlooker—the theories of Goethe, Runge and Chevreul had seen to that. So it only remained for the individual to carve a personal niche out of the mass of fruitful sources which surrounded him in the momentous years before 1914.

The museums and galleries steadily filled with young painters exploring and analyzing not just modern and classical art, but primitive and prehistoric art as well. They went farther afield: to quasi-religious movements like spiritualism and theosophy, and to budding sciences like biology, electro-chemistry and applied physics. One entirely new science looked especially promising—experimental psychology. A Swedish psychologist, David Katz, formulated the phenomenon called 'colour constancy'. 'The way in which we see the colour of a surface', he declared, 'is in large measure independent of the intensity and wavelength of the light it reflects.' For example, in twilight a white newspaper may reflect less than a twelfth of the light reflected by the black print in full sunlight. But the paper is still perceived as white. The idea is that colour is not simply recorded by the eye, but is perceived by the mind. So, if a colour can remain constant to the mind in spite of drastic changes of illumination, a painter can reverse the process, as it were. He can give different appearances of illumination simply by manipulating the colours of his surfaces.

At the same time, Katz made an important distinction between the 'surface' colours of objects and 'film' colours that are homeless, or only loosely attached to objects. It is as if certain colours can drift away, or become abstracted from their objects to lead their own life. An extreme example is the 'visual grey' we experience when we close our eyes—it bears no relation to any object. Similarly, at the opposite extreme lies the infinite blue of an unclouded sky. These two 'film' colours form, in a sense, the limits between which the entire visual world exists.

This dislocation of colour from object is strikingly echoed in the experience of the painter Wassily Kandinsky who in 1913 vividly recalled the colours that had impressed him at the age of three, though the objects were far less distinct in his mind. Sensitivity to colour permeated the whole of Kandinsky's life; he even experienced music in terms of colour, the sounds of trumpets and flutes appearing to him in successive flashes of scarlet and light blue. It was little wonder, therefore, that he came to regard colour as a power that, independent of form, 'directly influences the soul'.

The mystic in him was attracted by theosophy, a system founded by Helena Petrovna Blavatsky, which claimed that man, as a divine being, can attain a knowledge of nature far more profound than that offered by the empirical sciences. He must have been particularly intrigued by *Thought-forms*, a work by Annie Besant and Charles Leadbeater, which contained abstract coloured shapes that were said to be the actual colours and shapes of thoughts clairvoyantly perceived by the authors. His own experiments on the psychological relationship between form and colour included sending 1,000 postcards to the citizens of Weimar and asking them to relate the three primary colours to three basic shapes. An overwhelming preponderance of yellow triangles, red squares and blue circles seemed to bear out his theories. The poet W.B. Yeats even attributed magical powers to combinations of colour and abstract shapes; such symbols could induce trances or visions—on one occasion he pressed one to his forehead and

Delaunay once called his *Disk* a 'blow with the fist', rightly expressing the immediacy of its impact. He was excited by its completely non-objective appearance—unlike the prolonged analysis he devoted to his *Windows*, it had no meaning beyond its purely visual effect on the observer; it became a precursor of abstract painting. Delaunay described how he composed the colours, with 'red and blue tones in the centre, juxtaposed—red and blue result in ultra-rapid vibrations which can be seen with the naked eye. . . . Round about, always in circular forms, I placed other contrasts, always juxtaposed to each other, always simultaneous in respect to the picture as a whole, that is, to the totality of its colours. . . . I might well shout: *I've found it. It rotates!*'

instantly saw in his mind's eye a huge sphinx-like beast rising from the sands of the desert.

Yeats's desert was a realm that deeply interested Kandinsky as a potential source of a more spiritual art. It was the territory mapped out by Freud, an unconscious level of ourselves which seethes with a dark and erotic life of its own. One group of painters set out to depict the raw material of this landscape—the Surrealists. Chance images, hallucinations, visions and, above all, dreams were faithfully set down and charged with the brilliant colour that is the hallmark of the unconscious—the numinous hues of Salvador Dali's spacious scenarios are those of visionary or dream landscapes.

Early in 1912, Kandinsky received a letter from a young painter named Robert Delaunay who had been experimenting not with his own psyche, but with traditional colour theories. He was excited about his discoveries concerning 'the transparency of colour, which can be compared to musical notes', and which he elaborated in a series of pictures called *Windows*. But, before long, it was colour itself that gripped him more than the search for its transparency. 'Colour, the fruit of light', he declared, 'is the foundation of the painter's means of painting—and its language'. The result, late in 1912, was what Delaunay described later as a breakthrough to the 'actual nuclear problem of painting', an experiment boldly entitled *Disk, First Nonobjective Painting*. It

Joán Miro's surrealist *Painting*, right, was created after four years of drawing material increasingly from his own subconscious to obtain a simple statement purged of all irrelevancies. By 1925, he was painting almost entirely from hallucinations; a simple blue spot on an atmospheric background was labelled *Photo: This is the Colour of My Dreams*. By 1927 the blue spot had expanded to fill the whole cosmos of the canvas against which his elemental images gather a symbolic power characteristic of the unconscious mind.

The dull red flashes of this aura (the invisible counterpart of the physical body) published by the Theosophist Leadbeater in 1901, indicate a state of intense anger. The murky appearance betokens an unenlightened mind; brownish green stands for jealousy while the brown of selfishness darkens to the black of malice.

Ostwald demonstrated that to create a scale of greys which appear to darken evenly it is not enough to increase the percentage of grey in simple arithmetical proportions: one, two, three, four, five and so on. In the scale of five greys, *top*, the first grey's absorption value is added to itself once, twice, three times and so on along the scale; but, as can be seen, there seems less and less difference visually between each succeeding step. To obtain a scale of greys which is perceived as an even progression from light to dark, *above*, each grey square must increase its absorption value in geometrical proportions: one, two, four, eight, sixteen and so on.

provides striking indication that the early development of abstraction had a close affinity with the work of contemporary experimental psychologists.

During World War I a new colour theory was published in Germany. The work of a retired chemist, Wilhelm Ostwald, it came to dominate colour thinking for the next decade. Ostwald applied the findings of an early physiologist, Gustave Fechner, to the problem of colour, and established precise rules for a scale of greys. By the addition of these greys, hues could be darkened in a regular and quantifiable way. The great attraction of this scheme to schools like the Bauhaus—probably the century's most important body of arts and crafts—was the promise that it held of freeing artists from the psychological difficulties of colour by turning it into a purely mathematical study.

The theory was not without opposition, however. A leading light of the Bauhaus, Johannes Itten—whose *Art of Colour* is a standard text in today's art schools—frankly disliked Ostwald's scheme, although ironically he had arrived at a similar grey scale via an analogy with music. But bitter conflict between the traditional, dynamic view of colour and Ostwald's new technical approach had already burst upon the art world at the 1919 conference of the *Deutsche Werkbund*, the German equivalent of the English Arts and Crafts Movement. The chief opponent of Ostwald was Itten's mentor, Adolf Hölzel, who held the view that

colour-contrast falls under seven categories—contrast of hue, of saturation, of area, of light and dark, of complementarity, of warm and cool, and of simultaneous contrast. To suggest that harmony of colour could be obtained by manipulating the light and dark content, or value, of colours was deeply offensive to Hölzel. Nevertheless, Ostwald's theory prevailed sufficiently for Walter Gropius, the Bauhaus' founder, to introduce it in 1923. He also included the older system of Philipp Otto Runge—a diplomatic move since Runge had the approval of Bauhaus teachers such as Itten and Paul Klee.

Klee, in particular, was deeply sceptical of what he saw as Ostwald's 'negative reaction to colour' and, indeed, of any attempts to classify colour in a scientific way. Like Runge, he wished to preserve its essential mysteriousness. This is hardly surprising when we consider that colour had already revealed its secrets to him—on a trip to Tunis—in a way that was far from scientific and recalls Delacroix's experiences in the same part of the world. Klee wrote in his notebook: 'Colour has me. I don't need to strain after it. It has me forever. I know that. That is the meaning of this happy hour. I and colour are one. I am a painter.' Thus Klee asserted his oneness with the men to whom colour was a living force—Goethe and Runge, Delaunay and Kandinsky— and who asserted the power of colour to act dynamically on the imagination.

Other times, other faces

When the nomadic peoples that inhabited Egypt during the fifth millenium BC began to adopt a settled way of life, in addition to the established colours used in self-decoration they developed new paints for protective and medicinal uses. Galena, a lead ore, was used to blacken the lashes and outline the eyes to screen them from the sun, and eye paints are thought to have contained remedies for suppurations caused by heat and glare.

Body paints became cosmetics when ancient peoples began to use them for decorative purposes. The Egyptians used the traditional green malachite, grey and black kohl and red ochres to emphasize the eyes and redden the lips, palms and finger nails. Women tinted their bodies with dilute yellow ochre and gilded their nipples, and on the shorn heads of both sexes were wigs dyed black or red.

The Egyptians evolved a palette arguably more extensive than that of any subsequent society up to the twentieth century and, like modern societies, they painted to enhance a healthy complexion. Many future generations suffered from such dismal levels of health and hygiene that paint was needed for concealment, and the toxic ceruse or white lead masks, fashionable from ancient Greek to Victorian times, often aggravated the very flesh they set out to glorify. They were abandoned finally during the twentieth century, but other natural pigments and dyes—ochres and other oxides, henna, cochineal—are in use to this day.

Greek women wore little make-up, but the *hetaerae*, like all courtesans and harlots throughout the ages, painted lavishly. Their rouges, made from vegetable dyes, white lead and kohl were the prototypes on which ensuing centuries of attempted beautification were based. Roman matrons, who were allowed a wider social role than their Greek counterparts (and future cultures displayed the same relationship between women's influence and freer use of artificial colour) had their own variations on the red, white and black theme. The Roman fancy for the flaxen hair of the subjugated Gauls led them to crop it for wigs, or to bleach their own hair with dyes made from the tree bark containing tannin, alkali beechwood ashes and goat tallow, and chemicals for bleaching textiles.

The early Christians considered cosmetics vain, and therefore evil, and the expression 'painted woman', reinforced by scripture, became a term of bitter opprobrium. Ironically, knights returning from the crusades reintroduced cosmetics to Europe. By 1558, when Elizabeth I was crowned Queen of England, make-up had spread northwards from Italy. An engraving of Elizabeth in middle age shows the practice of painting blue veins on the forehead to simulate the translucent look of youth.

The prevalence of smallpox scars led to a craze of tiny, concealing black, or occasionally scarlet, patches on the face during the seventeenth and eighteenth centuries, and the heavier use of ceruse and rouge. Many men painted as overtly as the ladies, but the eighteenth century ended with a backlash against the unprecedented artificiality of appearance and the intolerably high cost of cosmetics. Punitive taxes made even the beloved white hair powder inaccessible.

The Victorian notion of innocent beauty meant that women had to make up as indetectably as possible, but the popularity of the theatre exposed society ladies to the cosmetic prowess of actresses. With stars like Sarah Bernhardt wearing colour openly off-stage, public censure subsided and women made up again. Carmine was the preferred rouge, derived from the pulverized bodies of female cochineal insects. It is the only natural bright red pigment permissible today for eye make-up. The public passion for Diaghilev's 1910 production of the ballet *Schéhérazade* put coloured and even gilded eyeshadow permanently into vogue, and in the twenties lipstick was firmly re-established.

Modern developments come less from new pigments than from more delicate colour in media kinder to the skin. Hair colour which throughout history has been altered, if at all, mainly to black, red or blond with deadening dyes or bleaches, has benefited from chemists' new knowledge, so that a growing range of more natural-looking colours, more sympathetic to hair pigment and structure, has appeared. Temporary shades work by 'hanging' colour on to the outer surface of the hair. Permanent colour penetrates the cuticle and becomes sealed in the hair.

Most cosmetics in use today contain synthetic pigments. All are too vivid for use in their pure form and are muted, mainly with white titanium dioxide. Combinations of the approximately 40 organic and 20 inorganic pigments available bring the total colour range into the hundreds. Some nacreous pigments still contain the ground pearls or guanine (the shimmering substance in fish scales) or mica (the scales that glitter in granite) that launched the lustrous look; but these are also mainly synthetic, affording a wide range of iridescent effects.

Should Cleopatra be reincarnated on the ground floor of Bloomingdales or Harrods she would find many of her old familiar colouring agents and ingredients cosmetically concealed behind evocative trade names and glamorous packaging. She could probably even find her favourite green eye shadow somewhere amid the infinite variety.

The Egyptians accentuated the eyes, which were boldly outlined with kohl. This is not a specific substance, but a generic term for a range of eye preparations—mainly black, but also grey or coloured—made from powdered antimony, lead, magnesium oxide, burnt almonds, black oxide of copper, carbon, iron oxide, brown ochre, malachite or chrysocolla (a green-blue copper ore) among others. These pigments were ground and mixed with animal fat, vegetable oil or saliva just prior to use, or else applied in powder form over a base of ointment. It was customary to colour the upper and lower lids in different shades, and the eyeliner would be a different shade again.

Since Elizabeth I wore make-up English women followed suit. White lead was used to coat the face. Calcined in vinegar, it was beaten into flakes and then ground to a powder, ruining many a workman's—and wearer's—health. Rouge was made variously from red ochre or cinnabar (mercuric sulphide) and lip colour from crayons of ground alabaster and cochineal. The whole face was often varnished with an egg-white glaze and had to be protected outdoors with a mask. It was fashionable to lighten the hair with camomile, or to henna it red.

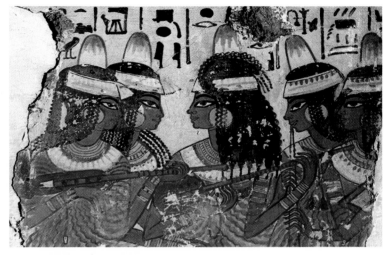

During the twenties, *below,* the traditional home-made face powders concocted from pulverized rice, corn starch, oatmeal, potatoes, spermaceti, chalk and even pearls were being replaced by safer commercial kinds which combined talc for 'slip' with kaolin or oxides of zinc or titanium (a component of clay) for opacity. Like rouges and lip salves they were coloured with carmine or iron oxides, or the new coal tar dyes. Eye shadows were blue, green or brown, coloured with artists' pigments—ultramarine, chromium oxide and ochre, and eye pencils and mascaras were made from ingredients the ancient Egyptians used: earths or soot.

Japanese women traditionally masked the face with the pink and white rice powders, vermilion rouge and black eye and eyebrow colouring still seen on the geisha. Today, *above,* frosted and iridescent nacreous—or pearl—pigments are considered more suitable than opaque pigments for translucent oriental skins, or black skins.

Indian women rouged the lips with alacktaka, a red lacquer, and the feet and fingertips, *left,* with lac-dye, saffron or henna. Collyrium, a black eye salve, and antimony, a metallic pigment, outlined the eyes and mascara was prepared from an unguent of herbs and lampblack. The body was often covered with a coloured sandalwood paste.

Glossy thirties' lipstick, based on paraffin reinforced with wax and cocoa butter and tinted with carmine and titanium dioxide, gave Hollywood lips their 'black' look, *above.* By the seventies, *left,* natural colourants were being replaced. Synthetics had greatly expanded the range of eye colours, but blacks were still being manufactured from carbons, blues from ultramarine and greens from chromium oxide. Hydrogen peroxide, used as a hair bleach from the early 1900s, produced not only Hollywood blonds, but also the punks, whose hair had to be bleached before pink, blue and green dyes of the kinds used in food were added. Henna, a reddish plant dye, is one of the few herbal hair colourants still used.

Colour on the page

Whatever the invention of printing did for the mass dissemination of learning, it did nothing for colour. Those jewels of quality, the hand-illuminated manuscripts, were superseded by the sheer quantity of print which spread outwards from Germany in the early fifteenth century. The only remaining vestige of illumination lay in the occasional practice of printing larger initial letters in red, and sometimes blue. Such a device was employed by Fust and Schoeffer of Mainz in their famous psalter of 1457; and if those two German gentlemen could have walked into an average letterpress printer's premises as recently as 1950, they would have felt quite at home—the moveable type raised from a metal surface is not very different from the earliest typefaces carved out of woodblocks.

It was not until nearly three centuries later that another German, James Christopher Le Blon, made an apparently simple but fundamental discovery which laid the basis for modern colour printing: he realized that a whole range of colours could be produced out of only three—red, yellow and blue. He chose not to use the earliest type of printing surface, carved out in relief so that the ink is carried on the raised surface of the blocks or plates. Instead, he used one of several intaglio methods—in fact, mezzotint—which, similar to gravure, is carried out by engraving or etching the plate so that ink is retained in the incision. The depth of the incisions determines the amount of ink, and therefore the weight of colour, that is transferred on to the paper from the plate.

Having no equipment to help him gauge the colour composition of a picture, Le Blon had to trust his eye. His reproductions of paintings by Rubens, just by printing three plates (one for each colour) over one another, were so accurate that once heavily varnished they were passed off as originals. But his three-colour process had to wait some time for its full application—until the development of photography.

Meanwhile, at the end of the eighteenth century, the third main method of printing had been discovered: lithography. Neither relief-carved nor engraved surfaces were necessary; just a flat stone. This has its origins in the moment when a Bavarian, Alois Senefelder, applied to printing the simple principle that oil and water do not mix. A greasy drawing on a smooth stone will accept ink while the background will reject it as long as it is kept moist. Artists were delighted with lithography: their control over the finished product was absolute.

They could draw directly on to the stone with special crayons and the amount of colour was, theoretically, unlimited; it was just a matter of using a new stone for every patch of a different colour required. The famous 'Bubbles' advertisement for Pears' soap was lithographed with more than 20 stones from an original painting by Sir John Millais. Sir John was a trifle peeved when he heard what had been done, but was deeply impressed when he saw the result—he even liked the bar of soap that had been added in the corner of the print.

Such detailed lithographs were comparatively rare. Paintings or book illustrations were usually reproduced in the early nineteenth century by woodblock or by combinations of letterpress and intaglio (gravure) methods. George Baxter's incomparable prints of 1853 used up to 30 letterpress printings in separate colours on a neutral grey or terracotta base laid down by intaglio steel plate. The strength of lithography was the ease with which bright, flat colours could be turned out, making it a natural choice for posters of all sorts. The gaudy circus advertisements which swept across America in the 1850s were like 'trailers' for all the glitter and excitement of the Big Top. In France, the exquisite images of Jules Chéret raised advertising to an art form; so did the early twentieth-century posters of the man who now overshadows him, Toulouse-Lautrec. But while his stylish *Moulin Rouge* posters are thought of as attaining the peak of the hand-lithographer's art, a new technology was already ousting the older craft—the application of photography to colour printing.

Initially the real platform for the colour printing of photographs was magazines. Suddenly in the mid-thirties, a whole range of bright and relatively cheap magazines brought colour into the poorest and drabbest of lives. Housewives were a favourite target, and a host of sensational magazines came on to the market to give them dreams of other, better ways of living. Fashion plates were no longer the prerogative of a few highly skilled French illustrators who had ensured that only their own hand-lithographed or stencilled figures could do justice to what was considered an art. The expensive and beautiful *Gazette du Bon Ton* disappeared with the fashions it had propagated. The trend towards simplicity of dress enhanced the new availability of display.

The advent of really commercial colour printing was brought about not only by the development of cost-effective photographic processes, but also by a less obvious advance—the improvement of ink. The problem has always been to find an ink that is transparent enough not to block off the colour on which it has been laid, and yet dense enough to reproduce a colour accurately. Modern offset lithography, so called because the image is 'offset' on to a rubber roller before being transferred to the paper, owes a special debt to the ink manufacturers.

Since the roller has to be moistened before ink is applied, the difficulty had been to obtain a proper balance of ink on every impression. Modern, highly-concentrated inks have not only solved the problem but have met the stringent demands of food manufacturers for print on packaging that is light-fast, scuff-resistant, odourless, non-toxic and able to withstand boiling and freezing conditions. The formidable combination of such inks with the ability of offset litho's rubber rollers to handle virtually any surface from plastic to cardboard to tin, largely accounts for the explosion of colour packaging during the sixties.

The arrival of colour television and film in this colourful decade put enormous pressure on printers to keep abreast of the tide of colour that the public had come to expect. Magazines, books, posters and all the paraphernalia of the supermarket had to appear as gorgeously clad as possible. But colour printing had also to be extremely accurate. If anything had held back the development of photo-engraving, it was the lengthy and costly process of correcting colour on a negative before the printing plate was made—all by hand.

There was no alternative; a green dress ordered from a catalogue had to be the same green in print. And because it was easier to colour correct a drawing than a photograph, more than 90 per cent of book covers before the sixties were hand-drawn. The situation was saved by the invention of electronic scanners; their wizardry consists in being able to scan an original transparency, take out the unwanted colour over specific areas (with none of the old danger of tell-tale brush marks) and produce a perfect four-colour film ready for platemaking in a matter of minutes.

The bombardment of colour from all sides is now accepted as a desirable thing; the more we see, the more we want. But can we still experience the excitement of the Victorian child who opened a book and lifted a thin veil of fine paper to reveal the delicate shades of a rare colour plate?

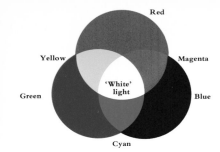

An image which is to be printed in full colour has first to be separated into three images, each of which contains one of the subtractive primary colours, yellow, magenta, and cyan (which together make a brownish black). These are translated on to three printing plates—usually with black as a fourth—and recombined on the press to form the original colour image. The separations are made by photographing the image through three filters of additive primary colours—red, green and blue (which together make 'white' light). With a blue filter, *above*; red and green light (which together make yellow) are absorbed and only blue is transmitted, producing a negative with a record of the yellow content of the image contained in the light areas. A positive will reverse these light areas into solid areas of the subtractive primary yellow, *below left*. The same process is repeated with red and green filters to produce magenta and cyan separations; a fourth, black separation is usually made from a yellow filter.

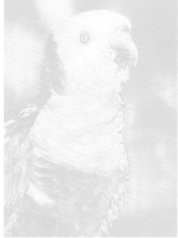

Yellow separation

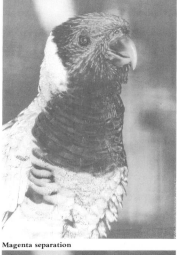

Magenta separation

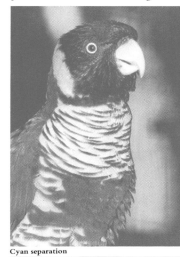

Cyan separation

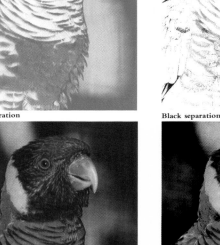

Black separation

Once the original image has been separated into positives of yellow, magenta, cyan and black, they are ready to be screened. Glass screens consist of a finely ruled grid pattern placed between the camera's lens and the film; contact screens consist of a pattern of vignetted dots and are placed in direct contact with the unexposed film. The image is photographed through the screen which, in effect, breaks down the image into thousands of tiny dots, small in the light areas and larger in the dark. These result in gradations, or halftones as the process is called, *bottom right*. The dots are engraved on plates, one for each of the primary colours (and usually black) and superimposed on each other in the printing press to reproduce the original image in full colour. Since neither the quality of paper nor of inks is yet perfect enough to reproduce colours exactly, a certain amount of colour adjustment, or correction, has to be performed manually or photographically on the separations. In practice, images are frequently separated and screened in a single operation, as the image pictured here has been. Electronic separation, as distinct from photographic separation shown here, is done by an electronic scanner which 'reads' the colours in the original image and produces images which can be screened or unscreened, corrected or uncorrected, positive or negative. Its only disadvantage is that the image must be flexible —a transparency, for example.

Yellow and magenta

With the combination of yellow and magenta separations, *above*, other colours are produced; but the full range is not perceptible until cyan is added. By adding black to the three primaries, a proper density is given to the areas which were unsatisfactorily shaded by a mixture of three primaries alone.

Halftones give the impression of solid colour but an enlargement reveals that they are really composed of dots. These are mixed by the eye of the observer, rather on the principle of a neo-Impressionist painting by Seurat. Some colours, such as a very light pink, cannot be reproduced even by a mixture of the smallest possible magenta dots and the white area surrounding them.

Yellow, magenta and cyan

Yellow, magenta, cyan and black

Capturing colour

Almost as soon as Joseph Nicéphore Niepce had produced a misty black and white image of the view from his work-room in 1826, the search for colour photography began. Initially, the most practical way of producing colour was to paint black and white photographs, a method which persisted for generations—wedding photographs were still being hand-tinted 30 years ago. But in 1861, the physicist James Clerk Maxwell applied the theory of the additive mixture of light to photography.

He photographed a tartan ribbon three times through red, green and blue filters, then superimposed a positive transparency of each photograph on to a screen through three magic lanterns, each fitted with the relevant coloured filter, to produce an accurate colour image of the tartan. Until recently, it was a puzzle as to how Maxwell had successfully achieved his colour image, for the photographic emulsion available at the time was sensitive only to blue, violet and ultraviolet light (a panchromatic plate sensitive to red and green as well did not become commercially available until 1906). In fact he was helped by two lucky coincidences: the reds in the tartan reflected some ultraviolet light and the green filter let some blue light through.

Maxwell's additive technique was none the less black and white photography at heart, with colour being provided by ingenious use of filters. The subtractive process which ultimately became the basis of all modern colour photography found its origins in the work of a Frenchman, Louis Ducos du Hauron, in the 1860s. Like Maxwell, du Hauron photographed his subject through red, green and blue filters, but he then printed the negatives on translucent paper and coated the images with dyes of colours which complemented the colours of the filters. The positive made from the green-filter negative, for instance, was given a magenta (bluish red) dye which subtracted green. When the three coloured images were superimposed in register and illuminated by a white light, each layer subtracted red, green or blue from the white light to give a full-colour image.

The inconvenience of three separate colour positives and the difficulty of precise registration postponed the full application of du Hauron's ideas until chemical research had developed a way round the problem. Meanwhile, another idea of his was finding commercial favour. A more sophisticated additive technique, the new process incorporated the three filters on a single screen which was then placed against the plate in the camera. The screen filtered the light that was transmitted on exposure and recorded its different tones in black and white on the plate. To restore colour to the image, a positive transparency needed only to be bound up in register with the same screen and projected.

A Dubliner, John Joly, made the earliest successful screen by ruling extraordinarily fine (less than 0.1 mm wide) red, green and blue-violet lines on a gelatin-coated glass plate.

In 1912 the chemist Rudolf Fischer announced his discovery that colour-forming chemicals could be incorporated into the light-sensitive emulsion coating on plates and films. These chemicals, known as dye-couplers, produced dyes when acted upon by the developer, generating colour images.

Dye-couplers did not find their true niche until the twenties, when two young musicians in the United States, Leopold Mannes and Leopold Godowsky, began to experiment with them

This portrait of a Japanese girl is an example of hand-coloured black and white photographs at their best. Produced about 1890, it contrasts sharply with the modern technique of density-slicing which was developed to help scientists analyze photographs of the moon. The black and white image of an eagle, *right*, was scanned by a television camera and relayed to an analyzer which examined the exact density (the tones and shades of greys) of the image by 'slicing' through it. It then converted each 'slice' into a different colour and displayed the image on a cathode ray tube, with striking results.

The Autochrome process of the Lumière brothers enabled this view of the Antarctic to be taken on Scott's last expedition in 1911. Instead of Joly's finely ruled lines, about 4,000,000 potato starch grains adhered to every square inch of the screen, each dyed reddish orange, green and violet. Varnished and coated with panchromatic emulsion, the first fully practical combination of screen and plate was offered to the public. By 1913, 6,000 Autochrome plates were being made every day and production continued for 30 years. The density of the plates—which transmitted only $7\frac{1}{2}\%$ of the light reaching them—and their long exposure time may partly account for the strange hue of the snowscape, taken at 6.15 a.m.

in making multi-layer plates—each layer sensitive to green, red and blue light. They had already been successful with a two-layer emulsion, but the addition of a third layer had proved extremely difficult to regulate.

But Mannes and Godowsky succeeded at last, only to find that the dye couplers tended to 'wander' from one layer of emulsion to another, spoiling the quality of the tones. They deftly sidestepped the problem by switching the dye couplers from the emulsion to the developer, and in 1935 Kodachrome was born. All film had to be returned to the Kodak laboratories for the highly complicated business of developing, but Kodak turned this to their advantage by mounting the transparencies on cardboard and initiating a fashion for slide shows. Within months, the German firm Agfa cracked the problem of in-corporating dye couplers in the emulsion and, for the first time, photographers were able to process their own colour film.

Six years later, Kodacolor came on the market. A colour negative as opposed to a colour reversal film (producing transparencies), it put good, paper prints within the reach of everybody's photograph album and made colour snaps literally child's play. The only shortcoming was the delay between clicking the shutter and seeing the result, and the Polaroid Corporation stepped in to remedy that. They sold their first black and white instant picture camera in the late forties and by 1963 the first 60-second colour photographs were practicable through a roll of film on which all the layers of chemicals for automatic processing and colouring were fitted to a depth no more than a quarter of a hair's breadth.

Posterization is just one of many techniques for producing unusual colour effects. This photograph was shot in black and white; the negative was then separated into three sets of high contrast positives and negatives—one for the shadows, one for the middle tones and one for the highlights. A combination of the negatives and positives was then placed in register and photographed through colour filters to produce the strongly contrasting hues.

Solarization makes similarly strange pictures by an altogether different process: the negative is briefly exposed to a coloured light while still being developed. This reverses the colour of the final print; a red light, for example, produces a greenish hue. The effects created are oddly surrealistic.

Infrared film registers not only infrared light, enabling pictures to be taken of objects in darkness, but it also records unpredictable colours from wavelengths shorter than infrared. Vegetation such as the cornfields, *above*, reflect infrared radiation strongly. Infrared film is especially sensitive to blue light so that unless a yellow filter is used on the camera to compensate, pictures tend to be predominantly magenta. The prime military application of infrared photography is in camouflage detection; a development of this, based on the heat-seeking heads of missiles, can discriminate less than 1°C difference in temperature between an object and its background, revealing the presence of a human being or the engine of a tank.

Colour in motion

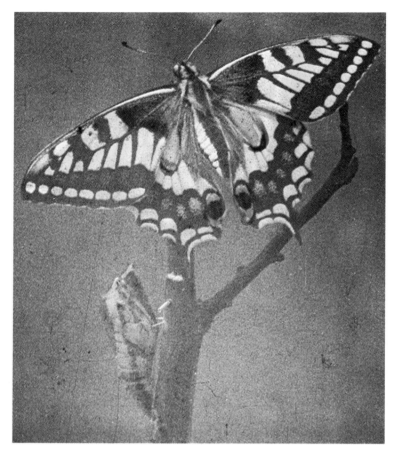

Colour in motion pictures has existed almost as long as the movies themselves. By the late 1890s pioneer cinematographers had projected the first colour film, painstakingly tinted frame by frame, before the complacent gaze of the public. If the gaze was not more admiring, it was probably because hand-tinted photographs had existed for some time, and mere movement was insufficient to slake public thirst for sensation.

The British Kinemacolor system, developed by George Smith and Charles Urban, was more successful. This used a camera to shoot alternate frames through revolving red and green filters. Part of the secret lay in Smith's invention of a panchromatic film which was sensitive to all the colours of the spectrum. Their moment of triumph came at the 1912 première of *The Delhi Durbar*, a film which recorded the Indian celebrations of the coronation of King George V. For a marathon two and a half hours, audiences were stirred by the peacock splendour of the rajahs and their gaily apparelled elephants.

But success was short-lived; the system only operated to maximum effect under strong natural light, and what was lovely to behold under the bright Indian sun was rather drab when shot at a London studio—even one equipped with a stage which could revolve to face the sun. But even as Kinemacolor declined, a veritable spate of colour film systems were being patented, most of which have long been forgotten. One certainly was not. Its name has long become synonymous with Hollywood and the colour spectacular: Technicolor.

Herbert Kalmus founded the Technicolor Motion Picture Corporation in 1915. Unlike the Kinemacolor System which took (and projected) sequential pictures through red and green filters, Kalmus's prototype used a beam-splitting device in the camera which recorded red and green images simultaneously on the film strips. After these had been developed, they were shown through a special projector fitted with filters. But this process was still, like Kinemacolor, an 'additive' one; and although in 1917 it produced a film called *The Gulf Between*, it was soon to be replaced by a 'subtractive' process in which the colour was no longer mixed through the filters but was carried on the film itself.

For the next ten years, movie directors were wary of the trouble and expense of full-length colour films, preferring to insert tentative colour sequences into a black and white film, such as *Ben Hur* (1927) to heighten the excitement at critical moments. But Technicolor was improving all the time; *The Black Pirate* (1926) was shot entirely in two-colour and enjoyed highly favourable reviews. However, Douglas Fairbanks showed a shrewd understanding of colour's power to distract. As *The New York Times* remarked, he was well aware 'that audiences will at first be engrossed with the natural colours . . . and does not himself appear until nearly ten minutes after the picture started.'

In the early 1900s, Mr. J. Williamson's ingenious Kinematograph was proud to present such beautiful and educational films as the lifecycle of the swallowtail butterfly. Each frame of film had to be laboriously hand-coloured, usually by teams of girls. This was not as expensive as it might sound: in 1902, colouring 700 frames (50 ft) of film cost only 35 shillings (less than ten dollars), a harsh reflection on the wages of the time. Stencils were introduced by the Pathé brothers in 1905 which speeded up the process, but not enough to keep pace with the demand from the many new bioscopes and nickleodeons that were springing up everywhere.

This animated film is based on the Russian scientist, Ivan Pavlov, who pioneered behavioural psychology with his celebrated experiments in training dogs. The film was made for television, so strong colours were chosen to compensate for sets tuned to a low intensity. The colouring was matched to that in the artist's free drawings—the pink of the waistcoat was chosen to enhance the pink of Pavlov's cheeks—but colour brings a character alive and changes were made while the film was being prepared. Pavlov's shoes, for example, seemed to need colour to emphasize his character.

Colour film, it seemed, was poised to sweep the board.

Then, in 1927, an ordinary black and white film caused a sensation. Called *The Jazz Singer*, it became immortal as the first talkie; Al Jolson's voice frustrated the Technicolor work of years. Warner Brothers announced in vain that they were going over 100 per cent to colour; in vain Technicolor produced a new camera that could use three-colour subtractive film. Only one full-length colour feature was produced in 1933, and none at all in 1934. Besides, audiences complained that colour film was ill-defined and painful to watch. If any one man kept colour alive during these depressed years, it was Walt Disney whose feature-length cartoon, *Snow White and the Seven Dwarfs* (1938) was a major hit.

Colour cinema underwent a great revival in the late thirties. Judy Garland's yellow brick road led to the enchanted castle of box-office success, while a year later *Gone With the Wind* (1939) kindled the hearts of cinemagoers all through the dark forties. Technicolor was almost as important as the stars of the film, but not for long. A major new competitor arrived on the scene that sent a shudder through the colour film industry such as had not been felt since the advent of the talkies—television.

By 1952, American cinema audiences, previously 80,000,000 strong, had been cut almost in half. The film industry hit back with the most effective weapon it could bring to bear against television: colour. The Eastman Colour process, which could use conventional rather than beam-splitting cameras, improved the quality of colour film, reduced the cost and helped make possible the wide-screen movie. Cinerama, Vistavision and Cinemascope, colouring and stretching the spectacular epic from wall to wall, began to draw the crowds back to the cinema. Movies were not going to capitulate to television as the music hall and vaudeville had surrendered to the movies.

Size and scope were not the only improvements. By 1953, the potential quality of colour film was being realized by Japanese films such as Teinosuke Kinugasa's *Gate of Hell*. The West was greatly struck by their naturalness of colour and by their directors' use of different highlights and shadows to suggest deeper meanings within an ostensibly simple story line.

Today colour rules the silver screen and sophisticated camera filters and printing techniques can combine to give practically any colour 'look' required—harsh and bright or rich and varnished like an old master. Only avant-garde and experimental film-makers remain wary of colour film; they prefer to shoot in the more austere medium of black and white to which mainstream directors also revert at times, to help evoke a nostalgic atmosphere. But the story of colour film is one of such hard-won battles that it is not likely to relinquish our screens again for a very long time.

An image in an animated film is drawn in outline on the front of each piece of flimsy, transparent celluloid or 'cell', while the colour is applied to the back to give greater freedom of brushstroke.

Each movement in this film had to be drawn and coloured on a separate cell, and combined with other cells, before being photographed to produce a single frame.

The colours of this film were selected to be consistent within a tonal range. This involved much trial and error, since paints dry a shade darker than they appear when wet. There are so many greys that their choice posed special problems.

Some cells, such as the background and spotlight, remain constant. Like the cells laid over them, it is essential to keep them in register by fixing them to a peg bar, *below left.*

Special plastic emulsion paints, which will adhere to the cell, are mixed beforehand to ensure colour consistency. They are usually applied in a runny state to obtain flat colour that is not too thick. Since the piling up of layers of cell tends to deaden the colour of the bottom ones, a painter may have to mix several grades of the same colour in order to compensate for the greying effect. The dog in this cartoon was originally olivey-green, but looked so downtrodden that the animator 'warmed him up' with brown. The spotlight was painted with a yellow felt-tip pen to give a translucent effect.

Colour by the line

In 1926, John Logie Baird demonstrated the first distinct television pictures in front of a group of scientists in his London attic. His mechanical system used rotating disks with apertures to scan an image; and the addition of blue, green and red filters, blended to give a colour image, formed the basis of Baird's colour images two years later. But although his ingenuity was shortly to produce three-dimensional and infrared television, not to mention his colour system of 1938 with its nine feet by twelve screen, the cumbersome mechanics were clearly doomed to give way to the budding science of electronics.

Of the many rival electronic systems, the one promoted by the National Television Systems Committee (NTSC) was finally adopted in the United States. The deciding factor was its compatibility with the 10,000,000 existing monochrome receivers operating nationwide by 1951. Europe reaped the benefit of American pioneering development by widely adopting the improved PAL System. The BBC broadcast a documentary about Washington, D.C. on the opening night of colour transmission in 1967. One critic described the cherry blossom as 'enchanting' and remarked that 'even the rat-infested streets . . . seemed so much more alive in colour. Colour is life . . .'. Another reviewer noticed how bad the complexions of Washington's society hostesses appeared next to those of the Wimbledon tennis stars shown earlier in the day.

Rather as in the early days of sound when everything had to squeak, bang or rustle, the first colour pictures tended to be as bright and busy as the painting of a child with a new box of paints. But it soon became apparent that on the small screen the eye became confused by a welter of different colours and tended to resolve them into one dominant hue. There was an immediate reaction to tone down the over-enthusiastic use of colour, for which the commercial advertisers were partly responsible: they did not want their products to be overwhelmed by the bright hues of their surroundings. They knew, too, that the viewer's eye is drawn immediately to the brightest patch of colour on the screen. Drama directors overlooked this fact to their cost; for a play could be ruined by a single bunch of flowers whose vivid colour distracted attention from a movement vital to an understanding of a plot. At the same time viewers respond more 'naturally' to sudden splashes of colour if the scene is shot on location in a street, say, rather than in the studio.

Unlike monochrome television where mistakes could be glossed over in a confusion of tones and shadows, colour television has virtually no margin of error—a small mistake can ruin a whole effect. Until recently the fact of colour itself was sufficiently novel to satisfy the public quite easily, but growing critical awareness has made increasing demands on the teams of individuals whose skills—lighting, make-up, costume, scenic design—have to be minutely co-ordinated. Fortunately, the advantage of television over film is that everyone responsible for a scene can see it instantly on a colour monitor and make adjustments: a change of camera angle, a dab of paint over distracting furniture, a dimming of the lights.

Set designers have to tread the finest line, perhaps, when making monochrome viewing compatible with colour. To sustain the impact, black and white scenes have to be busy-looking, and this is not easy to tally with the much simpler environments needed for colour. Graphic designers, too, have to be careful to use colour of a tonal contrast that will not be illegible in monochrome. In the beginning, make-up artists had to cope with a host of problems—the lime-green aura given off by dyed blond hair, the glare of a nicotine-stained finger and the beetroot complexions of celebrities who had spent too long in the refreshment room. They had to compensate (with red make-up, for example) for a technical hitch which placed a blue cast over faces, only to change the make-up yet again when the distortion was corrected. They are responsible for the flesh tones which are, for most people, the key to acceptable colour balance—although the wide range of red to ghoulish green faces on a cross-section of average viewers' receivers is testimony to the huge differences in people's perception of the norm.

Since actors have always needed authentic costumes to help project themselves into a part, costume designers have had to adjust less. But they now receive the recognition so long denied them in the monochrome days when only those on the studio floor saw the splendour of the actors' costumes. In newscasts where film sequences appear behind the newscasters using the Chromakey technique, dress is particular important. For there is only a coloured (often blue) board behind the newscaster. Every time the studio camera 'sees' it, one of the three colours is 'switched out' and replaced by a film which is fed into the outgoing signal. Thus a blue tie could inadvertently trigger the invasion of the newscaster's chest by the Red Army.

Every evening millions of viewers scrutinize colour in a way that is foreign to the rest of their perceptual life. The increase in awareness is reflected in fashion, make-up, interior decoration, and so on. But whether, by reflecting so faithfully the colours of nature, television takes us nearer to or farther away from the real world, it has yet to be decided.

The PAL colour television system was widely adopted in Europe after it was shown to have overcome the problem of slight hue distortion present in America's NTSC system, introduced in 1954. For all the strides that television has made, the principles of transmission and reception remain the same as those outlined in the twenties by Vladimir Zworykin, a Russian emigré to the United States: an image of the scene to be televised is registered in the camera on a 'target', which generates on its rear surface a pattern of electrical voltages proportional to the brightness of the corresponding part of the image on the front. The rear surface is then scanned by an electron beam in lines, exactly as the eye scans a printed page, to build up an electronic reproduction of the image for transmission. The greater the number of lines, the higher the definition of the picture. The PAL system scans 625 lines every 0.04 seconds, so that 25 complete pictures are transmitted every second, as compared to the NTSC system's 525 lines and 30 pictures per second. Baird's early television scanned only 30 lines to produce his historic, if rather dim, image; the Japanese are experimenting with 1100 lines, or more.

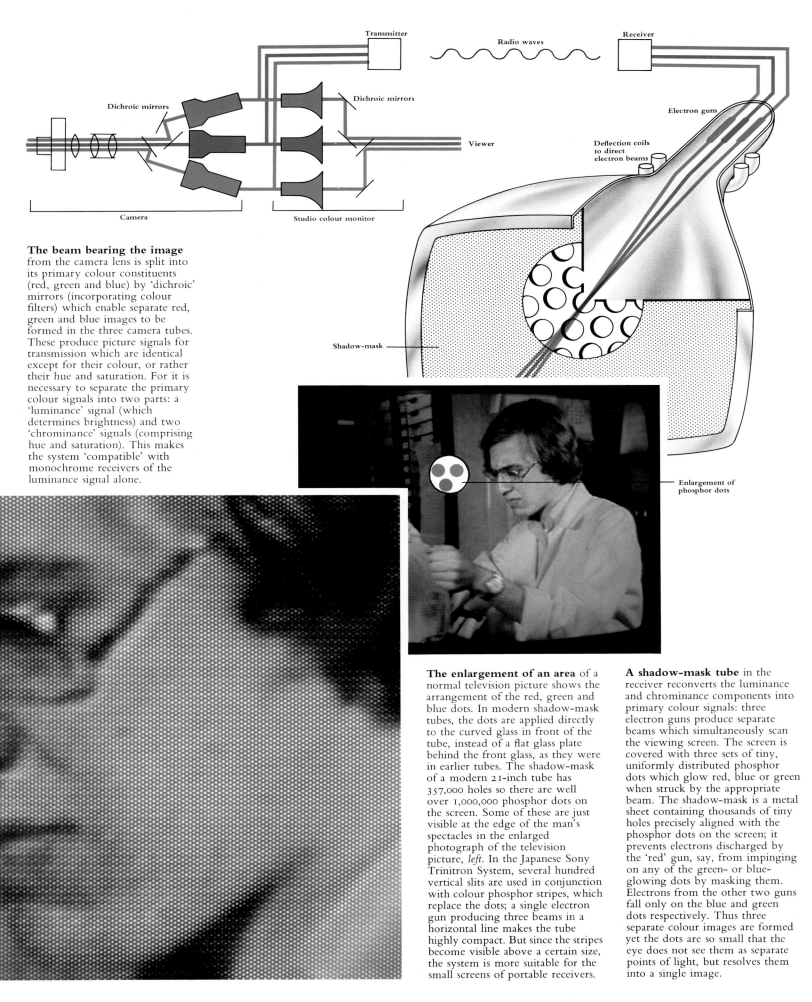

Transmitter

Radio waves

Receiver

Dichroic mirrors

Dichroic mirrors

Electron guns

Viewer

Deflection coils
to direct
electron beams

Camera

Studio colour monitor

Shadow-mask

Enlargement of
phosphor dots

The beam bearing the image from the camera lens is split into its primary colour constituents (red, green and blue) by 'dichroic' mirrors (incorporating colour filters) which enable separate red, green and blue images to be formed in the three camera tubes. These produce picture signals for transmission which are identical except for their colour, or rather their hue and saturation. For it is necessary to separate the primary colour signals into two parts: a 'luminance' signal (which determines brightness) and two 'chrominance' signals (comprising hue and saturation). This makes the system 'compatible' with monochrome receivers of the luminance signal alone.

The enlargement of an area of a normal television picture shows the arrangement of the red, green and blue dots. In modern shadow-mask tubes, the dots are applied directly to the curved glass in front of the tube, instead of a flat glass plate behind the front glass, as they were in earlier tubes. The shadow-mask of a modern 21-inch tube has 357,000 holes so there are well over 1,000,000 phosphor dots on the screen. Some of these are just visible at the edge of the man's spectacles in the enlarged photograph of the television picture, *left*. In the Japanese Sony Trinitron System, several hundred vertical slits are used in conjunction with colour phosphor stripes, which replace the dots; a single electron gun producing three beams in a horizontal line makes the tube highly compact. But since the stripes become visible above a certain size, the system is more suitable for the small screens of portable receivers.

A shadow-mask tube in the receiver reconverts the luminance and chrominance components into primary colour signals: three electron guns produce separate beams which simultaneously scan the viewing screen. The screen is covered with three sets of tiny, uniformly distributed phosphor dots which glow red, blue or green when struck by the appropriate beam. The shadow-mask is a metal sheet containing thousands of tiny holes precisely aligned with the phosphor dots on the screen; it prevents electrons discharged by the 'red' gun, say, from impinging on any of the green- or blue-glowing dots by masking them. Electrons from the other two guns fall only on the blue and green dots respectively. Thus three separate colour images are formed yet the dots are so small that the eye does not see them as separate points of light, but resolves them into a single image.

Paints for all purposes

The origins of home decoration lie in the coloured clays or soot applied to cave walls thousands of years ago. Unlike modern emulsions or alkyd-based paints, which give tasteful mat or gloss finishes to twentieth-century homes, their purpose was not to adorn but to perform powerful magic. By adding adhesives such as milk casein, fish glue, egg white and plant gums to colours gathered and ground from natural minerals, early man had the recipe for paint as we know it: a pigment and a binding medium.

By the time of the Egyptians, paint technology could convert plant dyes into solid pigments and synthesize at least one mineral—Egyptian blue out of copper ore. Decoration was still largely a sacred activity whether for tombs and mummy cases, the 'whited sepulchres' of the Bible or later Greek temples.

The early water-based paints underwent a major transformation in medieval times with the recognition of the protective qualities of resins and oils. Woodwork especially could be preserved and adorned simultaneously, taking its place alongside the colourful mosaics and tapestries of wealthy homes. Cheap distemper and whitewash remained the staple of ordinary folk who added colour where they could; English half-timbered cottages which are now painted in 'traditional' black and white were also likely to have been painted in red and yellow ochre.

The growth of the paint industry began before the eighteenth century. By the 1730s, professional colourmen like Alexander Emerton 'at the sign of the Bell near St. Clement's Church in the Strand' produced paints—ground by the new horse-mills and ready-mixed in linseed oil—which bore enigmatic names: 'pearl colour', 'stone colour', 'pea colour', 'blossom colour', and so on. Only now that the original recipes have begun to be mixed again can we have an idea of what these colours really looked like; and even so, it is possible to mix a whole range of kindred greys which would have been described by their makers as 'French grey'. The advertised colours came with instructions so that 'any gentlemen . . . may set their servants or labourers to paint their houses.' But, clearly, the instructions could be followed by the householder himself; and the beginnings of Do-It-Yourself can be discerned in 1747 with the crusty complaint of Mr. Campbell, author of *The London Tradesman*, that the painting profession had reached a very low ebb thanks to ready-mixed paints, horse-mills and amateurs doing it themselves.

On the predominantly wooden houses of the early American settlers, weatherproof pitch was as common as paint, which was often used to simulate brick or stonework on a wood surface: powdered brick dust or powdered stone was sprinkled over a thick layer of white paint before it dried. By the early years of the nineteenth century, white painted walls, green shutters and slate-coloured shingles had become the usual livery for most homes.

Nineteenth-century European houses benefited from the Industrial Revolution: brighter greens became available from the new chrome yellows and new blues from artificial ultramarine. Zinc white replaced lead white in rooms where gaslight fumes turned the lead paint grey. Industry and commerce, too, were demanding paint for bridges, boats, trains and, later, automobiles and aircraft—mostly for protection from the elements. But oceanic steamships added the occasional light-hearted touch with colours which reflected their itineraries: black and white for the stormy Northern Atlantic and plain white for the tropical routes to the East. The Blue Funnel Line spoke for itself. The pride and joy of the Victorians, the railways, had their own liveries—the 'Caledonian' blue of one Scottish line, for example—while in Swindon, Wiltshire, a town which had grown up around the Great Western Railway, many houses were painted in distinctive 'chocolate and cream' with paints that had 'escaped' from the coach sheds.

Up until the thirties, paints improved steadily in the range and quality of both pigment and medium. There was an occasional sensation, such as the invention after World War I of the brilliant but inexpensive titanium white which has since superseded all other whites. White pigment is the basis of most light colours and these, in turn, have transcended the vicissitudes of fashion over the years; oranges, purples and magentas may come and go but, after white, magnolia—a pink-toned off-white—has remained the world's best-selling colour for domestic decoration. By World War II, paintmaking had effectively moved into the laboratory where developments in synthetic rubber and plastics had the happy side-effect of producing polymer resins, the ideal plastic base for modern emulsion, or latex. At the same time, linseed oil and natural resins were being replaced after two thousand years of good service by synthetic resins called alkyds. These paints, which every home decorator now takes for granted, enabled walls to be covered effortlessly—an achievement crowned by the discovery of 'thixotropic' chemical structures which brought 'non-drip' paint on to the market.

To obtain complete consistency of colour in every batch, manufacturers mix each paint to an individual formula tailored to the pigment used, and match it against a standard sample; computers do much of the colour measurement but the final arbiter is the trained eye of the colour matcher. Once the colour-fastness has been tested, either under arc lamps or Weather-Ometers which put paints through years of wear in a few days, the product is ready for the public. The only problem, perhaps, is to find names for the almost inexhaustible range; one manufacturer might favour Delphinium, Hydrangea or Fuschia from the garden; another will inspire the home decorator with a colour card full of great painters' names—Raphael, Rembrandt and Constable can adorn the living-room, the hall and the kitchen.

Ships at sea are less at risk from rock and tempest than from the constant presence of salt water. Many small craft are made from fibreglass or other synthetics, but most are wood, while ships are made from steel—both vulnerable materials. The first 'paint' for boats was probably pitch, used for sealing the timbers and caulking the seams between them. In the twentieth century, pitch was ousted by paints based mainly on chlorinated rubber or epoxy resins. Red is a popular colour for ships' hulls as it makes 'rust flowers' less conspicuous—red oxides, grey zinc and yellow lead chrome are good anticorrosives.

Modern aircraft make drastic demands on paints. Changes of temperature (from sub-zero at high altitude to burning heat in a desert touchdown an hour later) and the corrosive action of chemicals in the atmosphere are neutralized by several layers of protective paint.

In the sixties Braniff International Airways broke with white and grey and introduced liveries in primary colours, like that of 'Big Orange', *below*. Later designs included original work by the American kinetic artist Alexander Calder.

Expensive automobiles need a durable, high-quality paint. Without it, they will literally fall to pieces after a time. Metallic colours, which became best sellers during the seventies, have an extra coat of varnish which will give extra protection to the body as long as it remains unscratched.

Automobile paints undergo the most rigorous testing of any consumer paint: samples are exposed to variable weather for three years or even longer. The paint is baked on in the factory, but custom jobs and resprays are likely to be air-dried or given a low bake, making them slightly less resilient than the original coat.

Each automobile manufacturer devises his own formulae and offers a range of colours based on those in current fashion.

Paints for interiors and exteriors may be similar in formula but totally different in character. Classic high-gloss alkyds (white gloss is the universal best seller) are the most versatile household paints, indoors and out, for wood, metal and even masonry. The glowing red gloss in this kitchen is resisting the ubiquitous kitchen evils of steam, fumes and condensation, as well as brightening the room. For walls, lightweight emulsions in flat, eggshell, silky or glossy textures are the usual choice, giving a quick-drying, easy-care décor. Some manufacturers produce glazing liquids for ultra-high gloss.

Most emulsions are for indoor use, but, given a well-prepared exterior wall, some survive better than alkyds—being plastic, they are almost indestructible. Really tough exterior paints contain sand, mica, or nylon fibres, while some pigments (such as iron oxides) are more weatherproof than others. If this brilliantly coloured genie was created in sand-textured paint, he may be around for years; but if he was painted in cheap emulsions, or artists' colours, he may vanish like a puff of smoke within weeks.

The highlights of drama

Twenty-five centuries ago, the stage for those great cycles of drama, the Greek tragedies, was lit by sun or moon or fire. Often all three were called for, as performances could last all night. The mood and content of the plays were thus enhanced by the glow of the setting sun, the fervour of torchlight and the reconciling light of the rosy-fingered dawn. Today, the gods that light amphitheatres are lighting designers. They command armouries of high-powered lamps and a virtually inexhaustible variety of colour filters, remotely controlled by fingertip from a console display that would not look out of place in Houston space control.

But the lighting designer is a modern phenomenon. Even gas lighting was only introduced at the beginning of the nineteenth century, and until then plays were lit by naked flames much as the Greek tragedies were. Perhaps the most important change was the move indoors; Shakespeare's plays were performed in simple cockpit theatres, open to the sky, like the Globe at Southwark—but only in summer. In colder weather they moved inside the nearby Blackfriars theatre, exchanging natural light for atmospheric candle-light.

However, in Italy the embryo Commedia dell'Arte was performing indoor extravaganzas that required much more than candle-light. Called masques, these entertainments were part drama, part song and dance, but above all they employed special effects on an unprecedented scale. Great machines worked off-stage to move planets through their courses and to carry gods in chariots across the heavens. Light was as much a part of the spectacle as a means of illuminating the stage. Glass bottles were filled with coloured chemicals, or even wine, and lit from behind by great lamps to produce starlit skies or stained-glass window effects. Candle-light reflected off metal bowls and, in the auditorium, off crystal chandeliers, causing the stage to scintillate.

From all over Europe, men came to gaze at the Italian masques and returned to their native countries full of ideas and innovations. In Germany, Joseph Furttenbach introduced the first footlights—oil lamps or candles along the edge of the stage and in columns in the wings; in England, Inigo Jones built elaborate stage sets studded with 'Jewel glasses' which were filled with coloured fluids and 'glowed like Diamonds, Rubies, Sapphires, Emeralds . . . the reflexe of which, with other lights placed in the concave, upon the Masquers habits was full of glory'.

The advent of gas had a marked effect on stage lighting. It was brighter and easier to control, but dangerous; theatres burned as

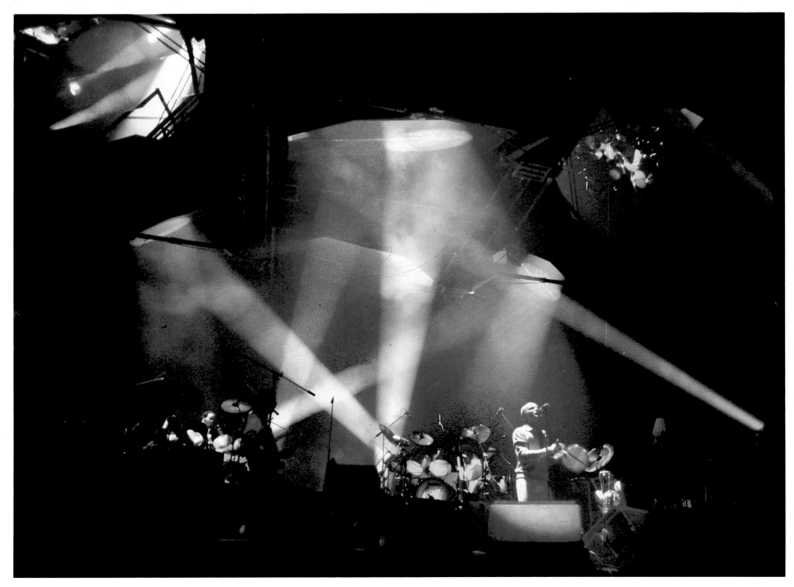

regularly as bonfires—385 in America, Britain and France during the first 77 years of the nineteenth century. Another form of lighting at this time was to leave its mark not only on the stage but also on the language—limelight. Produced by a jet of flame directed on to a cylindrical block of lime, it emitted a brilliant white light which could be concentrated by a reflector into a powerful beam. At last star performers could stand out in the blaze of glory that was their due.

Surprisingly, little creative advantage was taken of gas lighting except by the enterprising actor-manager Henry Irving, who improvised coloured filters from sheets of thin silk, placing them in front of the lights. And, for greater effect, he instigated the practice—now standard—of darkening the auditorium during performances. A member of his company, the famous Ellen Terry, was to recall the unique atmosphere of gaslit drama which had replaced the flickering magic of candle-light: 'the thick softness of gaslight, with the lovely specks and motes in it, so like natural light, gave illusion to many a scene which is now revealed in all its native trashiness by electricity.'

Trashy it may have been, but with the development in the twenties of the projector lamp, whose intense spotlight could be remotely controlled by dimmer switches, electric stage lighting achieved an unprecedented flexibility and subtlety. Now scores of such lights are strung around the stage, producing beams with soft or hard edges for flooding whole areas with light or pinpointing small spots. Fitted with colour filters and controlled by a lighting 'score' planned by the designers in rehearsal, they evoke a whole spectrum of moods throughout the performance. Like a good musical score for a movie, the lighting should never intrude, but rather enhance the production by illuminating an actor's face in warm or cold, soft or hard colours.

Modern stage lights are easily positioned above or to the side of the stage to create mood or special dramatic effects—the tender glow of a love scene, perhaps, or the menacing elongated mask of a solitary man standing underneath a street lamp. By picking out the hand that is pouring poison into the glass or reflecting the colours in a costume, lights can draw attention to significant events or dramatize the entrance of a new character far more easily than in ancient Greek times, when the stage had to be laboriously angled to catch the rays of a rising or setting sun. But it would be hard to equal the beauty of Greek torchlight, used to draw a delicate 'snowstorm' of moths out of the dark night.

A simple stage set can be infused with tension by a bold use of coloured light. The unearthly red glow which has descended on this scene from above might blot out the main performer altogether, if the lighting designer had not contrived to keep an inconspicuous spotlight on his face. An angle of 45° from the vertical of the face is the most natural angle from which to be lighted; sideways or overhead lighting is a deliberate distortion to create particular effects.

Very different from the coloured popping lights which surrounded the rock'n'roll bands of the fifties, the massive rig, *left*, holds six gigantic mirrors above the musicians. They can be pivoted at any angle to reflect and mix the coloured beams of light strategically placed around the stage, *far left*. The mirrors are black on the reverse side so that they can be turned round to stop all reflection. High-intensity lights are hung around the mirrors to shoot down vertical, solid-looking shafts which create a 'cage' around the performers. At least six differently coloured lights are used to help create the right atmosphere; strong primary colours suit the dynamic medium of rock 'n' roll. The American stars Bruce Springsteen and Jackson Browne toured at various times with predominantly blue lighting rigs—their 'moodier' kind of music was reflected in the distancing effects of blue light. It is up to the lighting engineer to keep his red and gold light beams bouncing up and down on the band during an up-and-rocking number or, for example, to cut the lights to a few, very still, beams during a moody solo; atmospheric organ music can be backlit in red to great effect, while a sparkling shaft of gold light is ideal for a saxophone, wailing like a damned soul in torment.

Lasers: the purest light

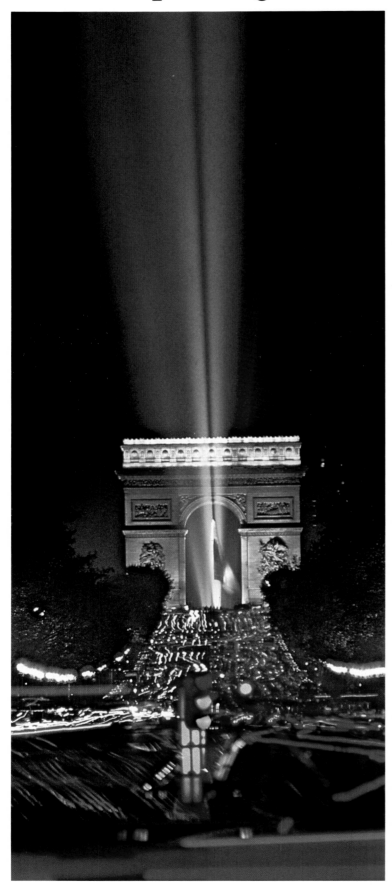

True public lighting began when arc lamps replaced gas lighting on city streets. The white glare they emitted was very different from the mauves and oranges of today's high-intensity mercury vapour and low-intensity sodium street lights. But neither presents so striking a contrast with arc lamps as neon lights, discovered at the end of the nineteenth century when an electric current was passed through a tube of neon gas. By the sixties neon lighting was inspiring pop-art sculpture; and, together with the vogue for *son et lumière*, the spotlighting of buildings and coloured light displays on special occasions, the transition from functional to decorative public lighting was complete.

But of all the new techniques of illumination that modern science has brought, none seizes the imagination more than Light Amplification by Stimulated Emission of Radiation: the laser. A laser beam is so razor-sharp and so dense that it can be focused by a lens on a spot no bigger than a micrometre (one millionth of a metre) or even smaller. Colour is determined by its wavelength —a laser is a concentrated beam of monochromatic light—and the result is a purity of hue unknown in nature.

The principles which underlie the laser are as complicated as the nature of light itself, but the apparatus is relatively simple. A laser amplifies light waves, rather in the way that it is possible to amplify sound. But the problem with light is that it is naturally chaotic; sunlight, electric or candle-light scatters a mixture of wavelengths in all directions, in a way that is described as incoherent. Laser light is coherent, a single pulse of such intensity that it will emerge from a prism exactly as it went in.

The first laser was created in 1960 when scientists in a Californian laboratory produced a blinding pulse of light which, when focused, could drill a hole through a diamond. The medium they used was a rod of synthetic ruby, soon to be replaced by a hollow tube filled with gas which produces a continuous beam rather than a series of flashes. Both these types of laser consist of sealed tubes in which the internal ends are reflective, one end only partially, like a two-way mirror. The atoms in the laser medium, gas or solid, are then stimulated by an outside power source—bursts of light from a flash tube, for instance, similar to those used in 'strobe' lighting. This causes the atoms to emit photons of light which are unable to escape randomly as they do, for example, in a conventional incandescent bulb or fluorescent tube.

Instead, they bounce backwards and forwards between the reflecting ends until they fall into a regular or coherent wavelength of great intensity. This is emitted through the partially mirrored end of the tube either in the vivid flashes of the pulse laser or in an even beam from a gas laser. The heat and brightness of such a beam has boundless potential, from micro-surgery (where the controlled precision of its heat can be used like a surgeon's knife) to communications. Light has a far higher frequency than radio waves, and a laser beam could be used to carry millions of television or other signals through fibre optic cables which enable the beam to turn corners.

The colour of a laser beam is determined by the kind of gas used in the tube. The most familiar colour is the red light emitted by a laser using helium-neon gas. More expensive gases like krypton can produce red, green, blue and yellow, while argon is basically used for a green that can be adjusted to produce a bluish green. Orange lasers have not yet been produced. However, a way of expanding the colour range has been found by introducing a second laser-chamber filled with dye instead of gas. This acts as a 'fine tuner' of the frequency of the original laser beam, and may in time be able to produce the three specific

primary colours necessary for all the colours of the spectrum.

Laser lights have become enormously popular for prestigious civic displays and even for rock concerts. But more intriguing, and potentially more valuble, is their use in the art of holography. From the Greek word *holos* meaning 'whole', holograms are three-dimensional photographs you can actually walk around without being able to tell the difference between the real object and the image—until you put your hand through it. The principle has been known since the late forties but no light source was powerful enough to produce one until the advent of the laser.

To make a hologram, the laser beam has first to be split into two, one part of which is called the reference beam. This is directed by mirrors and spread by an expanding lens on a holographic plate. The other, called the object beam, is directed at whatever object is to be registered; unlike a photograph, which records only different intensities of light and dark, the whole shape and surface of the object is recorded by the beam. Where the reference beam and object beam overlap, interference wavelengths are set up which reproduce the shape and depth of the object on the plate.

The predominant colours of such images are usually rather weird greens or reds—laser light neither is nor looks natural. But colour variation does occur according to the type of emulsion used to record the image on the holographic plate. A gelatine, for instance, will shrink or expand in warm or cold so that a thermostatically controlled environment would have to be used to obtain a true colour balance. Secondly, the type of light that is shone on the hologram for viewing affects the colour quality. But a small, monochrome hologram that can be 'hung' in a living-room may soon become as commonplace as photographs are today. Full-colour images may take a little longer; one expert claims that they would require six secondary dye-lasers, putting the cost well out of reach of the average householder.

The uncanny, monochrome light that is characteristic of holograms is best used in reproducing objects which are metallic, gold, silver or even crystal like this Aztec skull. Although they appear to be realistically floating in mid-air holograms can only be produced by means of a film or plate. But, unlike the optical illusion of stereoscopy, the shapes in a hologram retain their spatial relationship to each other and therefore change with the changing viewpoint of the observer. Several images can also be stored on a single plate.

Arc light beams in the colours of the French *tricolore, far left*, were shone from the Arc de Triomphe as part of the Bastille Day celebrations. They are direct descendants of the first arc lights which appeared in Paris around 1841 simply to illumine the streets. Some forty years later, the advent of the new dynamo-electric machinery enabled 90,000 such lamps to light up America. Even more sophisticated display lighting is provided by lasers. They were originally referred to as inventions with no use; in the sixties their application was unclear. Now, lasers can be used for the remote control of satellites, for precision eye surgery and just for fun. The coloured light display, *left*, is particularly impressive because the intensity of the beams gives the illusion of solid, almost tangible bars of light. Prolonged working with the razor-sharp light of lasers can have harmful effects.

FASHIONS IN COLOUR

A stylishly dressed woman appraises her reflection in a mirror. The glass reflects the colours of her outfit, as well as its cut and style; the colours of her hair and make-up, as well as those of her dress, and the colours of the décor in the room behind her.

Fashions, and the colours in fashion, mirror the spirit of their age; their changes reflect the changing influences at work on society. Religious symbolism, ubiquitous in the Middle Ages, made red the favourite colour in medieval dress, for it signified courage and purity. In later centuries, when monarchs held absolute power, fashion colour trends were set and changed at the whim of a ruler, a capricious queen or a successful courtesan. Ladies of the French court adopted in the eighteenth century the light pastels beloved of Marie Antoinette.

The French court had long influenced the fashion styles of Europe. And when Worth, the Empress's courturier, began designing for foreign aristocracies in 1855, Paris became the centre of the world fashion trade. In recent years it has lost some of its pre-eminence. Its first challenge came from Hollywood during the thirties, when Jean Harlow created a craze for platinum blond hair and sensuous red lipstick. The fashion for black leather jackets begun by James Dean reflected the emergence of an affluent post-war generation bent on negating the values of the past. Black has been a constant among the post-war revolutionary young.

But the impact of personalities is only one of many influences that combine to change fashions in colour. During the sixteenth and seventeenth centuries the dark tones in dress painted by Holbein, Poussin, Caravaggio and Rigaud inspired contemporary fashion colours in dress, while the influence of the clear, delicate pastel tones of eighteenth-century colourists was evidenced in décor as well as in costume. The new interpretations of everyday hues wrought by Renoir and Monet, Pissarro and Sisley had an appreciable influence on the colours of clothes between 1860 and 1885. Now, new movements in art combine with popular retrospectives on Tutankhamun, for instance, or Pompeii, in bringing into vogue new colours and styles.

Technology's impact on lifestyles initiates social upheavals that are reflected by changes in mode. The availability and cost of textiles, and dyestuffs with which to colour them, once dictated the colours that could be the protegées of fashion. Now, the available range of both is so wide that fabrics and dyes are produced in anticipation of consumer demand.

For there is today little that is accidental about the new colours of clothes, cosmetics, carpets, cars, even though the exuberance with which they are publicized simulates spontaneity. They are the fruits of international consensus, albeit individually interpreted, as to what the consumer is going to want to see in the stores, and they are thrashed out, rehashed and finalized months in advance of their public debuts. The little-known but widely influential professional, the colour consultant, monitors the trends and brings together designers, manufacturers and retailers so that decisions may be reached in concert.

The process begins with an idea for a colour range which must then be dyed into a yarn, a plastic or a paint. Because the influential apparel fashion fields change faster than the home furnishings, automotive or kitchen appliance industries, and because there must be fabric before there can be fashion and yarn before there can be fabric, it is the fibre manufacturers who must make the crucial early decisions. Working roughly six months ahead of launch season, they devise their 'colour stories' (collections of compatible shades given umbrella titles—'pearls and shells'; 'oriental colours') and confer with one another to co-ordinate with the trend predicted.

At least twice a year, in Paris, Milan, New York and London, makers of cotton, silk, wool and synthetics meet with design and colour consultants from all over the world, with members of such organizations as the American Color Marketing Group and the British Colour Council, and with designers, manufacturers and retailers. The mass market fashion world is no place to go it alone: the investments are such that the accessories and separates produced by different makers should tone sympathetically with one another.

Representatives bring their predictions and interpretations as manifest on cards with little fluffs of custom-dyed yarn. The dyers will have worked from briefs as abstract as a photograph, a tear-sheet from a magazine, an object or a scrap of some old fabric—anything the colour consultant could find to suggest the desired new colours. Remarkably, time after time the colour cards brought from all over the world to the Paris meetings are already so attuned that only slight adjustments are necessary.

The ideas for a new season's colours generally grow out of the existing popular palette. They assimilate the impact of everything from media events (a hit film, a book, play or major art exhibition) to living trends (the vogue for jogging, the trend towards smaller apartments, the craze for disco, an increase in foreign travel) and international events (an economic slump or the *détente* with China). These must be rationalized with a host of practical considerations—cost (the dyestuffs for a deep wine red might be 16 times as expensive as for a beige); the number of dyestuffs needed to make the colour (too many variables can cause inconsistency in matching); suitability to fibre; end use; the look of the colour seen in bulk on racks.

The regular semi-annual to biannual pattern into which colour changes have settled is a compromise between insatiable demand for novelty by consumers and financially and logistically feasible methods by producers. For the simple reason that colour is the first thing to seize a shopper's gaze and the last thing to clinch a purchase, fashion colours will always change.

The century opens quietly

The new century opened with an old custom—that of giving an exhibition in Paris to stimulate international trade. Much had happened since the Great Exhibition of 1851. Edison had harnessed electricity and the shimmering illuminations marked the opening of a decade in which the decorative arts explored the colour possibilities of iridescence. Art Nouveau had given glass a new rainbow glaze, and the currently fashionable half-moon or star-shaped diamond brooches were being replaced by Lalique's dragonflies and strange orchids set with opals, moonstones and chrysoprase, in colours that seemed chiselled from moonlight. A woman was president of the Exhibition's Fashion Section.

Mme Paquin, the *grande couturière* and a great beauty, showed off her splendid figure to advantage in new styles in which the corset pushed the bosom forwards and pulled the waist backwards. Skirts flared out into fullness around the feet and sometimes developed into slight trains, thus giving the wearer an opportunity of holding them up to show off the frills and flounces of her petticoats.

Lingerie, of unprecedented importance, was trimmed with lace, with insertions through which coloured ribbons could be threaded. So important was the theme of lingerie that whole dresses, and even coats, were made of lace or *broderie anglaise*, often with a lace-trimmed hat and parasol to match. The parasol was essential to protect the owner's complexion. A milk-and-roses skin was the ideal; sun-tan would have been a disaster and

even a freckle was frowned on. Cosmetics were scarce, and, save for a slight blush on the cheeks made discreetly with rachel pink powder (schoolgirls experimented with rose and geranium petals), were not overtly used.

Replacing the brilliant maroons, purples and black of the old century, the favourite shades for the rustling silks, soft satins and flimsy chiffons of the new were the colours of the sweet pea. Young girls wore white. Mauve predominated for older women; *l'heure mauve* was a term to describe twilight.

The coiffures were as elaborate as the lingerie and as free from synthetic dyes—although contemporary recipe books included time-tested preparations of herbs such as henna and camomile, intended for bleaching and tinting the hair. The complicated coiffures were topped with large hats heavy with flowers and feathers—sometimes even fruit.

Women's shoes and stockings were universally black, with cotton for the poor and silk for the rich. Brown shoes were for the country with stout lisle thread stockings to match. The favourite accessory was the feather boa, well-curled and obtainable in any colour to match the costume, and the favourite fur—pale grey chinchilla. Gloves were worn by both sexes and all classes. There was a daytime choice of white, pale grey or fawn, with the inevitable black for mourning. In the evening both sexes wore white gloves. Pastel shades were augmented by brilliant spangles in the elaborate evening gowns worn for formal occasions.

The colours of roses were featured in the *Album des Blouses Nouvelles* in 1910. They reflected the watercolours of Madeleine Lemaire, of whom Alexandre Dumas said that no one after God had created more roses. Blooms that seemed as heavy as cabbages were common motifs for wallpapers and furnishing fabrics, and adornments for cartwheel hats, worn both in the street and the drawing-room, which grew larger and larger as the decade advanced.

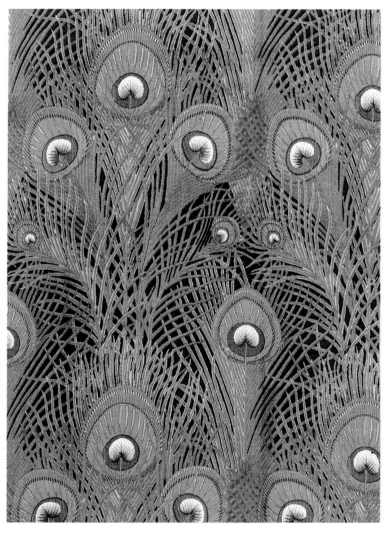

In reaction against the crude and violent purples, greens and reds resulting from the production of the first synthetic dyes, William Morris and the founders of the English Arts and Crafts Movement had sought to restore the colours of natural vegetable dyes to wallpapers, chintzes and other furnishing fabrics. Morris's doctrine of craftsmanship became the basis of a new style of interior design led by the Glasgow School. Charles Rennie Mackintosh's first Art Nouveau cabinets were white, the insides of the doors were painted silver and inlaid with opaque, coloured glass. In 1904 he designed the first of his off-white rooms with pale green and pink decorations. Rooms coloured in pastel shades and furnished in inlaid and enamelled light woods became the signature of the decade.

In Paris, Robert de Montesquiou, patron of the arts, cut a figure of elegant harmony dressed in shades of grey. But men's clothes were sober. Suits were formal and dark; black suits were worn with black top hats in London in the City. Women were expected to be fragile, men protective—or predatory. Good manners hid bad habits just as careful corsetry and elaborate gowns hid bad figures. Into this decorous and deceitful world fell a bombshell. In June, 1909, the Ballets Russes arrived in Paris and caused an uproar. For instead of pastel shades, the Russian artists who designed the décors and costumes for Diaghilev's ballets used brilliant primary colours in combinations unseen outside the Orient.

Delicate pastels decorated rooms designed in the revolutionary Art Nouveau style. Exotic woods— tulip, amboyna, mimosa, maple, coromandel, ash and walnut—were made to harmonize in strangely asymmetrical furniture, and curtains were of pastel-dyed Japanese silk. Typically, the bedroom, *left*, a design of the Ecole de Nancy, the French centre of Art Nouveau, has wall coverings and upholstery in the same luminous Japanese brocade. The peacock-feather vase was designed by Tiffany, who devised new techniques to capture iridescent colours in glass. American Tiffany glass was made by exposing hot glass to metallic fumes and oxides; verdigris produced the greens in the wisteria table lamp, *below*.

Iridescent hues enlivened the decade—and peacock feathers became a recurrent theme in design. The peacock feather cotton fabric, *left*, was commissioned by Liberty's of London from Arthur Silver, founder of the first English design studio. His schemes were intended to be practical in colour and form, and adapted peculiarly to the material for which they were designed.

For cycling, French girls wore blue bloomers and sailor hats, white blouses and black shoes and stockings, *below*; but English girls bicycled in tweed skirts. For motoring, khaki dustcoats were popular: the word khaki was coined by British troops from the Afghan word for dust.

A brilliant explosion–and a war

The influences of modern art pervaded thinking about fashion colours during the second decade of the century. Paul Poiret replaced the pale mauves, pinks and frail laces in vogue early in the decade with the violent colours of the Fauves, shocking Society with simple tunics in cerise, scarlet and apple green. He forbade corsets and changed the shape—and improved the health—of thousands of women. He bared the knees with skirts slit to reveal flesh-coloured or 'champagne' stockings and, later, stockings in all colours—and designed knee-high boots of dyed Moroccan leather to accompany them.

The palettes of the Impressionists and neo-Impressionists influenced Poiret, just as they influenced the artists who designed décors and costumes for the Ballets Russes in gaudy combinations of colour. A Russian painter, Leon Bakst, made the greatest impact with the décor for the audacious oriental ballet, *Schéhérazade*, performed in 1910, in which he abandoned painted scenery in favour of soft draperies, cushions and carpets. And in his costumes, which both concealed and exposed the body, the dancers formed kinetic images composed of juxtapositions of hot colours unprecedented in the theatre.

The influence of the Ballets Russes was all-pervasive. It affected interior decoration for an ephemeral season in which salons and drawing-rooms were converted with richly textured and patterned draperies, and heaps of cushions, into oriental harems coloured in greens, reds and oranges.

Delaunay, Picasso, Matisse, Braque, Gris and Utrillo designed décors and costumes for the Ballets Russes. Cartier began setting emeralds and sapphires together and Fortuny designed pleated dresses dyed in colours that glowed like jewels. Store windows in London and New York were dedicated to advertising the influence. But Paul Poiret both anticipated and was the most successful protagonist of the surge of orientalism which followed the Ballets. He revolutionized not only women's wardrobes, but also their homes. His firm, Martine, named after his eldest daughter, brought bright colours, simple but luxurious furniture in rich new woods, and wallpapers designed by young enthusiastic artists to replace the false antiques and dull brocades which still lingered in staid homes.

With the outbreak of World War I, fashion changed and many a soldier home on leave was astonished to find his womenfolk, whom he had left hobbled in long, tight skirts, walking freely in full skirts short enough to show off their feet and ankles—often shod in scarlet Russian boots which were the favoured footwear of Lucille, a famous London couturière. Khaki, adopted by the British Army as a uniform colour during World War I, was a preferred colour for the novelty pastime of motoring which demanded a totally new wardrobe: dust-proof, rain-proof and wind-proof.

In 1911, a New York store advertised a Motor Box of cosmetics intended to protect a lady's skin against the coarsening influences of sun, wind and dust. It contained rouge. In 1912 *Vogue* magazine, tentatively legitimizing the use of *maquillage* by the advocates of orientalism, opined that the discreet application of a little paint would enhance a lady's appearance. The first American lipsticks in slide tubes appeared around 1915.

Men's clothes lightened a little after World War I with the introduction of grey flannel Oxford bags, but women's fashions took a darker turn. Navy blue rivalled brown for morning wear, and a restrained check or stripe was all that was permitted to offset the dullness of the new one-piece day dress. But women retained bright colours for their evening wraps—and for the tunics worn over long skirts of a paler shade: one of Poiret's favourite whims.

The use of primary colours in endless harmonies, which characterized the colour schemes of Serge Diaghilev's influential Ballets Russes, are epitomized in Bakst's watercolour, *right*, of the costume he designed for Nijinsky in *Les Orientales*, performed in 1910.

The colours of the Orient captured the imagination of the French couturier, Paul Poiret, who in 1905 designed the first of his revolutionary high-waisted gowns. By rejecting the corseted S-curve in favour of a natural outline and styles of simple elegance that hung from the shoulders, Poiret liberated the female figure. His bold patterns in vivid colours predated the arrival in Paris of the Ballets Russes, though his later designs reflect the canary yellows, bright blues, jades, cerises and cyclamens popularized by Bakst. The theatre cloak, *above*, appeared in a 1912 issue of the lavish new French fashion magazine, *La Gazette du Bon Ton*. But while Bakst used black in one costume only, many of Poiret's creations were trimmed or executed in black. Black kohl encircled the eyes of Poiret's models, for with the new style came a new face, accentuated with make-up. And to accompany the short hairstyles he introduced to emphasize the elongated lines of his designs, he chose a turban in a contrasting colour, adorned with a tall upstanding aigrette.

Influenced by the colours in the paintings of Mikhail Vrubel, and the Impressionists and their successors, by Russian folk costume and by the 1900 visit of the Royal Bangkok Ballet to St. Petersburg, Leon Bakst's designs dominated the Ballets Russes from 1910, their second season in Paris. The erotic, exotic images he created with the widest range of colours the stage had ever seen, seduced Paris: his mustards, violets, yellows and blues had never been seen in dress before. The face, the outline and home décor changed within a year.

The rich flowing colours Bakst put into backgrounds such as the décor for *Les Orientales, above*, began a craze for oriental-style interiors in which to display the peacock hues of 'modern dress'. Drawing-rooms became scaled-down stage sets draped with richly textured velvets, satins and chintzes patterned with bold designs. Smart people lounged on cushions and huge pillows in exotic garments and, for the first time, the divan became a standard item of furniture in fashion-conscious European and American homes.

During World War I, aircraft were boldly identified with heraldic markings painted in the primary colours characteristic of the decade. In 1916 Manfred von Richthofen, an officer pilot in the German Imperial Air Service, had his fighter painted bright red because he wanted to be recognized as a formidable opponent. Shortly afterwards, his own squadron, Jasta 11, followed suit. In 1918, von Richthofen was killed in his distinctive Fokker tri-plane, *right*, which had earned him the title 'The Red Baron'.

The subdued twenties

A new colour spectrum began to creep across the fashion scene during the early twenties. This was partly a reaction against the fantasies of the Ballets Russes, and also due to the increasing influence of sport, and to the emancipation of women.

It was Chanel who made the greatest impact. In 1922 beige came in and Chanel promoted it, the story goes, to use up an army surplus. Her salon was beige. She translated the understated elegance of the Englishman's tailored clothes into slim skirts and collarless jackets of tweeds especially woven for her in subtle shades of beige. She teamed flesh-coloured stockings and pale beige shoes with toes and heels of black to emphasize the length of the leg. She introduced the pullover in palest shades, counterpointed with magnificent costume jewellery in emerald green or ruby red. Rodier produced and marketed beige kasha, a wool that felt like silk, from the pelt of a Himalayan goat to which he had secured exclusive purchasing rights.

When Suzanne Lenglen leapt on to the tennis courts in a short white pleated skirt and a sleeveless white jumper top, her audacity hit the headlines. Her outfit was designed by Patou, who created delectable chiffon dresses in white, sometimes glittering with sequins or fluttering with feathers, for another star—the ballroom dancer, Leonora Hughes. Evening occasions in the twenties gleamed with pale but lustrous satins, crêpes, silks, velvets and taffetas, trimmed with gilt lace, *diamanté* and beads. Bracelets and rings encircled with diamonds were in vogue and pearls became part of every fashion-conscious woman's uniform. Black and white jewellery was made from white gold, silver or platinum, set with diamonds, rock crystal or black onyx.

Glitter invaded the home in the form of glossy lacquered furniture and screens, shiny tiled floors and varnished walls. Furniture was ornamented with metals—gold, silver, bronze, steel and chrome, combined with marble and glass. During the early twenties there was a fashion for silver and black décor. In London, Lady Irene Ravensdale, daughter of Lord Curzon, had a

dining-room lined with black glass. The carpet and curtains were black, and niches in the walls held black vases in which stood white arum lilies. Such rooms glowed softly with concealed and indirect lighting.

Photography and film influenced the twenties, especially in disseminating the cult of make-up. In 1924 it was estimated that 50,000,000 American women were using 3,000 miles of lipstick a year—and nails became red after Peggy Sage brought out the first coloured nail varnish.

High points of colour were introduced into the decade by the painter Sonia Delaunay who brought the intense colours beloved of Van Gogh and Gauguin, and forms inspired by Cubism, to textiles and fashion designs in which she attempted to express colour in terms of musical scales, harmonies and rhythms.

In London the Prince of Wales, heir to the throne, advocated more colourful dress for men, influencing and sometimes shocking Society with his sartorial eccentricities.

At the 1925 *Exposition des Arts Décoratifs* in Paris, Poiret's showroom—three barges moored on the Seine and decorated in the style of his firm, Martine—seemed *vieux jeux* in comparison with the new interiors in restrained harmonies of black and gold, grey and silver and brown and white by designers such as Ruhlmann and Sue et Mare. Furniture in very light or very dark woods, plain cream walls and curtains, and all-over carpeting in neutral tones created an impression of light, space and hygiene. Over-trimmed lampshades were replaced by pleated parchment or by large, plain glass globes, and strip lighting gave a new colour aspect to a vogue for monochromatic rooms in pale blue, green, yellow or burnt orange. Silver rooms had walls and ceilings pasted with the speckled silver paper used to line tea chests, and there was a fashion for black and white rooms. Black varnished walls were a dramatic foil for lacquered and gilt furniture, chinoiserie or African art and artifacts. The art of lacquering was taught in Paris early in the century by a Japanese artist, Sugawara, and became a fashion in the hands of his pupils, Eileen Grey and Jean Dunand, who were famous for their spectacular black, red and gold screens.

These bold new ideas which re-established France as a leader of fashion were transported across the Atlantic. American movies, produced in black and white, reflected the subdued and sophisticated tones which prevailed as the decade advanced. But the Hollywood image of Art Deco, typified in this set from *Our Dancing Daughters* (1928), was a glamorization. Movie sets of the twenties took a style that had begun as a luxury for an exclusive clientele and converted it into an illusion of luxury for the many.

The production-line Fords were painted with a stoving-enamel dubbed 'Japan enamel' because of its lacquer-like qualities. It dried faster than coach paints, but came only in black. This became a production gimmick for the Model Ts: 'a customer can have a car painted any colour as long as it is black'. The Model A, launched in 1927, was painted with a new range of coloured lacquers.

In France, where the fine and decorative arts were traditionally allied, Cubism was one of the strongest influences on twenties' designers. The forms and colours of Cubist and abstract art, applied to architecture, textile design, costume and artifacts gave the period the Art Deco look. France led the world in the development of new crafts: the arts of ceramics and glass-making benefited from technical innovations and revivals of techniques such as enamelling on glass, *above*. Black enamel, like black lacquer, was popular in the decorative arts as a background for Chinese motifs.

'A heron's plume of black more sharply throws/Into relief the white that ermine shows' wrote Madeleine de Scudéry, the seventeenth-century aesthete. The twenties took her words literally, *left*. Black and white, worn either separately or together, came into fashion during the early years of the decade, when black evening dresses were sometimes seen, trimmed with glittering *diamanté*, and worn with long ermine wraps. By the end of the decade ivory satin was the vogue for evening wear, with white fox—and black and white predominated at the 1920 Paris Collections.

White satin and glitter

A period of indecision began with the thirties. Fashion hesitated at every turn. Should skirts be long or short? Hair curled, shingled or bobbed? Should colour replace the white satin evening gown, by now the feminine equivalent of men's black dinner suits?

The post-Depression years saw some novel social developments. During the twenties, scientists first publicized the role of the sun in combating dietary deficiencies. Annual vacations for employees were introduced. A sun-tan became essential to look stylish on the beach, and, to enhance it, white swimming suits and evening gowns were *de rigueur*.

The all-white interior grew out of the twenties' vogue for monochromatic rooms; its charm lay in the impression of lightness and space it created. The greatest names in the new profession of interior design interpreted the theme in different ways: Arundell Clarke had an all-white showroom in Mayfair, London; the early work of the French designer, Jean-Michel Frank, was executed in variations on the theme of white and beige; the American photographer, Curtis Moffat, designed white rooms in the 'modernist' style. Furniture was lacquered or upholstered in white, and pale sycamore was popular for wooden furniture; 'modernist' designers used tubular steel, chrome, or metal plating. Walls were painted with the new washable distempers, or with unremovable plastic paints made of powdered marble or mica mixed with powdered plastic; once pasted on the wall they were incised. There was a fashion for textured wallpapers in off-white shades.

The all-white interior had its apotheosis in Syrie Maugham's famous drawing-room with its white rugs designed by Marion Dorn and woven by Wilton in different stitches and depths to give a pattern of shadows. White satin was used for the curtains and covered the sofa and chairs. Madonna lilies stood in glass containers; even the Christmas tree was dressed with white gardenias instead of tinsel.

The white craze was dying by 1934, and colour slowly returned to fashion. Pale evening dresses in crêpe, *matelassé* (a pure silk with a crinkled surface) or ciré (lacquered satin) were worn with long, dark gloves. Hats and gloves of brightly patterned material were added to plain suits and dresses, and floral motifs returned. Certain thirties' colour schemes are so distinctive they have rarely been revived: cocoa brown with hyacinth blue, prune with turquoise, mustard yellow with grey are now thought of as characteristic of the period. The little black dress appeared at every cocktail party.

In 1929, the 'Men's Dress Reform Party' was founded in London, to try and establish colourful and comfortable fashions for men. Its members suggested replacing trousers with tunics or one-piece suits with zips. They succeeded in establishing shorts for sports clothes—for tennis or on the beach, but had to concede the lead to colourful American sportswear.

In 1930 New York received a bombshell almost as stunning as that of the Ballets Russes in 1916. The Museum of Modern Art exhibited Van Gogh, and the event attracted so much attention that the doors had to be closed. Sunflower prints, fabrics in stark yellows, greens, blues and browns from the mad painter's palette appeared in dress.

A bombshell of a very different kind reached London in 1936 when the first International Surrealist Exhibition was held at the New Burlington Galleries and caused an uproar. The startling colours motivated such a serious artist as Paul Nash to write in praise of the exhibition and to design a bathroom for the dancer Tilly Losch in what was then a novelty—coloured glass.

Schiaparelli was the catalyst who transformed the fantasies of the Surrealists into fashion. Her hat shaped like a shoe was designed in collaboration with Salvador Dali. She launched a vivid new colour, 'shocking pink', intended to startle. Her colours have been recorded by her artist friend Bébé Bérard, whose beard was always as colourful as his exhibits owing to his habit of wiping his brush on it. Surrealist motifs and Surrealist art found their way into interior design, and appeared in furniture, glass, ceramics and jewellery.

This renewed pleasure in colourful surroundings was exemplified in the furnishings of the Orient liner *Orion*, where artists of note were called in to design the furniture and furnishings and to decorate the walls. It became the fashion to have painted wall panels in the house, and Rex Whistler, John Armstrong, Vanessa Bell, Gino Severini and Nickie de Molas all painted murals.

At the end of July 1939, just before the declaration of war, the couture collections in Paris were the most magnificent ever seen. They were a gala with every style, every fantasy imaginable—the final fling of a world about to vanish. In the winter of 1940, with the phoney war still hanging over darkened cities and cold houses, the couturiers bravely showed their Spring Collections as usual. Among the multitude of extravagant models were a number of trim suits in rather subdued colours with military-style braided jackets and square shoulders—a prophetic gesture, to be much copied in the years to come.

Sculpture in fabric produced the willowy, elegant look that characterized the earliest years of the decade. The bias cut introduced by the French couturière, Madeleine Vionnet, utilized the cross grain of the fabric to make dresses flow along the contours of the body. Such elegant lines were best emphasized by shimmering satin; decoration and colour served only to enhance form. The decade began with a craze for white. Bias-cut evening dresses in white and ivory dominated the Paris Collections of 1932, and the movies of Jean Harlow, whose glamorous blond image epitomized the thirties' 'white' look. Coloured evening gowns were dyed in the palest *eau-de-Nil* or the shades of peach illustrated on this cover from a 1932 issue of *The Bystander*.

Coloured leather shoes first appeared during the thirties with matching leather clutch bags. The most popular jewellery was a pair of clips that joined together to form a brooch, made of frankly artificial paste—or diamonds. Silver fox was the favourite fur.

Until 1931 lipsticks and nail varnishes came in three shades of red: dark, medium and light. There were eight or so shades of rouge, and eye shadow and mascara came in four or five shades. Eyebrows were plucked and pencilled. After 1931, when Elizabeth Arden launched a range of seven lipstick shades, women faced a growing range of available colours in cosmetics.

The ubiquitous titanium dioxide, the opaque white pigment used to colour cosmetics as well as artists' and household paints, was married with a new fast-drying cellulose lacquer to produce a durable white car paint during the thirties. The post-Depression generation of automobiles was typically as large and ostentatiously luxurious as this 1935 Auburn 851. Nowadays, white means 'luxury' in advertising, and 'classic white' is one of the most popular vehicle colours in Europe and the USA.

Sculpted figures in porcelain, theatrical, life-sized blackamoors in painted and gilded wood and realistically painted hands and legs forming supports for furniture relieved the bareness of thirties' rooms. Coloured and gilded bronze and ivory figurines, *above*, were produced in Europe. Though popular—and costly— they were ignored by arbiters of taste as suited only to the homes of the *nouveaux riches*.

The influential white drawing-room of Syrie Maugham's London house, *right*, which was featured in *The Studio* in 1933, was painted in shades of white ranging from bright white through cream to beige. The effect was enlivened by contrasts of texture and form, and reflections in numerous mirrors, including the mirror screen behind the sofa.

New technology made possible the white rooms of the thirties. White paints made of white lead colouring, natural resins and linseed oil—which tend to yellow rapidly after application—were being replaced by new paints coloured with titanium dioxide, which dried more quickly, yellowed more slowly, and were smoother and more resilient. But white rooms needed more maintenance than servants could provide, and were unthinkable during the age of open cooking ranges and fires, before the introduction of gas cookers, central heating, vacuum cleaners or detergent washing powders made cleaning easier.

Bright badges of wartime courage

'Dusty lime . . . cherry red, tulip pink and orchid mauve; shrill peacock blue; much yellow; much grey . . . this is the spring palette divided between smoky pastels and clear bright colours', reported *Vogue* in February 1940. 'We're not caught napping over dyes this time. In 1914 we were in great difficulties, having left it to Germany to develop the dyeing business . . . As war goes on it may be more difficult to get the strong dark shades of navy, brown, grey and black, because they use up such a quantity of dye; but if we're reduced to pastels—so much the gayer.'

Strong colours were morale-boosters during the gloom of the early war years. Contrasting colours, the theme of the last Páris couturier collections held in summer 1939, were still high fashion in 1941: grey and red, yellow and brown or black, navy and black or red. A suit shown by Molyneux with a square-shouldered scarlet jacket and neat black skirt was translated into khaki or olive and became the standard costume of the young women engaged in war work both in Britain and in the USA.

Textiles and dyestuffs *were* rationed and colours became chalky. Bright reds became muted plums, while lime green greyed and yellowed, and warm beiges, greys and unsaturated blacks were much in evidence.

CC41, introduced in 1942, was the code name for the British Government scheme devised to ensure, by the use of coupons, an equal distribution of scarce resources. Utility clothes (known as 'futility' clothes) were designed by members of the Incorporated Society of London Fashion Designers, a body that included such distinguished names as Hardy Amies, Victor Stiebel, Hartnell and Worth. Utility clothing came in blue, black, brown and green.

In the face of this drab uniformity, colour was somehow retained and used to express individuality. In spite of regulations and shortages, colour appeared in accessories—in caps and gloves hand-knitted with wool from old pullovers and jerseys, and in headscarves. Hitherto worn only by peasants, these became the universal—and colourful—head-covering of British women.

There were no regulations in occupied Paris and although there were many shortages, they did not extend to invention. Girls made up for the lack of pretty clothes by creating extraordinary hats, as large and colourfully trimmed with flowers and ribbons as any worn by their grandmothers. They wore thick cork-soled shoes with coloured uppers made of felt.

In May 1945 the British Board of Trade allowed the coupon-free sale of red, white and blue bunting. Three months later, French couturiers assembled the *Théâtre de la Mode*, a collection of dolls dressed by 41 couturiers. At the first post-war collections Madame Grès received a standing ovation, because she had made the gesture of showing her first collection after the Occupation entirely in red, white and blue—and the Nazis closed the house.

These collections created a sensation by demonstrating· the progress that had been made in the production of *ersatz* materials. Synthetics, it was realized, could be fashion fabrics. But it was not until Christian Dior opened his house in 1947 that French good taste reasserted itself and renewed its traditions of elegance. The colours of the New Look were soft and gentle. Those of Dior's only rival in elegance, the Spanish couturier Balenciaga, were derived from Goya and Velázquez and the bullring. These strong colours predominated during the years following World War II.

During the war years the American fashion world had been cut off from Paris, its main source of inspiration. North American designers turned to South America for inspiration, and to the South Seas. The bright scarlets, yellows and magentas beloved of the Mexicans eventually changed the aspect of resort clothes all over the world.

Posters were produced in quantity and displayed in public and work places for British and American civilian populations during World War II. Many showed women wearing cosmetics, for keeping up appearances meant keeping up morale. The British Ministry of Supply issued a special allowance of high-grade face powder and foundation to its female munitions workers in 1942, although in Britain cosmetics were rationed.

Munitions workers used aircraft 'dope' as nail varnish and, for rouge, lipstick ends were melted and mixed with almond oil.

Americans spent $400,000,000 on cosmetics in 1941, and Helena Rubenstein offered 115 lipsticks. Production of cosmetics was limited for a short time only: they had a role in maintaining morale. American women used Max Factor's pancake make-up, devised for films but now available in six skin tones. And since stockings were scarce on both sides of the Atlantic, leg make-up became a substitute.

Air force blue, *right*, appeared on October 1, 1919. A story says that the colour was chosen by a popular actress, Lily Elsie. Another says that this was the colour of a consignment of cloth ordered by the Imperial Russian Army in 1917, but never delivered.

The truth may be that the choice was an act of diplomacy. To avoid offending its parent services, the Army and the Navy, by adopting the colours of either, the Royal Air Force chose the colour of the sky for its uniform.

American rifle regiments first adopted a camouflage colour—dark green—for their uniforms during the War of Independence. In the 1890s British colonial troops in Afghanistan daubed their white uniforms with dust to be less conspicuous. Khaki, named after the local word for dust, was later adopted as the colour of British army uniforms.

Blue and white became the colours for British naval uniforms in 1746. The choice is said to have been due to George II's admiration for the French Duchess of Bedford's dark blue riding habit with white flashes.

British fighter aircraft were painted in bright heraldic colours until 1938 when the camouflage schemes, *below*, were devised. Spitfires' under-sides, seen against the sky, were painted blue and grey while the upper surfaces were painted green and brown, or in shades of grey, to make them inconspicuous on the airfield or when seen against the sea.

Frank Lloyd Wright designed and built his low-cost Usonian houses, *left*, during the thirties and forties. Based on geometrical construction modules—rectangles, hexagons, circles—they embody Wright's principle of organic or 'natural' architecture: they appear to grow out of the ground, forming an integral part of the environment just as a plant does.

Wright believed that rooms should be as much 'architecture' as façades. He did not have them plastered and decorated, but allowed the natural colours and textures of the building materials to harmonize. 'I began to see brick as brick. I learned to see concrete or glass or metal each for itself. . .' Only the concrete floors of Usonian houses are artificially coloured. They are red to blend with exposed red brick walls and ceilings of rich red-brown pine or cypress. Wright used glass, *above*, to enable the changing daylight and green of nature to become, as it were, part of the house.

The fifties thought pink

'Fun, fantasy and colour' was the keynote of London's Festival of Britain Exhibition in 1951. It struck a note of optimism during the post-World War II years of austerity. Primary colours became hallmarks of modernism.

In clothes, the matching ensemble was one of the chief features of the early to mid-fifties. A billowing wrap or semi-fitted coat in paper-thin taffeta or glistening satin would open to reveal a slim dress of the same fabric and colour, but rich with an all-over design. The colours were exquisite: green, turquoise and king-fisher blue, pale maize, amethyst and lilac, pink and geranium. Most evening dresses were extremely *décolleté*, strapless and held in place by cleverly boned bodices. Dior designed magnificent necklaces and earrings in colours to match—emeralds or peridots for the greens, turquoises or sapphires for the blues, topazes for pale maize and tourmalines for misty pink. He also introduced Italian stiletto-heeled shoes in matching colours.

Italian couture, centred in Florence, began to rival Parisian fashion during the fifties; the colours of the Italian Renaissance were a strong influence on Pucci and Simonetta whose designs, executed in magnificent materials, were shown in Renaissance palazzos. Italian colour sense was much talked of. 'Hot Pink' was the colour of the decade. The designs in 'Hot Pink' Honan silk launched by Jacques Fath in 1951 were so successful that in 1952 an even brighter version appeared, 'Very Hot Pink'. This colour was promoted by *Vogue*, and amidst some controversy it took off to become a best seller, not only in dress, but in sheets, towels and furnishing fabrics.

Until the fifties turquoise blue dyes were inferior in quality and only just passable for delicately handled, little-worn evening wear. In 1951 the Bayer Company in Germany perfected Alcian—kingfisher—blue, the first fast turquoise dye for cotton. The colour became a fashion sensation.

Colour finally invaded the wardrobe of the conventional male during the fifties. Resorts the world over reverberated to the strident colours and patterns of the shirts American tourists wore. When the intellectuals and artists of London's Kensington and Chelsea attempted to revive the fashions of Edward VII's reign, working-class youths took up the style. They called themselves Teddy boys and dressed in elongated jackets of light blue, or silver or gold lamé, with high, stiff velvet collars. These were worn over tight black 'drainpipe' trousers and the suede shoes immortalized by Elvis Presley in song. Eventually, men of a sterner complexion came out in dinner jackets of dark blue, green or wine-coloured velvet.

Rock 'n' roll called for full skirts in bright colours, or gaudy patterns with musical motifs. An unexpected flash of colour was afforded by the frilly petticoats which were allowed to show beneath. Stiffened nylon caused much conjecture when Dior first showed his full-skirted models. It remained an industrial secret for a short time—but was soon seen in every girl's wardrobe.

There was an attempt to revive a fashion for veils early on, requiring heavy eye make-up and strongly marked eyebrows. The veils failed to catch on, but doe eyes with turned-up corners did. Eyes were emphasized with a growing range of eye shadows, eye-liners and mascaras in mat and pearl shades. Late in the decade the little girl look replaced the doe eyes with paler shades of eye colour, pearly white over pink lipstick and pearl nail varnish.

The fifties was a decade of technological advances in fabrics and finishes, and draperies returned in interiors. The dyeing industry met the challenge with furnishing fabrics in orange, pistachio and the fashionable kingfisher blue. These colours in juxtaposition made the fifties a gaudy decade.

Colour invaded the kitchen during the fifties. Coloured enamel kitchenware became popular—and materials and machinery developed during World War II were exploited to the benefit of a hitherto plainly utilitarian area. The model American kitchen, *below*, demonstrated how the 'housewife's prison' could be as glamorous as any room in the home. Dyes and pigments were found to colour the new plastics. Steamproof paints, wallpapers, flooring and surfacing materials appeared in the bright pinks, oranges, reds, golds, turquoises and beiges that were stylish in other areas. But fifties' kitchens still gleamed with metal cookware, for the heat-resistant coloured metal coatings that made the colour co-ordinated kitchen a reality did not appear until the sixties.

The little black dress reappeared in a new guise when Audrey Hepburn dressed in skin-tight black satin pants, *above*, a chic version of the beatniks' uniform. Emilio Pucci brought colour to the outfit by way of blouses in wild hues; lamé or beaded satin jackets varied the theme further. Socks in the new fluorescent dyes gave pink and lime green underpinning to black pants worn by the rock 'n' rollers with black leather jackets.

Scandinavian designers, adept at exploiting the different aesthetic qualities of natural and synthetic materials, reigned supreme during the fifties. Their palette was inspired by the Nordic countryside, but primaries were chosen for the linoleum tops of these children's birchwood tables and chairs designed by the Finnish architect, Alvar Aalto.

'Think Pink', sang Kay Thompson in *Funny Face* (1956). With Audrey Hepburn and Fred Astaire she boosted the craze for 'Hot Pink' that came in with the fifties. Rose pinks and fuchsias in plain fabrics, prints and polka dots, matched with black or white, dominated the decade. Pink men's shirts suddenly appeared in 1955 to accompany soft Irish tweeds.

Cosmetics had become so acceptable by the fifties that even schoolgirls were allowed to wear lipstick. Advertising campaigns for Revlon's 'Paint the Town Pink' and 'Fire and Ice' in the opening years of the decade made such a hit that cosmetics companies learned to launch a new lipstick colour every six months.

Most automobile interiors were leather-lined or coloured dull brown after World War II. Colour co-ordination was made possible by a flood of bright new synthetic lining fabrics. The first durable red automobile paints resulted from the development of new pigments, quinacridones, by Dupont. There was a craze for two-tones, like the Ford Fairlane, *right*. Metallic finishes first appeared on mass-produced vehicles in the USA during the fifties, and light metallic blue became popular.

Psychedelia and pale faces

The colour explosion of the sixties was due in part to the mid-fifties discovery of a new and dramatic range of dyestuffs—the cotton reactives. Until they appeared, cotton could be brightly coloured only with dyes too costly for use in mass production. The new dyes brought a range of cheap, brightly coloured cottons into the stores. Since they were combined with new finishes and a widening range of synthetic fabrics, it became possible for all items of clothing from the skin outwards to be washed, dripped dry and not ironed. New fabrics included such novelties as waterproof coats and boots in coloured plastic.

France lost a little of her pre-eminence as a leader of fashion during the sixties. Irène Galitzine, an Italian designer, had made pyjama suits in startling colours acceptable for evening wear during the fifties; in the sixties the trouser suit was launched—from New York by Norman Norell and from Paris by Courrèges. The colours of the ready-to-wear collections launched by the French couturier Saint Laurent in 1966 were dull and muted, but the Italian collections were a riot of coloured stripes and knits. British design, led by Mary Quant, enjoyed a brief reign of popularity. Coloured panty-hose appeared as a necessary accompaniment to the miniskirt, and remained popular well into the seventies, long after the influence of the film *Doctor Zhivago* replaced the mini with the maxi.

But the ethnic look was the overwhelming fashion story of the sixties. The indigo blue of jeans became a classic. Worn by all ages and both sexes, jeans were bought to fade.

Khaki made a brief post-war appearance during the mid-sixties. The fashion began among American college students and was exported to Europe. In Swinging London it joined brightly coloured military uniform jackets worn in undisciplined fashion, with long hair and jeans or white sailor's trousers. After 1967 when the 'hippy' look predominated, city streets looked like a great international exhibition in which Peruvian peasant costume mingled with the chamois leather dress and beadwork jewellery of the North American Indians.

Even conservative males appeared in brightly coloured shirts, and in polo-necked pullovers instead of collar and tie. For casual wear there were sports shirts of dazzling abstract designs, and in winter, suits of equally dazzling plaids.

During the late sixties high fashion took inspiration from the streets, from films and exhibitions, and from ethnic dress. Saint Laurent's colours were influenced by the paintings of Mondrian. In Britain Zandra Rhodes interpreted the enthusiasm of the psychedelic era in hand-painted materials. Her natural sense of colour and design contributed to the creation of some of the most original and beautiful clothes of any decade.

A happy medium between the extremes of ethnic fantasy and *haute couture* was the work of Laura Ashley. Her two-tone designs, usually in brown or pale shades of blue or green and cream were made into the simplest of pseudo-peasant dresses. They were such a success that decorators found their younger clients asking for curtains and loose covers in similar fabrics. Now she is as well known for furnishing materials as for clothes.

Only the face was pale during the sixties. Make-up changed dramatically. The eyes were accentuated by giving prominence to the lower lashes and by surrounding them with blue shadow. Foundation make-up appeared in the whole range of skin tones, and Florrie Roberts brought out the first range of cosmetic colours especially for black skins. Black became beautiful during the sixties. Colour almost disappeared from the face, to be replaced by gloss in the sixties' nude look or, as *Time* magazine put it, 'The Big Fade'.

The oriental influence which appeared during the late sixties was imported by an affluent post-war generation with a thirst—and the means—for world-wide travel. They brought back from the East colourful ethnic fabrics, clothes and jewellery, and a consuming interest in all things oriental.

Barefoot, long-haired flower children appeared in multicoloured Afghan dresses, Indonesian batik skirts and North African caftans during the summer of 1967. Men wore Nehru shirts, caftans of Indian cotton and Arabic djellabas. Oriental beads and silver jewellery inset with amber and semi-precious stones were essential components of the 1967 street fashions. Kohl became popular for eye make-up, and red henna for colouring hair.

The influence of psychedelic drugs and the 'hippy' movement of 1967 inspired a new colour consciousness, epitomized in the British cartoon film, *Yellow Submarine* (1968) which featured

The Beatles, *right*. There were long, multicoloured dresses with skirts, sleeves and bodices in contrasting prints, *below*. Peasant skirts teamed with blouses embroidered in every colour, boleros bound and decorated with coloured ribbons, high red boots and patterned headscarves gave the streets a carnival air. Body-painting and the painted decoration of the face became a short-lived craze which asked a great deal of the model: Twiggy and Veruchka were among the few who could survive an entire reconstruction of the features. Caftans and Indian prints invaded cocktail parties, and the fashion for oriental colours lasted well into the seventies.

Oriental interiors had walls, ceilings and even floors painted in brilliant colours and often decorated with murals, covered with wallhangings or lined with multicoloured Indian prints. Sofas, divans and floors were covered in oriental carpets and rugs.

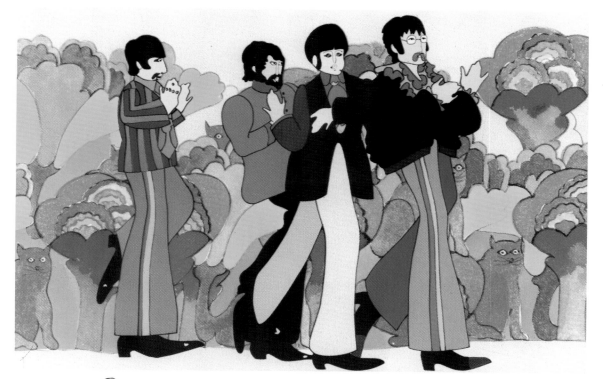

The experimentation with new synthetic materials that had begun during the fifties gathered momentum during the sixties. New plastics appeared and synthetic fabrics and finishes were improved. Success in finding dyes suited to the properties of these different materials meant that a new range of cheap and versatile furnishings became available in an unprecedented range of colours, giving a new impetus to interior designers.

In 1960, Verner Panton, a Swiss architect, designed the first plastic chair with no joints. Thereafter, synthetic moulded furniture in geometric shapes—from solid moulded foam cubes in bright colours, *below*, to air-filled colourless transparent plastic chairs and sofas, epitomized the casual sixties' look in interior design.

Courrèges introduced an incipient miniskirt into the Paris Collections of 1964. Two years later Mary Quant converted his midi into a miniskirt. Op Art influenced mini fashions in 1966, *above*. Black and white geometric designs appeared in dress, in footwear and as a make-up fashion. There were even false finger-nails in black and white with Op Art motifs.

In the winter of 1966, Paco Rabanne, a Spanish architect turned couturier, showed the most futuristic of the sixties' fashions. The influence of the space race was apparent in his minidresses made of geometric shapes riveted and clasped together in metal, leather and a range of plastics.

A new generation of jets made air travel faster and cheaper during the sixties. Braniff International Airways met the growing demand with jets in the bright, solid colours that were the theme of the decade. Some years later, they flew a travelling generation out of the psychedelic era with Alexander Calder's colourful livery, *right*.

The satiated seventies

The seventies were a decade of colour plenty. It was now possible to dye or print almost any colour on almost any fabric—and the range of fabrics available was larger than ever before. Moreover, a fashion or fashion colour idea generated in Milan, Paris, London or New York could be reproduced in almost any country in the world within a few months.

Yet the seventies opened on an uncertain note. Psychedelic colours, the miniskirt and the ethnic look (which was now drawing inspiration from Russia, Japan and Turkestan) were still around, but were fast becoming tired clichés. Nothing new had emerged from Paris to revitalize the large ready-to-wear concerns which still assiduously followed the dictates of *haute couture*. After digressing into hot pants in 1971, the British designers who were stars during the sixties retreated into nostalgia.

Barbara Hulanicki, who had established Biba boutique in London during the late sixties, had revived the vampish thirties' look. Her designs in peach, beige and chocolate brown satins and crêpes were worn with felt hats and ostrich feathers—and a sensational new mahogany lipstick. Laura Ashley's turn-of-the-century pastels and prints made into smocks and long dresses established the 'milkmaid' look that endured for most of the decade. Both boutiques set a style of interior décor by selling furnishing fabrics, carpets, wallpapers and paints in the colours and styles they popularized in fashion.

During the summer of 1970 model girls dyed their hair in violent colours to match faces—and feet—painted in wildly extravagant designs, but this brief fashion gave way to the natural look, the keynote of the decade. Foundations were produced to match every skin tone and eye shadows and lipsticks came in brown and terracotta, pink and yellow, or were replaced by colourless gloss.

For the first time in history it was possible for men, women and children to be colour co-ordinated in under- and outerwear, and from head to toe. Colours were worn layer on layer, and so were patterns. It became smart to wear a skirt of a small check, a blouse patterned in large squares and a pullover of another check, plus a sleeveless jerkin of stripes.

The combination of brown and cream became so popular that it invaded the furniture stores and many rooms were decorated in these tones. Avocado and old gold, introduced as *House and Garden* colours during the fifties, lived out the last years of their long reign in bathrooms, living-rooms and kitchens.

Men took advantage of colour plenty by appearing in suits, shirts and California-inspired sportswear in all colours, but the young retreated into black. The punks wore 'bondage' suits (so-called because the legs were joined by straps) in real or frankly synthetic leather. They matched them with vests in synthetic fabrics and colours, and with luminous socks reminiscent of fifties' street fashions. They dyed their hair bright blue, green, red or orange, or in coloured stripes and tufts.

By the end of the decade the layered outline and natural colours seemed *passé*. During 1979 the colours changed from earth tones and naturals to mail box red, royal blue, saffron yellow, turquoise and a brilliant acid green. Glitter accompanied a sudden craze for disco. Day wear was speckled with rhinestones, and night clubs and discos were full of dancers' practice suits made in shiny stretch fabrics in the colours of neon signs. American cosmetics companies responded with the most glittery eye shadows yet devised, in silver, gold and metallic colours.

High-tech arrived towards the end of the decade, a sophisticated new movement in architecture and interior design which turned the paraphernalia of industry into an art form.

The use of industrial materials and products in a domestic setting created high-tech during the seventies—a synthesis of 'high-style' and 'technology', *below*. High-tech materials are industrial metals and synthetics which have no indigenous colour, and so impose no colour style on the designer; they can be painted or left plain. High-tech designers contrast the gleam of chrome and polished steel with the dull greys and browns of heavy-duty carpeting, or the embossed patterns of rubber industrial flooring. Yellow foam block furniture is juxtaposed against pink factory stair rails and coloured neon light sculptures are reflected from the uneven surface of corrugated steel.

Colour applied to the amorphous decking and steel framing used in factory construction gives this award-winning high-tech home direction and form. Red and blue provide a focal point in a room designed to carry the eye outward. Walls and ceiling are painted in a green that links the décor visually with the leafy green trees beyond.

High-tech is not just a style for interiors: it extends outdoors, *right*. Entrance gates painted in the colours that prevail indoors give an impression of structural unity.

In 1970 white was a winner. Girls wore long white frilly dresses and the new space-cum-jumpsuits were in white or silver, worn with acrylic boots. None the less, the space age turned out to be remarkably colourful.

As the decade advanced, the great fashion story was that of co-ordinates. Skirts, blouses, waistcoats, boleros, jackets and slacks as well as knitted scarves and hats, boots and panty-hose were all made in toning shades. Brown was the most popular catalyst, teamed with lighter shades—yellow and, above all, cream. Unisex was high fashion during the seventies: men wore yellow suits and pullovers and girls wore tweed sports jackets. Green was a favourite in many shades: dark bottle-green, vivid emerald and leafy shades were all worn together.

By the mid-seventies skirts had descended to maxi length and colours had become subdued and musty—there were dusty pinks and blues, ochres, sage and shades of brownish-greyish-green dubbed 'greige'. The whites dulled to a shade the industry calls 'dirty'— little flecks of a dark colour were woven into the fibre to give an off-white appearance.

Colours darkened during the late seventies when earth tones—russets and dark browns—prevailed.

Mass-produced automobiles came in an unprecedented range of colours during the seventies. In a decade necessarily concerned with conserving energy, there was a trend towards small cars with a low fuel consumption, *below*. In the USA blue-greens and metallics were popular; silver and grey-blue headed the charts as the decade ended. In Europe the success of this bright green reflected the trend towards bright colours in clothes at the end of the decade.

The colours to come

Change is the essence of fashion. No sooner had the summer '79 craze for bright, acid colours manifested itself in the wardrobes of the fashion-conscious than what should appear but the little black suit. If this almost forgotten sign of respectability is to develop during the eighties, only time will tell; but at the end of the seventies colour consultants were predicting a resurgence of classic black and white, triggered by such divergent stimuli as London's punk fashion and the vast Picasso retrospective exhibition in Paris.

As the eighties unfurl, the brights that ushered out the seventies have paled to pastels. To accompany them, grey is replacing beige, after so many years, as the principal neutral. And influenced by the gradual opening up of China, consultants in both ready-to-wear and home furnishings agree that oriental colours will dominate the early eighties.

The interor décor market takes its cue, as does the cosmetics industry, from clothing, and in future the time-lag in seeing the effects of the latter on the former is expected to shorten. However, because many home-related products are a more serious investment than garments, the emphasis is likely to be on 'safe' colours. The fact that greater numbers of people are occupying smaller quarters implies that interior colours will lighten in order to maximise available space. The cool, Nordic clear-glass inspired colours formulated for the early eighties' summer palette are expected to be highly commercial because they are fashion shades equally applicable to interiors.

The effects of the straitened economic circumstances of the affluent West will be felt throughout the range of consumer goods. Better educated, more eclectic, more creative consumers will demand quality; purchases will increasingly be regarded as investments. Clothes will be designed along classic lines, but sparingly cut to save material, and will be expected to last. So much for H.G. Wells' prognostication: 'In 1980 we shall have simpler and more beautiful clothes, wide at the sleeves . . . We shall wear cloaks, too. Clothes will last a week and then be thrown away. The filmy underwear will last for three days.' For all his foresight, Wells did not allow for the petroleum crises and the way they would steepen the costs of formerly inexpensive synthetic materials, let alone their impact on automobiles.

As cars get smaller, they will assume the conservative and elegant colours formerly used on large models, as they must still bear whatever burdens of symbolism or image their owners require on their narrower shoulders. Richer, darker bodies, less greyed than in the seventies, will accommodate interiors lightened to suggest spaciousness.

Despite the economic crunch, colour ranges for all sorts of products should not be reduced. There is evidence that multiplicity of colour acts as an incentive to buy more—perhaps two sweaters, instead of just the one.

It would be an extraordinarily perspicacious colour consultant who could predict the fashions and colours bred on the streets that may influence designer fashions during the eighties; who could have predicted the psychedelic explosion of the sixties? Yet, just as the seventies saw a revival of the fashion looks and colours of the twenties, thirties, forties and fifties in unimaginative succession, perhaps the eighties will begin with a return to the colours of the psychedelic sixties.

Or perhaps a synthesis will emerge. The young often take their fashion cue from the pervasive pop music business. Just as punk slunk from the street into *Vogue*, so could Two-Tone, the new musical style entering Britain with the eighties, drape the world in its iridescent two-tone look. In fashion, anything is possible.

A small room, lined from floor to ceiling with colours in transparent tubs, *left*, is the fount of inspiration for one company of international colour consultants. Each tub contains scraps of fabric—leather, cotton, felt, taffeta, plastic, tissue paper, wool, metal, feathers—all on the theme of a single hue of a particular saturation and lightness. Around the room the colours of the spectrum merge almost imperceptibly into one another, so that being inside the room is like being inside a huge colour cone.

This room is the colour consultant's 'think tank'. Using samples from the boxes, he builds a germ of an idea into his new season's predictions, adapts his selected range of colours to the peculiarities of the Indian or German or Japanese market and scales it down to fit the particular needs of, say, knitwear or lingerie manufacturers.

The colours in these tubs have been selected as part of the projection for the early eighties, which has been strongly influenced by oriental colours.

Samples of wool dyed with the newest dyestuffs in the season's projected colours are displayed as a range, *right*. The dye houses may have been working in shifts around the clock for weeks to produce these shades to the specifications of the colour consultants. The whole range must be co-ordinated in saturation and lightness, and also price, and precise formulations have to be calculated for mass production.

A pin-board crowded with tear sheets from magazines, photographs, art prints, book jackets and fabric designs tells the colour story predicted to be a best seller two years hence. This board, *left*, assembled during the latter months of 1979, depicts the oriental colours consultants believed would be influential in 1981. Yarn and textile samples in colours isolated from the images have been pinned to the board as a guide for designers.

The proposal for a space shuttle during the late seventies fired the imaginations of colour consultants to the automobile industries, influencing the trend towards metallic silvers and blues. Brightly coloured cars are expected to become less popular during the eighties; instead, the demand for metallic two-tones may increase, to give the highway a more elegant look. Black, silver and dark blue are tipped to be the biggest selling colours for smaller cars.

COLOUR AT WORK

Colour has power. Colours can cheer and depress, stimulate and tranquillize, provoke and antagonize. Used inadvisedly, colour may cause strain and tension, but considered use of colour can enrich the environment, reduce boredom and prevent accidents. And colour is used by everyone—there is nothing you can buy that is not coloured.

'There are reds which are triumphal and there are reds which assassinate', wrote Leon Bakst, stage designer for Diaghilev's Ballets Russes, 'There is a blue which can be the colour of a Saint Madeleine and there is a blue of a Messalina. The . . .director of the orchestra who can with one movement of his baton put all this in motion . . . who can let flow the thousand tones from the end of his stick without making a mistake, can draw from the spectator the exact emotion which he wants (him) to feel.' Colour is a tool, but few people see it as such, or think about how it should be *managed*.

Colour consultants manage colour when they awaken interest and increase productivity with a thoughtful colour scheme for a factory, create moods with discotheque lighting schemes or make quiet diesel locomotives more visible at highway crossings. Colour management is designing sleep-inducing colour schemes for bedrooms, or dressing children in clothes that stand out against grey, brown and buff streets and in poor lighting conditions, reducing the risk of street accidents.

That colour merits management is evident in the extent to which advertising uses it to manipulate the consumer. Whenever money is at stake, and colour a factor, it is deployed with military precision—in advertising and packaging designed to arrest the eye and lodge indelibly in the imagination; in the chain-store's instantly recognizable logo and the insurance salesman's confidence-inspiring dark suit.

Some psychologists claim to be able to analyze individuals from the way they choose and use colour. Certainly, the layman's use of colour tends to be intuitive and to fall readily into patterns. The way a woman paints her face, colours her hair and assembles an outfit; the shade of a man's suit and shirt, his car, his kitchen, his bed sheets all contribute to the image we have of ourselves and each other. Colour is an interface between us and the world.

Insufficient education in colour makes most people's handling of it a hit-and-miss affair. The emphasis is given to dress, paintwork and furnishing fabrics; other colour decisions are left mostly to chance. Thus girls pore over lipstick samples and men try ties with shirts for half an hour, yet hurriedly buy a light bulb without considering its effects on their most expensive and painstaking purchases—from cosmetics to clothing to décor.

Many people use colour impressively in their dress, yet their homes evince neither taste nor courage. Or so it appears, because they never practise. People dress once or twice a day but decorate, on average, biennially. Yet their clothes are seen most often by others; it is the colour around them that affects them most. Only by constant practice do possibilities inherent in the use of colour become apparent, and the desirable results become attainable.

Everyday things that are small, changeable and cheap offer unlimited possibilities for experimenting with new colours. Notepaper, ink, pens and pencils, table cloths, cushion covers, even drying cloths, offer opportunities for indulging fantasies because tomorrow they can be changed. When the screaming yellow pillow slips begin to annoy they can be replaced immediately and used again later, or dyed a different colour if their brightness has really begun to pall.

Think not in terms of a breakfast set and a teaset and a Sunday set of dishes but create a wardrobe of things you like—expensive and cheap and old and new. These are the raw materials for experiments with colour combinations. You can learn about colour as you arrange fruit, putting the yellow apples next to the limes or making salad of red fruit or green vegetables. Every time you set a table you create a colour composition, and this brings joy to the task. Unless you are composing, setting a table is dull.

A simple flower arrangement offers real scope for practising the rules of harmony. You can look for ways of animating green or white, of emphasizing pink or yellow and of making silver-grey foliage take on an unaccustomed hue. A garden can become a living demonstration of simultaneous contrast.

Consumers tend to think that they can make colour decisions in the shop, but since every colour is modified and defined by its surroundings, and by the type of light shed on it, it is fruitless to contemplate an upholstery or carpet sample except *in situ*. Light plays tricks with dyes. A fabric that looks greyish green under fluorescent store lighting can look bluish green in the living-room; a small cutting may not show this difference. It is better to buy something, perhaps enough furnishing fabric for one cushion, and take it home to look at in morning light, evening light, artificial light and in proximity to the other colours it will have to live with. And because a small red chip looks entirely different from a red-painted wall, only a trial painting of part of the wall in question will give an accurate idea of the possible effect the colour on the chip is likely to have.

Knowledge, judgement and intuition are combined in the capable management of colour. It is a discipline, an art, a craft. Among the rewards of its mastery are a greater sensitivity to the medium of colour and increased satisfaction from its handling. Knowing how colours are named and standardized, how they change under different kinds of lighting, why they fade and how they can be used to alter mood, line, form, shape and perspective, understanding the optical effects of certain colour combinations and the psychological impact of coloured lighting . . . all are useful if you are to succeed in making colour do what *you* want it to do. The rules of colour management given in the following pages are not rigid laws, but flexible guidelines for directing the role of colour in your life.

Naming and identifying colours

Of the thousands of colours now available to industry, only a small percentage is selected for inclusion in the ranges of goods on sale in the stores. For producing colours is a costly business, and mass production of a limited colour range keeps prices low. Manufacturers build their ranges upon a nucleus of steady-selling shades, around which fashion colours orbit.

So while there may be a range of, say, 25 eye shadow colours from which to choose, 20 different shades in bed sheets and as few as six colours in plastic buckets, the manufacturers will have had a far more bewildering choice. And because consumers are accustomed to see on sale the exact shades presented in fashion or home furnishings magazines, a shade can mean the difference between satisfaction and disappointment, profit and loss.

Yet how can you accurately describe a colour? The problem is pinpointed by the instance of 27 different American paint companies each offering a 'sky blue', no two of which are alike, and no one of which matches the sky blue specified by the Textile Color Card of America. One American colour consultant, working in carpet printing at the beginning of the fifties, was hampered by the lack of any colour reference system which included dye formulations. His colour ideas were presented to the printer in the form of swatches, which the printer had, by trial and error, to match. He kept all the rejected samples with their formulations, numbering them so that any shade could be reformulated without further trials.

The timely appearance of the Pantone colour order system made his job easier. Now used internationally by graphic designers, it consists of a collection of colour chips formulated for accurate reproduction on the basis of the yellow, cyan and magenta subtractive primaries. Other colour order systems have since emerged. ICI, for example, introduced a Colour Atlas, a book containing 27,850 textile dye colours.

But the founding father of practical modern colour order systems was the American artist and professor, A.H. Munsell. He became frustrated with the ambiguity and limitations of names like 'primrose yellow' and 'smoke grey' which do not classify colours in relation to each other and which give only a vague indication of identity. He sought to rectify 'the incongruous and bizarre nature of our present colour names . . . with an appropriate system based on the hue, value and chroma of our sensations'. In his system these three dimensions (chroma= saturation) are measured against an appropriate scale.

The ideal of such systems is to provide a colour language sufficiently standardized and detailed to meet the needs of science, to accommodate art and industry, and still be generally comprehensible to the public. Yet since a colour with a mat finish looks entirely different with a glossy surface, or on nylon or tin, almost every industry in which colour has an important role has developed its own system. And because the managing director likes the upholstery fabric to match the metal paint on his office chairs, and the householder wants wallpaper to match the colour of his carpet, almost every major industrial country has its national colour standards to which industries can refer. There is the West German DIN-Colour Chart; the British Standards Institute specifications; the Natural Colour System of Sweden. All are used primarily in their country of origin, and none are interchangeable, leading to great difficulties when, for example, an American company wants to have shoes manufactured and dyed in Spain or Italy.

The most advanced colour order systems are based not just on the appearance of colours—the matching of sample against chip—but on colorimetry, the identification and matching of colours by precise measurement. Colours can be matched by tristimulus colorimeters, machines based upon three coloured filters, the additive primaries: red, green and blue. They are mixed in different proportions until the resulting mixture matches the colour of a chip or swatch. Still more advanced is the spectrophotometer which measures the amount of light reflected or transmitted by a sample at each wavelength in turn throughout the visible spectrum. A curve plotted from the results can be converted into tristimulus values to show exactly how any given colour is built up in terms of its wavelength measurements.

The Commission Internationale de l'Eclairage, an international body which specifies methods of measuring colour,

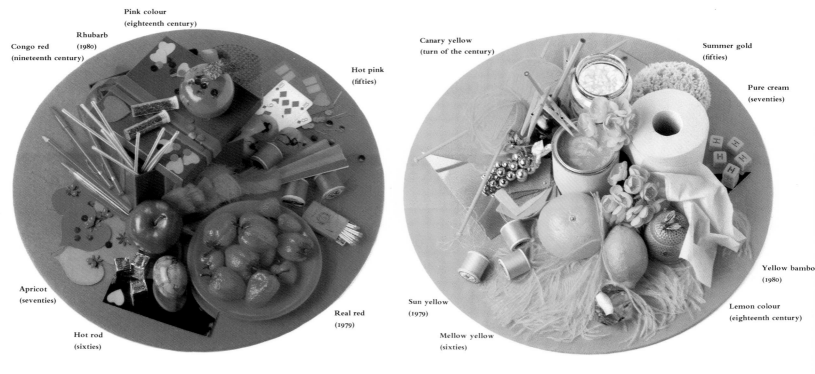

Pink colour
(eighteenth century)

Rhubarb
(1980)

Congo red
(nineteenth century)

Hot pink
(fifties)

Apricot
(seventies)

Real red
(1979)

Hot rod
(sixties)

Canary yellow
(turn of the century)

Summer gold
(fifties)

Pure cream
(seventies)

Yellow bamboo
(1980)

Sun yellow
(1979)

Lemon colour
(eighteenth century)

Mellow yellow
(sixties)

devised a colour order system based on spectrophotometric measurements of colour samples illuminated by specified types of lighting, and related to the visual response of a 'standard observer'. A sample may reflect green light, and look green under northern skylight, for example, yet under tungsten light it may appear slightly more yellow. But the C.I.E. specifications are presented in mathematical form; they do not *show* what colours look like, so reference has to be made to colour samples built up from the co-ordinates.

So although the C.I.E. system is the last word in accuracy, it is of less day-to-day use than those systems consisting of coloured chips or patches with which a sample can be matched visually. To its credit, the redoubtable Munsell system affords both notations based on instrumental measurement (which can be cross-referenced with the C.I.E. co-ordinates) *and* samples in the *Munsell Book of Color*. Other well-known visual reference systems include the *Colour Harmony Manual*, based on pioneering colour work by the German scientist, Wilhelm Ostwald, the Maerz and Paul *Dictionary of Color* and the U.S. Government's *Universal Color Language and Dictionary of Names*, a book that aimed to unify all existing and future colour order systems.

The problem all have tried to overcome is that the 'light green' in the *Universal Color Language* is called 'griseo-viridis' by biologists, 'serpentine' in high fashion and 'mint green' in mass-market terms. Meanwhile, the evocative if imprecise names that dismayed Munsell remain crucial at retail level. The power of a colour name to sell is exemplified in a story from an American paint company. When its perennial strong-seller 'Ivory' began to slide to the bottom of the sales charts during the seventies, a name change to 'Oriental silk' boosted it back to the top.

Colour designation is, of necessity, a growing field. A guide for consumers would be invaluable in cases such as mail order, where choices are made on the basis of a printing ink image that has no chance of accurately duplicating the colour of a silk shirt or a set of plastic kitchen utensils. The public may one day be educated to the point where a rose is not merely a rose, or even 'Maiden's Blush'. It could be l.gy.pR 261.

When ready-made household paints first became available to householders during the eighteenth century, their names were simple and descriptive. 'Lead colour', 'Wainscot' and 'Pearl colour' were offered by a London colourman, Alexander Emerton. In the mid-nineteenth century the new synthetic colours had more exotic names such as 'Rose Magdala' and 'Lyons blue'. Mid-twentieth colour names were more evocative, and changed more quickly. Names like 'Blue frost', 'Calypso' and 'Fire and Ice' are unmistakeably fifties while 'Tequila Sunrise', 'Kinky Pink' and 'Yellow Submarine' are redolent of the sixties. By the seventies, names were changing with the fashions, every season.

The colour names around the trays of coloured goods, *below*, reflect three centuries of changing fashion names.

The Colour Tree, *above,* grew out of the system devised by A.H. Munsell in the early years of the century. It is organized according to the three dimensions of colour: hue (determined by wavelength); value (lightness) and chroma (saturation). Value is represented in a scale of greys on the trunk; each hue increases in chroma from the axis out to the ends of the branches.

The shape of the tree is irregular because the maximum chroma of which the hues are capable vary (red has 14 degrees of chroma, but bluish green only six). Virtually any coloured matter can be matched against the colours of the tree and accurately described in Munsell terminology; 5R4/8, for instance, defines an intermediate red hue with a value of four (fairly dark) and a chroma of eight (fairly highly saturated).

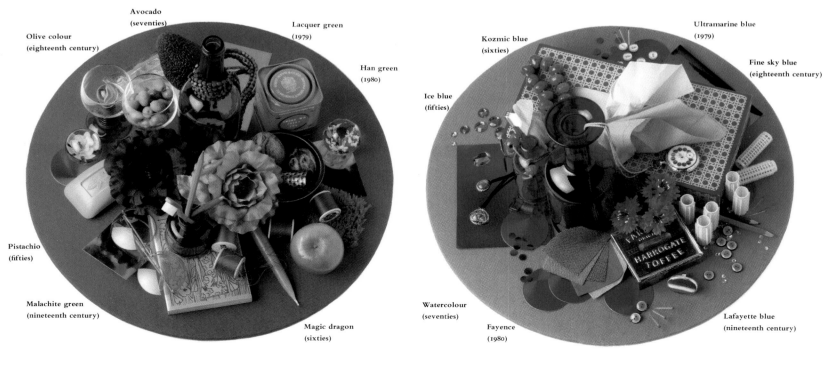

Olive colour
(eighteenth century)

Avocado
(seventies)

Lacquer green
(1979)

Han green
(1980)

Pistachio
(fifties)

Malachite green
(nineteenth century)

Magic dragon
(sixties)

Kozmic blue
(sixties)

Ultramarine blue
(1979)

Fine sky blue
(eighteenth century)

Ice blue
(fifties)

Watercolour
(seventies)

Fayence
(1980)

Lafayette blue
(nineteenth century)

The colours of cultures

The ever-widening circle of Western technology has thrust new fabrics, new building materials, new cosmetics and even new artists' materials into the farthest corners of the world. Cheap means of colouring have turned conventional ideas about material colour preferences topsy-turvy. The indigenous palette of tribal societies has often undergone radical change in a few short years and in almost every case they have shown a voracious appetite for bright colours, the gaudier the better. Earth-toned cloths have willingly been exchanged for brilliant prints and the natural hues so admired in the West are gradually fading into obscurity.

The brown and beige rugs of the Persians are now multi-coloured with synthetic dyes; East Africans have exchanged rough cloth (and even body-painting) for mauve T-shirts complete with slogans. Indeed, the aesthetic sense that we so eagerly attributed to the tribal state might be simple practicality: the dark shades of South East Asia are chosen for camouflaging dirt and, in Sumatra, white cotton is worn until no longer presentable, and then dyed black.

But there are always constants. It is unthinkable to produce a range of coloured materials for Germany or Austria without their perennial favourite—regardless of fashion—forest green. Highland Scots retain their love of traditional tweed whose subtle shades reflect the interwoven colours of the changing Scottish landscape. Not very different are the red-brown robes of the Masai tribesmen in Kenya who proudly ignore Western colours and styles, even as surrounding tribes succumb. Their lavish use of henna has both ritual and cosmetic significance, a function of self-decoration that still remains amongst the Moslems who smear their heads and feet with henna because of its medicinal and strengthening virtues, as well as its beautifying qualities.

The power of the climate and landscape to suggest a colour range finds superlative expression in the refinements of Japanese culture. Warmness and coolness, humidity and wind, sunlight and fog are characterized in terms of textures and brightness such that the humid, foggy atmosphere of parts of Japan dictates soft, but clear, subdued colours. In fact, the Japanese do not care for the purple, pink or green kimonos often associated with them. These are regarded as somewhat vulgar; brash colours are reserved for geishas and for the export market, where ritual robes for tea ceremonies are debased to dressing gowns. The Japanese respond deeply to the gentle colours of water, sky and wood.

The value of colour is frequently indistinguishable from the deepest collective values of a community. Whether, for instance, the beloved green of the Moslems is only derived from the legendary hue of the Prophet's cloak or whether it is associated, too, with the green oasis—fruitfulness in the heart of the barren lands—is hard to determine. Similarly, how far are the bright colours of Mediterranean climes a peculiarly Roman Catholic phenomenon, while the dour Northern countries retain a Protestant, perhaps even a Puritan, reticence? That Catholic stronghold in the northern hemisphere, Ireland (Eire), shows what the English regard as surprisingly bad taste in painting its oblong, pebble-dash bungalows in bright purples and oranges—often with 'clashing' colours on doors and windows. Their proper place would seem to be among the vineyards of Italy or France and not the potato patches of Eire.

Peking's Forbidden City is called Purple, but is in fact many-coloured. The predominant hues are the red of the walls, the white of marble terraces and stairs and the gleaming yellow tiles on the roofs whose colour, by blending into the yellow earth of the landscape, was said to camouflage the city from evil spirits

Traditional Indian dyes and dyeing techniques vary so much from region to region that from the colours of a woman's sari the initiated know which part of the sub-continent she comes from. Traditional dyeing methods extract from native plants and insects colours as bright as those from modern synthetic dyes, so the peacock blues and shocking pinks of these saris seem as distinctively Indian as rich earth reds or saffron yellows.

winging overhead. In contrast to these luxurious colours, the Chinese colour *Ch'ing* in Mandarin can mean green, blue, black or red depending on what is being described. Used for the colour of the East, for albumen and even for lapis lazuli, it denotes the natural colour of the object: a bird or flower is *Ch'ing*, its own colour. Such subtleties are denied European languages.

Another obvious criterion for colour preference, quite apart from climatic or cultural influences, is simply complexion. The darker the skin the brighter the colour seems to be the rule from India to Spain to the West Indies—at least where overriding considerations, such as a state of mourning, are ruled out. Pale complexions introduce their own complexities as cosmetics' manufacturers have discovered. The pigments of British cosmetics were deemed too harsh for the face of America which, like Australia, prefers softer colours. But still environment plays its part: the American East favours reds and green with a blue bias for its body-paint, while the sunny West (and especially the South West) require a yellow bias. But sensitivity to complexions is more than skin deep. Light and dark have been antagonists since the fair-skinned Saxons fought the dark-skinned Celts; the Negro Fulani of Central Africa revile subservient tribes as 'black' even though it is doubtful how much darker their skins actually are.

Peoples the world over are still surprisingly conservative, for a variety of reasons. Bedouins are as fastidiously sombre as bankers; Mediterranean peasant women avoid alluring colours and dress in black as austerely as Islamic ladies (although, under the veil and robe, the clothes are rumoured to be gaudy). The Chinese have exchanged the gorgeous silks of the rich and the weeds of the poor for the uniform blue-collar of the worker. But as cheaper, easier dyes and materials spread, colour may creep into China, Nigerians may continue to return from Western sobriety to tribal robes, and the dark suit for Sunday Best may assume the chequered delights of golfing trousers or the saturated hues of an Indian sari.

The piercing hues of the sky and the myriad colours of the landscape, flora and fauna are mirrored everywhere in Indian daily life. The brashest colours look bright and gay under a blazing sun. Indian arts and crafts, whether traditional or modern, decorative or practical, natural or stylized, have a common theme of vivid, even gaudy, colour. Nor is this love of colour wholly secular: every aspect of life is imbued with religious connotations. To the Hindus, the Brahmin, the highest caste, is associated with white; the warrior, or Kshatriya caste, with red, the Vaisya, or merchant caste, with yellow and the 'untouchable' Sudra caste with drab black.

Little piles of bright pigments are displayed for sale before the great temple of Venkatesvara at Tirupati in southern India. Worshippers taking part in temple ceremonies purchase them to paint their faces. Ground earths, sandalwood and turmeric, saffron (for the rich) and white clay are traditional pigments. Women in northern India stain their faces and hands with mehndi, a green vegetable powder that stains red.

Colour is an integral part of Hindu worship. Vermilion and ochre represent blood in sacrificial rites; brides are sprinkled with turmeric; yellow clothes are worn and food eaten at the spring festivals, symbolizing the ripening of the crops. At the festival of Holi, which celebrates the visit to Earth of the God Krishna, people throw coloured powder and water over one another.

In the past, red and white clay, black soot and yellow spices were often the only pigments available. Bright chemical colours are used today—but with the same artistry that has characterized their use in India for millennia.

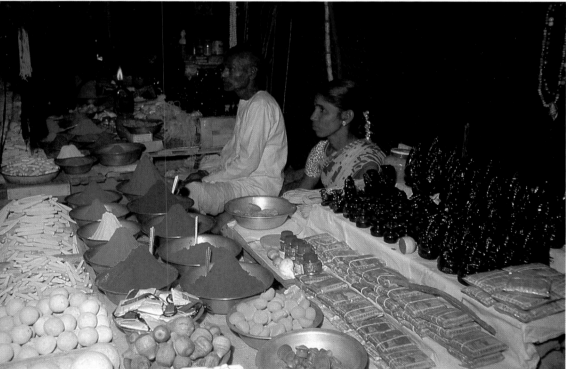

137

The power of colour

For anyone who works with colour, its power requires no apologist. Scientific evaluations of the physical and psychological influences of colours are, to them, literally academic because the sensations of relaxation or pleasure, irritation or tension, spirituality or passion are self-evident.

Leon Bakst, prodigious stage and costume designer for the Ballets Russes at the turn of the century, was a passionate adherent to the gospel of power in colour: 'I have often noticed that in each colour of the prism there exists a gradation which sometimes expresses frankness and chastity, sometimes sensuality and even bestiality, sometimes pride, sometimes despair'. It was his livelihood to manipulate the public with these effects and he succeeded conspicuously. While moralists fulminated that 'the Russian Ballet is a degenerate affair and Bakst clearly an erotomaniac', society ladies hastened to incorporate his exotic hues into their dress, décor and make-up.

Goethe thought that the effects of colour, at all times decided and significant, are immediately associated with the emotions. Jung believed colours to be potent symbols. Lüscher based his analysis of personality on individual colour preferences. These seem almost as exact a definition of individuality as a thumbprint.

The way in which certain colours become preferred, or disliked, and hence a source of satisfaction, unease, security or stimulation may be traced to happy childhood associations; reactions in favour of or against the traditional symbolic meanings attached to them; an undeniably flattering effect; or any combination of these. There may be even deeper determinants—but depth psychology is the province of the professional. Laymen can make colour serve their best interests by paying it due attention, rather than leaving its choice to chance, or to the vicissitudes of fashion.

Everything in life is coloured, and a surprising amount of that colour is subject to individual control. Individuals seen in the context of their own home can have dictated not only the colour scheme of the décor, but that of their own clothes and cosmetics, even the colours in the paintings selected for display and in the garden outside. Given that colour has a profound effect on emotional well-being, time spent in exploring the impact of different colours on one's psyche can only be an investment. Where confusion reigns, experiment is indispensable; and there is at best insight, at worst diversion, to be had from taking Max Lüscher's readily available colour preference test. Knowledge is power, in colour as elsewhere.

Reddish browns, russets and ochres, the earth colours, are instinctively associated with warmth and cheer. People who like strong, saturated earth tones respond to the stimulating and invigorating qualities they see in them. These are autumnal colours.

The earth colours symbolize deep worth and elemental root qualities, Although to many people they are friendly, cosy colours, others find even the most saturated earth colours dull and uninteresting. The lighter tones, the warm beiges, umbers and sandstones, they dismiss as lifeless and boring, suitable only as foils for brighter shades. The shy and retiring, on the other hand, may prefer the sober, soothing qualities of these warm neutrals—as may the sophisticated. But for some, 'safety' in dress or décor means no bright colours at all; even these earth colours are too bright.

Dark browns have contradictory qualities: some people see them as sensuous, and many people find them warm and reassuring, whereas others find them utterly drab and depressing.

This strong, sultry red is an imperious colour; it seems to challenge, to command attention. Maroon is an elegant, dignified colour, at its most dramatic when reflected by glossy materials and contained within a geometric shape. Dulled by the nap of a velvet or wool, it is rich and powerful. This is a pure red, inclining neither to blue nor to yellow, its fieriness darkened and constrained. Its regal qualities can be oppressive. Essentially a sophisticated colour, it can become tiring.

Strong yellows, oranges and reds are hot colours, recalling the hues of flames. They are cheerful and stimulating. People may find them provocative, arousing, even erotic. The vigorous energy of these bright colours provokes strong reactions; they can seem over-stimulating and obtrusive, and people tire of them easily. Yellows, oranges and reds are warning colours, in nature as in industry. In the wrong context they look frenetic, and like all bright colours they can look cheap and tawdry.

Goethe believed colours should be employed according to their effects on the mind. He divided them into 'plus' colours: red and yellow, which excite quick, lively feelings, and 'minus' colours: blue, green and bluish red which give a restless, anxious impression. In his triangle he ranged colours he considered 'lucid' along the left, and 'serious' colours along the right. In the apex are the 'mighty' colours; the four in the angle on the left are 'serene' and those opposite are 'melancholic'.

This intense magenta was 'Shocking Pink' in the thirties, 'Hot Pink' in the fifties and 'Kinky Pink' in the sixties. These names proclaim it as a bright, exciting, fun colour. This pink, which has appeared in the vanguard of more than one youth revolution, either leads fashion or lurks behind scenes, condemned as ostentatious and showy.

To some it is zany and sensational; to others, over-intense and maddening. To some it sings, to others it screams.

The evocative power of colour can be represented as a stimulus gradient, *above*. The hot, intense colours along the top are the most provocative, eliciting the most acute emotional responses. Those in the row below them are commanding, powerful colours, more restrained, yet somehow more substantial. Below them the hues are harder and more austere. At the bottom of the gradient the tones are lighter, more tranquil and least provocative. The four squares in the centre are warmest; those on the right are coolest.

Strong pinks and reds with a hint of blue are sensuous and voluptous, Pale bluish pinks, on the other hand, are pretty and feminine. Two out of three women. Lüscher has observed, prefer bluish reds which they think of as restrained, distinguished and delicate. Two out of three men prefer yellowish reds which they associate with impulsiveness and achievement. Those who dislike pinks and reds find their vitality cloying and their vibrant intensity antagonistic and irritating. Many people find bluish reds cold.

The power of colour 2

Mankind's first perceptions of colours seem to have been associated with the human body: the colours of blood and of the bodily emissions were the first to be given names.

Even now, people see something 'physiological' in colours. Almost the only universally agreed colour associations are physical ones: reds, oranges and yellows are thought of as warm colours; blues, greens and violets are felt to be cool. Although there is no clear dividing line between the two, it is generally agreed that adding a touch of red to a colour warms it and adding a little blue cools it—so there are cool reds and warm blues; pinks can be warm or hot and greys may seem cold, cool or warm.

Beyond these two basic divisions there is little agreement about the physical or psychological effects of colours: the green that makes one person feel nauseous will seem bright and refreshing to another. The seemingly endless and changing range of colours available in nearly everything for sale can be bewildering, but is ultimately a boon to consumers who can now choose the colours of the objects that surround them.

Green evokes the tranquil peace of the countryside. 'The eye', said Goethe, 'experiences a distinctly grateful impression from this colour'.

Some people love this mid-green while others hate it. Such a restful green is too subdued for some who find it, consequently, uninspiring. A pure green, half way between yellow and blue, it is the colour of fertility. Many of those who like it respond to the life and vitality of its symbolism. But this richness may be wearisome.

Mid-way between light and dark, greys are quiet, reserved colours, provoking no strong emotions. They encourage curiosity, reflection and imagination: designers often work in rooms with a grey décor, the perfect background in which to foster colour ideas; but most people find them both visually and emotionally insipid.

Lüscher has observed that people with driving tensions prefer bright and light colours. 'Grey-containing pastel colours, whether light or dark, are preferred by sensitive persons of distinction.' Greys are neutrals, essentially cool, non-commital and uninvolved. Like all achromatic colours, they can be used to create a sophisticated atmosphere.

The colours along the top of the stimulus gradient, *below left*, are clear and lucid, provoking the strongest excitation. The darker colours, ranged along the two rows beneath, are more saturated and look more stable; those above look richer and more powerful; those below are more austere, and have a serious air.

The hues in the bottom row are the quietest and least stimulating. They are mere whispers of colours, with an atmosphere of wistfulness.

The warmer colours are ranged along the left and right of this stimulus gradient; the cooler colours are in the centre.

There is something nostalgic about these mellow greens. They are colours our grandmothers wore. These greens are restrained, the epitome of tasteful elegance. People who like them delight in their cool qualities.

Yet these yellowish greens are colours rarely found in hospitals: they make patients feel more ill. They can be cloying and over-indulgent, a little too lush if not tempered by neutrals.

These subdued colours have mystical associations. They are the colours stage lighting designers use to create an atmosphere of mystery and suspense, even ghostliness. There is an old-fashioned air about them, an atmosphere of old-world elegance.

The paler shades are feminine and pretty, yet contain a hint of sadness. Greater intensity of colour warms the pinks, but makes the blues look lugubrious and cold.

Deep blues recall the mysterious depths of the ocean, creating an impression of deep, contemplative calm. Blue is the colour of silence.

Blues, as a rule, are cold, but this deep oceanic blue, associated with burning sun and hot sand, is perhaps the warmest of the cool colours. This blue provokes the least emotional reaction, almost everybody likes it. 'Blue', wrote Goethe, 'is a kind of contradiction between excitement and repose'.

But blue is also a detached, aloof hue, the colour of melancholy and of loneliness.

Pale blue is one of the coolest colours. A pure blue has a fresh quality, but greyish blues, the colours of the northern skies and polar seas, can seem forbiddingly cold. The paler blues on a mat surface appear to recede, but on a shiny or glossy surface they have a crystalline eye-catching sparkle, and seem to advance.

These are unobtrusive colours with an airy quality, creating a relieving sense of space. But they can seem empty and vapid and their refreshing coolness is often interpreted as frigid.

Colour combinations

Most people know what colours they like. Choosing a colour for the walls of a living-room, for a street-front door or for a new car is a matter of personal preference. But colours are rarely seen, or used, in isolation.

Putting colours together is the thing people find most difficult about managing colour—perhaps because there are so many colours. And colours when juxtaposed play tricks with the eye, because as soon as they are put together, they seem to change.

To see how this happens, make a simple experiment. Cut a hole in the centre of a square of paper coloured yellowish green, and another in the centre of a square of medium blue paper. Place each one on top of a square of deep turquoise colour, so that the turquoise shows through each hole. Against the green, the turquoise will look blue; against the blue it will look green. This phenomenon was called simultaneous contrast by the French chemist, Michel Eugène Chevreul, director of the Gobelins tapestry works during the nineteenth century. He explored it and applied his findings to the weaving of tapestries.

Simultaneous contrast occurs whenever two or more colours are juxtaposed: grey placed next to yellow takes on a purplish hue, but when it is placed next to blue, the blue looks yellowish.

Such phenomena have fascinated artists for centuries. Many made careful studies of colour combinations. The knowledge they gained is applied by craftsmen involved with the use of colour. Weavers, for example, design checks using grey and blue yarn woven in such a way that a yellow stripe is visible, although no yellow yarn is used.

The Bauhaus artist Johannes Itten explored the different ways of contrasting colours. He observed how colours divide naturally into warm and cool shades, and how the two combined affect each other. A pattern of warm neutrals combined with cool blues and greens was high fashion for wallpapers and furnishing fabric designs at the end of the seventies. They look cool and sophisticated, but the visual effect they create is not cold.

Understanding the effect that one colour placed next to another can have helps to create a certain atmosphere. Or it can prevent the atmosphere subtly induced by one colour from being destroyed by its proximity to another. Perfect harmony and intentional clashes will only come with practice, but it is worth exploring colour theory to be sure of the effect one colour will have upon another.

The eye easily adapts to the sensation of a single hue, and such adaptation affects the perception of other colours seen immediately afterwards.

To test this phenomenon, mask off all the illustrations on these two pages except for the top one on this page. Stare at the blue circle for about 30 seconds, then cover it and unmask the illustration below. The blue spot will look distinctly paler than the brighter blue now surrounding it. Cover this illustration and unmask the bottom one. The blue circle will again seem paler than originally estimated. If a yellow square with a circular hole in it is placed over the black, the blues will look even deeper by contrast with the yellow.

This phenomenon of successive contrast was exploited by Gertrude Jekyll, a nineteenth-century gardener. She planted monochromatic flower borders in which flowers of palest pink, for example, would merge gradually into blooms of progressively stronger shades of the same hue. Their brightness would be accentuated by contrast with the paler blooms.

She noticed that although the orange African marigold has dull green leaves, after looking steadily at the flowers for 30 seconds, the leaves appear bright blue. She made spectacular use of this after-image effect in monochromatic borders edged with flowers of a complementary hue; and devised series of monochromatic schemes in which, for instance, a garden planted with greyish blue flowers would lead into another planted with flowers in shades of yellow and orange, whose brilliance would be intensified, since the eye had been prepared for it.

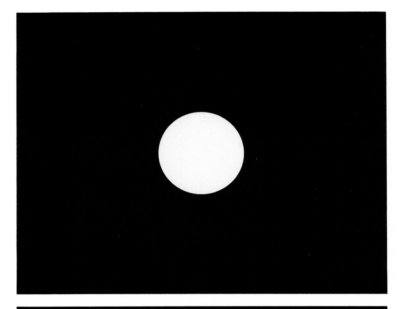

Red and blue are colours that flicker when seen together. The same happens with combinations of cyan (greenish blue) and orange, yellowish red and greyish blue, and red and green. These combinations will flicker only if both hues have the same saturation and lightness.

Some colour pairs exhibit this effect more intensely than others. Red and green, and cyan and orange, have the same brilliance when at their most saturated. Blue,

The flickering effect of red and green is most vivid when the two colours occupy an area in equal proportions. An entirely different visual effect is created when these proportions change. As a result of its confinement to a small area, the green appears to gain in intensity in the illustration, *right*. Conversely, when green dominates red seems to become more intense and active.

Many colour theorists, from Goethe to Johannes Itten, have believed in a natural harmony of colour area, which is dependent upon the measurable brilliance of

on the other hand, is darker than its complementary, yellow, even at its most saturated; together, these hues will not seem so dazzling.

Flicker is an attention-getting colour device, most often used in advertising, in packaging and on signs, where the information conveyed by graphics or wording must have immediate impact. Flicker tends to irritate, and for this reason is used only rarely in textile or interior design.

different colours at their highest saturation against a neutral grey background. Yellow is the brightest colour, followed by orange, red and green, then blue, and violet, which is naturally deep in tone.

To create the quietest and most static effects, yellow and violet, Itten believed, should occupy a given amount of space in the proportions three : one; orange and blue in the proportions two : one, and so on. When combined in different proportions, as in this illustration, strange and often lively colour effects result.

Exploring colour contrasts is the basis of designing with colour. Contrast of hue, one of the simplest, produced the lively effect in the illustration, *left*. Here, four hues of medium tone have been used; if they were separated by black or white lines each would seem sharper and more distinct, and if each was at its most saturated, the visual effect would be more vigorous.

In this design, emphasis is placed on the red, which occupies the greatest area; the visual effect would be quite different if the red were replaced by the green or the blue. The emphasis of the central colour could be further accentuated by increasing its saturation so that it looked much brighter.

Contrast of saturation, *centre left*, is the contrast between pure colour and greyed tones of the same hue. Here, the pure, saturated greenish blue stripe looks almost luminous by contrast with the three greyer stripes. Although these may appear to be different colours they have, in fact, a similar hue, differing only in their grey content.

Variations on this theme could be made by increasing the number of greyed stripes in the design, or by juxtaposing pastel hues with light grey or dark hues with dark grey.

The tie, *far left*, illustrates another variation on the theme of lightness to darkness. Here, a bluish pink increases in saturation from pale at the top to purple at the bottom.

Colour combinations 2

'The eye undoubtedly takes pleasure in seeing Colours, independent of design and every other quality in the object which exhibits them . . .' wrote Chevreul. The principles of colour harmony he established are the basis of modern aesthetic traditions governing the use of colour.

He stated that colours of the same hue but different saturation harmonize when juxtaposed. Similarly, light and dark—or greyed—tones of the same hue should harmonize as long as the tones when put together do not dull each other. Complementary colours are harmonious, and there is harmony in a series of contrasting colours all having a dominant hue—as if they were being looked through a piece of coloured glass.

Harmonious colours are always related in some way according to traditional teaching, but tastes change and with them, the rules of harmony. The painter Josef Albers compared good colouring with good cooking: they both demand repeated tasting.

Everyone has the same problems with colour. There are always problematical objects that will not 'tone'—the old sofa and the new rug, for example, that are both supposed to be beige or grey, but are very different colours.

Greys are especially difficult to match: one is bluish and cold, another has a brown tint and looks warmish. But pull in four or five more greys with very different textures—some silk pillows, a thick fur rug, a metal table, a lead statue and so on—and the two offenders are part of a symphonic scheme. Two similar colours may clash, but it is difficult to find five greys or beiges or blues that will not harmonize. There are gradations between them and a relationship is possible. The addition of a neutral will link two colours.

Contrasting textures help a family of colours to harmonize. The walls of the office of Robin Guild, a British designer, are polished to a high gloss to increase the reflection of the light filtering through the venetian blinds. The soft absorbent texture of the upholstery, in contrast, mitigates the cold effect created by some of the steely greys.

Textile designs are usually produced in three colourways to appeal to different colour preferences. The colour of the background may change while that of the pattern remains the same; the pattern colour may change while the background colour remains constant, or both background and design may have different colours. In all cases, the visual effect will be radically different. Against a black background, the hues of the pattern, *above left*, stand out distinctly. Against a dark grey background, *above centre*, the colours seem to lighten slightly, and against a light grey background, *above right*, they seem paler and the pattern looks diffused and less distinct.

During the eighteenth century, when textile printing was in its infancy, a colour would often appear to change in transition from small-scale design to printed fabric. A green pattern in a blue field might turn yellowish; black against red might appear green.

Chevreul, investigating these effects, realized that they were due to the influence of one colour on another. The phenomena, which he named simultaneous contrast, were later shown to be the result of after-image effects; the green pattern looked yellow because it was tinged with orange, the after-image of blue; the black was tinged with the after-image of red, which is green.

Many colour theorists have attempted to depict these after-image effects. This colour circle by a twentieth-century colour theorist and practitioner, Robert F. Wilson, shows in the inner circle the coloured after-images produced by each of the twelve hues in the outer circle.

The size of colour

Nature is full of examples of the ways in which colour affects our perceptions of dimensions. The hues of the ocean deepening towards the horizon and the changing colours of mountains as they merge into the sky demonstrate the distancing effects of blue, grey and violet. A grove of fiery maples identifiable from a distant hillside and the undistorted hues of Dutch tulip fields seen from a climbing aircraft are proof that red, orange and yellow appear to advance towards the eye.

Man has always taken lessons from nature. When armies engaged in open warfare the bright colours of their banners and uniforms enabled soldiers to recognize their side, just as bright colours enable birds and animals to recognize their own species. But when weapons were invented that could fire over long distances, armies adopted the camouflage colours of animals: dun colours for desert armies, white for ski-troopers and blue and grey for battleships and fighter aircraft flying over the high seas.

Artists emulating nature in times of peace realized that colour's aesthetic role is not merely to embellish. The Mediterranean sunlight shining through the columns of ancient Greek temples appeared to eat away their thickness, destroying the perfection of their form. To compensate, architects designed columns to thicken towards the base—a device known as entasis—changing the form to allow for the effects of light. To emphasize the forms of their monuments, they coloured them with strong hues: reds, golds and terracotta, colours that are highly visible from a distance and which counteracted the bleaching effect of the sun.

Architects of later ages lightened the massive forms of Romanesque churches with pattern and accentuated the width of Renaissance buildings with horizontal bands of coloured marble. Colours, they learned, change apparent distance, size, shape, line, form and perspective, even weight and movement.

This knowledge is as applicable to make-up, dress and home decorating, but it is rarely studied, except by some architects and professional designers who use it to emphasize the proportions of architecture, and to effect harmony or proportion where these are lacking.

The study of colour effects is the study of colour deception. Take a couple of cubes—small cardboard boxes, perhaps, turned upside down. Paint one black and compare it with the lighter one. It will look more solid and homogeneous since the dark colour emphasizes its form.

Colour the top and one side of the other cube yellow. Its form

With an instinctive feeling for colour, the builders of Gothic cathedrals often painted the vaults of these lofty buildings blue. It is a colour that appears to recede, and by using this effect the height of the nave was emphasized, as it was in the upper Church of San Francesco at Assisi in Italy, *left*, whose frescoes were painted by Cimabue and Giotto.

The receding quality of blue often emphasized perspective in other ways. The length of a cathedral would be accentuated by a pictorial window of predominantly blue glass in the chancel, for example. Such techniques are used in modern interior design, to extend the apparent width of a narrow room by painting one wall blue, or to alleviate the overpowering effect of a low ceiling.

Colours change with distance. Green loses its hue completely, *above*, becoming yellowish in the middle distance, then turquoise, and blue in the far distance. This is an atmospheric light-scattering effect, as a result of which we associate blue with distance. Far-off brown hills look mauve, and rocky grey mountains lighten in tone towards the horizon. Blues and purples darken as they recede.

It is also an optical effect—objects moving away lose their colour before they lose their shape. Yellow kites look lighter in the sky, although reddish yellows retain their hue for miles. Bright orange and red hardly change with distance, and because of their excellent visibility, these are safety colours, conspicuous in clothing and as markers of all kinds visible from afar in low levels of illumination.

will be distorted—it will look like a piece cut off a longer bar, which is yellow inside. If each side is painted a different colour, or in different shades of the same hue, its form will be distorted even more. Colour another cube all over with blobs and stripes. The cubic form will be so distorted that it will be difficult to distinguish. This is the principle of camouflage.

Turn the cardboard box round so that its open end is facing you and cut out a 'window' square in one of its sides. Paint the walls and ceiling with different colours and cover them with patterned 'wallpaper' to see how the room changes shape, size, form and character with the different colours.

Colour can be used as a way of overcoming defects, as well as emphasizing perfection. Repeat the experiment with rectangular boxes, and boxes of irregular shape.

Colour can seem to change all four dimensions. Bright colours create tension and aggression; soft, subtle colours have the opposite effect. According to the results of an experiment conducted by one British university, a meeting held in a brighly coloured room seemed to its participants to last three-quarters of an hour shorter than another held in a room painted in subtle colours. Colour, apparently, affects perception even of time.

Sheep on a snow-covered mountain are so effectively camouflaged by their white coats that they are barely distinguishable from their habitat. This same camouflage principle is commonly used to make ugly pipes and radiators, or awkward wall and ceiling projections, merge into the background if painted in the same colour. Receding colours: light blue, grey, beige and mauve are best for camouflage.

Alternatively, of course, features can be emphasized using contrasting colours.

Light colours emphasize area and reduce impressions of depth, an aesthetic device exploited in Islamic architecture. In the Alhambra Palace in Granada, Spain, line and shadow are the only clues by which one can judge depth. In the Hall of Judgement, *right*, the stuccoed stalactite decoration emphasizes height and width but neutralizes depth. The arches all appear to be on the same plane.

The colour in the traceried decoration serves principally to outline the elements of the pattern, but such structures in other styles of Islamic architecture are lined with mosaic tiling glazed with brightly coloured patterns. These break up the outline of an arch or wall into an amorphous filigree, intended to symbolize the transitional space between the temporal and spiritual worlds.

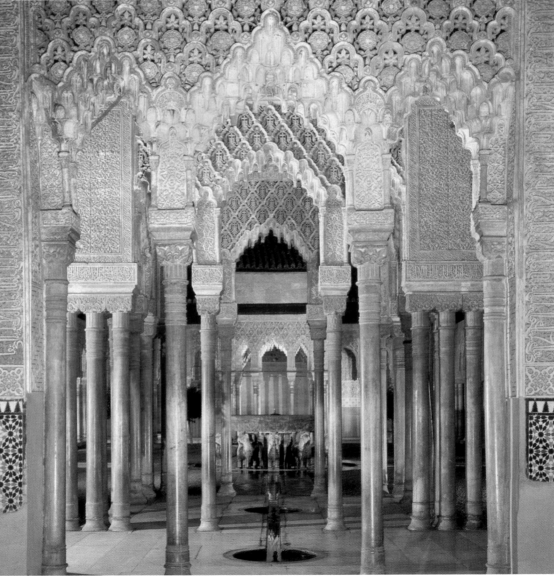

147

The size of colour 2

Colour creates perspective, and this is nowhere so apparent as in the *trompe l'oeil* effects that were popular during the Renaissance. Line and form play an important role in Paolo Veronese's decoration from the Villa di Maser in Italy, *below*; but large areas of monochromatic hue can be used to create an illusion of perspective—to give depth and to foreshorten.

If a bank of vivid red or orange flowers, or red-leaved trees and bushes, is planted across the bottom of a long, narrow garden, for instance, the garden will look shorter. Similarly, a short, square garden can be made to appear longer by emphasizing a diagonal. The eye can be led towards one side by the line of a curving lawn and surrounding beds of shrubs—and on into the distance by the hazy effect of a bank of blue flowers following the contours of a corner. Bright colours foreshorten; pale colours give depth.

The length, width, height, depth and area of interior space can be masked or accentuated with colour. Advancing hues make distant walls seem nearer and box large rooms in, reducing their apparent size. Ceilings in very dark hues look weightier and lower; light colours have the reverse effect. On the floor (the lightest surface) and the ceiling and window walls (the darkest) light-reflecting colours emphasize space.

But the effects of just one colour are multiple. In these two rooms browns seem to reduce the apparent height of the ceilings; but in the scheme, *right*, it also serves to unify the two areas of a large room. In the same room, *far right*, it has the opposite effect; it divides. A lighter colour separates the background area and makes the ceiling look higher. The foreground area, unified by dark brown, has an apparently lower ceiling and looks smaller.

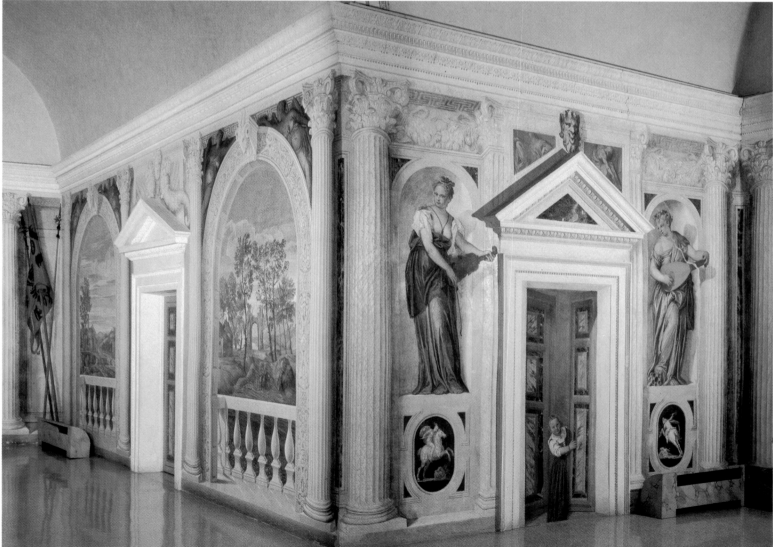

Hold this page at arm's length and look at these two objects from the point of view of size. The darker-coloured car looks smaller than the lighter one. Dark colours reduce apparent size; light colours increase it. That is why small rooms look larger the lighter their colour. For the most spacious effect, small rooms should be a uniform as well as a light colour; the effect is destroyed if another colour is introduced. In dress, dark colours are slimming while light colours have the opposite effect.

Consider the relative weights of the two objects. The dark-coloured car looks heavier than the light-coloured one. A black suitcase looks heavier than a white one and in trials people have found dark-coloured boxes heavier to lift than light-coloured ones, even though their weight was equal.

The position of the darker car above the lighter one makes the illustration look top-heavy—an

effect used in the rooms, *left*.

Lastly, look at the perspective effect created by the two cars. Clearly, the car below looks nearer than the one above. The effect is the same even when the page is turned upside-down and it is entirely a colour effect. The bright colour appears to advance, an effect that can be used in package design, in interior décor, (a wall or ceiling in a bright colour will appear to advance and look nearer, or lower) in dress and, with surprising results, in make-up.

A sensation of movement was achieved using black and white in Bridget Riley's painting, *Fall, right*. The same flickering effect can be created using colour pairs that dazzle when the hues have the same saturation: red and green or cyan (greenish blue) and orange.

But the combination of black and white in this painting creates another effect: sensations of pastel colours appear among the curves.

Bridget Riley declared herself indebted to the neo-Impressionist painter Seurat for her interest in the application of optical effects to art. Dazzling moiré effects can be created with dots as well as lines or any other geometric forms.

The many moods of natural light

How trusting we are of daylight to show us things as they really are! We judge the colours of prospective purchases in the light by the shop window, firmly believing that the appearance things have in broad daylight is their true one, and that any other effects created by artificial light are somehow deviations from the norm.

And yet, the natural light we see and dismiss as white is a constantly changing coloured illuminant, affecting the colour appearance of everything it illuminates. Because the human eye compensates and adjusts continually and rapidly, we scarcely perceive the variations, although we experience an emotional response. The red and yellow light of a bright morning is elating, but the world looks drab and dull under the grey light of an overcast sky.

The colour composition of natural light changes from dawn to dusk, from winter to summer, from north to south and east to west. Observe a white or neutrally coloured room at different times of day to see the subtle colour changes from morning to late afternoon to evening. Morning light is faintly chill—palish yellow, or a flat greyish-white on a cloudy day. By midday the room will be flooded with 'white' light, and look more like the colour it was painted than at any other time of the day. The late afternoon sun has a special character—a rich gold; the colour content increases in the evening when sunsets produce warm reds, strange magentas and longer shadows. These distinctions are of importance to photographers, architects and interior designers, whose work is to some extent interpreted by natural light.

The orientation of different rooms in a house dictates the time and manner in which the light visits them, and so may suggest their function. A bedroom facing east receives the early morning sun. A south-facing living room or kitchen will be sunny for the greater part of the day. A patio opening towards the west will have the sun during the evening. North daylight, with a minimum of red, orange and yellow wavelengths, is cold-looking but valuable for reliable colour-matching. The Roman architect Vitruvius recommended a northern aspect for 'the picture galleries, the weaving rooms of the embroiderers, the studios of the painters . . . so that, in the steady light the colours in their work may remain of unimpaired quality.' In fact, even north daylight does not afford a constant spectrum, but the changes are minimal and gradual. It is the ideal light in which to put on make-up or to work with colour.

The unmistakable rosy gold light shed by the winter afternoon suggests that certain tones are intensified when the days are shorter. After all, northern midwinter light has less than half as long to run through its repertoire as midsummer light. Spring and autumn daylight get about equal time, with slightly more afternoon light in spring and slightly more morning light in autumn. Winter light tends to be greyer, bluer and cooler, summer light to be yellower and warmer, suggesting a flexible interior colour scheme based on neutrals, perhaps, with elements that can be varied seasonally.

Natural light changes dramatically with the different latitudes. The degree of cloud cover common in northern Europe has conditioned the population to muted colours. Inhabitants of the Mediterranean region are accustomed to strong, mellow light. Pastels and deep, rich colours cheer the façades of houses in the diffused blue northern light; bright yellow-biased hues glow in the Californian sun. But nearer the Equator, it is pointless to use strong colours on the outsides of buildings, because of the bleaching effect of the sun. Where natural light is so formidable, colour is best used inside—in cool tones—or in the shade of a veranda, or porch.

Although most of our exposure to colour in natural daylight is outdoors, it is largely indoors that we can apply what we know about the vast and delicate range of changing hues. The natural coolness of a room with north light may be emphasized by decorating in the blue-grey range, or counterbalanced by the use of warmer shades. The strong colour impression a sunset makes can be accentuated or mitigated in the colour of a west-facing room. However the room is coloured, the wall on the side opposite the window will be brighter than the others; snow on the outside will make the ceiling inside appear brighter. Light's endless mutability makes it impossible to keep the indoor environment a constant colour. The point is to use and appreciate the infinite spectrum offered every day.

The first light of day is eerily grey and white. There are no shadows. As the level of illumination rises, the grey becomes tinged with blue. But the appearance of colour may be delayed until the morning mist, which imbues the atmosphere with a pearly whiteness, evaporates. As the longest wavelengths of light appear, the sky turns red and orange, and the light seems instantly warmer. The first shadows thrown by the low sun are long, and reflect the blue of the morning sky. Colours look muted until the sun is high and its light intensifies enough to deepen the shadows, which emphasize the contrasts between hues.

Fog gives the same subdued colours as the period just before sunrise. Cloud limits the number of red, orange and yellow wavelengths reaching the Earth; so colours look flat beneath an overcast sky, but a storm dramatizes the deeper hues.

Daylight is at its most intense at noon, and looks white. Colours undistorted by atmospheric conditions appear in their true hues, and colour contrasts are greatest. Shadows are short and black. Light intensity increases from winter to summer, and from the far southern and northern reaches of the Earth towards the Equator: in Calcutta, on the 22° latitude line, the light is twice as intense as in London, 29° to the north; Kenya, *left*, on the Equator, has a light intensity 2¼ times greater than London. Intense light tends to dazzle the eyes, so that colours look bleached.

Natural light is composed of direct sunlight and reflected skylight. Sunlight performs the function imitated by artificial incandescent light sources: it highlights and accentuates form and texture; it casts shadows. Skylight is a diffused light which, like artificial fluorescent lighting, is even and casts no shadows. As the sun passes its zenith, the proportion of reflected skylight falls as more and more of the blue light is filtered out of the atmosphere, and the long wavelengths of light begin to predominate, so that the day takes on a yellow cast. As the afternoon progresses, the light turns redder and dims almost imperceptibly. Colours change their cast accordingly, becoming warmer and richer, and colour contrasts become less distinct. The assaulting intensity of the sun lessens to a brilliant glow, and shadows turn gradually blue and lengthen, strongly accentuating the textures in the landscape.

When evening falls, the only light remaining is reflected skylight, and because as darkness falls the eye becomes more sensitive to the short light wavelengths, the atmosphere looks blue. If sunset colours reflected from clouds maintain the level of light intensity for a while, the blue twilight mixes with the red light reflected from the clouds to bathe the air in a violet glow. When dense clouds mask the colours of sunset, the light looks greyer and colder as it fades, but a sunset seeping through storm clouds bathes the ground in an unearthly reddish glow.

Evening light changes rapidly. Shadows disappear and reds, oranges and yellows turn purple, then black, while greens, blues and whites linger. In winter, dusk fast overtakes twilight. Towards the Equator, where the Earth's movement is most rapid, the dusk falls too fast for a period of mysterious blue twilight.

Artifice with light

What we think of as plain white electric light, ubiquitous in our daily lives, is in fact subtly coloured. Its hue is apparent in the windows of houses glowing amber at dusk, subliminally so in the enticingly red meat (illuminated by a De Luxe Warm White fluorescent tube) in some butchers' shops or our whey-faced reflections in many a public restroom mirror.

The purpose of artificial lighting is not only to illuminate. Aesthetic considerations have been no less important than practical ones in the evolution of the lighting industry. Professionals speak in terms of 'colour appearance' (the apparent colour of a light source) and 'colour rendering' (its effect on the colours of objects it illuminates). The most efficient form of illumination, low pressure sodium-discharge lamps, render colour so poorly that they must be relegated to the street where safety is a higher priority than beauty. The reason sodium lamps are so effective is that they radiate only those wavelengths to which the eye is most sensitive, the green and yellow, and provide the greatest visibility for the least expenditure of energy. The distorting effects of discharge lamps can be gauged by the disappearance of prostitutes from a Central London street into which mercury lamps were introduced in 1936, because of their unflattering effect upon make-up. More power must be expended to get the same luminous intensity from red or violet light, or to get a balanced colour rendering, as from an incandescent source which radiates a broader spectrum.

Incandescence is light produced by a heated material, of which the sun, oil lamps, candles, gaslight and the tungsten-filament light bulb are all examples. The hotter the given material is heated, the greater the light it gives—glowing first red, then yellow, then very nearly white. When the tungsten filament bulb became a mass production item, manufacturers could supply a subdued light with an almost infinite life, or a bright white, but short-lived, light. They compromised on light slightly yellower than daylight, but whiter than either oil lamp or candle, which would burn an average 1,000 hours. Its colour rendering is on the warm side of natural, enriching the reds, pinks, tans, yellows and neutrals in the room, while dulling the greens and blues.

Fluorescent lighting is characterized by its flat, cold, bright illumination which casts few shadows and no highlights. It is uniform, undramatic, cheap to run and clean. It evolved from the original vapour-tube devices which produced light through the electrical excitation of gas atoms. The gas used determined colour: neon made red, mercury blue. By coating the inner surface of vapour tubes with phosphors, fluorescent lighting was created, the colour of which could be controlled by the phosphors selected.

Lighting manufacturers offer guidance on the colour-rendering properties of their fluorescent lights. The trade names can be misleading because some of the best known were established during World War II and have proudly been retained

Light reflected from a cloudless northern sky has no particular colour bias and extends fairly evenly across the spectral range, permitting coloured objects to render—or appear in—their true hues. Fluorescent Northlight imitates northern skylight as accurately as possible: compare the colours in the table-setting illuminated with fluorescent North-light *above*, and with Warm White *left*. The latter has a bias towards yellow.

The types of fluorescent lighting most commonly used in stores, factories and offices differ from north skylight in that their spectra contain very little blue or red light, but peak in the yellow part of the spectrum, to which the eye is most sensitive. The light they produce, though highly efficient, has a yellow to orange bias. Compare the colours in the table settings illuminated by North-light, *left*, and a Daylight fluorescent tube, *above*.

(by illuminating the munitions factories cheaply, they helped the Allies in the war effort) even though lights have subsequently been produced that do a better job of living up to the pioneers' ambitious labels. The first fluorescent tube marketed was dubbed daylight, but the name would now be more aptly applied to a Trucolor, or a Kolor-rite.

In the home, fluorescent light is still used most often in the kitchen which, like a factory or office, needs superior visibility to allow close work. The bluish fluorescent lights, such as Daylight, which tend to turn blue colours purple and to dull the reds have been superseded by fluorescent tubes which give a light more like tungsten lamps—White, Warm White, or De Luxe Warm White. Home workshops and bathrooms can also benefit from fluorescent light, but when it comes to their influence on colour, different types of fluorescent lighting vary from one another nearly as much as they do from incandescent light.

A plethora of choice leads, of course, to a wider range of aesthetic possibilities. Lighting can be chosen to enhance the décor, or perhaps to correct the greenish glow that green-painted walls tend to reflect. A common tip for correcting the colour bias of certain types of fluorescent lights is to use a mixture of tungsten and fluorescent. If they mix well, their combined spectra will emit light across the spectral range. Kolor-rite or Trucolor, for instance, will supplement natural daylight in a dark apartment.

Shoppers and retailers have both learned, sometimes to their rue, the importance of colour-rendering. An American colour consultant developed a range of colours for a leading blanket manufacturer, but when the line was launched, it became conspicuous both for its success and failure in different stores. Lighting was the variable. The largely rose and gold shades were snapped up in stores with incandescent lighting, while they languished under fluorescents, which rendered the colours muddy. Subsequently, specifications were issued for lighting displays and the blankets sold well. Similar errors occur more often among inexperienced buyers—obviously, it is essential to try and view the item you want under the same sort of light it will live with later. There are rules for matching colours. If you want to buy furnishing fabric to match a carpet, take a sample at least six inches square, and try out the match under *all* the different lights you have in your living-room. Dyes reflect differently under different types of lighting, and the yellow sample that matches the carpet exactly under tungsten light may turn greenish under a fluorescent source. This is known as metamerism.

There are the inevitable stereotypes with artifical lighting—that cool and efficient fluorescents equal work and modernity; warm and cheerful incandescents equal relaxation and tradition. But while Northlight tubes are likely to remain too cold in their aesthetic and emotional effect, and too costly to run for all but professional colour-matching purposes, there is a different light to suit every situation, every mood and every purpose.

Warm White, the most popular fluorescent light for household use, was introduced into British munitions factories during World War II. The girls complained that their make-up colours were ruined by the bluish cast of the Daylight tubes then in use. Its spectrum is biased towards the orange to pink wavelengths. Though warm in hue, it gives a poor colour rendering—compare the colours of the table setting under Northlight, *left*, with Warm White *above*.

A tungsten light bulb has a spectrum containing almost no blue, but with a strong red bias. A candle gives a yellowish pink or peach-coloured light. Although red light has a distorting effect on the colours of clothes and furnishings (compare the table-setting under Northlight, *left*, with the same setting illuminated by a mixture of tungsten and candle-light *above*) these types of lighting are the most flattering—the light most people like to see themselves in.

Painting with light

The work of stage lighting designers should assist, never dominate, the scene. Similarly, there is little point in drenching a living-room in so much intensely coloured light as to evoke an aquarium or an inferno. Used judiciously, coloured lighting may perform the same tasks in the home as it does in the theatre: imperceptibly create a serene or lively mood; subtly enhance the décor; indetectably flatter complexions.

There is a distinction between coloured lighting that is ostentatious and coloured lighting that is subliminal. Most people's experience is with the former—the fairy lights at Christmas, coloured bulbs strung round the garden for a barbecue, the ubiquitous red lamp at parties. These, and such things as stained glass, neon sculptures, holograms, even fireworks, are all light for light's sake. This kind of coloured lighting has reached its apogee in discos, at rock concerts and staged light shows, inspiring home experiments with flashing coloured light and black (ultraviolet) light to make clothes and posters fluoresce. These are the lights that say 'Look at me!' They are used to create instant atmosphere. When people react negatively to suggestions that they employ coloured lighting at home, it is doubtless a mental picture of living in a night club that puts them off, but there is another side to the story.

The layman tends to assume he may either see properly or have atmosphere, but not both. But contemporary light fixtures and sources *do* combine the two. Lighting equipment mounted on track gives unprecedented flexibility, and there are coloured fluorescent tubes and dichroic filters which actively produce coloured light rather than filtering 'white' light; spots and floods; bulbs with internal reflectors and framing projectors which shape the beam. The range of red, blue, green, amber, pink and smoke bulbs is gradually being augmented with bulbs aptly called 'candletip' and 'wild flicker'; dimmer switches will control the intensity of all. Most theatrical lighting is achieved by mixing the red, green and blue light primaries in the proportions needed to achieve the required colour, or by making use of filters. These are available to the public in up to 300 colours.

A very pale blue filter will give a lustre to a collection of silver or an indoor pool. An amber bulb strung low over a pot of marigolds will enhance their radiance. Properly angled pale pink or candlelight gold downlighting the dinner table will flatter any woman. If the use of coloured lighting is to be successfully unobtrusive, it must agree with its subject, for colour distorts colour, and this may be the reason why the notion of coloured lighting at home strikes people as tasteless, superfluous or irritating. A subtle, sophisticated decorating scheme could be distorted or obliterated.

Yet a blue light may make a blue room even more relaxing, and a kitchen kept bright during cooking could be put to rest later with just a shaft of blue-tinged moonlight in a dark corner— a touch of mystery to fuel the imagination. And the psychological impact of colour is so great that in these energy-conscious times real savings can be made in the cost of running a home by letting colour do some secret work. Subtle use of warm or cool tones can spare the thermostat a few degrees: amber is associated with warmth and comfort; a blue light can make a hot evening seem cooler. Coloured lighting can be made to ring infinite changes in a white or pastel room.

The handling of coloured lighting is a complex and sensitive field. The layman must take his place alongside the professional. He can acquaint himself with the basic rules from texts on theatre lighting, then keep or break them. Like the master he will learn from trial and error.

The stage lighting principle that says 'always project on to a subject something of its own colour, so that it will reflect that colour back to you' is a cardinal rule for using coloured lighting for decorative and atmospheric effect. A coloured light will distort all the colours in a room—except its own—so radically that the room may look almost unrecognizable. These distortions will be lessened if pale —or unsaturated—light filters or bulbs are used.

Under 'white' light, *below*, the colours in the clown's costume are reflecting their true hues, and the contrasts between colours are distinct; but under an intense green light, *right*, only the black and red remain distinguishable and the red has distorted to reddish-brown. Green light greys all colours, including orange and violet, and intensifies greens. Pale green light is tricky to use; it makes skin look sickly and mercilessly shows up any blemishes.

Under a deep blue light, *far right*, black and red have become maroon and yellow has turned green. Dark blue light will grey everything except greens, blues and violets, which it intensifies. Pale blue light looks cold—or cool— and makes skin look ghostly.

Yellow light, *right*, makes almost all colours look more orange, and orange look yellower. Light blues turn greyish violet; dark blues look brown; greens become greyish and blue-greens look greener. Pale yellow light affects only the palest colours, and white, and has a slightly warming effect. A peachy light is most flattering to the skin; it picks up the pinks and flesh tones, and flatters make-up. Dark amber and orange lights tend to redden yellows, intensify reds and oranges and make greens, blues and violets look greyish-brown.

Violet light makes yellows look orange, and makes oranges redder.

Red light, *far right*, destroys colour. It converts pale and warm colours into a uniform red hue, and makes dark colours look black. Even reds are distorted under red light: yellow-reds turn into blue-reds and dark reds turn brown. Perhaps because of the strange atmosphere it creates with its distorting effect on colours, red light is common at parties and in discos. Pink light is more flattering, warming all colours except greens and blues, which it greys. Purple lights make skin look pink, orange or red, depending upon their intensity; blues look purple and greens are greyed.

Making faces

The colours a woman puts on her face do not so much mask her character as map it. Colour in make-up is rich with clues as to the age, personality and preferences of the wearer. Shy young girls wear soft pastel colours and 'safe' combinations that are clichés in the industry, the adventurous and revolutionary branch out into brights and metallics in unusual or shocking combinations. Make-up colours reflect fashion colours which change with the seasons, and sometimes even the geographical origins of the wearer. Europeans like mat shades, Americans prefer pearls, but aqua greens and blue-reds are best sellers on the West Coast while women on the eastern seaboard prefer yellower greens and reds.

Make-up is a means to the end of physical perfection and derives from the dream-creating media. It is from stage, screen and high-fashion that modern commercial make-up has evolved. In the thirties Garbo routed her pink-and-white predecessors with sparing colour: pale cheeks and a line of black pencil to accentuate the upper eyelid. Rita Hayworth epitomized forties Hollywood glamour with gleaming lips and long nails of matching brilliant red. The soft, 'natural' colours displayed on Jean Shrimpton were embraced by the sixties. Then the cult of the individual took hold and since the seventies, colour in make-up has been used as a tool for personal expression.

Cosmetics companies break down the market for colour into four categories: basic need (one lipstick, one eyeshadow and so on); cosmetic-dependent (the majority, who use a full range, have established preferences and are slow to change); experimenters (the young and avant-garde who will try anything and change quickly) and the elite (those who maintain a stable of shades and support the expensive ranges).

The range of colours available varies with the area the cosmetic is used for and the rate at which it is bought and consumed. Nail varnish affords a prodigious selection because women try new

A combination of cerise lips and blue eye shadow, *far left*, is a cosmetic cliché for a blond, but bright blue enhances the eyes and gives them a tranquil expression. Although a blue eye shadow will usually make blue eyes look grey, here blue eye pencil inside the bottom lids reflects upwards, making this model's green eyes look blue. Blond hair and pale skin emphasize the fullness of the face, an effect counteracted by a shadow made with a blusher beneath the cheek bones. Blusher just under the chin softens the point and warms the centre panel of the face.

A gold tan skin colour narrows the face, *left*. Lip gloss in a natural shade and brown eye shadow enhance the healthy 'natural' look, but here the brown shading has a secondary role. It makes the eyes look bluer than any other eye colour. Blusher is used just as on the pale skin, but is less effective on a dark foundation.

Different colours alter the length, width, shape and perspective of a face just as much as they affect the dimensions of a room or garden. These eight photographs are all of the same model. By changing her hair, skin and make-up colours, she has eight different faces.

Brown hair and pale skin have a soft look that can be strengthened by strong colour and an emphatic eyeline, *right*. Orange lips and terracotta eye shadow balance this colouring. Terracotta shadow narrows the eyes and makes them recede, and blusher low on the cheeks narrows the face. The orange lip colour has a hint of yellow to tone with the hair.

Pink lips and turquoise eye shadow, *far right*, is a 'safe' combination for women with light brown hair. It is soft and understated, but 'tame' and makes the model look younger. Blusher used directly on the cheek bones rounds the face and flattens it.

colours freely. Hands are a safe distance from the face, so no radical change of identity is threatened and nails relate more to clothing than character, so they may be treated as ornaments or accessories. Lipsticks are bought more liberally than eye make-up. They have been accepted for some decades, match nail colours and do not require so much hard thinking about end result. Eye make-up colours outnumber those of foundation or blusher because the jewel tone of the iris may be accentuated by a wider spectrum of tints than would be appropriate on the skin. However much make-up colour may redress the balance of nature, natural colour must be consulted before artificial colour is chosen; thus, foundations are designed to harmonize with complexions. The term rouge (due to its links with harlots and grandmothers) has been succeeded by blusher, but its aim is still the same—to enliven the face with the colour naturally associated with health and excitement.

There are more make-up colours now than there have ever been, making choice more bewildering. This necessitates detailed instruction in an expanding range of specialist magazines, and expert advice at sales points. Colour choice may be based on intuition, or the laws of colour harmony and contrast and the rules by which colours change apparent dimensions, but a good lead may be gleaned from the colours that predominate in one's wardrobe as well as from the natural indicators of eye, hair and skin colours.

Advances in cosmetics have furnished specialist lines in latter years—rich, more transparent colours for black skins, sparkly metallics for discophiles and discreet ranges of cosmetics for men. But there is at least one market left to please. The post-World War II population boom is aging. Skin changes colour with age, yet there are no mass-marketed cosmetics ranges especially designed for older skins.

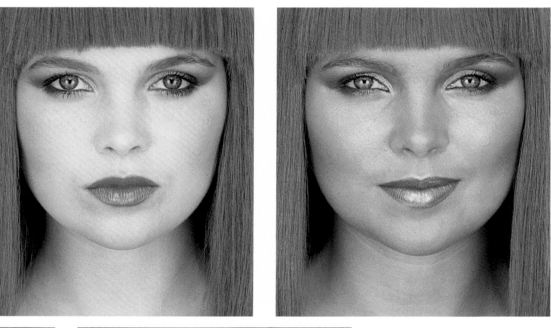

Orange lips and green eye shadow are a cosmetic cliché on a redhead, *right*, but green shadow brings out the natural green of the model's eyes, and green pencil lining the bottom lids makes them look greener still. Yellowish orange lip colour would look sallow with this colouring; the orange used here is reddish to tone with the hair. Blusher used high on the cheeks emphasizes the bones and accentuates the shadows beneath.

A darker skin tone, *far right*, narrows the bridge of the nose. With a dark skin, eye make-up has to be dark to be effective. Gold eye shadow is combined with brown shading at the corners and a turquoise line inside the bottom lid to make the eyes appear green. Blusher on the cheek bones is highlighted with gold for emphasis. A gold line along the cupid's bow and on the reddish brown lips highlights the mouth, making them rounder and fuller.

Black hair creates a dramatic effect. The dark frame absorbs the light, darkening and elongating the entire face.

A dark skin tone in the photograph, *left*, narrows the face still further. Here, the blusher and skin tone are the same as those used in the photograph, *above right*, but against the frame of dark hair they appear darker and slightly redder. Silver and black eye shading make the eyes look grey— and the silver shadow has taken on a greenish tint, an unintended effect that may be caused by a predominance of red in the skin tone surrounding it.

A paler face looks slightly wider, *far left*. A dark blusher gives more shape to the face than the lighter shade in the photograph in which the model's hair is blond. A lighter highlight on the plum-coloured lips makes the mouth look rounder and fuller. Mauve eye shadow makes the model's eyes look blue.

157

Colour in dress

When people say 'that's my colour', they invariably mean the one in which they feel they look their best, the shade that makes them feel comfortable, the colour with which they identify. People's ideal colours are based on personal points of reference—on an intuitive understanding of the rules of colour harmony and contrast as applied to their hair, eye or skin colour, and on their ideas about their status, role, age or disposition.

Everyone recognizes the language implicit in the colours of clothes. Teenagers out to shock say so in discordant combinations of brights, or symbolize the uniformity of their outlook in negative black monotones—customs that are not so new. In 1925 Oxford undergraduates outraged society with lavender, cinnamon, mauve and green trousers with legs 40 inches wide; and in 1931, a fashion historian notes, 'black sweaters appeared on young men in London who sought the spotlight. They hailed from Chelsea and Bloomsbury, and had artistic leanings'.

The colours of clothes have complex meanings. Young girls try out black, hoping to appear older; women wear black to look sophisticated and elegant; men's black suits are symbols of tradition and formality. People often wear black when depressed because they see it as self-effacing, the only colour in which they can face the world; but conversely, an office worker tired of the daily grind might feel more cheerful in red. Unmarried girls, out to attract, might wear red for parties.

The psychology of colour in dress is studied minutely by costume designers, who use it in the interpretation of the characters they dress. 'As the colour of the costume makes its presence felt more rapidly than its actual form it is necessary for the designer first of all to feel and reproduce the fundamental nature of a character through its colour presence', wrote a television costume designer in a professional journal. 'It is, in fact, this last which will immediately force itself on the viewer's attention, which will trigger off his first reaction and create a state of mind in which he will accept or reject the character proposed.'

Children express themselves most aptly in their choice of colour. The very young consistently opt for cheerful, bright primaries, the bright reds, yellows, blues and kelly greens found in many of their toys. Blue is their favourite. The fashion phenomenon of khaki was a disaster with children, who stick to their preferences, unmoved by trends or practicalities. However, they embraced disco glitter.

Although men now have more opportunity to sport their colour preferences, business attire remains essentially conservative. Flamboyant colours detract from the individual and at work would constitute an egotistical distraction, except in some creative fields where they can be justified as part of the image. Meanwhile, the increasing numbers of working women adhere to tradition, wearing dark, sombre colours in office dress, with brights reserved for accents. Professional women want recognition for professional skills, not for their skills in dress.

People's notions about the colours that suit them may be altered to a degree by a tan, a change of hair colour, a change of status (from teenage rebel to working man, from working woman to wife and mother) or even by a new job. But they are stable in comparison with the perennial carousel of fashion shades. The perpetual change in fashion colours means that individuals take it in turns to be flattered. It is difficult, bar clinging to neutrals, to ignore fashion shades because they dominate the choice in shops.

Yet fashion works better when interpreted than when conformed to: shoes or a scarf in the yellow or green at the top of the fashion charts are more subtle than a sweater that makes the wearer look trendy, but jaundiced. In fact, anyone can wear any colour so long as its saturation and degree of lightness or darkness is aptly chosen. And apparel colours are modified by their relationship to other colours in the ensemble, and by the coloration and dimensions of the wearer. Thus, a red scarf or sweater below pale cheeks casts a rosy reflection as effective as rouge, while a greenish blue version may tone a ruddy complexion down to one that just looks healthy. If it matches the eyes, it will accentuate their hue.

It is worth experimenting, always, to see how colours thought controversial or unlikely look in place. A canny saleslady, sizing up her customer's features and make-up, is often right to insist, 'you have to see it on'. For colour can change, as well as express, character. 'One does not walk in the same way when dressed in pink, as when dressed in black', observed the television costume designer. Just as brighter colours sometimes work to alleviate a depression, so might they work to boost confidence, or to change the reactions of people at work towards a colleague too long inured to respectable grey. And the old, who tend to wear pale or dull colours, might feel younger if they ceased to renounce colour as they age.

Men who see themselves as liberated react in the colours of their dress against what they see as the stultifying conservatism of traditional menswear. An uninhibited use of colour in male dress identifies its wearer as young and 'trendy', and possibly classifies him as a member of one of the artistic professions: a hairdresser, a designer, a pop singer or, *right*, a model. Yet few men would opt for a suit in bright red. The cost of men's clothes is still high, and they are generally chosen in colours that will endure both wear and the vicissitudes of fashion; and perhaps because of old associations between bright colours and homosexuality, men tend to venture into strong, dark colours, or pastels, rather than into primaries in their dress.

Beau Brummell, the nineteenth-century English dandy, is said to have been responsible for the Englishman's traditionally drab and sombre taste in dress. He believed that the English psychology is best expressed in subdued colours and elegance of cut. Despite the contemporary revolution in men's fashion colours London businessmen still retain formal, conformist and conservative dress. In the Stock Exchange, *right*, and in other institutions in the City, London's financial heart, black, white and grey are confidence-inspiring colours of respectability.

It was 'ladies first' in fashion colours from the end of the nineteenth century until after World War I. On the dance floor, women traditionally wore colour, glitter and sparkle; in modern competition ballroom dancing they wear stylized dresses in brilliant, eye-catching colours. The men's formal suits of sombre black act as foils for the hues their partners wear.

During the post-war years, men have liberated themselves from this subordinate role on the dance floor, and styles of dancing have changed as a result. Dressed in colourful shirts, trousers, shoes and even jewellery, they compete with the women in the gaudiness of their dress. Yet women's wear still leads fashion colour trends: new styles and colour stories filter gradually out to men's and children's clothes.

Even those indifferent to fashion use colour in their clothes intuitively to make a statement or to comply with an image. The life and soul of the party will doubtless visit the bank manager wearing clothes of a more sober hue.

The clothes men buy for lounging at home in the evenings or at weekends tend to be more colourful than those they buy to work in. Americans on holiday are identified by the uninhibited flamboyance of their shirts—a fashion that became a national custom after 1950 when President Truman was photographed in a gaily coloured Caribbean 'Carioca' shirt. Americans also have a long-standing tradition of using colour to emphasize their personal relationships. Husbands and wives began to dress in identical colours and patterns in 1939. This fashion never died, but spread to mother-and-daughter fashions and twin and sibling fashions in the fifties.

Furnishing with colour

Colour in the home is, essentially, colour that is lived in. It defines space, indicates function, suggests temperature, influences mood, projects personality. Yet the challenge of interior design is that people must make these most costly decisions in an area where few get the chance to practise. Hence the profession of 'interior designer' for which the prerequisite talent is skill in handling colour.

There are many factors to be juggled in choosing colour effectively—from room size, shape, orientation and use, to cost. By breaking the task into categories of large and small rooms; rooms of greater or lesser use; fixed and variable colour (wall-to-wall carpeting or rugs); large and small colour areas (walls or cushions) and so on, colour choices may become less confusing.

It is axiomatic that large rooms may be broken up with colours, that darker and warmer make for smaller, that small rooms look more spacious decorated in a single light colour or white, with strong colour reserved for accents. Bright colours foreshorten, but must be used judiciously because of their impact. They can be cheering in hallways, stairs or lobbies which are seen mainly in passing, in guest- or dining-rooms not in constant use, and in north-facing rooms which tend to look chill. Because of the emotional effect of colour, it can make living space feel exciting or subdued. People working in a dull environment may crave a bright place to recharge. Others, in high-pressure work, may require a tranquil sanctuary.

Attitude toward colour can be static or kinetic, which may be reflected in the choice of a period or modern house, and can be used to govern basic colour decisions. Another suggested starting-point is to reiterate colours favoured in dress: people may be flattered by their environment as much as by their clothes.

But for most people, decorating must be a cumulative art, informed by compromise. One rarely starts entirely from scratch. There will be a major item of furniture, a favourite painting, perhaps an existing fitted carpet, with which to reckon.

Everything in a room makes a colour statement. The governing items are paint, wallpaper, curtains, carpets, upholstery. Accents come from rugs, lampshades, bed, bath and table linens. Dominating neutrals can be brightened with small areas of variable colour in portable or cheaply replaceable items. Paint, ready-mixed and available in up to 1,000 colours, is the most easily manipulated colour device. Fabric, in which different textures give distinct interpretations of the same colour, comes second. The evolution of protective finishes has expanded the useful range of light and delicate fabric shades. Much can be done to ring the changes seasonally simply by switching curtains, rugs and slipcovers from autumnal reds and browns to vernal greens and yellows by circulating accessories.

In all decorating decisions it is crucial to examine the proposed colours *in situ* as opposed to in the store, so as to judge the effects of natural and artificial light. Volume, too, radically influences colour. A paint chip can hardly be expected to give a proper sense of what the painted room will look like. The aggregate power of four walls and a ceiling will lighten its hue and brighten its effect by about 50 per cent, so a lighter and duller chip will be more likely to give the finished effect first visualized.

Paint and many fabrics cost less than carpets and wallpaper. By living for a week with a corner of a room experimentally daubed in the colour that came in with the season, or a cluster of cushions trying out a new fabric design, the overall effect of colour on room—and room on colour—can be more easily visualized.

Changing fashions and greater mobility make for frequent changes of colour. But furniture, floor and wall coverings constitute major investments which, once made, will have to endure and be endured. Neutral creams and beiges seem 'safe', but these colours become more dull than safe when used overall, and when teamed with brown furniture. Contrasting colours are needed for stimulation in a room with a neutral background of white, off-white, beige or grey. A wall or door painted in a distinct colour will relieve the monotony of such a scheme and may serve to alter apparent dimensions. Colours in pale shades are labour intensive, and a carpet in a dark colour will help to reduce maintenance.

Accessories such as the paintings, cushions and flowers in the white room, *right*, and acquisitions such as lampshades and ornaments, make bright spots of colour that attract the eye and the attention; if selected to harmonize, they will bestow colour upon an otherwise neutral background scheme.

Dark rooms painted white will look lighter if the paint has a light-reflecting sheen. Contrast between light and shadow may be heightened by textural contrasts— rough weaves against shiny woods; mat walls beside glossy doors.

Primary colours stimulate. In rooms where children play, in kitchens, lobbies and teenagers' bedrooms, primaries look cheerful and enliven the mind. But unbroken areas of primary greens, blues, reds and yellows tend to be overwhelming, even depressing, especially if two or three meet without a relieving break. The secret of using primary colours for stimulus without letting them overpower a room is to break them with neutral colours—whites, beiges, greys and blacks. Bands of white separating the primaries, *below*, create a unified pattern, brightening each component hue, and the overall effect of the scheme.

Strong primary colours work best in sunny, south-facing rooms; in dark rooms they tend to look sombre. Yellow, in particular, needs strong light to look bright.

Colour can be as functional as the room it adorns. Some colour constultants recommend decorating bedrooms in red or orange to make the atmosphere sensuous, colouring dens and libraries in relaxing tones of brown, and bathrooms in clinical, hygienic white or aqua greens and blues. The Pompeians coloured bedrooms in sleep-inducing black and, following the same principle, the bedroom, *above*, is painted in a soothing shade of blue.

A monochromatic room is never all one colour. The intense light from the windows in the living room, *left*, bleaches some walls and intensifies the hue of others. The colours of this room change hour by hour, from morning until night, and from season to season.

While a monochromatic scheme effectively unifies the elements of a small room, or an irregularly shaped room, contrast, in the form of texture, tone, hue or pattern, is necessary to avoid monotony. Here, the tans, browns and off-whites of furniture and ornaments both harmonize with and alleviate the tedium of a dull green. But such a large room, in which different areas have been designated to different functions, may be broken up with walls and alcoves painted in different colours, or various tones of a single colour.

Bright colour could be a cheap and immediate solution to the problem of moving into such a large space with few possessions to furnish it. For the young, especially, bright colours seem fitting. But as acquisitions increase in quantity and quality, the need for strong colours or a lot of colour lessens. Costly furniture, art and artifacts contribute texture and pattern, and a beauty that might be overwhelmed by strong colour or too many colours.

Cultivated colour

A garden's first impact comes from its colour. Flowers may have sublime shapes and scents, but initially our senses respond to their colour. Flowers and foliage are nature's primary, and most spectacularly varied, colour medium. They deserve to be managed as carefully as colour in any art. The romantically misguided notion persists that because flowers are lovely, and nature is never in bad taste, any combination of plants must be pleasing. But one cannot invoke nature on aesthetic grounds once man, for good or ill, has intervened. The mutant colours of countless cultivated species have not been nature's choices.

Serious gardening combines art and nature with results that exceed mere beauty. Creatively exploited garden colour can foster joy, contemplation and repose. The laws of complementary colours—of harmony and contrast—that affect colour in gardens are the same that affect colour anywhere. They apply not just to neighbouring blooms, but to foliage, light and shade, position, season and such integral elements as walls, paths, hedges, ornaments and furniture.

Historically, gardens have reflected the prevailing artistic and architectural styles of their day. The formal knot gardens of English Tudor houses used heraldic colours. The Stuarts favoured evergreens and variegated forms. The baroque tendency to work patterns in parterres with blocks of solid colours survives in the beds of annuals in public parks. Nineteenth-century gardeners indulged a taste for sensation, juxtaposing, for example, scarlet geranium and blue lobelia—subsequently repudiated by Gertrude Jekyll, founder of the herbaceous border, whose subtle, Impressionist painter's handling of flower colours made her the first English lady of modern gardening.

Using the law of complementary colours, Gertrude Jekyll chose each grouping of foliage and flowers to prepare the eye for the succeeding hue. Typically, she would arrange a border starting with grey or glaucous foliage, progressing to darker grey with blue, grey-blue and white flowers, gradually incorporating palest yellow and pink—partly in distinct masses, partly intergrouped—giving way to stronger yellows, and finally orange and red, so that the colour reached a palpable crescendo in the middle, receding again towards cool colouring at the other end, this time resolving more to purples and lilacs (which she kept apart from true blues) *en route* to the terminal greys. She felt blues benefited from contrast with white or pale yellow.

Gertrude Jekyll is also identified with monochromatic gardens, wherein a variety of species on the same colour theme are juxtaposed so that they produce a whole greater than the sum of its parts. Polar opposites in style would be the traditional country cottage garden, with its artless riot of colour, and Japanese Zen gardening, influenced by monochrome ink painting with its sparse, metaphysical use of colour.

Where there is shade in a garden, contrast is of greater value than harmony. Shade-loving blues are best set off by pale pinks and creams, which benefit both from their contrast to the blue and to the shade. Flower and leaf colours have either a blue or yellow bias, especially discernible in shades of pink which can be either purply or peachy, accordingly.

Certain colours naturally evoke specific times of the year. The spring is hailed by a myriad of yellows. Summer is a bazaar of every hue, weighted towards the reds and yellows that preponderate in the sum of all flower colours. In autumn the tawny shades of chrysanthemums and marigolds echo the rich, rusty tints of fallen leaves. Bright berries, deep evergreens and bark in camouflage colours keep the winter scene alive until the yellow winter jasmine and crocus gently herald the returning spring.

If a red and a blue object, each reflecting equal amounts of light, are placed side by side and observed at the beginning and end of the day, in daylight the red will look brightest and in twilight the blue. This optical phenomenon, known as the Purkinje shift, after the Czech physiologist who discovered it, can nowhere be exploited to better effect than in the garden. A gradually changing emphasis on different parts of the spectral range will take on distinctive atmospheres at different times of the day.

In the cottage garden, *right*, on a sunny afternoon, the stocks in the foreground are a brilliant shocking pink; the red, yellow and white snapdragons are bright and conspicuous and the green foliage softens the stridency of strongly contrasting hues. By early evening, *centre right*, the bright pinks have a bluish tone and look distinctly mauve. The yellows are still bright, but the greens are darker and the reds have shifted towards the blue end of the spectrum.

A garden planned to exploit the changing light of day takes on a new dimension, for when the flame colours so cheerful at noon are lost in purple shadows, diffident blue flowers, scarcely noticeable before, dominate the garden with a pearly luminescence.

Colour creates atmosphere, and monochromatic gardens, in which a single colour, or colour theme, predominates, can also be practical. Silver-grey plants are drought-resistant, and many foliage plants thrive in shade. The green garden, *right*, of trees, shrubs, ground-covering plants and climbing ivies, is easy to care for. Such a garden resembles woodland and has a faintly mysterious atmosphere. Greenery is cool and refreshing during a hot summer, but large-leaved 'architectural' green plants look modern and sophisticated. In an arid region green cacti and succulents have a surrealistic air.

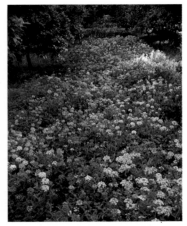

A pleasant harmony in the choice of colour is the secret of a pictorial garden. Borders of red flowers ranging from the palest pinks to the deepest maroons, of blues, lilacs and purples or of yellows, oranges and browns are more homogeneous than an assortment of contrasting hues. If a monochromatic border or garden seems to demand the addition of a second hue, a complementary colour will blend harmoniously.

Contrasts can be exploited to create optical effects. The magenta and white mixture in this long border becomes mauve as it recedes into the distance.

Pavings, walls, fences, ornaments and furniture all contribute to the colour in a garden; natural woods and stones team more easily with the colours of trees, plants and flowers than the bright colours of man-made materials. Japanese Zen Buddhist monks applied philosophy to the art of gardening and created gardens entirely without plants, contrasting the subdued natural colours of rocks, sand and pebbles. Each element represented some aspect of an imaginary landscape: the raked white sand in the Daisen-in Temple Garden, *above*, symbolizes waves on the surface of an ocean.

The Japanese exploit the subtle interplay of light and shade on materials of contrasting textures in gardens designed for retreat and contemplation. Differences in texture produce interesting colour effects: the shiny upper surfaces of evergreen leaves are a darker green than their mat undersides, and bluer than the translucent foliage of deciduous plants. The shiny, gloss-painted surface of the white window in the garden, *right*, reflects more light than the mat surface of the whitewashed wall whose stones make different patterns as the shadows wax and wane. Where colour is subdued, the eye is drawn to the subtle contrasts between leaves of different textures and different greens—and notices the changing patterns made by the light and the breeze.

The Japanese use colour sparingly; a yellow chrysanthemum may be the only flower in a garden furnished with foliage and paved and fenced with natural stone and wood. Here, the concept has been translated into the garden language of another culture. A tub of scarlet geraniums makes a focal point among the muted greens and yellows in a small garden where too many colours may only succeed in confusing the eye and bewildering the mind.

Colour gets down to business

Only since World War II has the vast expansion in the range and durability of coloured paints, pioneered in the first half of the century, begun to be fully exploited. Designers, architects, decorators and a new breed of professional, the colour consultant, have all been involved in a reassessment of the importance of colour in public institutions and communal places of work.

The forbidding hues of old-style schools, dingy factories, oppressively antiseptic hospitals, grey and boring offices—these have not disappeared, but all the signs are that they are on their way out. Whenever trouble has been taken to actually think about the use of colour (and associated factors, like illumination levels) there have invariably been reductions in absenteeism and increases in production. Morale has been raised and atmospheres lightened. No great creativity is required; simply a willingness to experiment in a spirited way.

First of all, the purpose of the building has to be considered. The same intense hues (dark reds and blues, say) which might cause restlessness and eye-strain when applied to large areas of a classroom might easily provide welcome relief or a sense of warmth to a factory floor. Different areas can be treated with distinctive tones. Soothing neutral colours are suitable for hospital wards or classrooms which are occupied for long periods; warm colours for commercial cafeterias and cool for dignified assembly halls, both of which are large communal spaces; vivid colours in corridors and stairwells stimulate people to keep moving: as the hues are not dwelt upon, they do not become oppressive.

Space can be further broken down into 'extensive' elements (walls, floors, doors, ceilings) and 'linear' elements (beams, pipes, pilasters). The tendency has been to camouflage the linear elements, to paint them into the background; but more recently, successful attempts to accent these elements have brightened up many functional areas. Blue piping or a bright red radiator cease to be ugly accessories and become interesting forms in their own right. As for light, the more the better is a common notion for working areas. But glare and dazzle can ruin as many eyes as insufficient light; and now that paints have reached the point where their reflectance levels are numbered to assist the buyer, there is no excuse. A pleasant pastel with good reflectance is often less fatiguing than plain white, while in dull environs a high-reflective paint can increase light levels by a third.

Factories are the real Cinderella story in interior face-lifts. Extravagant claims have been made for the power of colourful working conditions to increase productivity, lower accident rates and reduce strain. The secret seems to be partly personal and partly practical: on the one hand, machines and blank walls are 'humanized' by a dab of paint and on the other, the product itself has to be taken into account. Bright blues, greens and reds were applied to the walls of a South Carolina cotton mill to relieve the eye of so much white. Similarly, girls at a lipstick factory suffered from nausea and dizziness as a result of the green after-images caused by staring at red lipstick. The walls were painted green and the dots in front of their eyes vanished. In addition, industry has used colour intelligently to promote safety. Equipment is colour-coded red for fire protection, green for first aid, yellow for caution and purple for radiation hazards; machinery is coded according to its dangerous, moving parts and its stable, safe parts.

In schools, as in factories, colour can transform space: different areas in open-plan designs can be demarked while retaining an overall unity when the colours conform to a single 'set' of primary or auxiliary hues. Walls opposite windows can be decorated to reflect sunlight back on to the darker-toned window

The economic boom of the sixties helped to put colour into offices. Just as businessmen began to wear more daring ties and pastel shades crept into shirts, so furniture and fittings started to exhibit stronger, more dynamic hues. The combination of yellow and green has a meaning that extends beyond the aesthetic, according to the psychologist Max Lüscher. It represents a desire to prove oneself and achieve recognition and is the choice of an ambitious person.

wall. Primary school children favour primary colours, but these can be interleaved with neutral hues to prevent the visual vibration caused by adjacent power colours.

Classroom colours are sometimes adjusted according to direction: warmer for north-facing and cooler for south-facing. But one series of West German schools, conceived as 'mechanisms' whose every part is defined in varying hues, made colours increasingly cooler in north-facing rooms to help children locate the points of the compass—the buildings are part of the educational process.

Hospitals are a perpetual source of colour controversy. Since people cannot bring the colours of their own homes into the wards, the décor can only hope to succeed in a negative way by being as inoffensive as possible to people who are at their most vulnerable to the impact of colour. If a calming green is a fraction off-key, the effect is sickly. Short-stay patients can be jaundiced, or at least made to feel a little off-colour, by the same yellow that long-stay patients grow fond of.

Public buildings and institutions reflect traditional and changing views of colour. The mature oak woodwork of law courts with discreet splashes of red carpet around the judge's bench, and blue on the public side, exude the equilibrium of the law. Jet-age airports, dressed in hues as bland as canned music to calm nervous passengers or picked out in colours that identify boarding gates, embody the psychological and functional value of colours. But whatever is done to brighten the environment, there will always be somebody to complain about it.

From the twenties to the forties, wall-paintings by Rex Whistler, Allan Walton and a host of other decorative artists brought life to the formerly sober walls of both private houses and public buildings. A few of the great ocean liners had murals painted by well-known artists of their day.

Restaurants and coffee bars have become a traditional focus of this ancient art which, since World War II, has been revived by a new generation of artists. Their humorous themes and vivacious colours enliven dull surroundings and, like this wall-painting in the coffee bar of a British university, succeed in humanizing the austere lines of modern public buildings.

Suffused with a cool, blue light, the boardroom of the British Brick Development Association clearly opted for serenity rather than stimulation as the keynote for the meetings to be held there. It may have followed the lead of the colour psychologist Max Lüscher whose London office is predominantly blue, a psychologically relaxing colour.

Old factory buildings with low ceilings, poor lighting and none of the advantages of modern construction can be made into cheerful places where it is no longer a penance to work. The Bacofoil factory in East London is one of Britain's success stories. The men began by transforming working and storage areas with bright green and red paint; gangways were painted in black with white borders and the walls in yellow. One of the machine operators revealed a hidden artistic talent and altered corridor perspectives with a series of landscape murals, *right*. Primary colours on passageway walls, including big red arrows, sustained the sense of action and movement. Not only were accidents cut to a quarter of their number within a year, but the clean, new look obviously enhanced the hygienic image of a firm whose business is to provide enough foil to wrap 2,500,000,000 bars of chocolate every year.

Colour's grand façades

A new boldness in the use of colour began to infuse western building façades—public, private and industrial alike—from that point in the nineteenth century when architects reacted against the drabness of latter-day neoclassic and imperial architecture. The reign of creamy monochromes, enthroned by a mistaken belief in ancient Greek austerity, came under exquisite attack from the foliate forms and haunting colours of Art Nouveau. Colour was a vital element in a shift of attitudes which, fostered by the economic and technological exigencies of two world wars, changed the face of architecture across the Western world.

British, French and Belgian Art Nouveau had a recognizable coherence; however, the style's most famous Spanish practitioner, Antonio Gaudí, had a unique, even bizarre interpretation. His passionate regard for colour, which he deemed essential to producing a sensation of life, may be seen in the uninhibited dressing of his undulating façades with bits of rubble and brick, shards of pottery and tiles, paint and whitewash.

The turn of the century brought about a series of movements that unified painting, sculpture and architecture for the first time, and in a manner not repeated since. Constructivism used colour to emphasize function; for example, moving parts (such as doors) were distinguished from fixed parts (such as walls). Purism used colour to define space, to make it advance or recede. Piet Mondrian's abstract canvases painted in primaries with black, white and grey deeply influenced architects of the Dutch de Stijl movement such as J.J.P. Oud and Gerrit Reitvelt. In Germany, the Bauhaus school evolved a utilitarian aesthetic that saw architecture as indivisible from the socio-economic conditions out of which it grew—a vision that hallmarked European and American building for decades.

But if one designer and one material were to be selected for their impact on modern façades, the designer would be the French architect, painter and writer, Le Corbusier, and the material, reinforced concrete. Although Le Corbusier endorsed the utilitarian link between colour and object, colour and space, his palette extended beyond the primaries of his contemporaries to natural colours. But the concrete with which he was so eloquent proved a mixed blessing in less gifted hands. Although it was indispensable for the rebuilding and expansion necessary after the two world wars, it is also the one material people single out as symbolizing the dehumanization of modern architecture.

The backlash against raw concrete has taken various forms. The Germans responded by dressing façades with tiles, or with bright colours directly derived from their rich tradition of folk art. Their instincts have been echoed throughout Europe and America, where a reaction against drab, utilitarian buildings and the social dangers inherent in a soulless environment have combined to spark a new awareness of the need for individual expression in domestic architecture.

Examples of such expression abound in traditional domestic architecture the world over. In tropical Brazil, houses are painted in pastels and primaries. Expatriate Jamaicans often continue similar folk traditions in the countries to which they emigrate. The chalets of Austria and Switzerland and the country houses of Central Europe display façades adorned with floral motifs, the elements of which differ from family to family. Examples of modern folk art include the home-made murals embellishing old San Franciscan houses and the striped awnings and polychromatic façades lining dignified streets in London.

Modern skyscrapers are now beautified with solar-control glass in a range of greys, greens and metallics, but in their shadows are run-down residential areas craving improvement.

The effect of colouring and texturing the cement used in one New York low-income housing project was to increase the residents' pride in appearance: they painted their own windows and doors, improved their gardens and even ceased to vandalize the contractor's equipment.

City and suburban streets now present a whole range of hues that vary according to the different styles and forms of their public and domestic buildings. Some colours are immutable: no one, for example, is likely to paint the White House pink, nor are the citizens of Venice allowed to paint their houses in any colours but the traditional earth whites, yellows, browns and reds (bright blue and green are considered *abusivo*).

The problem confronting anyone responsible for decorating the façade of a building is whether to blend safely and discreetly with the surroundings, or whether to be deliberately conspicuous, memorable and individual—at the risk of being controversial. The majority of corporations and householders shy away from making spectacles of themselves. Something in the collective consciousness, of bureaucrats especially, regards bright colour as frightening and dangerous. In the absence of legal restraint, public opinion can be gauged by a trial painting of a corner or a gate. And there is individuality in the colours of front doors and windows. Distinguished colours—greyish brown with sand, perhaps; grey with buff; bottle green with toning cream—may be strong without antagonizing; earth tones are bright but safe. An old house could benefit from the advice of the local historical society as to the colours in fashion in its youth.

Yet colour infallibly commands attention. In streets of uniform boxes, the house with a certain individuality commands the highest price.

In their design for the Pompidou Centre (nicknamed the Beaubourg, which is where it stands) Renzo Piano and Richard Rogers used a form of industrial colour-coding on a grand scale. The colours of pipes exposed on the exterior of the building fit their function—blue for air-conditioning, green for water, red for elevator machinery. These, plus salmon and black, are the colours nineteenth-century engineers applied to their bridges and their iron and glass architecture—the Paris Metro stations and London's Burlington Arcade. Such colours have the requisite strength to define the forms of modern high-tech architecture.

Megamurals brighten some of the once-dreary buildings in urban America. Paul Levy's *Nut-And-Bolt* (1972) in Cincinnati, *below*, 'bolts' an orange façade to a building in a surreal, almost humourous way. 'Big art' grew from several traditions: early twentieth-century Mexican murals, the styles of modern billboards and the alternative art of the psychedelic sixties, which exchanged the closed world of the gallery for the open public arena. Whether in the vertical abstractions of the enterprising City Walls group in New York or the pastoral scenes of the Mid-west, the murals invariably bear the distinctive flavour of the region they adorn.

Natural materials still largely predominate for buildings, even in an urban environment. Multi-storey dwellings are an exception; and if synthetic materials and prefabricated construction continue to increase at the present rate, architecture will be in danger of losing its 'natural' connections. The cosiness of country towns blending into valley and hillside with walls of local stone will become a thing of the past. The rooftops of the Romanian village, *above*, are covered in local tiles. Their mellow hue is echoed in the coloured walls which, although bright, are not discordant; the greens and reds retain the texture of natural earths. In contrast, the high-rise apartment block in crowded Singapore, *left*, has tried to achieve the urban equivalent of natural blending: brash lights of primary hues seek to break up the uniformity of façade and enhance the brittle neon gaiety that brands a city by night.

The perennial charm of Tudor house patterns stems from a subtle deploying of beams, woodwork and whitewash, as at Speke Hall in Liverpool, *right*. Contemporary half-timbered cottages, it has recently been discovered, were just as likely to have been painted red or yellow and black, as the traditional black and white.

Bright lights, city flickers

Cities are rife with conflicting colour associations. Noël Coward complained in song of being 'World weary, living in a great big town/So dreary, everything is grey or brown'. But this impression can be reversed in an instant by the random thrill of fragmented pageantry—a guardsman's scarlet uniform against the sober façade of Buckingham Palace leaps to the eye like a cardinal spotted in New England winter woods. And to many a country dweller, the city suggests the essence of colour and excitement: the bright lights. After dark the massive areas of neutral tones dominant by day—tall buildings of brick and stone, macadam streets and parking lots, concrete sidewalks—recede before the intensity of artificial light. Neon glitter and sodium glare, the glowing allure of shop windows lit after hours, the chains of white headlamps and red tail-lights, combine to give life to the night.

Some old cities are beautifully coloured in daylight by the hues of uniform building materials—the honey-coloured stone of Siena, the hazy blue tile of Isfahan, the mellow brick ochres of Ghent and Bruges. The ancients were frequently bold about painting public buildings in a manner modern eyes would find flamboyant: the colour so pervasive in ancient Pompeii has been designated Pompeian red ever since it was discovered. Time and technology changed the colours of cities. The neo-classical capitals of Europe—London, Paris, Vienna—were built of white stone. Now we romanticize about the repertoire of greys, accented by velvety black in sheltered corners, adorning their walls. These, along with the powdery green expanses of verdigris where old copper has oxidized, have the charm of evident age; to restore them to their pristine brilliance is to divest them of a patina as noble and meaningful as any other in history. Will time and industrial grime be as kind to our buildings of modern synthetic materials?

Set against the backdrop of buildings and streets in low-key tones, much daytime colour in modern cities is incidental and in motion—the kinetic mosaic of cars in traffic, the gaudy plumage of sophisticated pedestrians, the fruit and flowers, beads and scarves of street-vendors.

And cities are colour-coded: London by its red buses and mail boxes, New York by its yellow cabs and street signs, Paris by the green-painted shutters and railings of the old quarters and the blue street signs. Chains of shops have liveries, too, which the initiated identify by the colours of the signs overhead. Advertising, for good or ill, makes up a considerable portion of urban colour. Efforts are being made to control its scale and location so that it may sensibly provide colour and interest in pedestrian areas without brutalizing the environment.

Not all civic attempts at brightening the cityscape succeed. Controversial murals as often highlight the drabness of their surroundings as alleviate it. Vast stretches of urban wasteland seem doomed to no better colour accents than are afforded by litter, graffiti and billboards. But masses of intense colour tire the eye. If the Chrysler Building or St. Paul's Cathedral or the Eiffel Tower were painted bright red we would find them overwhelming and might fail to discern the timeless beauty of their lines. A city of white buildings has a perennial appeal, a certain glamour, be it Washington D.C., Udaipur or Leningrad. Cities that have had to work harder for a living, from Glasgow to Newark, New Jersey, wear the evidence of industry on their blackened façades.

The world-weary may find the city dishearteningly dull but the observant eye seeking colour—subtle or shocking—will find it in any city in the world.

The yellow cab has become a symbol of New York City—and the New Yorkers made a conspicuous colour choice for their cabs. Yellow cabs are visible in the most sombre urban streets, and because they are light-coloured, they look larger and wider than the dark-coloured automobiles in the traffic lanes. Yellow does not darken with distance, so a New York cab is easily spotted.

Visibility can mean safety to a driver. Fluorescent orange is the most conspicuous colour, but non-fluorescent yellow, white and cream stay bright in twilight and fog, and under the yellow glare from sodium street lights. These colours head the popularity charts of the safety-conscious European drivers. Fashion is a higher priority in America where blues and browns—the least visible automobile colours with the highest accident rates—are often uppermost in the sales charts. Bright 'school bus' yellow, with distasteful municipal associations, never reaches the American charts, despite its low accident record.

The most colourful cities are found in countries with warm climates where street life goes on around the clock. On Sunday afternoons in Mexico City, *below*, vendors display a kaleidoscopic assortment of wares at the gates of Chapultepec Park to catch the trade of families out for the traditional *paseo*, or promenade.

City night-life is unimaginable without the dazzle of multi-coloured stroboscopic lights, but until the twentieth century, when street lighting became widespread, cities were gloomy, colourless places after nightfall. In 1913 London's first red neon name sign decorated the West End Cinema. Ten years later the first neon advertisements coloured the city centre red and blue and, later, an inefficient green. City streets burst into colour in the thirties when the mauve and amber sparkle of mercury and sodium street lighting first appeared, and the fluorescent-powder coating of neon tubes introduced the range of colours, *below*, in Piccadilly Circus, London.

Cities have colour signatures. London, for example, with 800 parks and countless garden squares, grassy commons and tree-lined streets is a cool, leafy green. But tourists remember the bright red city buses.

Red buses have dominated in London from around 1910, when the omnibus was motorized. Horse buses were colour-coded according to their routes as an aid to the illiterate; at the turn of the century the city was ablaze with their colours. But red is not the most conspicuous colour, nor the safest for the driver. Red automobiles figure high in the accident statistics, especially at twilight when the eye becomes less sensitive to the red colour range. And in darkness or under yellow street lighting red turns a dull brown.

But London buses are conspicuous enough in size and shape, and are rarely involved in accidents. And because fleets of red buses are so much part of London, the transport authorities are unlikely to colour them white, nor high-visibility flourescent yellow.

Colour is information, and as such has been used for centuries to help the stranger orientate himself in an unfamiliar town. The red-and-white-striped poles outside barbers' shops and the bulbous bottles of coloured liquids in apothecaries' windows were once advertisements for largely illiterate populations. For the motorized inhabitants of twentieth-century cities, colour-coding often replaces words where information must be grasped and acted upon almost instantaneously. These street markings, *right*, in a Japanese town tell pedestrians to walk in the black areas and cyclists to keep to the green. Red marks the highway for drivers and the yellow lines mean 'no parking'.

To a trained eye a city is a study in transient colour. Architects analyze the rhythmic play of light and shadow on the varying shades and textures of brick, stone and concrete; artists capture the wavering reflections of river-side buildings bathed in the strange magenta hues of city sunsets and poets record the picaresque colourfulness of individual urban lives. Once, in a London street market, *above*, a trader arranged a still life of marrows and red cabbages against a blue-washed wall to the delight of a passing photographer, but city dwellers embroiled in the speed of urban living fail to perceive the subtle visual language which enlivens their environment.

Colour in the market-place

Elvis Presley is singing *All Shook Up* on the Motorola as a shopper leaves a new two-tone Ford (dark blue and black; it is '57) in the parking lot of the all-new, all-glass supermarket. Stylishly dressed in pink pants, swinging her pony tail, she walks through the electronic beam that opens the doors on the most publicized show on Earth . . . the consummation of the American Dream, starring the most studied person in history, the average American housewife.

Her habits, needs, hopes, attitudes, dislikes, family and home have been minutely recorded by battalions of behavioural scientists, motivational analysts, psychologists and researchers of all persuasions. She has been interviewed, depth analyzed, probed, measured and evaluated. And even as she walks down the aisle of the supermarket of '57 she is stalked by secret cameras.

The observations of the people Marshall McLuhan called 'the frogmen of the mind' were now deployed to manipulate the consumer. Their findings were confident: 'People have so much to choose from that they want help—they like the package that hypnotizes them into picking it. . . . It takes the average woman exactly 20 seconds to walk along a supermarket aisle without pausing, so a good package design should hypnotize her like a flashlight waved in front of her eyes. Colours such as red and yellow are helpful in creating such hypnotic effects.'

'When you work with colours, you work on the sub-symbol level. There is a hierarchy of communication. At the top are words—high-order symbols. Next there are illustrations and overt symbols such as crowns, crosses, etc. Then there is the sub-symbol world of colour. Colour is so primitive that colour reactions may be closer to physiology than perception. . . .'

In Europe, Dr. Max Lüscher, Professor of Psychology at Basle University, was also working on the effects of colours on the human mind. Lüscher developed his Colour Test in the belief that colours have 'emotional value' and that a person's colour preferences reveal basic personality traits. A strong preference for blue, for instance, shows a need for peace and tranquillity, while a dislike of blue indicates a wish for a complete change of circumstances.

The inclination to judge a book by looking at the cover is so strong we have to make a conscious effort to overcome it. Tellingly, the lettering on the cover of *The Lüscher Colour Test* is red and yellow, a colour combination that, according to Lüscher's own theory, means a desire for experience, expansiveness. Black and red, Lüscher claims, mean 'suppressed excitement, which threatens to discharge itself in aggressive impulses. Emotional violence; what cannot be mastered will be destroyed.' Insect poisons are traditionally packed in these colours.

Few designers or marketing men acknowledge the influence of Lüscher. Their choices of colours for the packages they design are, they say, based on what 'feels right'. But supermarket shelves are replete with examples that tally with Lüscher's theories.

The theorists of the fifties are now no longer heeded for it is fully accepted by the people who package products that colour is one of the most important means by which a favourable, hopefully irresistible, impression may be created. Colours call attention, impart information, create lasting identity, and so on. The object is always the same: to sell the product, and it is easy to recognize the rules of thumb by which colours are chosen for their sales impact.

It is no secret that colours from the long wavelength end of the spectrum, notably yellow and red—the 'hot' colours—seem to leap out at the eye. Because red appears to advance, it makes the pack look both larger and more visible than a neighbouring blue one. It is intrusive and attention-getting. Most 'money-off' and 'new' flashes on packages are red (the perennial scene-stealer) and sometimes yellow. Orange is particularly common on baked food packs. Combinations of these 'hot' colours, sometimes with blue, are invariably used for cleaning products. They create an impression of energetic cleaning powder. Altering the packet for J-Cloths (cleaning rags made of synthetic fibre, sold in the British market) from plain blue and white to a deeper blue with a three-dimensional effect, red and yellow J, boosted sales by 23 per cent, the designer reports. The plain blue and white looked insipid under supermarket lights.

It is found that primary colours and earth colours appeal to children, and primaries and bright colours to poor people. Consumers who make few purchases, it is believed, like each one to stand out as much as possible. Pastels and neutrals, conversely, appeal to up-market, sophisticated consumers. Dark colours appeal to older people and to men. Cool colours—green and blue—and also bluish red, appeal to women and are used on cosmetics and skin-care preparations. Violet and purple are reserved for especially luxurious products such as jewellery and expensive chocolates. Black, silver and gold, and sometimes white, afford that touch of class.

Having first attracted the customers' attention, the pack must make them feel good about what they are getting. If the product is expensive, it must look worth the cost. Whenever goods are competitively priced, a more attractive pack can make the crucial difference in clinching a sale.

Cigarettes provide extravagant examples of the importance of colour in a pack (blindfold tests prove that smokers cannot distinguish their brand from any other; people often consume little more than their preconceptions). In the case of gold packs, the gold is what is really being promoted. It works. A gold cigarette pack is the heart of the most successful brand campaign ever launched in its field in Britain.

'I never notice the TV ads', people often say, but the fact is that the advertisements register at the periphery of consciousness and a reflex decision is made not to take any further notice of them. But like all reflexes, this 'recognition reflex' is a learned response and depends for its success on advertisements or packs that conform to the style of the one by which the reflex was formed. An advertisement that does not conform meets no reflex and makes an impression. Techniques to overcome the recognition reflex have included advertisements in black and white that mimicked the typography and layout of the editorial matter of newspapers and magazines, coloured lines playing tricks with perspective, much as Escher paintings do, to trap the eye in the page in a *tromp l'oeil* effect, and colour associations. These include exploitation of the sensuous symbolism inherent in red in advertisements for everything from cars to perfumes.

Even food is subject to increasingly sophisticated market research as to which colours, deployed how, most reliably enhance sales. The colour of food has a power so strong that the favourite food colours, red, yellow, orange and brown, exert a measurable effect on the autonomic nervous system, stimulating appetite. This physical effect is exploited by producers who market tasteless, but brightly coloured, fresh food and add colour to processed food to make it look more appetizing.

The colour additives used today are based on the aniline coal tar dyes prescribed for textiles and it is proven or suspected that some are carcinogenic. Stringent controls have been imposed by the government of the USA, and in Brussels in 1975 a committee of food toxicologists recommended that further research should be carried out on nine colourants permitted in Britain.

Such research takes years, and it is difficult to relate the results of toxicological studies conducted on animals to people. Meanwhile the need for colour additives in food can be demonstrated by the case of the dry navy bean.

Haricot beans, the basic ingredient of canned baked beans, grow only in warm climates. An alternative bean has been developed which is more hardy and resistant to damp, but it has a drawback: it is black, and consumers will not buy black baked beans. Black in food has associations with poison and decay.

Market researchers regularly test unusual colour and taste combinations and try out the same product in packs of different colours, asking which tastes or smells best. It is a measure of the eye's power over other senses that subjects dutifully express preferences based on colour.

The information imparted by colour in packaging becomes so much a matter of reflex that we could spot a fellow traveller at the far end of the bus and know whether his chocolate was milk or plain, his paperback a textbook or a novel and his cigarettes for cowboys or low-tar adherents. So much so that we can be temporarily disoriented when packages of favourite products are changed. We have to relearn how to spot them. Consequently, effective packs are updated very gradually.

Tests reveal that the gaze of the consumer glancing along a supermarket shelf rests on each pack for less than .03 seconds. In that twinkling, packaging experts presume not only to attract attention, but to convey content and plant a desire to buy deep in the shopper's psyche. When products can have their sales careers made or broken at that moment, it is the designer's lot not to show the colour of his money, but the money in his colour.

John Player Specials were packaged in a colour previously considered taboo for cigarettes—black. The primary associations of black are funereal; in combination with gold, it has connotations of luxury and glamour. This imagery was extended in the publicity for John Player Specials, a large part of the campaign for which was the sponsorship of the Lotus Formula One racing team. What better symbol could there be for bravado in the face of death than a 200 mph black racing car?

Colour in the market-place 2

Dr. Max Lüscher, Professor of Psychology at the University of Basle, has evolved a test based on colour which he claims can reveal personality traits by the analysis of individual preference for, dislike of or indifference to, certain colours. Lüscher believes that colours have objective psychological significance.

The full Lüscher test involves 43 selections from some 73 colour swatches. A shorter version of the test has only eight colours of which four, greenish blue, red, yellow and dark blue, are what Lüscher describes as 'psychological primaries'.

Applying his theories to packaging, Lüscher devised a colour range he considered psychologically effective. His suggested package colours correspond to the need (real or imagined) that the product fulfils. Products offering security, for example, should be packaged in dark blue while those whose promise is the enhancement of life should have red packs.

A package in the colours of the psychological primaries, Lüscher believes, creates a subliminal need for the complementaries, for the mind responds to colour as a whole. A package of a greenish blue colour, therefore, engenders a deep psychological craving for its absent complementary, red. Greenish blue is a common colour for men's aftershaves and perhaps creates an inner desire for yellowish red, a colour to which Lüscher ascribes masculine characteristics and which might seem a more appropriate choice. The designers may have felt instinctively that greenish blue appealed more subtly to the consumer.

A survey of the most successful brands on the market seems to bear out Lüscher's theories. Yet few packaging designers claim any knowledge of them. When they hear of his ideas, many designers deride them. Most deny that colours, the tools of their trade, have any meaning or significance. Their choice seems to be an intuitive one aided by long experience of trial and error.

Lüscher describes many packaging 'mistakes': pepper in a sky-blue pack instead of the brilliant yellowish red that suggests its strength; caffeine-free coffee in a pack of red, indicating strength; a label for canned meat in a greyish violet colour reminiscent of decay. The packages illustrated below were more successful. Some were designed half a century ago, without any advice from Dr. Lüscher, yet many of them embody his theories. Most of these products have grown from small beginnings to become recognized internationally. Perhaps the quality of the products they advertise is so high that their success was ensured, but who knows what help psychologically effective packaging gave them?

Greenish blue, according to Lüscher, corresponds to a need for clarity and certainty. His theory says this colour is an expression of firmness, or constancy and, above all, of resistance to change. The person who places a greenish blue high on his colour preference list values possessions as symbols both of security and self-esteem.

A preference for a yellowish red, according to Lüscher, indicates a desire to conquer, an urge to achieve and to win. Red, he says, is an impulsive colour, attractive to people who value things that offer intensity of living and fullness of experience. It represents all forms of vitality and power.

A predilection for yellow means 'a need for something new, modernity, the future and development', says Lüscher. Yellow, he believes, provides the spontaneous enjoyment of action and provokes a response of an active, cheering kind. Combined with red it equals 'a desire to conquer + expectancy of something new'.

Dark blue, a passive and tranquil colour, is not associated with work in Lüscher's theory, but with peace and contentment. People who prefer dark blue are motivated by a need for security.

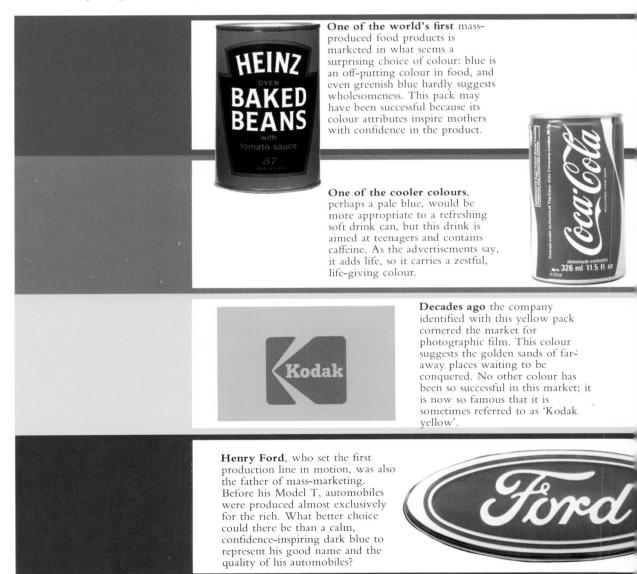

One of the world's first mass-produced food products is marketed in what seems a surprising choice of colour: blue is an off-putting colour in food, and even greenish blue hardly suggests wholesomeness. This pack may have been successful because its colour attributes inspire mothers with confidence in the product.

One of the cooler colours, perhaps a pale blue, would be more appropriate to a refreshing soft drink can, but this drink is aimed at teenagers and contains caffeine. As the advertisements say, it adds life, so it carries a zestful, life-giving colour.

Decades ago the company identified with this yellow pack cornered the market for photographic film. This colour suggests the golden sands of far-away places waiting to be conquered. No other colour has been so successful in this market; it is now so famous that it is sometimes referred to as 'Kodak yellow'.

Henry Ford, who set the first production line in motion, was also the father of mass-marketing. Before his Model T, automobiles were produced almost exclusively for the rich. What better choice could there be than a calm, confidence-inspiring dark blue to represent his good name and the quality of his automobiles?

Black and gold are superlatives to advertisers. They are used to represent the ultimate in sophistication and the highest quality. In this softly shining perfume pack styled for a French couture house, the pack designer used both his available superlatives to express the quality of the product. 'Black', says Lüscher 'represents the ultimate surrender or relinquishment'.

'Colour sells' is the message implicit in the hues of this range of aerosol cans. It was marketed in 1979 by a company that specializes in filling aerosol cans with products for other companies to market. The lettering suggests just a few of the many products these colours could sell.

A package in red and greenish blue conveys the impression of a strong, reliable and incorruptible content, especially when applied to machines and their accoutrements. This pack has been accompanied in advertisements by pictures of tools and the legend 'liquid engineering'.

Clarity and certainty are admirable qualities for a bank, whose success relies on the trust of its clients. This colour perhaps elicits confidence in the security of growing assets.

Red is a common choice for cigarette packs. Many cigarette smokers feel erroneously that a cigarette makes them feel more lively. None the less the association with vitality and high living is real enough to make red-packaged cigarettes consistently good sellers.

Primary colours sell to children, to poor and uneducated people and to tribal communities living outside the direct influence of the industrialized West. The bright colours in this toy package evoke an immediate emotional response in young children.

A colour that symbolizes the future seems an apt choice for the packaging of gasoline. According to the teachings of colour psychology, the combination of red and yellow in this logo advertises fuel to power the search for new horizons.

Almost all financial institutions suggest their trustworthiness by choosing dark blue for their corporate identities. Dark blue appeals, perhaps, to an innate need for security among the clients of this British insurance company. It is also found in the logos of most American corporations.

Sobriety and sturdiness are implicit in this mid-blue cigarette pack. Dark blue packs are associated with interludes of peace and contentment. The mild cigarettes now increasingly in demand are packaged in light blue packs, to symbolize calm and tranquillity perhaps.

The flavour of colour

So much of taste is expectation that colour is the most important consideration in the mass marketing of food, and even in decisions about which varieties of vegetables should be grown commercially. But just as different countries attach different meanings to colours, so their preferences for food colours differ. The British like green apples, the Americans red and the Italians like them deep red. West Indians buy bananas when they are ripe—a deep brown colour—while Europeans eat them when they are yellow and immature. Canned peas sold in France are a greenish grey colour from blanching; the British will buy them only if they are dyed green and the Danish like not only the peas, but also the water in the can to be green.

Such colour conditioning, which begins at birth, is overcome only by education in the dangers of artificial food colouring—and fashion has a decisive role. Because perception and taste both contribute to the enjoyment of food, all nations agree that they like it highly coloured.

Red has such strong associations with flavour that in some countries tomatoes and other red vegetables are grown commercially in brightly coloured varieties that are almost tasteless. Perhaps the association of redness with ripeness and discoloration with disease is the reason why pale tomatoes do not sell as well.

A taste for organic foods has made inroads into some of these conditioned attitudes during the last few years. In Europe, for example, large, ribbed, ugly, French tomatoes which are rarely brightly coloured are beginning to compete with the flavourless beauties found prepacked on supermarket shelves.

Like most fruit and red vegetables, tomatoes are scalded before canning to kill yeasts and moulds. This does not affect the natural colour, so no artificial colouring is needed.

Golden brown is so appetizing a colour that the baking and roasting of bread, cereals and nuts is precisely controlled so that they emerge neither too dark nor too light for consumer taste. Breakfast cereals may be packaged in orange-red, like soup cans, to suggest warmth, but yellow is more appropriate to sunshine breakfasts and the start of a new day.

Children's responses to colour in food are not as conditioned as adults'. Most children will consume food and drink of any colour, but foods dyed in unfamiliar colours —blue, purple or yellowish green—sometimes make adults feel nauseous.

But give children and adults a drink that is orange-coloured, yet flavoured with lime, and both will believe they are drinking orange, as a recent American test proved.

Soft drinks, and their labels, are usually colour-coded according to flavour in the primaries children love; adults' drinks are packaged according to strength. Green is for light beers; red and brown for strong ales and gold or silver suggest quality.

Colour is a gauge of freshness in food and blue says 'mould'. This response is so strong that in tests many people could not bring themselves to sample prepared food coloured blue or mauve, and many of those who tried it felt ill. Blue cheese was acceptable because blue is its natural colour.

The same rules apply to fruit. Many blue, mauve, purple and black berries are poisonous. By trial and error we have learned which are poisonous and which are not. Fruit-flavoured drinks and foods, cordials and yoghurts, for example, may be coloured blue or mauve to suggest the flavour of blackcurrants, blackberries and purple grapes. Without colour people find them uninteresting.

Blue on white has been almost *de rigueur* for the packaging of dairy produce. These colours suggest the coolness and hygiene of the dairy—a green pack in a chiller cabinet could suggest decay. But the rules are changing: some butter is packaged in gold or silver, associated with luxury, or in the colours of the countryside—yellow and green.

Green, symbolic of fertility, is almost universally used for the packaging of frozen, as well as canned and dried vegetables, and the bright colours of fruits have crept into the traditional blue and white packs of frozen fruit and flavoured yoghurts.

Blue has long had associations with sweetness; sugar packs are usually blue and white, and sweets and candies are often packaged in blue or violet.

The colours that indicate freshness in fresh vegetables are carefully studied by the processed food companies. The subtlest variations in hue from cultivar to cultivar are meticulously charted.

There is no artificial colouring in frozen foods: frozen peas, for example, are picked while immature, scalded at a temperature just below boiling point and frozen.

But the natural colour of green vegetables is destroyed during blanching for canning. They turn a greyish green that is unacceptable to some nationalities, so colouring matter is usually added. A large British store chain tried marketing blanched canned peas, with disastrous results.

A process has recently been developed in the USA in which peas are canned in a medium with a different level of acidity from that in current use. This preserves the natural greenness—but the method cannot be used in the canning of beans and certain other green vegetables.

White in food signifies refinement and delicacy. Refined white flour, sugar and rice—more costly because of the extra processing needed to produce them—were traditionally favoured as status symbols in preference to the coarse-textured, brown-coloured, unrefined foods that were the lot of the peasant. Attitudes have changed in recent years as a result of the understanding of nutrition—but more white flour, sugar, bread and rice are sold than brown. These products are often bleached to make them whiter.

Surveys on individual colour preferences have shown no significant difference between those of men and those of women—but airlines, having learned from experience that women generally prefer white meat and fish, usually take on more chicken and fish for women passengers than for men.

Milk products are invariably coloured to suggest sweetness and flavour, but in some countries white ice cream is whitened to suggest the milk content it rarely has.

Dark-coloured foods, suggestive of strong flavour, are generally preferred by adults. Depth of colour can be an indication of strong flavour—as a rule fresh meat that is dark-coloured has more flavour than light-coloured meat. But the colour of meat is also an indication of its age and tenderness: meat darkens as it ages. This quality is exploited by some salesmen who illuminate raw meat with lights whose spectrum is biased towards red, which makes the meat look redder. If you put your hand into a display fridge that is illuminated by such a light, it will take on the colour of raw meat—a sure test.

Coffee beans are generally baked to a deep brown colour, and also packaged in brown or red to suggest strength. Yellowish brown coffee beans indicate a mild flavour, as does a yellow or blue coffee pack. Beers are similarly colour-coded: lagers (aimed at the women's market) and light beers are pale yellow to deep gold; strong beers are deep brown to black.

Brown gives a meal man-appeal, as advertising agencies know. Dark brown sauces and chutneys, intended to add relish to meat dishes, are almost always coloured and packaged in brown if they are aimed at the male market.

THE PALETTE OF COLOURS

We live in an age of colour plenty. Technically it is now possible to reproduce almost any colour in any material. When there seems to be a frustratingly small range of colours for a manufactured product, the reason is most likely economic: colour is costly.

Colour is subject to the same economic laws that govern all saleable products: where the resources are available, supply will quickly meet increased demand. After Diaghilev's Ballets Russes made Europe and America aware of the potential of new synthetic dyestuffs, between 1910 and 1915 the range of colours available in dress, cosmetics and home furnishings expanded spectacularly. And hundreds of new colours became available in household paints, men's shirts, lingerie and a host of other goods as a result of increased colour consciousness during the sixties.

The advent of colour film and television and the more widespread availability of colour printing made the greatest contribution to the colour explosion of the sixties. Colour brought new dimensions to these media; not only did it add beauty, it reproduced reality. The result was a rise in the general awareness of colour's role in everyday life. Cinema and television viewers were no longer obliged to translate black and white images into their own colour concepts—but were often disappointed by the ordinariness of everyday life as expressed in colour, or surprised by the unexpected emotional content of scenes formerly presented in impartial shades of black, white and grey.

And perhaps for the first time, people were given the opportunity to assess and judge colour in a way that was rarely possible even in real life. 'I can't help noticing that women, on the whole . . . don't come off so well in colour. Some radiant beauties on monochrome turn out very disappointingly . . . the eyes particularly: one touch of red in the corners, one false step with the make-up, and they look raddled. In real life you might not notice, simply because in real life you don't stare so hard: in real life you are much gentler and more considerate than you are as a box-watcher; you won't allow yourself to notice because you know it shows on your face immediately'. Thus wrote a leading television critic shortly after the opening of the British colour service.

For those in the business of colour—stage, cinema and television, graphic, interior and fashion designers, as well as artists—a grasp of the traits of different hues is a professional tool. The layman is rarely given the opportunity to develop a comparable awareness of the palette. But if people are to put colour to work in their lives, if they are to avoid costly mistakes and achieve really satisfying results, they must learn, like television set designers during the sixties, to see afresh: 'Information is conveyed more efficiently with the additional information-bearing element of colour, as shown by features and reports', wrote a set designer in 1970. 'Rubbish, on the other hand, becomes more rubbishy, and tastelessness more tasteless'.

For the most part colour is perceived only incidentally, like background music, when it would repay the full attention accorded a concert. One well-documented charm of psychedelic drugs was their tendency to render ordinary sights—and colours in particular—extraordinary. Fortunately there are less controversial ways to achieve a heightened sensitivity to colour.

You can start by considering colours in isolation. In the following pages, the spectral hues are examined in their natural sequence, so that each may have its moment in the spotlight. Beginning with the versatile achromatic colours and ending with violet (taking in popular cousins like pink, brown and purple which, although not spectral colours, are so widely used as to merit inclusion) the hues emerge as distinct personalities. The opening essays provide a backdrop for each, noting their behaviour as wavelengths, reflecting on their occurrence in nature and history, citing animal, vegetable and mineral sources of colourants and telling the stories of how various familiar expressions involving specific colour terms became part of the language.

All too often our mental image of a colour occurs within arbitrary fixed limitations. The term red tends to evoke a crimson or scarlet, yet red extends into pink, orange, brown and violet. From the three primary printing inks, magenta, cyan and yellow, some 300 reds can be reproduced, but few people have ever seen a range of reds. Accompanying each colour essay, a colour star, showing sample gradations in saturation and lightness of each spectral hue serves as a reminder of just how broad its scope is.

And following each colour star is a photographic essay whose purpose is to explore the role of colour in everyday life, and to question its use in familiar situations. Why does a red traffic light always mean 'stop'? Why are leaves green? Why are zebras black and white? Their aggregate impact should afford insights into colours which will result in greater enjoyment and flexibility in their future use.

How many colours are there? In the spectrum there are estimated to be about 200. Green light ranges from 490 to 560 nanometres, but green light of 490 nanometres is turquoise while green light of 560 nanometres is yellowish. Although the difference between light of 490 and 491 nanometres is imperceptible, each discrete light wavelength is in fact a different hue.

Since each colour varies according to its degree of saturation, and its lightness to darkness, this number is multipliable by millions. A trained eye confronted with a great many colours and shades presented in contrast to each other could probably discern the approximately 9,000,000 range of the Lovibond half-inch glass colour filters—and these, laid end to end, would stretch the 60 miles from The Tintometer's Salisbury home to London.

The colourless colours

Black is the negation of colour. It is maximum darkness. The perception of black appears to depend on contrast with surrounding stimuli; complete blackness is rare. An underground cavern or windowless room would be totally black; a dark night is bright by comparison. Perceptually, black implies weight and solidity; darkness implies space, which is infinite. There is a theoretical ideal called a black body which absorbs all incident radiation, but even the darkest materials, like soot and black velvet, reflect at least three per cent of incident light.

White is maximum lightness. In theory, a white surface reflects all light, but even the whitest materials, like magnesium oxide or newly fallen snow, will absorb three to five per cent. The eye is sensitive to tiny differences in whiteness when two materials are juxtaposed, and this makes standards of whiteness most important for manufacturers of such white goods as textiles and paper, not to mention the shrill fanaticism it engenders in advertisers of bleach and detergents.

Grey spans the extremes between white and black. A neutral grey is obtained when all spectral wavelengths are absorbed more or less to the same degree.

Man has always been able to express himself in black and white, for the pigments with which to smear his person and surroundings came readily to hand. Carbon, mostly in the form of soot, gave a permanent, commonplace black. Anything white—lime, shells, chalk, clay—could be ground and applied.

The most splendid natural black dye came from logwood, the bark of a Brazilian tree. Ironically, no man-made dye could impart anything like so fine a bloomy blue-black to nylon or silk, so it was this marriage of nature and synthetics that produced the ultimate in provocative lingerie. An innocent look is scarcely easier to obtain. No fibre is born snow-white; they must all be bleached, either with whiteness as an end in itself or preparatory to dyeing. The classic means of bleaching cloth is to spread it out on the grass under the sun. The oxygen given off by the grass whitens as well as strong sunlight and air. Natural soaps and alkalis were used to speed the process prior to the big chemical breakthrough, the discovery of chlorine in 1774; today, hydrogen peroxide is widely used. Synthetics, which in their raw state are called grey goods, are coated with fluorescent substances to make them look whiter than white and as these wash off, the fabric yellows. Detergents contain small fluorescent flecks which serve to delay yellowing. Because bleaching is essentially a decomposing process, the problem is to ensure that the fabric is not destroyed along with the unwanted colour.

Black flowers are bred: they are not the product of nature. All-black animals are rare, but where black occurs in animals it is generally given by the pigment melanin. This ubiquitous pigment colours the skin and hair of the black races of man but true blue-black hair, only seen among oriental races, owes its blue sheen to Tyndall scattering.

Major fuel resources, coal and crude oil, are mostly black. Grey is the colour of spent fuel, ash. Pure grey is rare in nature; it mainly occurs as an optical mix. The many rocks with a grey appearance show, on closer inspection, a blend of colours. Slate and graphite are exceptions. So are cats and doves, but most grey animals, like grey-haired people, have a mixture of white and at least one other colour. Nature discreetly dresses her leviathans, the whales and elephants, in this perennially fashionable neutral.

It appears in plants not as a flower, but as glaucous foliage. Silver-grey plants are drought-resistant, a coating of white dust on their faintly blue-green leaves reduces evaporation.

The most pervasive human experience of grey is in cloud and shadow, although for urban dwellers less conversant with the sky, grey is first and last the colour of the man-made environment—massive, mechanical and metallic. Concrete, cement, cinder block, office and heavy machinery make grey the colour of business and industry. Gunmetal, aircraft and battleships make it the colour of combat. And grey is the colour of aftermath—the cobwebs and dust, soft and ephemeral in texture, that settle on weightier matters. Grey can be gossamer or granite.

Grey suggests intelligence—the grey matter of the brain reinforced by the grey head of wisdom. The *eminence grise* wields influence from the shadows. But in addition to clear thinking, grey also suggests confusion and the loss of distinction in a world where it is claimed that nothing, finally, is either black or white, but simply shades of grey.

In the realms of symbolism, however, white and black are free to be absolute. For there they are literally the alpha and the omega, the good and the malevolent. Apart from their individual implications, they are frequently paired: day and night, good and evil, lucky and unlucky, birth and death.

Black is inherently ominous in that it is the unknown—a feature it holds in common with death. Fear of the dark is spontaneous. But black is also a tremendous source of strength. It combines mystery with power which may be used for good or ill.

Most of black's associations are negative; blacklist, blackmail, black-ball, black market, Black Mass. Black looks are threatening, and the way Black Monday, Thursday, Friday and Saturday commemorate random disasters confirms that black is the worst that can be said of anything. Black sheep are sometimes met with amused tolerance, but a *bête noire* is still unwelcome. Legend says the police van used to convey prisoners took the name Black Maria from a prodigious negress who kept a Boston lodging-house. The police would send for Black Maria to drag in any miscreants they could not manage themselves.

White's image is so good it is subject to irony. Reference to the favourite white-haired boy, or self-consciously fair behaviour, is sometimes tongue-in-cheek. White magic and white lies are benign. The white flag signifies truce or surrender, and to send a white feather is to accuse someone of cowardice, because a white feather in a fighting gamecock's tail betokened degenerate stock. A king of Siam used to make a gift of a white elephant to courtiers whom he wished to ruin by the cost of its upkeep, hence its meaning as a burdensome possession.

White suffers a certain inhumanity—the clinical cool of men in white coats, the chilly chastity of the moon goddess. Whereas the Scots called a go-between in love affairs blackfoot, should he turn traitor he was called whitefoot. So white's reputation is something of a grey area.

The night sky pulses with the force of the achromatic colours, the moon and stars winking in brilliant contrast to the void. Small dense stars, or white dwarfs, implode into mysterious black holes which, if science fiction is to be believed, are gateways into a separate universe where a whole new spectrum may be found.

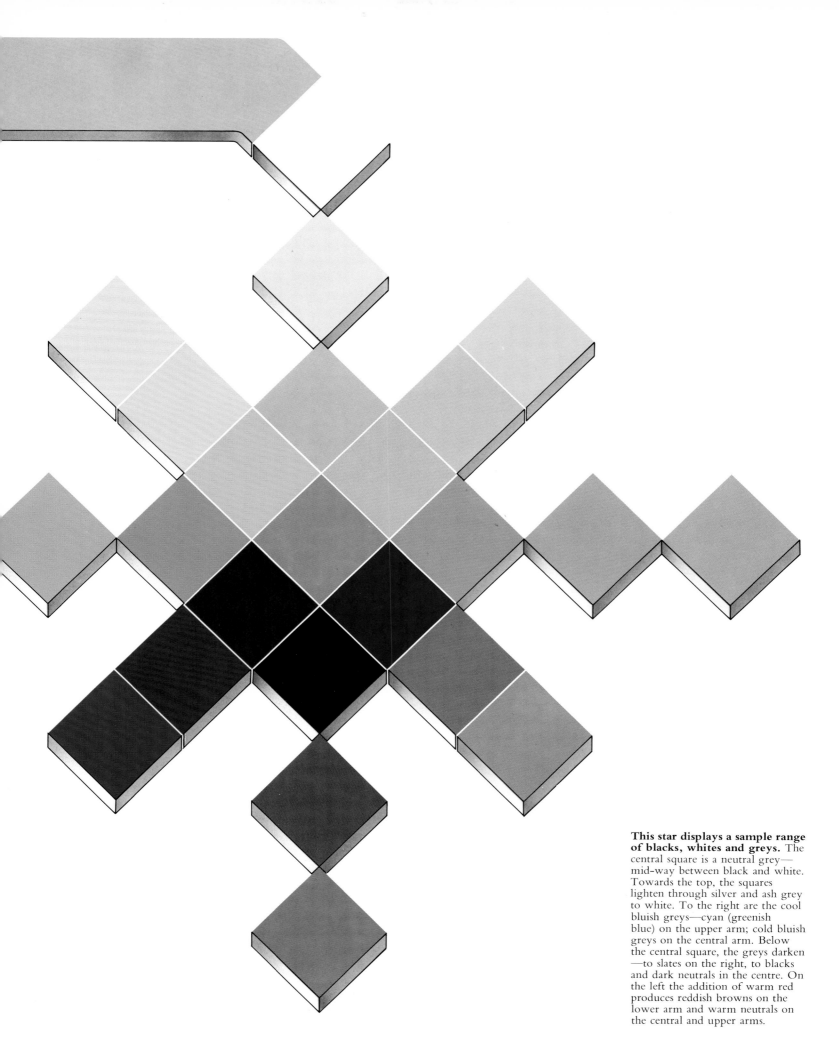

This star displays a sample range of blacks, whites and greys. The central square is a neutral grey—mid-way between black and white. Towards the top, the squares lighten through silver and ash grey to white. To the right are the cool bluish greys—cyan (greenish blue) on the upper arm; cold bluish greys on the central arm. Below the central square, the greys darken—to slates on the right, to blacks and dark neutrals in the centre. On the left the addition of warm red produces reddish browns on the lower arm and warm neutrals on the central and upper arms.

U.S. Astronauts Walk on Moon

'I want to see it in black and white,' sums up a desire many people express for the final authority, the ultimate truth, on any subject. The psychological power of print is such that, however colourful the real world may be, people trust black ink on white paper almost more than the evidence of their own eyes.

In *Understanding Media* Marshall McLuhan said: 'Like any other extension of man, typography had psychic and social consequences that suddenly shifted previous boundaries and patterns of cultures [yet] . . . explicit comment and awareness of the effects of print on human sensibility are very scarce'.

Moored in print, the fantastic truth of the lunar landing had added impact. The episode itself had a black and white character, played out in achromatic tones of mylar, aluminium and white Teflon against the moon's surface.

The black Japan enamel used on Henry Ford's production-line Model Ts could be sprayed on, dried fast and needed no hand-finishing. Ford was a farmer's son and liked to 'grow' as much of an automobile as possible; he manufactured textiles, rubber substitutes and oil-based body paints (mostly black) out of soya.

Black automobiles fell out of fashion when coloured body paints appeared. In the sixties almost the only ones around were expensive symbols of officialdom—as seen here at Ascot, the race meeting traditionally attended by the British sovereign. By the seventies, black cars had assumed an aura of status and luxury.

As energy crises reduced the size of cars the colours associated with expensive models were applied to smaller ones. Black has joined suave white, silver and shades of grey as a symbol of taste in a luxury product.

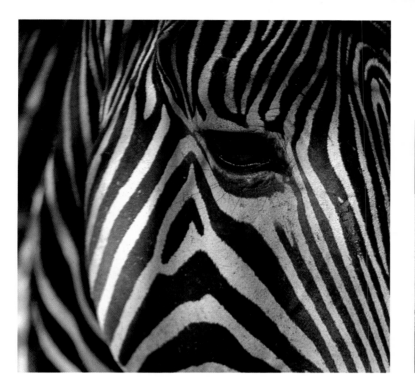

The series of majestic white cliffs, hundreds of feet high, that guard England's South coast are known as the Seven Sisters. They were formed some 70,000,000 years ago and are made of chalk—layer upon layer of the shells of miniscule marine animals called Foraminifera.

In grassland, the zebra is well camouflaged. Its stripes form an irregular pattern of light and dark tones that break up the contours of its body and effectively conceal it from its chief enemy, the lion, in the African veldt. This is especially true in moonlight when its stripes make it almost invisible. To understand how, think of a sphere illuminated from above. It is lightest on top, shading to a darker colour below. This shading throws the sphere into relief, giving it solidity and defining its shape. If it is painted dark above and pale below, the natural shading is counterbalanced, its solidity disappears and it looks like a uniformly coloured thin flat disk.

Shadows similarly define the shapes of animals—the zebra's black stripes are a form of countershading. They are wide above, narrow beneath, counterbalancing the effect of moonlight on its back. So, unlike many wild animals, the zebra sleeps at night.

Arctic birds and animals change colour with the seasons. This Arctic hare moults into a white winter coat as a camouflage in the snow. In summer, its coat is grey-brown, the colour of the lichen-covered tundra.

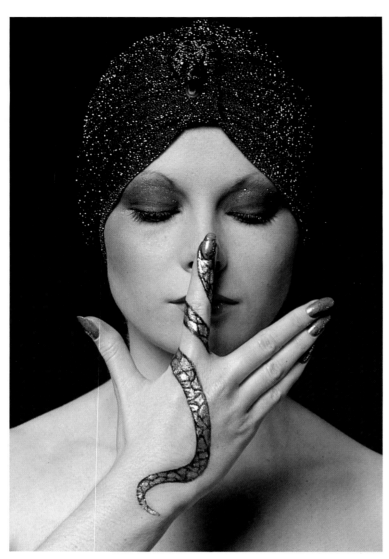

In the silvery belly scales of the herring, deposits of minute, plate-like crystals lie parallel to the scales' surface, giving a pearly gleam to the grey fish. As long as 200 years ago, this pearlescent pigment was extracted from the fish and injected into beads to simulate pearls. The demand for pearlized plastics, paints and cosmetics has become too much for the herring to cope with alone. In the sixties, the Dupont Corporation devised a pearlescent pigment by coating mica (the sparkling mineral in granite) with microscopically thin layers of the brilliantly white pigment titanium dioxide. This both reflects and transmits light, giving the lustre seen in natural pearl.

This pigment can also be controlled to give iridescence of a single hue: if the titanium layer is very thin, an iridescent yellow or gold is seen. Thicker layers produce other hues.

Traditional pigments like black oxide of iron, titanium white, aluminium and bronze are now combined with pearlescent pigments to give cosmetics a sheen the ancients would have envied.

The very essence of pearl is the diffraction of light by myriad striations in the transparent nacre, giving a softly reflective white touched with delicate colours. Mother-of-pearl oysters and other sea shells have been used to supply pearl for buttons for hundreds of years. The rarest and most expensive is the fine grey Tahiti pearl; the best white, called Macassar pearl, comes from the Celebes Islands.

Distant hills look grey on an overcast day. The farther away the hills are, the lighter they become, until the last hill is almost indistinguishable from the sky. These gradations in tone give the scenery perspective.

Black Africans traditionally associate black with death and evil, and wear bright colours. Westernized Africans and the black populations of Western countries think of black as a sophisticated fashion colour for both sexes and all ages after the teens. And teenagers from the beatniks through the rockers to the punks have adopted black as a symbol of the negation of a society whose values they reject.

Black became beautiful in the sixties and for the first time black American girls could find ranges of cosmetics in colours especially formulated for black skins. Opaque colours look 'caked' on black skins; dark transparent and pearl colours suit them best. Lip colours for black skins are rich with metallic highlights.

White is by far the best-selling paint colour. Light bounces off white surfaces, especially those with high reflectance qualities, creating an incomparable feeling of airiness and space.

White sells so well that most paint manufacturers offer a range of shades, from the highly reflective brilliant white to cool blue or grey off-whites and warm whites with a yellow or pink bias. Brilliant white paint with a sheen will lighten a dark room, cool shades will tone with blues or greens, or with toned-down shades of any hue. Warm shades will enhance the brightness of rooms in which yellow, orange or red predominate.

The sheer quantity of white paint sold by leading manufacturers accounts for most of their profits. But during the last few years, new companies have been formed to sell only white paint, causing a reduction in the profits of the older manufacturers and forcing them to reduce the numbers of other, less profitable, colours on offer.

White tennis dress has been the rule of Wimbledon from 1903. Women players then wore linen dresses, or skirts and blouses, shortened to just above the ankles; men wore cream or white trousers, shirts, ties and blazers. Pale straw boaters were worn by all. Although they were decorous, these outfits were hot and hampering.

Suzanne Lenglen set the fashion for calf-length white tennis dresses in 1925. Legs were concealed by white stockings until 1933 when Alice Marble shocked Wimbledon with shorts. Trousers shortened for men too and ties disappeared—but blazers remained. Skirts became diminutive in 1948 when Gussie Moran's frilly white panties made the headlines. In 1959 Maria Bueno startled the crowd with shocking pink ones.

But white is the rule, and although in the seventies Jimmy Connors was permitted red, white and blue striped sleeves, other players still have to substitute white for the coloured outfits they wear in other tournaments.

Electrical appliances for the kitchen were invariably white until the sixties, when coppertone and later gold, avocado and brown came into kitchen fashions. These colours were superseded by naturals during the seventies, but coloured appliances are still more often found in American kitchens than in European ones. Appliance whites may vary from country to country. Whites with a blue or green cast are sold in the USA; in Mediterranean countries such as Italy they tend to be pinkish and those on sale in Britain are bluish whites. They vary also from product to product, depending on whether they are produced using high-temperature paints or with porcelain enamel on metal.

While Westerners strip off their clothes in hot weather, the desert Arabs exploit the phenomenon of body insulation. Layers of cloth keep a pocket of cool air trapped close to the skin—and the heat out. Like sunglasses, the black veils and cosmetic kohl worn by desert Arabs—both men and women—tone down the glare from the sun and sand, and also filter the dust, keeping the air around the face breathable in intense heat.

Colours are sober in orthodox Islam. The concealing black in which Arab women are clothed from head to foot conforms to Islamic standards of decorum laid down in the seventh century. Rich wives can be distinguished by a gold trim to their veils and rich Tuaregs wear a veil of indigo blue on important occasions. The blue colour shines in the sunlight with a purplish metallic sheen and easily rubs off onto the skin, giving faces a bluish tinge. This is much admired since the price of the indigo cloth is high.

But the brightly coloured slips worn by conformist Arab women are not a sign of social rank. Attracted by the peacock hues of modern synthetic dyes, the women today dress gaudily beneath their black veils.

During the 1830s eccentric dandies affected sky blue cravats, dove grey pants and primrose waistcoats, but one or two appeared all in black. The idea caught on. The late nineteenth century—an era in which the virtues of hard work were extolled, industrialists rose to prominence and sober outlooks prevailed—saw colour disappear from men's clothes.

Black, grey and brown, the colours of respectability, dominated men's clothes until World War II, when morals relaxed and American designers, cut off from European influence, broke the fashion rules.

The black cat is an ambivalent symbol. Ancient legends identify him as both sacred, which he was to the Egyptians, and evil, being the ally of witches and the Devil.

In Europe, a black cat is a lucky omen. A stray at the door means money to come and one crossing your path merits a wish. But in the USA the superstitious would no more have a black cat cross their path than walk under a ladder.

Red, the dynamo

The attributes of red are almost all superlatives. Red has the longest wavelength and lowest energy of all visible light. It is thought to be the first colour perceived by babies or by any person long unexposed to light, the first hue to re-intrude on awakening senses. This physical phenomenon is reflected in language where it is among the oldest colour names, the first to appear after distinctions between light and dark. Of the warm colours, it is the hottest and nearest in wavelength to infrared which actually produces the sensation of heat. It is the fastest-moving colour in terms of catching the eye, and has the greatest emotional impact. Red sits at the top of the rainbow.

The physical effect of red is said to be such that exposure to quantities of the colour quickens the heart rate, prompts the release of adrenalin into the bloodstream and engenders a sense of warmth. Children are invariably attracted to red (the first paint or crayon to be used up) but will become fractious in a red-painted classroom. When the film director Antonioni had a factory restaurant painted red while shooting *The Red Desert*, the film workers became argumentative, but settled down again when it was repainted green.

The lens of the eye has to adjust to focus the red light wavelengths; their natural focal point lies behind the retina. Thus, red is literally a come-hither colour. It advances, making red objects seem nearer than they truly are. A bossy colour, it grabs the attention and overrules all surrounding colours. The way it says 'here I am!' makes it stand out in a crowd—whether as a party dress, an official's red cap or a package on a supermarket shelf. Its conspicuousness and power to command makes it the obvious safety colour for stop signs and lights.

The traditional use of red for military uniforms had the built-in merit of charging the spirits, as well as the practical one of not showing blood—although it could hardly have been a worse choice in terms of giving the enemy a target. The aggressive, masculine nature of red has always linked it to combat. The Red Planet, Mars, is named for the god of war. The red flag symbolizes revolution, and in China red also symbolizes the south, where its Revolution began.

Red is also the colour of aristocracy, of royal livery and hence, it is said, adopted for fox-hunting in England when Henry II declared it a royal sport. (The reference to scarlet hunting coats as 'pink' in fact recalls the name of the tailor who popularized them.) Red plush and velvet became standard in theatres to lend them an aura of grandeur, and to roll out the red carpet, whether literally or figuratively, is to show the greatest respect.

Red's multifarious meanings start with its most salient association—blood. In Chinese the word for blood-red is older than the word for red, and in other languages the same word has both meanings. Red is equated with the heart, flesh and emotion, compared to its fellow primaries, blue (spirit) and yellow (mind). The emotions evoked by red are those that get the blood up; from love and courage to lust, murder, rage and joy.

The bond between red and life has made it a significant colour in every culture on Earth. The ritual representations of blood with the colour red pervade all tribal societies. Since blood held the secret of life, the colour was credited with special powers. According to the poet Yeats, 'Red is the colour of magic in every country, and has been so from the very earliest times.'

If red blood embodied the secret of life to ancient man, a phenomenon know as the red shift may help reveal the secret of the universe to modern man. Red shift refers to the change in the frequency of waves of sound or light which occurs when the source and observer are in motion relative to one another. It is most often experienced in the sound of a passing siren. When the source and the receiver are approaching each other, just as sound becomes higher pitched, light becomes bluer. It becomes redder when source and observer are moving apart.

Many astronomers surmised from their observation of the shift to red of light from far-flung nebulae that galaxies around us are all receding from one another. They deduced that the entire universe is expanding, and hypothesized that it began aeons ago as a result of an explosion of unimaginable magnitude.

Centuries ago red was thought to hold the key to all knowledge for, in alchemy, red denoted final attainment of the Philosophers' Stone which transmuted base metal into gold. Although not all alchemists succeeded in making gold from red, the process was reversed successfully in language. From the fourteenth to the seventeenth centuries, red was a standard English equivalent for gold; it has lived on as thieves' cant, with red kettle meaning gold watch, and so on.

The language surrounding red is as rich as the colour deserves. Names like crimson and carmine derive from the Latin *kermesinus*, the name of a dye extracted from the kermes insect, long thought to be a berry or grain. Hence the Middle English expression, 'dyed in grayne', which first meant dyed an excellent red, later simply dyed to high quality. Vermilion is synonymous with the evocative archaic name for mercuric sulphide, cinnabar. This mineral was sometimes also called Dragon's Blood, which in turn was the name of one of the earliest red dyes, recalling a time when the dyer's art was so jealously guarded that betrayal of trade secrets was punishable by death. Appropriately, the best red dye came from the heart of the madder—the root of the plant *Rubia tinctoria*

The ancient Egyptians began the tradition of marking headings, important events or good dreams in red ink. The Christian Church later used rubric to distinguish the order of service in prayer books and to show feasts on the ecclesiastical calendar. Thus a red-letter day came to mean a lucky one.

Red's malign associations are usually passionate. The fat of a dead red-haired person, ever presumed to be of fiery temper, used to be in demand as an ingredient for poison. Red is for blood violently spilt, from the mindless rapacity of 'nature red in tooth and claw' to the hapless felony of being caught red-handed—still stained with the victim's blood. Ordinary lust as well as bloodlust was red, so that a scarlet woman in Puritan times was branded with a scarlet letter, and temptresses of later times congregated in the red-light district.

Red's dynamic range alters dramatically where the colour turns pink. It becomes gentle, acquiescent and changes gender to feminine. The paragon of flowers is as often associated with pink: rose literally means pink in the Latin languages. Among medieval colour terms, pink had some splendid flights of fancy, such as Nun's Belly and Nymph's Thigh. No one really has a bad word for pink. It suggests tip-top condition and high spirits—if you're in the pink, everything's rosy.

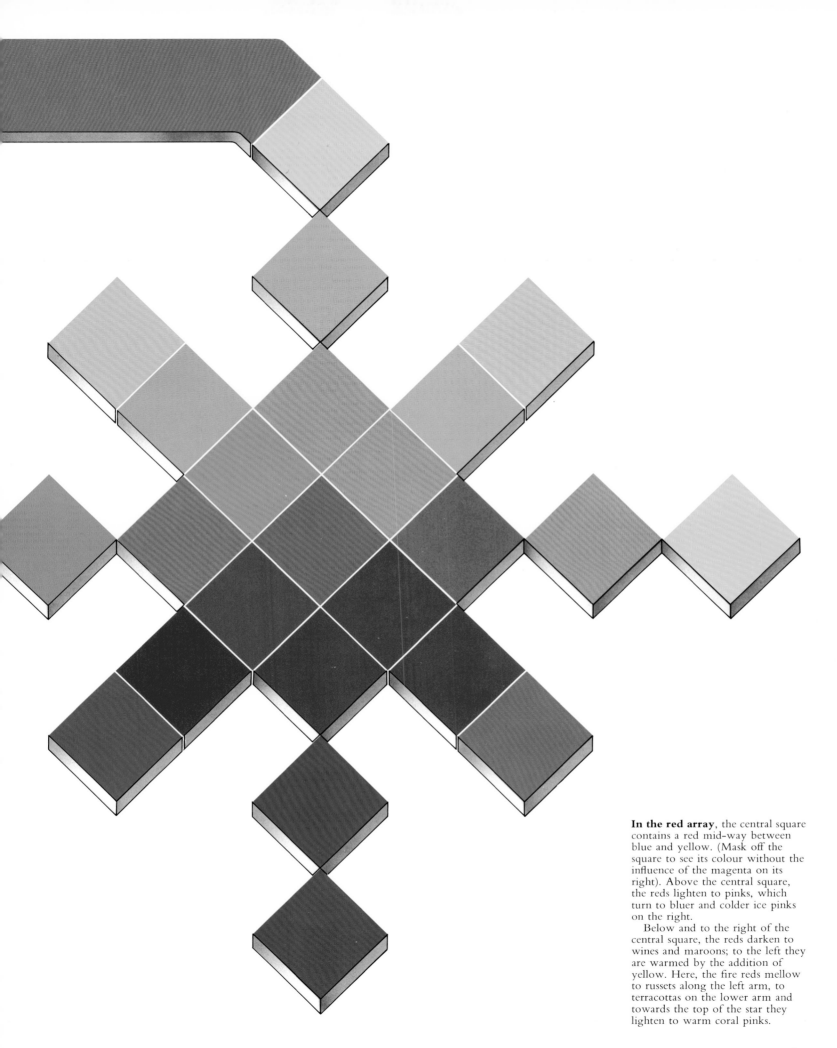

In the red array, the central square contains a red mid-way between blue and yellow. (Mask off the square to see its colour without the influence of the magenta on its right). Above the central square, the reds lighten to pinks, which turn to bluer and colder ice pinks on the right.

Below and to the right of the central square, the reds darken to wines and maroons; to the left they are warmed by the addition of yellow. Here, the fire reds mellow to russets along the left arm, to terracottas on the lower arm and towards the top of the star they lighten to warm coral pinks.

New Yorkers wear their hearts on their lapels, flaunting one of the few shapes synonymous with a word. Stylized hearts were popularized by nineteenth-century Valentine's Day cards, but they appear in much older motifs—in medieval tapestries and heraldic devices, for example. A red heart has long been identified as the receptacle of the passions, and more particularly of love and affection. In ancient Egyptian times the vital organs were removed from a corpse and preserved in special Canopic jars. The jar containing the heart was presided over by the red-painted visage of a god.

Red was considered the sacred colour of Lakshmi, the Indian goddess of beauty and wealth. Such desirable attributes appear to be embodied by modern goddesses, *right*, although self-adornment in red is not without its ambiguities: the original 'scarlet woman'—the great whore of Babylon—is pictured in the Revelation of St. John as decked in scarlet and gold, carrying a cup 'full of abominations' and sitting on a scarlet seven-headed beast 'full of names of blasphemy'.

Up to 100 years ago all the reds in these wools would have been obtained from one dye, madder, and a variety of mordants—chemicals used to fix the dye to the yarn. Different mordants would produce different shades and many variants; coral pink, for example, could be obtained by overprinting or dyeing a second time with a yellow, or with some other colour. But the final result would not have been entirely predictable.

Today each shade of red is the result of a variation on a chemical theme. The results are *almost* predictable, although different dye batches still vary slightly. Experienced knitters buy all the wool they need for a garment from the same batch.

There may soon be no risk of colour differences between batches. Colour can now be measured precisely, and complex technical formulae can be stored, and the dyeing processes controlled, by computer. A colour batch produced in one dye works can be matched with absolute accuracy to a batch produced in another place at another time without even a sample to guide the dyer.

Frigate birds (or man-of-war birds) develop enormous red throat pouches during the breeding season. They act as a threat signal to other males and a 'come-hither' to females.

Red, meaning joy and happiness, is a principal colour in old Persian and Turkish carpets, which have always been hung on walls and valued in the same way that fine paintings are valued.

Centuries ago wandering tribes gathered plants, minerals and insects that would yield colour—indigo, sumac, woad, ochres, and madder, kermes and lac for the reds—and learned to process them in different ways to produce colours so light-fast that carpets, unlike clothes and other washable articles, lasted unfaded for hundreds of years. In the Middle Ages, dye plantations were cultivated like flower gardens.

When, during the last century, the first synthetic dyes appeared on the market, the Persian Government forbade their import because they were not fast enough to light.

Blood close to the surface of the skin colours white skin pink. Exposure to the sun burns the cells, and this damage causes capillaries near the surface of the skin to expand with the increased blood supply needed for repair, so the skin turns red.

But human skin tans after a while. As a protection against exposure to the harmful ultraviolet light of the sun, melanin pigment is manufactured, and this gives the skin its brown colour.

Melanocytes, the cells that manufacture melanin, are no more abundant in black-skinned people than in those with white skins but in black people they are larger and produce more melanin. Some white people have these large melanocytes in certain areas of their bodies, causing freckles and brown patches. Three times as much ultraviolet penetrates white skins as black skins, but sun-tanning reduces the penetration of radiation from 25% to only 5%.

Melanin pigment in different forms and concentrations colours human hair black, brown, red and also blond. When hair turns white it is because small pockets of air form inside each hair shaft, and scatter the incident light in all directions.

Albinos have no pigment in hair, skin or eyes. And white-skinned women are yellower than white-skinned men: their skins contain more carotenoid pigment.

The pink in pigs' ears and noses is the colour of blood in capillaries near the surface of their skin; the whiteness of their covering hair is caused by minute pockets of air in each colourless hair, which scatter the light.

The opening of the British Parliament by the sovereign is an annual occasion when the powers of Church and State gather in the House of Lords. The predominant theme of red and gold befits the event. Both colours have long represented nobility and rank, whether in the golden crowns and crimson robes of monarchs or in the red, ermine-trimmed gowns of peers of the realm and gold military insignia—in this case of Her Majesty's bodyguard of the honourable corps of Gentlemen-at-Arms. Immediately in front of the Queen, the wigged figures of the High Court Judges whose red gowns are academic in origin and date back to medieval times, contrast with the pale splendour of the Bishops' ecclesiastical robes.

Mail boxes, and also telephone booths, are traditionally painted red in Britain and in The Netherlands,—a colour appropriate to monarchies. Mail boxes are blue in New York, yellow in France and Sweden, and in Spain they are silver. But new ones tend to be left unpainted. Like the new telephone booths, they are made of aluminium which needs no protective coat of paint.

Pink sugar candy appeals more to children than white sugar; red candy is more appealing than purple, green or yellow—not least because it stains and smears more readily, a characteristic of food that children love.

Red and pink foods are associated with flavour. Bright red apples, red beans and meat and tomato sauce are firm favourites in the West; in the East, Indians chew the red-staining betel leaf, and relish 'hot' foods coloured with red cayenne pepper, paprika and red chillies. Red wine, more popular than white, tastes stronger because it is made partly from grape skins. It is traditionally a drink of revelry. The colouring of food for festivals is an old custom which still continues in countries with a strong folk tradition. The Mexican bread, *right*, may have been coloured with cochineal which, like extract of tomato, paprika, chile and even beetroot juice (used to colour lemonade pink) have been in use for centuries and are among the few natural food colourants still permitted today. Most synthetic food dyes have their origins in these colourful condiments; their use has decreased in recent years mainly because they are more costly, and their supply is less reliable, than permitted substitutes.

The natural complement of red in food is white—delicate white meat, luxurious white sugar, bread and rice. White says 'refined'; red says 'strength'; pink combines the two, suggesting tenderness and sweetness.

This lone figure at London's Speakers' Corner, engaged in a protest against the world's injustices, carries a home-made red flag as a symbol of his one-man revolution. His blood-coloured banner is a warning that social upheaval and strife will attend all opposition to his plans for social reform.

Goethe remarked of red that 'it is not to be wondered at that impetuous, robust, uneducated men should be especially pleased with this colour. Among savage nations the inclination for it has been universally remarked, and when children, left to themselves, begin to use tints, they never spare vermilion.' No exception to this rule is the Kop, *right*, the collective name for the supporters of the Liverpool soccer team whose club colours are red. Ritual banner-and-scarf-waving are usually accompanied by victory chants and the invocation of the sacred names of outstanding players.

A red cross on a white flag of truce was chosen as the emblem of wartime voluntary aid societies.

The idea was born of a book, a bestseller of 1852, in which the Swiss author published his account of the dead and dying left untended on a battlefield.

As a direct result, the first Geneva Convention in 1863 declared that anyone with medical competence *must* assist the wounded of all sides in war, and that all signatories should have a voluntary aid society to assist the military.

The colours of the Swiss flag in reverse, highly visible and instantly recognizable, became a much-needed symbol of medical aid—for prior to 1863 the different colours of the flags used by different countries (the British had a white flag, meaning 'truce', and the Americans a yellow one, meaning 'quarantine') often went unrecognized. Only authorized voluntary medical societies and the military medical corps may use the international symbol.

In all, 14 states originally signed the Convention, and many have since followed suit. But for some the red cross was unacceptable. The cross is an abhorrent symbol to Moslem states and 17 of them use a red crescent. Iran's samaritans have traditionally shown a red lion and sun.

As iron is heated, it emits some invisible infrared radiation (felt as heat) and subsequently some visible red light. As the heat increases, more short-wave light is emitted until eventually it offsets the red, and the result is 'white' heat.

If iron could absorb and emit all incident radiation (such an ideal is called a black body) its temperature would be around 6223°C or, in Kelvins, 6500K. This is its colour temperature. Daylight is 'white'; its *colour* temperature is around 6500K, but this has no relation to its true temperature. It is a convenient measurement of its colour.

It is as well that traffic lights were not essential until this century, for it was only recently that an inexpensive means of producing deep red glass was discovered.

Red glass has always been tricky and expensive to make. The modern selenium ruby glass, used in great thicknesses for railway and traffic signals, followed on the earlier forms called copper ruby and gold ruby, which were usually used decoratively. These reds are caused by suspensions of microscopically fine metal particles in the glass. Ruby glass involves a two-stage process which does not reveal the colour until the second stage. When the object is first made it is colourless; then it is reheated. At precisely the right temperature it 'strikes': the colour appears. The mystery is how medieval glassmakers, with no thermometers, got it right.

Selenium glass does not have to be 'struck'; the colour is developed while the glass is being moulded, a much simpler process.

Orange, the understudy star

Orange has always suffered something of an identity crisis. It has spent its history playing second fiddle to red, and occasionally to gold. It has virtually no negative associations, neither emotionally nor culturally (no one comes down with depressing fits of the oranges; sees oranges under the bed; gets orange with rage or envy; or has a nasty orange streak) and its emphatically positive meanings are few.

Its career as an amiable but second-string hue begins with the fact that orange is not a primary colour. Even though it is a spectral colour people perceive it as a mixture of red and yellow, the primaries which flank it in the spectrum. But whereas yellow and red can stray towards the cooler blues and greens, orange is unequivocally a warm colour.

A significant aspect of orange's identity problem is the language barrier. As a distinct colour term, it arrived very late in European languages. There was no word for orange until the fruit arrived—during the tenth or eleventh centuries, and it was not freed from its associations with fruit until the seventeenth century. This was not due to any shortage of orange in the environment, simply that many of the colour's most important manifestations were not thought of in terms of orange. Just as it is physically perceived as a mixture of red and yellow, so was its abstract expression usurped: red hair, red clay or goldfish all being arguably orange. Fire, which should rightly be orange's most formidable ally, is always called red, and ironically the terms fiery or flame evoke colours which are not the true colours of flames at all. The so-called red glow of incandescing bodies is usually orange, whether the bars of an electric fire or a horseshoe half-forged. Perhaps a vestige of the former association between colour and fruit still inhibits the mind from calling things orange.

Although it is historically most often lumped with red, orange is physically classed with yellow, as yellow and orange are the only colours in which deep is equivalent to bright, rather than dark. In this respect, reinforced by the strong mental image of oranges and lemons, orange is nearer the spirit of yellow than red. Psychologically it behaves like yellow—cheerful, expansive, rich and extroverted—although somewhat more restrained. It effects a gear-change between red and yellow, possessing the impact of neither. The muddier, desaturated shades can be irritating, spineless and cheap.

Orange is an earth colour: in the form of iron compounds it is common in the Earth's crust; Utah's Bryce Canyon National Park is one vast panorama of the hue. Orange gemstones include amber, citrine quartz and topaz, the latter named from the Sanskrit word for fire. Birds, butterflies and fish display orange, and many mammals have fur of a rusty hue.

If autumn has a colour, it is orange. Blazing foliage and orange flowers seem to coincide, and many fruits have orange skins and flesh: luxurious mangoes, persimmons and peaches, plus homely yams, pumpkins, squash and carrots. Orange has exotic overtones, partly because it is a common colour for spices, which also enhance its sense of warmth. It is strongly oriented toward food, the colour of crunchy, crusty, fried and baked goods. It is a pottery colour and so has a domestic quality, redolent of the comforts of the hearth. Not surprisingly, it is one of the most popular kitchen colours.

If orange is akin more to yellow than to red in temperament, it is more akin to brown than either. The warm neutrals that occur between orange and brown are in constant demand for fashion and decorating. Its historical function in clothing is humble. 'Orange-tawny' was the colour traditionally assigned to clerks and those of inferior position, and to Jews. 'Usurers should have orange-tawny bonnets', wrote Bacon, 'because they do judaise'.

There were no strong orange dyes in the ancient world. A dull burnt orange or weak desaturated orange were the best that plant dyes could muster unaided, although by the nineteenth century, an impressive deep orange was obtained by mordanting madder. Today, synthetic oranges are ubiquitous and flamboyant. The high visibility that makes orange a premium safety colour also recommends it for advertising and packaging. It has been found stimulating in the décor of sales offices and other places where it is desirable to generate energy.

Brown, a darkened orange, is a pigment, not a spectral hue. An older colour term, it has not had such a struggle to assert its individuality. Brown is the first and last word in natural colours, encompassing nearly all shades of earth and wood. It is the most common colour for mammals (because it is the colour of earth and of much vegetation), and occurs throughout the animal kingdom. Like orange, brown has appealing gustatory associations, such as coffee and chocolate. Although some find brown drab or grubby, it has enjoyed outstanding popularity in recent years. Psychologically, it is linked to comfort and security. Its practical, conservative nature makes it more popular with adults than with children, who use it to convey sadness in painting. In French, brun, like sombre, means melancholy, gloomy, dull; and sombre rêverie means brown study—thoughtfulness of expression concealing vacuity of mind.

The oranges and browns have their glamorous facets. Copper, brass, bronze and gold produce a metallic lustre which differs from a standard shine or gloss in that it is coloured. Most metals are extremely opaque, even in thin sheets, and although a proportion of the incident light is selectively absorbed, the lustre is produced because almost all of the reflection is from the surface. The French Empress Eugenie used this aspect of physics to aesthetic advantage: to soften the harsh bronze tint of her hair, she dusted it with fine gold powder.

Red (or orange) hair was popular in ancient Rome; it was considered legitimate for women to redden or bleach their dark hair to give pleasure to their husbands. The red hair popular in the sixteenth century was given in Italy the name of imbalconata from the custom adopted by the proud owners of red rose bushes, then a great novelty, of putting them out on to the balcony when a bloom appeared. In England red hair was fashionable at this time in imitation of the Virgin Queen (although reports of the colour of her hair differed as much as reports of her virginity).

Somewhere, orange collected a sexual connotation. It figures predominantly in the paintings of erotically precocious children, and in psychiatric painting it suggests flesh suffused with blood. Orange was low Restoration slang for the female pudendum, the way pink is today. In classical times, the seeds of the pomegranate were considered aphrodisiac. And the custom, originally French, of adorning brides with orange blossoms symbolized hope of fruitfulness; few trees are more prolific than the orange.

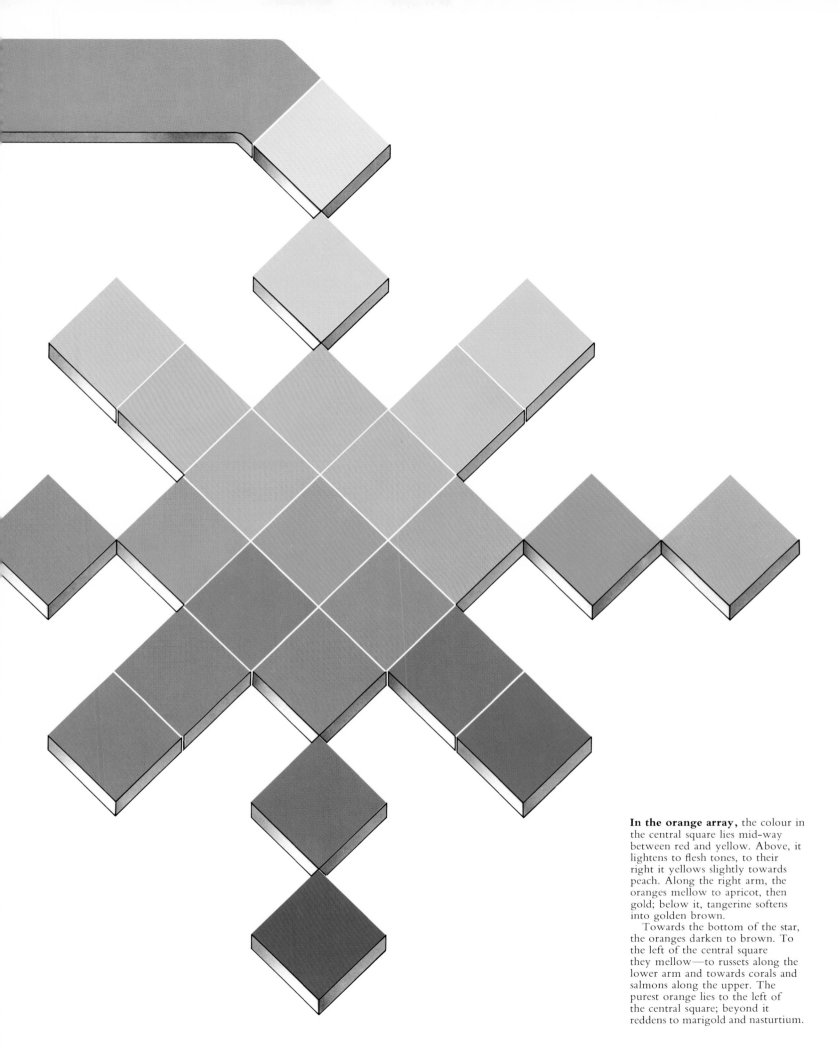

In the orange array, the colour in the central square lies mid-way between red and yellow. Above, it lightens to flesh tones, to their right it yellows slightly towards peach. Along the right arm, the oranges mellow to apricot, then gold; below it, tangerine softens into golden brown.

Towards the bottom of the star, the oranges darken to brown. To the left of the central square they mellow—to russets along the lower arm and towards corals and salmons along the upper. The purest orange lies to the left of the central square; beyond it reddens to marigold and nasturtium.

Sunsets of so vivid an orange were rarely seen in the past. Octogenarians say that sunsets today are more brilliant than those they remember in their youth. A century or two ago, when the air was more clear, there were fewer particles in the atmosphere to scatter the blue and violet wavelengths of light emitted by the sinking sun, so sunsets were rarely as vivid as this. Almost 200 years of continually ascending industrial smoke and dust have polluted the atmosphere so much that by early evening most of the blue light has been scattered, and only the long red, yellow and orange wavelengths remain to brighten the sky above seas and fields—and dirty red-brick industrial cities.

Despite its warm orange glow, neon light, *right*, is 'cold' light. It is produced by passing an electric current through neon gas to excite its electrons. Around 1913, when neon lights first appeared as advertising signs, they were all orange—a neon discharge gas is naturally orange-red. Alternative gases, argon and krypton, emit blue light when electrically stimulated, but these are costly; a substitute can be found in mercury vapour gas which emits ultraviolet light and, by exciting phosphors that coat the inside of the glass tube, can cause them to give off light of any colour. Such lights are called 'cold cathode'; they require a high operating voltage. Ordinary fluorescent tubes are 'hot cathode': the electrodes have to be heated before the arc will strike.

Clay changes colour when it is fired. The clay used to make the red and black pottery of ancient Greece was rich in iron oxides which coloured it. If it were fired at 900 to 1000°C in a ventilated—or oxidizing—atmosphere it would turn reddish brown, and if it were fired in an oxygen-starved—or reducing—atmosphere it would turn black. The Greeks graded the clay by levigation: letting the fine particles float and the coarse ones sink in water. The finest grade had the highest concentration of iron and was used in diluted form as a slip, or paint.

When the pot had been formed on the wheel, the figures, lightly drawn in with a brush, were painted with a slip that would produce a black colour. Details—hair, skin, horses' manes, clothes—were incised and filled in with a slip that would give red, or with a white clay similar to modern pipeclay.

The pot was first fired in an oxidizing atmosphere until the clay turned red; the furnace was then closed off and a reducing atmosphere developed. The iron oxide in the clay, starved of oxygen, was converted into black ferrous oxide, a protective layer of quartz was formed, and the pot turned black. The furnace was re-ventilated and the pot began to turn red again. But the clays in the different slips and the clay of the pot absorbed oxygen at different speeds. If the firing were correctly timed, and the temperature high enough, the fire would be damped at the point where the dense clay in the finest slips remained black, while that in other slips had turned red, and the pot had turned reddish brown. The white trimmings remained white.

Minerals in the clay used in the pot, *above*, produced during the mid-sixth century, coated the surface, giving it a special sheen.

The colour of kippers is often caused by a brown food dye developed especially for them. This golden brown—which could be produced by heavy smoking, but only at the cost of drying out the fish—is considered more attractive than the silvery gold skin and greyish brown flesh of the undyed kipper. Bright orange-red food has a strong psychological impact; it looks appetizing, and the promise of flavour imparted by the colour is sometimes fulfilled by painting dyed smoked fish with smoke essence, derived from smoke tar.

The paler golden colour of undyed kippers is produced by a light smoking with a hardwood sawdust, particularly oak, which is best for smoking fish because it smoulders slowly and gives a fine flavour. Kippers are often soaked in brine before smoking since the more salt there is to be cooked in the juice of the fish, the deeper the resulting colour.

The colour term orange derives from the fruit. The word comes from the Arabic, *naranj*, which in turn may have come from a Sanskrit word meaning 'fruit approved by elephants'. Before the arrival of the fruit there was no word in any European language to describe the colour; the nearest were 'gold', 'tan' and 'tawny'.

Oranges are thought to have originated in South East Asia, and to have been brought to Europe by the Arabs. They were first mentioned in English in a poem written about AD 1044; by 1750 the word was in general use as a description of the colour. But until the eighteenth century the fruit was a rare luxury—and may have been paler. Carotenoids colour oranges, but blood oranges, *left*, a relatively recent mutation, contain anthocyanins which colour the juice and fleck the skin red.

Fluorescent orange is one of the most conspicuous colours, and as such is widely used wherever safety through visibility is crucial. This colour is brightest at twilight and gives the greatest contrast with the sea in any light; its brilliance seems to increase as the sun's diminishes. This is because the greater ratio of ultraviolet light present at dawn and dusk emphasizes the fluorescent properties of fluorescent dyes.

Orange is used at sea in both fluorescent and non-fluorescent versions (the latter, still highly visible, is longer-lasting). For the rubberized finish of the life raft, *right*, the dye must be converted to pigment form, by dyeing a resin and grinding it. Although pigments are more durable than dyes, all fluorescents fade quickly. Modern ones can endure exposure to light for a good four weeks— the time castaways can be expected to survive.

Day-Glo is the trade name for the fluorescent dyed resin pigment developed during World War II by the Switzer brothers, founders of the Day-Glo Color Corporation. Its attention-getting powers were used initially for military warning and safety colours. By the late forties fluorescent pigments were in commercial production, the orange-reds derived from dyestuffs called rhodamines.

The ginger tom is such a fixture among British house cats that females of this coloration are scarcely credited with existence. But this popular fallacy is justified only insofar as the females are rare.

The genes for black and yellow in cats are unusual in that they are co-dominant—they are carried in the same position on the chromosome. A ginger tom must have a parent who is either ginger or tortoiseshell (a pattern of black, yellow and white) but the other parent can be either colour. Because of his genetic make-up he will inherit either ginger or black and be one or the other.

A ginger female must have two ginger parents. The orange gene is carried only on an X chromosome and the female has two (XX) compared with the male's one (XY). If only one parent is ginger, she inherits *both* parents' colours and the colour carried on her other X will make her tortoiseshell.

Male tortoiseshells are far rarer than female gingers as they can be produced only by the genetic aberration of three chromosomes (XXY).

The depth of the orange hue is determined by an independently inherited gene—a rufus polygene—which raises the common yellow ginger to the rich red of the pedigree cats sought for exhibitions and for breeding.

Although bricks are now supplied in hundreds of colours, via dyes added to the modern calcium-silicate variety, to say 'brick-coloured' still suggests the familiar warm, orange-red hue of fired clay. Ancient, pre-kiln bricks were sun-dried, deriving their colour from impurities in the clay, such as red from iron. Alluvial Mesopotamian brick was cream or beige. The Romans fired brick and used it extensively, but often concealed it behind decorative facings. The Byzantines featured its colour and strove for polychrome effects. Since the Middle Ages, brick has lent itself to every type of architecture, to create buildings which mellow agreeably with age.

The conventional red is achieved by firing clay at 900–1,000°C in an oxidizing atmosphere. Greater heat or a reducing atmosphere give purples, browns and greys—hues that an inventive architect can employ for variety on an otherwise uniform housing estate.

Ayers Rock, rearing high out of the flat central Australian desert, looks bright orange in the late afternoon sun, *left.* As evening draws on, its colour deepens to magenta and then to black. Shortly after sunrise, it looks deep maroon, and at noon it is golden.

Ayers Rock is composed of arkose, a coarse sandstone rich in feldspar and iron. The iron gives it the orange-red colour that alters so dramatically with the sun's angle. The rounded top is scored with grooves from six to 15 ft deep which continue, like great claw marks, down its precipitous sides. They cast shadows and, like the different minerals in the rock, these change colour with the changing spectral composition of the sunlight. Sunrise and sunset cause the most spectacular effects.

Marble, the royal family of stone, is, strictly speaking, rock metamorphosed from limestone into calcite or dolomite, during which change its colour alters dramatically. Its broader commercial definition embraces any decorative, calcium-rich rock that can take a polish. The name comes from the Greek for shining stone.

Although the marble with which the classical world is primarily identified is white, the Romans had a high regard for the ornamental qualities of the coloured varieties, setting slabs in walls and even imitating it enthusiastically in painted stucco. Marble's use for facings inside and outside buildings is a prestigious finishing touch. No other building stone is so highly valued.

The different colours in different marbles are determined by impurities, texture and structure. One or more of the iron oxides would produce the pizza-like orange of the French-quarried *Rouge Jaspe* shown here. Polishing decreases the lightness value through scattering and intensifies the hue. A darkish colour will show greater contrast from its unpolished to its polished state than will a light one.

Yellow's tidings of joy

Yellow is the bond between two phenomena of the utmost importance in human history: the life-giving sun above, and gold, the measure of earthly wealth, a tangible glory. Yellow is always a comparatively light colour, for when it ceases to be light, it ceases to seem yellow. Thus it is a natural symbol of enlightenment. With its fellow primaries, red and blue, standing for the heart and spirit, yellow represents the intellect.

The malign aspects of yellow are few. Overall it is a cheerful colour, but despite its connotation of joy, it is conspicuously lacking in popularity. It is nothing like so comprehensively used as, say, blue: it is not flattering to most complexions or eyes.

Pure, spectral yellow occupies a narrow band in the spectrum compared to the other primaries. Most of the yellow we perceive comes from a mixture of red and green light. Yellow light is absorbed by the majority of cones in the retina (the 'red' and 'green' sensitive); during the day, when the cones are working together, the eye is most sensitive to yellow light.

Yellow has the highest reflectivity of all colours and appears to radiate outwards, to advance, in contrast with blue and grey, which seem to recede. It is the one hue that is brightest when fully saturated, whereas other colours darken. Its ease of perception has made it a favourite among advertisers and packagers, as well as the warning colour of heavy machinery.

Yellow in the mineral world runs the gamut from its commonest form, sulphur (the foul-smelling brimstone of hellfire) to perennially precious gold, the artist's medium for the radiance of heaven, and the supreme metal in aesthetic and material terms. The pigment orpiment was one of the primary mineral yellows of the ancient world, a sulphide of arsenic.

The yellow and brownish colours in minerals are usually caused by iron; ochre processed for pigments can give golden yellow to red to brown. During World War II enterprising schoolteachers manufactured paints for their pupils from locally occurring ochres, yellow marls and fine yellow sands, all of which contain the yellow pigment limonite. Vegetable colours were not generally toxic except for gamboge, a gum, which survives now only as a colour name in synthetic paints.

Yellow is the characteristic colour of spring because spring flowers are almost all yellow—daffodils, crocuses, primroses, forsythia, winter jasmine—and emerging leaves have a yellowish tinge to their green. In food, especially fruit, yellow signals the presence of iron and vitamins A and C. Different shades of the colour evoke either the citrus astringency of lemons and grapefruit or the richness of butter and cheese. Most yellow in nature is caused by pigments, chiefly carotenoids, sometimes melanin, and not by structure.

Yellow is a common colour in the animal world—not in the vast expanses comparable to green or blue, for sand and 'amber waves of grain' are more neutral than bright—but in creatures in which it is best known as a warning colour: tropical fish, stinging insects and exotic poisonous frogs. The subdued yellow of the big cats acts as camouflage; blond hair on humans does the opposite.

The special significance accorded to fair hair undoubtedly began with the ancient Greeks. 'The sun's rays', wrote Menander, 'are the best means for lightening the hair, as our men well know. After washing their hair with a special ointment made here in Athens, they sit bare-headed in the sun by the hour, waiting for their hair to turn a beautiful golden blond. And it does.'

Greek courtesans bleached their hair, while European folk lore is full of stories of fair-haired heroines—Gretchen, the Goose Girl and the golden-haired princesses of legend—whose pale tresses are an emblem of purity. Jean Harlow, Marilyn Monroe and Brigitte Bardot replaced the goddesses of folklore.

Oriental races have skins that look yellow possibly because the outer layer of Mongoloid skin is thicker than that of Caucasoid skin; since the underlying blood vessels are masked, the skin looks yellowish instead of pinkish—although the reasons why this should occur are not clear. The Chinese have venerated yellow as an auspicious colour from time immemorial. During the tenth century the Sung dynasty adopted it as the imperial colour and thereafter its use was reserved exclusively for the emperor, his retinue and for imperial regalia.

Besides the imperial family, Buddhist monks wore yellow, their robes dyed with saffron which gives a slightly orange hue. Yellow dress is today more prevalent in the Orient than in the West. It was in the Christian world that yellow fell into disrepute. Although gold preserved a reputation as sacred and divine (despite being the focus of obsessive greed) yellow suffered from an association with hostility during the Middle Ages. Henry of Württemberg and his entire retinue dressed in yellow and passed before their enemy, Philip of Burgundy, who was left in no doubt of the intended message.

Yellow suffered too from the medieval artistic convention of portraying Judas Iscariot in yellow robes. Some countries passed laws ordaining that Jews must be clothed in yellow because they betrayed Jesus, and the Nazis made the Jews wear yellow armbands. In sixteenth-century spain *auto-da-fé* victims wore yellow to denote heresy and treason, crimes for which they were often burned alive. By 1833, yellow was expressly forbidden in the garments of priests.

Whether or not from that precedent, yellow took on its well-known pejorative meaning of cowardice. A twentieth-century American cartoon called *The Yellow Kid* led to the coining of the term yellow press to describe unscrupulously sensational newspapers. Yellow journalism may have publicised the Yellow Peril, a scare that arose in Germany at the turn of the century that the yellow races would overrun territories occupied by the white.

The yellow-back novel was a vulgar breed, sold on railway stalls in Victorian Britain, not to be confused with *The Yellow Book*, the more sophisticated avant-garde reading of the naughty nineties. Aubrey Beardsley and Oscar Wilde, among others, contributed to this quarterly magazine.

Yellow has the Apollonian virtue of magnanimity alongside the vice of inconstancy. It can represent the death of green, as in yellowing leaves and grasses. And it suggests the depreciation of white, as in yellowing with age. Yellow in the Caucasian complexion is a sign of jaundice (from *jaune*, the French for yellow). From medieval times it has signified sickness: yellow is the colour of the quarantine flag for ships at sea. The English word yellow is ultimately derived from the Indo-European *★ghelwo-*, related to gold.

A sullied yellow feels treacherous, but in its pure form, yellow radiates warmth, inspiration and a sunny disposition. It is the happiest of colours.

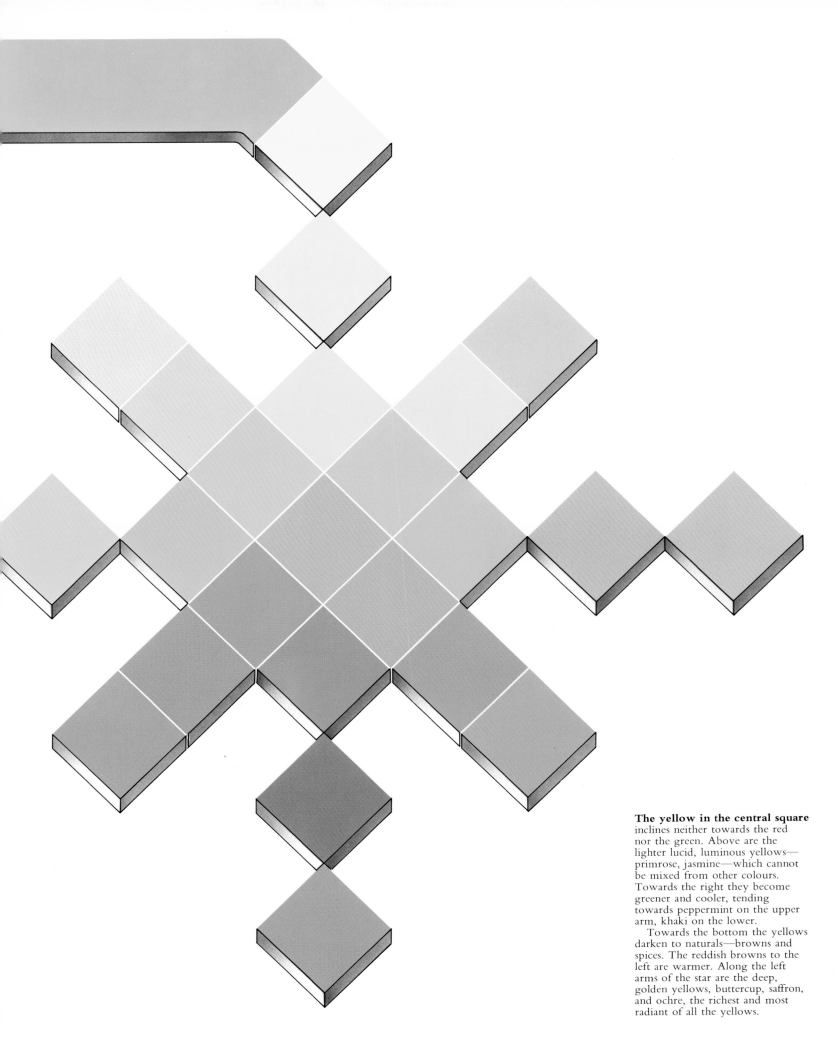

The yellow in the central square inclines neither towards the red nor the green. Above are the lighter lucid, luminous yellows—primrose, jasmine—which cannot be mixed from other colours. Towards the right they become greener and cooler, tending towards peppermint on the upper arm, khaki on the lower.

Towards the bottom the yellows darken to naturals—browns and spices. The reddish browns to the left are warmer. Along the left arms of the star are the deep, golden yellows, buttercup, saffron, and ochre, the richest and most radiant of all the yellows.

201

This hoverfly, with black and yellow warning coloration, has all the appearances of a stinging insect. Yet it has no sting. Its colours, which mimic the patterning of a wasp, protect it from attack by insectivorous birds.

Many venomous wasps, bees and hornets are mimicked by harmless insects—to the great disadvantage of predators. In response, some of these have evolved extraordinary powers of discrimination. American cliff swallows and purple martins, for instance, can distinguish between worker bees, which sting, and drones, which are harmless.

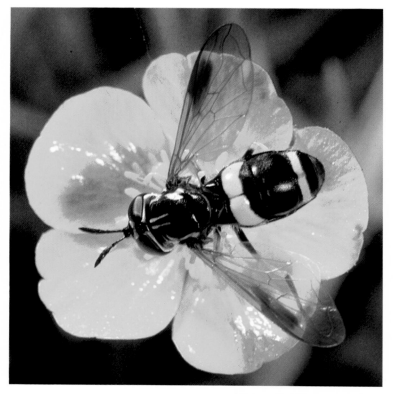

A century ago, the many rooms in large houses were given different monochromatic colour schemes for ease of identification. There would be a blue room, a rose room, sometimes a green and perhaps a mauve room.

Rooms decorated on the theme of a single colour range are fashionable again, but never have the colour possibilities been so many. Today's monochromatic rooms, an indulgence more than a convenience, exploit the emotional effects of colour—the relaxing qualities of green or blue, the cheering effects of sunshine yellow. Here, some colours from the yellow family are brought together to unify a small room. A large expanse of a single colour might be overwhelming, but in this room the tones of yellow are multiplied by a variety of textures.

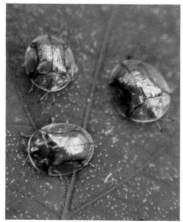

A dress of a single hue is never just one colour. A yellow dress looks almost white where the sun reflects off the folds and in the creases it deepens to brown.

The rules of good taste hold that a dress of as bright a yellow as this will clash with a pink-toned skin, and bring out the blue in the veins. Bright yellows are most flattering to dark and sallow skins, making their hue appear more sallow. The browner yellows—buff, sandstone, bamboo, parchment and naturals enhance healthy Caucasian skins—though they do little for pallid complexions.

This brilliant yellow needs strong sunlight to look its best, and a sun-tan, bringing pink skin into the yellow tonal range, redresses the aesthetic balance and harmony prevails.

This is the gilded living jewel that inspired Edgar Allan Poe's short story, *The Gold Bug*. Most metallic, iridescent bugs and beetles come from exotic, tropical locations —South America, Malaysia, Australasia. The natives make ornaments of them, for the structural colours of tropical bugs and beetles are permanent. In the temperate zones, the golden hue of species like this Golden Foolscap Beetle vanishes within hours of death, resolving to a dull brown. The reason is not known: the scales that cover the wing cases are difficult to detach, and the colour-producing structures have not yet been studied.

During the sixth century, when mosaics reached their apotheosis as an art form, their manipulation presented certain problems which gold could help solve. Because they were executed on such idiosyncratic surfaces as curved vaults, domes and odd corners, they did not lend themselves to the conventional applications of three-dimensional perspective possible in painting. Therefore gold, with its characteristic warmth and lustre and its light-reflecting qualities gave mosaics a needed vitality. Its colour, even more than its value, made gold attractive to the artisan.

Gold also possessed numerous religious connotations. It was the colour of divinity, of martyrs, of priesthood, of the royal majesty of Christ. It was a synonym for light in its natural and metaphysical aspects—from fire to salvation.

Because gold is so remarkably ductile, a little could be made to go a long way. The tesserae—the tiny squares of which mosaics are composed—could be made of tissue-thin sheets of gold fused with glass.

Fixed at an angle, they gave point and sparkle to details, especially clothing, or were used as a background for holy events.

The acknowledged peak in mosaics was reached under the six-century Ostrogothic king, Theodoric. Gold gives depth and spirit to this contemporary detail from the Church of Sant'Apollinare Nuovo at Ravenna. It depicts the Magi, who are reminiscent of W.B. Yeat's invocation in *Sailing to Byzantium*: 'O Sages standing in God's holy fire/As in the gold mosaic of a wall, Come from the holy fire . . .'

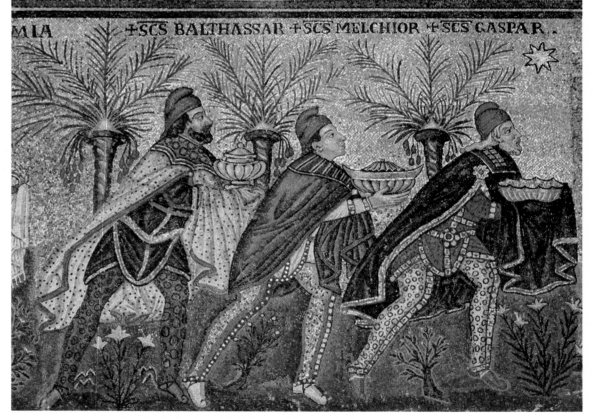

+SCS BALTHASSAR +SCS MELCHIOR +SCS GASPAR

To fish as well as humans yellow means caution. Reef fish are thought to have good colour vision, and the gaudy appearance of this boxfish reminds predators that poison is secreted through its skin when it is attacked. Its bony armour is the real protection, but predators associate the effects of its venom with the black and yellow combination of warning colours and learn to avoid them. The same striking colours that effectively dissuade marine attackers appeal to man, who hunts the fish for food and dries it as a curio.

'**L'étendue est immense,** et les champs n'ont point d'ombre,/ Et la source est tarie où buvaient les troupeaux;/ La lointaine forêt, dont la lisière est sombre,/ Dort là-bas, immobile, en un pesant repos./

'Seuls, les grands blés mûris, tels qu'une mer dorée,/ Se déroulent au loin, dédaigneux du sommeil;/ Pacifiques enfants de la terre sacrée,/ Ils épuisent sans peur la coupe du soleil.'

'The expanse is vast, the fields have no shade, and the spring where the flocks used to drink is dried up; the distant forest, whose edge is dark, motionlessly slumbers over there in a heavy sleep.

'Only the great ripe cornfields, like a golden sea, roll far away disdaining sleep; as peaceful children of the sacred earth, fearlessly they drain the sun's cup.'
Midi by Leconte de Lisle

The number of yellow automobiles involved in road accidents is few. Tests show that fluorescent yellow and orange, white and non-fluorescent yellow are the most conspicuous colours.

Signal yellow is an expensive automobile colour due to its high pigment content, yet it is enjoying a resurgence of sales—perhaps because the buyer likes it enough to pay the surcharge more than for considerations of safety.

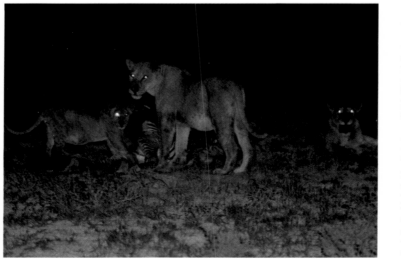

The amber gleam of a cat's eyes caught in a beam from a car headlight or of the moon has none of the sinister meaning so often attributed to it. The eyes of diurnal mammals have a layer of black pigment at the back of the retina to absorb the light that escapes the light-sensitive cells. It prevents reflection, which distorts the image.

Nocturnal creatures have eyes that make the most of all the light that reaches them. The cells at the back of their retinas reflect light not absorbed backwards and forwards within the eye, giving the photoreceptors a second chance to use it, but at the cost of some loss of sharpness in the image. These cells reflect a metallic green colour which, from a distance, shines with an amber glow.

Green for life and love

Green is a most ambivalent hue. The colour of mould and decay, it is, none the less, the colour of life itself. Despite its traditional negative associations with nausea, poison, envy and jealousy, on this green planet it is the colour of foliage, of rebirth in spring, of the silent, abiding power of nature.

Ancient Egyptian mythology accommodated green's contradictory nature. The colour represented Osiris, the god of both vegetation and death. The Greeks also acknowledged its dual nature by linking it to Hermaphrodite, offspring of blue Hermes and yellow Aphrodite. Plato found it titillating and, for that reason, hateful.

'Emerald delights the eye without fatiguing it', maintained the Roman, Pliny. His comfort-loving contemporary, Nero, duly peered through an emerald to enjoy the spectacle of lions devouring Christians. In later centuries, engravers habitually kept a green beryl to contemplate as a visual respite from close work. Belief in green's beneficial effects on the eye has manifested itself down the ages from ancient Egyptian times, when green malachite was used as a protective eye-liner, to the green colour of twentieth-century office steno pads. Theatres since 1678 have afforded the customary backstage sanctuary called the Green Room to actors awaiting call or entertaining friends. The colour of the décor was thought to relieve the actors' eyes from the glare of stage lights.

Green is the most restful colour to the eye. The lens of the eye focuses green light almost exactly on the retina. In daylight, when the majority of colour receptor cells in the eye are working together, they are most sensitive to yellowish green light.

Perhaps the association of this colour with the qualities of stability and security stem from its ease of perception. Most nations number a green bank note among their currencies. The confidence of a nation rests ultimately in its primary resources and the colours of money are also the colours of the earth.

Historically, man has found green an elusive colour. However lavish Nature may have been in adorning the Earth with green, she guarded it jealously from man, refusing to supply more than a few green minerals that could be ground as pigments, obliging him to synthesize it chemically, a feat that became possible only during the nineteenth century. No bright green dyes could be obtained from nature—only murky or pale ones with poor light-fastness. The synthesis of a green dye called Caledon jade, half a century ago, was a milestone in dyestuff chemistry.

A starting point for understanding the green of malignance, malaise and mystery is the human body. It is never green unless seriously ill with seasickness, poisoning or a form of anaemia called chlorosis, riddled with infection, covered with maturing bruises, or dead. The greens the body generates—urine, pus and phlegm—are unpleasant and disgusting.

Green is physically alien simply because humans are mammals and mammals are not green. Slithery green creatures like frogs, snakes and lizards, to which many people feel antipathy, became the fantasy models for everything from ancient dragons to current science fiction monsters. Their colour renders imaginary characters suitably weird, from green men in space ships to the Incredible Hulk. Children's appetite for sensation causes them to be fascinated by slime, decay, mould, mildew, putrescence, the horrific thrill of rotting cadavers or disembowelled viscera. Green is the colour of creepiness.

If asked 'What colour is poison?' many would answer 'green'. The expression 'poison green' as a colour term evokes a distinctively bilious shade. Doubtless the precedent for this is the notorious, arsenic-laced pigment, emerald green, also known as Paris green. This, used in what turned out to be a lethal nineteenth-century wallpaper, was inadvertently responsible for numerous deaths before the cause was discovered.

Among green's crowning ironies are the facts that the colour associated with emotional balance (bred, as it is, from happy yellow and tranquil blue) also signifies the most vertiginous emotion, jealousy; that the colour of freshness is also the colour of decay; that the colour of greatest visibility is also the colour of camouflage; that it is used to express both the curse and the blessing of youth, as in green meaning inexperienced or gullible, compared with a desirable, vigorous green old age. Green fingers make good gardeners, but green hands betoken novice sailors.

The wearing of green has had its share of meanings. It is, of course, the emblematic colour of Irish patriots. Lincoln green, worn by the outlaw Robin Hood in the forests of medieval England may have been the first recorded use of this colour for camouflage. It was the first army uniform colour in America: in the War of Independence, Revolutionary soldiers fought a guerrilla war with rifles and made green a symbol of this future style of warfare. The British, armed with muskets, fought in strict formation in battalions as brightly identified as football teams.

The Revolutionary brotherhood called the Green Mountain Boys took their name from the etymology of their native state, Vermont (*vert mont*). When, in 1946, the Royal Marines assumed the commando role in the British Army, they set themselves apart by being the only regiment to wear green berets. The expression became synonymous with commandos.

Green is the colour of the planet Venus, and therefore of love. Green was traditionally worn at weddings in Europe, where it symbolized fertility, a custom ironically portrayed in Van Eyck's *Wedding Portrait*, in which the pregnant bride is wearing green.

Fate and poetry have conspired to link green with its complementary colour, red. Greenland was discovered by Eric the Red who felt that 'It could make men's minds long to go there if it had a fine name'. The peak of Lady Macbeth's hallucinatory guilt is conveyed in the image '... this my hand will rather the multitudinous seas incarnadine, making the green one red.'

Green is associated with apparently supernatural phenomena: the eerie optical effect that sometimes occurs for a few instants at sunrise and sunset, most often seen in the tropics, called the green flash; the seemingly portentous green moon. The moon sometimes looks green when a catastrophe, such as the eruption of the volcanic island of Krakatoa in 1883, results in excessive quantities of minute particles in the atmosphere. These scatter the green wavelengths of light and the moon, as a result, takes on a verdant hue.

Green puts things into perspective: it was here before man, and it is ever ready to reclaim its own. Like the jungle tangle that methodically obliterated the ancient Mayan city of Palenque, green will have the last word.

In the green colour array, the central square of the star contains a green that is mid-way between yellow and blue. Towards the top, the greens become lighter, more limpid and less saturated. To the right, the addition of yellow warms them slightly.

Below and to the right of the central square, the greens darken and mellow; they are mixed from browns, greys and greens. The bluish, peacock greens lie below and to the left of the central square. Above them are the lighter aqua greens. Their blue content makes them cooler than those at the top of the star.

Agreement as to whether there is a natural green carnation seems to break down over semantics, with the two points of view served by the observation, 'There is green and green.' Horticulturists confirm that true green is not genetically possible in the *Dianthus* species, although one white variety with the faintest greeny-yellow tinge has been reported.

The *boutonnière* associated with Oscar Wilde's heyday at the Café Royal was dyed by the expeditious but injurious dunking method. The usual procedure today is to stand the cut stem in vegetable dye for 10 to 15 minutes, enough time to absorb a subtle, pale green like the bloom shown here.

The natural colours of vegetables and fruits have earned them a hallowed position in still-life paintings. But the vegetable garden has for so long been severely functional that the idea of vegetables as garden ornaments seems unlikely.

Yet an artist observing this cabbage would notice how the leaves, pale yellow-green in the centre, deepen and change to blue at the edges. Few green leaves are just plain green. There are many kinds of chlorophyll; they colour plants different shades of green. And because of the presence of yellow carotenoid pigments some green leaves have a yellowish hue.

Most vegetables flower. There are varieties of cabbages that are sold as ornamental houseplants. They have clusters of diminutive, delicate florets and are coloured red and pink, white and yellowish green. Herbs have long been appreciated for their beauty; in modern décor as well as gardens common vegetables are taking on a new lease of life.

'The mind, that ocean where each kind/Does straight its own resemblance find;/Yet it creates, transcending these,/Far other worlds, and other seas;/Annihilating all that's made/To a green thought in a green shade.'
The Garden by Andrew Marvell

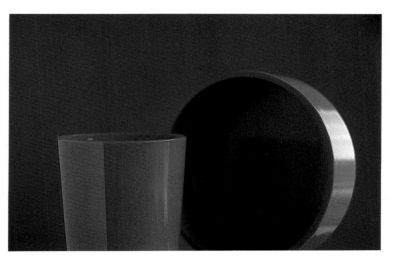

The visual impact of any colour seems most powerful when it is reflected from a glossy surface. The smooth surfaces of highly polished materials reflect light waves largely in one direction, a phenomenon known as specular reflection. Light striking the irregularities in rough surfaces is reflected in all directions, and this is known as diffuse reflection. The same hue will look darker and more saturated when reflected from a glossy surface than if it is reflected from a mat surface.

The magical, mysterious green glow of the glow-worm is caused by bioluminescence, a phenomenon insects use for intermittent signalling. Its use to bioluminescent fungi, and the bacteria that cause fallen trees to glow in the dark, has yet to be discovered.

The cold light emitted is produced by the interaction of two chemicals. Luciferin is oxidized in the presence of the enzyme luciferase (both words from the Latin *lucifer* meaning light-bearer). Although oxidation is a kind of burning, virtually no heat is generated. Consequently bioluminescence is the most efficiently produced light there is.

In different species, the luciferins and luciferases are different and biologically specific. Thus the luciferase from a luminous fish would not catalyze the luciferin of a glow-worm. The colour of the light depends upon the particular luciferase—and is usually greenish yellow or greenish blue.

The signals sent by this unusual visual communication system are also different in different species. Mating codes have variables in the intensity, duration and number of flashes. It is not just their association with warm summer evenings that makes fireflies seem romantic; they have literally turned on their lovelights: sedentary females signal cruising males and airborne males signal females.

Fireflies and lightning bugs are neither flies nor bugs, but beetles. Glow-worms are wingless larvae.

Chagall painted the face of his self-portrait green in *My Village and I, below,* an early work painted shortly after his move to Paris. The green face reflects his nostalgia for the peaceful green soul of his native Russian landscape: 'I returned in soul, so to speak, to my own country'.

Chagall described himself as an abstract colourist: 'must we jib at a big man with a green face when one accepts so easily the everyday spectacle of a great man with a red face?' remarked one critic. Yet other abstract artists expressed antipathy towards green, especially bright green which Kandinsky thought was self-satisfied. 'This green is like a fat, very healthy cow lying immobile, only capable of chewing the cud, regarding the world with stupid, apathetic eyes'.

Mondrian hated green, and painted only in red, yellow and blue—to him the basic colours. He disliked green so much that at a luncheon in Paris he changed his seat at table to avoid the view of leafy trees in the Bois de Boulogne.

The twentieth century could be characterized fittingly by this estrangement from green, one art critic pointed out.

In the 1730s and 1740s, during the Palladian era in England, damasks and heavy velvets in green and other rich colours had been fashionable in state rooms. Dark green paint was extensively employed, and was considered ideal on wainscot to set off dark-toned portraits in oils to great advantage.

At this time too, it has been suggested, poetic fancy and a degree of symbolism influenced attitudes to colour. Green was described, for example, as 'the colour of Venus', being associated with 'Felicity and Pleasure' in Randle Holme's *Academy of Armoury,* a seventeenth-century book on heraldry.

By the 1750s a lighter taste came to prevail in houses such as Heveningham Hall, *right,* originally decorated by James Wyatt during the closing decades of the century. A whole range of pastel tints became fashionable, including, besides green, light blue, lilac and delicate greys. The vaulted ceiling in the elegant entrance hall at Heveningham seems to provide an apposite illustration of the lightness of touch with which the paler greens were exploited.

The domes and towers of neo-classical cities such as Vienna, or Copenhagen, *right*, are coloured green because of corrosion. They are made of copper or bronze and the patina is due to the corrosive effects of the atmosphere. Although it is considered beautiful it may be poisonous—copper cooking pots have to be lined, or they corrode.

The patina on roofs and bronzes is called verdigris—a corruption of *vert-de-Grece*—but it is not the green pigment that was used by the ancient Egyptians to treat eye complaints and that was described by the Renaissance painter, Cennino Cennini. Two bright green pigments were used by artists from ancient times: one was malachite (a kind of copper carbonate akin to the patina produced by the sea air on this tower in Copenhagen) and the other was verdigris, a copper acetate made with vinegar and copper. Both pigments ceased to be used when more durable artists' greens were synthesized during the eighteenth century.

Operating-room walls, surgeons' and nurses' gowns and the sheets covering the patients are usually dark green. This green is the complementary of the red colour of blood, and its purpose is to neutralize the after-image produced by prolonged concentration on a wound. If the wound were surrounded by white the surgeons would see a disturbing after-image whenever they looked up.

Girls working on lipstick production lines are reported to have complained of nausea and dizziness as a result of after-image effects when factory walls were painted in colours that were not complementary to red.

In such circumstances the green of the background must be a close complementary in lightness and saturation of the colour to be neutralized: surgeons would still see an after-image if the sheets, gowns, operating-room walls were a very pale green.

The evergreen leaves of the conifers of the northern hemisphere, *right*, are thick and leathery to prevent evaporation. Conifers grow close together, and coniferous forests are dark. To admit as much light as possible conifer leaves have a higher concentration of chlorophyll, making them greener than deciduous leaves, which are yellowish.

And conifers have needle-like leaves, which in many species are covered with a waxy layer to prevent evaporation. The shorter blue and violet wavelengths of light are scattered by the molecules of the waxy surface layer, and mix with the green wavelengths reflected by the chlorophyll to give the leaves a bluish tinge.

The infinity of blue

Vast expanses of sky and ocean accommodate the spirit craving release through a sense of infinity; their loftiness and depth have endowed their colour with a noble character. Blue has historic and symbolic associations with royalty, yet it is also the people's colour. In use, especially in clothing, it flatters nearly everyone. It is the peacemaker of colours: cool, soothing, orderly. Its negative meanings, confined mainly to sadness or depression, are merely extensions of its positive traits—cool taken to cold, solitude to isolation, tranquillity to inertia. Blue is fundamentally salubrious; blue skies are a patent cure for the blues.

The mystery of why the sky is blue is explained by the phenomenon known as Tyndall scattering, also responsible for non-iridescent structural blue colour throughout nature, in blue eyes, feathers, dragonflies' wings, the mandrill's face and posterior, even cigarette smoke and the chin of a man with a five o'clock shadow. The effect is seen when sunlight is scattered by atmospheric particles of the same magnitude as the blue wave length, so that blue light is reflected in all directions. This scattered light, to look blue, must be viewed against a dark background. For example, protein particles in the iris of the eye are backed by a layer of brown melanin pigment, while dust in the atmosphere is backed by the blackness of outer space. When forest fires in Canada in 1957 temporarily increased the numbers of particles in the atmosphere, the moon turned faintly but distinctly blue.

For all blue's abundance in sky and sea, it is scarce underground. The only mineral blues were turquoise, azurite (a copper compound likely to turn green when extracted and used) and the much-prized lapis lazuli. These could be ground and used directly as pigments. Other blues, such as those from copper and cobalt, required some technology for the colour to be extracted. Even the natural dyes indigo and woad were called hidden colours, in that they required a series of chemical reactions to reveal any colour at all. The pigment called ultramarine (literally 'from across the sea') was processed from lapis lazuli. In the Middle Ages, when it was used for illuminating manuscripts, it cost as much or more than gold. But once it was chemically synthesized the colour formerly so precious that artists reserved it for the Blessed Virgin's mantle was used in the common laundry bluing that whitened housemaids' unmentionables.

'Blue for a boy, pink for a girl' is traditional in Britain, but French mothers dress their baby girls in the colour of the Virgin's cloak. The blue signifies her status as Queen of Heaven. The association of blue with royalty has a broad and ancient base. In both the Greek and Roman pantheons blue represented their respective gods, Zeus and Jupiter. When in Great Britain scarlet became the colour of royalty, blue was chosen by the Covenanters or Presbyterians as a badge of opposition, in accordance with a Biblical instruction that the children of Israel put a fringe on their garments with 'a ribband of blue'. The colour subsequently stood for Whigs, then Conservatives, the Union Army in the American Civil War and the police.

Blue as a synonym for best had been symbolized by a blue ribbon since 1348 when the garter shed by a lady at a court ball was recovered by King Edward III. He chose that moment to coin the phrase, *honi soit qui mal y pense* ('shame to him who evil thinks') as he fixed the blue band around his own knee, creating the highest order of Knighthood in England. Thus it came to be applied to the greatest honour in various fields: Archbishopric of Canterbury, Blue Ribbon of the Church; the Derby, Blue Ribbon of the turf. Blue-chip, meaning high quality, or a safe investment on the Stock Exchange, comes from the high-valued blue chips used in poker. Blue blood, meaning high-born, has a Spanish origin: the veins of aristocrats with no Moorish blood looked bluer than those with mixed ancestry.

The term bluestocking, applied to a learned or pedantic female, goes back to 1400 when a Venetian society distinguished its members by the colour of their hose. But the direct derivation comes from a Mrs. Montagu's mid-eighteenth century British society, taking its name from the French *bas-bleu*. This garment, which contrasted with formal evening dress, denoted literary as opposed to strictly social interests. 'True blue will never stain', meaning a worthy heart would never disgrace itself, was a high-flown sentiment based on the prosaic fact that butchers' aprons did not show blood.

Blue is the favourite clothing colour for children and young adults, whose affinity for blue denim is apparently boundless. For millions of Chinese, and for peasants and industrial and manual blue-collar workers in the West, blue is a fact of working life, partly because the hardy indigo plant grows the world over and partly because blue bears dirt more gracefully than other colours.

Blue has its seamy side. 'Blue gown' was an expression for a harlot, stemming from the dress prostitutes were obliged to wear in the house of correction. Blue movies (which escape the censor's blue pencil) and blue humour are indecent. Blue Monday, the one before Lent, is so called due to the presumed alcoholic excesses preceding Lenten austerity. 'We can drink til all look blue', said seventeenth-century playwright John Ford; blue meant tipsy and blue ruin was bad gin. The puritanical blue laws still govern the sale of spirits in some American states.

Blue has sometimes been used to mean 'darkness made visible', the feeling at evening when the very air seems blue. The classic French perfume *L'Heure Bleu* takes its name from the intensely romantic hour between dusk and dark when the atmosphere is a deep blue, a time when ladies entertained their lovers, while husbands called on their mistresses.

Blue surroundings are credited with a calming effect, even with lowering the blood pressure, which recommends them for bedrooms or any area designed to be restful. People turn blue with fear or cold; the Chinese used the blue-faced image in art to convey a fierce mood.

The Romans, in linking blue with black, associated it with the Saturnine, melancholic humour. The emotional meaning of blue then and now divides itself naturally according to light and dark. The jubilant colour of summer skies could never evoke depression. The blues as an expression for despondency was first popularized by Washington Irving in 1807, as an abbreviation of the older term, blue devils. The blues as music may traditionally draw its lyrical inspiration from romantic and other woes, but the whole point, and effect, of singing or listening to blues is relief and pleasure. This is typical of the colour blue's self-righting character. Its negative side is never threatening; rather a natural, sorrow. Ultimately, it points to the realm of the transcendental. And, of course, heaven.

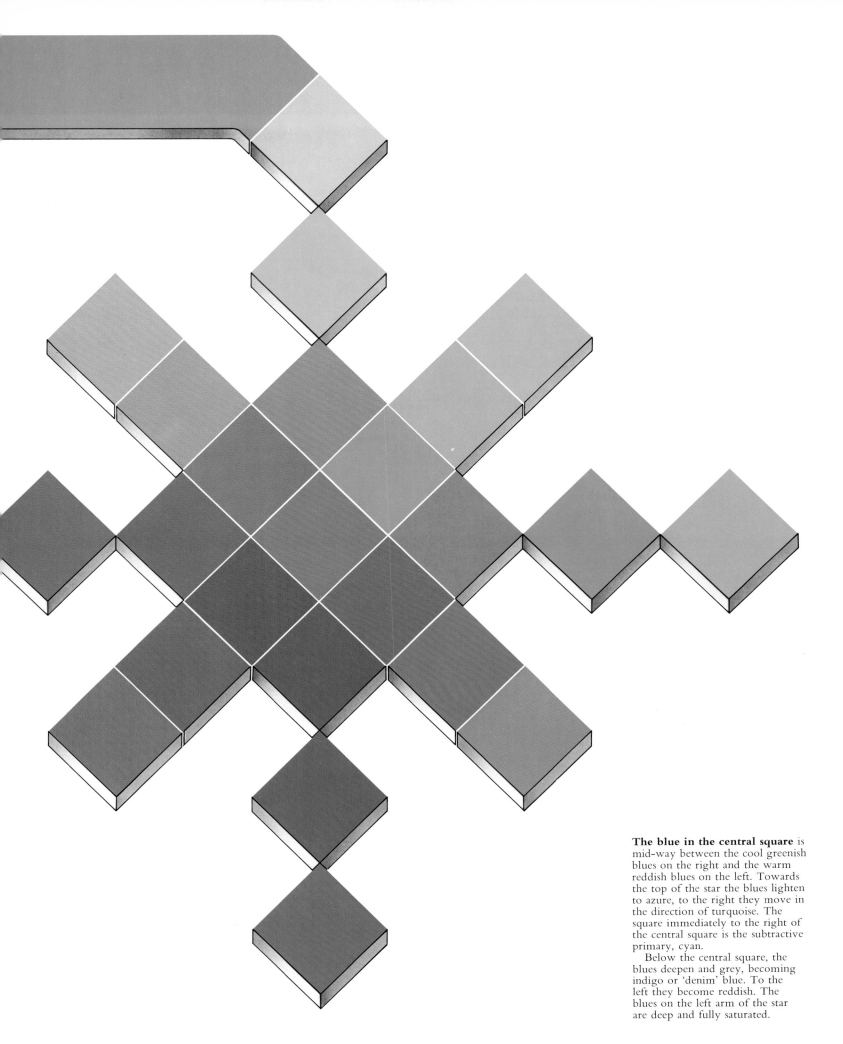

The blue in the central square is mid-way between the cool greenish blues on the right and the warm reddish blues on the left. Towards the top of the star the blues lighten to azure, to the right they move in the direction of turquoise. The square immediately to the right of the central square is the subtractive primary, cyan.

Below the central square, the blues deepen and grey, becoming indigo or 'denim' blue. To the left they become reddish. The blues on the left arm of the star are deep and fully saturated.

213

Turquoise is the national colour of Persia, source of some of the oldest and finest turquoise gemstones, which were called *piruseh*, meaning joy. Ancient Persians trusted this lively blue to ward off the evil eye, protecting their animals as well as themselves with turquoise charms.

Copper is responsible for the ideal sky blue colour both of the stone and of the alkaline glazes made in imitation. The Persians displayed a partiality for turquoise glaze early on and used it liberally to decorate bricks and tiles, so that their buildings sparkled with this lucky colour. Both copper and cobalt (the blue often used in conjunction with turquoise) were cheap to obtain and simple to work with, despite their tendency to run. This tile is a map of the sacred mosque at Mecca in 1666.

The American western skink (*Eumeces skiltonianus*) has striking black and white markings and a blue tail when young. The blue is caused by the scattering of the short wavelengths of light by protein particles in its scales. The blue serves to distract predators' attention from the skink's vulnerable front end. If it is caught, the tail breaks off easily, enabling the skink to escape. Later, the tail regenerates.

As the skink matures it loses its vivid markings and turns dull brown, though at least one species retains its disposable blue tail into adulthood.

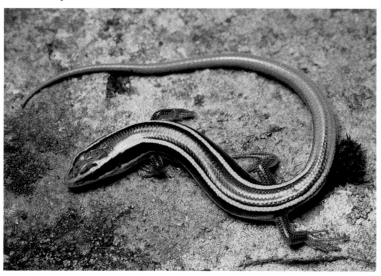

There are more blue flowers at high altitudes. The numbers of species of blue and violet flowers increase with altitude. Alpine plants such as gentians, that grow along the snowline, are abundant in anthocyanins—the pigments that colour plants blue, while the same species growing in warm lowlands tend to be white.

Early in the century there was a theory that anthocyanins are synthesized in conditions of intense light and low temperatures to protect plants against radiation and cold, but this has not been proved.

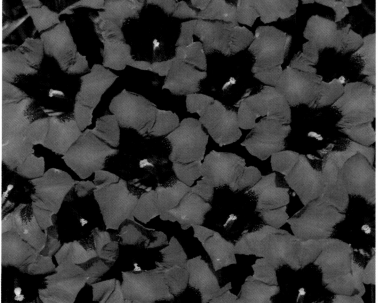

Monochromatic blue light seems chill and ghostly, and makes skin look grey. These sombre qualities can be relieved by combining the blue with a 'white' light: the chill becomes cool, the atmosphere mysterious, and if the 'white' light source has a warm cast, skin colour remains natural.

People who feel comfortable with blue light find that it relaxes the atmosphere at a dining table, in a bedroom or on a patio. The effect may be more marked on a hot evening. Different blues have different qualities: daylight blue is almost white and light enough to read by while dark blue gives everything a purplish cast. All blue light tends to look cold.

The thin glass tubes which house neon lighting are easily bent, giving new scope to lighting designers who are beginning to explore the possibilities of introducing coloured light sculptures into the home, *right*.

Blue is not the easiest colour to achieve with a primary gas laser. The electrons in the molecules of gases such as argon, krypton or cadmium, which give blue laser light, need maximum electrical charges to stimulate them to the high energy levels of blue light. Although the colour of a gas laser can be adjusted by altering the pressure of the gas, or by using a prism to select the frequency of the laser light, the range of wavelengths that any one gas can give is limited. Argon gas, used in this laser, and to a lesser extent krypton, give a greenish-blue light; a purer blue can be obtained using helium-cadmium.

Dye lasers can produce monochromatic light of a very wide range of blue wavelengths. They have a separate dye chamber filled with a yellow dye that absorbs only a very narrow range of blue light wavelengths. A blue laser is used to irradiate the dye molecules. As they absorb the photons of blue laser light their electrons become excited, and they 'lase' or irradiate the light.

By carefully selecting a yellow dye that absorbs the required wavelength of blue, a wide range of blue laser light can be achieved.

The laser has found a multitude of uses: as an anti-missile device, as a range finder, in communications, as a gyroscope, as an industrial tool and even in delicate eye surgery.

Yet coloured laser light beams are essentially decorative and their latest use is as an art form. The variable colours of dye lasers may soon be matched up into three-colour systems for full-colour hologram projection.

Male satin bower birds (*Ptilonorhynchos violaceus*) have feathers with a glossy blue sheen produced by the same phenomenon that causes the blue of the sky. The shorter wavelengths of light are scattered by particles of protein in the filaments of the black feathers. These birds build a bower at mating time—a platform of woven twigs about 1 ft high which they decorate with blue objects, sometimes even blue flowers which they discard and renew when withered. One aviarist reported that his pet bower bird was killing blue finches and hanging them on its bower. These birds even chew fibrous bark and use it as a brush to daub the bower with a blue paint they make out of fruit juices and saliva. The blue décor helps to attract a mate.

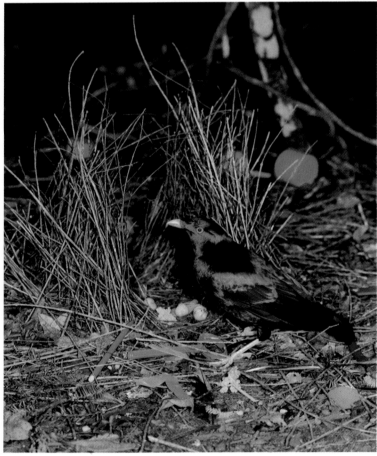

The dye responsible for this sea of denim is synthesized indigo. It now stretches credulity to think that by the late forties this colour had become an endangered species. With the machinery required for indigo's laborious vat-dyeing technique wearing out, and little demand, there seemed no incentive to replace it when other, faster blues could be obtained with simpler methods. Then, starting in the fifties, and escalating madly in succeeding decades, the jeans revolution rescued indigo from near extinction.

The indigo plant furnished the world's only colour-fast blue dye for millennia. Its eventual synthesis in 1880 was a great coup for dye chemists, but virtually wiped out the huge market for the natural product. Natural and synthetic indigo produce identical colours because they are chemically indistinguishable, bar the plant's impurities, and both are vat-dyed.

Whereas most dyes are valued for their fastness as well as their colour, the quality that endeared indigo to all of Western youth was the way it fades. The prized whitey-blue of seasoned jeans is a colour impossible to obtain by any other method. This felicitous fashion had the added advantage of being economical for the manufacturers, for a truly fast indigo is costly to produce. The dye proved fast in wool, but in cotton it is vulnerable to washing, light and rubbing.

The reason indigo-dyed denim fades the way it does is that the cloth is woven with a blue warp (the vertical threads which show on the surface) and a white weft (the horizontal threads which make the underside light). As it wears, the white shows through.

Before faded indigo became the voluntary uniform of millions, it was the official uniform of the Royal Navy. As fading betokened long service, new recruits scrubbed at their issue to emulate their seniors—who were piqued when a non-fading blue replaced indigo and eliminated this traditional distinction.

Since fading was also a badge of honour with the jeans-buying public, who measured status by the degree of pallor, store-keepers stocked fast-fade, pre-faded and recycled second-hand jeans. No dye could hope to match the subtle variegation of the genuine article.

William Morris's mastery of the discharge method of dyeing with indigo is exemplified in the pattern of this chintz, *Strawberry Thief*. He was convinced that the colours of plant dyes harmonized naturally, that they were more permanent than the new synthetic dyes (which faded rapidly and unevenly, and that their restricted colour range would provide exactly the kind of discipline necessary to restore high standards of design. In a catalogue of 1911 he described his technique: 'The cloth is first dyed all over in an indigo vat to a uniform depth of blue, and is then printed with a bleaching reagent which either reduces or removes the colour as required by the design. Mordants are next printed on the bleached parts and others where red is wanted and the whole length of material is then immersed in a madder vat calculated to give the proper tint. This process is repeated for the yellow (welds), the three colours being superimposed on each other to give green, purple or orange. All loose colouring matter is then cleared away and the colours are set by passing the fabric through soap at almost boiling heat'.

Wedgwood jasper has been produced in a range of colours for more than 200 years, but the colour its creator called, simply, pale blue is so distinctive and popular it has come to be known as Wedgwood blue.

The tranquil, dignified colour of this urn gives no indication of the depth of research that went into producing it. In his zeal to achieve a coloured body with which to contrast the white applied relief, Josiah Wedgwood performed more than 10,000 recorded experiments which, he confided to a partner, drove him 'almost crazy'.

Pale blue was his first success and because it was coloured with the costly mineral cobalt it was his most expensive. It was a darker blue than that of this late eighteenth-century urn, nearer the royal blue of the ware Wedgwood now produce to commemorate royal occasions. But owing to the vagaries of the old bottle kilns it would vary from firing to firing— so much so that there was a company maxim that the depth of blue depended on the way the wind was blowing.

This blue was such a best seller that for 200 years it was the only blue in continuous production by the Wedgwood company. In 1978 a dark blue, called Portland blue, was introduced.

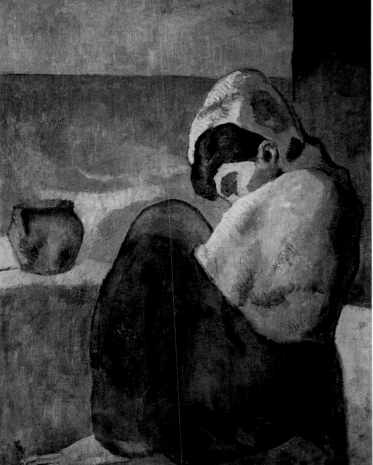

The pervasive atmosphere of poverty, isolation and suffering in Picasso's *Crouching Woman* is intensified by the almost monochromatic blue of the paintings he produced during his Blue Period from 1901 to 1904.

Picasso's concentration on blue to express the 'sincerity . . . that cannot be found apart from grief' has never been decisively explained. It may have originated in something as simple as the use of laundry-blue as a cheap watercolour during a period of poverty, or as complex as a synthesis of Symbolist, Romantic and Decadent influences. Blue had connotations of night and secret love, of an elevated spiritual existence, of death or sinister evil.

Through blue's essential mystery, Picasso expressed life's inherent sadness in figures of beggars and outcasts, such as he saw in Barcelona. But he also showed its continuity in his *Maternités*, pictures of Madonna-like mothers with their children. His cool, profound blues are intuitively right for these contemplative, melancholy pictures.

Picasso had a lasting personal allegiance to blue: '. . . that which exists best in the world . . . the colour of all colours, the bluest of all blues', he wrote.

Deep, deep violet

When opposites attract, their union may be anything from subtle to stormy. The red and blue of which violet and purple are composed are physically, emotionally and symbolically poles apart. Skilfully combined they evoke heavenly delicacy or incomparable richness; mishandled, they are unsettling and degenerate. Since the mind may be confused as to whether it is responding to masculine, physical red or feminine, spiritual blue, these hues are defined as 'psychologically oscillating'. They are colours about which people feel either delight or aversion.

Purple and violet between them encompass vast differentiations in hue. Violet is not merely a lighter shade of purple, it is a pure spectral hue. Purple is a dual, or mixed, colour. There is violet light, but not purple.

Nature provides few good, true violet or purple pigments or dyes. Manganese oxide was the pigment used to colour medieval purple glass, but purple pigments for other purposes were fugitive if cheap, costly if superior. Enduring purple inks and paints are mixed from blue and red pigments to give good lightfastness at reasonable cost. Until fairly recently there were problems of such mixtures separating out after use, but modern purple paints are unlikely to deteriorate.

Purple has been the most significant colour in the history of dyeing. Yet the famous Phoenician Tyrian purple, the colour most prized in the ancient world, is lost. It was a derivative of the mollusc, *Purpura* (the source of the colour name) and is thought to have been a dark red by modern definition.

With the advent of synthetic dyes, purples were in the vanguard. They were the accidental brainchild of a teenage laboratory assistant, William Henry Perkin, who was ultimately knighted for the career that began with 'Perkin's mauve'. The paucity of good purple and mauve dyes meant that these colours enjoyed a memorable vogue in the mid-nineteenth century. Their popularity was largely due to the fashion-conscious French. British dyers stuck stubbornly to the dyes they knew, but an error in the patent for Perkin's mauve invalidated it in France and the silk dyers of Lyons put it into production, christening it mauve after the delicate purple of the mallow flower.

Before long a kind of purple piracy was abroad in Europe, patent notwithstanding. Perkin's mentor, Professor Hofmann, generated a range of brighter, bluish red aniline dyes, including 'Hofmann's violets', which he called Rosanilines. Almost simultaneously the French produced an analogous dye called fuchsine, after the fuchsia plant. The unusually bright new reddish blue was named magenta after the Italian village near which an especially bloody Franco-Prussian battle was fought shortly before the dye was introduced.

Purples in fashion have had a chequered career. The brighter magenta overtook mauve in popularity during the latter half of the nineteenth century, perhaps because the latter eventually became associated, in the British Empire at least, with Queen Victoria's prolonged period of mourning for her Consort, Prince Albert. 'For half mourning, black and white, white, mauve, or grey should be worn' was the rule of dress in British Court circulars as late as the forties, accounting, perhaps, for mauve's lugubrious associations.

When magentas led colours in fashion during the thirties and fifties, a campaign to promote mauves and purples to commemorate the centenary of Perkin's achievement withered in the fifties. But the whole family of colours had a raving renaissance in the sixties, when their unconventional, provocative qualities were just the image sought by a generation bent on flouting the rules. Magenta was used in deliberate conjunction with orange, the clash making for a psychedelic vibration.

Chemical synthesis gave purple to the people. Historically, it was a regal prerogative. Tyrian purple had been 'precious as silver'. Porphyrogenitus ('born to the purple') was a surname of the tenth-century Byzantine Emperor, Constantine VII. It is the designation for a son born to a reigning sovereign, literally reinforced in the Byzantine Empire by the purple-draped chamber of the Empress used for her confinement. 'Raised to the purple' refers to a priest being created cardinal, although his insignia are actually red.

Purple is the colour naturally synonymous with sensuality. It rivets the attention in Shakespeare's tableau of Cleopatra on her barge: 'Purple the sails, and so perfumed that the winds were love-sick with them'. The 'purple-stained mouth' in Keats' ode smacks of wine and wantonness. The supine Roman in his purple toga poised to consume a branch of grapes is decadence incarnate. Purple can be orgiastic and ostentatious; not exclusively the colour of power, but also the colour of power corrupted.

In ecclesiatical symbolism, purple expresses the mystery of the Lord's passion. It is identified with the Easter period, especially Ash Wednesday and Holy Saturday, while nature obliges at this time of year by decking the Earth with crocuses and their complementary yellow daffodils.

Purple is not abundant in nature. Most of its manifestations are in flowers, the piercing purity of whose hues long mocked any human attempt at duplication. Flowers furnish the majority of colour names for various purples—violet, lavender, lilac, mauve. Where purple occurs in wildlife, it tends to be a showy, iridescent colour, as in the purple emperor butterfly. The amethyst is the sole purple gem, though occasional sapphires are violet. Before the invention of faceting distinguished the truly precious stones by revealing their fire, the amethyst was ranked among them because of its excellent colour.

Spectral violet is the shortest wavelength, occurring in an extremely narrow band at one end of the spectrum, whence it resolves into ultraviolet which is largely invisible to humans. Violet light has the highest energy. Some flowers are ultraviolet in a way that affords precise instructions to those insects able to perceive it; the colour in plants is sometimes called 'bee purple'.

When a beam of pure violet light shines on a metal plate, the plate throws out a shower of electrons. There is an energy exchange, with radiation as well as absorption taking place. This photoelectric effect operates electric eye doors.

In psychology, violet is associated with internalization and sublimation. It indicates depth of feeling. The appearance of violet in the human aura is interpreted as spirituality if light and depression if deep. Self-esteem radiates purple, but a preference for violet in the Lüscher colour test indicates immaturity. The ambivalence inherent in lavender has sometimes caused it to be labelled effeminate and linked it to homosexuality. But no one can pin these red-and-blue bred shades down to a single identity. Florid purple prose may be written by a shrinking violet.

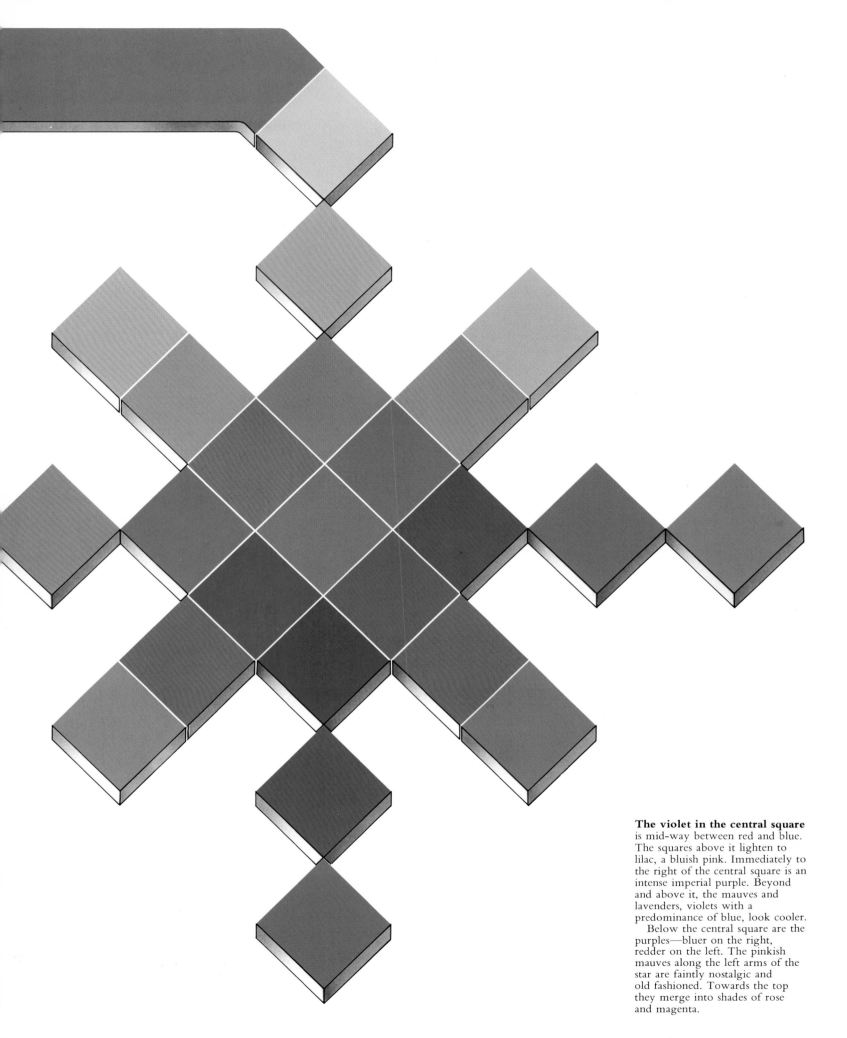

The violet in the central square is mid-way between red and blue. The squares above it lighten to lilac, a bluish pink. Immediately to the right of the central square is an intense imperial purple. Beyond and above it, the mauves and lavenders, violets with a predominance of blue, look cooler.

Below the central square are the purples—bluer on the right, redder on the left. The pinkish mauves along the left arms of the star are faintly nostalgic and old fashioned. Towards the top they merge into shades of rose and magenta.

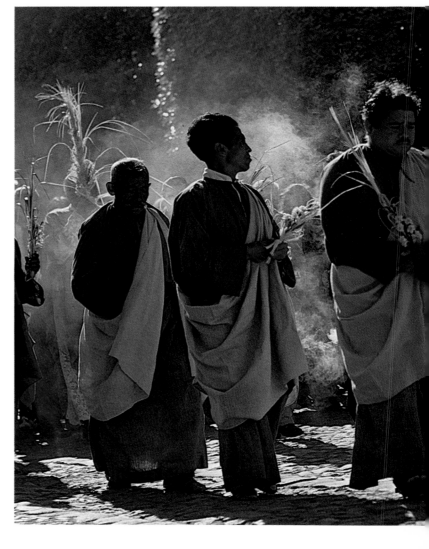

This Art Nouveau advertisement, in fashionable violet and yellow, appeared in a printing trade magazine around the turn of the century. Protected from light the dense, flat colours printed by letterpress remain bright, but then as now, pigments for violets and purples were a problem. Few have been discovered and most of these are notoriously fugitive. Reliable purples are far too expensive for use in all but the most costly printing inks.

The same simple method of making purples used by painters through the ages has been adopted by both ink- and paint-makers: they are mixed from reds and blues (today usually synthetic phthalocyanine blue) to give strong, stable pigments not too vulnerable to light.

Magenta pigments are easier to obtain and gained a special significance with the advent of photographic three-colour separation techniques used in colour printing. But today magenta is only a name: the true blue-red has been replaced by much purer reds which give a 'cleaner' mix for printing.

Purple robes have long been the prerogative of those engaged in sacred activities, such as the priests who officiated at the ancient Greek mysteries at Eleusis. Roman emperors later appropriated the colour to represent their personification of the god Jupiter; but their power was more earthly than divine and, by the sixteenth century, purple was simply the colour of royalty. In a Christian context purple robes, such as the ones worn by these Guatemalan priests during a Holy Week procession, have regained some of their divine connotations. For the colour not only represents the penance of the sinner; as a combination of red and blue, it also symbolizes Christ's shed blood and the power of the Spirit—the Resurrection implicit in the Crucifixion.

Violets were medicines in medieval times. Oil of violets, still used as a perfume and to flavour drinks and candy, was a medieval sleeping draught.

In English and in the Latin languages, violet is a medieval colour term. Purple is an older term, derived from the ancient Tyrian shellfish used to obtain dye centuries ago. But the cloth worn by kings was, it is thought, a deep crimson, redder than the deep reddish blue of these flowers.

This minute copepod, about six mm long, flickers violet and blue as it swims. Its colours are caused by light diffracting through the microscopic hairs on the appendages it uses to swim through the water.

Copepods' brilliant colours are thought to be useful; in courtship, and to ward off predators, they flash them. And in the blue environment of the sea, where violets and blues are inconspicuous, they are camouflage colours. They break up the outline of the copepod's body so that is is invisible from below.

Only 30 years ago, a businessman in a magenta shirt was unthinkable. World War II changed all that. After seven or eight decades of monotonous achromacy, coloured shirts appeared.

The revolution began with a thirties' fashion for the khaki bush shirts worn by Europeans in the tropics. They were shocking then because they were worn informally *outside* the trousers.

Then, during World War II, American designers introduced into male fashions colours and styles hitherto seen only in sportswear or in gaudy South American folk dress. President Truman, his outline distorted by the vivid patterning of a South American 'Carioca' shirt, set a presidential seal on the trend in a photograph taken in 1950. By 1956 even city shirts had colour: they were discreetly decorated with coloured stripes. In the sixties James Bond (007) overcame the strongest resistance: his blue shirts appeared everywhere in the wake of his box office successes.

Behind the scenes, the dyeing industry worked to encourage a trend that would create colour obsolescence in a slow-moving industry. Reactive dyes introduced bright colours into cottons; vat dyes brought brilliant magentas to acrylics. As a result, the psychedelic era has never ended as far as men's shirts are concerned—and by the seventies colour had reached men's suits.

Purple is rarely used in packaging. When it is, it means 'luxury'. Decades ago, a British chocolate company packaged its chocolates in the colour that suggests royalty; the brand has had such success that now a purple pack signifies 'chocolates' to the British.

All purple foods and drinks have a hint of the exotic. There are mauve sweets to scent the breath with a name from the East: cachou. The zaniest cocktails are purple and the liqueur, *left* called *Parfait Amour* in Europe, *Crème Yvette* in America, is flavoured and perfumed with oil of violets.

Amethyst meant 'not drunk' in ancient Greek. In former ages this purple gem was held to be proof against the effects of the purple grape, and the association became so ingrained that large amethysts are traditionally found in ecclesiastical rings, guarding their wearers from unseemly intoxication at church banquets.

The amethyst was a love charm, an aid to sleep, protection against thieves and the birthstone for Aquarians. It can be violet, dark purple, or any colour in between, and has reddish and bluish shades. Its worth is determined by its clarity and the depth of colour.

So intimately linked are the characteristic colour and scent to which the lavender flower has given its name that the fragrance invariably conjures up the hue and vice versa. But lavender was a perfume so much used by our grandmothers and great-grandmothers during the pre-World War II decades that both colour and smell have a slightly old-fashioned connotation.

There are many varieties of lavender, most of them grown in France, where they fill some 50,000 acres with their variety of dusky purple blooms.

Light shining through coloured glass produces certain optical effects, among them the phenomena of irradiation and halation. The former was a preoccupation of the Frenchman, Eugène Viollet-le-Duc, who, in the nineteenth century, attempted to systematize the principles which, he believed, underlay all medieval stained glass.

Blue glass appears to advance when light is transmitted through it, while red glass seems to recede. Viollet-le-Duc asserted that the irradiating effect of blue glass was liable to turn a neighbouring red glass to violet, and that medieval glaziers controlled this tendency with a barrier of white glass, reducing the blue area.

A twentieth-century American art historian, James Rosser Johnson, tested these ideas and found them less than scientific. Johnson believed that any such violet effect might be deliberate. And he points out besides that when some people stare at window glass it appears to turn violet, as a result of retinal adaptation, after 20 to 40 seconds. This optical phenomenon, known as delay, Viollet-le-Duc might well have experienced.

The violet light of the spectacular south rose window in Notre-Dame Cathedral, Paris, is due in part to the phenomenon of halation. This effect occurs when the light transmitted by one coloured glass spills over into a neighbouring, usually darker, glass to create a different overall colour in the window when it is viewed from a distance. The blue light transmitted by the glass of this rose window, built in about 1260 (but much restored), is overlapping the adjacent ruby glass to cause the violet hue; but, since halation can be avoided by placing white glass between the blue and the ruby, it is not unlikely that the distinctive violet hue was deliberately planned by a canny medieval glazier.

THE POTENTIAL OF COLOUR

Fear of trying stops many people from venturing into a circle of colour wider than the one they have, often unconsciously, established in their lives. Motivated by practicality, we surround ourselves with a useful palette of neutrals, earth tones or pastels enlivened by the one or two bright colours with which we feel comfortable. But often these colour habits have been fixed merely by default.

People drift into a pleasant and functional scheme or ensemble and abandon any further search. They do not always reach their conclusions empirically, but adhere vaguely to the dictates of fashions while falling back on various shibboleths as to which colours must, on no account, be used in conjunction. In fact, the most unexpected colours may be persuaded to work together.

A name can only too easily send a would-be colour explorer off-course. To help overcome inhibiting (and often groundless) prejudices about colour combinations, try thinking of hues without attaching names. It would be as well to take a leaf from the book of the ancient Greeks and reconsider colour according to light and dark, or with regard to purity or greyness. For it is compatibility in these areas which may reconcile warring hues and calculated contrast which may give a fillip to insipid groups.

The way in which the colour-shy cling to the so-called natural shades—cream, terracotta, raw umber—implies that nature is unremittingly conservative, when, of course, it is more flamboyant than man dares to be. There are obvious examples in the fiery New England autumn foliage, the colours of pebbles on a beach, the unregimented hues of an English country cottage garden in summer. The Japanese, acknowledged arbiters of discreet yet striking handling of colour, have traditionally taken their cue from nature. Women tuck orange and magenta blossoms into their blue-black hair, a clash westerners might find outrageous. It was inspired by the proximity of these colours in the wild, and nature works.

To invoke nature or fashion or the tenets of good taste as an excuse for laziness or timidity in using colours is to stifle creativity. Fashions benefit from interpretation and like taste, they change. Blue and green, once never seen in combination in dress or décor, are now classics. There is no such thing as a 'bad' colour scheme.

Ideas cribbed from nature make useful first steps in expanding colour awareness and usage. Giving reign to intuition—by adding one bright colour to a collection of 'safe' naturals—is another. Whatever the satisfaction one's current use of colour may provide, the wherewithal for its extension is readily available in the form of a child's box of watercolours.

To demonstrate the possibilities of such simple ideas, Sydney Harry, a British artist, put colour theory into practice in the series of paintings reproduced in the following pages. All the gradations of hue in the painting, *Hannelore*, opposite, come from mixtures of just two colours: yellow and purple. The painting does not exhaust the possibilities of the two colours used. By adding increasing quantities of black to darken the mixtures, new colours would emerge, and the boundaries of the composition would be extended well beyond the confines of this page.

Sydney Harry did not set out to demonstrate colour theory in a self-conscious, calculated way. Having studied and assimilated the science of colour, he painted spontaneously. The insights gained from theory give his paintings an unexpected dimension, for the results of the synthesis of science and art often surprise even the artist. That is why these paintings have a charm that transcends the academic.

Mixing and matching

The range of colours that artists and householders can buy is limited—necessarily so, for no paint store could stock all the colours there are. Artists become familiar with the techniques for mixing colours so as to obtain the exact match in pigment of a subject's eyes, or the colour of sunshine on grass. They mix all they need from a basic range of 14 or 15 colours and learn to analyze colours in terms of pigment. To an artist the sea may be ultramarine mixed with viridian green and a touch of white.

Those without this training have to live with the yellow that was just a little brighter in the can than on the label or the paint

Tubes of paint in the six spectral hues make a good basis for experimental colour mixing and matching. Try the colours out with a child's box of paints, or tubes of acrylic or gouache.

If the six paints are mixed together, the resulting colour will vary from deep brown to black, depending upon the type of paint used and the proportions. Water paints will produce a brownish black while acrylics, which are more opaque, will mix to a blackish brown and the transparent spirit-based inks in felt-tipped pens will produce an almost pure black.

Starting with the simple colour range of the tubes, *above*, mix the opposite colour pairs, adding one to the other in equal parts. These have always been termed complementaries, although opposite colours are truly 'complementary' only in light beams.

This results in a range of dark-coloured, warm neutrals, *right*.

1 part yellow+1 part violet

1 part yellow+1 part violet
+6 parts white

1 part red+1 part green

1 part red+1 part green
+6 parts white

1 part orange+1 part blue

1 part orange+1 part blue
+6 parts white

The neutrals above can be lightened by the addition of white, producing the neutrals most often used in interior design, *right*.

A true neutral is a grey with no hue bias and looks very 'dead'. Tinted neutrals are used as backgrounds in painting, just as they are used as background colours in décor, as a foil for stronger colours. An opposite neutral will intensify a really strong colour—a neutral with a greenish tinge, for example, will make red stand out.

card, or with the pink that just was not the colour they thought it was. The reasons for the discrepancy can be many—lighting conditions at the point of sale, the size of the colour sample, lighting again at the point of application. It sounds complicated, and it is, but the important thing is—it is possible to alter the colour on the spot, in the place where it will be seen, under the lighting that will be used to illuminate it.

Media differ, and techniques differ accordingly, but the principles of colour mixture apply to all media. Only water-colours can be lightened by adding water; other kinds of paint are lightened by following the rules that apply to the mixing of all paints—children's poster paints, polyurethane high gloss, artists' gouache, stone paints for exterior use, washable emulsions and the venerable oils that the masters use.

Nearly everyone can remember from school that red and yellow make orange, and yellow and blue make green, but there is more to colour mixture than that. Experimenting with colour is fun and there is no substitute for carrying out your own trials. A little knowledge will put at your disposal all the colours you have ever seen—and perhaps a few more.

To darken a colour, the first instinct is to add black, but this may have the effect of 'greying' the colour—making it look dirtier—and it may lose its hue. Red, blue, green and brown can be successfully darkened by adding a little black, but to prevent the hue from changing, add a touch of a darker shade of the colour being darkened—to red, for example, add a touch of a dark red.

Do not add black to light colours. Black added to yellow makes it turn green. Instead, add a touch of red and blue.

To darken colours, try adding a small quantity of the strongest hue in the range nearest the colour you are aiming for, *right*. Again, this may cause a slight change in hue as a result of the type of pigment being used. To maintain the apparent hue of a red, add a touch of yellow, and to blue, add a touch of green. To darken a colour, *always add dark to light*.

To lighten a colour the rule is: add it to white. But the addition of white often changes the hue—adding crimson to white, *right*, results in a bluish pink. The hue can be maintained by adding a touch of yellow to the pink.

Yellow can be used to lighten colours, but it will also change the hue slightly—to lighten orange with yellow, add a touch of red. Yellow and orange can be used to lighten burnt sienna, light yellow to lighten orange and green. The light colour must be in the same family as the colour being lightened—yellow will turn blues green, and green added to blue will change it to turquoise.

Always add colours to white. Never add white to colours. It takes a large quantity of white to lighten a colour even slightly.

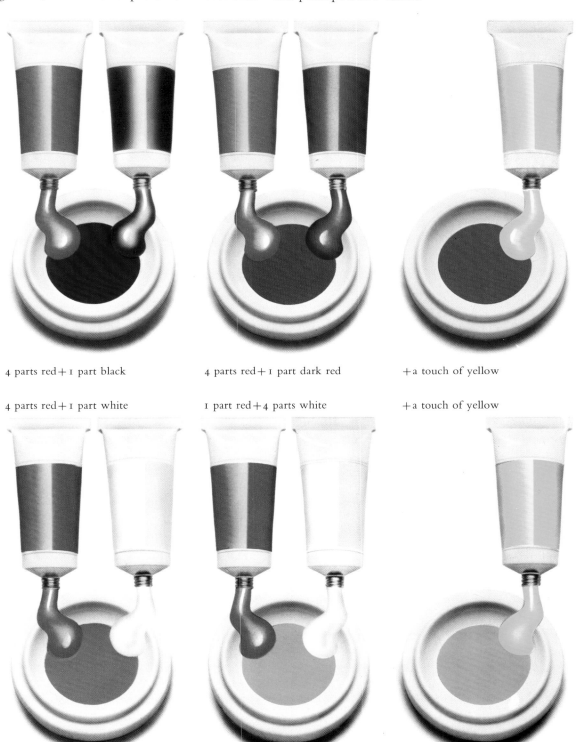

4 parts red + 1 part black

4 parts red + 1 part dark red

+ a touch of yellow

4 parts red + 1 part white

1 part red + 4 parts white

+ a touch of yellow

Mixing and matching 2

Colours are not immutable, but to change them requires a little knowledge. It is relatively simple to lighten or darken a hue, but there are complex rules for mixing colours, just because there are so many, and the possible permutations are infinite.

Begin by mixing the six colours of the spectrum with one another. Add a touch of white to each hue and to each mixture, then a touch of black. Try varying the proportions. A touch is just that—lightly touch the colour with the brush and mix it in. After each trial, observe the results and compare them with the results of the other mixtures.

Experimenting with colour mixtures is a rewarding game. Having exhausted the possibilities in the six basic colours of the spectrum, branch out and experiment with a wider range.

To match an existing colour successfully, you will have to observe it closely. Select a colour from a sample card that seems a close match with the wall paint, sofa cover or carpet you want to match and then buy a small can of the paint that matches the sample. Paint out an area *in situ* (not less than a square metre if it is to be on a wall). Let it dry. Examine it only when it is thoroughly dry: some colours dry darker, some lighter and sometimes there

When two colours are mixed together, each is degraded to some extent. When beams of light mix additively the resulting colour is brighter and more saturated, but pigments subtract colours from the light falling on them and the mixture can only be darker than the lightest contributory colour.

Take each of the six spectral colours and mix together the related colour pairs—yellow and red, red and violet, blue and green, green and yellow—adding one to the other in equal proportions, *right*. The resulting mixtures will be a different hue from that of either contributory colour.

Variations on the tonal range of all three hues can be produced by mixing the paints in different proportions, and by adding the result to white.

Mixing yellow and black together will produce a green; a wide range of greens will result from using different yellows and different blacks, and by varying the relative proportions of yellow and black, *right*.

Other colours can be used to vary black. Adding red will 'warm' it; adding blue or green will 'cool' it.

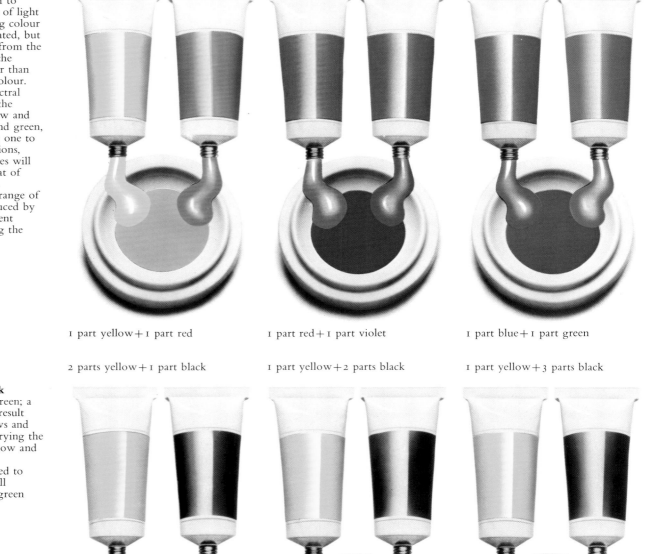

1 part yellow + 1 part red

1 part red + 1 part violet

1 part blue + 1 part green

2 parts yellow + 1 part black

1 part yellow + 2 parts black

1 part yellow + 3 parts black

will be a slight change of hue, a particular colour bias. Colours containing a blue pigment, for example, will often dry looking even more blue.

Live with the colour for a while and notice how it changes with the changing light of day and under artificial light. Decide whether you want it darker or lighter, warmer or cooler, or changed in some other way. Experiment with changing just a small sample (of the same kind of paint) to the exact shade you require, but note the proportions and multiply them for large quantities of paint. Then mix, in a single batch, more paint than you are going to need—it will be difficult to reproduce an *exact* colour match a second time; some trial and error is necessary.

The rules below are not hard and fast. Colours are affected by the constitution of the paint, which varies from gloss to satin to mat and from one manufacturer to another; and colours are not pure; they will almost always be slightly bluish, reddish or yellowish. But the principles apply to all types of paint and all hues. To mix and match colours you have to analyze them visually, like picking out the notes in a chord. This skill comes only from constant practice.

The easiest way to make grey is to add at least one part black to three parts white; different tones of grey can be obtained by varying the proportion of black to white. The resulting mixture will have a discernible hue depending on the particular black and white pigments chosen. There are three main blacks and three main whites in the range of artists' colours.

Warmer greys are produced by adding a little red; different ranges of greys can be produced by varying the hues added.

Add the black—and the tinting colour—to the white, just a touch at a time.

To obtain more subtle greys, mix three colours together: red, green and yellow; red, violet and yellow or red, blue and orange in different proportions.

3 parts white + 1 part black

3 parts white + 3 parts red + 3 parts blue + 1 part yellow

3 parts white + 2 parts red + 3 parts blue + 1 part yellow

15 parts white + 1 part yellow

15 parts white + 1 part red

15 parts white + 1 part blue

Make a range of pastels by adding each of the six basic colours to white in the proportions 1:15. Pastel peach can be made by adding a touch of yellow to pastel pink; and a pastel green by adding a touch of yellow to pastel blue.

Cream can be produced by mixing equal quantities of pastel yellow and pastel pink. But there are many 'creams' and many ways of mixing them: white with a touch of yellow and red and a minute quantity of black; 20 parts white with a touch of red and a touch of yellow. Creams can be colourful, light, subdued or greyish.

Solo

A few of the many possible variations on a single red are illustrated in *Solo*, *right*. Varying proportions of white have been added to a red of medium tone in the top parallelogram; a medium grey has been added in increasing proportions in the central parallelogram; and to the bottom one increasing proportions of black have been added. By modifying the red with other lighter or darker greys, the range could have been greatly extended.

The red used in *Solo* is of medium tone—or lightness— giving a relatively short range of gradations to black, *below right*. Gradations of this kind can be made by adding black to any colour, gradually increasing the proportion of black to colour step by step. The number of steps in the gradation will vary, though, from colour to colour: the gradation from yellow to black, for example, is much longer than the gradation from red to black, because yellow is much lighter than red. The scale of gradations from yellow to white, *bottom right*, is shorter than both.

One of the curious things about the yellow to black range is the way in which yellow becomes green as black is added. This is because, since yellow reflects both the red and the green zones of the spectrum, the addition of black partially neutralizes the red content of the reflected yellow light, giving a shift towards green. Yellow does not change hue when lightened with a pure white, although an impure white may affect it slightly.

THE POTENTIAL OF COLOUR
Mixing and matching

The range of colours that artists and householders can buy is limited—necessarily so, for no paint store could stock all the colours there are. Artists become familiar with the techniques for mixing colours so as to obtain the exact match in pigment of a subject's eyes, or the colour of sunshine on grass. They mix all they need from a basic range of 14 or 15 colours and learn to analyze colours in terms of pigment. To an artist the sea may be ultramarine mixed with viridian green and a touch of white.

Those without this training have to live with the yellow that was just a little brighter in the can than on the label or the paint

Tubes of paint in the six spectral hues make a good basis for experimental colour mixing and matching. Try the colours out with a child's box of paints, or tubes of acrylic or gouache. If the six paints are mixed together, the resulting colour will vary from deep brown to black, depending upon the type of paint used and the proportions. Water paints will produce a brownish black while acrylics, which are more opaque, will mix to a blackish brown and the transparent spirit-based inks in felt-tipped pens will produce an almost pure black.

Starting with the simple colour range of the tubes, *above*, mix the opposite colour pairs, adding one to the other in equal parts. These have always been termed complementaries, although opposite colours are truly 'complementary' only in light beams.

This results in a range of dark-coloured, warm neutrals, *right*.

1 part yellow + 1 part violet

1 part red + 1 part green

1 part orange + 1 part blue

1 part yellow + 1 part violet + 6 parts white

1 part red + 1 part green + 6 parts white

1 part orange + 1 part blue + 6 parts white

The neutrals above can be lightened by the addition of white, producing the neutrals most often used in interior design, *right*. A true neutral is a grey with no hue bias and looks very 'dead'. Tinted neutrals are used as backgrounds in painting, just as they are used as background colours in décor, as a foil for stronger colours. An opposite neutral will intensify a really strong colour—a neutral with a greenish tinge, for example, will make red stand out.

Duo

Mixtures of yellow ochre and a bluish green will produce intermediate colours as in the scale, *right*, depending upon the amount of green added. In *Duo, far right*, the yellow looks luminous by contrast with the increasingly darkening colour surrounding it. Gradations like this are made by adding a dark colour to a light colour, step by step. Some interesting and sometimes unexpected intermediate colours may result.

Any two of the colours in such a scale will harmonize, a useful fact to consider when trying to decide whether one colour will 'go with' another. Occasionally a mixture of two colours will produce a new colour which is darker than either of the colours used in the mixture, especially when mixing complementaries where often a neutralization point is reached, giving not only great loss of colour but also loss of tone as compared with the tones of the two parent colours. For example the gradual addition of ultramarine to a chrome yellow will result, at a certain point, in a dark bluish grey which, incredibly, is darker than the ultramarine.

Trio

The three additive primaries, red, green and blue, all lightened by the addition of white, are combined with four gradations of grey in *Trio*.

Look at the painting from varying distances. The colours will appear to change at different viewing distances, due to optical mixing. The changes coincide closely with the colours produced when different coloured lights mix to produce a single coloured beam: yellow appears where red and green are adjacent; magenta (bluish red) appears where red and blue are adjacent and cyan (greenish blue) appears where green and blue are adjacent.

Trio illustrates four of the many ways in which four colours can be placed next to each other to produce different visual effects.

The greys may also take on colour in *Trio* by association with the neighbouring red, blue or green.

Happy Family

A group of closely related colours from the yellow to orange region of the spectrum, *below left*, is seen in a quietly harmonious arrangement in *Happy Family*, *right*. The four compositions beneath it show how the addition of small amounts of distantly related, strongly contrasting colours can enliven the effect—a device often employed in various kinds of surface design. It is easier to change just one colour to alter the appearance of a design than to change all the colours; small changes can make big differences in the appearance of colour schemes.

Look at the paintings from different viewing distances. Despite their small areas, the contrasting colours, *below right*, change the overall colour of these yellow and orange stripes—the result of optical mixing.

Happy Family

Exploring Contrasts

Different hues in contrasting tones make an unusual colour composition. The painting, *top*, contains four hues at full strength. They vary naturally in tone: the orange is bright, contrasting with the darker green and blue; the purple is darkest. After staring at the painting for about 30 seconds, the greens in the centre bands on either side of the orange look lighter—or yellower—than the outer bands of green, which have a bluish tinge.

The colour and tone contrasts of this scheme may seem crude and raw, and of less practical use, than that of the painting, *bottom*, in which the colour contrasts have been reduced by bringing the colours much closer together in tone. This unification of hue and tone has been achieved largely by adding grey to the original colours in the scheme above. Grey has the effect of reconciling violently contrasting colours, making them more acceptable to those who prefer quiet colourings.

Again, after prolonged observation, the greens surrounding the central yellow band may appear lighter and yellower than the green in the outer bands.

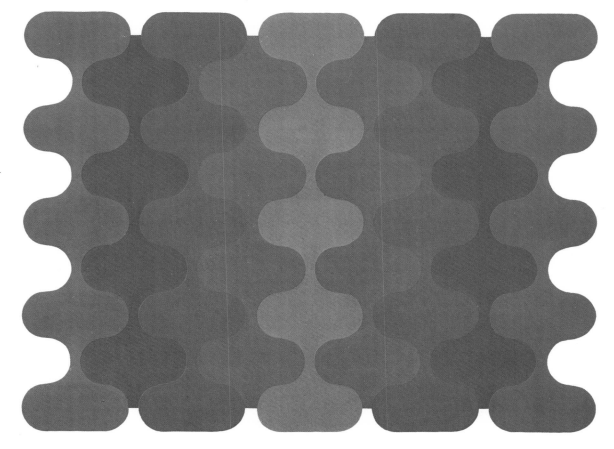

Each composition contains only four hues, although there may appear to be five in both. The colours in the top illustration are reproduced *below left*, and those in the bottom illustration, *below right*.

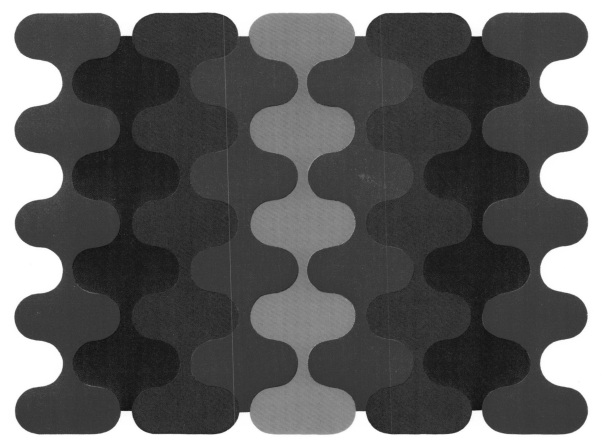

233

Discords

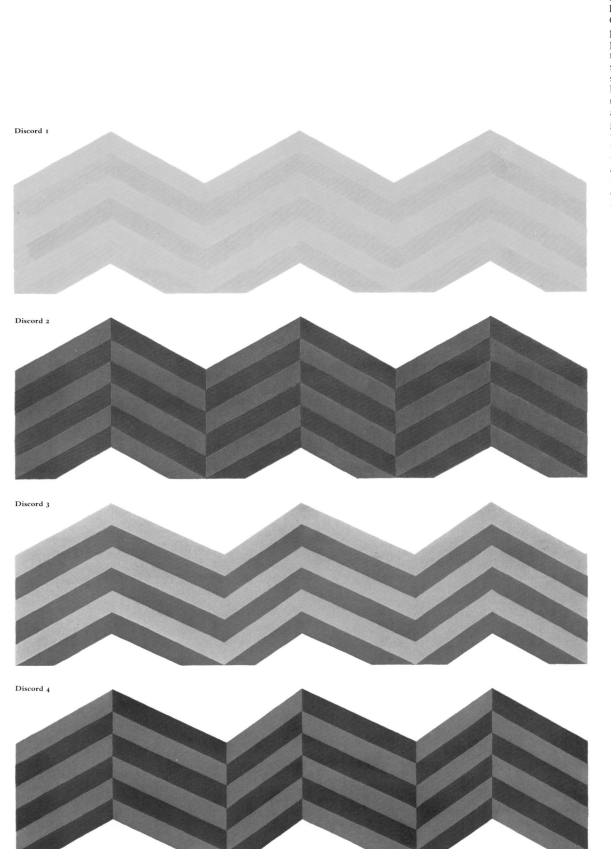

Discord 1

Discord 2

Discord 3

Discord 4

Colour combinations, like musical chords, can be discordant. During the nineteenth century, Ogden Rood, an American physicist and colour theorist, proposed that colours fall into a natural order, just as musical notes seem to fall naturally into ordered scales. In colour scales, Rood believed, yellow is the lightest tone, orange is darker, red follows and the scale descends through green, bluish green and blue to violet, the darkest tone. Purples vary in tone between red and violet. If a colour is lightened or darkened so as to be out of its natural order of tone, then used in combination with unmodified colours, the resulting scheme will be discordant.

This idea still persists, and although colour combinations that would have been unacceptable 50 years ago (blue and green for example, black and brown or even orange and magenta) are generally acceptable today, some people still find them unpleasant.

Yet discords *can* be pleasant, even exciting. Those illustrated occur in nature: garden flowers such as pyrethrums have pink petals with yellow centres, yet the pink in *Discord 1* is lighter than it should 'naturally' be. Country dwellers live with brown earth and blue sky, yet the brown is 'unnaturally' darker than the blue in *Discord 2*. Michaelmas daisies often have pale violet flowers and dark green leaves, but the violet in *Discord 3* is lighter than it should be, according to theory. Limestone can be the dark shade combined 'unnaturally' with magenta streaks, as in *Discord 4*.

For centuries the Japanese have used the colour combinations of nature in design: objectively there is no such thing as a 'bad' colour scheme. Taste is a matter of personal preference.

Perm 4

There are hundreds of different ways of permutating the four different colours, *below. Perm 4* shows 12, each making a different colour statement.

In this painting the colours are taken in pairs: green inside orange, green inside violet, green inside blue, and so on. Each permutation explores the different effect created by one colour influencing another optically. In other permutations these colours could be used concentrically in threes; in threes, with one colour repeated; in fours, with or without colours repeating, and so on, providing great variety of overall appearance and individual colour appearance. In the many different possible permutations, only the colours would remain the same: the visual effect would change each time.

Complementary contrasts

Every colour has an opposite, or complementary, colour. Together, the two hues have strange properties: two lights of complementary colours—blue and yellow for example—if mixed together will produce white light. Similarly, the yellow and blue pigments in the illustration, *left*, together reflect the three additive primaries of light. The yellow pigment reflects yellow and red wavelengths of light; the blue pigment reflects mostly blue wavelengths. In terms of combined reflected light, then, these two colours reflect the full *complement* of spectral hues.

The same applies to the other pairs of complementary colours illustrated: the red, *top right*, reflects a third of the spectrum; the bluish-green, the rest. Each is complementary to the other.

In the green and purple design the green reflects the middle third of the spectrum and the purple has two outer zones: red and blue.

Orange and turquoise divide the spectrum down the centre. Viewed through a spectroscope, with a polarizing filter to cut surface reflections, the oranges seem to reflect all the red zone and (surprisingly) about half of the green. The turquoise reflects all the blue zone and the other half of the green zone.

The violet, *bottom*, reflects all the blue and about half the red, leaving the yellowish green to reflect all the green zone and the rest of the red; hence the yellowish appearance of the green.

Complementary colours, when adjacent, excite each other to the maximum vividness; they make the strongest possible colour contrasts.

To find the complementary of any colour, take a small square of it, mark a point in black in the centre and then put it on to a black background. Stare fixedly at the centre point for about 30 seconds, then look at a sheet of white paper. An after-image of the complementary colour will appear.

Zing

A small area of highly saturated colour is introduced into a large area of quiet, greyish colouring, in *Zing*. Again, this painting uses the greatest contrast possible: the contrast of complementary colours. A similar effect could be created by using a highly saturated yellow with a greyish violet, a vivid orange with a quiet blue, and so on. The four colours, *below right*, will also 'zing' against a background of cobalt blue or grey, though less forcefully. 'Zing' effects can be used to give a note of visual excitement.

Zinging colours provide visual shocks, usually pleasant because the 'zing' areas are small and not overwhelming. The principle can be applied in all fields—interior design, dress, textile design, advertising and packaging, record sleeve and book design, cinema, theatre and television.

Fret

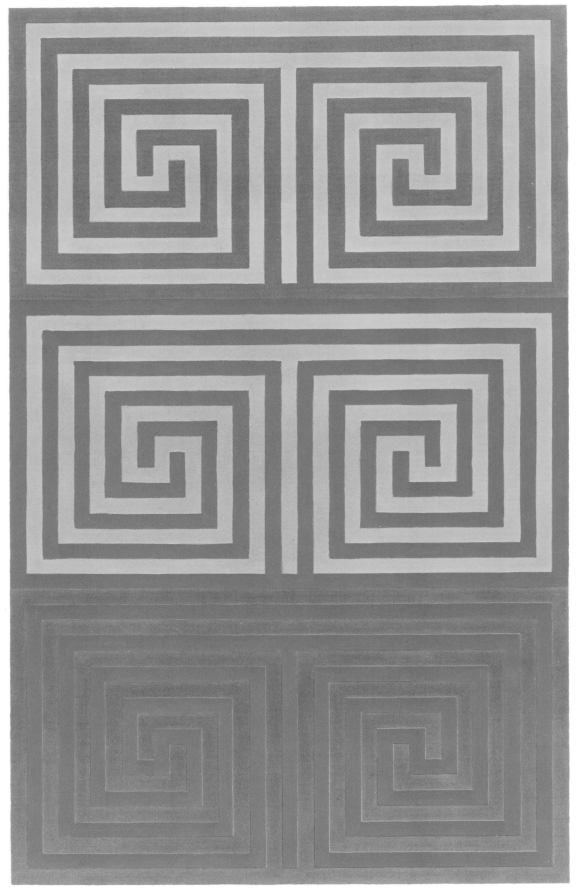

When colours are side by side they appear to change hue, an optical illusion which is explored in *Fret*. Viewed from a distance of no less than eight ft, the design appears to contain six colours; from normal viewing distance it is clear that *Fret* contains only the three colours reproduced, *below*, juxtaposed in a different way in each of the three linear formations.

These three colours are closely related to the spectral hues to which the eye is most sensitive: yellowish orange is close to red, bluish green is close to green and violet is close to blue. When seen from the appropriate distance, the wavelengths of light reflected from each colour are mixed together by the colour receptor cells in the eye and brain. As a result, the yellowish orange looks redder when juxtaposed against violet, but yellower when next to green; the green looks yellower and warmer by the side of yellow, but bluer or colder when it is placed beside violet. The violet looks bluer next to green and redder beside yellowish orange.

This is the effect known as simultaneous contrast, discovered by the French chemist, M.E. Chevreul.

Grid

Gaze at the painting on this page for about 30 seconds, keeping the book close to the eyes. Concentrate on the green. As the receptor cells in the eye become adapted to the colour they respond less and less and the green seems to become greyer.

Focus on the grid inside the parallelogram. It should look purple. Then look at the grid lines that extend beyond the green. The whole grid is painted in that same grey tone. Grey is simply a darkened white, reflecting the whole spectrum, but less strongly than white. As the eye adapts to the green, the grey grid is seen as purple—the complementary of green. Effects of this kind are directly related to the after-image phenomenon.

Jazz

Colour when juxtaposed against the black and greys *right,* will change. In this painting the grey in the central square looks neutral when surrounded by black and white; when placed next to blue, however, it looks brown. This is another adaptation effect, as in 'Grid'. Grey placed beside blue takes on the hue of the complementary of blue—yellow—and looks brown. If another hue were substituted for blue, the grey would similarly appear to be tinged with the complementary of whatever colour was used.

Sphere

Luminous effects can be produced by using discrete gradations of tone from white to black. In *Sphere*, the greys darken or lighten successively to create perspective effects, and to accentuate the perspective suggested by the spiral shapes. Shades of grey or black closely juxtaposed look darker around the edges and this enhances the perspective effects of both sphere and spirals. To understand this, isolate a single square by surrounding it with pieces of white paper. It will be apparent that the grey is uniform across the whole area of the square. When the papers are removed the edges again appear darker. This is known as the Mach effect. The white appears to shine by contrast with the increasing darkness of the greys surrounding it.

Gazing intently at the sphere for 30 seconds or more sometimes produces an optical effect: flickering illusions of colour may appear around the periphery.

There are as many greys as there are colours. A full scale of gradations from white to black would be impossible to print, and although the difference between 1% grey to 2% grey could be measured by a spectrophotometer, only a trained eye would be able to distinguish between the two. The six tones reproduced in the scale, *below*, were used to produce the luminous effects in *Sphere*.

This gradual scale of greys shows the Mach effect even more strongly than in the painting, giving a fluted appearance to the bands of grey.

Glossary of terms

A

Achromatic colours
Black, white and the greys—the colours devoid of hue.

Adaptation
The eye's tendency to reduce differences in the changing brightness and colour of a scene. On entering a dark room, the pupils of the eyes dilate to admit more light. The cones in the retina become active in a change to bright light; the rods in a change to dim light. Colour adaptation enables us to make accurate colour judgements in vastly different lighting conditions.

Additive colour mixing
When light beams of different colours are projected on to a white area, the light reflected is a mixture whose colour derives from the adding together of the colours of the beams. Red, green and blue lights, projected at equal intensities, add together to produce 'white' light; but red and green lights mix additively to produce yellow. By mixing the additive primaries, red, green and blue, in varying proportions, a wide range of colours can be produced. The resulting colour is always brighter than that of any of the contributory colours, due to the addition of three light beams.

Additive primaries
A set of colours that can be combined to form a wide range of colours by additive colour mixture, but not capable of being produced from each other. Only three are needed to match any hue: although there is some latitude in their choice, red, green and blue produce the widest range of colours.

After-image
A colour patch that seems to float in front of the eyes when they are stimulated for a period of time by a colour that strongly differs from that of its background. After-images arise when the cones in the retina become adapted to a particular colour; if the colour is replaced by a white surface the eye fails to respond to it fully, seeing white minus the colour to which it is adapted—that is, the complementary colour of the stimulus. A green patch will appear if the eye is adapted to red, and vice versa. After-images remain visible when the eyes are closed.

Amplitude
The intensity of a wave; in the case of a wave in a material medium, the range of oscillation (the height of the crests of an ocean wave, for example); in an electromagnetic wave, the intensity of the varying electric and magnetic fields constituting the wave.

Anomalous trichromatism
A colour vision defect in which sufferers try to match a colour sample using three primary colours in abnormal mixtures. There are three kinds of anomalous trichromatism: (1) protanomalous vision: a reduced sensitivity to red, and some confusion between red and green; colours are matched with abnormal amounts of red; (2) Deuteranomalous vision: characterized by some red-green confusion and a reduced sensitivity to green. Matches are made with abnormal amounts of green; (3) tritanomalous vision: a reduced sensitivity to blue, with all matches made with abnormal amounts of blue.

B

Brightness
An ambiguous term, meaning the intensity of a light source or a luminous sensation when describing light, 'highly saturated' when describing colour. Sometimes used as a synonym for lightness. To the physicist, essentially the amount of light an area sends out per second from each unit of area at right angles to the line of sight.

C

Chroma
In the Munsell System, chroma is the degree of saturation of a surface colour.

Chromaticity
The colour quality of a visual stimulus—that is, the proportions of any two of the three primary stimuli needed to match it. For example, the chromaticity of a coloured light would be totally specified by saying it could be matched by a light mixture containing 40 per cent of a specified red primary and 35 per cent of a specified blue (there would be no need to specify the proportion of the third, green, primary—it has to be 25 per cent). Thus the chromaticity makes no reference to the brightness of the light. Chromaticity corresponds to the hue and saturation of the colour perceived by a standard observer under standard conditions of illumination.

Chromaticity chart
A chart in which colours are plotted according to their chromaticity (ignoring their brightness or lightness). The colours are plotted within an area whose boundary represents the most saturated colours (the spectral hues plus the saturated purples) which shade through the unsaturated colours into white near the centre.

Colorimeter
A device for specifying a colour by matching it with a known stimulus that can itself be specified quantitatively. Colorimeters are of several kinds: (1) In additive colorimeters, the coloured surface or light to be measured is compared with a mixture of radiations of various fixed colours. Three or more primary colours are used for the match; the mixture being varied until a match is achieved. (2) In subtractive colorimeters, 'white' light of variable intensity is shone through combinations of coloured glass slides, the intensity of the light being adjusted until a match is achieved. The slides are coloured magenta (green-absorbing), cyan (red-absorbing) or yellow (blue-absorbing), with a density ranging from very pale to very deep. (3) Photoelectric colorimeters automatically analyze the light whose colour is to be measured in terms of its intensity at each wavelength.

Colorimeters using human observers (that is, all but the photoelectric type) may differ according to whether they present the observer with a small field of $2°$ diameter), in which the response of the fovea in the retina is important, or a larger field (usually $10°$ in diameter); colour matches differ according to the size of the field used.

Colour
The attribute of a visual sensation or, by extension, an object or a light that can be described by such terms as red, green, white, black and so on. In a narrower sense (not used in this book) black, white and grey are excluded from the colours. The colour perceived as belonging to an area depends on the composition of the light reflected from it, the surrounding visual field and the state of the observer—his expectations, state of adaptation, and so on.

The qualities of colour include flicker, glitter, sheen and other variations in surface appearance but ignoring these, perceived colour has three basic dimensions; or defining attributes: hue, saturation and lightness or darkness. Hue corresponds to the dominant wavelength of a colour; saturation to its relative colourfulness (colours can be pale or bright) and lightness to the amount of grey in it.

Colour defect
Erroneously termed 'colour blindness'. The reduced ability to discriminate between colours. This reveals itself when a subject matches a test colour with an abnormal mixture of lights of the primary colours. Colour defects fall into three classes. (1) Anamolous trichromatism, in which three primary colours are needed to match all colours, but are combined in abnormal proportions. (2) Dichromatism, in which all matches are made with only two primaries, suggesting that essentially only two kinds of colour receptor are functioning. (3) Monochromatism, in which any colour is matched by varying the brightness of a single primary.

Colourfulness
A term coined by the C.I.E. (Commission Internationale de l'Eclairage) as a synonym for 'saturation' or 'intensity' as descriptive of colour.

Colour solid
An imaginary systematic arrangement of colours in three dimensions. In such arrangements, white and black are invariably placed at the top and bottom respectively of a vertical axis; each colour is placed at a height corresponding to its lightness (assuming the solid is composed of surface colours), at a distance from the vertical axis corresponding to its saturation and in a direction from the axis (north, south-east, etc.) depending on its hue.

Colour temperature
A specification of the proportions of light of various wavelengths present in a given sample of light. It thus describes the overall colour of the light and is not necessarily related to the temperature of the light source. Thus, to say that a fluorescent lamp has a colour temperature of $4,500°K$ (K=Kelvins, a scientific unit of temperature) means that it gives out a whitish light resembling that emitted by a (theoretical) white-hot body at $4,500°K$; but the gas in the tube is not actually at that temperature. Blue skylight has a colour temperature of $25,000°K$—matching the colour of the light given out by a blue-hot body (some stars are this hot). Again, there is nothing in the atmosphere at this temperature. On the other hand, the colour temperature of a 100-watt electric light bulb is $2,860°K$—virtually the actual temperature of the bulb's glowing tungsten filament. The hotter a body is, the greater the proportion of short-wavelength blue light it emits, hence the higher the colour temperature, the bluer the light.

Complementary colours
Pairs of colours which, when mixed together in the form of light beams, produce 'white' light; for example, blue light and yellow light of the right intensities will add to give 'white' light. Traditionally, pairs of colours were felt to be 'opposite'; blue and yellow were always regarded as opposites before it was demonstrated that they are, in fact, complementary in additive mixture. Red and green have also been regarded as complementaries (since red cannot be perceived as containing any trace of green, nor vice versa); but, if red and green lights of roughly equal brightness are combined, they give a yellow result and so are not truly complementary.

D

Dichroism
(1) The property of certain coloured materials or liquids to differ in colour according to thickness, or (in the case of liquids) to the concentration of the colouring material. (2) The property of certain crystalline materials to appear different colours when viewed from different directions. (3) The property of certain thin films to transmit some colours and reflect others.

Dichromatism
A colour defect in which the subject will match any colour by mixing only two suitably chosen primary colours in varying proportions; people with normal colour vision require three primaries, since they can distinguish colours the dichromat confuses.

Dichromatism falls into three main classes: (1) Protanopia: 'red blindness', in which the subject is less sensitive than the normal person to long-wavelength light—red, orange and yellow—and will confuse these colours with the greens. Thus, he will match a green with a blue, for example. (2) Deuteranopia: 'green-blindness' in which the subject confuses green with red, and matches all colours with yellow and blue light. (3) Tritanopia: 'blue-blindness'; the subject matches all colours with red and green light.

Diffraction
The spreading of a wave, especially light, when it meets an obstacle, or passes through an aperture. It becomes significant on the small scale; thus, when a beam of light passes through a slit no wider than the width of a few of its wavelengths, it 'spreads' around the edges of the split and is dispersed into the colours of the spectrum.

Diffraction grating
An optical device comprising a flat surface ruled with a system of closely spaced parallel lines. When a beam of light strikes the grating, transmitted or reflected waves spread outward from each line, owing to diffraction (rather like ocean waves spreading out after passing through gaps in a breakwater). Interference takes place among these spreading waves, and the result is that the original light is broken into rays of its component colours, diverging at different angles from the grating. The result is a spectrum.

Dispersion
The separation of light into colours by refraction or diffraction; more generally, the separation of any type of radiation into its component wavelengths.

Dye
A soluble colouring material. When a dye is applied to a material from solution it penetrates and combines with the substrate (such as a fabric). It always reduces the lightness of the substrate and so a fabric cannot be dyed to a paler shade.

E

Electromagnetic spectrum
The entire range of electromagnetic waves, from the very short gamma rays found in cosmic radiation, through ultraviolet light, visible light and infrared light, to radar and radio waves.

Electromagnetic wave
A wave consisting of cyclic variations in the intensity of electric and magnetic fields, travelling from a source. Light and radio waves are examples.

F

Film colour
A perceived colour occupying an area that has no definite localization in depth or distance from the observer, and which therefore is not seen as belonging to a surface; an example is a homogeneous area of colour viewed through a hole in a black screen. It exhibits saturation but not lightness.

Fluorescence
The emission of light following the absorption of light of shorter wavelengths. Thus, fluorescent paints absorb the invisible ultraviolet radiation present in sunlight and emit some of the energy as coloured light. Added to the light reflected by the paint in the usual way, fluorescence gives an extra brightness.

Fluorescent lamp
A lamp incorporating a glass tube coated on the inside with a powder that emits visible light on absorbing ultraviolet radiation generated by an electrical discharge inside the tube.

Fovea
A small depression in the retina that lacks rod but is rich in red- and green-sensitive cones; the acuteness of vision is greatest there.

Frequency
The number of times in a second that a periodic phenomenon repeats itself. The unit of frequency is the hertz (Hz), which is equal to one cycle per second. Electromagnetic radiation consists of rapidly varying electric and magnetic fields; in the case of light, the frequency is of the order of 500 terahertz (500,000,000,000,000 Hz). Since the frequency equals the number of waves passing a point each second, the speed of any wave phenomenon equals its wavelength multiplied by its frequency.

G

Grey
An achromatic colour, intermediate in lightness between black and white. A grey surface partially absorbs some or all visible light wavelengths, but the light it reflects or transmits has the same chromaticity (hue and saturation) as the illuminant. Thus a surface that is grey under one illuminant may be coloured under a different illuminant (or even the same illuminant at a different intensity).

H

Hering Theory
A theory of colour vision proposed during the nineteenth century by the German physiologist and psychologist, Ewald Hering. Hering regarded yellow and blue, red and green and black and white as pairs of 'opponent' colours; one member of each pair is perceived when a corresponding visual pigment in the retina is broken down by light, while the other is perceived as it recombines. This would account for the fact that there are no colours that we would describe as 'yellowish blue' or 'reddish green' (although people with colour vision defects sometimes describe such colours). The theory has been discarded as an account of the working of the retinal cones, but the transmission of colour signals to the brain is thought to be conducted according to the opponent process theory formulated by Hering.

Hue
The attribute of a colour by which it is distinguished from another. All colours are judged to be similar to one, or a proportion of two, of the spectral hues: red, orange, yellow, green, blue and purple. Thus crimson, vermilion and pink, though different colours, are close in hue. Black, white and grey lack hue. Together with lightness and saturation, hue is one of the three basic colour terms. Physically, hue is determined by wavelength.

I

Infrared radiation
A form of electromagnetic radiation that is continuous with the red end of the visible spectrum but lies beyond it and is of longer wavelength. It is strongly emitted by hot bodies and has a heating effect when it falls on matter.

Intensity
The measurable brightness of a light source. A synonym for saturation.

Interference
The interaction of wave motions, with the result that certain wavelengths among them are intensified and others weakened. If two sets of ocean waves of identical wavelength overlap, they will reinforce each other if their peaks coincide, but cancel each other if the peak of one coincides with the trough of the other. Light acts in an analogous way whenever a ray is split into two rays that can interfere with each other. Thus when light strikes an oil film on water, some will be reflected from the upper, and some from the lower, surface of the film. The two sets of reflected rays can interfere; at a given place, light reflected in a given direction will be weakened at some wavelengths and strengthened at others. Thus interference colours depend on the geometry of the bodies that are forming them.

Iridescence
The play of colours with change of position—seen in soap bubbles, certain butterflies' wings and so on; due usually to interference of light, but also to refraction and diffraction.

L

Laser
A device that can produce brief but intense bursts of light in parallel beams; the light is monochromatic and coherent; that is, its waves are 'in step', unlike those of ordinary light.

Light
Electromagnetic radiation capable of stimulating the eye to produce visual sensations. Light forms an intermediate band within the electromagnetic spectrum ranging from violet light, with a wavelength of about 400 nanometres (nm), or 0.4 millionths of a metre, to red light with a wavelength of about 700 nanometres. The eye is maximally sensitive, in light of daylight brightness, to yellowish green light.

Lightness
The amount of grey in a colour—its lightness value as compared with black, or its darkest value as compared with white.

Lightness is also the attribute of a visual sensation by which an area is judged to transmit or reflect diffusely a greater or smaller proportion of the light falling on it. Thus, although the brightness of a powder-blue sweater may decrease greatly when its wearer walks from sunshine into shadow, it will still look light blue (since an observer judges it with respect to its surroundings, which are also less bright in the shadow) so the lightness has remained unchanged. Our recognition of objects in widely changing lighting largely depends on the near-constancy of lightness.

Light-scattering
The reflection of light in all directions by fine particles suspended in a transparent medium. The wave length of the reflected light approximates the diameter of the particles. Most commonly the colour is blue, though violet and green may also be reflected. Often referred to as Tyndall scattering, after the scientist who discovered it.

Local colour
A term used by artists to describe the 'true' colour of an object seen in average daylight from near by, so that its colour is not affected by, for example, atmospheric absorption of the longer wavelengths of incident light, which makes distant mountains look blue, although their local colour may be grey.

Luminescence
Emission of light that is not directly due to incandescence. It takes place at low temperatures and can be due to electrical or chemical processes, when it is known as chemi-luminescence. It includes fluorescence and phosphorescence.

Luminous intensity
The property of a light source that determines the amount of light radiated in a given direction per second. It is measured in candelas. A source of a given luminous intensity will appear to have less brightness the greater the distance from which it is viewed.

M
Metameric pair
Two surfaces or other light sources that look the same colour to a standard observer, but the light mixtures they send to the observer's eye have different wavelength compositions. If the illuminant is changed, a metameric pair will usually appear different colours. The most familiar example is a pair of fabrics that look the same under fluorescent store light (because the mixture of wavelengths in their reflected light stimulates the eye to give the same response) but do not match in daylight (because the compositions of the light reflected from the dyes in the two samples have shifted and now stimulate the eye in different ways). The term is also applied to the lights themselves rather than their sources; thus the test light and the matching mixture of primary colours used to match it in a colorimeter are described as metameric pairs.

Monochromatic light
Light having a very narrow range of wavelengths so that it shows one of the vivid colours seen in the spectrum.

Monochromatism
A very rare colour defect in which hue cannot be distinguished at all; only variations in brightness are perceived and only one primary coloured light is required to match any sample colour.

Munsell System
An arrangement of surface colours in a colour solid. *The Munsell Book of Color* contains several hundred colour samples or chips printed in highly stable inks. There are 40 pages, each containing samples of a given hue; the rows consist of samples of equal value or lightness judged on a scale of ten subjectively equidistant steps from black to white. Within each row the samples are placed according to their chroma, the Munsell term for saturation, again in subjectively equal spacings. The system, devised in its original form by A.H. Munsell in 1915, is easily extended as improved colouring materials appear; but there are theoretical limits to the boundaries of the colour solid it forms, determined by human colour vision.

N
Nanometre (nm)
One thousand-millionth of a metre.

Newton's Rings
Colour effects that can arise when a thin film of air or other transparent medium is enclosed by the surfaces of transparent bodies. They are frequently seen as systems of narrow coloured bands where the protective glass does not make close contact with the surface of a colour slide. They are due to the interference of light reflected from one side of the air film with that reflected from the other. Different colours in the light are reinforced or cancelled out according to the angle of view.

O
Optical mixture
The combining of differently coloured lights by the eye to produce a new colour. The apparent blending of the colours on a multicoloured spinning wheel (a kinetic colour fusion disk) is one example of optical mixture; so is the blending of the dots in a coloured photograph to give the impression of a continuous range of colours.

Ostwald System
A system of arranging colours in a colour solid. In the Ostwald colour atlas colours of a given hue are arranged in an equilateral triangle lying in a vertical plane. The best white obtainable lies in the top angle; the best black obtainable at the bottom and the most saturated form of that hue in the third angle. All other colours are positioned according to the amount of white, black and colour they contain—usually as judged by matching in a colorimeter. Thus a vertical series of colours will form a series of isochromes, or colours of equal colour content. The colour solid is imagined as being formed by rotating the triangle about the vertical axis, sweeping through the different hues. The greys, lying on the vertical axis, form a series of zero colour content. The system is limited by the available full colours. Many existing and possible surface colours lie outside the constant-hue triangles making up the atlas.

P
Phosphorescence
Fluorescence that persists for an appreciable time after the stimulating radiation has ceased.

Photon
A quantum or 'packet' of light energy. Light behaves under certain circumstances as if made up of these invisible packets of energy. The amount of energy that a photon represents increases with the frequency of the light: quanta of violet light have about twice the energy of quanta of red light.

Pigment
An insoluble colouring material, requiring to be applied to a surface in conjunction with a binding material. Pigments coat the colour of the underlying surface rather than combining with it.

Primary colour
One of a set of colours that can be combined in a colour mixing process to produce a wide range of colours, but no two will together produce the third. In additive colour mixing, red, green and blue are primary; in subtractive colour mixing, magenta, cyan and yellow are primary.

Psychological primaries are the colours other than black and white that are said to be perceived as basic and quite unmixed with any other (regardless of how they are actually produced). Red, yellow, green and blue are usually proposed as fundamental in this sense while orange and purple, for example, are regarded as psychologically secondary. Thus, orange always contains some red and yellow, while it is possible to have a green that is completely free of yellow and blue.

Prism
Usually a transparent glass or plastic block of triangular cross-section. Light passing through it is spread out into a spectrum. Prisms can also have other cross-sections and can be used as highly reflective mirrors in binoculars and cameras.

Purity
A synonym for saturation.

Purkinje shift
A shift in the relative apparent brightness of objects of different colours as the light level falls. The change is associated with the switch from cone to rod vision, an adaptation to low levels of illumination. This effect is named after the Czech physiologist J.E. Purkinje who in 1825 described the changes in the appearance of colours at twilight.

R
Radiation
Energy that travels from a source in the form of waves or particles. Light is a form of electromagnetic radiation, as are X-rays and radiant heat.

Reflection
The return of light waves from a surface. We see non-luminous objects by the light they reflect; light that is not reflected is either absorbed or transmitted. In diffuse reflection the waves are sent in all directions, regardless of the direction from which they came; a perfectly mat surface reflects diffusely. In specular reflection, each reflected light wave makes the same angle with the surface as the incident light wave; mirrors and mirror-like surfaces reflect specularly. The proportion of light reflected is always less than 100 per cent, and the composition of the light by wavelength is always changed to some extent. Objects look coloured because they reflect certain wavelengths preferentially.

Refraction
The bending of light rays as they pass from one medium to another. In general, when light enters a denser medium from a less dense one—water from air, for instance—it is bent towards the perpendicular to the interface. When it travels the opposite way it is bent away from the perpendicular. Rays of shorter length (toward the blue end of the spectrum) are bent more than those of longer wavelength. This results in suitably shaped transparent bodies, such as prisms, breaking up 'white' light into its component colours to form a spectrum.

Refractive index

The ratio of the speed of light in empty space to its speed in some transparent medium. The higher the refractive index (that is, the more the light is slowed by the medium) the more strongly the light is bent (refracted) on entering or leaving the medium.

Retina

The light-sensitive inner surface of the eye on which images are projected by the lens.

S

Saturation

A term used to describe the strength, or vividness, of a hue—a red, for example, can increase in saturation from a pale pink to a vivid vermilion. The term was originally coined by dyers to describe the strength of a dye. It is used to describe the purity of a colour—the quality which distinguishes it from a greyed colour.

The C.I.E. (Commission Internationale d'Eclairage) distinguishes between colourfulness and saturation, defining the latter as the amount of colourfulness judged to be present in a visual sensation in proportion to its total brightness. So saturation is relative colourfulness. Judgements of saturation remain remarkably constant while overall brightness varies. Thus, suppose a green dress is seen in various conditions of ('white') light and shade: its brightness will vary, and so will its apparent colourfulness, but the saturation will remain constant.

The less white a pigment colour contains, the more saturated it is—a pure ultramarine paint can be desaturated to sky blue, for example, by adding white.

Colourfulness, intensity and purity are terms synonymous with saturation.

Secondary colour

A colour obtained by mixing two or more primary colours—however, the term is largely obsolete.

Selective absorption

The unequal absorption by a coloured surface of different wavelengths of light. The wavelengths it reflects to the eye give the surface its colour. Thus an object that absorbs green and yellow wavelengths will reflect blue and red, and so look purple.

Shade

In common usage, a colour differing slightly from a specified hue or colour ('a shade of blue' or 'a greyish green shade').

In industry the term is used synonymously with 'lightness'—a colour obtained by mixing a pure colour with grey or black.

Simultaneous contrast

Contrast between areas of different colours that are simultaneously present in the visual field. It can have striking effects on the judgement of colours, as when a grey object looks dark against a light background, yet dark against a light background—or seems to be tinged with the complementary colour of the background. Simultaneous contrast is an optical effect.

Spectral colours

The colours that appear in the spectrum of sunlight, ranging from red through orange, yellow, green and blue to violet. They are perfectly saturated and over most of the spectrum are vivid; they do not contain browns, pinks, purples or greys.

Spectroscope

A device that splits light into its component wavelengths. It is used to gain information about light sources. If it is equipped to make measurements on the spectrum produced, it is called a spectrometer; if it records the spectrum photographically or as a graph, it is called a spectrograph.

Spectrum

The coloured image formed when light is spread out according to its wavelength by being passed through a prism or diffraction grating. By extension, the result of analyzing any sample of electromagnetic radiation according to its wavelength. The relative intensities of the colours in the spectrum of light from, say, a tungsten lamp are different from those in the spectrum of sunlight.

Structural colour

Colour that is not due to the presence of some pigment or other colouring material, but solely to the action of light upon the geometry of a transparent medium. Examples are the iridescent colours of an oil film or of the thin scales on a butterfly's wings, which change with the angle of view.

Subtractive colour mixing

The production of colours by mixing dyes or pigments, or superimposing transparent coloured filters; the resultant colour is the result of the simultaneous or successive subtraction of various colours from the light passing through the combination. Yellow, cyan and magenta printing inks, for example, together absorb almost all the wavelengths of incident light, and when superimposed one on top of another, look brownish black: the yellow absorbs blue and some violet light; the cyan absorbs red and some orange light and the magenta absorbs green and some yellow light.

Surface colour

Colour belonging to (or perceived as belonging to) a surface that sends (or appears to send) light to the eye by diffuse reflection. The perception of surface colours is strongly influenced by their context, and by judgements concerning their conditions of illumination.

T

Tertiary colour

A painter's term, now almost obsolete, for colours formed by mixing two secondary colours. They include russet and olive.

Tint

A colour or pigment containing a large amount of white. In common usage, a colour appearing to weakly modify another ('grey with a green tint'). Loosely, any shade of a colour.

Tone

A colour differing slightly in any way from a specified colour ('a tone of blue'). A colour that appreciably modifies another ('blue with a greenish tone'). In printing, a slight variation from a specified hue. In art, the dominant colour of a painting in which the colours are drawn from a limited range. A synonym for lightness.

Trichromatism

Types of colour vision in which any colour can be matched by an appropriate mixture of three primary colours. Normal vision is trichromatic, while anomalous trichromatism comprises several types of colour defect.

U

Ultraviolet radiation

A form of electromagnetic radiation continuous with the violet end of the visible spectrum, but lying beyond it and of shorter wavelength. Some ultraviolet light is present in sunlight and can affect photographic film and cause sunburn. It is responsible for the brightness of fluorescent paints and the fluorescent 'whiter than white' additives of washing powders.

V

Value

A synonym for lightness. The estimated lightness of a surface colour, as expressed numerically in the Munsell System. A series of greys is imagined to run along a vertical axis with a perfect black (value 0) at the bottom and a perfect white (value 1) at the top. The greys lighten—or increase in value—in steps that are subjectively equal. Colours of the same lightness as a given grey are assigned the same value and arranged on the same horizontal level.

W

Wave

A cyclically varying disturbance in which energy is transferred through some medium (as in the case of an ocean wave or a sound wave) or through space (as in the case of an electromagnetic wave).

Wavelength

The distance over which a periodic wave phenomenon repeats itself. In the case of waves in water, this is the distance from one peak to the next (or from one trough to the next). Electromagnetic radiations consist of oscillating electric and magnetic fields, and wavelength is the distance from one peak of, say, the electric field to the next. The wavelength of light determines its hue.

'White' light

A mixture of all visible wavelengths of light in the same proportions as they are found in sunlight.

Y

Young-Helmholtz Theory

The theory proposed by Thomas Young in the early nineteenth century, elaborated by H.L.F. von Helmholtz, that our judgements of colour are based on the functioning of only three kinds of receptors in the eye. The theory rested on the experimental fact that vision is trichromatic—that a light of any colour can be matched by a mixture of lights of three suitably chosen primary colours. They suggested that the three types of receptor have their peak sensitivities in the red, green and blue parts of the spectrum respectively. No one receptor provides any colour information by itself: a given signal from the receptor that is maximally sensitive to red could represent a weak red light, or a very strong green light, or any number of other possibilities. But the combined information from the three kinds of receptor in each part of the retina can be combined to yield a judgement of colour. It is now accepted that the cone cells are receptors of just this type.

Index

Where the entries in this index have several page numbers, the most important have been indicated in bold type. Illustrations are indicated by page numbers in italics.

A

Absorption: 20; 22–23; 30; 95
 selective absorption: **20–21**; *20*; *21*; *22–23*; *24*; 32
Achromatic colours: 140; 176; **178–185**; *179*; 221; 242
Acid: 24; 60; 61
Adam, Robert: 82; 83
Adaptation: 32; 40; 43; 142; 239; *239*; 240; *240*; 242
Additive colour mixing: 10; **13**; *13*; 15; 16; 18; 21; *21*; 22; 36; 43; 48; 93; 100; 102; 105; 228; 231; 242 (*see also* Optical mixing; Subtractive colour mixing)
Additive primaries: 10; **13**; *13*; 21; *21*; 36; 48; 92; 93; 99; 105; 111; 231; 236; 242 (*see also* Subtractive primaries; Primary colours)
Advertising: 98; 104; 132; 168; 169; **170–71**; *170–71*; **172–73**; *172–73*; 178; 194; 196; 200
Africa: 48; 52; 53; 54; 59; 69; 119; 126; 136; 181
 Central: 37; 54; 136
 language: 50
 South: 37
 West: 59
African marigold (*Tagetes erecta*): 142
After-image: **40**; 43; *43*; 84; 144; 211; 236; 239; 242
Afternoon: 151; *151*
Aircraft: 44; 106; 107; *107*; 117; *117*; 123; *123*; 127; *127*; 146
Albers, Josef: 144
Albinos: 190
Alchemy: 44; 48; 63; **78–79**; *79*; 82; 86; 90; 186
Alexander's dark band: **18–19**; *18–19*
Algae: 24; 31
Alhambra Palace: 69; 147; *147*
Alkali: 24; 62; 63; 70; 74; 96
Alschuler, Rose H.: 44
Altamira: 56
Amalienburg: 82
Amber: 65; *65*; light: 38; 126; 152; 154; 169
America, Central: 51; *51*; 61; 69
 North *see* USA
 South: 61
Amethyst: 50; 64; 79; 124; 223; *223*
Amphibians: 28; *28*; 30–31; 200; 206
Amplitude: 13; *13*; 242
Amulet: 63; 64; 65; 79
Anastasis (*Christ in limbo*): 70; *71*
Anatolia: 60; 62
Anglo-Saxon language: 50; peoples: 136
Animals: **24–25**; 26; **28–29**; *28–29*; 30–31; 34; 50; 53; 56–57; 58; 60; 62; 64; 76–77; 78–79; 146; 181; *181*; 185; 190; *190*; 198; *199*; 205; *205*
Animation: 102–103; *102–103*
Anna's humming-bird (*Calypte anna*): 27; *27*
Anomalous trichromacy: 36; 38; 242
Anthocyanins: 20; 21; **24**; 27; 197; 214
Anthropology: 45; 51; **52–53**; **54–55**; 57; 60
Antimony: 62; 63; 97
Apollo 8: 23; *23*
Arabia: 197
Arabs: 185; *185*
Archaeology: 52; 56; 62
Architecture: domestic: 68; 70; 74; 82; 83; 106; **166–167**; *166–167*
 civic: 66; *66*; 67; **68–69**; *68–69*; 70; 74; 75; 82; 86; 87; 119; 123; 128; 150;

164–165; **166–167**; *166–167*; 168–169; 211
Arc lights: 106; 110; *110*; 111
Arctic: 37; 181
Aristotle: 8; 12; 14; 85
Armed services: 36; 38; 76; 78; 115; 116; 117; *117*; 123; *123*; 146; 186; 206; 212; 216
Armenia: 63
Arrow-poison frogs (*Dendrobates* spp.): 28; *28*
Art Deco: 67; *67*; *118*; 119
Art mobilier: 56
Art Nouveau: 114; *114*; 115; 166; 220; *220*
Art, prehistoric: **56–57**; *56–57*
Arts and Crafts Movement: 95; 115
Ash: 52; 58; 60; 61; 74; 96
Ashley, Laura: 126; 128
Asia: 69
Assissi, Church of San Francesco: 146; *146*
Aura: 46; 70; 95; 104; 218
Aurora australis: 22
Aurora borealis: 22
Australia: 37; 52; 136; 199
Austria: 38; 136; 166
Autochrome process: 100; *100*
Automobiles *see* Transport
Autumn: 20; 24; 25; 30; 58; 78; 138; 150; 160; (*see also* Seasons)
Ayers Rock: 199; *198*
Azurite: 64; 70; 81; 212

B

Babylon: 61; 69
Baird, John Logie: 104
Bakst, Leon: 116; 117; 132; 138
Balenciaga: 122
Bali: 48; *48*; 59; 60
Ballets Russes: 115; **116–117**; *116–117*; 132; 138; 176
Baroque: 82
Bathrooms: 120; 161
Batik: 61
Baudelaire, Charles: 86; 87
Bauhaus: 85; 95; 142; 166
Bavaria: 82
Baxter, George: 98
Beads: 53; 62; 63
Beau Brummell: 158
Bedrooms: 161; *161*
Bees (Apidae): 26; 31; *31*; 202
Beetles: 16; *16*; 22; 24; 26; 28; 30; 46; 202; 203; 209
Beige: in fashion: 112; 118; 120; 121; 122; 124; 128; 130; 136; 138; 147; 160
 in interior design: 124
Benham's top: 41
Berlin, Brent: 51
Berries: 24–27; 60
Besant, Annie: 94
Bête noire: 178
Biblical figures: 59; **70–71**; 70; 71; **72–73**; *72*; **74–75**; 75; 77; 85
Bioluminescence: 209; *209*; (*see also* Chemi-luminescence)
Birds: 16; **24–25**; 26–27; 26; 28–29; *28–29*; 30; 31; 32; 53; 56; 73; 76; 79; 146; 178; 181; 189; *189*; 194; 202; 212
Birth: 52–53; 54–55; 58–59
Black: 12; 20; 21; 23; 25; 26; 28; 29; 32; 33; 34; 40; 41; 42; 44; 46; 48; 50; 51; 52–53; 54–55; 56–57; 58–59; 62; 64; 67; 68; 70; 73; 74; 79; 84; 85; 86; 88; 92; 94; 95; 96; 97; 99; 99; 100; 101; 103; 104; 105; 106; 112; 114; 115; 116; 118–119; *118–119*; 120; 122; 124; 125; 126; 127; 128; 130; 131; 136; 137; 144; *144*; 146; 149; *149*; 151; 154; 157; 158; 159; *159*; 161; 165; 166; 167; 168; 169; 170; 170; 171; 173; *173*; **178–185**; *179–185*; 224; 227; *227*; 228; *228*; 229; *229*; 230; *230*; 240; *240*; 241; *241*

Black body: 142; 178
Black hole: 178
'Black' light *see* Ultraviolet
Black Maria: 178
Bleach: 146; 178; 217
Blind, the: 41; 48
Blood: 20; 24; 44; 46; 48; 52; 54; 58; 59; 60; 64; 65; 78; 79; 87; 90; 140; 190; 192; *192*; 211; (*see also* hemoglobin)
 blue blood: 212
Blood pressure: 44; 46; 47
Bloodstones: 46; **65**; 65
Blue: 21; 26; 30; 32; 34; 36; 38; 39; 42; 43; 44; 45; 46; 48; 50; 51; 57; 59; 60; 62; 63; 64; 67; 68; 69; 70; 71; 72; 73; 75; 76; 77; 78; 79; 80; 82; 83; 84; 85; 86; 87; 89; 90; 92; 94; 96; 97; 98; 99; 100; 104; 105; 106; 110; *110*; 111; *111*; 115; 116; 117; 119; 120; 1122; 123; 124; 125; 126; 128; 129; 131; 132; 134; 135; 136; 140; 141; *141*; 142; *142*; 143; *143*; 144; 146; *146*; 147; 148; 150; 151; 156; *156*; 158; 161; *161*; 162; 165; *165*; 166; 167; *167*; 168; 170; 171; 172–173; *172–173*; 174; *174*; 175; *175*; **212–217**; *213–217*; 220; 226; 229; *226*; 229; 231; *231*; 233; *233*; 234; *234*; 235; *235*; 236; 238
 blue light: 16–17; 20; 21; *21*; 22; 23; 31; 32; 36; 40; 41; 43; 44; 75; 100–101; 152–153; 154–155; *155*; 168; 212–217; *213*; 214; *215*
Blues: 78
Bluestocking: 212
Body-painting: 25; 31; **52–53**; *52–53*; **54–55**; *54–55*; 58; 59; 60; 64; 96; 126; 136; 137 (*see also* Cosmetics)
Bolivia: 59
Bond, James (007): 221
Book of Changes, Chinese: 45
Book of Genesis (Vienna O.N.B. Cod. Gr. 31): 72; 197
Book of Hours (Les Tres Riches Heures du Duc de Berry, Chantilly Musée): 73; 73
Books: 72–3; *72–3*; 98
Borneo: 28; 59
Botswana: 44
Böttger: 82
Boucher, François: 82
Boxfish: 204; *204*
Boyle, Robert: 85; 90
Brain: 10; 30–31; 32; **34–35**; *34–35*; 36; 40–41
Brazil: 37; 48; 52; 53; 54; 166; 178
Breuil, Abbé: 56–57
Bricks: 51; 68; 69; 106; 165; *165*
Brigade of Guards, British: 61
Brightness: **13**; *13*; 38; 40; 42; 51; 55; 72; 80; 84; 86; 104; 105; 242
Britain: 34; 36–37; 54; 58; 61; 64; 73; 80; 82; 86; 95; 136; 144; 165; 174; 191; 222
British Colour Council: 112
British Parliament: 190; *190*
Brown: 25; 26; 28; 30; 36; 39; 44; 45; 50; 51; 56; 57; 62; 63; 64; 67; 69; 70; 73; 74; 82; 88; 89; 90; 92; 95; 97; 103; 106; 114; 116; 119; 120; 122; 123; 125; 126; 128; 129; 132; 135; 136; 138; 144; 148; *148–149*; 156; 157; *157*; 161; *161*; 166; 168; 170; 174; *174*; 175; *175*; 226; *226*; 234; *234*; 240; 241; *241*
Bruges: 80
Buddhism: 45; 58; *58*; 68; 200
 Zen Buddhism: 162; 163; *162–163*
Buff: 28; 62; 66; 70; 132
Bugs *see* Beetles; Insects
Bulgaria: 71
Bull's eye moth (*Automeris io*): 28; *28*
Burlington Arcade: 167
Buttercup (*Ranunculus* spp.): 27; 27
Butterflies: **16**; **17**; *17*; 26; 28; 102; *102*
Byzantium: 64; 67; 70; 71; 72; 73; 75; 76; 199; 218

C

Cabbage (*Brassica* spp.): 24; 208; *208*
Cafés *see* Restaurants
Calcite: 56; 62; 199
Camouflage colours: **24–25**; **28–29**; *28–29*; 30; 146; 147; **147**; 181; *181*; 221
Candle-light: 32; 108; 153; *153*
Caravaggio: 112
Carbon: 70; 97
Cardinals: 78
Caribbean: 159
'Carioca' shirts: 159; *159*; 221
Carmine: 89; 96
Carnation, green: 208; *208*
Carotenoid pigments: 10; 20; 21; **24–25**; 28; 30; 190; 197; 208
Carpets: 78; 83; 112; 160
 Persian: 136; 189; *189*
 red carpet: 78; 186
Cars *see* Transport
Cartier: 116
Castles: 68
Cathedrals: 68; 74
 Augsberg: 74
 Beauvais: 75; 75
 Chartres: 74; 75; north 'Rose de France': 75
 Florence: 69
 Paris (Notre Dame): 74 south rose: 223; *223*
 Rome (St. Peter's): 69
 Salisbury: 10
 Wells: 68
 York: 75
Cats (Felidae): 31; 178; 185; *185*; 198; *198*; 205; *205*
Cave-painting: 52; 56–57; *56–57*; 62; 90; 106
Ceilings: 83; 148; 149; *148–149*
Celts: 50; 67; 136
Cennini, Cennino: 70; 211
Ceramics: **62–63**; *62–63*; 66; 69; 82; 83; 119; 120; 121; 197; *197*
Chagall, Marc *My Village and I*: 210; *210*
Chalk: 80; 91; *91*; 97; 181; *181*
Chanel, Coco: 118
Charcoal: 52; 54; 55; 57; 64; 91; *91*
Chemi-luminescence: 22
Chéret, Jules: 98
Chevreul, Michel Eugène: 43; 89; 92; 93; 94; 142; 143; 144; 238
 law of simultaneous contrast: 92
Chiaroscuro: 80; 92
Children: 36; 38; 41; 44; 45; 47; 53; 54; 58; 58; 59; 132; 158; 161; 164; 165; 171; 173; 191; 192
Chimbu: 55; 55
China: 45; 46; 50; 54; 58; 59; 62; 63; 64; 67; 68; 69; 78; 82; 83; 119; 130; 136; 186; 200; 212
Chlorophyll: 10; 21; **24**; 30; 31; 90; 208; 211
Christianity: 54; 58; *58*; 59; 65; 67; 68; 70; 71; 74; 75; 78; 80; 87; 96; 106; 186; 190; 218
Chroma: 134; 242
Chromatic aberration: **14**
Chromaticity: 242
Chromaticity chart: 10; **13**; *13*; 242
Chromo-luminarism: 92
Chromotherapy: 46
Churchill, Sir Winston: 48
Cigarettes: 36; 171; *171*; 173; *173*
Cimabue: 146
Cinnabar: 60; 66; 71; 81; 97; 186
Cities: 23; **168–169**; *168–169*
Clay: 48; 52; 53; 60; **62–63**; 69; 71; 97; 137; 197; *197*; 199
Climate: 56; 61; 80; 87; 136; 150–151; *150–151*
Cloisonné see Enamel
Clouds: **22**; 23; 50
Cobalt: 62; 63; 67; 75; 82; 90; 214; 217
Cochineal (*Dactylopius coccus*): **61**; *61*; 96; 191

Colombia: 16; 28
Colorimeter: 10; 134; 242
Colorimetry: 10; 134–135
Colour: 42; 242
Colour appearance: 152; 153
Colour atlas: 135
Colour awareness: 50; 176
Colour blindness *see* Defective colour vision
Colour circle: 31; 34–35; 42; **85**; *85*; 89; 144; *144*
Colour-coding: 34–35; 36; 38–39; *38–39*; 46–47; *46–47*; 164; 166–167; *167*; 169; *169*
Colour combinations: 38; 40
Colour constancy: 41; *41*; 94
Colour consultants: 132; 161; 164
Colour defects: 242 (*see also* Defective colour vision)
Colour dictionary: 135
Colour filters: 10; 30; 99; *99*; 100–101; 102; 104; 105; 108; 134
Colourfulness: 42; 242 (*see also* Saturation)
Colour harmony: 80; 85; 93; 95; 132; 142; 143; 156; 158; 203; 232; *232*
Color Marketing Group: 112
Colour-matching: 36–39; 134–135; 144; 153
Colour measurement: 10; 134
Colourmen: 90; 106
Colour names: 106; 134–135; *134–135* (*see also* Language)
Colour order systems: 42; *42*; **134–135**; *135* (*see also* Colour circle; Colour solid)
Colour pairs: 43; 84–5; 235; *235*
Colour preferences: 10; 44; 136; 138; 139; 142; 156; 158; 159; 172; 173; 174; 175
Colour rendering: 152; 153
Colour separation: 99; *99*; 105; 220
Colour solid: **42**; *42*; 84; *85*; 242 (*see also* Colour order systems)
Colour temperature: 193; *193*; 242
Colour terms *see* Language
Colour theory: 14–23; 84–85; 92; 93; 94; 95; 134–135; 144; 234
Colour wheel *see* Colour circle
Columbine (*Aquilegia* spp.): 27; *27*
Commission Internationale de l'Eclairage (C.I.E.): 135
Complementary colours: 13; 31; 40; 41; 43; 85; 92; 93; 95; 142; *143*; 162–163; 172; 211; 218; *218*; 236; *236*; 237; *237*; 239; *239*; 240; *240*; 242
Concrete: 166; 178
Cone cells: 30; 31; **32–33**; *33*; 34; *34*; 36; 39; 41
cystalline cones: 31; *31*
Conifers: 211; *211*
Constable, John: 38; 106
Constructivism: 166
Contrast: 24; 27; 30; 40; 41; 70; 72; 73; 80; 85; 93; 94; 95; 142–143; *142–143*; 147; 156; 181; *181*; 233; *233*; 237; *237*; 238; *238* (*see also* Discordant colours)
Cool colours: 44; 47; 95; 139; 140–141; *140–141*; 142; 144; 153; 171; 214
Copepods: 221; *221*
Copper: 46; 60; 62; 63; 64; 67; 68; 69; 74; 75; 79; 97; 106; 211; 214
Cornfields: 101; *101*; 205; *205*
Cosmetics: 61; **96–97**; *96–97*; 104; 112; 114; 116; 119; 120; 123; 124; 125; 126; 128; 130; 136; 146; 149; 153; **156–157**; 176; 182; 185; 221; *221* (*see also* Body-painting)
Cotton (*Gossypium* spp.): 24; 38
Countershading: 181
Courrèges: 126; 127
Coward, Noël: 168
Crahó Indians: 52; *53*
Cream: 26; 106; 119; 121; 126; 128; 129; 134; 160; 224; 229; *229*
Crème Yvette: 222; *222*

Crete: 70
Crimson: 51; 61; 78; 80; 90
Crustacea: 20; 25; 30
Ctenophores (Ctenophora): 16
Cubism: 119
Curtains *see* Hangings
Cuvilliés the elder, François: 82
Cyan: 10; 13; 21; *21*; 40; 90; 99; *99*; 134; 143; 149; 172–173; 231

D
Daisen-in Temple garden: 162; *162*
Dali, Salvador: 94; 120
Dalton, John: 36
da Messina, Antonello: 80
Darkness: 33; 42; 48; 50; 55; 59; 84; 85; 86; 95; 178
darkening paint colours: 227; *227*
Darwin, Charles: 24; 27; 30; 85
da Vinci, Leonardo: 8; 85
Last Supper: 70
Daylight: 10; 20; 32; 40; 41; **150–151**; *150–151*; 152; 153; 192
Dean, James: 112
Death: 48; 52; 53; 54; 58; 59; 64; 79; 178
Defective colour vision: 30; 31; **36–39**; *36–39*; 86
Delacroix, Eugène: 86; 87; 93; 95
Algerian Women: 86
Delaunay, Robert: 94–95
Disk, First Nonobjective Painting: 94
Windows: 94
Delaunay, Sonia: 119
Denim: 53; 88; 216; *216* (*see also* Indigo)
Denmark: 174
Density-slicing: 47; *47*; 100; *100*
Design: 38; 51; 82; 91; 104; 108; 143; 144; 146; 158; 160–161; 164; 165; 214; *214*; 221
Diaghilev, Serge: 96; 132; 176
Dichroic mirrors: 105; *105*; 242
Dichromatism: 36; 39; 243
Diffraction: 10; **16–17**; *17*; 182; 221; 243
diffraction foil: 16
diffraction grating: 16; 17; *17*; 65; 243
Dior, Christian: 112; 124
Discordant colours: 234; *234*
Disney, Walt: 103
Dispersion: **13**; *12–13*; 14: 15; 18; 19; 22; 243
Dominis, Marco Antonio de: 14
Dreams: 44; 78; 94
Dress: 20; 46; 53; 54; 58; 60; 61; 77; 98; 104; **112–131**; *112–131*; 132; 138; 149; **158–159**; *158–159*; 160; 176; 180; 182; 184; *184*; 185; 194; 200; 203; *203*; 216; 218; 220; *220*; 221; *221*; 224
Du Hauron, Louis Ducos: 100
Dyes: 20; 42; 46; 48; 50; 54; **60–61**; *60–61*; 90; 96; 97; 100; 106; 110–111; 112; 115; 122; 124; 125; 126; 127; 128; 131; 136; 153; 171; 176; 178; 185; 186; 194; 197; 198; 208; 216; 217; 221; 243
wool dyes: 189; *189*

E
Earths: 48; 60; 61; 90; 166; 167
earth colours: 62; 70; 71; 78; 80; 90; 93; 97; 136; 137; 138; 166; 167; 171
East: 51; 59; 61; 62; 66; 69; 80; 81; 90; 106; 112; 116–117; 126; 130; 131
Eastman Colour process: 13
Edison, Thomas Alva: 114
Egyptians, ancient: 46; 48; 58; 62–63; 62; 64; 67; 68; 70; 96–97; 97; 106; 185; 187; 188; 206; 211
Electromagnetic spectrum *see* Spectrum, electromagnetic
Electrons: 20; *20*; 196; 215
Elements: 46; 78
Elizabethans: 78; 96; 97; *97*; 167
Emeralds: 64; **65**; *65*; 79

Emotions: 10; 41; 44–45; 46; 48; 58; 59; 78; 86; 92; 132; **138–141**; *138–141*; 158; 164; 165; 202
Enamel: 64; 66–67; 73; 82; 83; 87; 119; 124; 180; 184
English language: 50; 51
Eskimo: 50; 51
Euglena viridis: 30
Europe: 26; 37; 45; 46; 52; 56; 58; 59; 63; 68; 70; 74; 77; 78; 80; 81; 82; 87; 88; 89; 106; 108; 174; 221; 222
Eyebright (*Euphrasia micrantha*): 27; *27*
Eyes: 10; 20; 22; 25; **30–31**; *31*; 32–33; *32–33*; 34–43; 84–86; 94; 96; 200; 205; *205*; 206; 212; 232; 238; 239
compound eye: 30; 31; *31*

F
Factories: 166–167; *167*
Faience: 63; 64; 69
Fairbanks, Douglas: 102
Fashion colours: 44; 98; 104; 107; **112–131**; *112–131*; 158–159; *158–159*; 176; 180; 182; 184; 185; 194; 200; 203; *203*; 218; 224
Fauvism: 116
Film: 38; 48; 92; 98; **102–103**; *102–103*; 176
photographic film: 100–101
Film colours: 41; 94; 100–101; 102–103; 176; 242
Finland: 78
Fischer, Rudolf: 100
Fish: 20; 22; 25; 28; 30; 31; 53; 56; 96; 106; 197; 204; *204*
Flags: **76–77**; 78; 178; 186; **192–193**; *192–193*
Flanders: 80
Fleabane (*Erigeron* spp.): 31; *31*
Flicker: 41; 94; 143; *143*; 149; *149*
Flies: 16; **26**; 27; 202; *202*
Flowers: 21; **24–25**; 25; **26–27**; *26–27*; 31; *31*; 40; 50; 68; 76; 77; 83; 104; 142; 148; 178; 186; 194; 200; 208; 214; *214*; 218
Fluorescence: **22**; 152; 243 (*see also* Lighting, fluorescent)
fluorescent paints: 91; *91*
Food: 20; 46; 60; 61; 132; 171; 172; **174–175**; *174–175*; 191; *191*; 194; 197; *197*; 200
Ford, Henry: 119; 172; 180
Ford Fairlane: 125; *125*
Model A: *119*
Fortuny: 116
Fovea: 32; 35; 243
France: 36; 56; 57; 62; 67; 73; 76; 82; 86; 87; 88; 92–93; 112; 166; 176; 199; 222; 223
Frequency: **13**; 20; 22; 243
Freud, Sigmund: 44; 94
Friedrich, Caspar David: 86
Frigate birds (man-of-war birds; *Fregata* spp.): 189; *189*
Fruit: 20; 24; 26; 27; *27*; 60; 61; 79; 175; 194; 200; 208
Fungi: 60; 209
Furniture: 66; 67; *67*; 82; 83; *83*; 115; *115*; 116; *116*; 117; *117*; 118; *118*; 119; 120; *120*; 121; *121*; 125; 127; 128; 160–161; *160–161*
Furttenbach, Joseph: 108

G
Galileo, Galilei: 14
Galitzine, Irène: 126
Ganglion cells: 32; *32–33*; 34; *34*; 36
Garbo, Greta: 156
Gardens: 82; 142; 148; **162–163**; *162–163*; 208; *208*; 234
Gaudí, Antonio: 166
Gauguin: 92; 119
Gemstones: 12; 16; 45; 46; 48; **64–65**; 65; 73; 75; 79; 80; 87; 194; 214; 218; 223

Genetics: **24–25**; **36–37**; *37*
Gentians (*Gentiana* spp.): 214; *214*
Germany: 41; 44; 63; 78; 80; 85; 86; 88; 90; 94; 95; 98; 101; 108; 136; 164; 166
Gilding: 69; 82; 83; 96; 120–121; *121*
Giotto: 70; 146
Glass: 48; **62–63**; *62*; 114; 115; 119; *119*; 120; 166; 193; 204 (*see also* Enamel; Stained glass)
Glazing: 60; **62–63**; 64; 66; 69; 83; 214 (*see also* Enamel)
Gloss: 23; 62; 63; 70; 80; 106; 107; *107*; 118–119; 138; *138*; 141; 144; 160; **209**; *209*
Glow-worms (Lampyridae): 22; 209; *209*
Godowsky, Leopold: 100–101
Goethe, Johann Wolfgang von: **84–85**; 87; 94; 95; 138; 139; 140; 141; 143; 192; 195
colour circle: *85*
colour triangle: *139*
spectrum: *85*
Gold: 23; 32; 50; 58; 59; 61; 63; 64; 67; 69; 71; 72; 73; 74; 76; 76; 78; 79; 82; 86; 87; 118–119; 124; 128; 150; 157; 170; 173; 174; *174*; 180; 190; *202*; 203; 204; *204*
golden light: 45; 150; 153; 154
Golden foolscap beetle: *202*; 203
Goldstein, Kurt: 44
Gouras, P.: 34
Graphite: 62; 178
Gray, Eileen: 67; *67*; 119
Greek language, ancient: 12; 16; 20; 36; 50; 51; 59; 65
modern: 51
Greeks, ancient: 12; 18; 41; 46; 48; 50; 58; 64; 67; 68; 69; 70; 78; 87; 96; 106; 108–109; 146; 166; 197; *197*; 200; 212; 221; 223; 224
Green: 24; 25; 26; 28; 30; 38; 39; 40; 42; 44; 45; 46; 47; 48; 50; 51; 58; 59; 62; 64; 65; 67; 68; 69; 70; 72; 73; 74; 78; 79; 80; 81; 82; 83; 84; 85; 86; 87; 88; 89; 90; 92; 93; 95; 96; 97; 98; 99; 100; 103; 104; 105; 106; 115; 116; 118; 119; 120; 122; 123; 124; 125; 126; 128; 129; 132; 134; 135; 136; 137; 140; *140*; 141; *141*; 142; 143; *143*; 144; 146; *146*; 149; 151; 152; 153; 154; 156; 157; 158; 161; 162–3; *162–3*; 164; 165; 166; 167; *167*; 168; 169; 170; 173; 174; 175; *175*; **206–211**; *207–211*; 226; *226*; 227; 228; *228*; 230; *230*; 231; *231*; 232; *232*; 233; 234; *234*; 235; *235*; 236; *236*; 238; *238*; *239*
green light: 12; 15; *15*; 19; 20; 21; *21*; 30; 32; 34; 36; 38; 40; 41; 43; 44; 100–101; 154; 155
Green flash: 23; 206
Greenland: 18
Green vitriol (ferrous sulphate): 79
Grey: **20**; 23; 32; 36; 38; 40; 41; 42; 50; 51; 58; 59; 68; 74; 85; 85; 87; 89; 92; 93; 94; 95; 96; 97; 98; 100; 103; 106; 107; 115; 116; 119; 120; 122; 123; 128; 130; 132; 140; *140*; 142; 143; 144; 147; 164; 166; 168; **176–83**; *177–83*; 226; *226*; 229; *229*; 231; *231*; 233; 237; 238; *238*; 240; *240*; 241; *241*; 243
Guatemala: 16; 220
Guild, Robin: 144

H
Haematite: 60
Hair: 22; 50; 53; 96–97; *96–97*; 104; 112; 114; 126; 128; 156–157; *156–157*; 168; 178; 190; 194; 200
Hangings: 82; 160
Hanunóo language: 50
Harlow, Jean: 112

Harris, Moses: **84**
 colour circle: **84**; *84*
Harry, Sydney: 224; 230–241; *230–241*
Hatching, heraldic system of: 77; *77*
Hattwick, La Berta Weiss: 44
Haute couture: 38; 223
Hayworth, Rita: 156
Hellot: 83
Helmholtz, Hermann von: 41
Hemoglobin: 10; 20; 24; 25; 46; 90 (*see also* blood)
Henna (*Lawsonia inermis*): 20; 96; 97; 136
Heraldry: **76–77**; 76; 77; 79; 162; 188
Herculaneum: 70; 87
Hering, Ewald: **36**; 85; 243
Hermeneia (Dionysius of Fourna): 71
Heveningham Hall: 210; *210*
High-tech: 128; *128*; 167; *167*
Hilliard, Nicholas: 90
Hinduism: 45; 46; 59; 137; 188
Hindus: 46; 58; 59
Hippies: 126
Hippocrates: 8
Hittites: 64
Hittorff, Jacob Ignaz: 87
Hofmann, Professor von August Wilhelm: 88; 218
Holbein: 112
Hollywood: 97; 102; 112; 119; 156
Hologram: 111; *111*; 215
Hölzel, Adolf: 95
Homer: 50
Hong Kong: 78
Hooke, Robert: 15
Hormones: 44
Hospitals: 44; 164
How to mix paints: **226–229**; *226–229*
Hue: 12; 16; 40; 41; **42**; *42*; 43; 44; 48; 50; 51; 77; 79; 84; 85; 89; 92; 93; *93*; 95; 101; 104; 105; 144; 243
Hulanicki, Barbara: 128
Humours, Doctrine of the: 46; 78
Hungary: 38
Huygens, Christian: 15
Hypothalmus: 44

I

Ikat: 60; 61; *61*
Illuminated manuscripts: 64; **72–73**; *72–73*; 76; *76*; 79; *79*; 98; 212
Impressionists, the: 41; *41*; 92–93; *92–93*; 99; 116; *117*
Inca: 64
Incandescent light: 40; 152; 153; *153*
India: 58; 59; 60; 61; *61*; 68; 88; 90; 96; 97; 102; 126; 136–137; *136–137*; 188; 191
Indigo: 14; 46; 50; 60; 61; 70; 88; 89; 90; 126; 185; 212; 216
 Indigofera tinctoria: 60; *61*
Indonesia: 52
Infrared: **12**; *12*; 80; 101; 104; 186; 243
 infrared thermography: 46; 47; *47*
 infrared film: 101; *101*
 infrared television: 104
Ink: 20; 21; 24; 73; 90; 91; 98; 99; 170; 176; 218; 220; *220*
Inlaying: 66–67; 69; 82; 115
Insects: **16–17**; *16–17*; 22; **24–25**; **26–27**; **28–29**; *28–29*; **30–31**; *31*; 38; 61; 72; 88; 90; 194; 200; 202; 209; 212; 218
Intensity: 13; 42; 46; 94; 102; 243
Interference: **14–15**; *15*; **16–17**; 17; 18; 19; 29; 111; 243
Interior design: 38; 44; **82–83**; *82–83*; 87; 104; 106; 107; 112–131; *112–131*; 132; 138; 143; 144; 146–147; 149; 150; 153; **160–161**; *160–161*; **164–165**; *164–165*; 176; 184; *184*; 194; 202; *202*
Iran: 193
Ireland: 58; 64; 136
Iridescence: 10; **14–15**; *14–15*; **16–17**; *16–17*; 28; 29; 62; 96; 115; 243
Iris (rainbow): 16; 18

(eye): 32; *32*
Iron: 60; 62; 63; 64; 74; 79; 197; 199
 iron oxides: 66; 67; 70
Irving, Henry: 109
Irving, Washington: 212
Isfahan: 63; *63*
Ishihara colour test: 36; **37**; *37*
Islam: 46; **62–63**; 69; 78; 136; 216
Israel: 37
Istanbul: 62; 70
Italy: 50; 56; 70; 80; 96; 108; 146; 148; 174
Itten, Johannes: 85; 95; 142; 143; colour solid: 85; *85*
Ivory: 50; 62; 67; 82; 119; 120; 121; 135

J

Jamaica: 166
Japan: 58; 59; 60; 65; 67; 68; 69; 78; 97; *97*; 103; 104; 105; 162–163; *162–163*; 169; *169*; 224; 234
Japanese language: 50; 51
Jekyll, Gertrude: 142; 162
Jewellery: 16; **64–65**; 67; 73; 114; 116; 118; 120; 124; 126 (*see also* Gemstones)
 coloured: 16; 20; 21; 36; 43; 44; 101; **108–109**; *108–109*; **110–111**; *110–111*; 119; 132; **154–155**; *154–155*; 196; *196*; 209 (*see also* Lasers; Neon)
Jews: 59
Jinx wheel *see* Kinetic colour fusion disks
John Player Specials advertising campaign: 170; *171*
Johnson, James Rosser: 223
Joly, John: 100
Jones, Inigo: 108
Jones, Owen: 87
Jung, C.G.: 44; 45; 78; 138

K

Kalmus, Herbert: 102
Kandinsky, Wassily: 48; 94; 95; 210
Kant, Immanuel: 86
Katz, David: 94
Kay, Paul: 51
Kenya: 44; 136
Kermes (*Kermococcus vermilis*): 61; 72
Khaki: 115; 116; 122; 123; 126; *201*; 221
Kinemacolor: 102
Kinetic colour fusion disks: 41; 43; *43*; 93
Kirlian photography: 47; *47*
Kirlian, Semyon and Valentina: 47
Kitchens: 44; 106; 107; *107*; 124; *124*; 153; 154; 161
 kitchen equipment: 184; *184*
Klee, Paul: 95
Knights: 76–77; *76–77*
Kop, the: 192; *192*
Korea: 68; *68*
Krishna: 137

L

Lac (*Rhus vernicifera*): 66
Lac insect (*Lakshadia chinensis; Lakshadia communis*): 90
Lacquer: **66–67**; *66–67*; 68; 69; 97; 119; 120; 121
Lakes: 81
 'Lazouri' lake: 71
Land, Edwin: 40
Language: **50–51**; *51*; 78; 134–135; 136; 178; 186; 194; 197; 200; 206; 212; 221
Lapis luzuli: 50; 64; 80
Lapps: 51
Lascaux: **56–57**; *56–57*
Lasers: **110–111**; *111*; 215; *215*; 243
Latin: 50
Lavatory: 109
Lavender: 222; *222–223*
Lead: 62–63; 67; 71; 72; 74; 79; 81; 96; 97; 106
Leadbeater, C.W.: 94
 aura: 95; *95*
Leaf-mimicking moths (*Astylis* spp.): 29; *29*

Leather: 60; 61; 83
Leaves: 20; *24*; 25; 27; 28; 29; 40; 54; 59; 68; 88; 148; 178; 208; 211
Le Blon, James Christopher: 98
Le Brun, Charles: 82
Le Corbusier: 166
Leconte de Lisle *Midi*: 205
Léger, Fernand: 89; *89*
Lemaire, Madeleine: 115
Lemon: 50; 74
Lenard, Philipp: 20
Leroi-Gourhan, André: 57
Levant: 59
Lévi-Strauss, Claude: 54
Levy, Paul *Nut-and-Bolt* (1972): 167; *167*
Lichens: 60
Light: **12–45**; *12–23*; 48; 59; 74; 80; 84; 85; 86; 88; 90; 92; 100; 146; 147; 152; 153; *153*; 243
Lighting: 10; 94; 104; 132; **150–155**; *150–155*
 natural: **150–151**; *150–151* (*see also* Daylight)
 fluorescent: 40; 151; **152–153**; *152–153* (*see also* Fluorescence)
Lightness: **42–43**; *42*; 48; 50; 84; 85; 86; 95; 178; 243
 lightening paint colours: 227; *227*
Lilac: 82
Limbourg, Paul, John and Hermann: 73
Limelight: 109
Lindisfarne Gospels: 72
Lips: 25; 71; 96; 97; 112; 156–157; *156–157*; 211
Lisle, Leconte de *Midi*: 205
Lithography: 87; 98
Local colour: 86–87; 244
Locke, John: 48
Logwood: 178
London: 23; 169; *169*; 191; *191*
 London Underground: 38–39; *38–39*
Lovibond, Joseph: **10**
Loviot, Edouard: 87
 the Parthenon: *87*
Lowenfeld, Margaret: 45
Lowenfeld Test: 95; *95*
Luminescence: 243
Luminous intensity: 152; 244
Lüscher Colour Test: 138; 139; 170; 172; 218
Lüscher, Dr. Max: 138; 139; 140; 164–165; 170; 172–173

M

Mach effect: 43; *43*; 241; *241*
Macintosh, Charles Rennie: 115
McCollough effect: **40**
McLuhan, Marshall: 171; 180
Madagascar: 16; 59
Madder (*Rubia tinctoria*): 60; 61; 70; 88; 89; 90; 186; 189; 217
Magenta: 10; 13; **21**; *21*; 50; 85; 88; 99; *99*; 101; 106; 122; 139; *139*; 150; 163; *163*; 220; *221*; 224
 Battle of: 50
Magic: 52–53; 54–55; 56–57; 58–59; 64; 65; 94; 106; 186
Magnesium oxide: 96; 178
Mail boxes: 191; *191*
Malachite: 64; 67; 70; 72; 81; 88; 96; 97; 206; 215
Malaya: 61
Malaysia: 28
Mandala: 45; *45*
Manganese: 52; 56; 60; 62; 63; 67; 74; 90

Mannes, Leopold: 100–101
Maoris: 50; 51; 54
Marat, Jean Paul: 36
Marble: 68; 69; 70;
 Rouge Jaspe: 199; *199*
Marie Antoinette: 112
Mariotte: 36
Maroon: 57; 114; 138; 154
Marrakesh: 69
Marriage: 53; 54; 58; *58*; 59; 78; 100; 199; 214
Marvell, Andrew: *The Garden*: 208
Masaccio *The Tribute Money* (c.1427): 70; *70–71*
Masjid-i-Shah: 63; *63*
Masques: 108
Maugham, Syrie: 120; *121*
Mauve: 50; 69; 88; 90; 114; 116; 122; 136; 146; 147; 157; *157*; 162; 163; *163*; 178; 205
Maxwell, James Clark: **12**; 100
Maya: 69; 207
Medicine: 46–47; 58; 60; 64; 65; 96; 110; 111; 206
Mehndi: 137
Meissen porcelain: 82; 83
Melanesian language: 51
Melanin: 10; **25**; 28; 29; 32; *32*; 178; 190; 200; 212
Melanocytes: 190
Menswear: 88; 132; 158–159; *158–159*; 185; *185*; 221; *221*
Mercury vapour gas: 196
 lighting: 152
Mesopotamia: 64; 69; 199
Metallic colours: 23; 107; 125; 156; 166; 178; 205
Metals: 23; 48; 59; 60; 61; 62; **64–65**; 65; 66; 68; 69; 73; 74; 77; 78; 79; 80; 82; 107; 108; 156; 166; 178; 180; 205; 215
Metamerism: 153; 244
Methyl violet: 88
Mexico: 59; 69; 191;
 Mexico City: 168; *168*
Michael, C.R.: 34
Michelangelo: 70
Micro-electrode: 35; *35*
Microwaves: **12**; *12*
Minerals: 48; 60; 62; 64; 70; 90–91; 106
Miniature (Bibliothèque Nationale Paris Ms. Latin 10525): 73
Minoans: 70
Miró, Joan: 95
 Painting: 95
Mirror orchid (*Ophrys speculum*): 27; *27*
Moiré effects: 149
Molecules: 20; 22; 24; 32; 33; *33*
Molluscs: 16; 25; 30; 48; 50; 60; 66; 88; 182; 218 (*see also* Tyrian purple)
Mondrian, Piet: 210
Monet, Claude: 41; 89; 92; 112
 The Houses of Parliament, Sunset: 41; *41*
 Impression, Sunrise (1872): 41
Monkshood (*Aconitum* spp.): 27; *27*
Monochromatic light: **13**; *13*; 15; 16; 38; 40; 41; 110; 111; **154–155**; 214; *214*
Monochromatism: 36; 224
Monochrome: 56; 57; 70; 104; 105; 119; 142; 148; **154–155**; 161–162; *162*; 166; 184; *184*; 202; *202*; 214; *214*; 217
Mont St. Michel: 75; *75*
Montesquiou, Robert de: 115
Moon: 23; *23*; 32; 57; 58; 64; 79; 100; 108; 178; 180; *180*
Moonbow: 10; 11; 18
Moonlight: **23**; *23*; 32; 69; 181
Mordants: 60; 61; *61*; 217
Morocco: 61
Morris, William: 115
 Strawberry Thief: 217; *217*
Mosaics: 69; 73; 106; 204; *204*
Moslems: 48; 63; 69; 136; 193
Mosques: 68; 69
Mother-of-pearl: 16; 25; 66; 69; 182
Moths: 24; 26; 28–29; *28–29*; 30

Mount Hageners: 52; *52*; 53; 55; *55*
Mud: 54; 59; 60; 68
Munch, Eduard: *The Scream*: 48
Munsell system: 51; 134; **135**; *135*; 244

N

Nanometre: 12; 243
Nash, Paul: 120
Nazarene: 58; *58*
Negros: 78; 183; *183*
Neolithic era (New Stone Age): 58; 60; 64
Neon: 110; 152; 169; *169*; 196; *196*; 215; *215*
Netherlands, The: 191
Neutral colours: 140; 142; 158; 160; 161; 164; 178; 179; **226**; *226*
New Guinea: 37; 48; 51; 59
Newton, Sir Isaac: 10; **12–13**; *14*; 40; 42; 82–83
 colour circle: **85**; *85*
 Newton's rings: 15; *15*; 244
 spectrum: 85; *85*
New York: 23; 167; 168; *168*; 188; *188*
New Zealand: 37
Niepce, Joseph Nicéphore: 100
Nigeria: 136
Noon: 151; *151*
Norsemen: 18
Northumbria: 72

O

Ocelli: 28; *28*; **30**
Ochre: 28; 48; **52**; 53; 56; 60; 62; 65; 66; 70; 90; 96; 97; 106; 137; 138; 189; 200
Offices: 145; *145*; 166–167; *166–167*
Opal: 16; 65; *65*
Op Art: 127; 149; *149*
Operating rooms: *210*; 211
Optical delay: 223
Optical fusing *see* Optical mixing
Optical mixing: 41; 43; *43*; 92–93; *93*; 105; 118; 163; *163*; 231; *231*; 232; *232*; 244
Optics: 14–15; 84
Orange: 26; 30; 32; 36; 39; 40; 42; 43; 44; 51; 57; 72; 74; 80; 81; 84; 85; 90; 92; 93; 100; 106; 116; 119; 124; 128; 139; 142; 143; 144; 146; 148; 149; 150; 151; 154; 156; *156*; 157; *157*; 162; 167; *167*; 168; 170; 174; **194–199**; *195–199*; 224; 226; *226*; 227; 232; *232*; 234; *236*; 236; 237; 238; *238*
 Citrus spp. 197; *197*
 fluorescent: 168; *168*; 198; *198*
Orpiment (arsenic sulphide): 66; 70; 72; 81; 200
Ostwald System: 95; 244
Ostwald, Wilhelm: 95
 scale of greys: *95*
Oud, J.J.P.: 166
Outer space: 23; 46; 131
Oxygen: 20; 22; 23; 25; 46; 61; 62

P

Packaging: 98; 132; **170–171**; **172–173**; *172–173*; 186; 194; 200; 222; *222*
Paintings: 10; 38; 41; 42; 44; 45; 48; 56–57; 62; 70; 72–73; 78; 80–81; 82; 84–85; 86–87; 90; 92; 93; 94; 95; 116; 117; 119; 122; 126; 127; 130; 165; 194; 199; 210; 217; 224; 230–241
Paints: 20; 42; 43; 48; 56–57; 59; 62; *66*; 67; 68; *68*; 69; 70; 80; 81; 83; **90–91**; *90–91*; 100–103; **106–107**; *106–107*; 112; 119; 120; 121; 124; 125; 128; 160; 161; 164; 176; 182; 184; 194; 197; 200; 210; 217; 218; 220; 226–227; 228–229
 artists' paints: 90–91; *90–91*
 Fresco: 70–71; *70–71*
 Household paints: 106–107; *106–107*

Industrial: 106–107; *106–107*
Oils: 80–81; 90; 91; *91*; 106
Tempera: 70–71
Palenque: 69
Paleolithic era (Old Stone Age): 48; 52; 56–57; 60; 64
 tools: 64; *64*
Palladian style: 82; 210; *210*
Palmer: 36
Papua New Guinea: 52; 55
Parfait Amour *see* Crême Yvette
Paris: 67; 73; 74; 167; 210; 223
Parthenon: 68; 87; *87*
Pastel colours: 83; 112; 140; 143; 156; 158; 164; 171; 210; **229**; *229*
Patou: 118
Pattern: 40–41; 62; 63; 76; 87
Peacock (*Pavo cristatus*): 29; *29*
Peasant communities: 58–59; 60; 166; 191
Peppered moth (*Biston betularia*): 29; *29*
Perception: 34; 38–39; *41–43*; 50; 54; 142; 146–149; *146–149*; 160; 161; 171; 178
Perkin, William Henry: 88; 90; 218
Persia: 62; 63; 65; 136; 214
Perspective: **146–149**; *146–149*; 182; *182*
Philippines: 50
Philosopher's Stone: 44; 78; 79
Philosophy: 42; 46; 48; 69; 78; 79; 84
Phosphorescence: 22; 244
Phosphors: 22; 105
Photography: 38; 40; 47; *47*; 48; 92; 98; 99; **100–101**; *100–101*; 103; 150
 Infrared photography: 80; *80*
Photons: 20; *20*; **22–23**; 32; 33; 110; 215; 224
Photoreceptors *see* Rods; Cones
Phycoerythrin: 24
Piano, Renzo: 167
Picasso, Pablo: 116; 130
 Crouching Woman: 217; *217*
Pigments: 10; 14; 16; 20–21; 24–25; 26; 27; 28; 29; 30; 31; 43; 48; 52; 53; 56–57; 60; 64; 66; 67; 70; 71; 72; 80; 81; 84; 86; 90; 91; 92; 93; 96; 97; 106; 107; 121; 124; 125; 137; 178; 180; 182; *182*; 189; 190; 194; 197; 198; 200; 205; 206; 211; 212; 214; 218; 220; 227; 228; 229; 244
 visual pigments: 24; 25; 30–31; 32–33; *33*; 34; 36
Pink: 42; 43; 45; 51; 72; 73; 74; 78; 82; 97; 99; 102; 114; 115; 116; 120; 124; 125; 128; 129; 132; 134; 136; 139; *139*; 141; 142; 143; 152–153; *153*; 154; 156; *156*; 158; 162; *162*; 166; 184; **186–193**; *187*; *191*; 227; *227*; 229; *229*; 234; *234*; 237; *237*
Pissarro: 92; 112
Pitcher plant (*Nepenthes* spp.): 27; *27*
Planck, Max: 20
Planets: 64; 78; 79; 108; 186; 206
Plankton: 16
Plants: 22; **24–25**; *25*; **26–27**; *26–27*; 28–29; 30; 50; 51; 57; 60; 62; 74; 88; 90; 101; 162; 163; 178; 194; 200; 206
Plato: 8
Pliny: 8; 60; 80
Pompadour, Mme de: 82
Pompeii: 70; 87; 112; 161; 168
Pompidou Centre: 167; *167*
Porcelain: 62–63; 66; 67; 82
Posterization: 100; *100*
Pottery *see* Ceramics
Poussin: 112
Prehistoric man: 25; 52; **56–57**; 60; 62; 64 (*see also* Weapons)
Presley, Elvis: 171
Priests: 54; 61; 78; 220; *220*
Primary colours: 10; 44; 48; 68; 84; 85;

87; 94; 107; 160–161; 166; 167; 170; 171; 172; 242 (*see also*: Additive primaries; Subtractive primaries; Psychological primaries)
Primates: 28; 34; 53
Printing: 21; 42; **98–99**; *99*; 176; 180; *180*; 220; *220* (*see also* Ink)
Prism: **12–13**; *12–13*; 14; 15; 84; 85; 242
Progressive colouration, law of: 27
Psychological primaries: 172; 242
Psychology: 36; 41; **44–45**; *45*; 51; 78; 79; **94–95**; *94–95*; 102; 138; 139; 140; 150; 154; 164; 165; 170; 171; 172; 194; 197; 180; 200; 206; 212; 218
Puritans: 68
Purity *see* Saturation
Purkinje shift: 32; **162**; *163*; 244
Purple: 26; 31; *31*; 33; 36; 39; 40; 48; 50; 51; 59; 60; 61; 62; 63; 69; 72; 74; 76; 77; 78; 79; 84; 87; 88; 92; 106; 114; 115; 136; 146; 151; 162; 164; 170; 171; 174; **218–223**; *219–223*; 224; *224–225*; 234; 236; *236*; 239; *239*
 'bee purple': 31; *31*
 purple light: 154

Q

Quant, Mary: 126; 127
Quartz: 48; 62; 63

R

Radiation: 10; 12; 22; 24; 25; 45; 46; 47; 164; 178; 190; 192; 244
 electromagnetic: 10; 12; *12*; 15; 244
Rainbow: 12; 16; **18–19**; *18–19*; 22; 186 (*see also* Moonbow)
Raphael: 70
Realgar: 81
Red: 26; 32; 39; 40; 42; 44; 46; 48; 50; 51; 52; 53; 54–55; 56–57; 58–59; 60–61; 62; 65; 66; 67; 68; 69; 70; 72; 73; 74; 78; 79; 80; 84; 85; 86; 87; 88; 89; 90; 92; 93; 94; 95; 96; 98; 99; 100; 112; 115; 116; 117; 118; 119; 120; 122; 123; 124; 125; 126; 128; 132; 134; 136; 137; 138; *138*; 139; *139*; 143; *143*; 144; 149; *149*; 150; 151; 156; *156*; 158; *158*; 162; 164; 166; 167; 168; 169; 170; 171–172; *171–172*; 173; 174; *174*; **186–193**; *186–193*; 227; *227*; 228; *228*; 229; *229*; 231; *231*; 234; *238*
 red light: 12; 13; *13*; 14; 18–19; *18–19*; 20; 21; 22; 23; 24; 30; 32; 34; 36; 38; 40; 41; 44; 75; 84; 100–101; 154; 155
Red Baron: 117; *117*
Red Cross: 193; *193*
Red Sea: 24
Red shift: 186
Reflection: 10; 12–13; *13*; 15; *15*; 16–19; *19*; 20; 21; 22; 23; 29; 41; 144; 148; 178; 205; 209; *209*; 244 (*see also* Interference)
Refraction: **12–13**; *13*; 14–15; 16–17; 18–19; *19*; 22; 29; 144
Refractive index: 245
Reitvelt, Gerrit: 166
Rembrandt: 86; 106
Renaissance: 64; 70; 74; **80–81**; *80–81*; 88; 90; 124; 146; 148; 211
Renoir, Pierre Auguste: 92; 97; 112
Reptiles: 25; 28; 30–31; 206; 214; *214*
Restaurants: 44; 165
Retina: 245;
 animal: 30–31; *33*
 human: 32–33; *32–33*; 34; *34*; 36; 40; 41; 43; 205
Revolution: 58; 59; *59*; 78; 186; 192; *192*
Rhodes: Zandra: 126
Rhodesia: 53
Rigaud Hyacinthe: 112
Rila Monastery, Bulgaria: 71; *71*

Riley, Bridget *Fall*: 149; *149*
Ritual: 52–53; 54–55; 57; 58–59; 60; 62; 68
Rod cells: 30; 31; **32–33**; *33*; 35; 36
Rodier: 118
Rogers, Richard: 167
Romanesque: 146
Romania: 166; 167; *167*
Romans, ancient: 46; 48; 60; 61; 62; *62*; 64; 69; 70; 78; 80; 87; 96; 150; 168; 194; 199; 206; 212; 218; 221
Romantic painters: 85; 86–87; *86–87*
 Romantic revival: *87*
Rood, Ogden: 92; 93; 234
 scale of hues: *93*
Rorschach test: 45; *45*
Rosarium Philosophorum (The Philosopher's Rosegarden): 79; *79*
Rose: 50; 86; 90; 115
 Rosa spp.: 77
 Rose Pompadour: 82; 83
Royalty: 46; 60; 61; 68; 69; 73; 76; 78
Runge, Philipp Otto: **85**; 87; 94; 95
 colour solid: *85*

S

Safflower (*Carthamus tinctorius*): 60
Saffron: 51; 70; 74; 137
St. Edmund (Pierpont Morgan Library M.736): 73
St. Mark (Paris Biblioteque Nationale Latin 8850): 72
St. Matthew (B.L.A. 135 f.q.v.): 72
Sandarac: 80
Satin bower bird (*Ptilonorhynchos violaceus*): 215; *215*
Saturation: 13; 36; **42**; *42*; 44; 50; 70; 85; 95; 105; 131; 144; 149; 176; 200; 207; 213; 237
Sautuola, Don Marcelino S. de: 56
Scarlet: 48; 51; 80; 96; 116; 122; 162
Scarlet woman: 186; 188
Schiaparelli: 120
Scotland: 12; 136; 178
Sea *see* water
Seasons: 58; 60; 78; 150; *150–151*
Secondary colours: 84; 245
 additive: **13**; *13*; *21*
 subtractive: **21**; *21*
Seeds: 26; 27; 54
Selective absorption *see* Absorption
Sellner, Christiane: 74
Seurat, Georges: 92; 93; 99; 149
 The Bathers (1883–4): *93*
 La Grande Jatte (1886): 92
Sèvres porcelain: 82
 pot-pourri vase: *82*; 83
Shade (of colour): 50; 58; 84; 245
Shade and Shadow: 12; 16; 21; 28; 30; 31; 40; 42; 45; 73; 80; 81; 84; 86; 92; 101; 103; 104; 105
Shrimpton, Jean: 156
Shrines: 68–69
 Toshogu Shinte Shrine at Nikko: 69; *69*
Siamese: 51
Siberia: 54; 56
Signals and signs: 36; 37; 38; 56; 57; 76–77; 79; 193
Silver: 23; 63; 64; 65; 67; 76; 77; 79; 82; 115; 118–119; 124; 126; 128; 129; 131; 132; 157; *157*
 silver stain: 74
 silver sulphide: 74
Simultaneous contrast: 23; 40; 92; *92*; 95; 144; 235; 238; 240; 245
Singapore: 166; 167
Sistine Chapel: 70
Skin, animal: 60; 61; 64
 human: 22; 24; 25; 46; 47; 54; 71; 80; 81; 96; 104; 136; 156; 178; 190; 203
Skink, American western (*Eumeces skiltonianus*): 214; *214*
Sky: *22–23*; 40; 41; 57; 59; 64; 67; 68;

81; 86; 108; 151; 152 (see also Sunrise; Sunset)
Sloe (blackthorn; *Prunus spinosa*): 27; 27
Smith, George: 102
Snow: 20; 28; 50; 100; *100*; 178
Soap bubble: *14–15*; 15
Sodium: 16; 33; lighting: 152
Solarization: 100; *100*
Sonography: 46
South East Asia: 136
Spain: 56; 57; 58; 61; 69; 78; 136; 147; 166; 191
Spectrophotometer: 10
Spectroscopy: 16; 245
Spectrum, alchemical: 78
 diffraction: 10; 16–17; *17*
 electromagnetic: **12**; *12*; 15
 of light: **12**; **13**; *12–13*; 14–15; 16; 17; 18; 19; 20; 30; 32; 36; 42; 84; 176; 178; 245
 Goethe's: 85; *85*
 Newton's 85; *85*
 visible: 10; 21; 30; 31; 33; 152; 153; 178
Speke Hall, Liverpool: 167; *167*
Sport: 58; 76; 104; 115
 clothes: 118; 120; 184; *184*; 192
Spring: 58; 73; 78; 150; 160
 snow: 178
S.S. *Isaac Bell*: 38
Stained glass: 10; 68; **74–75**; *75*; 78; 108; 223; *223*
Step Pyramid of Zoser: 68
Stimulus gradient: 139; *139*; 140; *140*; 141; *141*
Stock Market, London: 158; *159*
Stone: 53; 56; 57; 62; 64; 68; 69; 82; 106
Stucco: 69
Subtractive colour mixing: 10; **21**; *21*; 43; 48; 92; 93; 99; 100–101; 102–103; 226–227; 228–229
Subtractive primaries: 10; **21**; *21*; 48; 85; 92; 93; 99; *99*; 176 (see also Additive primaries; Primary colours)
Successive colour contrast: 40; 142; *142*
Sudan: 53; 54
Sugar candy, pink: 191; *191*
Sugawara: 67; 119
Suger, Abbé: 74
Sulphur: 63
Sumatra: 136
Sumeria: 64
Summer: 58
Sun: 57; 58; 64; 75; 79
Sunlight: 10; 14; 16; 18; 22; 30; 31; 32; 41; 47; 84; 90; 92; 94; 96; 108; 146; **150–151**; *150–151*; 152; 178; 190
Sunrise: 12; 18; *22*; **23**; 32; 108; 150; *150*; 206
Sunset: 10; 12; 18; 22; **23**; *23*; 41; *41*; 48; 59; 69; 84; 108; 150; 151; *151*; 196; *196*; 206
Sun-tan: 158; 190; *190*; 203
Supersaturated colours: 13; *13*
Surf: 23; *23*
Surface colour: 40; 94; 245
Surrealism: 94; 120
Swahili: 51
Swallow-tailed gull (*Creagrus furcatus*): 29; *29*
Sweden: 59; 191
Switzerland: 38; 166
Symbolism: 41; 52; 53; 54; 55; **58–59**; *58–59*; 60; 65; 76–77; **78–79**; *78–79*; 112; 138; 140; 171; 178; 185; 186; 188; 189; 194; 200; 206; 207; 212; 218
Synaesthesia: 44; 48; 85; 87; 94; 95
Synapses: 32; *32–33*; 34
Syria: 60; 72

T
Taj Mahal: 69
Tamerlane's Mausoleum: 69
Tamil: 51
Tanning: 60; 61; *61*; 96

Tapestry: 82; 89; *89*; 106; 142; 188
Tattooing: 54
Tawny: 29; 74
Technicolor: 102; 103
Teddy Boys: 124
Teenagers: 158
Television: **12**; *12*; 13; 46; 98; 100; 102; 103; **104–105**; *104–105*; 176
Temples: 66; *66*; 68; *68*; 69; 70; 106
 Temple of Heaven, Peking: 66; 67
Tennis: 184; *184*
Tertiary colours:
 Tests: 36–37; *37*; 38; 39; *39*; 44; 45; *45*
Textiles: 38; 60–61; 83; 89; 112; 115; 116; 117; 119; 120; 121; 124; 126; 127; 128; 142; 144; *144*; 176; 216; 217
Texture: 40; 41; 50; 160–161; 166
Thailand: 58
Theatre: 82; 96; **108–109**; *108–109*; 116–117; 154; *154–155*; 176; 186; 206
Theophilus: 74; 75
Tiffany glass: 115
Tiger (*Panthera tigris*): 29; *29*
Tiles: 63; *63*; 69; 147; 166; 214; *214*
 Isfahan, Masjid-i-Shah: 63; *63*
 Dome of Shir Dar: 63; *63*
Tin: 61; 62; 63; 64; 79
Tinctures: 76–77; *77*
Tints: 83; 245
Titanium dioxide: 90; 96–97; 106; 121; 182
Titian: 80–81; *Diana Surprised by Actaeon*: 81; *81*
Tombs: 68; 70; 106
Tone: 26; 38; 39; 42; 72; 89; 100; 103; 104; 245 (see also Lightness)
Tortoiseshell: 82; 198
Toshogu Shinto Shrine: 69; *69*
Totemism: 57
Toulouse-Lautrec: 98
Tournaments: 76–77; *76–77*
Traffic lights: 10; 35; *35*; 38; 193; *193*
Transport: 36; 38; *38*; 38–39; 106; 107; *107*; 112; 119; 121; 123; 125; 127; 129; 130; 131; 168; *168*; 169; *169*; 171; 172; *173*; 180; *180*; 193; 205; *205*
Trees: 26; 57; 60; 68; 69; 83; 211; *211*
Trianon, Grand: 82
Trianon, Petit: 82
Tribal societies: 50–61; 62; 136; 185; 186; 189
Trichromacy: 10; 30; 31; 32–33; 34–35; 36; 38
 anomalous: 36; 37; 38
Trichromatism: 36; 245
Tropics: 25; 26; 61; 136–7; *136–7*; 151; *151*
Turbeville: 36
Turkey: 62
Turmeric (*Curcuma tinctoria*): 58; 60; 137
Turner, Joseph Mallord William: 86; 90; *The Slave Ship*: 86
Turner, Victor: 54
Turquoise: 62; 63; 64; 65; *65*; 69; 82; 83; 120; 124; 128; 142; 157; 176; 214; *214*; 227; 236
Tyrian purple: 46; 48; 50; 60; 88; 218; 221
Tzeltal: 51

U
Ultramarine: 50; 70; 72; 80; 81; 90; 97; 106; 212; 231; 226
Ultraviolet: **12**; *12*; 15; 22; 25; 26; 27; 30; 31; *31*; 32; 47; 75; 100; 190; 196; 198; 218; 245
Umber: 69; 70; 90; 224
Urban, Charles: 102
Uruku: 52
USA: 34; 37; 38; 44; 60; 61; 78; 104; 106; 134; 136; 153; 156; 159; 174; 175; 214; 222; 223
USSR: 56; 210

V
Value see Lightness
Van Eyck, Jan: 80; 206
Van Gogh, Vincent: 48; 90
Van Goyen, Jan: 38
Vasari: 80
Vauquelin, L.N.: 90
Vaux-le-Vicomte, Château of: 82
Vegetables: 20–21; *20–21*; **24**; 30; 54; 174; 191
Venetians: 59; 80; 166
Verdigris (copper acetate): 46; 72; 81; 115; 168; 211; *211*
Vermilion: 51; 66; 67; 71; 81; 97; 137; 192
Veronese, Paolo: decoration from the Villa di Maser: 148
Versailles: 82
Vertebrates: 10; 25; 28; 30; 46; 214
Victoria, Queen of Great Britain: 88
Vincennes: 82
Violet: 24; 26; 42; 44; 50; 57; 58; 74; 85; 86; 87; 88; 90; 92; 93; 100; 117; 140; 141; *141*; 151; 171; *218–223*; 226; *219–223*; 226; 228; 229; 234; 235; 236; 237; 238
 Viola spp. *220*; 221;
 violet light: 13; 14; 15; 18–19; 21; 22; 23; 75
Viollet-le-Duc: 223
Vision: 14; 20; 22; 24–25; 26; 28; **30–43**; *30–43*; 50; 204 (See also Eyes)
Vitamin A: 25; 30; 33

W
Wallace, Alfred: 27
Wall-paintings: 68; **70–71**; *70–71*; 72; 78; 83; 120; 126; 164; 165; *165*; 166; 167; *167*; 168
Wallpaper: 83; *83*; 115; 116; 119; 120; 124; 128; 160; 206
Walton, Allan: 165
War: 54; 58; 59; 64; 76
Warm colours: 44; 47; 85; 95; **138–139**; *138–139*; 142; 144; 153; 164; 171
Warning colours: 25; **28–29**; *28–29*; 202; *202*; 204; *204*
Water: **22–23**; *23*; 28; 30; 31; 40; 46; 50; 54; 60; 61; 73; 78; 80; 86; 88
Water crowfoot (*Ranunculus aquatilis*): 27; *27*
Wave: 13; *13*; 245
Wavelength: 10; **12–13**; *13*; 15; 16; 17; 18; 19; 20; 21; 22; 30; 31; 35; 36; 40; 42; 110; 176; 215; 245
Wax: 60; 70; Punic: 70
Weapons: 62–63
 Stone Age blade: 62; *62*
 nineteenth-century Persian dagger: 63; *63*
Wedgwood, Josiah: 82
 jasper ware: 82; 217; *217*
Weld (*Reseda luteola*): 60; 89; *89*; 217
Welding: 64
Welsh: 51
West: 45; 54; 59; 66; 67; 73; 79; 103
West Indies: 59
Whistler, Rex: 38; 165
White: 26; 27; 28; 31; 32; 33; 40; 42; 46; 50; 51; 52; 53; 54–55; 56; 58; 59; 62; 63; 64; 67; 69; 70; 71; 74; 77; 78; 79; 80; 81; 82; 84; 86; 90; 92; 93; 94; 99; 100; 101; 114; 115; 118; 119; 120; 121; 122; 123; 124; 125; 126; 127; 129; 130; 132; 136; 137; 147; 150; 151; 160; *160*; 162; *162*; 166; 174; 175; **178–185**; *179–185*; 226; 227; 228; 229; 230; 231; 236; 239; 240; 241
 'white' light: 12; 13; *12–13*; 14–15; *14–15*; 18; 20–21; *20–21*; 34; 36; 40; 41; 42; 99; 100; 152–3; 154; *154*
White dwarfs: 178
White elephant: 178
White feather: 178
White House: 166

White rooms: 120–121; *121*; 184; *184*
Whitewash: 54; 68; 83; 106; 167
Wilde, Oscar: 208
Willendorf Venus: 56
Wine: 20; 50; 58; 89; 108; 191; *191*
Woad (*Isatis tinctoria*): 60; 70; 72; 89; 188; 212
Wood: 56; 66; 68; 69; 78; 80; 106
World War I: 158; 166
World War II: 30; 60; 61; 88; 152; 153; 156; 164; 165; 166; 198; 221; 222
Worms: 30
Worth: 112
Wright, Frank Lloyd: 123; *123*
Württemberg: 56
Wyatt, James: 210

X
X-rays: **12**; *12*; 47; *47*; 80

Y
Yantra: 45; *45*
Yellow: 25; 26; 27; 28; 31; 32; 36; 38; 39; 40; 42; 44; 45; 46; 48; 50; 51; 53; 56; 57; 58; 59; 60; 62; 66; 67; 68; 69; 70; 74; 78; 79; 81; 82; 84; 85; 86; 87; 89; 90; 92; 94; 96; 98; 99; *99*; 116; 117; 119; 120; 121; 122; 126; 128; 129; 132; 134; 135; 136; 137; 139; 140; 142; 144; 146; 150; 151; 158; 161; 162; 168; 170; 172–3; *172–3*; 174; *174*; **200–205**; *201–205*; 224; *224*; 226; *226*; 227; *227*; 228; *228*; 229; *229*; 230; *230*; 231; *231*; 232; *232*; 233; *233*; 234; *234*; 236; *236*; 237; *237*; 238; *238*; 240; *240*
 yellow light: 16; 20; 21; *21*; 22; 23; 30; 32; 34; 36; 40; 43; 84; 92; 152–3; 152–3; 154–5; *154–5*
 yellow stain: 74
Yemen: 68; *68*
Young, Thomas: 15; 36

Z
Zebra: (*Equus quagga*): 181; *181*
Zeki, S.: 34–35
Ziggurats: 69
Zodiac: 79; *79*

Recommended books

The following list of titles is a select bibliography of the books and journals that have been consulted during the preparation of *Colour*, or recommended by consultants.

Ades, D. *Dada and Surrealism*; Thames & Hudson 1974
Adler, I. *Colour in Your Life*; Dobson Books 1963 (UK); John Day 1962 (USA)
Adrosko, R.J. *Natural Dyes and Home Dyeing*; Dover Publications 1971
AGA Infrared Systems, *AGA Thermography*; Leighton Buzzard (UK)
Albers, J. *Interaction of Color*; Yale University Press 1971
Amory, C. & Bradlee, F. *Cavalcade of the 1920s and 1930s*; Bodley Head 1961
Alschuler, R.H. & Hattwick, La B.W. *Painting and Personality: A Study of Young Children* Vol. 1; University of Chicago Press 1969
Anderson, T.F. & Richards, A.G. 'Electron Microscope Study of Some Structural Colors of Insects', *Journal of Applied Physics* No. 13; 1942
Angeloglou, M. *A History of Make-up*; Studio Vista 1970
Arnold, J.A. *A Handbook of Costume*; Macmillan 1973
Arwas, V. *Art Deco Sculpture*; Academy Editions 1978 (UK); St. Martin's Press 1975 (USA)
Autrum, H.J. (Ed.) 'Vision in Invertebrates', *Handbook of Sensory Physiology* Vol. VII Part 6a; Spring 1979
Babbitt, E. *The Principles of Light and Color*; University Books, New York 1967
Barley, Nigel F., 'Old English Colour Classification: Where Do Matters Stand?', *Anglo-Saxon England 3*; Cambridge University Press 1974
Battersby, M. *Art Deco Fashion*; Academy Editions 1974 (UK); St. Martin's Press 1974 (USA)
Battersby, M. *The Decorative Twenties*; Studio Vista 1976 (UK); Walker 1969 (USA)
Battersby, M. *The Decorative Thirties*; Studio Vista 1976 (UK); Walker 1969 (USA)
Beck, J. 'The Perception of Surface Color', *Scientific American*; August 1975
Benny, W.T. & Poole, H.E. *Annals of Printing*; Blandford Press 1966
Bentham, F. *The Art of Stage Lighting*; Pitman 1976
Bergman, G.M. *Lighting in the Theatre*; Almquist 1977 (UK); Rowman 1977 (USA)
Berlin, B. & Kay, P. *Basic Colour Terms: Their Universality and Evolution*; University of California Press 1970 (UK); 1969 (USA)
Besant, A. & Leadbeater, C.W. *Thought Forms*; Theosophical Publishing House, 1970
Bettembourg, J.M. 'Etude des Verres Bleus de Vitraux, Analysé par Spectrométrie d'Absorption Atomique', *Proceedings of the Ninth International Congress of Glass*; Versailles 1971
Birch, G.G., Spencer, A. & Cameron, A.G. *Food Science*; Pergamon Press 1977
Birren, F. *Color, A Survey in Words and Pictures*; New York University Books 1963
Birren, F. *Color for Interiors*; Whitney Library of Design
Birren, F. *Color Psychology and Color Therapy*; Citadel Press 1978
Birren, F. *Creative Color*; Van Nostrand Reinhold 1961
Birren, F. *The History of Color in Painting*; Van Nostrand Reinhold 1965
Birren, F. *Light, Color and Environment*; Van Nostrand Reinhold 1969
Birren, F. *Principles of Color*; Van Nostrand Reinhold 1970
Black, J. Anderson & Garland, M. *A History of Fashion*; Orbis 1975 (UK); Morrow 1975 (USA)
Blake, J. *Colour and Pattern in the Home*; Design Council 1978 (UK)
Blum, H.F. *Photodynamic Action and Diseases Caused by Light*; Reinhold 1941, Hafner 1975
Blunt, W. *Isfahan*; Elek Books 1966
Blunden, M. & G. & Duval, J.-L. *Impressionists and Impressionism*; Distributed by The World Publishing Company
Boas, O.V. & C.V. *Xingu—The Indians, Their Myths*; Souvenir Press 1973
Borradaile, V. & R. (Trs.) *The Strasburg Manuscript*; Alec Tiranti 1966
Boyer, C. *The Rainbow*; Sagamore Press 1959
Brault, G.J. *Early Blazon*; Cambridge University Press 1972
Bristow, I. 'Ready-Mixed Paint in the 18th Century', *Architectural Review*; April 1977
Brochmann, O. *Good or Bad Design?*; Studio Vista 1970
Broughton, W.B. (Ed.) *Colour and Life*; Institute of Biology, London 1964
Brown, P. & Watts, G. *Arts and Crafts of India*; Cosmo Publications 1979 (India)
Brunello, F. *The Art of Dyeing in the History of Mankind*; Neri Pozzo Editore 1968 (Italy); Phoenix Dye Works 1973 (USA)
Bruno, V.J. *Form and Colour in Greek Painting*; Thames & Hudson 1977 (UK); Norton 1977 (USA)
Budge, Sir E.A. Wallis *Amulets and Superstitions*; Dover 1978
Bühler, A. 'The Significance of Colour Among Primitive Peoples', *Palette* No. 9; Sandoz Ltd. Switzerland 1969
Burney, C. *From Village to Empire*; Phaidon 1977
Burton, M. *The Sixth Sense of Animals*; Dent 1973 (UK); Taplinger 1973 (USA)
Bushell, S.W. *Chinese Art*; Victoria and Albert Museum Handbooks 1921
Candee, R.M. *House Paints in Colonial America, Their Materials Manufacture and Application*; Reprint from *Color Engineering*, 1966–67; Chromatic Publishing Co. Inc. (New York)
Cennini, Cennino D'Andrea *The Craftsman's Handbook* Trs. D.V. Thompson; Dover 1933
Cerbus, G. & Nichols, R. 'Personality Variables and Response to Colour', *Psychological Bulletin* Vol. 60 No. 6; 1973
Chamberlin, G.J. *Visual Aids to the Teaching of Colour and Colorimetry and Colorimetric Analysis*; The Tintometer Ltd., Salisbury, England 1965
Chambers, B.G. *Colour and Design in Men's and Women's Clothes and Home Furnishings*; Prentice-Hall 1951
Chase, E.W. *Always in Vogue*; Gollancz 1954
Cheskin, L. *Why People Buy*; British Publications Ltd. in association with Batsford Ltd. 1960
Chevreul, M.E. *The Principles of Harmony and Contrast of Colours and Their Applications to the Arts*; Reinhold Publishing 1967; Garland Publications 1980
Child, H. & Colles, D. *Christian Symbols Ancient and Modern*; G. Bell 1971
CIBA-GEIGY Review; CIBA-GEIGY Ltd., CH-4002, Basle, Switzerland.
Clair, C. *A Chronology of Printing*; Cassell 1969
Clark, D. (Ed.) *How It Works*; Marshall Cavandish 1977
Clulow, F.W. *Colour: Its Principles and Their Applications*; Fountain 1975 (UK); International Publications Services 1973 (USA)
Cockett, S.R. *Dyeing and Printing*; Pitman 1964
Coe, B. *Colour Photography – The First Hundred Years 1840–1940*; Ash & Grant 1978
Coe, B. 'The Development of Colour Cinematography', *International Encyclopaedia of Film* (Ed. Manwell); Michael Joseph 1972
Collins, D. *The Human Revolution: From Ape to Artist*; Phaidon 1976 (UK); Dutton 1976 (USA)
Color Engineering; Chromatic Publishing Co. Inc., 18 John St., New York, NY 10038, USA
Color Research and Application; John Wiley & Sons, 605 Third Av., New York, NY 10016, USA
Constable, W.G. *The Painter's Workshop*; Oxford University Press 1954
Contini, M. *Fashion: From Ancient Egypt to the Present Day*; Hamlyn 1965
Cook, A.M. *Greek Painted Pottery*; Methuen 1960
Cornsweet, T.N. *Visual Perception*; Academic Press 1970
Corson, R. *Fashions in Make-up From Ancient to Modern Times*; Peter Owen 1972
Cosgrove, M.G. *The Enamels of China and Japan*; Dodd 1974
The Costume Society *Costume* (The Journal of the Costume Society); published by the Textile Department of the Victoria and Albert Museum, London
Cott, H.B. *Adaptive Colouration in Animals*; Methuen 1940
Cowen, P. *Rose Windows*; Thames & Hudson 1979 (UK); Chronicle Books 1979 (US)
Cowles, V. *1913*; Weidenfeld & Nicolson 1967
Craig, J. *Production for the Graphic Designer*; Pitman 1974 (UK); Watson-Guptill 1974 (USA)
Cruz-Coke, R. *Color Blindness: An Evolutionary Approach*; Thomas 1970
Danger, E.P. *Using Colour to Sell*; Gower Press 1968 (UK); *How to Use Color to Sell*; CBI Publications 1969 (USA)
Davidoff, J.B. *Differences in Visual Perception: the Individual Eye*; Crosby Lockwood 1975
Day, Lewis F. *Enamelling*; Batsford 1907
Diringer, D. *The Hand-Produced Book*; Hutchinson 1953
Doerner, M. *Materials of the Artist*; Hart-Davis 1969 (UK); Harcourt Brace 1949 (USA)
Dormer, J. *Fashion in the 1920s and 30s*; Ian Allen 1973
Drexler, A. (Ed.) *Architecture of the Ecole des Beaux-Arts*; Secker & Warburg 1977

Dronke, P. 'Tradition and Innovation in Medieval Western Colour-Imagery'; *Eranos Jahrbuch* 1972

Dunlop, I. *The Shock of the New*; Weidenfeld & Nicolson 1972

Durrant, D.W. (Ed.) *Interior Lighting Design Handbook*; The Electricity Council, London 1977

Eastlake, Sir. C.L. *Methods and Materials of Painting of Great Schools and Masters*; Dover 1960

Ebin, V. *The Body Decorated*; Thames & Hudson 1979

EBU Review; The European Broadcasting Union, Case Postale 193, CH-1211, Geneva 20, Switzerland

Editors of Time-Life Books *Color*; (Life Library of Photography); Time-Life International (UK); Time-Life Books (USA)

Eisenstein, S. *The Film Sense*; Faber 1968

Elkin, A.P. *Australian Aborigines*; Angus & Robertson 1964 (Sydney)

Entwistle, E.A. *The Book of Wallpapers: A History and an Appreciation*; Kingsmead Reprints 1970

Fabri, R. *Color, A Complete Guide for Artists*; Pitman 1975 (UK); Watson-Guptill 1967 (USA)

Die Farbe; Musterschmidt-Verlag, Turmstr. 7, Postfach 421, 3400 Goettingen, West Germany

Scientific American; December 1976

Faris, J.C. *Nuba Personal Art*; Duckworth 1972

Farnsworth, S. *Illumination and Its Development in the Present Day*; Hutchinson 1920

Favreau, O.E. & Corballis, N.D. 'Negative Aftereffects in Visual Perception',

Faulkner, W. *Architecture and Color*; Wiley Interscience 1972

Fehervari, G. *Islamic Pottery: A Comprehensive Study Based on the Barlow Collection*; Faber 1973

Fernie, W.T. *Precious Stones: For Curative Wear; and Other Remedial Uses: Likewise the Nobler Metals*; John Wright & Co., Bristol 1907 (UK)

Fisher, R.B. *Syrie Maugham*; Duckworth 1978 (UK); 1979 (USA)

Flanner, J. *Paris was Yesterday*; Angus 1973 (UK); Penguin 1979 (USA)

Fogden, M. & P. *Animals and Their Colours*; Peter Lowe 1974

Fossing, P.S. *Glass Vessels Before Glass-Blowing*; Ejnar Munksgaard 1940 (Denmark)

Fowler, J. & Cornforth, J. *English Decoration in the 18th Century*; Barrie & Jenkins 1974 (UK); 1978 (US)

Fox, D.L. *Animal Biochromes and Animal Structural Colours*; University of California Press 1976

Fox, H. Munro & Vevers, G. *The Nature of Animal Colours*; Sidgwick & Jackson 1960

Frisch, K. von *Bees: Their Vision, Chemical Senses and Language*; Cornell University Press 1972

Fry, C.R. *Art Deco Interiors in Color*; Dover 1977

Gage, J. 'Colour in History, Relative and Absolute', *Art History* (Journal of the Association of Art Historians); March 1978

Gage, J. *Colour in Turner*; Studio Vista 1969

Gage, J. 'The Psychological Background to Early Modern colour; Kandinsky, Delaunay, Mondrian', *Towards a New Art*; Tate Gellery, London 1980

Garbini, G. *The Ancient World*; Hamlyn 1966

Garland, M. *The Changing Face of Beauty*; Weidenfeld & Nicolson 1957 (UK); M. Barrows 1957 (USA)

Garland, M. *The Changing Form of Fashion*; Dent 1970

Garland, M. *Fashion*; Penguin 1965

Garland, M. *The Indecisive Decade*; MacDonald 1968

Gerber, F.H. *Cochineal and the Insect Dyes*; Frederick H. Gerber, Box 1355, Ormond Beach, Florida 32074, USA

Gerber, F.H. *Indigo and the Antiquity of Dyeing*; Frederick H. Gerber, Box 1355, Ormond Beach, Florida 32074, USA

Gerritsen, F. *Theory and Practice of Color*; Studio Vista 1975 (UK); Van Nostrand Reinhold 1975 (USA)

Gettens, R.J. & Stout, G.L. *Painting Materials: A Short Encyclopedia*; Dover 1965

Gilbert, L.E. & Raven, P.H. (Eds.) *Co-Evolution of Animals and Plants*; University of Texas Press 1975

Gimbel T. *Healing Through Colour*; C.W. Daniels 1980

Girard, R. *Color and Composition*; Van Nostrand Reinhold 1974

Gloag, H.L. & Gold, M.J. *Colour Co-ordination Handbook*; H.M.S.O., London 1977

Goethe, J.W. von *Die Farbenlehre*; 1810

Goethe, J.W. von *Theory of Colours* Trs. Sir C.L. Eastlake; Frank Cass 1967, MIT Press 1971 (UK); MIT Press 1970 (USA)

Goldstein, K. 'Some Experimental Observations Concerning the Influence of Colours on the Function of the Organism', *Occupational Therapy and Rehabilitation*; June 1972

Graham, C.H. (Ed.) *Vision and Vision Perception*; Wiley 1965

Grant, M. *Cities of Vesuvius: Pompeii and Herculaneum*; Thames & Hudson 1976

Graves, R. & Hodge, A. *The Long Weekend: A Social History of Great Britain 1918–1939*; Penguin 1971 (UK); Norton 1963 (USA)

Gregory, R.L. *Eye and Brain: The Psychology of Seeing*; Weidenfield & Nicholson 1971

Greysmith, B. *Wallpaper*; Studio Vista 1976 (UK); Macmillan (USA)

Gunn, F. *The Artificial Face*; David & Charles 1973

Halliwell, L. *The Filmgoer's Companion*; Hart-Davis 1977

Hamer, F. *The Potter's Dictionary of Materials and Techniques*; Pitman 1975 (UK); Watson-Guptill 1975 (USA)

Hardoy, J.E. *Pre-Columbian Cities*; Allen and Unwin 1973

Hardy, A.C. (Ed.) *Colour in Architecture*; Leonard Hill 1967

Harley, R.D. *Artists' Pigments c.1600–1835*; Butterworth 1970

Harris, M. *Natural System of Colours*; 1811 (London)

Hatje, G. & Kaspar, P. *Decorating Ideas for Modern Living*; Abrams 1977 (USA)

Hatje, G & Kaspar, P. *Design for Modern Living*; Thames and Hudson 1975 (UK)

Heath, F.J. *An Introduction to the C.I.E. System*; The Tintometer Ltd., Salisbury, England

Heaton, J.M. *The Eye: Phenomenology and Psychology of Function and Disorder*; Tavistock 1968 (UK); Lippincott 1968 (USA)

Hedgecoe, J. *The Art of Colour Photography*; Mitchell Beazley 1978 (UK); Simon & Schuster 1978 (USA)

Henderson H., Cooke E., Bowcock S. & Hackett M. 'After-Exercise Thermography for Predicting Post-Operative Deep Vein Thrombosis', *British Medical Journal No. 1*; 1978

Henderson, S.T. *Daylight and Its Spectrum*; Hilger 1970

Henderson, S.T. & Marsden, A.M. (Ed.) *Lamps and Lighting*; Edward Arnold 1972

Herberts, K. *Oriental Lacquer*; Thames & Hudson 1962

Herriot, D.R. 'Applications of Laser Light', *Scientific American*; September 1968

Hetherington, P. (Trs.) *Dionysius of Fourna: The Painter's Manual*; Sagittarius Press 1974

Hillier, B. *Art Deco of the 20s and 30s*; Studio Vista 1975

Hillier, B. *Austerity Binge*; Studio Vista 1975

Hinks, P. *Jewellery*; Hamlyn 1969

Hodges, H. *Technology in the Ancient World*; Allen Lane 1970

Holm, W.A. *Colour Television Explained*; Philips Technical Library 1963 (Germany); 1965 (UK)

Homer, W.I. *Seurat and the Science of Painting*; Cornell University Press 1978

Honor, H. *Romanticism*; Allen Lane 1979 (UK); Harper & Row 1979 (USA)

Horridge, G.A. 'The Compound Eye of Insects', *Scientific American*; July 1977

House & Garden Color Guide; Condé Nast Publications Inc., 350 Madison Av., New York, NY 10017

Howell, G. (Ed.) *In Vogue: Six Decades of Fashion*; Allen Lane 1975 (UK)

Howell, G. (Ed.) *In Vogue: Sixty Years of International Celebrities and Fashion from British Vogue*; Schocken 1976 (USA)

Hubel, D. 'The Visual Cortex of the Brain', *Scientific American*; November 1963

Hubel, D. & Weisel T. 'Brain Mechanisms of Vision', *Scientific American*; September 1979

Huizinga, J.H. *The Waning of the Middle Ages*; Penguin 1972 (UK); St Martin's Press 1924 (USA)

Hunt R.W.G. *Reproduction of Colour in Photography, Printing and Television*; Fountain Press 1975 (UK); International Publications Service 1975 (USA)

Huxley, F. *Affable Savages*; Hart-Davis 1957

I.C.I. *In Search of Colour*; Imperial Chemical Industries Ltd., Dyestuffs Division, Manchester, UK

I.C.I. *Schools Science Series 1–3*; Imperial Chemical Industries Ltd., Paints Division, UK

I.E.S. *I.E.S. Code for Interior Lighting*; Illuminating Engineering Society, London

Itten, J. *The Elements of Color*; Van Nostrand Reinhold 1971

Jahss, M. & B. *Inro and Other Forms of Japanese Lacquer Art*; Kegan Paul 1970 (UK); C.E. Tuttle 1970 (USA)

Jekyll, G. *On Gardening*; Studio Vista 1979

Jenkins, A. *The Twenties*; Heinemann 1976

Jensen, H. *Sign Symbol and Script*; Allen & Unwin 1970

Jobé, J. (Ed.) *The Art of Tapestry*; Thames & Hudson 1965

Johnson, L. *Delacroix*; Weidenfeld & Nicholson 1963

Jones, O. *Grammar of Ornament*; 1910 (London)

Jones, T.D. *The Art of Light and Color*; Van Nostrand Reinhold 1973

Judd, D.B. & Wyszecki, G.W. *Color in Business, Science and Industry*; Wiley 1975

Jung, C.G. *Archetypes and the Collective Unconscious*; Routledge 1959 (UK); University of Princeton Press 1969 (USA)

Jung, C.G. *Man and His Symbols*; Aldus 1964

Jung, C.G. *Memories, Dreams, Reflections*; Fontana 1967 (UK) Random House 1963 (USA)

Jung, C.G. *Psychology and Alchemy*; Routledge 1953 (UK); Princeton University Press 1968 (USA)

Kalmus, H. *Diagnosis and Genetics of Defective Colour Vision*; Pergamon Press 1965

Kandinsky, W. *Concerning the Spiritual in Art*; Arts Council of Great Britain 1978 (UK); Wittenborn 1967 (USA)

Kaufmann, E. *The Rise of an American Architecture*; Metropolitan Museum of Art 1970 (USA); Pall Mall Press 1970 (UK)

Kaufman, L. *Sight and Mind: An Introduction to Visual Perception*; Cambridge University Press 1975

Kelly, K.L. & Judd, D.B. *Universal Color Language and Dictionary of Names*; National Bureau of Standards, Department of Commerce 1976 (USA)

Kirkaldy, J.F. *Minerals and Rocks in Colour*; Blandford Press 1968 (UK); Hippocrene Books 1969 (US)

Klossowski de Rola, S. *Alchemy, the Secret Art*; Thames & Hudson 1973 (UK); Avon Books (USA)

Kobayashi, S. *The Japanese Heart and Their Color*; Nippon Color and Design Research Institute, Inc., Tokyo

Kornerup, A. & Wanscher, J.H. *Farver I Farver*; Politikens Forlag 1961 (Denmark)

Kornerup, A. & Wanscher, J.H. *Methuen Handbook of Colour*; Methuen 1978 (UK)

Krippner S. & Rubin, D. *Galaxies of Life: The Human Aura in Acupuncture & Kirlian Photography*; Gordon & Breach 1973

Kuhn, H. *The Rock Pictures of Europe*; Sidgwick & Jackson 1956

Künz, G.F. *The Curious Lore of Precious Stones*; Lippencott 1956

Küppers, H. *Du Mont's Farben-Atlas*; Dumont Buchverlag, Köln 1978 (Germany)

Küppers, H. *Color: Origin, Systems, Uses*; Van Nostrand Reinhold 1974

Laming, A. *Lascaux*; Penguin 1959

Land, E.H. 'Experiments in Colour Vision', *Scientific American*; May 1959

Land, E.H. 'The Retinex Theory of Colour Vision' *Scientific American*; December 1977

Land, M. 'Nature as an Optical Engineer', *New Statesman*; October 1979

Laurie, A.P. *Materials of the Painter's Craft*; Longwood 1979 (1910 Edition)

Laurie, A.P. *The Pigments and Mediums of the Old Masters*; Macmillan 1914

Laver, J. *Age of Illusion*; Weidenfeld & Nicolson 1972

Laver, J. *Edwardian Promenade*; Edward Hutton 1958

Lawler, C.O. & Lawler, E.E. 'Colour-Mood Associations in Young Children', *Journal of Genetic Psychology*; 1965

Leadbeater, C.W. *Man Visible and Invisible*; Theosophical Publishing House 1920 (UK); 1969 (USA)

Lee, L., Seddon, G., & Stephens, F. *Stained Glass*; Mitchell Beazley 1976

LeGrand, Y. *Light Colour and Vision*; Chapman & Hall 1957

Lelong, L. *Théâtre de la Mode*; Aljanvic Imprimerie de Bobigny 1945

Leroi-Gourhan, A. *The Art of Prehistoric Man in Western Europe*; Thames & Hudson 1968

Levin, B. *The Pendulum Years: Britain and the Sixties*; Cape 1970, Pan 1972 (UK)

Levi-Strauss, C. *Structural Anthropology*; Allen Lane, The Penguin Press 1968

Light Fantastic, Catalogue of the Exhibition at the Royal Academy, London 1978; Bergstrom & Boyle Books Ltd.

Lowenfeld, M. *The Lowenfeld Mosaic Test*; Newman Neame 1954

Lucas, A. *Ancient Egyptian Materials and Industries*; Edward Arnold 1948

Lüscher, Dr. M. *Colour Test*; Test-Verlag, Basle, Switzerland 1948, 1969

Lüscher, Dr. M. *Four-Colour Person*; Simon & Schuster 1979

Lüscher, Dr. M. *The Lüscher Colour Test*; Cape 1970, Pan 1972 (UK)

Lüscher, Dr. M. 'Package Design and Colour Psychology', *Palette* No. 5; Sandoz Ltd. 1960 (Switzerland)

Lüscher, Dr. M. *Personality Signs*; Warner Books 1979

Lüscher, Dr. M. 'The Psychology of Colours', *Palette* No. 1; 1959

Lynes, J.A. (Ed.) *Developments in Lighting I*; Applied Science Publishers 1978

Lynes, J.A. *Principles of Natural Lighting*; International Ideas 1968

MacKean, D.G. *Introduction to Biology*; John Murray 1979

MacNichol, E. 'Three-pigment Colour Vision', *Scientific American*; December 1964

Maddock, K. *The Australian Aborigines*; Allen Lane 1973

Mann, F. *Acupuncture: The Ancient Chinese Art of Healing*; Heinemann Medical 1978

Margetson, S. *The Long Party*; Gordon & Cremonsei 1976 (UK); Saxon 1975 (USA)

Marshack, A. *The Roots of Civilisation*; Weidenfeld & Nicholson 1972

Marx, E. *The Contrast of Colors*; Van Nostrand Reinhold 1974

Mayer, R. *The Painter's Craft*; Nelson 1976 (UK); Penguin 1979 (USA)

Medley, M. *The Chinese Potter*; Phaidon 1976

Merrifield, M.P. *Original Treatises on the Arts of Painting: 1849*; Dover 1967

Michael, C.R. 'Colour Sensitive Hypercomplex Cells in Monkey Striate Cortex', *Journal of Neurophysiology*; May 1979

Minnaert, M. *The Nature of Light and Colour in the Open Air*; Dover 1973 (UK); Dover 1948 (USA)

Mitchel, S. *Medieval Manuscript Painting*; Weidenfeld & Nicolson 1964

Montgomery, J. *The Fifties*; Allen & Unwin 1965

More, L.T. *Isaac Newton: A Biography*; Dover 1962

Morenz, S. 'The Role of Colour in Ancient Egypt', *Palette* No. 11; Sandoz Ltd. 1962 (Switzerland)

Morgans, W.M. & Taylor, J.R. *Introduction to Paint Technology*; Colour Chemists Association 1976

Mueller, C.G. & Rudolph M. (Eds.) *Light & Vision*; Time-Life International (UK); Time-Life Books (USA)

Munsell, A.H. *The Munsell Book of Color: Munsell's Color Notations*; Munsell Color— MacBeth Division of the Kollmorgan Corp. 1976

National Gallery, Technical Bulletin; Publications Department, National Gallery, London

Needham, J. *Science and Civilization in China*; Cambridge University Press

Neubecker, O. & Brooke-Little, J.P. *Heraldry: Sources, Symbols and Meanings*; Macdonald & Jane's 1977 (UK); McGraw-Hill 1976 (USA)

Newton, Sir I. *Opticks*; Dover 1952

Nuckolls, J.L. *Interior Lighting for Environmental Designers*; Wiley 1976

Nussenzveig, H.M. 'The Theory of The Rainbow', *Scientific American*; April 1977

Osborne, H. 'Colour Concepts of the Ancient Greeks', *British Journal of Aesthetics* No. 8; 1968

Packard, V. *The Hidden Persuaders*; Penguin 1962

Palette; Sandoz Ltd., Dyestuffs Dept., CH-4002, Basle, Switzerland

Parsons, J. *Introduction to Colour Vision*; Cambridge University Press 1924

Patchett, G.N. *Colour Television with Particular Reference to the PAL System*; Norman Price 1974

Pavey, D.A. 'The Eclipse of the Blue Moon', *Arc No. 22*; 1958

Pettit, F.H. *America's Indigo Blues*; Hastings House 1974

Pilbrow, R. *Stage Lighting*; Studio Vista 1979

Pirenne, M.H. *Vision and The Eye*; Chapman & Hall 1967

Polhemus, T. *Social Aspects of the Human Body*; Penguin 1978

Polyak, S. *The Vertebrate Visual System*; University of Chicago Press 1958 (UK); 1957 (USA)

Pope, A.U. *Persian Architecture*; Thames & Hudson 1965

Porter, T. 'Investigations into Colour Preferences', *Designer*; September 1973

Porter, T. & Mikellides, B. *Colour for Architecture*; Studio Vista 1976

Powell, T.G.E. *Prehistoric Art*; Thames & Hudson 1966

Pritchard, D.C. *Lighting*; Longmans 1978

Proctor, M. & Yeo, P. *The Pollination of Flowers*; Collins 1972 (UK); Lowe, 1978 (UK); *Colour in Plants and Their Flowers*; Everest House 1978 (USA)

Proctor, M. & Yeo, P. *The Pollination of Flowers*; Collins 1972 (UK); Taplinger 1973 (USA)

Pyke, M. *Food Science and Technology*; John Murray 1976

Pyke, M. *Synthetic Food*; John Murray 1975

Radcliffe-Brown, A. *The Andaman Islanders*; Cambridge University Press 1933 (UK); Free Press of Glencoe 1964 (USA)

Rewald, J. *The History of Impressionism*; Secker & Warburg 1973 (UK); Museum of Modern Art 1973 (USA)

Rice, D. Talbot *Byzantine Art*; Penguin 1968

Rice, D. Talbot *Art of the Byzantine Era*; Thames & Hudson 1963

Rice, D. Talbot *Church of the Hagia Sophia, Trebizond*; Edinburgh University Press 1968

Rickers-Ovsiankina, M.A.A., Knapp, R.H. & MacIntyre, D.W. 'Factors Affecting the Psychodiagnostic Significance of Colour Perception', *Journal of Projective Techniques* No. 27; 1963

Riefstahl, E. *Ancient Egyptian Glass and Glazes in the Brooklyn Museum*; Brooklyn Museum 1968

Riefenstahl, L. *People of Kau*; Harper & Row 1978

Robertson, M. *A History of Greek Art*; Cambridge University Press 1975

Robertson, S. *Dyes From Plants*; Van Nostrand Reinhold 1979

Rodiek, R.W. *The Vertebrate Retina: Principles of Structure and Function*; W.H. Freeman 1974

Rood, O.N. *Modern Chromatics A Student's Textbook of Color with Application to Art and Industry*; Van Nostrand Reinhold 1973

Rowan, J. 'Psychology of Colour in Sales Motivation', *The Print Buyer* No. 12; August 3 1969

Rubin, M. & Walls, G. *Fundamentals of Visual Science*; Thomas 1972

Rudofsky, B. *Are Clothes Modern?*; Theobold 1947

Ruffle, J. *Heritage of the Pharaohs*; Phaidon 1977

Ruhemann, H. *The Cleaning of Paintings, Problems and Possibilities*; Faber 1969

Rushton, W. 'Visual Pigments in Man', *Scientific American*; November 1962

Ryan, R.T. *History of Motion Picture Colour Technology*; Focal Press 1977 (UK); 1978 (USA)

Saint-Laurent, C. *L'Histoiré Imprévu des Dessous Feminins*; Solar 1966

Sandars, N.K. *Prehistoric Art in Europe*; Penguin 1968

Savage, G. *Porcelain Through the Ages*; Penguin 1963

Schafer, E.H. *Ancient China*; Time-Life International 1968 (UK); Time-Life Books (USA)

Schaie, K. Warner 'On the Relation of Colour and Personality', *Journal of Projective Techniques*; No. 30; 1966

Schapiro, M. 'New Light on Seurat', *Art News* No. 57; April 1958

Schawlow, A.L. 'Laser Light', *Scientific American*; September 1968

Schumann, W. *Stones and Minerals*; Lutterworth Press 1974

Scott-Giles, C.W. *Boutell's Heraldry*; Frederick Warne 1954

Scottish Arts Council *Fashion 1900–1939*; Catalogue of the Exhibition at the Victoria and Albert Museum, 1975

Seitz, W.C. 'Monet and Abstract Painting', *College Art Journal*; Fall 1956

Sellner, von C., Oel, H.J., & Camera, B. 'Untersuchung alter Glaser (Waldglas) auf Zusammenhang von Zusammensetzung, Farbe und Schmelzatmosphare mit der Elektronenspektroskopie und der Elektronenspinresonanz (ESR)', *Glastechnische Berichte* Vol. 52; December 1979

Sergeant, J. *Frank Lloyd Wright's Usonian Houses*; Watson-Guptill 1966

Sieveking, A. *The Cave Artists*; Thames & Hudson 1979

Simon, H. *The Splendour of Iridescence*; Dodd Mead 1971

Smythe, R.H. *Vision in the Animal World*; Macmillan 1975

The Society of Dyers and Colourists, Bradford, England *Introducing Colour* (Teaching Booklet)

Speiser, W. *Oriental Architecture in Colour*; Thames & Hudson 1965

Spencer, C. *Leon Bakst*; Academy Editions 1973 (UK); Rizzoli International 1979 (USA)

Spenser, W. *Oriental Architecture in Colour*; Thames & Hudson 1965

Strathern, A. & M. *Self-Decoration in Mount Hagen*; Duckworth 1971

Strong, R. & Brown, D. (Eds.) *Roman Crafts*; Duckworth 1976

Storey, J. *The Thames and Hudson Manual of Dyes and Fabrics*; Thames & Hudson 1978

Sumner, F.B. 'The Cause Must Have Had Eyes', *Scientific Monthly* No. 60

Swindler, M.H. *Ancient Painting: From the Earliest Times to the Period of Christian Art*; Yale University Press 1929

Taylor, E.S. & Wallace, W.J. *Mohave Tattooing and Face-Painting*; Los Angeles South West Museum, Leaflet No. 20; 1947

Taylor, F.A. *Colour Technology for Artists, Craftsmen and Designers*; Oxford University Press 1962

Thompson, D.V. (Trs.) *De Arte Illuminandi The Technique of Manuscript Illustration*; Yale University Press 1933

Thompson, D.V. *The Materials and Techniques of Medieval Painting*; Dover 1971

Thorn Lighting Ltd., London: *Technical Handbook*

Trevor-Roper, P. *The World Through Blunted Sight*; Thames & Hudson 1970

Tritten, G. *Teaching Colour and Form in Secondary Schools*; Van Nostrand Reinhold 1975

Turner, Dr. T. 'The Social Skin: Interface with the World', *New Scientist*; June 1979

Turner, V.W. 'Colour Classification in Ndembu Ritual', *Anthropological Approaches to the Study of Religion*; Tavistock 1966

Tylecote, R.F.A. *History of Metallurgy*; The Metals Society 1976 (UK)

Ucko, P. 'The Oldest Art', *Times Literary Supplement*; December 19 1963

Ucko, P.J. & Rosenfeld, A. *Paleolithic Cave Art*; Weidenfeld & Nicolson 1967

Van Zanten, D.T. *Architectural Polychromy of the 1830s*; Garland 1977

Vasari, G. *The Lives of Painters, Sculptors and Architects*; Everyman's Library 1973 (UK); Duttons 1960 (USA)

Vasari, G. *Vasari on Technique*; Dover 1960

Vaughan, W. *Romantic Art*; Thames & Hudson 1978

Veith, I. (Ed.) *The Yellow Emperor's Classic of Internal Medicine*; University of Chicago Press 1972

Voke, J. 'Colour Vision Requirements in Industry and Services', *The Optician* No. 165; March 30 1973

Voke, J. 'A Guide to Colour Vision Tests', *The Optician* No. 165; February 23 1973, February 30 1973

Voke, J. 'A Survey of Colour Vision', *The Optician* No. 165; February 9 1973

Wagner, Sir A.R. *Heraldry and Heralds in the Middle Ages*; Cambridge University Press 1960

Warren, G. *All Colour Book of Art Nouveau*; Octopus 1974 (UK); Crown 1974 (USA)

Warren, G. *Art Nouveau*; Orbis 1972 (UK)

Weale, R.A. 'The Tragedy of Pointillism', *Palette* No. 40; 1972; Sandoz Ltd. (Switzerland)

Webster, J.C. 'The Technique of Impressionism: A Reappraisal', *College Art Journal*; 1944

Wehlte, K. *The Materials and Techniques of Painting*; Van Nostrand Reinhold 1975

Wellington, S.I. *The Art of the Brazilian Indian*; Published under the auspices of the Brazilian Embassy in conjunction with the British Museum (Dept. of Ethnography) Exhibition 1978

White, P. *Poiret*; Studio Vista 1973

Whitehouse, R. *The First Cities*; Phaidon 1977 (UK); Dutton 1977 (USA)

Wiborg, F.B. *Printing Ink—A History*; Harper Bros. 1926

Wickler, W. *Mimicry in Plants and Animals*; Weidenfeld and Nicolson 1968 (UK); McGraw-Hill 1968 (USA)

Wigglesworth, Sir V.B. *Principles of Insect Physiology*; Halstead Press 1973 (UK); Chapman & Hall 1974 (USA)

Wild, A.M. de *The Scientific Examination of Pictures*; 1929 (London)

Wilkinson, F. *Edged Weapons*; Guinness Signatures 1970

Williams, C.A.S. *Encyclopaedia of Chinese Symbolism and Art Motives*; Julian Press 1960 (UK)

Williams, C.A.S. *Outlines of Chinese Symbolism and Art Motives*; C.E. Tuttle 1960 (USA)

Winsor and Newton Ltd., *Notes on the Composition and Permanence of Artists' Colours*

Wolken, J.J. *Invertebrate Photoreceptors: A Comparative Analysis*; Academic Press 1971

Wright, F. Lloyd *The Natural House*; Pitman 1971 (UK); Horizen 1957 (USA)

Wright, F. Lloyd *A Testament*; Horizen 1957

Wright, M. (Ed.) *The Complete Book of Gardening*; Michael Joseph 1978 (UK); Lippincott 1979, Warner Brooks 1979 (USA)

Wright, W.D. *The Measurement of Colour*; Hilger 1969 (UK); Textile Books 1969 (USA)

Wright, W.D. *The Rays Are Not Coloured*; Hilger 1967 (UK); Elsevier 1968 (USA)

Wurtman, R. 'The Effects of Light on the Human Body', *Scientific American*; July 1975

Young, D. *Douglas Young's ABC of Stage Makeup for Men* and *Douglas Young's ABC of Stage Makeup for Women*; Samuel French, London 1977

Youngblood, G. *Expanded Cinema*; Studio Vista 1970 (UK); Avon 1978 (USA)

Yule, J.A.C. *Principles of Color Reproduction*; Wiley 1967

Zeki, S.M. 'The Cortical Projections of Foveal Striate Cortex in the Rhesus Monkey', *Journal of Neurophysiology* Vol. 42; 1979

Zeki, S.M. 'Uniformity and Diversity of Structure and Function in Rhesus Monkey Prestriate Visual Cortex', *Journal of Physiology* No. 277; 1978

Acknowledgements

Research/writing/translations: Andy Armstrong; Russell Ash; Chris Cooper; Sarah Culshaw; Katherine Forman (USA); Robin Fox; Alicia Harpur; Cynthia Hole; Belinda Hunt; Caroline Landeau; David MacFadyen; Yvonne McFarlane; Sanda Miller; David Owen; Celia Parker; Oliver Slater; Victor Stevenson; Susan Wasson; Libby Wilson; Daphne Wood

The Publishers received invaluable help from the following people and organizations:

Nadine Bertin (Editor, House & Garden Magazine, New York); Ralph Broadhurst, B.Sc. (Curator of the Colour Museum, The Society of Dyers & Colourists, Bradford); Richard Bruce; Mary-Clare Clark; Painton Cowen; Doris Crary (Color Marketing Group; Director of New Product Development, Prince Matchabelli Division, Chesebrough-Ponds Inc.); Jacquelyn R. Denning (New Product Development, Chesebrough Ponds Inc.); Laura De Angelo (House & Garden Magazine, New York); Professor R.J. Fletcher (Head of the Department of Ophthalmic Optics and Visual Science, The City University, London); Stephen Foss; Dr. Stephen Fulder; Lou Graham (Color Marketing Group); Dr. Leon Greenstein (The Mearl Corporation); Margaret B. Halstead; Julia Hutt (Far Eastern Department of the Victoria & Albert Museum); Tom Heck (Wells, Rich & Green); Lawrence Herbert (President, Pantone Inc); Alice Howard; Roger Huntley (Richard Rogers & Partners); Mrs Leonard Ingrams; Camilla Kennet (Phillip Henderson Co); Kunimi (Richard Rogers & Partners); Jack Lenor Larsen; J.H. Leach (Director, Tootal Ltd); Bob Learmonth (Deryck Healey International); Audrey Levy (Head of the Department of Textiles & Fashion, Faculty of Art & Design, Manchester Polytechnic); Rena Lustberg (Ameritex Inc); Lt. Col. Marcus McCausland B.A., (Director, Health for the New Age); Dr. Christopher Macgregor; Dr. Kate Macsorley; Gerald Millerson; Ian Moo-Young; Dr. Howard R. Moscowitz (Executive Vice President & Technical Director, Developmetrics Inc); Dr Joseph Needham; John Oberle (Chief Chemist, Benjamin Moore & Co); Ruby Ordookhanian (Product Developments, Chesebrough-Ponds Inc); Robert Ornbo (Theatre Projects); Joyce Plesters (The National Gallery); Dr. Phillip Rawson; June B. Roche (Corporate Fashion Director, Milliken & Co); Mark Rothorne (Department of Health and Social Security); Dr. Jill Sales; Gordon Smith (Marketing Manager, The Tintometer Ltd); Andrew Spurling; Peter J. Staples; Martin Stevens (Vice President Creative Services, Revlon, New York); Charles Secret; A.R. Stanley (B.B.C.); D.W. Thornton (John Walton of Glossop); Dr. G. Boris Townsend (Head of Engineering Information Service, IBA); Morton B. Trachtenberg (Executive Vice President, Sweet & Company Advertising Inc); Geoff Treissman; Mrs. Tricario (Fashion Institute of Technology, New York); Keith Walker (John Walton of Glossop); Al Ware (Head of the Textile Color Association, Doric Publishing Co Inc); Larry Wilson (President, Doric Publishing Co Inc); Glenda Wood (Granada Television); Patrick Woodward; Douglas Young; John Young (Richard Rogers & Partners); Professor Zeki

AGA Infrared Systems Ltd; Ames Company; Ault & Wiborg International Ltd; ATV Network Ltd; Australian Information Service; Ronald P. Beesley (College of Psycho-therapeutics); Berger, Jenson & Nicholson Ltd (Berger Paints Division); Berol Ltd; Blythe Colours Ltd; J.W. Bollom & Co Ltd; Braniff International Airways; The Brick Advisory Centre; The British Carnation Society; The British Fish Processors Association; The British Library; The British Museum; The British Museum (Natural History); The British Museum, Department of Ethnology (Museum of Mankind); The British Optical Association; The British Red Cross Society; J.B. Brown (Celanese Fibers Marketing Co); Burrell Colours Ltd; Clive Burrows (Keeler Optical Products Ltd); Elizabeth Carmichael, MA (Assistant Keeper, Department of Ethnography, Museum of Mankind); Charterhouse Library, St Bartholomew's Hospital Medical College; Chemist & Druggist Directory Children's Research Unit, London; CIBA-GEIGY (UK) Ltd; Dr. R.P. Clarke (MRC Clinical Research Centre); L.S. Colchester (Hon. Archivist & Acting Librarian, Wells Cathedral); Concord Lighting International Ltd; The Courtauld Institute of Art; Crosse & Blackwell Ltd; Cumberland Graphics Ltd; Coventry Cathedral Publicity Office; Delawarr Laboratories Ltd; East Malling Research Station for Fruit; Educational Media International; Educational Productions Ltd; The Embassy of the People's Republic of Bulgaria; Exploratorium; John E. Fells & Sons Ltd; Films Inc; Ford Motor Company Ltd; John Foulds, ASDC (Head of Textile Research, Royal College of Art); The Fresh Fruit & Vegetable Information Bureau; Rodrick Friend; Glass Bulbs Ltd; Gunther Wagner Pelikan-Werke GmbH; Michael Hart (Food Manufacturers' Association); H.J. Heinz Co Ltd; E.W. Hine (Director, E.S.A. Creative Learning Ltd); Sandra Hunt; ICI Dyestuffs, Paint and Organics Divisions; Kendall L. Johnson, ABJD (Paraphysics Inc); Michèle Julien; Win Kent; Dennis G. King (G. King & Son (Lead Glaziers) Ltd); F.E. Large (Thorn Lighting Ltd); Mervyn Lloyd; A. Leete & Co Ltd; Lightolier Inc; Malcolm Menzies (Marks & Spencer Ltd); Dr. Thelma Moss; Mullard Ltd; The National Gallery; National Vegetable Research Station; The Norfolk Lavender Co; Susan Norris; Obex Ltd; The Optical Information Council; P & O Group Services, London; George Percy Painter (Lecturer in Fine Arts at the North East London Polytechnic); The Paintmakers' Association of Great Britain; Philips Electrical Ltd; Polymers Paint Color Journal; The Radionic Association; Rank Strand Electric Ltd; Reckitt & Colman Ltd, Pharmaceutical Division; Reeves & Sons Ltd; Bernard Ridgway; George Rowney & Co Ltd; The Royal College of Art; The Royal Horticultural Society; The Royal Society of Medicine; J. Sainsbury Ltd; St. Bartholomew's Hospital; Barry Salt, B.Sc; Sandoz Products Ltd; Seward Pharmaceutical; Jack Siderman (Pantone Inc); Brian Snellgrove, BA; School of Oriental and African Studies, University of London; J. Schwartz (Pantone Inc); Society of Cosmetic Scientists; The Soil Association; Swada (London) Ltd; Tabard Frères et Soeurs (Aubusson); The Tate Gallery; Technicare Imaging Ltd; Luke Thorington (Duro-Test Corporation); Professor William A. Tiller; Patricia Turner; The Victoria and Albert Museum; The Warburg Institute; Josiah Wedgwood & Sons Ltd; Wella (Great Britain) Ltd; The Wellcome Institute for the History of Medicine; Professor Morris Wilkins (Professor of Biophysics, City of London Polytechnic); R.M. Wilson, C.Eng; AMIChem.E., C.Chem., FRIC; Yardley of London Ltd.

Artwork credits
b=bottom c=centre l=left r=right t=top
Pages 38/39: courtesy London Transport; 42: Don Pavey; 43tl: Don Pavey; 43tr: Robert Wilson 'The Practical Wilson Colour System' courtesy Wray Wilson; 43b: Sydney Harry; 75b: Professor Roy Newton; 139tl: courtesy Hayward, Mitchell & Pavey Limited; 142/3: Audrey Mitchell; 144b: Robert Wilson 'The Practical Wilson Colour System' courtesy Wray Wilson; 152–3: cutlery by David Mellor; 156/7: make-up by Douglas Young; wigs by John Frieda

Illustrators: Ian Bristow (83); Tom McArthur (32/5)
Artwork and retouching: Roy Flooks
Photographic prints: Carl Henry Ltd.